German Art
from Beckmann
to Richter

German Art from Beckmann to Richter

Images of a Divided Country

edited by Eckhart Gillen

DuMont Buchverlag in association with
Berliner Festspiele GmbH and
Museumspädagogischer Dienst Berlin

DUMONT

This book is published to accompany the exhibition "Deutschlandbilder. Kunst aus einem geteilten Land", from September 7, 1997 to January 11, 1998 at Martin-Gropius-Bau, Berlin.

An exhibition of the 47. Berliner Festwochen in cooperation with Museumspädagogischer Dienst, Berlin

Under the auspices of the Federal President Roman Herzog

Organized by Berliner Festspiele GmbH
Director: Ulrich Eckhardt
Managing director: Hinrich Gieseler

Museumspädagogischer Dienst Berlin
Director: Jochen Boberg

Scientific advisers:
Ulrich Bischoff – Eugen Blume – Matthias Flügge – Dieter Honisch – Jörn Merkert – Lothar Romain – Karl Ruhrberg (chairman) – Karin Thomas – Klaus Werner

Enabled through Stiftung Deutsche Klassenlotterie Berlin

Supported by
Daimler-Benz – BVG – Lufthansa – DeutschlandRadio Berlin – Berlin-Fernsehen B1 – debis Immobilien-management – Fubac Großflächenwerbung

Issued by
Berliner Festspiele GmbH and Museumspädagogischer Dienst Berlin

Editor: Eckhart Gillen (MD Berlin)

English copy editing: Anita Brockmann, Alan Fear, Claudia von der Heydt

Editing and Coordination:
Henriette Kolb– Yvonne Rehhahn

Editing – MD Berlin:
Elisabeth Moortgat

Illustration editor:
Regina Schultz-Zobrist,
Dorothea Zwirner

Artists' biographies: Dorothea Zwirner

Research: Hauke Reich

Translation: Susan Bernofsky (pp. 352f.); Pauline Cumbers (pp. 46f., 84, 214f. [biographies], 289f., 293f., 342f., 416f., 429f., 458f., 500f.); Kimberley Duenwald (pp. 44f., 92f., 152f., 302f., 358, 404f., 440f., 466f., 474f.); Ishbel Flett (pp. 500f.); Madelon Fleminger (for all the texts not mentioned); Katherine Funk-Roos (pp. 429f. – Comment on the Constitution); Clifford Jones (pp. 8, 28f., 85f., 111f., 170f., 276f., 324f., 332f., 446f., 460f., 480f.); Claudia Lupri (pp. 139f., 261f., 381f.)

Design: Georg von Wilcken (MD Berlin)

Reproduction: Friedhelm Hoffmann

Production: Peter Dreesen

Assistant: Marcus Muraro

Composition: gluske + harten, Cologne

Lithography: HDL, Cologne – graphik atelier 13, Kaarst – Daiber, Sigmaringendorf – Litho Köcher, Cologne

Printing: Rasch, Bramsche

Binding:
Bramscher Buchbinder Betriebe

Distributed throughout the world by:
Yale University Press

Library of Congress Catalog Card Number 97-80501
A catalog record for this book is available from the British Library

Cover:

Max Ernst, *The House Angel* (The Triumph of Surrealism), 1937 (fig. 4, p. 31)

Contents

Thanks and Acknowledgements

The exhibition "Deutschlandbilder" on which this
book is based on could only be realized thanks to
the trust and extraordinary support of the artists
and lenders who were willing to part with their
masterpieces for an extended period of time. To the
artists who through many intensive conversations,
influenced and supported the work in conceiving
and realizing the exhibition, I offer my gratitude.
Eberhard Roters accompanied the initial explora-
tory talks with his encouragement and insightful
comments. • Ulrich Eckhardt, the Director of the
Berliner Festspiele, layed the foundation for the
project with endurance and energy. I am pleased
that the idea of an exhibition of German art that
transgresses mental and ideological boundaries,
which he had pursued even before the Wall fell,
will be realized in the year of his 25th anniversary.
Not least, he was able to convince the Stiftung
Deutsche Klassenlotterie Berlin to make the exhi-
bition at all possible with a generous donation. I
give my heartfelt thanks to the members of the
Stiftung's council. And starting with the Managing
Director Hinrich Gieseler, I also want to thank here
all of the employees of the Berliner Festspiele. •
Jochen Boberg integrated the exhibition plan into
the work context of the Museumspädagogischen
Dienst, Berlin. • The theoretical advisory council
under the judicious direction of Eberhard Roters
and later under Karl Ruhrberg, had accompanied
the conceptual progress with stimulating debates
since 1994. • The former Cologne gallerist Rudolf
Zwirner, supporter, way paver, and cultivator of West
German art of the 1960's and 1970's, committed
his help spontaneously and opened the doors for
me to important private collectors and artists. • In
night-long conversations in the painter Heribert C.
Ottersbach's atelier, the title "Deutschlandbilder"
emerged from his enthusiasm and the exhibition
took on its first contours. • Gerhard Richter's con-
tinual support and his personal efforts on behalf
of the exhibition were a great encouragement. I
also wish to thank his assistants Hubertus Butin
and Frank Wickert. That the cycle *October 18, 1977*
will be shown for the first time in Berlin is a result
of the efforts of Jean Christophe Ammann, Mario
Kramer, Peter-Klaus Schuster, and Kirk Varnedoe,
to whom all gratitude is due. Peter-Klaus Schuster

has also involved himself with great enthusiasm
on behalf of the exhibition. I extend my heartfelt
thanks to him as well as Dieter Honisch, Angela
Schneider, and Alexander Dückers as well as Fritz
Jacobi of the Nationalgalerie Berlin. • I thank Hans
Haacke for his trusting that from sceptical questions
and long walks, the cooperative and intensive work
in realizing his large Atrium project would come
about. Olaf Metzel surprised me with a colossal
"box" - I thank him for this and for the trusting
and supportive talks with him and Luise Metzel.
The conversations with Astrid Klein and Rudolf
Bonvie, backed up by Nicos Araldi's cooking, were
clarifying and constructive for the progress in plan-
ning the exhibition, many thanks for this. I thank
Georg Herold for the hours together with him, sunk
deeply in his panel works, when I could laugh from
the heart. I owe my thanks to the talks with Durs
Grünbein, Via and Pina Lewandowsky, Lutz Damm-
beck, Gustav Kluge, Mark Lammert, Reinhard
Mucha, Raffael Rheinsberg, Wolf Vostell, Franz
Erhard Walther, for the stimulation and many ideas.
My thanks goes most importantly to Carlfriedrich
Claus and also Klaus Werner and Gunar Barthel for
their support in the selection and presentation of
valuable language drawings: To Eva Beuys, Hannes
Heer, and Adam C. Oellers for making possible the
film reconstruction of the Festival of New Art in
Aachen. • To Irene Ludwig and Prince Franz von
Bayern I express my gratitude for their benevolent
support. I thank Johannes Gachnang not only as
lender and inspiring catalog author, but also for his
invisible presence and protective hand which he
lent the project. • To all of the authors who accom-
pany the exhibition round with their sensitivity and
new vision through their catalog texts, I offer my
gratitude for their commitment, particularly to
Siegfried Gohr for his introductory essay and his
advice. • For their spontaneous help during diffi-
cult phases of the project, I give my hearfelt thanks
to Eugen Blume and Matthias Flügge. I owe my
thanks to Klaus Gallwitz for his valuable insight
while looking for paintings by Beckmann and
Kiefer, and to Ernst Beyeler, for his mediation in
obtaining a key painting in the exhibition. Benja-
min H.D. Buchloh, Hubertus Gaßner, Kasper König,
Helmut Leppien, Elisabeth Nay-Scheibler, Andreas
Reidemeister, Werner Schmalenbach, Uwe M.
Schneede, Wilhelm Schürmann, Monika Stein-
büchel, and in deep friendship, Werner Spies, all
stood at my side in word and deed. • René Block,
Jan Sckera and Jiri Svestka supported and made
possible the reconstruction of the exhibition

"Hommage à Lidice". • With great commitment,
Walther König assembled a collection of bibliophile
books of encyclopedic quality which made its way
into the exhibition. • I thank Amnon Barzel and his
assistant Helmuth F. Braun for their immediate
willingness to expand the exhibition's horizon with
their own contribution. • Reiner Speck not only lent
exceptional works but also helped at all times in
word and deed. Martijn Sanders immediately made
central pieces from his collection available to the
exposition. Heinz and Simone Ackermans, Doris
Ammann, Heinz Berggruen, The Eli Broad Family
Foundation, Ruth and Samuel Dunkell, Christian
Graf Dürckheim, Annemarie and Günther Gercken;
Franz Joseph and Hans van der Grinten and their
assistant Barbara Strieder, Dominique de Menil,
Thomas Olbricht, Emily and Jerry Spiegel were just
as generous. • Ingo Bartsch, Wolfgang Becker and
his assistant Annette Lagler, Helmut Friedel, Jan
Hoet, Wolfgang Holler, Walter Hopps, Ulrich Krem-
pel, Hans-Ulrich Lehmann, Norbert Nobis, Veit Loers,
Karel Schampers, Marc Scheps, Evelyn Weiss, Guido
de Werd, and Armin Zweite were willing to part with
central, crucial works in their museums. Of the
many galleries who have helped us, my special
thanks is due Ernst Busche, Gisela Capitain, Bärbel
Grässlin, Hauser and Wirth, Max Hetzler, Fred Jahn,
the Produzentengalerie, especially Jürgen Vorrath,
Wolfgang Schoppmann, Christa Schübbe, and
Michael Werner. To the Director of the Berlinischen
Galerie, Jörn Merkert and his staff, I express my
gratitude for their cooperation. The editor Karin
Thomas was a stroke of luck; with her pathbreak-
ing publication *Zweimal deutsche Kunst nach 1945,*
she made her competence and overview available
at all times. Her personal counsel in difficult deci-
sions was an enormous help for me. Many thanks!
I thank Peter Dreesen and his staff, especially
Matias Möller, for their always professional and
cooperative production. My gratitude also goes to
the publishers Ernst Brücher and Gottfried Honne-
felder for their faith in the catalog project. The
technical direction of Gisela Märtz was an invalu-
able win for this undertaking. In her close and
creative cooperation with the architects Petra and
Paul Kahlfeldt, she always found surprising solutions
at times when nothing seemed to work. From my
heart, I thank the spirited and admirable exhibition
team, the editorial staff, the graphic and press
departments, who by committing their energies
with wit and intelligence made the exhibition and
this book possible.

E.G.

Lenders to the Exhibition

Austria

Neue Galerie am Landesmuseum Joanneum, Graz

Museum moderner Kunst Stiftung Ludwig, Vienna

Dr. Ernst Ploil, Vienna

Belgium

Museum van Hedendaagse Kunst, Ghent

Czech Republic

The Czech Museum of Fine Arts, Prague

France

Fondation Hans Hartung et Anna-Eva Bergmann, Antibes

The Philippe and Denyse Durand-Ruel Collection, Paris

Donation Freundlich Musée de Pontoise

Germany

Ludwig Forum Aachen

Lindenau-Museum, Altenburg

Dr. Karl Fritz, Annaberg

Erhard Klein, Bad Münstereifel

Stiftung Museum Schloß Moyland – Sammlung van der Grinten, Bedburg

Berlinische Galerie, Landesmuseum für Moderne Kunst, Photographie und Architektur, Berlin

Galerie Gunar Barthel, Berlin

Galerie Brusberg, Berlin

Galerie Neiriz, Berlin

Galerie Pels-Leusden, Berlin

The Berggruen Collection, Berlin

The Block Collection, Berlin

The M. Calabria Collection, Berlin

The Hoffmann Collection, Berlin

The Marx Collection, Berlin

The Dr. Rabe Collection, Berlin

The Stober Collection, Berlin

The David Vostell Collection, Berlin

The Rafael Vostell Collection, Berlin

Staatliche Museen zu Berlin, Preußischer Kulturbesitz
– Kupferstichkabinett
– Nationalgalerie
– Verein der Freunde der Nationalgalerie

Stiftung Archiv der Akademie der Künste, Kunstsammlung (John-Heartfield-Archiv), Berlin

Bundesrepublik Deutschland, Bundesministerium des Innern, Bonn

Jürgen Kühn, Bonn

Kunstmuseum Bonn

Josef Albers Museum Quadrat, Bottrop

Diözesanmuseum, Cologne

Fa. M. DuMont Schauberg, Cologne

Galerie Gisela Capitain, Cologne

Galerie and Edition Hundertmark, Cologne

Galerie Birgitte Ihsen, Cologne

Klemens Gasser und Tanja Grunert GmbH, Cologne

Dr. Andreas Hölscher, Cologne

Museum Ludwig, Cologne

Albert Oehlen, Cologne

Buchhandlung Walther König, Cologne

The Speck Collection, Cologne

The Dr. Michael und Dr. Eleonore Stoffel Collection, Cologne

Wallraf-Richartz-Museum, Cologne

Museum am Ostwall, Dortmund

Staatliche Kunstsammlung Dresden
– Gemäldegalerie Neue Meister
– Kupferstich-Kabinett

Wilhelm-Lehmbruck-Museum, Duisburg

Galerie Christa Schübbe, Dusseldorf

Kunstsammlung Nordrhein-Westfalen, Dusseldorf

The Olbricht Collection, Essen

Deutsche Bank AG, Frankfurt/Main

DG Bank, Frankfurt/Main

Galerie Bärbel Grässlin, Frankfurt/Main

Museum für Moderne Kunst, Frankfurt/Main

The Steigenberger Collection, Frankfurt/Main

Galerie Bernd Lutze, Friedrichshafen

Städtisches Museum, Gelsenkirchen

Kunstsammlung Gera

Hans Grüß, Großpösna

Staatliche Galerie Moritzburg, Halle, Landeskunstmuseum Sachsen-Anhalt

Annemarie und Günther Gercken, Hamburg

Hartmut Jatzke-Wigand, Hamburg

Sprengel Museum Hannover

Kunstsammlung der Städtischen Museen Jena

Burkhard Siemsen, Kaarst

Elena Granda Alonso, Kassel

Galerie Siegfried Sander, Kassel

Siegfried Sander, Kassel

Kunsthalle zu Kiel

Museum Kurhaus Kleve

Galerie für Zeitgenössische Kunst, Leipzig

Monika and Karl-Georg Hirsch, Leipzig

Landesmuseum Mainz

Städtisches Museum Abteiberg, Mönchengladbach

Private Collection Otto van de Loo, Munich

The Dürkheim Collection, Munich

The Günther Franke Collection, Munich

Staatliche Graphische Sammlung, Munich

Bayerische Staatsgemäldesammlung München, Staatsgalerie Moderner Kunst, Wittelsbacher Ausgleichsfonds Sammlung Prinz Franz von Bayern

Städtische Galerie im Lenbachhaus, Munich

Sammlung Felix Nussbaum der Niedersächsischen Sparkassenstiftung im Kulturgeschichtlichen Museum Osnabrück

Stiftung Preußische Schlösser und Gärten, Berlin-Brandenburg

The Gudrun and Peter Selinka Collection Ravensburg

Kunsthalle Recklinghausen

The Grässlin Collection, St. Georgen

Archiv Baumeister, Stuttgart

Galerie der Stadt Stuttgart

Galerie Valentien, Stuttgart

Staatsgalerie Stuttgart, Graphische Sammlung

Südwest LB Kunstsammlung, Stuttgart/Mannheim

Museum für moderne Kunst, Weddel

Kunstsammlungen zu Weimar

Kunst- und Museumsverein im Von der Heydt-Museum, Wuppertal

The Heinz and Simone Ackermans Collection, Xanten

The SUMAK Collection

Netherlands

The Sanders Collection, Amsterdam

Stedelijk Van Abbemuseum, Eindhoven

Museum Boijmans Van Beuningen, Rotterdam

Swiss

Kunstmuseum Bern – Paul-Klee-Stiftung, Berne

Verlag Gachnang & Springer, Berne

Otto-Dix-Stiftung, Vaduz

Thomas Ammann Fine Art AG, Zurich

Galerie Hauser & Wirth, Zurich

Kunsthaus Zürich, Vereinigung Züricher Kunstfreunde

USA

The Menil Collection, Houston

Collection Dia Center for the Arts, New York

Collection of Ruth and Samuel Dunckell, New York

Marieluise Hessel Collection, New York

Museum of Modern Art, New York

Emily and Jerry Spiegel, New York

The Estate of Eva Hesse, courtesy Robert Miller Gallery, New York

The Saint Louis Art Museum

The Eli Broad Family Foundation, Santa Monica

Collection of Tony and Gail Ganz, Universal City

And a multitude of private lenders who do not want to be named.

Foreword

Ulrich Eckhardt

Authentic art, as a mode of perceiving the world and as a possibility for the individual to attain self-assurance, is being created everywhere and at all times, irrespective of its actual evaluation and categorisation within our current cultural system, which can be appropriately described as a media culture. How the selection criterion of quality is gauged in the respective context, however, is something that is subject to uncertainty and fluctuation. It is astonishing to realise the extent to which an assessment of the broad spectrum of German art in the period after the Second World War is still being impeded by the — meanwhile outwardly eliminated — division of the world into divergent political systems, or being made to the distinct detriment of important critical positions taken by outsiders and lateral thinkers. Any such rash or superficial diminution of something which on closer inspection might provide deep insight hinders art's potential to explain the world and affect people. What is more, any form of one-sidedness offends against the principle of fairness, applicable to both human life and work and therefore to art that clearly refers to the individual.

Given the tension that exists between a conviction of the absolute status of artistic expression and the relativity of judgements, a selection of exemplary works from different contexts and historical backgrounds with diverging intellectual roots and converging realms of historical experience, can contribute towards promoting understanding and mediating between opposing positions. The work must always be the focal point. The artist ought not be abused as a mere subject of historical analysis. Art aims at change. Artists shape consciousness through their paintings. Their work ought to be read like a large open history book.

On our way towards an altered society, the time has come to calmly examine our heritage, to interpret the troublesome contexts, and to set out the common features and the differences. A diagnosis is well overdue in this the eighth year since the peaceful German revolution, especially as it has transpired that we must accustom ourselves to a longer transition period than expected. Ours is still a torn country, and the parts of the whole often seem Janus-faced, as in Harald Metzkes' painting *Januskopf,* 1977, and Ralf Kerbach's *Der Zwilling,* 1984.

The selection of paintings and drawings accompanied by music and texts that make up the Deutschlandbilder exhibition mirrors our time and depicts our common history. The point of departure is the German catastrophe of 1933. The following twelve years of state and ideological terror culminated in an internecine war and genocide, and also gave rise to forty years of global division. The period of joint deliberation in West and East after 1945 was short. Obviously the pensive period of the new departure around 1989-90, when the GDR imploded and the Federal Republic was plunged into a serious crisis, was also too short. The phase of troubled dialogue is still in progress, distorted by a saddening lack of fairness. Prejudice and suspicion, distrust and lack of consideration for biographical differences, are hindering that dialogue. Yet in the long-term, lending a voice to the undeniable differences, chronicling and making fruitful use of them, will constitute part of the country's future good fortune.

It is more than ten years since the plan was conceived to present and interpret as objectively as possible the two German cultural landscapes that emerged in the post-war era — on the assumption of a common historical point of departure. On the occasion of the 1987 City of Berlin jubilee, under the working title *Divergenzen — Konvergenzen,* the aim was to do some "German stocktaking". Unexpectedly, world history took another course. Yet the idea has taken on a new meaning and a greater urgency in the radically altered historical context.

This exhibition is the legacy of the unforgotten Eberhard Roters, who confronted the simplifiers with his inimitable subtlety and sparkling humour, pointing to the overt and subterranean links in the arts between different lifeworlds. Even in those difficult times when scarcely anybody believed in a renaissance in Central Europe, Roters was convinced that partitioned Germany was a totality at the heart of Europe, its art determined by different traditions that could lay claim to equal validity. It was Eberhard Roters who outlined initial contours of this exhibition. These were further defined in conversation with Peter Bender, Hans Mayer and Wolf Jobst Siedler. Eckhart Gillen continued the work. In the final phase of its realisation, Rudolf Zwirner thankfully contributed his rich experience. Karl Ruhrberg took over chairmanship of the advisory committee on which a broad range of varying positions could be debated. Our thanks are due to all those, in particular the exhibition organisers and designers, who participated in a process that aimed to illustrate without ideological constraint. The works on loan for the exhibition have been donated by prominent art galleries and museums and numerous private collectors who have contributed greatly to the cause of post-war German art. The exhibition managers' success in acquiring exhibits is proof of the importance of opting for the path of rational argument and persuasion, and of engaging in the discourse on the role

of art in analysing our historical situation. This task fell to Eckhart Gillen, who has fulfilled it more than effectively. As a member of the *Museumspädagogischer Dienst* in Berlin he also brought with him the wealth of experience acquired by this important educational institution. Special thanks are due, therefore, to the head of the *Museumspädagogischer Dienst,* Jochen Boberg, for his fruitful cooperation. Also essential in achieving the exhibition's specific aim were the sensitivity and restraint demonstrated by the experienced architects Petra and Paul Kahlfeldt, renowned for their innovative, clear, and convincing exhibition designs at the Nationalgalerie.

This project could only succeed because, as in the case of all the major exhibitions to date at the Martin-Gropius-Bau, its economic basis was guaranteed by the Stiftung Deutsche Klassenlotterie Berlin. Our thanks to this foundation are combined with respect for its unique contribution towards enhancing the international cultural flair of the city of Berlin — an important consequence of such exhibitions.

The 47th Berliner Festwochen are taking place under the motto *Deutschlandbilder — oder: Die Zeit und die Kunst* (German Images, or: Time and Art). The main exhibition, *Deutschlandbilder,* represents not so much a complete as an exemplary selection of artistic testimonials from East and West that bear witness to persecution and emigration, protest and internalisation. Its aim is to illustrate the earnestness and the aesthetic means with which artists exercised their responsibility for the historical processes in their divided and torn

country. The year 1933 is the collimating point, as it were, from which to view the artistic accounts rendered in the Federal Republic and the German Democratic Republic, which sometimes vehemently contradict one another. What they have in common are the years between liberation from the terror of National Socialism and the foundation of two states that, as constituents of hostile global systems, confronted each other along a dividing line. Understandably, their respective reflections on contemporary history in the FRG and the former GDR issued from different starting points and, in terms of content and aesthetic approach, assumed different forms. Any consideration of the works of artists from the two German states will be more exact, objective, and unprejudiced if they are viewed together. This provides a whole new perspective on the current, often enough strained, East-West dialogue by highlighting the differences, the rifts, and the continuity, as well as the differing recourses to traditional artistic themes and forms. Art, music, and theatre in the GDR influenced developments in West Germany, just as vice versa the artists in the GDR often oriented themselves around the phenomena of Western art.

This process is still on-going, even if some of the differences are becoming blurred. The former imposed oppositional front-line stance has developed into a meaningful and productive rivalry as to the correct direction to be taken. In our era of social crises and change, this exhibition can also contribute towards re-gaining ground for an ethical aspiration in the future developments of the arts.

After the Satires III (The Long Sleep)

Durs Grünbein

How in the morning hours the wind
Sweeps the streets where people, yesterday, were walking —
Tomorrow they'll be corpses, spirits restless in the inner city;
How every day takes hostages anew — at night, benumbed,
They wrinkle up the sheets, throw shadows on the ceiling,
At large as long as sleep can keep them free of gravity;
And how the dying still continues, spends its fury from behind
On a soon-dishevelled bunch of tulips
Which filled the room, the feeble stems as stripped of leaves as by
10 A downpour, and the flower water stinks, a liter
Of the Wannsee on the table.

How teeth grow from the walls, where through the wallpaper
After a night of heavy dreams, old newspapers
Are clearly visible, black with the news
Of war on all the fronts, of casualties and of advances,

And of entire cities vanishing in minutes,
Where someone sang some hits and a piano concert captivated
An audience, while at a conference table far away
Three men, laughing hard, divided up the world
20 Among themselves — ecstatic minutes, boring minutes;
And news of Job's afflictions in the air-raid cellars, news of how
Cain, the heartless Cain, was cheated of the wages of fear.
And that already long ago the dice had fallen,
Decades earlier, and decades later
One reads with pleasure over coffee of
The rout of one's own gangs of murderers.

How clear it is when it begins, the day
They all are gone, the ones, the others dead. A street sign
Still records a name: a doctor who accomplished much
30 In an age of horse-hair sofas in the clammy cellar holes
Where a woman, weakened, died soon after giving birth
To another future starveling. Cleared of trees, a boulevard
Honors the bearded prophet whose complete contempt and whose epistle
To the Romans, his manifesto, agitated
The day laborers and the theologians and the army
Of dreaming comrades whom another agent, missionary
Of the unconscious, at his post behind a curtain made of whispers,
Watched awaken from one sleep to fall into the next.

How harshly light falls through the maple's newest leaves
40 Onto the peeling trunk where none will ever see,
On the branch, the deserter, the cold noose —
A summer light which always is today, in every gleam
Of wheelchair or perambulator; how it dances
And plays with glasses, tips, and cutlery upon the tables
Where the widows have stood up from breakfasts eaten late
With a paper heavy with so much reported death,
Subscribed to long ago. How quickly
A heart attack can shred the morning's charm. How easily,
On a prong which sticks out from a wall, or on a thorn,
50 Here, another bloody episode begins.
And then?

Then an announcement warms the snow from yesterday
And makes it melt, and underneath the lawn
One sees the fragments gleaming, green bottle glass
And drugstore porcelain, the heads of dolls, the knuckles,
The bones from an age when families separated into camps
And a bible passage hung above the sink
And party meetings were soon followed by the killing
And ten commandments were nine too many. And then?
60 Then lead was poured on every New Year's Eve throughout the war; a house
Was what one had to hit and its collapse
Appeared to be a gift from God; the marksman,
A silent Giselher behind the sight, a drunken grenadier,
Was a mascot under tank debris and rubble.
The cities were delivered to the skies. The final walls
Still standing from the time of their foundation fell.
On an open stage was played, in rooms laid bare,
The final act ("The Holy Family's Death"); the street
Barely noticed when the sofa hung above the sidewalk.
70 With every cemetery, memory went bankrupt,
In aerial photos, the milieu. And resurrection
Was a newsreel running backwards. And then?

> The diggers dragged a pale thing from the loam —
> It crunched and then gave way. Was that the skull
> With which a new Reich's youngest dreamer dreamed?
> *Dark brown is the hazelnut* ... My girl
>
> Did not see my death in cluster mines.
> The helmet's steel did not protect the warm
> And soft. Between machines, it's hard to die.
80 > I was not made to be a callow private corpse.

How the old hits, which distance has distorted,
Sing a little something in the phones, of light and moths.
And women's voices, raw with smoke, transform a room
That nothing still to come has access to. A string concerto
Plays at the spot where, underground, what once set forth
Into the city to its death decays. A gnome,
Foaming at the mouth, was once the main attraction here.
His number was the dance of hate between the *Eintopf* bowls.
From beer tent to arena and to opera he did go
Before his audience fell silent in the ruins' holes.
And That was Europe was the line heard on the radio ...

(That was Europe ... and a witch's broom the steer.)
Now the horrors under glass are safely on display,
The golden cup of bone meal, human skin
Become a lampshade, the cannibalistic hoard
Of terror — as it fell, it clawed itself into the earth.

How it reeks from cable shafts, this messed-up earth.
And from the mud the bubbles surface in the one canal
Which past the weekend gardens bore the corpses of the slain.
Behind the curtains of the houses that were spared,
The final witnesses spoon out their meals from cans.
And one saw walls spring up, with tunnels under them, walls fall,
The city, a huge playground, chopped to bits
By the Four Powers, hardening to transsiberian
Concrete on the shining sand.
 Berlin was seen
To disappear (the last of it), return, and disappear once more
With every detonation, when, in front of gray, the dust wall fell —
Above the uncleared cellars and beneath divided skies,
The rebuilt houses closed their ranks, the plane trees,
Blown to pieces, once again grew leaves, and buses under limes
Advertised for Socialism and Persil.

How they dreamed their dead in every corridor ...
Since as much as this whole shabby century has been contained
In just one day. And upon the intercom each name
Erases ten which witness for themselves no more. Selected in
A moment's weakness, some were still surprised while listening
To the civil sibilance — no amulet remained
Of them, not even one small knuckle. What the smoke relates,
The crumbling balconies and all the bullet holes negate,
As do the polished knobs, which have forgotten all their hands.

Stiff in graveyard grass, no finger threatens,

As the fairy tale would have it, from a grave.

And how a city seems defenseless when a plane descends

For its approach and casts its shadow in the sunset

On gray domestic districts, parks beside depositories

Where goods are waiting for their transport

Which will tomorrow be but junk or grounds for bloodshed.

In a thousand back rooms, folks who play the lotteries

130 And lose a fortune every day console themselves with sport,

With eyes gone glassy from the television, red

From lengthy marriage rows.

 And how forgetting

Exhorts the hours till, what's left of dinner cold,

The anecdote drops off, and the war novel, too. How night

Takes the fortress of the city and in restaurants

The guests are irritated by the picking

In the ashtrays, by the yawns when every joke's been told.

How only seeing metal parked to line

140 His way back home can lead the last to laugh. How, when the sated sing,

The salivary gland joins in, as does the fear that teeth

Will finally go the way of these facades. They see,

Weakened, the carriageway which makes, like litmus, spots

Of oil, and gas, and animal blood. How, as a compound shadow,

A statue runs along beside, upon his mount

The Prussian King, larger than life and plagued with gout,

With hammer in his heavy hand the prole,

Brow bowed as if before the Fall.

And then into the sky a pothole spirals.

150 How many lives a lullaby contains … the lilting air

For a nihilist who's nameless … How much silence rolls,

In conurbations, buried … How from everywhere

Yackity-yack … Berlin … absorbed through skin and walls

Into their sleep, into your sleep, into my sleep.

Notes

Line 44: "The shame-reddened wound on the body of society oozes and heals. It covers itself with a metallic scab." Walter Benjamin, *The Arcades Project: Notebooks and Materials.*

Line 73: A half century after the end of the war, the skull of a young German Army soldier came to light during construction at Potsdamer Platz in Berlin. Until the remains of the unknown man were removed, work around the site stopped for almost an hour.

Line 131: Television: the dead grandmother, as people say.

Line 140: "In someone's neck (someone it choked), the bone / is just as much itself as in the fish." R.M. Rilke, "with the voice of a ventriloquist", *the poems From the Papers of Count C.W.*

Tabula Rasa and Inwardness
German Images before and after 1945

1 Hans Belting, "Weltsprache und Natio-nalcharakter. Deutsche Kunst - ein Tabu der deutschen Kunstgeschichte", *Frankfurter Allgemeine Zeitung* 2 Nov. 1991.

2 Quoted by Christoph Dieckmann, "Das schweigende Land", *DIE ZEIT* 20 June 1997: 4.

3 Sample of text from Germany's repre-sentation video for "Expo 2000."

4 Peter Bender, *Episode oder Epoche? Zur Geschichte des geteilten Deutschlands* (Munich, 1996).

5 "Wo leben eigentlich die Deutschen?", *Frankfurter Allgemeine Zeitung* 29 June 1996.

6 "The memory of the nation should not be extinguished. A nation is deadened most thoroughly when its memory and history are extinguished." Heiner Müller in the pro-gram guide to "Leben Grundling, Schiller" Theater Berlin, 1983

7 "What appears to be the pure begin-ning without a history, is then really the spoils of history, unconscious and for that reason disastrous." Theodor W. Adorno, "Über Tradition", *Ohne Leitbild, Parva Aesthetica* (Frankfurt/Main, 1967) 34.

8 See Serge Guilbaut, *How New York Stole the Idea of Modern Art* (Chicago and Lon-don, 1983) 192.

9 Quoted from Thomas Mann, *Schriften zur Politik* (Frankfurt/Main, 1970) 181; 172f.

10 Helmuth Plessner, *Die verspätete Na-tion. Über die politische Verführbarkeit bür-gerlichen Geistes* (1959; Frankfurt/Main, 1974) 64.

11 Mann 1970, 178; 180f.

12 Friedrich Nietzsche, "Zur Genealogie der Moral", 1887, *Werke in drei Bänden*, ed. K. Schlechta (Munich, 1966) 837.

13 Reprint, Darmstadt, 1972.

14 See Stefan Breuer, *Ästhetischer Fun-damentalismus. Stefan George und der deutsche Antimodernismus* (Darmstadt, 1995) 212. Rudolf Borchardt, 1914: "As surely as God exists, our triumph of power must put an end to this 'civilisation' or 'European civilization'."

15 Franz Marc, *Im Fegefeuer des Krieges*, qut. in Thomas Anz and Michael Stark, ed., *Expressionismus. Manfeste und Dokumen-te einer künstlerischen Revolution 1909-1918* (Stuttgart, 1982) 304.

16 Letter to Gustav Roethe, August, 1914, in: Friedrich Gundolf, *Briefe*, Neue Folge, (Amsterdam, 1965) 143, quoted in Stefan Breuer, *Ästhetischer Fundamentalismus. Stefan George und der deutsche Anti-modernismus* (Darmstadt, 1995) 75f.

An exhibition and presentation of German art after the last war raises questions that do not arise in similar under-takings in the neighboring West Euopean countries. Why then, "German Images" as title of an exhibition of German Art? In a time of political and economic globalization and internationalization, the European neighbors clearly possess more solid historical images and national art histories, with which they can respond more calmly to the challenges of the world market and of world art. "That cannot apply to the Germans. The notion of their art is not even better than the notion of their history."[1]

Although the postwar era came to its close on November 9, 1989, the day that rejoined a world which had been divided for a half century, the Germans, who until 1989 saw themselves as "one folk in two countries", have in the meantime become "two folks in one country" (Lothar de Maizière).[2] They must decide what common German images they want to create and which cues they want to discard. The more cohesively Europe grows together politically, economically and culturally, the more often Germans will be asked by their neighbors about their image of themselves. German marketing has an easier time of it: "Germany is beautiful, its landscapes are classic, its beer goes down lightly ..."[3]

In no other country in the European Union "was Europe talked about as much as in the Federal Republic, and nowhere else did they so eagerly try to systematize Socialism into a theory as in the GDR. The paragons remained for other countries exactly what they had repressed: the Germans. With no other alternative, the hostile brothers remained fixed on each other and struggled for the only real consequence of a ruptured national history. The more the United Socialist Party tried to establish a Socialist nation with GDR citizenship, the more German history caught up with it, finally going down with the slogan, we are the people."[4] Andrzej Szczypiorski asked West Germans – who wanted to explain to him that they actually more resembled the French (in Baden) or the English (in Hamburg) – where the Germans lived? He received the answer: "Go to East Germany, the Germans live there." In 1989, the people in the GDR went into the streets calling: "We are the people." After three generations (from 1933 until 1989) "went through the wheels of Totalitarianism and were robbed of their identity" it was suddenly revealed that the true Germans lived in Leipzig, Jena, and East Berlin."[5]

With the question about the German images creat-ed the artists between Düsseldorf and Dresden, Hamburg and Leipzig, the exhibition touches on the tabooized noti-on of nation, which in reflex was paired with the danger of a new nationalism. The politically correct consensus thus conveniently repressed and avoided examining the rupture in the comparatively short national history since the foundation of the Prussian Empire in 1871.[6] This loss of memory fostered a restorative climate in West Germany in the 1950's that settled in the nowhere-land between yesterday and tomorrow.[7] The artists of both countries existed under the influence of the incompatible educational models of their respective occupying powers. The U.S.A. exported the utopia of freedom, the idea of the individual's autonomy in the form of a cultural Marshall Plan to West Germany.[8] In the GDR, the utopia idea of an education leading to general human well-being, propagated under the sign of equality, was only achieve-able by force. Realism was not in demand on either side of the Cold War power blocs in the 1950's.

On May 29, 1945, three weeks after the German army's unconditional surrender, Thomas Mann was assigned the delicate mission of speaking in English about "Germany and the Germans" at the Library of Congress, Washington, on the occasion of his 70th birthday. To those who had triumphed over the Nazi barbarism, he tried to explain the rupture of national history in terms of the dualism of spiritualized, internalized freedom and political subservience, which he traced back to Martin Luther's Reformation (on the one side, a strengthening of the individual conscience, on the other side, subservience and serfdom). All of the German revolutions; the Peasant War of 1525; the patriotic uprising against Napoleon of 1813 and the revolutions of 1848 and 1918 failed because the Germans never learned "to unite the notion of nation with that of freedom", as the French had in their Revolution. "The German idea of freedom is nationalistic and anti-European, with barbarism always very near ..."[9]

Helmuth Plessner, exiled in Holland, had developed similar thoughts on the Germans as early as 1935: Never having been able to achieve peace, the Germans had always sought the mythical origins of their historical existence. When German national consciousness "proudly defended its eternal barbarism against the older, more fortunate, more rational West, it appeared as if all of the great transformations in German history formed ... a struggle of the giants against Rome, which Armin the Cherusker started. ... That is why they are of the day before yesterday and the day after tomorrow and never of today."[10] The tradition of German inwardness, which found expression in the German Romantic's confusing paradox of depth of thought and "Seduction unto death", stands in contrast to the inability to cultivate a continuity

17 Quoted in Breuer 76.

18 He received his doctorate in 1921 from the "half Jew" von Waldberg, who he esteemed just as highly, with a "Contribution to the History of Drama in the Romantic School".

19 Oswald Spengler *Der Untergang des Abendlandes* (Munich, 1923).

20 Joseph Goebbels, *Michael. Ein deutsches Schicksal in Tagebuchblättern,* new edition (Munich: Verlag Franz Eher, 1929).

21 Ralf Georg Reuth, introduction, *Joseph Goebbels, Tagebücher 1924-1945, Vol. 1,* (Munich-Zürich, 1992) 33f.

22 Reuth 36

23 Breuer 15.

24 Quoted in Modris Eksteins, *Tanz über Gräben. Die Geburt der Moderne und der Erste Weltkrieg* (Reinbek bei Hamburg, 1990) 464.

25 Eckstein 484.

26 Frank Thiess, "Die innere Emigration", *Die große Kontroverse,* ed. J.F.G Grosser (Hamburg, 1963).

27 Botho Strauß, "Anschwellender Bocksgesang", *Der Spiegel* June 1993. The essay by Botho Strauß is an indication that with the fall of the Wall, even the Romantic tradition of an "aesthetic fundamentalism" is revived.

28 See Helmut Lethen, *Verhaltenslehren der Kälte. Lebensversuche zwischen den Kriegen* (Frankfurt/Main, 1994) In a 1924 book by Helmuth Plessner about the "Limits of Community", the life-philosophical playing out of natural drives against social constraint, and the unalienated being against objectivication, was replaced by a plea for the distanced civilized behaviour in the Western culture that emerged in the alliance of the ethics of nobility and middle-class sense: The human being is artificial by nature! Nature is neither good nor moral. We have projected all good characteristics and aesthetic qualities onto nature. The notions of the great plan of creation's inner logic and wisdom are products of a human weakness for endowing meaning.

29 Anselm Kiefer, "Bei Anselm Kiefer im Atelier", *Art,* (January, 1990).

30 Hans Jürgen Syberberg, *Hitler, ein Film aus Deutschland* (Reinbek bei Hamburg, 1978) 9f.

31 Alexander und Margarete Mitscherlich *Die Unfähigkeit zu Trauern* (Munich, 1967) 34 f. See also, Tilmann Moser, "Die Unfähigkeit zu trauern: Hält die These einer Überprüfung stand? Zur psychischen Verarbeitung des Holocaust", Tilmann

as state and nation. It represented, according to his 1945 speech, "the irrational revolutionary vitality against abstract reason ... and glorified what is vital against what is merely moral".[11]

Culture against Civilization

This inwardness became the intellectual weapon of the German soul's defensive action against a world of enemies in "Antagonism of Culture and Civlization",[12] which Nietzsche formulated for the first time in 1887, and which Ferdinand Tönnies countered with "Community and Society" in the same year.[13] The wartime volunteers of August, 1914, believed they had to defend spiritual values and "inner freedom" against the English-French civilization of "petty minds". At the same time, the approaching war was experienced as an inner necessity, as a catharsis and an overcoming of the "inner foreignness" in the struggle against their own bourgeoisie.[14] This vital spirit of setting out on a new beginning before the first World War was captured in German art as well. The defense against what is foreign joined the quest for the German essence in Gothic art and the old German paintings of Matthias Grünewald. "Only the good things remain, the genuine, significant, endure. They go enlightened and toughened through the bonfire of the war. ... He who experiences it in action and foresees the new life that we win with it, will certainly think that one does not pour new wine into old barrels. We will carry on into the new century with our will to visual form."[15] German artists believed themselves to be absolutely more spiritual and cerebral as their neighbors, that they created their forms not from nature outside, rather from an inner vision which only they had.

Friedrich Gundolf, a disciple of Stefan George, wrote, overwhelmed by the August 1, 1914 frenzy of fusion, in which millions of people became "a German folk", a "holy body":[16] "He who is strong enough to create, may also destroy ..."[17] In 1920, Joseph Goebbels was studying under Jewish Germanists whom he then admired in Heidelberg.[18] At nearly this same time, under the influence of reading Oswald Spengler,[19] he associated the "soulless" materialist age of "civilization" as the beginning of the end of all "culture", and with Judaism. In his diary-novel "Michael" (1923),[20] he had his title figure search for the "strong genius", whom he very soon found in Hitler, the "incarnation of our faith and our idea".[21] As prophet and apostle of the future redeemer, he henceforth proclaimed his gospel in his position as Chief of Propaganda. In his unconditional allegiance to the *Führer,* the "tool of Providence" and in the quasi-religious description of the resurrected Germany as "one single, great place of worship encompassing every station in life, profession and denomination",[22] his thoughts culminated on August 1, 1914,

with his faith in an "inner worldly redemption" through the religion of art practised by the George circle.[23] Hitler saw himself as the incarnation of the artist-tyrant summoned by Nietzsche, as the executor of the "Dictatorship of Genius" longed for by Wagner.[24] Anselm Kiefer thematized these fantasies of omnipotence in his painting *"The Unknown Painter"* (fig. 328, p. 337), which shows a palette in the Munich Temple of Honor to the "heroes of the movement" who fell in 1923. The barbarism in a culture of permanent destruction and new creation, glorified by his teacher Friedrich Gundolf, was fulfilled for Joseph Goebbels once more in 1945, just before the end, in view of the destroyed Germany: "The last so-called achievements of the middle-class 19th century are finally buried under the rubble of our devastated cities. ... The last obstacles in the fulfillment of our revolutionary task fall, together with the cultural monuments. ... The enemy who endeavored to destroy Europe's future was only able to destroy the past, and with that, everything old and past has ended."[25]

The fatal juxtaposition of culture and civilization, deepness and surface, community of people and the masses was transferred to the splitting of Germany after 1945. In the GDR, the West was considered part of the Anglo-American civilization of Capitalism and Materialism. In contrast, the East believed that they had preserved the German essence, the inwardness, the truth, morality, and the soul. Party members and dissidents were united among the artists and poets under the GDR's legitimization by anti-fascism and anti-capitalism. The current dispute over the evaluation of Socialist Humanism in the GDR had many parallels to the debate after 1945 between the "inner emigrants": Walter von Molo, Frank Thiess, and Thomas Mann who, as representative of exile literature, was said to have been a traitor of his people and Fatherland because he received American citizenship by declaring himself for Western Democracy. During both the Nazi time and in the GDR, the illusion was stubbornly cultivated that one could hold the balance between the controlled public life and the screened private life, in the sense of a double life – the "niche society", as Günter Gaus called it. After 1945, explained Frank Thiess: "... the world on which we inner German emigrants supported ourselves, was an inner space which Hitler could not conquer despite all efforts."[26] This withdrawal into the aesthetic as a bulwark of German inwardness was a declaration of turning away from the world and a farewell to politics.

In the GDR as well as in the Federal Republic, artists, writers, and intellectuals from Stefan Heym, Heiner Müller, Christa Wolf, Stefan Hermlin up to authors such as Hans-Jürgen Syberberg and Botho Strauß,[27] out of different motivations, had again positioned culture and community against the Anglo Saxon-American civilization and

Moser, *Vorsicht Berührung. Über Sexualisierung, Spaltung, NS-Erbe und Stasi-Angst* (Frankfurt/Main, 1992) 203f.

32 Theodor W. Adorno, *Jargon der Eigentlichkeit* (Frankfurt/Main, 1964) 43.

33 *Erstes Darmstädter Gespräch,* ed. Hans Gerhard Evers (Darmstadt, 1951).

34 Alfred Schmeller's commentary to Willi Baumeister's painting *Han-Aru* 1955, in *magnum* 24 (1959) 27.

35 Werner Haftmann, *Malerei im 20. Jahrhundert,* 2 vol. (1954/55; Munich, 1965) 429.

36 Yule Frederike Heibel, ts., Toward a Reconstruction of Modernism, or, The Subject's Dialectic of Evacuation: Modern Painting in Western Germany After World War II, Harvard University, Cambridge, Mass., September 1991.

37 Werner Haftmann in a conversation with Thomas Kempas; in: *Topic: Informel,* Part I, (Berlin, 1973) 94.

38 Eduard Trier, "Was will die II. documenta?", *magnum* 24, (1959) 52.

39 Erhart Kästner, in: "Mythos Documenta", *Kunstforum* 49 (1982) 51.

40 Jürgen Claus, *Kunst heute* (Reinbek bei Hamburg, 1965) 12.

41 Hermann Lübbe, "Der Nationalsozialismus im politischen Bewußtsein der Gegenwart", Martin Broszat, ed., *Deutschlands Weg in die Diktatur* (Berlin, 1983) 334.

42 Norbert Frei, *Vergangenheitspolitik. Die Anfänge der Bundesrepublik und die NS-Vergangenheit* (Munich, 1996) 406.

43 Olaf Groehler, "Antifaschismus - Vom Umgang mit einem Begriff", Ulrich Herbert and Olaf Groehler, *Zweierlei Bewältigung. Vier Beiträge über den Umgang mit der NS-Vergangenheit in den beiden deutschen Staaten* (Hamburg, 1992) 31f.

44 Thomas Bernhard, *Auslöschung. Ein Zerfall* (Frankfurt/Main, 1986) 108f.

45 Christoph Zuschlag, *"Entartete Kunst". Ausstellungsstrategien im Nazi-Deutschland* (Worms, 1995) 171.

46 Hans Wielens, ed., *Bauen Wohnen Denken. Martin Heidegger inspiriert Künstler* (Münster, 1994) 47.

47 Heinrich Welfing, "Botschaften des politischen Neubeginns. Die deutschen Pavillons dreier Weltausstellungen", *Frankfurter Allgemeine Zeitung* 19 July 1997.

48 "Deutschland in einem Wald von Türmen", *Frankfurter Allgemeine Zeitung* 18. July 1997: 4. "Yet a few years before, a design like this would have fallen under suspicion of Fascism immediately if a

society. The masks and rituals of objectivity, coldness, and reservation still have no chance in Germany against the soul, feeling, and inwardness.[28]

Loss of Identity through Flight from Reality

Artists and intellectuals such as Anselm Kiefer or Hans Jürgen Syberberg first tried in the 1970's to recover the loss from the total repression of words and notions abused by the Nazis and to proccess and sublimate them in their own work. Yet the logic of repression suggested that these romantic props themselves, which the Nazis had once politically occupied and used for their own purposes, cannot be innocent of this abuse. Thus, artists like Anselm Kiefer who dirtied their hands by looking at the repressed legacy in the national attic, were denounced as mythomaniacs. "The concealment of myths ... is not enlightenment but rather anti-enlightenment ... Because the Nazis used the myths or, one should say, managed them, we should now let them disappear. But that is wrong. That is the same as the heresy that says you can triumph over fascism by blowing up buildings."[29]

Hans Jürgen Syberbberg, in the commentary to his Hitler film, complained provocatively about the threatening loss of identity: "Germany had really lost the war, mainly – and perhaps solely, because of Hitler's voluntary self-abandonment of his creative irrationality. ... Can and may a film about Hitler, of all people, and his Germany explain, recover identities, heal, and redeem? But, I ask myself, will you ever free yourself from the oppressive curse if you don't get to the center of the gnawing disease? Yes, only here, ... precisely about this Hitler in us. ... For our future, we have to overcome and triumph over him and therefore ourselves, and only here can a new identity be found through recognition and separation, sublimation, and work on our tragic past. ... And how else would it work, as ... in faith and trust in the rightness of mourning named in the old tragedies, just as they portrayed their ceremonies in the myths, the fears they overcame and their compassion with what frightened them, so must we accept the monstrousness from which we are made. Acceptance as the healing process of art, as a method for overcoming and recognizing guilt and ourselves, for many others. A sad model. It is about the art of mourning."[30]

This art of mourning in the 1970's is known to have come from the "inability to mourn" diagnosed in 1967 by Alexander and Margarete Mitscherlich. Hitler's death as the collective self-ideal and "his devaluation by the victor also signified the loss of a narcissistic object and with it an impoverishment and devaluation of the self." The Nazi past is derealized in defense against guilt, shame and fear.[31] Art from the 1950's is also characterized by this de-realization of reality. Coming from inner emigration,

artists such as Willi Baumeister sought the innocence of occidental culture by going back to archaic, prehistoric cultures. This artistic simplicity, as a small dose of "irrationality in the midst of the rational" compensates and transcends the rule of reason in the "working atmosphere of actuality".[32] Not the past but rather the shocks that "modern life unleashes on people", should be absorbed by Modern art. In the year of the II. documenta, *magnum,* the magazine for modern life, compared art works with photos "from life", for example, the photo of a nuclear bomb explosion with a painting by Wols from the year 1946. Artists like Willi Baumeister saw an unexpected confirmation of abstract art in atomic physics: "All materiality dissolves in the forces Here also ... reality is removed, is demateriality!"[33] All familiar ideas of reality are mere illusion and the artists now take the freedom, the "incomprehensibility of the world ... not to represent the world in images."[34] The nonrepresentational art work produces new realities from the societal and creative chaos, "realities of harmonical characters as pure, self-consisting color – structures; ... realities of psychic characters as shapes of the human inner world; ... realities of a set actuality to which the settings of modern knowledge of nature corresponded."[35] An absolute painting in which everything was held in suspension did not want to cause offense anywhere, allowed free association, without being restricted to anything, and necessarily resulted in a "dialectic of evacuation"[36] which allowed the notion of freedom to become an empty formula because it ruled out every contradiction. The signs of fatigue in painting, which in the works of Wols, Jean Fautrier, and Hans Hartung in the 1930's took its civilizaton-critical impetus from the destruction of all conventional ideas of image, were not to be overlooked. The emotional arousal emerging from the unconscious into the authentic psychogram of spontaneous gestures and running paint – as a generally recognized painting method – lost some of its credibility. Even its most eager promoter himself, Werner Haftmann, later had to admit "that when the Tachist painting became a general style in 1952, 1953, and 1954, it was used for purposes of decoration by a large number of people, who were actually unauthorized to do so, so to speak, because of the people they were."[37]

While abstract-informal art, as the nation's good conscience, struggled for public recognition in museums and art asociations, it had already, though unremarked, become integrated into the everyday as wallpaper and fabric patterns, and lamp and furniture design in people's living rooms. It no longer raised existential questions there but rather represented the liberal-democratic consumer society's feeling of modern life. "Abstraction as world language", which the Federal Republic had "to some extent 'deprovincialized' ",[38] became all the more a useful

highly public sensor had at once seen the ominous German spirit spit into the grove of towers. But in the meantime, the once well-trained anti-symmetric reflex has grown weary ..." Heinrich Wefing, "Die Form folgt dem Fragezeichen", *Frankfurter Allgemeine Zeitung* 19 July 1997: 31. In contrast, the new building of the Hotel Adlon on Pariser Platz embodies the Neo-Historicism of the Berlin Republic: "It is a soothing tale. Now, because everything is old again, the woodwork murmurs that everything is alright, after all ... Its new old existence constructs a continuity which is devoured by the interim. No Nazis, no bombs, no Wall, no Cold War, no, now we associate anew, with the Belle 'Epoque, with the better Prussians, with the golden 'twenties ... It is a gap-filler, it fills the black hold between '33 and '89. And that may never become visible. That is the task of neohistoricism today." Benedikt Loderer, "Marmor adelt, Holz macht alt, Geld sinnlich", *Die Zeit* 31 July 1997: 49.

49 J. Boberg et al., eds., *Die Metropole. Industriekultur in Berlin im 20. Jahrhundert.* (Munich, 1986) 304.

50 As early as 1931, Walter Benjamin had analyzed the "destructive character" of dispassionate, uncreative technocrats like Albert Speer or Rolf Schwedler (SPD Berlin Senator for Buildings): "The destructive character knows only one motto: make space; only one activity: clear away. ... The destructive character has no picture in mind. He has few needs, and that would be the very least: to know what takes the place of the destruction." Walter Benjamin, "Der destruktive Charakter", *Gesammelte Schriften*, Vol. IV, 1 (Frankfurt/Main, 1972) 396f. According to a letter to Gershom Scholem, Benjamin had in mind Gustav Glück, Director of the Foreign Department of the Reich Credit Society. (See Vol. IV, 2, 998f.)

51 Kulturkritik und Gesellschaft, published 1951 in: "Soziologische Forschung in unserer Zeit", Leopold von Wiese zum 75. Geburtstag, *Prismen* (Frankfurt/Main, 1955) 31.

52 *Vom Unglück und Glück der Kunst in Deutschland nach dem letzten Kriege* (Munich, 1990) 35.

53 Theodor W. Adorno, *Minima Moralia - Reflections from Damaged Life* (London, New York, 1996) 25.

54 James E. Young, *Beschreiben des Holocaust. Darstellung und Folgen der Interpretation* (Frankfurt/Main, 1992).

55 See footnote 51, p. 31.

56 Saul Friedländer, "Vom Antisemitismus zur Judenvernichtung", E. Jäckel, *Der Mord an den Juden im Zweiten Weltkrieg* (Stuttgart, 1995).

instrument in cultural self-representation and an ideological weapon in the Cold War. The "documenta gesellschaft mbH" near the "zonal border" in Kassel could always count on high public subventions: "A couple of ridiculous kilometers further, and all of the fascinating things shown here would be considered hostile to the state and forbidden."[39] In absolute art, "freedom had apparently become objectified, it was a kind of clean slate ... for the event organizer."[40]

The demonstrations of light and movement in the Zero Group's room declared a kind of second Hour Zero, a "new Idealism". Germany was supposed to finally come out of history's shadows with the vision of an optimistic society fulfilled by pure light. For Hermann Lübbe, the *Vibration of Silence* (Heinz Mack, 1959) of a "communicative silencing" was a "social-psychological and political medium necessary for transforming our postwar population into the citizens of the Federal Republic of Germany"[41] who had experienced the Third Reich as a "foreign regime that descended (over Germany) with a basically small number of 'collaborators' and an army of people who harmlessly went along."[42] National Socialism had also been downplayed in the GDR as the establishment of a foreign rulership over the German Folk.[43]

The dimension of removing the past from reality was conveyed by Thomas Bernhard's novel, *Auslöschung* (Obliteration), which clearly referred to Austria in his obsessive rhetoric of repetition: "At first it looked as if the war had ruined our cities and our landscapes, but they were ruined by this perverse peace with a much greater unscrupulousness in the last decades ... and in the same way that the architects have caused havoc in these decades!"[44] Egon Eiermann, the architect of the Propaganda Exhibition "Give Me Four Years Time" at the exhibition grounds at the Berliner Funkturm[45] in 1937 mentioned in his Darmstadt talk on the subject of "Person and Space" in 1951 that Martin Heidegger had embellished his lecture "Building Living Thinking" with: "The more I step into the future and the more I blindly believe in it, the better the future will be If that means we now have to bear the notion of homelessness, then I do it gladly ... I have a new homeland, which will then become the world ... What does it have to do with us architects when they don't feel at home in what we can set down for them!"[46] In 1958, he and Sepp Ruf built the German pavilion for the World's Fair in Brussels, the first one after the war to which the Germans were invited. They designed eight glazed pavilions flooded with light and sun as the constructed German image of a "newborn, innocent country" to counter the "words out of stone" of the 1937 Speerian tower construction in Paris.[47]

In contrast, the winning design for the German pavilion at "Expo 2000" presented "Germany in a Forest

of Towers."[48] Hans Scharoun, Berlin's first Urban Development Council since 1945, also longed for the chance of a radical new beginning, the Hour Zero of urban development: "Aircrafts had finished off the destruction and there was nothing more left standing in the center of the city. The time had finally come."[49]

German Images will be shown in Berlin, yet precisely this arena of the postwar era, divided as the front city of the Cold War and the artificial "Capitol of the GDR" conjured up out of nothing until 1989, symbolized a state of emergency and loss of identity "between the blocs" (Heinz Trökes, 1947) of a global politial Ice Age. In Berlin, the division of the countries was experienceable daily, the scars and traces of a ruptured history were not to be overlooked. Only in Berlin and in the GDR could you experience, almost physically the presence of a history repressed in the West. Berlin, shut down like a large central train station, became a hollow space in history. The site of the exhibition *German Images*, the former Arts and Crafts Museum, lies in the center of German terror and German history: The windows of the east wing offer an unobstructed view onto the grounds of the former Gestapo headquarters in the former Arts and Crafts School and the Reich SS Security Center in the former Prince Albrecht Palace, which since July 1987 has been open to visitors as the memorial "Topographie des Terrors". During the course of area redevelopment, which cleared up the city and at the same time the evidence of its history, following the motto – out of sight, out of mind – the politically incriminating buildings were torn down.[50] The Arts and Crafts Museum itself which was built by Martin Gropius and had already been given up by the Staatliche Museen Preußischer Kulturbesitz, would have nearly fallen victim to the model of a city "suitable for cars". The objections fom the reknowned nephew, Walter Gropius, undisputed authority on West German postwar architecture, and from personalities such as Werner Düttmann, Eberhard Roters, Wolf Jobst Siedler, and Wolf Vostell, prevented at the last minute the already determined demolition of the building to make room for a city highway along the Wall. This need for a tabula rasa, for a way to deal with the catastrophe of the past once and for all, and to make it disappear into the circulating currents of traffic and capital, is thematized by Hans Haacke in his central installation in the Martin-Gropius-Bau Atrium.

Rupture in Civilization

Hans Jürgen Syberberg made Theodor W. Adorno's much quoted and misunderstood dictum "Writing poetry after Auschwitz is barbaric"[51] responsible for an "absolute prohibition on poetry and feeling", for the inability to produce something beautiful in the aesthetic sense"[52] Adorno countered: "... there is no longer beauty or consola-

57 Hermann Rauschning, *Gespräche mit Hitler* (Vienna, 1988) quoted by Gunnar Heinsohn, in: "Auschwitz ohne Hitler? Die Tafeln vom Sinai und die Lehre von den drei Weltzeitaltern", *Lettre International*, vol. 33, Summer 1996, 23. In comparison with other statements, texts and actions by Hitler, the *"Gespräche"* (conversations) are taken as a serious source. Compare: Th. Schieder and Hermann Rauschnings *"Gespräche mit Hitler" als Geschichtsquelle* (Opladen, 1972).

58 Files from German foreign politics 1918-1945, Serie D (1937-45) (Baden-Baden, 1956).

59 Gunnar Heinsohn, 27.

60 Theodor W. Adorno, *Negative Dialektik* (Frankfurt/Main, 1975) 359.

61 See footnote 60, p. 358.

62 Theodor W. Adorno, *Ges. Schriften*, vol. 7, 229.

63 See footnote 60, p. 355 cont'd.

64 Quoted by Heinrich Stiehler, "Schwarze Flocken. Neues über Paul Antschel-Celan: Das Arbeitslager Tabaresti und drei Frühe Gedichte", *Die Zeit*, Nr. 44, 10/27/1995, 62.

65 Let us remember the suicide of Primo Levi (7/31/1919 - 4/11/1987). See: *Ist das ein Mensch?* (Munich 1988) and *Die Untergegangenen und die Geretteten* (Munich, 1990).

66 Walter Benjamin, N 8,2 (Erkenntnistheoretisches, Theorie des Fortschritts), in: *Das Passagen-Werk, Gesammelte Werke*, vol. V, (Frankfurt/Main 1983) 589.

67 See footnote 66, p. 491.

68 Peter Szondi, "Durch die Enge geführt, Versuch über die Verständlichkeit des modernen Gedichts", *P.S., Celan-Studien* (Frankfurt/Main, 1972) 102, cont'd., 52 cont'd.

69 Letter to the Editor, *Frankfurter Allgemeine Zeitung* from 6/25/1964.

70 Jean Bollack, "Deine trockene, immer noch sternsüchtige Seele", *Frankfurter Allgemeine Zeitung*, Nr. 193, 8/21/1993.

71 Marina Dmitrieva-Einhorn, "Wo ich mit meinen Gedanken bin", *Die Zeit*, Nr. 44, 10/27/1995, 63.

72 In his notes written after the Hitler film, Syberberg noted in a postscript: "Since Hitler, it can no longer be said in Germany: it is the Jews' fault. On the contrary. And that radically differentiates us from ... our father, from Richard Wagner to Karl Kraus. ... What kind of experiment was that, to have become 'pure' We are among ourselves. And how. ... everything became

tion except in the gaze falling on horror, they withstanding it, and in unalleviated consciousness of negativity holding fast to the possibility of what is better"[53]

Adorno had never entertained the thought of a prohibition on image or writing, as later interpreters, using notions such as *Betroffenheit* (consternation) and *"Verstummen"* (speechlessness), verbosely complained about the inappropriateness of "describing the Holocaust"[54] and thereby produced academic kitsch, which Adorno traced back to the critical spirit's adherence to "self-sufficient contemplation"[55]. For him, it was solely a matter of consciousness of the unbridgeable chasm which was opened by the civilization rupture of Auschwitz and made impossible any continuation of cultural traditions in Germany. Today, historians are still not in agreement over the singularity and significance of this rupture in civilization. "The paralysis of the historian resulted from the simultaneity and combination of completely heterogeneous phenomena: messianic fanaticism and bureaucratic structures, pathological drive to action and administrative edict, archaic ways of thinking in a highly developed industrial society."[56] Gunnar Heinsohn developed the thesis that Hitler wanted to exterminate the Jews because they, with the ten commandments - particularly the fifth: "Thou shalt not kill", which for the first time in history denounced the killing of unwanted children as sin – stood in way of his plan to reintroduce the archaic, pre-Moses right to exterminate nations in order to realize his plan to germanize Europe. "We stand before a tremendous revolution in the notions of morality and the spiritual orientation of mankind. ... We put an end to mankind's tortuous path. The slabs of stone from Mt. Sinai have lost their validity. Conscience is a Jewish invention."[57] On August 22, 1939, a week before the war began, Hitler swore in the heads of the armed forces to the genocide of East Europe. "Ghengis Khan drove millions of women and children to their deaths What the weak West European civilization thinks of me is immaterial. I have given the order – and I will have anyone who utters only one word of criticism executed by firing squad –, that the goal of the war does not consist in reaching certain lines, rather in the physical annihilation of the opposition."[58] Hitler wanted to reproduce the unbounded law of Nature against the killing taboo and the protection of minorities of the Jewish law. The uniqueness of the civilization rupture of Auschwitz lies not in the tremendous number of murdered Jews alone, but in the "removal of the prohibition of murder through the extermination of the Jewish people who identify with it",[59] in order to clear the way for the extermination of the peoples of East Europe.

Considering the fact that this radical transformation of notions of morality could take place "amidst all the traditions of philosphy, art and the enlightening sci-

ences"[60], Adorno expected, first of all, a "reflection on their own failure" from artists and intellectuals after 1945. He saw the task of art only in the refusal of reconciliation, in the uncompromising negation of the relations which had made Auschwitz possible. The crucifixions by Eugen Schönebeck, the mutilated bodies in the paintings by Georg Baselitz at the beginning of the 1960's and paintings such as *Escape, Half Burnt, Half Comforted* or *Transport* by Gustav Kluge from the 1980's are expression of a deep mistrust towards that Christian-occidental culture that always wants to extract sense out of suffering. "The somatic, non-spiritual layer of the living is the arena of suffering, which miserably incinerated everything soothing to the spirit and its objectification, culture, in the camps."[61] Adorno expected art works to "always relentlessly examine the context that generates meaning" and with that, turn "against this and against meaning at all".[62] However, the "perennial suffering ..." has "as much right to expression as the tortured have to howl. That is why it may have been wrong to say that after Auschwitz, no poem would let itself be written. But what is not wrong is the less cultural question, whether, after Auschwitz, there can still be life, if it is altogether allowed, for one who escaped by chance and by rights should have been killed. His continuing to live requires the cold, the basic principle of middle class subjectivity, without which Auschwitz would not have been possible: drastic guilt of those spared. In retaliation, he is plagued by dreams such as – of the one who no longer lives, but had been gassed in 1944, and his entire existence afterwards merely leads into illusion, emanation of the insane wish of one who had been murdered twenty years ago. ... The guilt of life, which as pure fact already robs the breath from other lives, according to a statistic, which supplements an overwhelming number of murdered people with a minimal one saved, as when what would be provided for by the calculation of probability, can no longer be reconciled with life. This guilt is continually reproduced because it cannot at any moment be present to the consciousness. That, and nothing else, compels philosphy."[63]

Paul Celan, born the only child of German speaking Jews in Chernowitz, Bukowina, survived in a Romanian work camp. There, he received the news in 1942/43 of his parents' murders at the hands of the German occupation in the Ukraine where they had been deported. On April 20 1970, he took his life in the Seine in Paris. The experience of the 22 year old of having survived by circumstances of luck, while his parents were murdered on the other, German occupied bank of the Bug River, became the central content of his poetry, which decoded the world as a sign system of death: "IT FALLS NOW, MOTHER, snow in the/Ukraine What would it be, mother: growth or wound –/I sunk too in the snowdrifts of the Ukraine?"[64]

unspeakably evil, coarse in joking or thinking and discussing The customs that became ideologies are ruthless in their complete indifference." (Munich 1981) 8.

73 Paul Celan, "Engführung", *Ausgewählte Gedichte* (Frankfurt/Main, 1970) 67.

74 Interview with Heiner Müller, *Der Spiegel*, Nr. 19, 1983, 205.

75 Bernd Nitschke, "Eine Generation der Ausgeschlossenen, von Anfang an", *Konkursbuch 2* (Tübingen, 1978) 16.

76 "Mitleid wurde verdrängt", *Die Zeit*, Nr. 32, 8/1/1997, 10. Already in his appeal in the department store arson trial in 1968, the defense attorney for Andreas Baader and Horst Mahler justified the motive for the crime with the rebellion against the generation of parents who tolerated millions of crimes during the NS time and thereby implicated themselves. (Stefan Aust, *Der Baader-Meinhof-Komplex* (Munich, 1989) 71. Jürgen Habermas warned the Student Movement in 1967 against attempting the "transformation of the subliminal violence of the institutions into manfested violence through challenge", which would give rise to a "fascism of the Left". (Speech at the "University and Democracy" congress, which the SDS had organized at the Free University, Berlin, on June 9, 1967, a week before Benno Ohnsorg was shot down.)

77 "Terrorismus als die Wiederkehr des Verfolgers." (Dörte von Westernhagen, Die Kinder der Täter, *Die Zeit*, Nr. 14, 3/28/1986, 18.)

78 Heinrich Breloer, *Todesspiel* (Cologne, 1997) 129.

79 "The first RAF generation claimed to move history." (Gefangen für alle Zeiten. Horst Herold, former Chief of the Federal Criminal Police Office, lives isolated in a high security wing, See footnote 76, p. 11.)

80 "Wenn ich will, legst du ein Ei für mich", Gespräch mit Horst Bubeck, *Frankfurter Allgemeine Zeitung*, 6/18/1997, Nr. 138, 35.

81 Der Spiegel, Nr. 2, 1987.

82 Norbert Messler, "Allemallachen: Büttner, Oehlen, Kippenberger, Herold", *Kunstforum International*, 120, 1993, 186-221.

83 Georg Herold, *Dachlatte vergoldet*, 1987.

84 "Many hopes continued living cheerfully in the GDR, which were more or less dead elsewhere in the East bloc. ... With most of the people I met, I didn't see the familiar look which I knew from other illusionless East Europeans. My East Berlin friends had, namely, faith of unmistakable character. ... In comparison with Prague,

His feeling of guilt, to have survived without being able to have helped those murdered, persecuted him his entire life long.[65]

Only in the moment of remembering, in bearing in mind, may art do justice to the dead. "Remembering can ... make what is concluded, unconcluded."[66] The historical facts can become something in art, "what just now happened to us."[67] Celan's poetry originates in bringing the dead to mind. "After Auschwitz, poems are no longer possible, unless it is because of Auschwitz. ... Remembering becomes the reason for the poet's 'speaking'." The language of poetry does not describe a reality, but is text-reality itself, which refuses "to touch on the reality of death and the extermination camp and to act as if a poetic image is made from them. At the same time, however, he lets the aesthetic reality withstand his poetry, which is dedicated almost exclusively to the memory of the dead."[68] On the question of whether Paul Celan's poems are a denial of sin justified by the experience of the death camp or only an expression of "artistic" associations, as the writer Hans Egon Holthusen, who became known as the defender of Christian positions against an "aesthetic nihilism", maintained in the *Frankfurter Allgemeine Zeitung* on 5/2/1964, a debate was sparked off, typical for the Federal Republic in that year, in which Peter Szondi intervened.[69] In the supposedly unjustifiable metaphors of Paul Celan, like "Mill of death", Holthusen saw no identifiable and most importantly, no assimilatable meaning. He thought that this linguistic image testified only to "the predilection of that time for the 'surreal', in genetive metaphor indulged in X-arbitraries". Szondi made clear that Celan used the language of the executioner, which in Eichmann's sphere described the death camps euphemistically as "death mills", as a point of departure and opponent of his poetic language. "Eichmann's monstrous 'metaphor' is transported from the reality of the extermination camp into Celan's own language, which had made possible that those killed had existed in history. Still, before the poem was written, it was believed that nothing appropriate can be created that does not refer to this reality. ... 'Yes, we blasphem'. The 'mills' of death: this is precisely the meaning that Holthusen ruled out."[70] Celan, the Jewish poet of the German language, remained in French exile until the end of his life and visited the Federal Republic only occasionally to receive literature prizes, for readings and seminars. In a letter of 8/10/1962 to Erich Einhorn, a childhood friend from Chernowitz living in Moscow, he wrote: "You're right when you say that I haven't been forgiven in Germany for having written a poem – "The Todesfuge" – about the German extermination camp. What this poem – and similar poems – has brought me, would be a long chapter. The literature prizes they have awarded me, don't let them deceive you: in the

end, they are only the alibi of those who continue with other, up-to-date means what they had begun under Hitler, respectively, what they have carried on, in the shadow of such alibis."[71]

In 1981, Anselm Kiefer referred to Paul Celan's poem "Todesfuge" in two paintings, painted parallel to each other, "Your Golden Hair, Margarethe" and "Your Ashen Hair, Sulamith" (fig, 327, p. 336). Roughly made furrows run diagonally across a high horizon with forest and houses in both paintings. Kiefer avoided those mythical profundities of homeland and soil for which he had been again and again criticized. Like an alter ego, a black brush stroke behind the straw, whch evokes Margarethe's golden hair, refers to Sulamith's black hair. Blueish smoke rises over the straw remains of the burning fields of the second painting, leaving ashes behind: "Your ashen hair, Sulamith, we will dig a grave in the / Skies where one does not lie in a tight space". The symbiosis of the Jewish-Christian culture of human rights and the prohibition on killing was irretrievably destroyed by the murder of the Jews and signified the self-mutilation of Germany.[72] The landscape as a source of nourishment and homeland were transformed into the "black field"[73] of death.

"The Nibelungen will be Played in Germany Like Before"[74]

Twenty years have passed since October 18, 1977, the night Andreas Baader, Gudrun Ensslin and Jan-Carl Raspe committed suicide after the failed hijacking of the Lufthansa airplane "Landshut" and the murder of the President of Employers, Hanns Martin Schleyer. Gerhard Richter dedicated his cycle to this date, giving it the same name. It is a painted requiem to the perpetrators, who had murdered many times and at the same time also became the victims of their mothers' and fathers' repressed fascism, "which persecuted the children who had to destroy themselves in order to escape from the persecution"[75] Peter-Jürgen Boock, who participated decisively in the Schleyer kidnapping, says today: "From my standpoint, the entire conflict that arose in '68 was reflected in Schleyer's person. He was an SS man, who after '45, came back into the German economy in a leading position. With our actions, we wanted to begin at the point where we saw historical processes which would have ended with – again – a fascist state. ... How close we came with our shot in the head actions to what we professed to have struggled for, is really the frightening thing."[76] What the parents could not overcome, continued to have an effect as the "Fascist in you".[77] In their "people's prison", the RAF wanted to prosecute the symbol figure of the "evil Nazi father"[78] in an imaginary "people's trial". In the macabre analogy to the Nazi "people's court of law", the mythical folk notion of a political Romantic of the 19th

people deal with things much more theoretically and they could, among other things, impressively substantiate completely intolerable political ideas with quantities of knowledge. Of that, "could many young Czechs only often dream; therefore, they possessed more healthy scepsis and lively ironie as the Germans." (Jan Faktor, "Die DDR in geographischer Umklammerung durch Irrtümer", *Die Leute trinken zuviel...*, (Berlin, 1995) 154.)

85 "... there is or was certainly ... in the GDR, a direct position, positive or negative, to history. While here, you could remove yourself from history much faster and easier. Because history really only takes place here as a movement of capital which one never really sees, it happens where you don't see it. And only when there are interruptions and when it doesn't go so smoothly any more do you notice again that you have something do to with and are connected to history." (Heiner Müller in an interview with Walter Höllerer, *Sprache im technischen Zeitalter*, vol 103, September 1987, 207.
"I had always believed that with Brecht also, the beauty of formulating a barbaric fact contains hope for the utopia. I don't believe that any more. At some point, you have to accept the separation between art and life." (Heiner Müller, *Krieg ohne Schlacht. Leben in zwei Diktaturen* (Cologne, 1994) 290 cont'd.)

86 According to Roberto Ohrt in his contribution to the catalog. The publisher and the institutions who had requested him to write a text, could not follow the author on all points in the evaluation of the new German, everday racism. The xenophobic excesses, particulary in the years 1991/92, in which 17 people lost their lives and about 452 were wounded, for example, to name them "progroms", signifies a belated playing down of the progroms organized by the government, supported and tolerated by the population before 1945 in Germany and the subjugated countries of Europe. This "image of Germany" also belongs in the catalog of German Images since 1933. However, one should from time to time examine "how much of his own tolerance is sincere and independent and how much is caused by the inhibited German self-hate, which welcomes foreigners, so that here, in his hated fatherland, the constellations finally emerge as that notorious ('fascistic') characteristic" (Botho Strauß, "Anschwellender Bockgesang", *Der Spiegel*, Nr. 6, 1993, 203.)

87 Wolfgang Max Faust, "Deutsche Kunst, hier, heute", *Kunstforum International*, 1981/82.

Century turns up again, which had to serve as a constructed replacement for an absent state conception of the left and right camps in Germany. The RAF hunter, Horst Herold, Chief of the Federal Criminal Police Office and inventor of the computer-controlled search list, was, paradoxically, just as fascinated by the utopia of a "Social Democratic Sun State's" internal security (Hans Magnus Enzensberger) as by the romantic-social revolutionary utopia of "the possiblitiy of history"[79], which took the field with deadly consequence and German self-destruction fury for the absolute truth. As "prisoners-of-war" of a society of former perpetrators and those who went along, they compelled the solidarity of their like-minded comrades and the intellectual sympathizers through excessive coining of such terms as "solitary confinement", "solitary confinement (as torture)",[80] etc. In contrast, however, the anger and aggressivity of a deeply disturbed society is spoken in paintings in the cycle such as *Confrontation* (fig. 355-357, p. 394), in which society's democratic-civil way of seeing itself was put to the test by the terrorists. The high point of their self-destructive campaign against the social-liberal state was the feigned "execution" of defenseless prisoners, who were supposed to have been executed by the SS shot in the neck. This strategy did not work, but it had robbed the Federal Republic of its innocence and mobilized revisionist powers. In the climate of the consequent intellectual-moral turn backwards, which in the historian debate of 1986/87 was meant to settle the past once and for all, the year 1968 repressed the trauma of 1933. Ernst Nolte: "... it is more important to get over the rebellion of 1968 than to overcome Hitler once again."[81]

In the West German climate of normalization and post modern randomness, a "New German Art" appeared on the plan in the 1980's, which, under the motto "everyone laugh together"[82], with swastikas and Hitler portraits, 'painted' with relish against the pedagogical theorizing and mass medial treatment of the horror (for example, through the television series *Holocaust*). It amused itself with full saracasm over the politicians' Laokoonesque struggling with the heavy burden of legacy and saw Germany as "the throw-away model of European history."[83]

The neoexpressive, painted apocalypse of their generational comrades in the GDR offered views into the turmoil of souls and witnessed the feelings of a post-Stalinist generation[84] shortly before the East bloc quietly imploded. Communist utopia's failure as part of the totalitarian barbarism of the 20th Century was the stuff of Heiner Müller's tragedies. When the model GDR was taken into the "capitalist system" after the *Wende*, sorrow and action became meaningless for a vision of the future.[85] The dramatist henceforth gave interviews and wrote

poetry. With the fall of the Wall, art in the GDR had lost its appeal as the seismograph of the societal political conflicts and as aesthetic revelation of new forms of society.

Voices from the left spectrum of the Republic had claimed as early as during the preparatory phase, that this exhibition would lay the groundwork for a new, binding image of Germany that would radiate from Berlin, the future seat of government.[86] The art works shown, however, bar themselves any reconciliation with the past and present of a still mentally divided country. They refuse the wish images of a new national identity. They show the *Sharp Turns* (Paul Klee), the beginnings, the generation gaps and change in perspective between remembering and forgetting as a mental confrontation with the ruptured consciousness of an irretrievable loss. The times of prescribed images of identification are over. In the dialogue with the German images of the artist, the many individuals themselves can lead the "Dialogue with the Germans who make no imperial claim, do not glorify themselves, but who also do not abase themselves".[87]

Eckhart Gillen

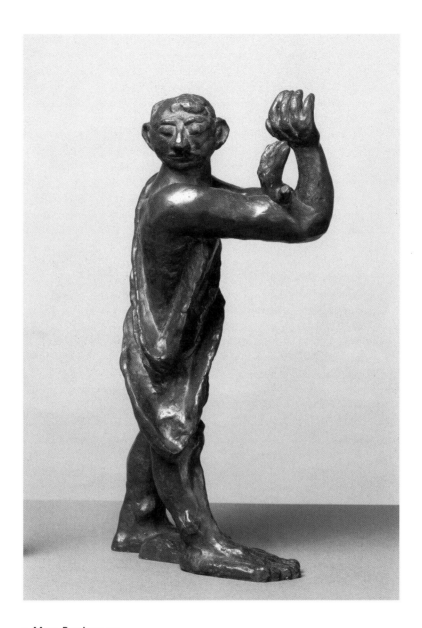

1 **Max Beckmann**
Man in the Dark, 1934
Bronze
Height 57.3 cm
On loan from Wittelsbacher
Ausgleichsfonds,
Collection Prinz Franz von Bayern to the Bayerische
Staatsgemäldesammlung München,
Staatsgalerie Moderner Kunst

Man in the Dark

As a blind man, explained the emigrant, he had possibly bypassed politics and its realities. He had left Germany for Amsterdam on July 19th, 1937, one day after Hitler's speech to open the "House of German Art." He never again set foot in "Germany", as he usually called it from that point on. His realities lay in another sphere. That's why he dealt with a ten year exile and made passage to America in the end. Painting and politics were two separate worlds for him, precisely because their demands kept crossing in his biography. He offensively countered the ideologies of the time with his colorful image of the world, which he as loner had developed in constant reflection over object, form and space. There was no place for aesthetic escapism. The urgent triptychs from the thirties and forties are Beckmann's antithesis to the zeitgeist. They availed themselves of its symbols for the purpose of giving the people a real picture of their lives. The artist's numerous self-portraits accompany this process. They function as a watchman's nightly inspection round: measures taken for his self-confirmation and encouragement. With his move from Frankfurt am Main to Berlin after his discharge from a teaching post at the Städelschule, Beckmann felt threatened by his situation.

Berlin 1934 - The painter who loved to live the high life and to be seen in bourgeois society's exclusive places gave up his apartment and atelier in Paris where he had again and again gone to work. This was consequence of the economic crisis, the effects of which even he felt. For four years in Berlin, the city that granted him his first triumphs, he felt to some extent secure under the protection of influential friends, in face of the harassment by the new rulers.

He is fifty years old as he models his first sculpture in plaster, *Man in the Dark* (fig. 1, p. 23). Not a portrayal of "inner emigration", rather, the model of an explorer in the protection of the night, who turns his deliberate steps with over-size feet towards the uncertain. He holds his equally gigantic hands as if groping the way ahead, raised in defense against unknown powers. They are like highly sensitive organs, through which the man receives the tremors of the space around him. He reacts to these like a blind man in absolute concentration with head averted and eyes closed. His hearing also participates in the exploration of the darkness, as indicated by the largely formed ears. The artist receives messages over the music from spaces beyond. The instruments, the musicians, and singers in his paintings, are harbingers of these topical truths. All the senses are directed to the exploration of the "self" and its uncertain path. Without a doubt - Beckmann captures his own situation in 1934 with "Man in the Dark". The fact that he undertakes this not only with the means of painting, but also takes on the three-dimensional qualities of sculpture with which he had no practice, points to his will to radically give form to his experience. The "Man in the Darkness" had no predecessor in the sculpture of its time nor later succesor. Like Beckmann, he has no one to rely on but himself.

Amsterdam 1940 - The *Self-Portrait with Green Curtain* (fig. 2, p. 25) with the head turned abruptly back over the right shoulder, seems like a replica of "Man in the Dark". In the nocturnal illumination, the curtain blocks the view into the depth. The atmosphere is dubious, and the emigrant had felt his situation in occupied Amsterdam to be just as contradictory; locked up in a cage which holds him captive but also protects him, an open hiding-place. One recalls Picasso's portraits of women from occupied Paris. In these paintings we also see even more radically the cage motif and the breaking down of the face into front and side view. Beckmann doesn't go so far in his formal freedom. But in both, the strong tension is the result of similar conditions of pressure.

As the German troups invaded the Netherlands, Beckmann burned his diaries. Only two pages remain: "I begin this new notebook in a stage of the most complete insecurity over my existence and the state of the planet." The self-portrait is the diagnosis of his mental state.

St. Louis 1947 - American friends take Beckmann out of his Dutch exile into the United States. The 63 year old took a good look at the new continent. His first "American" self-portrait came into being (fig. 3, p. 27). The painter, who now describes himself as "old fashioned", finds himself again in front of a painting class. What does the old "Realist" still have to teach? The narrow hand with the cigarette is demonstratively raised as if taking an oath, the eyes are narrowed to slits from strenuous use, as is often the case with Beckmann. The extended fingers point to this. "I want you to discover your own selves," he called to his new students, "at your own resonsibility." That is exactly the task Beckmann had always set himself, exposed equally to sensual experience and the inner faces.

Klaus Gallwitz

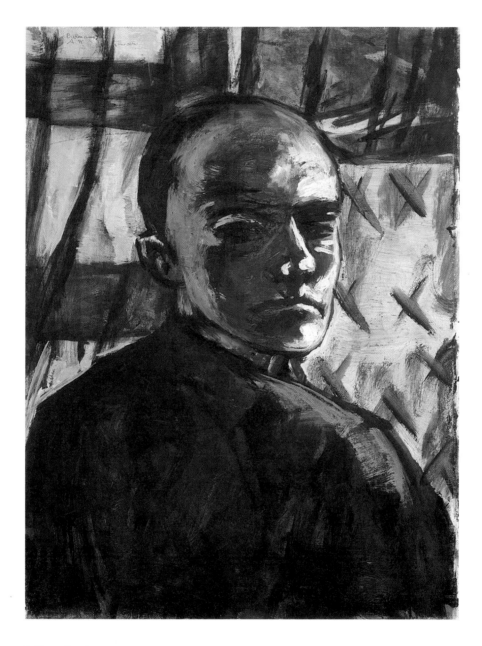

2 **Max Beckmann**
Self-Portrait with Green Curtain, 1940
Oil on canvas
75.5 x 55.5 cm
Sprengel Museum, Hannover

Max Beckmann
Self-Portrait with Cigarette

On September 18, 1947 via New York, Max and Mathilde "Quappi" Beckmann reached their destination Saint Louis, Missouri, the new home where they would be able to live and work. In his diary, the painter noted: "St. Louis. Finally a park. Finally trees, my feet finally on the ground ... It is likely, that here it will be possible to live once again".[1] He was alluding to his 10 year exile in Amsterdam, into which he and his wife had fled in 1937, the very day after Adolf Hitler's speech to opening the "House of German Art" in Munich. After all, 590 (!) works by Beckmann had been already confiscated that year as "Degenerate Art", of which 28 alone were paintings.

Unlike any other artist, Max Beckmann confronted us with his condition and mental state in around 35 self-portraits painted over the years and political circumstances. In view of the fluctuating developments in Berlin, Frankfurt, Amsterdam and in the U.S.A., this striking and expressive physiognomy of the artist reflects immediately and simultaneously the objective course of historical events as a subjective artistic expression before, during and after the second great war. Beckmann was appointed by the Washington University Art School in Saint Louis to teach painting, after he had turned down positions in Berlin and Indiana. In *Self-Portrait with Cigarette* (1947; fig. 3, p. 27), the third and absolutely last self-portrait, we are again struck by the artist's entire life scepticism, which continually reflects his inner world. According to his diary entries, he had begun the painting as *Self-Portrait with Parrot* on October 13th, 1947. After reworking it on November 5th ("Difficult and unnecessary reworking of *Self-Portrait with Bird* - Such nonsense"[2]) Beckmann noted at last on November 9th: "Finally produced *Self-Portrait with Cigarette,* this time I believe it's good."[3] He had thus eliminated the aforementioned parrot, whereby the painting certainly won in concentration. The peculiar under-proportioning of the hand holding the cigarette, especially at the wrist, increases the large format effect of the imposing skull, whose eyes, in this portrait, glance past us. Characteristic here is that the black contours sharply enclosing and restricting the forms, as well as the brown, green, blue and violet earth tones, distinguish the head and clothing from the diffuse surfaces of the background.

The motif of representing himself with the cigarette (or later also with a cigar) turns up already in *Self-Portrait Florence* from 1907, when Beckmann was able to take advantage of a grant for half a year at the Villa Romana there. He appears here "as someone who takes a firm stance of ironic composure, standing on the basis of traditions of the times."[4] "At that time, the cigarette signaled intellectualism and endowed him with a worldly flair."[5] In the self-portrait from Saint Louis, painted over forty years later, nothing is retained from the earlier intentions or their associated aura. After the portrayals from about 1923 and others from the following years, *Self-Portrait with Cigarette* is the first and only painting - except for his last *Self-Portrait in Blue Jacket* (1950) - in which the artist places the cigarette in front of his face, clamped in a pincer-like grip between almost endlessly long index and middle fingers. The rising swirls of smoke somewhat soften the blocklike strictness of the contours and form the only dynamic element in the painting's static system. This physiognomy, dominated as always in Beckmann's portraits by the sharpness and strength of his glance, conveys the continually self-questioning scepticism, which, as was his habit, he formulated in his diary two years later: "Well, what else does life have in store for me? Damned little, everything's already behind me, hardly a new adventure in mind and still healthy enough? A troublesome game of false youth played to the end. An increase of fame and success – hardly to be expected. The hunt for money at the doors of New York – unfortunately I don't come as a lord – I've lived too seriously for that and will just as well continue being eternally dependent on someone or other. And the painting scene itself? Will I also have the strength for something new?"[6] For this, he certainly didn't have much more time. On December 27th, 1950, Max Beckmann collapsed and died on the corner of 61st. Street and Central Park West.

Ingo Bartsch

1 Beckmann, *Tagebücher 1940-1950.* ed. Erhard Göpel (München/Zürich, 1987) 222.

2 Beckmann, 231.

3 Beckmann, 232.

4 Schneede, Uwe, M., *Der Künstler über sich selbst. Zu einigen Bildern und Texten von Max Beckmann, Max Beckmann - Selbstbildnisse.* exhib.-cat. Hamburger Kunsthalle und Staatsgalerie Moderner Kunst (München, Stuttgart 1993) 9.

5 Dorothee Hansen, "Selbstbildnis Florenz", *Max Beckmann - Selbstbildnisse,* 64.

6 Beckmann, M. *Tagebücher 1940-1950.* ed. Erhard Göpel (München/Zürich, 1987). Entry from July 6, 1949, Boulder, Colorado.

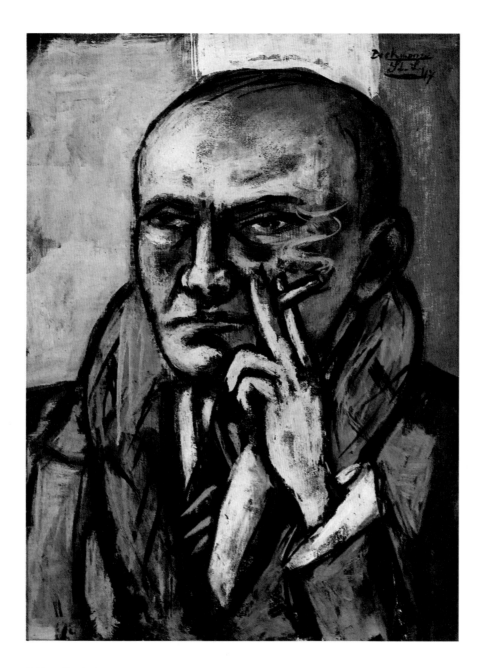

3 **Max Beckmann**
Self-Portrait with Cigarette, 1947
Oil on canvas
63.5 x 45.5 cm
Museum am Ostwall, Dortmund

Max Ernst: The House Angel

Max Ernst
La carmagnole de l'amour
1926/27
Oil on canvas
130 x 97 cm
Private Collection, Brussels

Max Ernst painted the *L'ange du foyer*, The House Angel in the year 1937, under the shock of the Spanish Civil War and the threat of National Socialism. It was for him an existential shock. In his autobiographical journal he noted: *"Cette année 1993, Max Ernst est mis sur la liste des proscrits du régime nazi."*[1] The impending danger of Hitler's terror appears in a series of images and motifs in his work during the 1930's. The collage series *Une semaine de bonté* (1934) can be read against this background as a modern version of the "Desastres".

The year 1937 also included another turning point in his life and work. The exhibition "Degenerate Art" denounced his important work the *Beautiful Gardener* (1923). Its role in this show was to illustrate the "denigration of the German woman." A moment of resistance against aesthetic exclusion was expressed in the title under which the *House Angel* first appeared: *Le triomphe du surréalisme* – "The Triumph of Surrealism." The double reaction of Ernst to the political events in Spain and the cultural politics of the National Socialists, is mirrored in his work. Years later he addressed the subject as follows: "A work that I painted after the defeat of the Republicans in Spain, is the *House Angel*. This is of course an ironic title for a kind of cretin that tears and destroys everything in its way. That was my impression at the time of what would happen in the world, and I was right about it."[2]

This statement, that relates the *House Angel* to a world historical event is crucial. The tensions between the Surrealists and the Communist Party that came repeatedly to the fore, and were apparent from the start of the relationship to the CPF, came to a head in 1933. The idea of revolution which had been propagated by the Surrealists in their publications and activities stood in crass contradiction to the Communist Party dogma. In 1933 they attacked "socialist realism" which had then become the official artistic doctrine. Aliquié wrote in *"Surréalisme au Service de la Révolution"*, that in films such as *The Way of Life*, a *breath of stupefication* is wafting in from the Soviet Union, after which Breton, Eluard and Crevel were closed out of the Communist Party.[3] Breton made repeated attempts at a rapprochement, and not simply out of self interest alone. In internationalism he saw the final hope.

In 1936 the Surrealists published a pamphlet under the title *As the Surrealists Were Still in the Right* which strongly attacked the behavior of Malraux at the "International Congress for the Defense of Culture". He and others including those earlier Surrealists who were already, or hoped to become, Communist Party functionaries were accused of childish thinking and ideological servility. Shortly before the opening of the Congress, Breton had acosted Ilja Ehrenburg, who belonged to the Soviet delegation, on the street. He defended himself against the attacks she had made in her book *Vus par un écrivain de l'U.R.S.S.:* "The Surrealists agree with Hegel, and Marx and with the revolution, what they don't want however is to work. They have better things to do, like studying pederasty, and dreams ... They are however diligent enough to go out of their way to use other peoples money, dowries, inheritances ... They started fabricating obscene word games. The most simple-minded of them admit that their entire program consists of chasing skirts."[5] Under pressure from the Soviet delegation, the Surrealists were to be shut out of the Congress. Only at the end of the proceedings was Eluard allowed to present a text that Breton had actually been intended to read. The questions that the Surrealists wanted to pose were never admitted to the debate. Central in this regard was the discussion of aesthetic freedom of expression.

The text *As the Surrealists Were Still in the Right* summarized their demands as follows: "The right in art and literature to experiment with all new means of expression, the right of the writer and artist to pursure in all forms all human problems, the demand for free choice of the object, rejection of the judgment of a work based on the popularity of its reception, resistance against every attempt to limit the realm of observation and action of those who are engaged in intellectual creation."[6] Here, it is not to be forgotten that the participation of Max Ernst in the Spanish civil war on the side of the Republicans was undermined by the objection of André Malraux.

Taking a look at the texts in the publications of exhibitions and galleries at the time, only Picasso's *Guernica* and the Surrealists avoid the powerless consensus of the time that sought to maintain "artistic freedom" in relation to political praxis. An aesthetic appeasement of dominated, one which tried to avoid unpleasant conflict. Surprising here is the function of the pictorial image. Occasion and demand made of it a historical image. The avant-garde of our century has done away with historical painting like they have with complex allegory and narrative as well.

Against this background it is fascinating to see that the only significant historical works of the time make use of a mode of presentation which tries to capture their object not through realistic reproduction, but rather with the means of symbolism. When asked about the technical execution of *Guernica* Picasso answered: "J'ai utilisé le symbolisme" – "I have used symbolism." The iconographic approach corresponded to the program of sur-

1 "In 1933 *Max Ernst* was by on the list of 'Undesirables' by the Nazi regime."

2 Quotation from *Max Ernst. Retrospective 1979*, ed. Werner Spies, exhibition catalog, Haus der Kunst, Munich, Nationalgalerie, West Berlin, (Munich 1979) catalog no. 251.

3 Ferdinand Alquié, André Breton, *Le Surréalisme au Service de la Révolution*, 5 (May 1933), 43.

4 André Breton, "Als die Surrealisten noch recht hatten", *Als die Surrealisten noch recht hatten. Texte und Dokumente*, ed. Günter Metken (Stuttgart, 1976), 158.

6 Breton, 156.

realist image production; only this permitted the possibility of finding a pictorial equivalent for horror and panic. But this aside, we do not encounter examples in these years were the discussions go beyond Surrealism. The more Surrealism moved to the center of political debates, the more vehement were liberal mainstream objections against it, that it was merely a literary-psychological disturbance which should be closed out of modern painting, reinforced. Through this movemennt that refused to separate social-political questions from aesthetics, the avant-garde felt itself compromised. Innumerable conflicts concerning the political situation of the group, are mirrored in their works.

In the first surrealist manifesto, published by Breton 1924, references to political and social conditions remain encoded. Of foremost importance was the rejection of realism. The critique of positivism ended then with the conclusion of *"L'existence est ailleurs."*[7] The only possibility for change that Breton saw in the narrative flow of the work, was the turn to a pre-realistic state. Childhood and dreams were therefore held up as a corrective against the hated world of reality. He cites Freud, who he misunderstood, and was forced to misunderstand. For Breton the dream-content meant a kind of surplus-value that he wanted to set directly into praxis. At the same time, knowledge of Freudian method served as a starting point for the question as to how surrealist praxis could synthetically bring these images into being. In the context of the search for *"applications du surréalisme à l'action"*[8] (applications of Surrealism in action) examples were named which could be considered forerunners of Surrealism.

Viewed formally, the *House Angel* drew without a doubt on the dynamic, dark "mob-images" that started to appear in his works after 1927. In the 1930's the titles of his works appear to reinforce a particular content. The descriptions given by Max Ernst become more concrete; to name only a few: *Barbares marchant vers l'ouest, La horde de barbares, Barbares regardant vers l'ouest* (all from 1935). Everywhere there dominates an ecstatic élan, which materializes even the creation of these works themselves in a mixture of activity and passivity, which in the eyes of Max Ernst characterized the principle of surrealist creation itself. Speed and tempo, expressed through an unorthodox technique, are basic elements of automatism. In ann interview for the journal *Indice* Breton had Tenerife in mind, the frantic movements of the "horde" when he inswered the question as to whether or not an artwork can express revolutionary feeling with reference to Picasso and Max Ernst. Both had proven the reality of this possibility. He referred to a work, *La carmagnole de l'amour*

(1926/27), which belongs to those in which the horde motif appeared for the first time.

Picasso's reference to symbolism and the openness of the surrealist theme itself, demands of us that we ask what lies behind the statements about the horde motif, which reaches its apogee in the *House Angel*. With regard to the surrealistic dimension of this motif, one encounters indications that ascribe to the horde, and to *violende*, a positive quality. In the text *"La Révolution d'abord et toujours!"* which appeared in *"La Révolution surréaliste"* in 1925 we read: "Without a doubt we are barbarians, we are repulsed by a particular form of culture Our rejection of every recognized law and our hope for new subterranean powers that can shake history, can break through the monotony of the given, brings Asia into view. The stereotypical gestures, deeds ans lies of Europe have closed the circle of revulsion. Now it's the Mongolians turn to spread out their tents on thiis territory."[10] For Breton the reference to barbarians overlaps with that which he believes himself justified in taking from the Freud. He sees culture threatened by a censoring super-ego. A return to automatism and spontaneity, which was called for in the first surrealist manifesto, is expressed in the reference to Asia. For Breton, the possibility of transforming the eye into a state of wildness, formas a pre-condition for breaking out of domestication through established style and imitation. Interesting is that the Russian writer and politician Anatoli Lunatscharski encountered this motif in his early meeting with the Surrealists, which the lyric poet Alexander Bloc, in his rejection of the bourgeoisie in the poem "The Scythians" also moved into the foreground. Lunatscharski moderated a discussion between Aragon and Breton, who is supposed to have said to him that "We respect and honor Asia as a place on earth where until now people have really lived out of the right sources of energy, unpoisoned by European reason. So come on Moscow, bring hordes of Asians with you, destroy the European culture. Even if we fo under to the sound of thumping huffs, so be it: if only reason goes under with us, calculation, the bringer of death, the suffocating bourgeois society!"[11] Max Ernst tells what an extraordinary effect the film from Wsewolod Pudowkin, *Storm Over Asia* (1929; France 1930) had on him, noting further the power of the movement, that transformed European psychology like in a time-lapse. The film reminds one of the principle motifs of his automatic works from the late 1920's.

In the context of the experiments with "automatic writing" this rejectionn of euro-centrism can be better understood, remembering here how deeply the western "civilized world" was pitted against the "barbaric" rest in the surrealist topography. A statement, dated April 2, 1925 and co-signed by André Masson, underlines this: "1. Be-

Max Ernst
Barbares marchant vers l'ouest
1935,
Oil on paper
stretched over box
24 x 31.5 cm
Private collection, Paris

7 "Existence is Somewhere Else". Compare: André Bretons "First Surrealist Manifesto", *As the Surrealists Were in the Right*, 50.

8 "Applications of Surrealism in Action", 48.

9 André Breton, "Interview with the Socialist Culture Program 'Indice', Teneriffa", *As the Surrealists Were in the Right*, 381.

10 "La révolution d'abord et toujours", *La Révolution Surréaliste*, 5, Oct. 1925, 31-32 quoted in "Zunächst und immer Revolution", *As the Surrealists Were in the Right*, 91-92.

fore the signers decide whether or not they should work surrealistically or revolutionarily, they must be filled with a certain rage. 2. In their view this is the best way to achieve that which one could call surrealistic illumination."[12]

There are a series of motifs in the surrealist iconography that we can interpret in the light of the

according the signs of the time by collecting on the surplus-value of automatism. The *House Angel* necessarily gestures away from impending disaster. Seen in this light, the work stands closer to Böcklin's *The Plague* or Kubins' *The War* than to his own earlier ecstatically open works.

Werner Spies

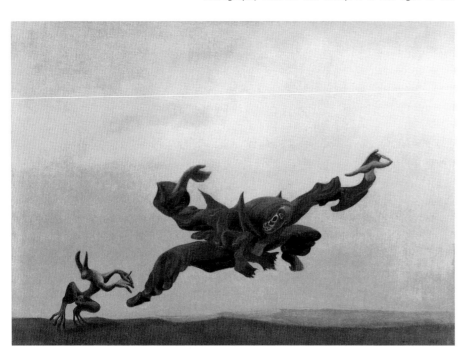

Max Ernst, *L'ange du foyer, 1937*
Oil on canvas, 53 x 73 cm
Theo Wormland, Munich

Max Ernst
House Angel
Oil on canvas

reference to the barbarians and their "new, subterranean forces." To these belong the frenetic, movement inducing phase of automatism which became central for both Masson and Max Ernst in the mid-twenties. For both, dynamic pictorial-writing is joined to the image of aggression. In this regard, the work of Max Ernst offers the most direct reference to a coupling of ecstatic elements in painting with anti-civilizational tendencies. A work like *La planète affolée* (1942) carries this over into the forties. The dripping method, which appears, later served as a technical model for Pollock and abstract expressionism.

It does not permit itself to be overseen that the apocalyptic element that springs out of the *House Angel* at the viewer is fundsmentally other than that referred to by Breton. *House Angel* takes its place in a series of works from the 1930's. In these works the indirect frottage/grattage techniques recede into the background to be supplanted by a type of painting that was characteristic of the veristic surrealistic method of the time. This technique strengthens the penetrating quality of the *House Angel*. It produces a more real definitive appearance than the hordes of the grattage works. Max Ernst corrected the Nietschean character of the horde images

11 Anatoli Lunatscharski, "Blok und die Revolution" (1932) *Die Revolution und die Kunst. Essays, Reden, Notizen,* second edition (Dresden, 1974) 216.

12 Maurice Nadeau, *Geschichte des Surrealismus* (Reinbek, 1965) 82 (French original, Paris 1945).

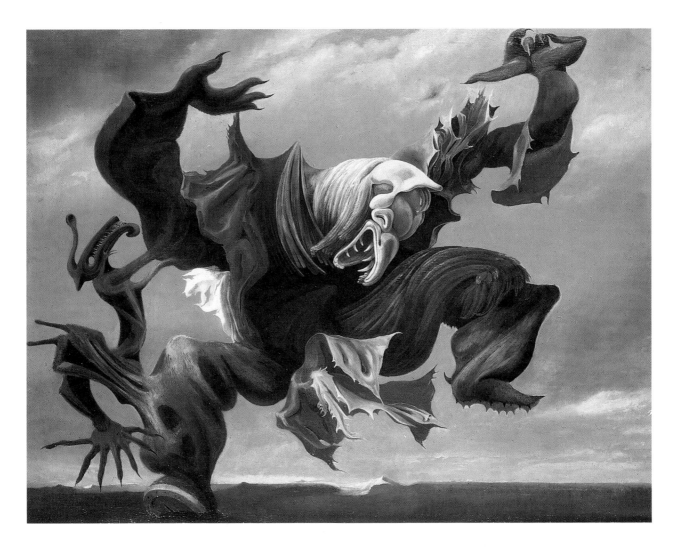

4 **Max Ernst**
L'ange du foyer (Le triomphe du surréalisme)
The House Angel (The Triumph of Surrealism),
1937
Oil on canvas
114 x 146 cm
Private collection

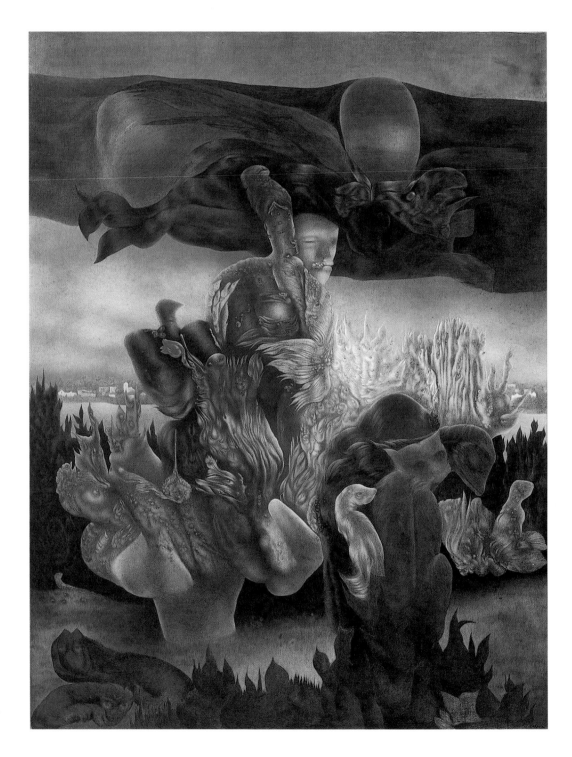

5 **Richard Oelze**
Daily Hardships, 1934
Oil on canvas
130 x 98 cm
Kunstsammlung Nordrhein–
Westfalen, Düsseldorf

Oskar Schlemmer's
wall painting Family

[1] *Oskar Schlemmer, Briefe und Tage-bücher,* Tut Schlemmer ed., (Munich, 1958) 119.

[2] Heimo Kuchling ed., *Oskar Schlemmer. Der Mensch,* Neue Bauhaus Bücher (Mainz, 1969), 25f.; Antje von Graevenitz, "Oskar Schlemmer Kursus: Der Mensch", *Oskar Schlemmer. Wand-Bild-Bild-Wand,* exhibition catalog (Kunsthalle Mannheim, 1988) 9f.

[3] After the NSDAP came into the Thüring state parliament, the notorious Paul Schultze arranged for the wall paintings to be painted over. Tut Schlemmer 271.

[4] "We went to war for the ideals of art out of our sincere enthusiasm for a great cause! In the names of my comrades killed in action, I protest against the defamation of their wishes and their works, to the extent that they are in museums and are now meant to be desecrated ... Artists are basically unpolitical in their nature and must be unpolitical, because their realm is of a different world. It is always humanity that they mean, the universal, to which they must be connected." Tut Schlemmer 309.

[5] On this entire complex: Karin von Maur, "Oskar Schlemmer 1933-1943", *Bildzyklen, Zeugnisse verfemter Kunst in Deutschland 1933-1945,* exhibition catalog (Stuttgart Staatsgalerie, 1987) 69f. and Stephanie Barron, *Degenerate Art. The Fate of the Avant-Garde in Nazi Germany,* Los Angeles, 1991.

[6] They first rented accomodations in Eichberg in the Südschwarzwald in April, 1934 (Tut Schlemmer 326) and then moved to their own home in Sehringen near Badenweiler (Tut Schlemmer 326).

[7] Because these camouflage activities ironically fell under the term architectural design, they are listed in the work catalog by Wulf Herzogenrath. Herzogenrath, *Oskar Schlemmer. Die Wandgestaltung der neuen Architektur* (Munich, 1973) 244; Tut Schlemmer 374; and the letter from 2/20/1942 to J. Bissier in: Julius Bissier, *Oskar Schlemmer. Briefwechsel* (St. Gallen, 1988) 71f.; Karin v. Maur 74.

[8] Tut Schlemmer 363.

[9] Karin v. Maur, *Bildzyklen* 74.

A lucky stroke of fate decreed that in the year 1940 Oskar Schlemmer got the chance, through friends, to realize a monumental wall painting without having to consider the ruling dictate over art.

Schlemmer's biography before 1933 was that of an avant-garde artist's in the time of great transformation: 1906 – studies at the Stuttgart Art Academy and master student under Adolf Hoelzel; 1914 – wartime volunteer; 1918 – continuation of his studies until his appointment at the Bauhaus in 1920. His friendship with the Swiss painter Otto Meyer–Amden was a significant impetus. Meyer–Amden was his most intimate partner for exchanging ideas on artistic questions and on the "last things", as he noted in his diary.[1]

The years in the Weimar Bauhaus brought Schlemmer success and recognition. He was master of the workshop for wall painting (1921) and for wood and stone sculpture (1922-1925). After the Bauhaus resettled in Dessau, he directed the theater department and worked with his students on the studio stage, which had been set up in the meantime (1925-1928). He took over a course in 1928 as well, which actually concerned drawing from nudes. He expanded the course in his own way, in order to teach the comprehensive subject "human". Schlemmer regarded the human being as a "psychological whole", as a "cosmic essence"[2] in his teaching plan and sought an artistic form for it, reminding us of the content in his conversations with Meyer–Amden.

The National Socialist persecution which began as early as 1930 with the whitewashing of his wall paintings in the workshop building of the Weimar Bauhaus hit Schlemmer hard. He was the earliest victim among the artists.[3] Schlemmer directed a fierce protest on the Reich Minister of Propaganda Joseph Goebbels and pointed out that his generation had voluntarily fought for the ideals of art and the Fatherland. He also protested in the names of his artist comrades who had died in the war, against the defamation of their works.[4] But events followed in quick succession.

In March of 1933, a retrospect prepared by the Württemberg Art Association was closed before it could open at the instigation of the SA. Schlemmer was dismissed form his teaching post two months later. His wall paintings in the Essen Folkwangmuseum were stored away and later destroyed. He was represented by nine works in the exhibition "Degenerate Art" and 51 of his paintings were removed from public collections.[5]

Financial hardship joined artist defamation. Schlemmer and his family had no other choice but to withdraw to their home in the country, where he tried his hand at breeding sheep and growing vegetables.[6] He had to take on work intermittently to earn a living. Through painting country-style cabinets and facade decoration, Schlemmer developed a certain skill in camouflage, so that he was commissioned to plan the camouflage of factory facilties, airfields, and gas tanks.[7]

Schlemmer's stage work and exhibitions found more and more attention abroad,[8] however, so that he considered emigrating to the U.S.A. as his friends advised.[9] Yet these plans were dismissed, partly out of indecisiveness, but surely also because Schlemmer identified himself strongly as German and still believed in the good strengths of his people, who could not be betrayed. He believed it was his desperate task to respond to the tide of "blood and soil art" with good art. Schlemmer wrote in his diary in 1936: "This mass production of relevant, but for the most part bad soldier and sport paintings must be countered with something that works with the pure means of art which, because of its purity, asserts itself purely optically in accordance with nature."[10]

In this extreme situation of ostracism and inner strife, which Schlemmer experienced as a "state of eradication of the self",[11] he was requested by the collector and entrepeneur Dieter Keller to create a wall painting (fig. 10, p. 36) in Keller's house.[12] Dieter Keller was one in the Stuttgart circle of unshakeable art patrons who committed themselves to the "Modern" despite National Socialism. Secretly, they set their hopes on the times "after Hitler". The attorney Arnulf Klett, who was appointed first Mayor by the allies, or the collector Hugo Borst, earlier the right hand of Robert Bosch, who unhesitatingly bought young art no matter if it was outlawed as "degnerate" or not - also belonged to this circle, along with many artists.[13]

Like Hugo Borst and many others, Dieter Keller had most probably also visited the "unofficial Schlemmer exhibition", which Fritz Valentien showed at the Stuttgart Königsbau in 1933. Valentien took the pictures that had been removed from the National Socialist Art Association into a separate room in his gallery, and made them accessible to interested persons who had already been informed of the event by letters.[14]

For Schlemmer, who had been spoiled by success in the 1920's and later had to struggle along with "craftsmanship works",[15] the wall painting commission was an enormous ray of hope, particularly since Dieter Keller left him complete freedom in design: "Schlemmer should in no way feel confined about a job, he should be free in what he wants to create for my house."[16]

10 Tut Schlemmer 347.

11 Tut Schlemmer 373.

12 Herzogenrath, 139f.

13 It is told how Hugo Borst would embarrass an acquaintance as they met in the street by grumbling about "the ones in Berlin" in an extremely loud voice. Hugo Borst was hard of hearing and was recognized by his large brass ear trumpet. Verbal account of Fritz Valentien.

14 Willi Baumeister was one of those invited by letter who embarrassed the gallerist by asking him loudly about the "Schlemmer exhibition" in the presence of a journalist who in the meantime had become true to NS line. The shocked answer: "Here's the key and take Herr X with you, he was earlier enthusiastic about Schlemmer." The "unofficial" Schlemmer exhibition" as Karin v. Maur calls it, included 34 works and was accompanied by an article in *Weltkunst*, in which Fritz Valentien protested against the closing of the exhibition in the Württemberg Art Association: F. Valentien, "Schlemmer und der Württ. Kunstverein. Grundsätzliches zur modernen Kunstpolitik", in: *Weltkunst* 7.13, 1f.; Karin v. Maur, *Oskar Schlemmer. Monographie* (Munich, 1979) 106, 23. The "unofficial Schlemmer exhibition" is usually not mentioned in today's "official" biographies. The exhibitions at Ferdinand Möller in Berlin and Fritz Valentien in Stuttgart in spring of 1937 are just as infrequently mentioned. Barron, *Degenerate Art* 337; Karin v. Maur, *Monographie* 256f.

15 Tut Schlemmer 382.

16 Herzogenrath 139. A letter from Schlemmer to Bissier illuminates his urgent sitation at the time he received the commission: "Despite that, I make my way to Stuttgart as the only place where I have the possibility to earn money, although there is nothing tangible, except for a wall painting for young friends with every freedom." In: Bissier, Briefwechsel, see footnote 6, p. 23.

17 Herzogenrath 139.

18 Herzogenrath 139f., A total of 76 preliminary designs were catalogued, additional sketches in West German private possession are unpublished. The wall painting was realized in six days from 19th to 24th of July, 1940.

For Schlemmer's creativity which in the previous years had been abused in such a degrading way, the 2.20 x 4.50 meter wall in the Keller family house meant a challenge to which he wanted to do justice by all means: he planned "... a demonstration of the type and the subject 'wall painting' " and it sounded like the outcry of the humiliated artist when he continued: "... I also want a new demonstration with regard to my cause".[17] The artist prepared the composition, which he would finally carry out in July 1940, with over 80 sketches and watercolor studies.[18] In the preliminary studies, (fig. 6-9, p. 35), the wall painting's theme gradually crystallized: a trinity-man, woman and child – in a number of variations, as well as different symbols of death are to be observed.[19] The design circled thematically around the real situation of the Kellers: they had just been married, expected a child, and the husband and future father was about to be conscripted to the front. [20]

The reality of the threat of death in that year, not only over the family father obligated to military service, but also over the Keller family house in Stuttgart Vaihingen, was yet to be confirmed in a frightening way. On the occasion of a bombing of the Vaihingens area on March 11, 1943, the neighboring house was hit and six people were killed.[21]

Composition and meaning
The picture structure of the wall painting develops to an impressive clarity and strength, in contrast to the preliminary drawings. On the left, the narrow, long silhouette of the back of a figure leaving, answers the large, narrow profile of a face at the right edge of the painting who seems to be "looking in" from the outside. The center of the otherwise undetermined, nearly empty picture surface is dominated by a trinity; two 3-dimensionally modelled figures referring to each other in a stylized dance-like posture – apparently man and woman – and a shadowy creature, painted without light or shadow – an indication of the unborn child, as suggested by the detailed preliminary drawings.

Geometric forms, circle, triangle and parallelogram envelop the figures from behind. The triangle's points in the center intersect with the circle and parallelogram and allow the elements of the trinity to appear linked together. A large yellow square lays behind the group of figures like protection, again binding them together into a compact triad organism. The place occupied by this central group of figures is spatially undetermined, there is no perspective alignment. Instead, slanting, opaquely indicated, broad stripes make the trinity appear suspended.

From Schlemmer's letters and diary entries, we learn more about the painting's metaphysical content: "... The calm, enlightened Greek profile, abstract intellectuality.

Reflecting. Dominant in size, then life, then death ...".[22] "... The large profile as fate and how it looks at us", Martha Keller-Schenk remembered from conversations with Schlemmer.[23] The figure on the left leaving is described as "passing", respectively, as fate stepping past".[24] In carefully interpreting this allusion further, it is surely permissable to use the notion of fate for the large profile as well as for the figure leaving, although Schlemmer's words for the "Greek profile" refer to something higher, which one could perhaps call "universal fate", or (what would not contradict the last), symbol for the all-pervading spiritual universe. Something active peals in the subject of the figure leaving. Is it the "passing", the temporally subjugated, active power of fate which influences the progress of human life? These dominating themes form the border between the empty painting surface and the outside, or, in other words, the triad group hovers between these "powers of fate", as if in a field of spiritual tension. The figures in the trinity have no perspective "hold" in the empty picture field, however, they are firmly connected with each other. Man and woman relate to each other through active and passive movement, all three figures are connected by the intersecting geometric elements. The connection is therefore bodily (movement) as well as intellectual-spritual (geometry). The central triangle with the essence of the unborn child points downwards, symbol for what "comes from above". The coloration also accords vividly with the metaphor that unfolds. The figures of man and woman, corporeally and 3-dimensionally modelled and painted with sand and gold-bronze, contrast formally to the motifs of fate. These are portrayed graphically, on the whole, although delineated only by contours and strangely enough, each get their light from outside, from the right, respectively, from the left.

Oskar Schlemmer endeavored to make the unconscious visible, an aim he shared with other artists. It is unique, however, that he constantly reflected on his artistic intentions and reported his thoughts and activities in his diary, letters and conversations. For him, it was a matter of clarity and order in thought and control over his feelings. Like Meyer-Amden, he wanted to avoid the threat of being labelled an enigmatic mystique.

A letter, which Schlemmer had written to Keller during the time he worked on the wall painting refers to its aforementioned content: "Whenever I have the opportunity to do a wall painting freely and without compromise, I decide on abstraction, and one should do that especially during a time in which abstraction is forbidden. A symbolic then emerges, which is justified by nothing and yet must have its roots in a mystery that compels doing that and nothing else. One is somehow the tool of the unconscious. ... I will always strive for and defend abstrac-

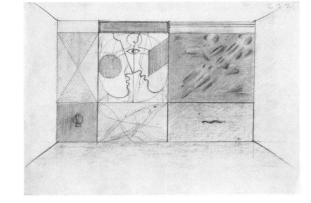

6 **Oskar Schlemmer**
Study for the wall painting in Keller family house,
1940
Pencil and crayon on paper
20.9 x 29.6 cm
courtesy of Galerie Valentien,
Stuttgart

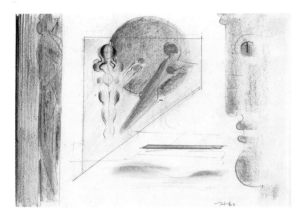

7 **Oskar Schlemmer**
Study for the wall painting in Keller family house, 1940
Pencil, crayon and tempera on paper
14.8 x 20.9 cm
courtesy of Galerie Valentien,
Stuttgart

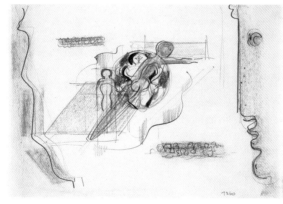

8 **Oskar Schlemmer**
Study for the wall painting in Keller family house, 1940
Pencil, crayon and tempera on paper
14.8 x 20.9 cm
courtesy of Galerie Valentien, Stuttgart

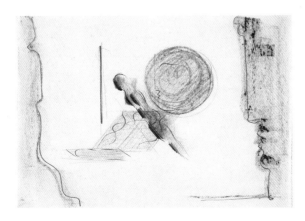

9 **Oskar Schlemmer**
Study for the wall painting in Keller family house, 1940
Pencil, colored pencil and tempera on paper
14.8 x 20.9 cm
courtesy of Galerie Valentien,
Stuttgart

tion, which not only amounts to indifferent forms and colors but rather tries to create symbol values, thereby raising itself above everything that is only formal or formulaic. I believed that essential and new things can only be represented by means of pure abstraction. But at the same time I still believe in the necessity of (or necessarily connection to) the figure, of what is human, as the standard of all things, as the link that connects with an understanding in general. ...".25

In this letter, it becomes clear how Schlemmer felt himself to be a "tool of the unconscious" – in other places he spoke of "visions and inner images" – and how he tried to create symbol values from them by means of abstraction. For him, abstraction did not mean non-objectivity, rather the abstracted human figure "as the link that connects with an understanding". What he aimed at avoiding also becomes clear: abstraction that amounts only to outward formulation (Constructivism) and pure nonbinding non-objectivity, which meant only decoration to him.

The title of the wall painting *Family* did not come from Schlemmer and it is actually misleading: because neither a "Keller" family painting, nor a "private symbolic" was intended, as Schlemmer had expressed it, rather, the theme is generally of the smallest cell of human community, which is based on love and nascent life and which finds itself, particularly in wartime, caught up in the relentless course of fate. Human life is contantly threatened but can also be unexpectedly protected by spiritual powers.

Wall painting in Schlemmer's Work
Some art historians found the wall painting's restrained colors and unstructured picture surface to be lacking in artistic quality. But the painting "Bauhaus Steps", painted eight years earlier, is happily mentioned. It is considered to be one of Schlemmer's artistic peaks because of its space-creating perspective and strong colors. During the years of persecution, there were certainly many reasons for resignation. Schlemmer lamented how "criminal it is to deaden the joy of creation and artistic freedom in the artist".26 The art critics tended to deduce a drop in quality. Yet the wall painting *Family* may not be seen as a step backwards compared with works from the 1920's and early 1930's, rather, it is much more a "remembering back to (still) earlier works", as Schlemmer declared programatically, while he was working on the preparatory sketches: "I will next devote myself to the cult of the surface and cultivate the delicate nuances in color, making up for what remained unpractised for too long; remembering".27

The painting *Composition in Pink* (1916) surely counts as one to which the artist's paintings "remember back".28 The delicate colors and the figures hovering on

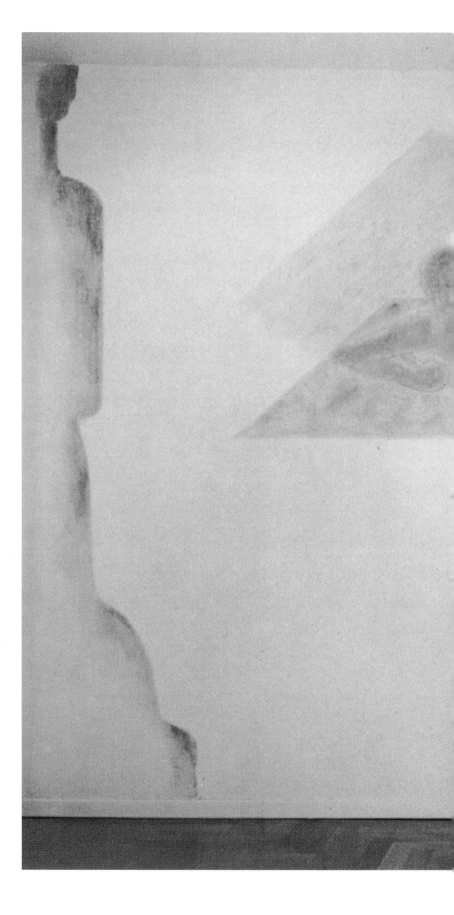

10 **Oskar Schlemmer**
Family, 1940
View on the wall painting in the living
room of the Dieter Keller family house,
Stuttgart-Vaihingen
(state before dismantlement)
Crayons and bronze on impregnated and
chalk-primed cotton, attached to the
plaster wall
256 x 417 x 7 cm
Illus. taken from: Kurt Herberts, *Wände
und Wandbild – Die Wandbildtechniken,
ihre baulichen Voraussetzungen und
geschichtlichen Zusammenhänge*, Stutt-
gart 1953, 430

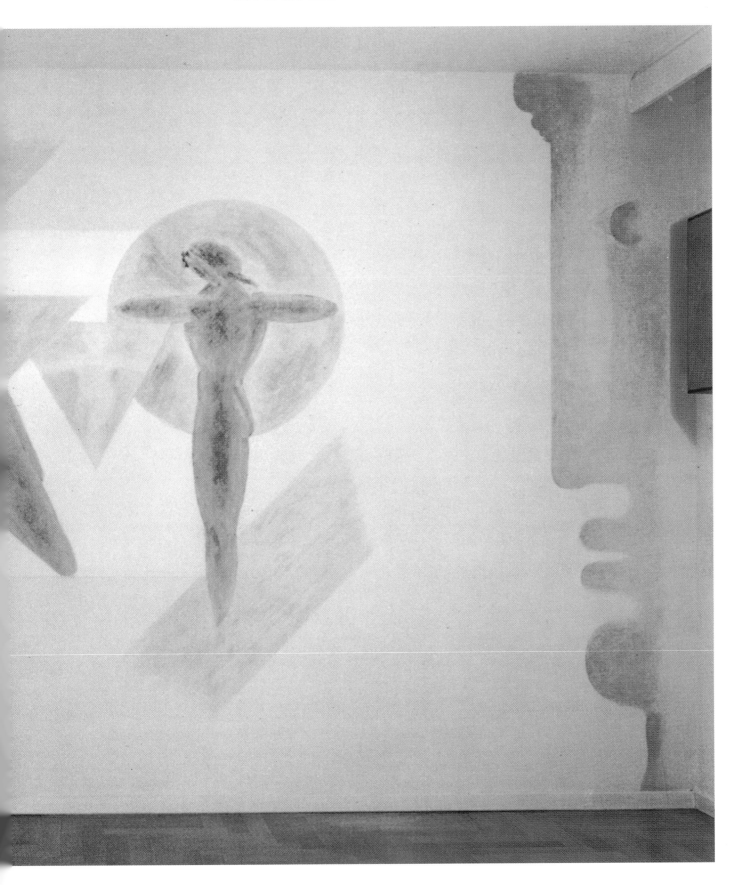

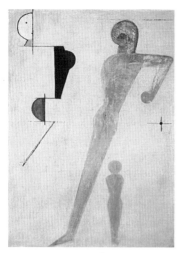

Oskar Schlemmer
*Composition in Pink – Relationship of
three Figures,* (1915) 1916
Oil and bronze on canvas
130.5 x 92.5 cm, Landesmuseum
Münster Depositum Schlemmer

19 The designs are thoroughly addressed in Herzogenrath's book, Schlemmer 139f.

20 Dieter Keller was not summoned to the East front, as it is generally read in the literature, rather to Italy as interpreter (according to concurring statements from his son Frank Keller and Fritz Valentien).

21 The author and his parents lived in this neighboring house until the end of 1942. Since the house had no air-raid shelter, they could be accomodated in the shelter in the Keller house. The attack on 3/11 was carried out by 314 four-engine English bombers.

22 Quoted from Herzogenrath, Schlemmer 294.

23 Quoted from Herzogenrath, Schlemmer 148.

24 Julius Bissier in a letter to Schlemmer: "Yesterday, E. from Stuttgart said that you painted one of the walking feet as fate walking past, or from the same one at Keller's." Bissier, *Briefwechsel,* 52.

25 Tut Schlemmer 376.

26 Tut Schlemmer 340.

27 Tut Schlemmer 378.

28 Karin v. Maur, Oskar Schlemmer. (Oeuvrecatalog der Gemälde, Aquarelle, Pastelle und Plastiken (Munich 1979) G 110.

29 Karin v. Maur, *Monographie*, 334.

30 Tut Schlemmer 244.

the surface point to the wall painting which emerged 25 years later. And when Karin von Maur writes on *Composition in Pink* of the nearly "shocking courage to have an empty surface", of "courage … to concentratingly abbreviate the human figure" and "of the courage to schematically line up types of figures on the surface and bring them into relations of tension with each other"[29], then this description can apply just as well to the wall painting *Family*. The comparison between *Composition in Pink* from the year 1916 and the few other paintings preserved from that time make clear how strongly Schlemmer connected the wall painting *Family* to these paintings from the stage of development before his Bauhaus time. Schlemmer had found his way to his art in the years during WWI. His studies were long behind him, his war experiences in France and Galicia, from which he was allowed a stay at home after being wounded, had intensified his search. Through his discussions with Johannes Itten, who in the meantime taught at the Stuttgart Academy, exchange of ideas with Meyer-Amden and a bottled-up need to paint, Schlemmer achieved a certainty regarding his artistic path. He closed himself to other current directions in art, such as Cubism, Futurism or Expressionism, which, like him, endeavored to a "new form". For a long time, he gave up the landscape theme, which was still keenly practised by the Hoelzel class. Instead, he now regarded the human as "supreme object".[30] "Portraying the human will always form the greatest mystery for the artist. Here – the flesh-and-blood human with the mystique of his existence, there – his play in art", Schlemmer wrote in 1918.[31] For his notion of humans, in which he saw "the spritual" itself, he found the formulaic reduction, the abstracted human figure during those years of world war, which were to determine his creativity and which made him into the greatest loner in 20th Century art. The abstracted figure required an abstracted environment, explaining Schlemmer's demand for empty picture surfaces – the symbol of unending cosmic space. "I can arrange the forms on the surface as an analogy to cosmic space so that they appear as visible functioning strengths in cosmic life and convey to us the great lawfulness, in whose law they are fulfilled."[32] This statement is as valid for *Composition in Pink* from 1916 as for the wall painting from 1940.

During his Bauhaus years, Schlemmer did take a step towards 3-dimensionality – the figures became more corporeal, yet it is the abstracted but not nonobjective "fictional character" which acts in the "abstract space", like a dancer acting out his theater productions on the state. When Schlemmer reflected in 1940 on the first fruits of his work from the Bauhaus time, his thoughts had to do with his then greater concentration on the pure langauge of symbol, which he now sought again.

Oskar Schlemmer – Julius Bissier

The friendship between Oskar Schlemmer and Julius Bissier began with that "coincidental/not coincidental" encounter on April 11, 1934 in the revolving door of the Kunsthalle Basle.[33] Bissier wanted to visit the memorial exhibition "Otto Meyer-Amden" which Schlemmer had organized for his friend.[34] A friendship grew from this encounter which included family members and lasted until Schlemmer's death. The situations of both artists were similar; humiliated by the dictatorship, handicapped in their creativity, and forced to work at jobs to earn their daily bread. Their letters were about everyday matters at first. Bissier, who ran a weaving mill together with his wife in Hagnau am Bodensee – he himself mainly took care of the bookkeeping – was repeatedly asked by Schlemmer, if he could take on and process the wool from Schlemmer's sheep.[35] But their letters soon deepened to an exchange of ideas, leading to questions of artistic existence which were pressing for both of them. Finally, they became each other's closest friend and their correspondence attained a fullness similar to that in the letters between Schlemmer and Meyer-Amden. Werner Schmalenbach, who discovered Bissier and pursued[36] his work since the first retrospective in 1958, found it surprising "that these two painters became so closely connected … On the one side, an artist who worked with strict, architectural laws – on the other side, an artist for whom there was only the law of life, the 'bio' principle. 'Classical' figural art on one side, 'eastern' sign writing on the other. Schlemmer turned towards the 'world' his work included stage design and décor. Bissier turned away from the 'world', introverted and entrusting 'everything' to his inconspicuous sheets of paper. There an art of this world, here an art of transcendence, belief, inwardness, and silence. And between the two, the figure of Otto Meyer-Amdens admired by both, who was already dead when Bissier, deeply moved, stood opposite his paintings at the exhibition in Basle where he met Oskar Schlemmer.

Bissier, though, saw Schlemmer differently and wanted to see him differently, not as the 'classic' and 'tectonic', rather as his and Otto Meyer's relative, a secretly 'eastern' painter, whose inwardness and intuition were buried by the willful and compositional. … To some extent, it was the Meyer-Amden in Schlemmer in which Bissier believed, in the spiritual principle, which in contrast made all principles of order appear insignificant."[37]

In the wonderful speech given by Bissier to commemorate Schlemmers 60th birthday[38], he came to the conclusion that the "classic and tectonic order" in Schlemmer's work could only be a transitional phase: "I experienced both his tectonic and his classic as an asylum for his dark feeling about the world, an ultimate forlornness and willfull deliverance in a fictive order. But

11 Julius Bissier
To Oskar Schlemmer's Death 15.4.43,
1943
Four ink drawings on packing paper
150.2 x 37.5 cm
Kunstsammlung Nordrhein-Westfalen,
Düsseldorf

the pillars of this order – color and image object, to him, remain magical, made up, without the reality of the object in the sense of the natural or animalistic – but from a superordinate intellectual or existential reality.

From my feeling, the precise study of such strange color tones, imagination for space etc., reveals the 'secret East', a painful insecurity of the world which he secretly carried for a long time, from which he rescued himself with the firm structure of architecture in painting, until finally, finally, after long suffering, the happy integration into the 'deep self' was fulfilled ...".[39]

Looking back at the difficult years, Bissier saw the humiliations through which the artist Schlemmer had to suffer as a kind of catalyst which led him to himself and his "interior": "His intellectual-spritual suffering, which imprisoned him for the last decade of his life, came into play here as a positive force. The energy that he disciplined and directed diminished more and more as he advanced in age, the dogma of order and the conscious recording of his own layers of creativity crumbled before the intensity of questions and the onrush of the uncertain life ahead."[40] Was it then, in the end, a stroke of good fate that Schlemmer had to turn away from the streets of success at the beginning of the 1930's? In the wall painting *Family* he did this consciously and took his bearings from his pre-Bauhaus time.

Freerk Valentien

31 Oskar Schlemmer, *Ein Hinweis,* 1918, first published in: Karin v. Maur, *Monographie* 334.

32 Quoted by Lothar Schreyer, *Erinnerungen an Sturm und Bauhaus* (Munich 1956) 183.

33 Bissier wrote to Schlemmer: "We have both still carried much of a difficult fate, since that revolving door in Basle blew us onto a common stage somewhere and into similar roles." In: Bissier, *Briefwechsel,* 51f.

34 After Meyer-Amden's death, Schlemmer brought his estate in order and organized a memorial exhibition which was shown in Zürich, Basle and Bern. Schlemmer also wrote the first monograph about Meyer-Amden (1934) and gave lectures in the exhibition. Meyer-Amden, *Begegnungen,* exhibition catalog, Kunstmuseum Berlin, Kunsthalle Tübingen, Centre Culturel Suisse (Paris 1986) 161.

35 Bissier, *Briefwechsel,* 17, 29f., 31f.

36 Julius Bissier, *Retrospektive,* Kestner-Gesellschaft (Hannover, 1958).

37 Werner Schmalenbach, *Julius Bissier,* Cologne 1974, 83f.

38 Commemorative speech from September 4, 1948, in: Bissier, *Briefwechsel* 125f.

39 Bissier, *Briefwechsel* 128.

40 Bissier, *Briefwechsel,* 127.

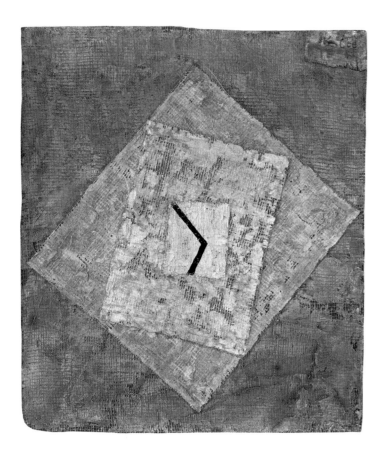

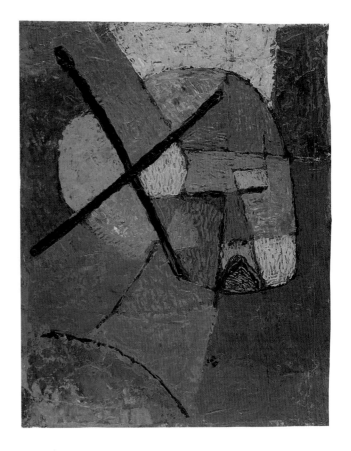

12 **Paul Klee**
Time, 1933, 281 (Z 1)
Watercolor and pen-and-ink on plaster
base over numerous gauze layers on
plywood; back side, watercolor
on plaster base,
25.5 x 21.5 cm
Berggruen Collection, in the
Staatliche Museen zu Berlin

13 **Paul Klee**
Struck from the List, 1933, 424 (G 4)
Oil on wax paper
31.5 x 24 cm
Private collection, Switzerland

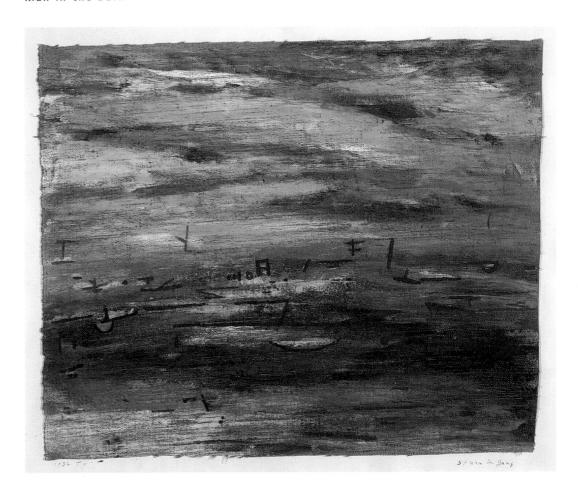

14 **Paul Klee**
Storm Underway, 1934, 191 (T 11)
Oil and paste on canvas
39 x 45 cm
Private collection

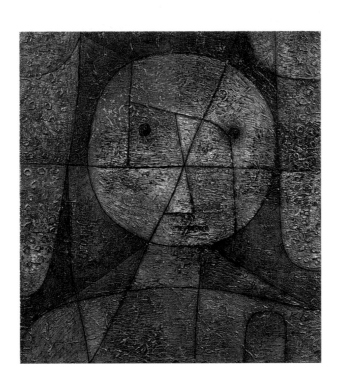

15 **Paul Klee**
Marked, 1935, 146 (R 6)
Oil and watercolor on gauze over
cardboard
30.5 x 27.5 cm
Kunstsammlung Nordrhein-Westfalen,
Düsseldorf

17 **Paul Klee**
Dancing from Fear, 1938, 90 (G 10)
Black watercolor on Ingres paper on card-
board
48 x 31.4 cm
Kunstmuseum Bern, Paul-Klee-Stiftung

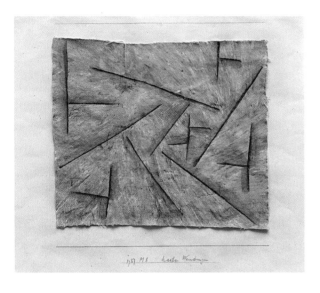

16 **Paul Klee**
Sharp Turns, 1937, 68 (M 8)
Charcoal and paste on canvas with flecks
of glue on cardboard
22 x 25.2 cm
The Menil Collection, Houston, Gift from
Pierre M. Schlumberger

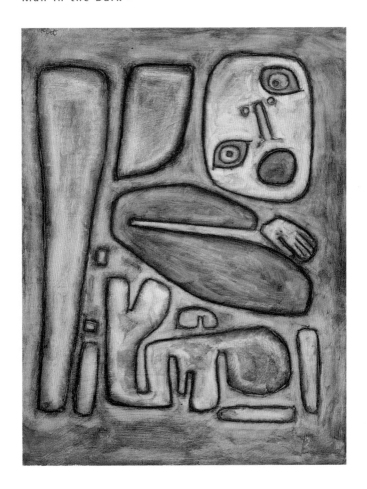

18 **Paul Klee**
Outburst of Fear III, 1939, 124 (M 4)
Watercolor on paper on cardboard
63.5 x 48.1 cm
Kunstmuseum Bern, Paul-Klee-Stiftung

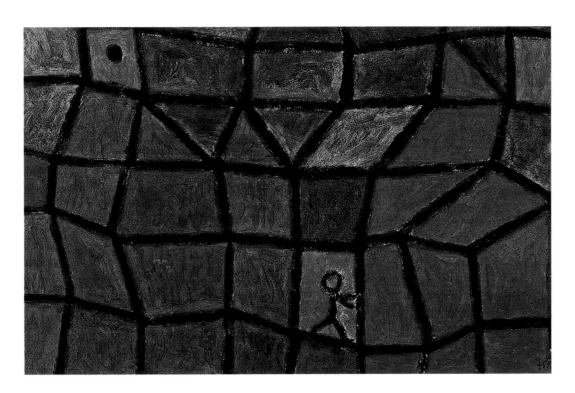

19 **Paul Klee**
At the Neighbour's House, 1940, 261 (L 1)
Paste paint on Fabriano watercolor
paper on cardboard
34.6 x 52.2 cm
Sprengel Museum, Hannover

Man in the Dark

Paul Klee's Late Works

Anyone who believes that art necessarily reflects the political and social realm and personal beliefs of its creator will be tempted to view Paul Klee's works of 1939 and 1940 as a response to his circumstances. Due to the oppressive events that haunted Klee in his later years, expectations of this sort are even more likely to be raised. In 1933, he was dismissed from his post at the Nazi-controlled Dusseldorf Kunstakademie. This was followed by a period of relatively lonely exile in Bern, the ostracism of his work, a fate shared by his Blaue Reiter and Bauhaus confederates, and the German-initiated second World War. Finally, in 1935, he was struck with the incurable skin disease scleroderma, ultimately leading to his death before he had reached even 61 years of age. ...

Among the drawings of Klee's late work, there are some examples of a commenting reaction to political events, but compared to works with other themes, their part in the total is, as in earlier years, very small. ... The discussion surrounding the "immediacy of art," or more exactly, the Berlin Dada movement, the "social realists," and the post-1968 assertion, even in the West, of art's explicit obligation to immediacy-these are particularly volatile topics in Germany because of their unavoidable association with the question of guilt in Hitler's regime, the War and the Holocaust.

But when the expectation of art's automatic reflection of politics is disappointed, the moralizing demand that art must approach politics, especially when it becomes criminal, in a critical, explicit way, is not fulfilled. And finally, when – as in Klee's case – written documentation of outrage and indignation is largely lacking, the viewer who clings to the above philosophies or postulates may in fact be led to think that "there is no evidence to confirm the assumption that Klee emigrated for political or moral reasons."[1] The judgement appears consequent, but rests on hastily drawn conclusions. Although Klee distanced himself "from the artists and intellectuals who promptly tried, in the name of freedom and democracy, to offer resistance to the National Socialists," that he in 1933 "probably still believed, like many other Germans" that "the National Socialist government would not last long," and based on this assumption, hoped that "he might be able to come to an arrangement with the new powers" at the Dusseldorf academy—in spite of all of this, the verdict is irreconcilable with Klee's life's work.[2] Roughly characterized, its main features may be designated as constant motion, metamorphosis, irony, and the comical

– all of them qualities that stand in diametrical opposition to the essence of a totalitarian state. ...

The "burning head,"still a powerful metaphor after four decades, is an example for the considerable continuity of Klee's works. Affinity with Romanticism[3] can certainly be found in his idea of the creator-like artist-I, but numerous early references to Nietzsche indicate that Klee took his primary impulse from this philosopher. Indeed, Nietzsche is clearly significant for further constitutive aspects of Klee's concepts of life and art. Not only were his endeavors to occupy a position of distance regarding the "world's appearances"[4] — including the war — derived from Nietzsche but so is the postulation, formulated in 1917 in his diary and later in his "Confession," to abolish traditional antinomies: "Something new is approaching, the Diabolical will melt into concurrence the Heavenly, not a treatment of dualism as such, but a complementary unity." And "the incorporation of good-evil concepts creates a moral sphere. Evil should be not the triumphant or humiliating enemy, but a power that helps to create the whole. Co-factor of creation and development."[5] ...

To the radius of passion belongs, though certainly in a completely non-literary sense, his *Anxiety Attack III* (1939; fig. 18, p. 43). The dissolving shape recalls a marionette exploded into its individual parts. The scream and wide-open eyes of aliveness, its ebbing announced by weak, wan colors. ...

Autobiographical features in the works of Klee's final two years are often only speculatively identifiable, but there is no doubt of their presence in *Detailed Passion* and *Eidola*. In one of his last letters, dated January 2, 1940, Klee writes: "Naturally, it is not by chance that I take the tragic course. Many of my drawings indicate it and say: it is time."[6]

Alexander Dückers

1 Otto K. Werkmeister, "Von der Revolution zum Exil", *Paul Klee, Leben und Werk*, exhibition catalog (New York: Museum of Modern Art; Paul-Klee-Stiftung; Kunstmuseum Bern, 1987). (Quote trans. K.D.)

2 Werkmeister 39 ff.

3 Jürgen Glasemer, "Paul Klee und die deutsche Romantik", *Paul Klee, Leben und Werk*, exhibition catalog, 21.

4 Otto K. Werkmeister, *Versuch über Paul Klee* (Frankfurt/Main 1981) 39; and *The Making of Paul Klee's Career 1914-1920* (Chicago 1989) 80.

5 Paul Klee, *Tagebücher 1898-1918*, ed. Wolfgang Kersten, new critical ed. (Paul-Klee-Stiftung and Kunstmuseum Bern, 1988) 439; entry 1079, Gersthofen 1917. Also in *Paul Klee, Schriften, Rezensionen, Aufsätze*, ed. Christian Geelhaar (Cologne 1976) 121.

6 From a letter to Will Grohmann in *Lieber Freund. Künstler schreiben an Will Grohmann*, ed. Karl Gutbrod (Cologne, 1968) 84.

This text is a shortened version of an essay of the same name. Alexander Dückers, *Paul Klee. Späte Werkfolgen*, exhibition catalog Kupferstichkabinett, Sammlung der Zeichnungen und Druckgraphik (Staatliches Museum zu Berlin-Preußischer Kulturbesitz, 1997) 9-23.

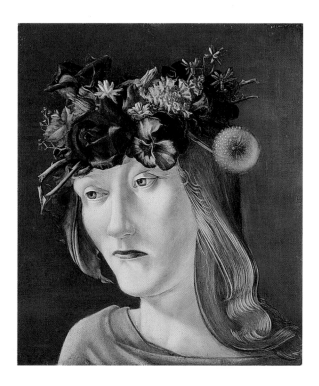

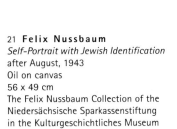

21 **Felix Nussbaum**
Self-Portrait with Jewish Identification
after August, 1943
Oil on canvas
56 x 49 cm
The Felix Nussbaum Collection of the
Niedersächsische Sparkassenstiftung
in the Kulturgeschichtliches Museum
Osnabrück

20 **Wilhelm Lachnit**
The Sad Spring, 1933
Oil on wood
35 x 29 cm
Staatliche Museen zu Berlin,
Nationalgalerie

22 **Otto Freundlich**
Composition, 1943
Gouache on cardboard
22.5 x 29 cm
Donation Freundlich,
Musée de Pontoise

Hans Hartung — Examples
of His Work from the 1930s

All sorts of rumours used to be in circulation about Hans Hartung. Now and then it was even claimed that he did not wish to be reminded of his German origins after the Second World War. As the reports go, Hartung himself vehemently rejected any such interpretations, and yet the catalogues and press releases of the past twenty years have paid more attention to his political opposition to National Socialism than to his painting.

Today, a more differentiated view not only of Hans Hartung's work but also of his life has been made possible by access to his estate, administered by a foundation set up in 1989, five years after his death. This is of relevance not only for the period from his youth, spent in Germany, to his first trip to Paris in 1927 — after which Hartung lived and exhibited regularly in Germany until 1935 — but also to his exile as of 1935 in France, where in 1946 he was awarded French nationality as a "war hero" on the Allied side. Hans Hartung emerges as an artist who was extremely politically aware, even though he rejected the notion of a political art or even of politics having a bearing on artistic problems. All through his life he sought to maintain close contacts with Germany, even after Paris had long since become his second home and he himself had become widely regarded as a "French artist". From 1946 to the 1980s, in an attempt to disseminate the tradition of modernism and abstraction in the socialist part of divided Germany, Hartung availed himself of the fact that as a French citizen he could correspond with people not only in the Federal Republic but in the German Democratic Republic as well. When Willy Brandt became Federal Chancellor in 1969, Hartung made contact with him — as he also did later with Federal President Walter Scheel — out of enthusiasm for the new Ostpolitik pursued by the social-liberal governing coalition in Bonn. Later he kept up this correspondence with Brandt and Scheel, although in France he had meantime gained the reputation of being a "right-wing artist" on account of his friendship with Georges Pompidou. However, there are no signs that he either considered returning to Germany or that he experienced his life in France as "exile".

That the *"Deutschlandbilder"* exhibition has chosen to show three oil paintings by Hartung dating from the 1930s (fig. 23-25, p. 47, pp. 49f.) is fully in keeping with a posthumous correction to the aesthetic evaluation of his life's work. Today Hartung's smaller paintings from the years prior to the Second World War are regarded as pioneering works displaying a graphically free abstraction

that anticipated the gestural painting of postwar abstract expressionism. At the time they were produced, similar works were already being accorded prominence, be it in the international modernism exhibition organised by Christian Zervos in 1937 at the Jeu de Paume in Paris (a counterpart to the "Entartete Kunst exhibition" of "degenerate art" in Munich), at the leading galleries of José Pierre in Paris and Peggy Guggenheim in London, or in the Cahiers d'Art published in 1937 on the occasion of a survey of modern art in Germany in the shadow of the Nazi regime and edited by Will Grohmann. Jean Hélion, who at the time was highly influential in the United States, drew attention to Hartung's paintings in New York with the help of photographic reproductions. However, this resulted in practically no sales. In a detailed draft of a letter to a schoolfriend in Dresden dated 1950, Hartung recalled that "after our arrival in Paris between 1935 and 1946" he had "sold only one single (small) painting ... That makes two paintings since 1922 (till 1947),[1] including the small one sold to Bielass in 1931." This remark illustrates the desperate financial straits that blighted Hartung's life between 1935 and 1947. It also throws some light on the outsider position he held as an artist during the 1930s. In the postwar period the works Hartung painted in that decade were overshadowed by the great international success enjoyed by his more recent works, despite the fact that he regularly included them in exhibitions. He himself had a very high regard for his works of the 1930s. From our current viewpoint they occupy an almost heroic position amidst the dominant trends in Paris at the time, the geometric abstraction of the Cercle et Carré and de Stijl groups, automatic surrealism, and post-cubist and neo-classicist figuration. They take a stand against the symbolist doctrines of geometric abstraction which, with reference to Mondrian and Kandinsky, postulated a universal understanding of the circle, square, diagonal, and colour harmony. They had deliberate recourse to the freedom and spontaneity of German expressionism with the aim of consummating it in an abstract idiom. The common basic concern of the paintings of the 1930s was to create a new pictorial language — somewhere between geometric abstraction and surrealist automatism — out of the gesture which, though it had become autonomous, was also bound up with a controlled pictorial composition.

The paintings were almost always modelled on drawings and coloured drafts done on paper. Hartung's limited financial means forced him to first draft the paintings on this cheap material and then transfer the best results to canvas. Separating the drawing process from the faithful transfer to canvas was a technical invention which enabled him to combine the highest possible degree of gestural spontaneity in the draft and the control he liked to exercise over the painting process and its effect.

[1] All the letters quoted here are contained in Hans Hartung's estate, preserved in the Hans Hartung — Anna-Eva Bergmann Foundation located in their former studio in Antibes.

23 **Hans Hartung**
T 1932-11, 1932
Oil on canvas
80 x 63 cm
Fondation Hans Hartung and
Anna-Eva Bergmann, Antibes

Up until the 1960s Hartung remained true to this process of enlarging and copying abstract drawings and pastels onto canvas by means of a grid system. The later advent of acrylic colours meant that a direct gestural approach to the canvas could have the same degree of precision and stringency.

Born the son of a doctor in Leipzig in 1904, Hartung produced his first abstract watercolours and ink and charcoal drawings between 1922 and 1924, at school and on his free afternoons. As of 1947 he regularly exhibited these together with his newer works to demonstrate that, unlike the other abstract expressionists, he had practised gestural abstraction even before the Second World War.[2] The diaries he kept from the years 1922 to 1924 reveal an adolescent who, having been a helpless observer during the First World War, was deeply moved by a inward turbulence of a Nietzschean hue. Apart from the old works of art in the Dresden collection, all Hartung was familiar with at that time was German expressionism, which he got to know from paintings by Emil Nolde and evening lectures given by Oskar Kokoschka. The much longed for radical change of values in post-monarchist Germany seemed possible to Hartung within the German expressionist tradition once it had advanced beyond the treasured figurative principle. The abstract watercolours and ink drawings he produced in those years were a direct expression of that conviction. Hartung described the realisation of the expressionist will to articulate outside a figurative framework not only as a decisive element in the longed-for moral and social revolution, but also as a triumph of "German painting".

As far as can be concluded from his correspondence, even his studies in Paris after 1927 were undertaken in a fundamentally patriotic mood which also motivated his 1924 diary entry to the effect that he wanted to help "German painting" to a triumph. At the time, Hartung was studying in Dresden and Munich and as a result of a lecture given by Kandinsky in 1925 had found the courage to stand by the abstract works of his youth. Out of scepticism about Kandinsky's dogmatic abstraction, he refused to go to the Bauhaus. To him Paris seemed like a bastion of painterly "savoir faire" which he required as a counterbalance to pure spontaneity. At the private academies of André Lhote and Fernand Léger, Hartung acquired that consistent control of the painterly act which distinguishes his gestural painting from the abstract expressionism of the 1940s. In a later interview Hartung claimed that Nolde's colour blotches may well be marvellously daring,

but they were not precise. Going to Paris, however, did not mean turning his back on the German scene, as demonstrated by the fact that at the same time he applied to study with Otto Dix at the Dresden Akademie. The latter rejected him, however, saying, "As I assume that your works are the products of your innermost conviction, it would not be useful for you to be admitted to study with me." Between the symbolist and geometric abstraction of the Bauhaus and the figurative dogma of the rest of the world of art there was simply no room for Hartung's concept of a spontaneous, gestural painting, not even in the Weimar Republic.

Nevertheless, in the 1930s Germany was still the only place where Hartung's painting had a modest resonance. In 1931 he had his first solo exhibition at the Heinrich Kühl gallery in Dresden. Will Grohmann became Hartung's most important advocate among the critics and remained faithful to him until he died in 1968. Until 1935 Hartung lived alternately in Paris, Minorca (where he and his young wife, the Norwegian artist Anna-Eva Bergmann (1909-1987) had a house built according to Hartung's own plans) and Berlin, where he hoped to be able to live from his inheritance after his parents' death.

T 1932-11 (fig. 23, p. 47) is evidence of Hartung's early search for his own particular path to abstraction, beyond surrealism and geometry. Jean Hélion, who was Hartung's closest friend and colleague in the 1930s, became the most influential abstract painter in New York, that is, until Mondrian's arrival there, with gestural works that seem to have emerged in a joint dialogue. Hélion made numerous contacts for Hartung in the USA and these became especially important after the Second World War. Later, when the tables were turned and Hélion was short of money and Hartung better off, Hartung repeatedly helped his friend out. To judge by the sources in the archive, Hartung would seem to have been an astoundingly forthright person.

In 1934 Hans Hartung and Anna-Eva Bergmann had to leave Minorca in the run-up to the civil war. An exhibition planned in Sweden did not come about because the Spanish customs would not release Hartung's paintings. In Berlin, where the Hartungs had an apartment, it often happened that when the artist was out people would arrive at his door pretending to be art collectors and feigning interest in his paintings. It turned out that they were from the Gestapo. When Hartung told an investigating magistrate among his friends that he was being observed, he advised him to leave Germany as quickly as possible. Will Grohmann and Christian Zervos, editors of the Cahiers d'Art, organised a temporary visa for France as well as contacts with Kahnweiler and Kandinsky, with whom Hartung later met regularly. Despite his integration into the art scene on Montparnasse, his living condi-

Hans Hartung as a legionnaire

2 This date was the cause of polemical reactions during a recent retrospective exhibition of Hartung's works on paper at the London Tate Gallery in 1996. However, the Hartung Archive in Antibes contains letters from the abstract painter Gottfried Fabian (1904-1984) and from Erich Lissner, art critic with the Frankfurter Allgemeine Zeitung, who as former schoolmates of Hans Hartung's at the Dresden secondary school both spontaneously confirmed, during an exhibition of those same works in 1960, that Hartung produced them during his school years.

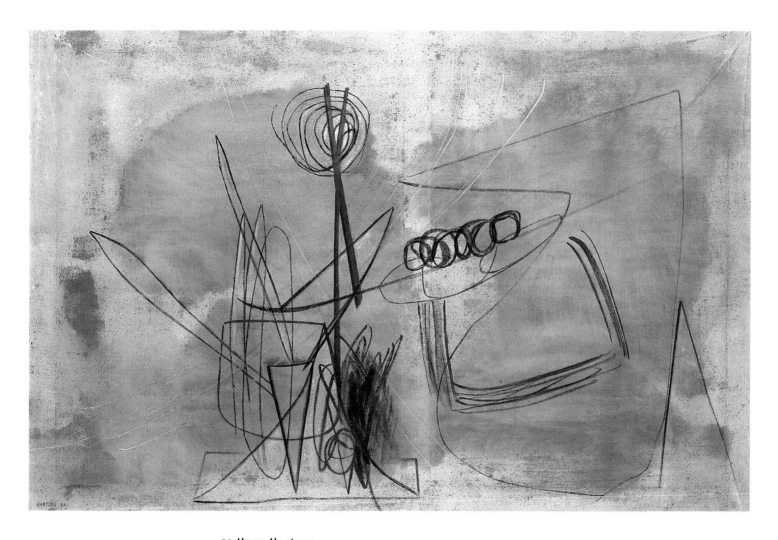

24 **Hans Hartung**
T 1938-2, 1938
Oil on canvas
100 x 149 cm
Kunstsammlung Nordrhein-Westfalen,
Düsseldorf

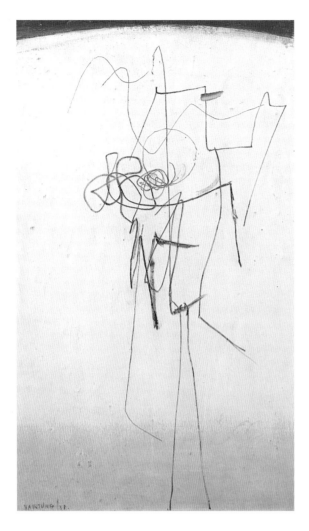

25 Hans Hartung
T 1938-3, 1938
Oil on canvas
51.7 x 30.5 cm
Fondation Hans Hartung and
Anna-Eva Bergmann, Antibes

tions in Paris were extremely confined. Later Hartung wrote that in Paris in the 1930s any kind of abstraction qualified as "non-French" and "Nordic". And as he was neither a Jewish nor a political emigrant, he was suspected of being a Nazi informer. He exhibited with Kandinsky, Hélion, Arp, and others at the famous Galerie Pierre, and in 1937 took part in the exhibition organised by Christian Zervos at the Jeu de Paume to counter the Munich *Entartete Kunst* show. As Hartung refused to earn his living in any other way than from his art, his financial situation became increasingly precarious and his wife Anna-Eva Bergmann became seriously ill, having spent two winters in an unheated flat. The couple were subsequently divorced. The German embassy in Paris then confiscated Hartung's passport and as a result the homeless and stateless artist sought refuge at the house of the sculptor Julio Gonzalez (1876-1942) in the Paris suburb of Arcueil. He had already exhibited with Gonzalez in 1937. A close friendship developed between the two artists, and Gonzalez' linear sculptures clearly influenced Hartung's artistic work during this period. In 1939 Hartung married Gonzalez' illegitimate daughter Roberta. Just before Nazi Germany declared war on France, Hartung applied to join the Foreign Legion to fight fascism. The moment had obviously come when he was finally able to take a clear political stand, whereas in 1937 he was still working as Paris representative for a German paint company.

Like the works produced between 1946-48, which finally brought him considerable success, Hartung's works of 1938 display the same tension that results from the desire to rediscover existential points of reference in a hopeless situation in life. In a kind of sandwich process that facilitated the technique of enlarging models done on paper, the ink and colour planes were carried out independently of each other. It was then that Hartung developed that dialectic of linear gesture and monochrome colour-fields which resulted in his emblematic works of the 1950s. One complete and one unfinished piece of sculpture bear witness to Hartung's interest in the work of Julio Gonzalez, as do his T-paintings. *T 1938-3* (fig. 25, p. 50) for example, originally presented to his second wife Roberta, adopts the Spanish sculptor's formal idiom though with the deliberate intention of liberating the line to the advantage of movement, whereas Gonzalez adhered to figuration. This paradigm was to become more planar and painterly in the wake of the Second World War, Hartung's serious wounds, and the amputation of his right leg. However, throughout the war years his paintings preserved the impression of an urgent existential necessity that imbues the gesture with meaning.

At the outbreak of war in 1939, Hartung was inducted into the Foreign Legion. He was demobbed in 1940 after the German-French armistice and lived under his

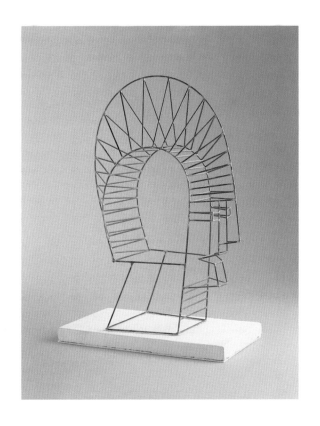

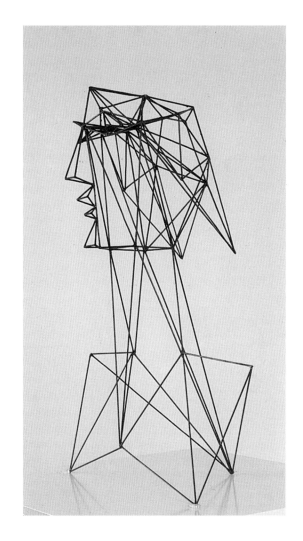

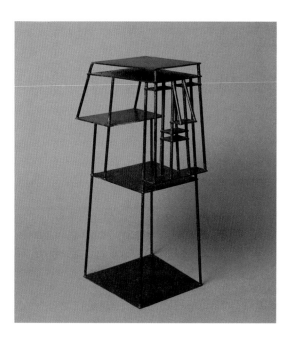

above left:
26 **Hans Uhlmann**
Head, 1935
Soldered steel wire
H.35 cm
Staatliche Museen zu Berlin,
Nationalgalerie

above right:
27 **Hans Uhlmann**
Female Head, 1938
Steel wire tinted red
H.51 x 40 x 25 cm
Private collection

below right:
28 **Hans Uhlmann**
Head.Femme aéroplane, 1937
Iron sheet and wire
H.35 cm
Private collection

assumed French legionary name in the department of Lot. After the occupation of southern France by the German Wehrmacht in November 1942 he fled across the Pyrenees. In the above mentioned draft letter of 1950 he recalls: "Mistreated in Spain by the Black Police and 7 months in a dreadful prison. Could have had myself released then (our family had a lot of connections down there)

Hans Hartung in Paris 1947

and awaited the end of the war in Spain. But — I don't now if you can understand this — I was so overwhelmed by torment about my own people that I saw it as necessary to at least give some example to the contrary. Went — with American aid — to North Africa and in late 1943 was active again — an altogether unusual case — in the Foreign Legion. Unfortunately I was dispatched to a terrible company. New training and then off to the front in the Vosges mountains as a collector of the dead and wounded. The Germans targeted the Red Cross as if they were the general staff in person."

By spring 1947 Hans Hartung had become recognised on the Paris art scene as the leading proponent of a radical gestural abstraction that rebelled against the decoratively lyrical trend in the École de Paris. He was also regarded as someone who had constant contact with abstract expressionism in New York via numerous acquaintances with artists and dealers. Initially, he was not questioned about his relationship to Germany, especially as in the eyes of western Europeans a German art scene only re-emerged in the mid 1950s. Yet, wherever possible, he maintained close personal contacts with the region of his birth in eastern Germany until 1989. The fact that as a French citizen he could correspond with such figures in the GDR art world as Werner Schmidt in Dresden stood him in good stead. The Hartung Foundation set up by the Dresden Museums in 1982 represents the crowning glory of those efforts.

In the 1960s Hartung was looked upon in France as an artist with right-wing leanings. Since the war years he seemed to have had a deep seated fear of a return to a political situation similar to that in the 1930s. In 1965 he spontaneously congratulated de Gaulle on his election victory over his socialist opponent Mitterrand, and Georges Pompidou later became one of his closest friends. On Mitterand's election victory in 1981 Hartung seriously considered retiring to his country home in Spain as he had done during the 1968 May revolt. Just how constantly Germany's fate was on his mind is evident, however,

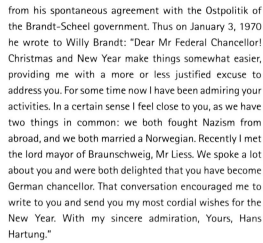

from his spontaneous agreement with the Ostpolitik of the Brandt-Scheel government. Thus on January 3, 1970 he wrote to Willy Brandt: "Dear Mr Federal Chancellor! Christmas and New Year make things somewhat easier, providing me with a more or less justified excuse to address you. For some time now I have been admiring your activities. In a certain sense I feel close to you, as we have two things in common: we both fought Nazism from abroad, and we both married a Norwegian. Recently I met the lord mayor of Braunschweig, Mr Liess. We spoke a lot about you and were both delighted that you have become German chancellor. That conversation encouraged me to write to you and send you my most cordial wishes for the New Year. With my sincere admiration, Yours, Hans Hartung."

It has only recently become possible to re-appraise posthumously the life and work of Hans Hartung. Above and beyond the theories of gestural abstract painting in the 1940s and 50s, one plausible hypothesis would be to recognise that the roots of Hartung's distinctive position lay in German Expressionism. Seen from this perspective, Hartung's oeuvre seems to form an essential link between the expressionist generation of Nolde and Beckmann and the post-abstract generation of Gerhard Richter, Sigmar Polke, and Georg Baselitz. Given German history during the 1930s, 40s, and 50s, such an achievement was only possible from outside the country.

Robert Fleck

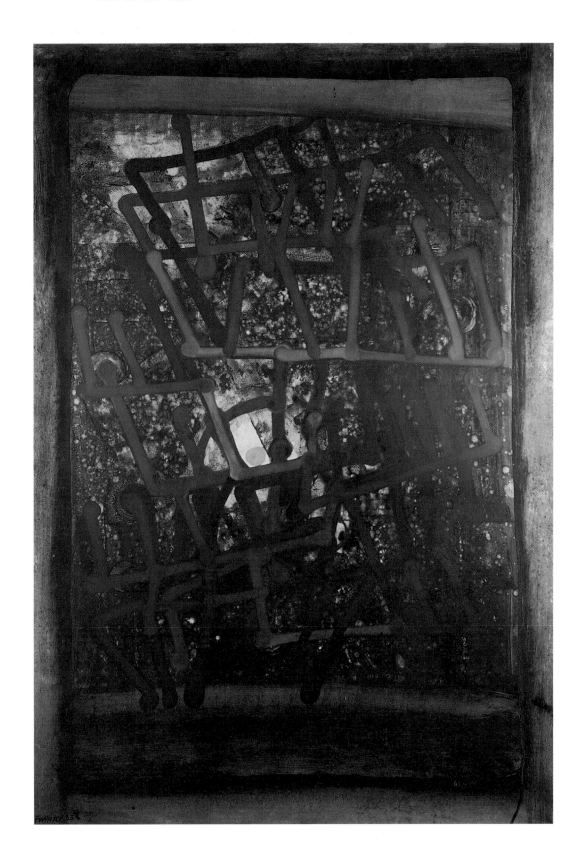

29 **Fritz Winter**
Scaffolding, 1933
Oil on paper on canvas
216 x 146 cm
Landesmuseum Mainz

Wols

Even more than four decades after Wols's death in 1951, descriptions and interpretations are still for the most part determined by the attitude which developed between the mid 1950's until the mid 1960's. Werner Haftmann saw Wols' "... psychological automatism as the most important fundament of this painting process", which he posited "at the margin of art"[1], in his *Painting in the 20th Century* (1954) - the first comprehensive representation of the epoch after 1945 in Germany.

Haftmann wrote in the documenta II catalog five years later, that Wols "wrote an account dictated by life, which concerns only himself".[2]

Only a few years later, in 1963, Haftmann wrote again about Wols' work that "Painting is direct action from existence" and the surface of the painting became a "slate, on which the chronicle of individual moments of fate is drawn."[3]

In the fourth expanded and revised 1965 edition of "Painting in the 20th Century", Haftmann articulated still more emphatically: "He was the gentle one, submitted to his fate, the one who drew what happened with him: not factually, but the images that flowed from the wounds in the soul, that were imprinted by life."[4]

The thought during those years accorded with understanding life and art as a unity and explaining art from life. This is why other authors, parallel to Haftmann, also came to similar interpretations.[5]

Searching for traces from the time between 1933 and 1945, in short, the war years, it was suggested to make Wols a witness of the times and his work documents "of the fate which made the person the people in the desolate years before and after the war".[6] The titles of some works were offered as proof. But not a single title came from Wols himself, and for the most part these titles were composed posthumously.

But how was Wols seen by his contemporaries? The first exhibition in Paris in December, 1945, of around 50 water colors, painted in Dieulefit between 1943 and 1945, remained practically unnoticed.[7] A second exhibition in Spring, 1947, of around 40 oil paintings which Wols had created after 1946, at least fascinated a number of artists. The painter Georges Mathieu can be taken as chief witness: "At the first attempt, Wols had briliantly and irrefutably used the linguistic means of his times and brought it to the highest intensity." In these paintings, Mathieu saw "40 moments from the crucifixion of a human being",[8] but more importantly, he recognized the novelty of the linguistic means.

In a booklet comprised of only a few pages which appeared for this exhibition, René Guilly undertook the first characterization of this language, a description of affected procedure and a definition of the artistic results.[9] Guilly sited Wols' painting at the crossroads between Surrealism and nonrepresentational art. Surrealism had discovered the unconscious and subconscious as source of inspiration, and nonrepresentational art had developed the possibilities and ways of action freed from all object description. Wols's psychological situation - the unconscious in the Surrealist sense - occasioned the painting, which was then consciously and controlledly developed further step by step. Guilly had very aptly described Wols' creation of a painting as an adventure, at the beginning of which the end cannot be foreseen. In the course of the work, the unconscious kept retreating further back. The work detached itself from the spontaneous and the individual to become a highly complex, thought through and self-contained organism. Whatever incidental things there may have been, indeed even consciously brought into play, everything random, was at once subjected to the precisely controlled ordering of images.

Wols' works tell the history of their conception and the history of their conception is their content. The observer is called upon to comprehend the emergence of the painting and to make himself aware of the essence and the way single artistic means effect the individual. It is a matter of visualizing tensions and harmonies, the relation of larger contexts and smaller details, frenzied action and thoughtful behavior, sweeping motion and selective articulation, in order to grasp the painting organism as a whole in terms of how these aspects are used.

While its creation is an adventure, observing a painting by Wols is an expedition into the jungle of forms. One has to use the surface of the painting as starting point to retrace the path that keeps leading into ever deeper layers. The history of the painting's creation unwinds backwards as you look at it.

Every painting by Wols is a self-contained unit, which at second glance proves itself to be a system designed acccording to clear principles. The composition is carried by a covered center axis or a veiled system of coordinates. The single parts of the painting are assigned to them in latent symetry. The formal event intensifies towards the painting's center. This corresponds to structural systems in nature, without identifying with forms in nature. Wols creates his structures out of his imagination, not in correspondence with nature, but parallel to it.

What was new in Wols' work, in contrast to prevailing unrepresentational painting, is that he did not build on a preconceived picture composition, nor did he project on the canvas a picture already present in the imagination. Rather, he developed the picture step by step.

1 Werner Haftmann, *Malerei im 20. Jahrhundert* (Munich 1954) 463.

2 II. documenta, exhibition catalog, Kassel, Vol. I (Cologne 1959) 450.

3 Werner Haftmann ed., *Jean-Paul Sartre/Henri-Pierre Roché, Wols.*

4 Werner Haftmann, *Malerei im 20. Jahrhundert. Eine Entwicklungsgeschichte,* 4th expanded and revised edition (Munich 1965) 474.

5 Jean-Paul Sartre, "Finger und Nicht-Finger", Wols. *Aufzeichnungen,* 32f.; Werner Hofmann, "Der Maler Wols", *Werk,* May, 1959, 180-186.

6 Haftmann, 474.

7 Haftmann, 474.

8 Haftmann, 28.

9 Wols, *exhibition catalog,* Galerie René Drouin, Paris (Paris 1947).

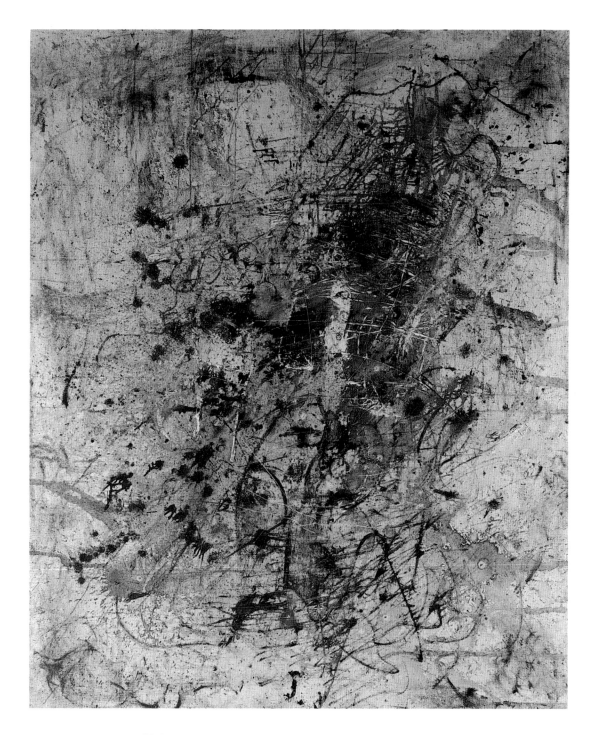

30 **Wols**
Vert cache rouge, around 1947
Oil paint, Grattage, imprints on canvas
162 x 130 cm
Philippe and Denyse Durand-Ruel
collection, Paris

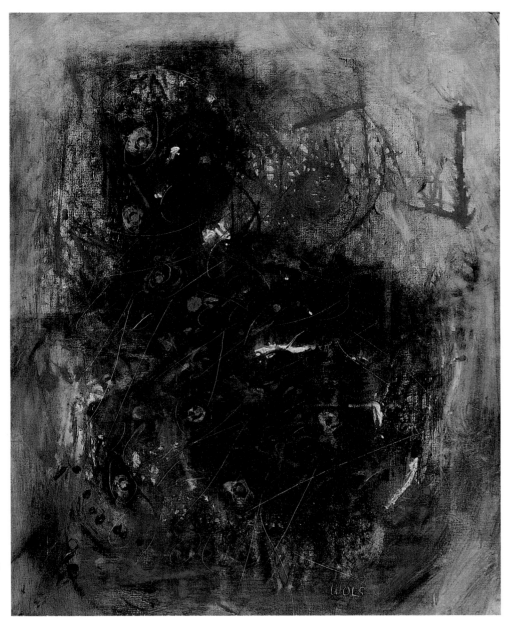

31 **Wols**
Oui, oui, oui, 1946/47
Oil paint, Grattage, tube imprints
on canvas
79.7 x 65.1
The Menil Collection,
Houston

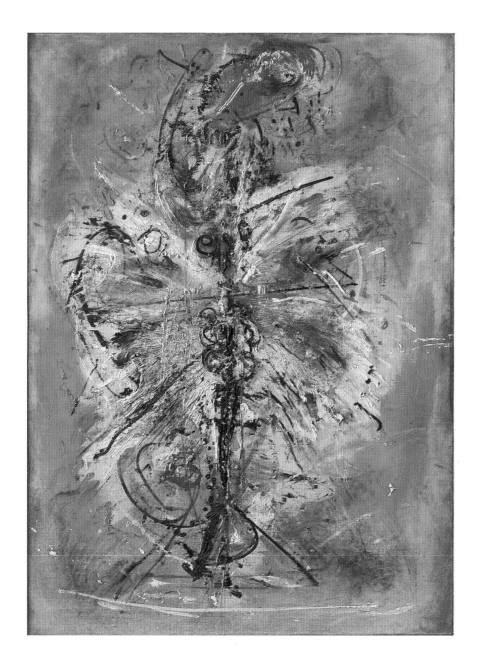

32 **Wols**
L'oiseau, 1949
Oil on canvas
92 x 65.4 cm
The Menil Collection,
Houston

The range of Wols' artistic abilities is made evident by comparing the three paintings *Oui, Oui, Oui* (fig. 31, p. 56), *Vert Cache Rouge* (fig. 30, p. 55) and *L'Oiseau* (fig. 32, p. 57). It is not only a matter of differing color tones, but also the differences between thin and thick paint application, between loose and condensed forms, between open structure and figural convergence. Even the diagrams of colored and formal activites reveal divergences. The surfaces are opened by ripping and the deeper layers are again exposed. Thereby, the picture becomes the object calling us to direct perception. The subjective form can be perceived directly, avoiding any association with things familiar.

Wols' oil paintings in particular, have had an essential influence on a number of artists, some his age, some younger. Wols' impact on the European Informel can be distinctly made out in many variations. Nevertheless, his creative achievement in its entirety and significance has not yet been seen.

Ewald Rathke

Hermann Glöckner's Board Work

Hermann Glöckner
Red Wedge between Black
1976
Folding, brush, tempera
74.5 x 48.7 cm
Hein Köster, Berlin

"If the simple and the open are found to be the model, then one recognizes the beginnings; only after the beginnings are recognized, can the guiding course be fulfilled. The prevailing Tao under heaven is five fold - that is the great guiding course of the birth giving people! If the guiding course is fulfilled, then the Tao is destined, events will be foreseen and (thus) stand, and one no longer doubts how things take their course." Chang Tsai (1020-1078)

Having entered the fourth decade of his life, Hermann Glöckner resolved "to start again from the beginning, to lay aside everything that has happened until now"; he dated his decision "around 1930".[1] Fully concentrated "on this question", he created around 150 works by 1937 - they were later called *Board*. An additional 120 boards came in a second phase between 1948 and 1980; Glöckner sees expansions in them "through variations and further formations".[2] At the bold and commendable exhibition at the Kupferstich-Kabinett of the State Art Collection in Dresden in 1969, the public and the world of art and art theory had a comprehensive look into Glöckner's work until 1945. *Board Work* was then shown for the first time. The works after 1945 were presented at the Zwinger and in the castle in Dresden in spring of 1976. Glöckner's independent and incomparable contribution to 20th Century art became evident. Becoming involved with Glöckner's work requires patience. At the time Glöckner resolved his new beginning, he could look back on a stylistically broad spectrum of work, a body of work which also included remarkable abstract paintings. The immediate stimulus to the artistic general revision follwed nearly logically from Glöckner's work method, namely, not to simply put the already created works away, but to continually examine them and mentally develop them further. For an abstract painting, that could mean that after many years "the top" would be redetermined. For the birth of the *Board Works*, it meant the dimensional analysis of some of the representational paintings composed from nature, such as, particularly *Little Steamer* from 1927. The procedure was conceivably simple. Glöckner photographed this painting, mounted the reproductions on large cartons and drew over them with drafting lines. In his paintings he discovered recurring subdivision proportions in horizontal and vertical directions, defined by striking painting elements. Musing on his "experience with and passion for geometry as a youth", Glöckner recognized the "constructive, geometric fundaments"[3] of his painting. To

him, they represented a network of lines in specific proportional relationships and module-like subjects. In the development toward consistent self-confirmation, Glöckner in turn relativized those network forms he had discovered and those he had constructed according to the rules of descriptive geometry, to "find their complex and fundamental interrelations".[4] He achieved this in innocence and independence from trends. In solitary and calm work, Glöckner found his way to tame the abundance of his ideas and to give them a central motif. He came across the logical start of his form inventions to come; it is a beginning, which - being equally abrupt as without prerequisite - has no other grounds for being, other than being the basis for the entire arising world of forms. Glöckner came as a matter of course to this beginning and it resulted fortunately from his highly subjective method, "to lay aside everything that has happened until now",[5] to forget it. Glöckner writes: "The first board, the point of departure for all entire developments, was white on one side and black on the other. The entire board was conceived as a body, in contrast to the normal board picture. Two black edges were bent to the white side and the white edges to the black, thus the edges are seen as the board's deep dimension, so that a complete six-planed body was created, which in my opinion, was finished for now and could be calmly set down."[6] With this radical departure, Glöckner broke through the seemingly overwhelming, Platonic rule about images and reversed the foundations, to date, of his art production into their opposite: no longer "imitating" and "transforming" reality, but rather "producing reality".[7] To be sure, Glöckner fulfilled this turning point in his artistic world image not with help from ruler and pencil, but rather, from the lasting encounter with the art philosopher Konrad Fiedlers, whose *Schriften über Kunst* (Writings on Art) accompanied Glöckner until his last year of life. These writings, which accompanied him over the years, may also have encouraged him to free himself from the paralyzing dictate of fashion and general movements, finally to trust only the "solitary strength". Fiedler writes: "There are always the individuals who begin art, as it were, from the beginning, who do not enter the art world, but rather, who create the world of art"[8] and he continued another point: "He who has never been on the vantage from which everything appears uncertain, will never attain certainty."[9] Such statements might have, in a flash of clarity, pointed the way Glöckner was to tread. Konrad Fiedler occupied a key position between Classical German Idealism and the Modern. He passed on their revolutionary, dialectical concept of being and carried over the speculative aesthetic to a work-directed theory of art. Fiedler has been a source of reference for renewers in art theory such as Julius Meier-Graefe, Wilhelm Worringer, Sigfried Giedeon, Josef Gantner, Hans Sedlmayr, but also

1 Herman Glöckner, "Meine Arbeit ist mein Leben", Hermann Glöckner. *Ein Patriarch der Moderne*, ed. John Erpenbeck, (Berlin (East) 1983) 57.

2 Hermann Glöckner, *Maschinenschrift vom 11.18.1967*, quoted from: Hermann Glöckner, *Die Tafeln 1919-1985*, pub. Hermann Glöckner Archiv (Dresden/Stuttgart 1992) 7.

3 Hermann Glöckner, "Meine Arbeit ist mein Leben", 57.

4 Glöckner 1983, 57.

5 Glöckner 1983, 57.

6 Glöckner 1983, 57.

7 Konrad Fiedler, *Schriften über Kunst*, pub. Hans Marbach (Leipzig, 1896) 180.

8 Konrad Fiedler, *Schriften über Kunst*, vol. 2, ed. Hermann Konnerth (Munich 1914) 125.

9 Fiedler, 65.

Herbert Read and Benedetto Croce. Fiedler confronted Glöckner with the "dialectical method" and made him aware that actually, every true artistic activity is nothing but "an attempt to go from the uncertainty of perception to the certainty of possession of one's own senses".[10] Beginning with the "Board Works", every single form motif, every group of works from the "most simple starting-points ..." were brought "to the most resplendent spheres of clarity"[11]. Glöckner became Hegelian without ever having read Hegel; the *Board Work* grew to become the visual parallel action of the "science of logic". But the immediate impulse came from Fiedler: "All art is development of ideas, as is all thought development of notions."[12] Glöckner's artistic giving of form became the dialectical process of an apparently inherent auto-movement of given determinations and their changing into their opposites. Glöckner noted: "large - small, smooth - rough, short - long, beautiful - ugly, slow - fast, light - dark, black - white, rich - poor, soft - hard, loud - quiet, moist - dry - sticky."[13] For him the oppositional becomes simile for all creation and all life. Glöckner finds his dialectical image categories such as contrast, inversion, rise and fall, reflecting, positive and negative form, arranging, piling, tilting, turning and twisting; they contradict the traditional, classic claim of displaceableness. Fiedler had once again pointed the way to Glöckner: "Each insight won becomes a barrier to further understanding, when it takes on the character of absoluteness and becomes a set rule."[14] The salto mortale of the white square opened the whole future and thereby initially created the new canvas: the board's body of surfaces. The boards are nothing but clean cut, hardened and polished, about 3 mm thick cardboard in the basic format of usually 500 mm x 350 mm. This format points to unity, some boards deviate in that they are doubled or divided in half, because of to special themes or to emphasize significance. Their artistic concept as well as their own enduring stability free the boards from frames. They are worked for both seeing and touching, inviting - held in the hand - to upright or tilted bending and turning as well as to spacial and perspective seeing.

The often contrasting forms of both surfaces of a board, as well as the form definition's illusion of movement are based on the concept of this corporeal canvas. It is established in the continuing dialectic from each preceding board. Thus, *Board Work*, with its initial extreme formal strictness is later handled in corresponding, broad rhythms of progressive variation. Coincidence rules

as it does in life, as a matter of course and with cunning. Glöckner described the logical progression of his thematic: "I began, with the following boards, to experiment in every way with the elementary divisions of the picture's front and back surfaces. In this way, additional boards were created. The second board shows the rectangular surface diagonally divided from the upper left to the botton right corner, whereby one of the triangles formed is covered in white and the other in black. It was one of the simplest divisions of a surface you could imagine, and actually also the simplest distribution of colors, if you want to call black and white colors. At the same time, it came to a new color tone on this diagonally divided board, namely, a gray on the back side. Silver was used, corresponding somewhat to the gray value, depending on how the light is adjusted. Further subdivisions were then found. In the third board, another diagonal was added, marking the center. From this point, the next boards developed from further divisions of the resulting fields; quarters, eighths, etc. This principle of subdivision remained the fundament through further development of the boards, even when it came to later elements of free play with forms and colors. The basic forms and divisions which finally arose, were two-sided boards, one black, where all lineal elements are bound to the edges, and the corresponding board, where everything connected in the center."[15] These natural laws of number and proportion escalate to figural-functional classifications of intrinsic aesthetic value such as conjoining, folding, arranging, breaking, penetrating, and superimposing. These arrangements also convey the emergence of elementary, symbolic configurations - wedge and ray, knots, waves, beam and star. In often recurring variations, the six-pointed star joins together the symbols for earth, water, air and fire in its signs; as for the time of creation, this board belongs to the first ones. It is fundamentally similar to the star's systematic beginning phase with its division of events into day and night. That which is natural and energetic flows, in essence and association, into *Board Work* what is rural, vegetable, technical, architectonic, typographic: the human face; earth, horizon, sun, moon, the universe. The rigorous redetermination of his work ultimately lead Glöckner to a rupture with the old culture of painting and its vain cult of handwriting: Glöckner's devices and methods are - here, he may have been equally inspired by Konrad Fiedler - influenced by industrial mass production with its new materials and technologies. The application of brush and knife are the exception. The foundation is most often created by mounting industrial, prefabricated wrapping paper and colored paper; dyed paper, but also newspaper and old bills; as well as by dyeing the board body with monochromes and - in few cases - by preserving the body's limed cardboard. Colored figurations result

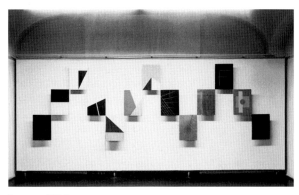

Hermann Glöckner
Exhibition in 1969 in the
Kupferstich-Kabinett of the
Kunstsammlung Dresden,
Tafelraum, east wall

10 Fiedler, 63.

11 Fiedler, 42.

12 Fiedler, 40.

13 Hermann Glöckner, handwritten notes on Fiedler, quoted from: *Glöckner, Ausstellung der Staatlichen Kunstsammlungen Dresden, Kupferstich-Kabinett*, exhibition catalog (Dresden 1989) 15.

14 Konrad Fiedler, *Schriften über Kunst*, 75.

15 Hermann Glöckner, *Meine Arbeit ist mein Leben*, 58.

Hermann Glöckner
Hand Prints
Linocut, others from structure
plates or paper, 1963/1973
35.8 x 50 cm
Hand Print 16/20
Hein Köster, Berlin

16 Glöckner 1983, 58.

17 Hermann Glöckner, letter to Hein Köster from 9.19.1975.

from paint application - mainly by applying over a stencil - or by glueing folded and unfolded strips, as well as collages of colored paper and newspaper, fabrics, tree bark or other materials. Lines are made by scratching, impressing, wrinkling and rolling a pattern cutter or are drawn with ruler and pen; also with putty knife and brush strokes as well as washing out in the later boards. Every board is waxed and varnished as finish; the homogeneous surfaces of all of the boards underscores their connectedness. Resulting from such handcrafted solidity, the boards age in dignity and obtain a refined surface patina. "Board Work" is Glöckner's very own and personal artistic encyclopedia: it accompanies his work experimentally, protects him from random fantasy and caprice and clarifies entrances and exits into and from other groups of works.

Board Work possesses a defined systematic beginning, but no such end. But in individual cases, Glöckner proceeds more with sovereignty than dogmatism; he adds a board later - or sorts one out. Glöckner writes about the board work as a whole: "Perhaps it corresponds nearest to what determines in music, namely, the division of rhythm by means of notes. Thus, it is not preconceived construction, but rather, came-to-be construction, exactly what every art work becomes in the end."[16] *Board Work* possesses a special artistic truth only in its entirety: in the sequence of emergence, unfolding and - exhaustion. The individual board gets its special position as result and moment through construction, theme, structure, material and technique, in this temporal formulating time of genesis. Substantiated and protected in such a manner, the individual boards and their specific formative problems become stations of transfer in individual groups of work, they carry out further and exhaust the concrete idea: "Roof Images" as free fashioning of nature impressions, the bodies of space and the large folded graphics-work group as successor to the folding principle, *Laying Game* as aesthetic building blocks for everyone and finally *10 Handprints* as demonstrative visualisation of his dialetic method. The technique of folding - already elaborated several times in *Board Work* - becomes the basis of serial graphic production.

Glöckner's work was first exhibited in 1969. For the catalog, a graphic supplement was requested, whose size would considerably exceed the catalog format. Glöckner found a working solution uniting the practical with aesthetic form: folding and "picture". Folding the picture together enabled the required size reduction of the page. Unfolding to reveal the "finished" picture creates a succession of pictures. Folding releases the surfaces in spatial gestures: in the making as well as in the result - folding over and on top of each other. But also, folded straight lines end in corners or intersect differently than do lines drawn with a ruler. The folded edges bring together different colored surfaces with each other. They openly show how the page was created and from which proportions and relationships the figure is constituted. Glöckner described this process as "unraveling"; it is the wondrous strength of separation, which discovers the form by searching. Fold graphics point to the space, the plastic availability. Folding is a constructive and methodic procedure, to allow the production of chosen signs. Fold logic and form work penetrate each other, they are method and result, are equally entitled as motif and structure, they form groups and sequels. The painting in the museum, even when abstract, is horizontally oriented, has a top and a bottom. Many of the fold graphics are different: although they occupy a preferential position, the position is not exclusive. The surfaces' rotation provokes the coordination of a theme.

Bringing together allows large figures to emerge with a new quality. If the size, determined clearly by the artist, is essential to many art products, then the repetition of folding makes this "aura" unessential: They can be enlarged or reduced, as can some of the *Board Works*, if only the division ratios are maintained. *10 Handprints* is different; Glöckner stated in 1975, "with this work, an expansion of the board work" was achieved.[17] A nearly trivial starting situation is given: Three intersecting curves and a circle form eight different forms. Everything else unfolds from this as a quasi self-constructed course. The beginning's aesthetic meaninglessness - its motionless in itself -, is broken up step by step and then brought into the dialectic moveability by - at first simple - (leaves 1 to 4) - and then strong - (leaves 5 and 6) - antitheses. Forms and colors rage. A process of resolution begins at leaf 7; the forms calm down, falling into clear figurations and step by step, single form parts are layed aside. No part is heedlessly eliminated. The final leaf needs only part of a form and a color: complete equality and supreme simplicity. A "construction of the whole in essence."[18] The development of modern art is neither a big sport event nor is art theory a court for determining authorship; both ideas however, (so it appears) are applied today and have risen to favorite past time of art critic journalists. Explaining the position of *Board Work* within the artistic and unartistic apparatus doesn't work; this kind of discussion remains outside and does not promote that understanding which it should be about, namely, recognition of the course and development of this artistic truth. Glöckner kept his will and courage to be free; he turned away from simple and popular categorizations: against the one-sided fixation on Constructivism, mathematics and geometry. "After all, I am basically not a 'constructivist' ",[19] and just as forthright is his rejection of the obdurate mathematical formulas and servile art of measuring, because number

Hermann Glöckner
Hand Prints
Linocut, others from structure
plates or paper, 1963/1973
35.8 x 50 cm
Hand Print H/20
Hein Köster, Berlin

18 Georg Wilhelm Friedrich Hegel, *Wissenschaft der Logik Erstes Buch: Die objektive Logik* (Leipzig, 1963) 16. Quote is translated in this essay. Available in English translation, see footnote 21.

19 Hermann Glöckner, *Meine Arbeit ist mein Leben*, 59.

20 Max Frisch, *Don Juan, or the Love of Geometry. Novels, plays, essays*, ed. Rolf Kieser (New York, 1989) 205.

21 Georg Wilhelm Friedrich Hegel, *Science of Logic, Volume III, The Doctrine of the Notion*, ed. H.D. Lewis (New Jersey, 1989) 841.

and proportion alone are unsensual and rigid. His artistic work, however, is directed at the formation of the most varying relationship determinations, at functions, at elective affinities and repulsions, at proportional intersections, at sliding and erratic transitions: at the poetry of the dialectic. When the 85 year old Glöckner saw his first football game on television at the invitation of a Munich art collector, he saw only lines, lines which moved on the square imager and the slants, wedges, rhombus as well as the deformed and divided circles which emerged. After about 20 minutes he recognized the trick and was bored by the insipidity, he left his host. Glöckner, having been held over long years in the disfavor of two political systems, both of which had banned abstract art, had become extremely cautious about allowing his work to be seen. For this reason, the first exhibition of the 80 year old's work created, in the comprehensive sense of the word, a furore: Rage among the Party and State officials, enthusiasm among the public. Because it was the first big exhibition of abstract art in the GDR, it posed an affront to the ruling culture political doctrine. Beyond all of the contemporary historical efforts at an explaination, the grounds for these angry reactions appeared to arise from impotence, in the powerlessness before the elementary truth of this history of work and their certainty of form. "Do you know what a triangle is?" asked Don Juan. Detecting in this shape an ideal of "the honorable", of "simplicity", of "the exact" in the face of an insufficient reality, he answered: "It's as inexorable as destiny. There is only one figure that can be made up out of the given parts; three parts; and hope, the illusion of unpredictable possibilities, which so often confuses our hearts, vanishes like an hallucination before these three lines. It is a "knowledge, that is correct", it is a "figure, which covers itself with the name".[20] No ideological interference.

How can the triangle become the vehicle for spiritual orientation? Wouldn't that mean overburdening this simple figure? Thales discovered the means of determining the position of mankind in space from the similarity in relationships in triangles. Pythagoras recognized connections of number and triangle and derived from them the laws of harmony theory. Archytes of Tarent sees a wise human recognition in the triangle. Nikolaus of Cusa formulated dialectic relationships: The triangle as expression of unity and the diversity of things. To Spinoza, the triangle served to illustrate what is necessary in nature. Glöckner took the triangle to a more sublime form, giving it continually new variations and meanings. The triangle incarnated his artistic concept allegoricaly to Hegel's absolute idea: "The richest is therefore the most concrete and most subjective, and that which withdraws itself into the simplest depth is the mightiest and most all-embracing. The highest, most concentrated point is the pure

personality which, solely through the absolute dialectic which is the nature, no less embraces and holds everything within itelf, because it makes itself the supremely free - the simplicity which is the first immediacy and universality."[21]

Hermann Glöckner's work acquires its center in simplicity – the simple becomes the pattern of a reconciled world.

Hein Köster

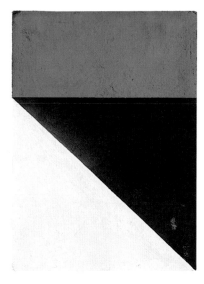

33 - 56 Hermann Glöckner
17 Boards from the *Board Works*

front and back sides
33 *Divided black and white square under blue,* around 1930-1932
A: Tempera, cardboard, lightly lacquered (yellowed white)
B: Tempera, unlacquered
50 x 35 x 0.3 cm
Staatliche Museen zu Berlin,
Kupferstich-Kabinett

34 *Red Pencil of rays in red-brown ground,* around 1930-1932
A: Tempera, scratching, cardboard, lacquered
B: Lining paper embossing
34 x 49.8 x 0.3 cm
Kupferstich-Kabinett, Dresden

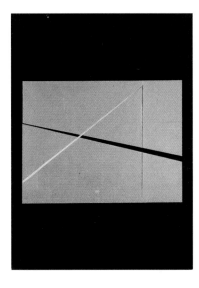

36 *Perpendicular and horizontal Parallels with black slants,* around 1932
A: Linen paper, chalk, collage
B: Tempera, collage
49 x 34.7 x 0.3 cm
Kupferstich-Kabinett, Dresden

35 *Right Triangle in silver with angle cut in and black slants,* around 1932
A: Collage, relief cut, cardboard
B: Paper, scratching
49.7 x 35 x 0.3 cm
Kupferstich-Kabinett, Dresden

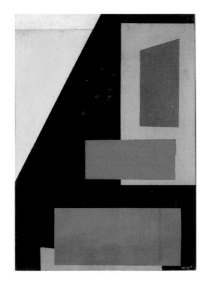

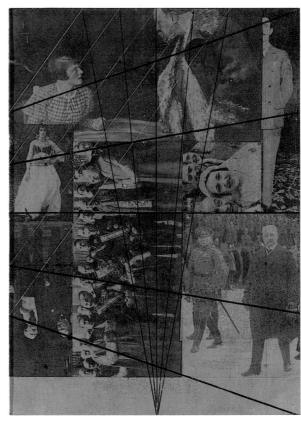

Front and back sides
38 *Planes of Color on white*, around
1930-1932
A: Colored paper, collage, cardboard
B: Colored paper, collage
49.5 x 34.8 x 0.3 cm
Kupferstich-Kabinett, Dresden

37 *Perpendicular Surfaces, White Wedge,
two Circles*, March 17-21, 1933
A: Graphite, paper, cardboard,
glue, lacquer
B: Paper, scratching, asphalt
33.5 x 23.2 x 0.3 cm
Kupferstich-Kabinett, Dresden

41 *Newspaper Illustrations under
Five Rays, Reflected Twice*,
around 1932
A: Collage, tempera, scratching,
cardboard, lacquered
B: Collage, embossed lines
34.7 x 24.9 x 0.1 cm
Kupferstich-Kabinett, Dresden

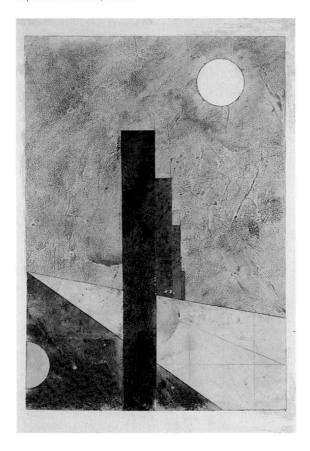

39 *White and Silver with
Slanting Black Stripes*,
April 1932
A: Collage, colored paper, folding,
cardboard, lacquered
B: Collage, silver curves, embossing
49.2 x 34.8 x 0.3 cm
Kupferstich-Kabinett, Dresden

40 *Six-pointed Star in
old Gold*, 1932
A: Tempera, asphalt lacquer, paper,
scratching, cardboard, lacquer
B: Damask paper over
embossed lines
47.3 x 32.5 x 0.3 cm
Kupferstich-Kabinett, Dresden
(no illustration)

42 *Folded strips in Red and Yellow on Black*, 1933
A: Collage, Japanese paper, lacquer, cardboard
B: Paper, embossing, lacquered
35 x 24.8 x 0.3 cm
Kupferstich-Kabinett, Dresden

43 *Six-pointed Star in black on gold field*, around 1933-35
A: Newspaper, goldbronze, tempera, cardboard, lacquer
B: Embossing
49.3 x 34.8 x 0.3 cm
Museum moderner Kunst Stiftung Ludwig, Vienna

44 *Red-white Folding on Brown Marbled Paper*,
around 1935,
A: Collage, folding, cardboard, lacquer
B: Paper
13.4 x 9.4 x 0.2 cm
Galerie Gunar Barthel, Berlin

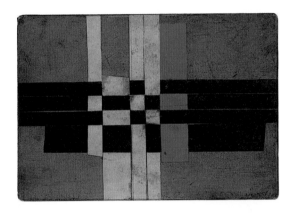

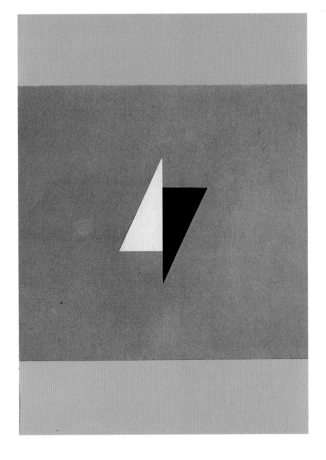

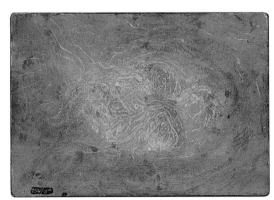

Front and back sides
45 *Black and White Network with Red Stripes on Gray*, around 1935
(24.3.1956)
A: Collage, tempera, cardboard, lacquer
B: Head drawing crossed through in gray
24.7 x 35 x 0.3 cm
Kupferstich-Kabinett, Dresden

46 *Addition of Black and White on Gray*, around 1933-1935
A: Tempera, paper, cardboard, lacquer
B: Embossing
41.8 x 35 x 0.2 cm
Kupferstich-Kabinett, Dresden

47 *Three Rays Reflected Three Times,*
July 16, 1935
A: Graphite, nib pen, ink, tempera,
cardboard
B: Corrugated paper, embossing
49.4 x 30 x 0.3 cm
Kupferstich-Kabinett, Dresden

48 *White-brown Wedge to the Left,* 1935
A: Collage, graphite, scratching, asphalt
lacquer, cardboard
B: Packing paper, embossing
48.5 x 34 x 0.3 cm
Kupferstich-Kabinett, Dresden

49 *Silver Radiation Between Black and
White,* 1935
A: Tempera, colored paper, embossing,
lacquer, cardboard
B: Paint, embossing
26.1 x 6.7 x 0.1 cm
Galerie Gunar Barthel, Berlin

51 *Wedge Broken Three Times on Black,*
March 12, 1937
A: Graphite, tempera, silver paper,
cardboard
B: Paint, nib pen, ink
34.8 x 49.5 x 0.2 cm
Kupferstich-Kabinett, Dresden

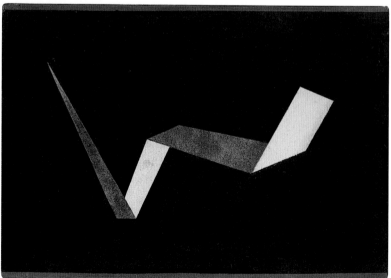

50 *Sächsische Volkszeitung,* 1946
Newspaper, graphite
27.8 x 42.5 cm
Galerie Gunar Barthel, Berlin

66

52 *Construction with Eight Points on Red-Brown Base,* 1948
A: Coal, tempera, roughened paper, cardboard, lacquer
B: Gold paper, embossing
49.4 x 34.8 x 0.2 cm
Kupferstich-Kabinett, Dresden

53 *Jagged cut-out and bird wings over four textural patches,* Mai 1956
A: Pressed cardboard, canvas, tempera, lacquer, cardboard
B: Newspaper, lacquer, paint
49.8 x 35.2 x 0.1 cm
Galerie Gunar Barthel, Berlin

54 *Folded Strips in Blue over Horizontal strips in Red,* April 28, 1956
A: Collage, tissue paper, glue, lacquer, cardboard
B: Scratching
29 x 41.8 x 0.1 cm
Galerie Gunar Barthel, Berlin

55 *White Right Angle over Green,* 12/13/1956
Collage, packing paper in Green, cardboard
35.8 x 49.3 cm
Kupferstich-Kabinett Dresden

56 *The Tree in Black/White,* 1968-1969
A: Graphite, tempera, paint
B: Graphite, tempera, paint
50 x 25 x 0.1 cm
Galerie Gunar Barthel, Berlin

Images around 1945:
Felix Nussbaum, Karl Hoffer, Werner Heldt, Otto Dix, Hans Grundig, Horst Strempel

Night over
Germany

[1] "... we believe in humanity's redemption through art", quoted in "An alle Künstler, Dichter, Musiker". Summons from the "Vereinigung für neue Kunst und Literatur", Magdeburg, 1919, in: *Kunstblatt*, III, 1919.

[2] Letter to the collector Viktor Bausch, November, 1942, quoted from "Karl Hofer", *Malerei hat eine Zukunft. Briefe, Aufsätze, Reden*, Andreas Hüneke (Ed.) (Leipzig/Weimar, 1991), 226.

[3] Letter to Hans Carsten Hager, 2/11/1947, Hüneke, 275.

[4] Hofer wrote in a letter to Bruno Leiner from 12/30/1943, "that our enemies, Churchill the drunk and Roosevelt the cripple, can't touch us with their ridiculous Hollywood army and their cabaret fleet, except for the useless destruction of Deutschland" Hüneke, 241.

[5] Leopold Ziegler, *Das Wesen der modernen Kultur* (Leipzig, 1903), 139.

[6] Karl Hofer, "Der Kampf um die Kunst", in: *Deutsche Allgemeine Zeitung*, 7/13/1933.

[7] Hüneke, 199.

[8] *78 Arbeiter, Angestellte, Schriftsteller, Politiker beantworten die Frage: Wie kämpfen wir gegen ein Drittes Reich?* (Berlin, 1931), 22f.

[9] Hüneke, 205.

[10] "It clearly could not be a matter of simple repetitions, rather of structuring anew, even when partially closely connected to the one that was destroyed"; letter to Leopold Ziegler, 7/9/1943, Hüneke, 235.

[11] Letter to Leopold Ziegler, 1/1/1944, Hüneke, 41.

[12] Sigmund Freud, "Das Unheimliche", in: *Psychologische Schriften, Studienausgabe* vol. IV (Frankfurt/Main, 1970), 260.

[13] Elias Canetti, *Die gespaltene Zukunft. Aufsätze und Gespräche* (Munich, 1972), 66–92.

[14] Quoted from the copy archive of the Berlinischen Galerie, Berlin.

[15] According to Hans E. Holthusen in 1947; Hans E. Holthusen, *Der unbehauste Mensch. Motive und Probleme der modernen Literatur* (Munich, 1964), 128.

Felix Nussbaum's *Self-Portrait with Jewish Identification* (fig. 21, p. 45) from 1943 shows the artist surrendering himself with raised hands, hopelessly cornered into a wall by his invisible persecutors. He is identified by the yellow star of David, which is otherwise hidden under his turned-up coat collar, as well as by the alien passport stamped with "JUIF-JOOD". The observer catches himself in the role of the persecutor and informer because he cannot evade the artist's fearful glance from the front most focal plane. Life in hell, under prolonged threat of physical annihilation, constantly on the run from arrest and transport to a concentration camp, is perceived in the relationships of tension: between the wall shown from a low angle and the artist from a high angle, and the portrait's reduction to chest level, which gives the impression that this world has no ground. This irreal scene was Nussbaum's attempt at visualizing a nightmare so that he could then exorcise it. Nussbaum's hiding place in the Rue Archimède in Brussels was in fact betrayed. He and his wife Felka Platek were arrested on June 21, 1944, and then sent to Auschwitz with the last transport from the Mechelen camp on July 31, 1944. They were murdered in Auschwitz, the Belgian authorities having recorded August 9, 1944, as their official date of death. Nussbaum's self-portrait is the last testimony to his existence handed down to us: art as self-conservation within persecution.

Karl Hofer belonged to the "spiritual revolutionary" generation, who, after WWI, wanted to rectify "what politics had ruined".[1] Along with his generation, Hofer saw himself as the lonely "Caller" (1924, 1935, 1938, 1940) in the timeless ascetic loincloth and as "German Prophet" (Julius Lanbehn, 1890) in the desert of a "stinking gasoline world of civilization ..., the world of Satan ...".[2] Paintings such as *Self-Portrait with Demons* (around 1930), *Imprisoned* (1933), *Man in the Ruins* (1937, lithograph bearing the same title in 1923/24), confirmed to Hofer's contemporaries his understanding of himself as "emotional seismograph that had registered the disaster in advance."[3] In the evaluation of the political situation and in practical life, the prophecies of doom (*Cassandra*, 1936) revealed its origins in the resentments of German "criticism of civilization" around 1900.[4] In contrast, for Hofer's childhood friend, the conservative philosopher of religion Leopold Ziegler, German culture meant "the realization of the idea of divine men, in the sense of a secularized doctrine of salvation."[5]

In July, 1933, Hofer tried to get friendly with the

new rulers by remarking, "that next to the military, there is no area of human activity so *judenfrei* than the visual arts".[6] With allusion to the saying "if the Führer knew that", Hofer still wrote in a letter to Ziegler on January 11, 1934: "Of what good is the pure and significant will and intention of the Führer, the only great personality, when everything ... is going to be twisted in its opposite by satellites."[7] In 1938, he divorced his Jewish wife Thilde, from whom he had lived separately since 1934, and married Liesel Schmidt, his model of many years, on November 7, two days before the euphemistically named "Kristallnacht", the progrom against the Jews. Thilde Hofer was denounced in Wiesbaden and murdered in Auschwitz on November 21, 1942.

But Hofer had another side; he had expressed criticism of "Fascism, the dark reaction"[8] as early as 1931. On April 1, 1933, he was denounced for being a "Marxist-Jewish element" and suspended from his teaching duties and on June 30, 1934, dismissed from his teaching post. He was represented by eight paintings in the exhibition "Entartete Kunst", afterwards over 300 of his works were removed from German museums. Responding to the news that Rembrandt was to have been a "Jew painter", he wrote to Leopold Ziegler on December 30, 1937: "It is clearly sheer insanity, an evil dream from which you can't wake up."[9] He formulated this nightmare in the second version of the painting *The Black Rooms* (fig. 58, p.72), which he reconstructed with help of photographs after having lost the first version from 1928.[10] The first version had burned along with about 150 other paintings during a bomb attack on March 1, 1943. As a spiritual being, he had "lost every connection to this world"[11] which had hostilely turned against him like the naked drummer in the center of the painting. In the juxtaposition between statuary figures staring at the one entering and the figures rushing aimlessly, driven by invisible forces through the hopeless labyrinth of the barren, dark rooms, Hofer created an atmosphere in the meaning of the word "sinister", which Sigmund Freud characterized as "that kind of fright", "which goes back to what is well-known, what always had been familiar".[12]

The brooding loner Werner Heldt, during his exile in Majorca, examined his similar traumatic fears of the faceless, vacillating masses. His drawing *March of the Zeros (Meeting)* (fig. 74, p. 78) evokes, in its rows of Berlin buildings, nightmarish associations to the street wars between the "reds" and the "browns" during the final days of the Weimar Republic. In a picture cycle created at the same time based on the Revolution of March, 1948 in Berlin (figs. 76, 77, p. 78), his interest lay beyond any historical documentation of the countenance of the crowds of thousands, whose spontaneous uprising could at any time turn into marching in step. In his book "Mass and Power",

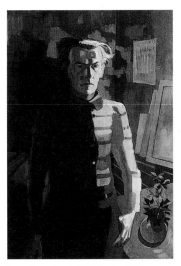

Hans Grundig, Self-Portrait, 1946,
Oil on canvas, 126 x 86 cm, Staatliche
Museen zu Berlin, Nationalgalerie

16 Werner Heldt, in: exhibition catalog,
Kestner-Gesellschaft (Hannover, 1968).

17 Wilhelm Rudolph, quoted by Henner
Menz in: *Wilhelm Rudolph: Document-
Werk 13. Februar 1945. Gemälde, Zeich-
nungen, Graphik* (Dresden, 1966).

18 Cf. Edmund Burke, *Philosophische Un-
tersuchung über den Ursprung unserer
Ideen vom Erhabenen und Schönen*, 1757.

19 "Armando, über die Schönheit", in: *Ar-
mando. Die Berliner Jahre* (Den Haag, 1989),
20.

20 Theodor W. Adorno, *Ästhetische Theo-
rie* (Frankfurt/Main, 1970), 80.

21 Diether Schmidt, "Selbstbildnis", in: *Otto
Dix*, exhibition catalog, Museum Villa Stuck
(Munich, 1985), 69.

22 Buch Job 2, 8, Das Alte Testament,
Aschaffenburg, 1961, p. 722. (The Old Tes-
tament.)

23 Hannah Arendt, *Besuch in Deutschland*
(Berlin, 1993), 25, 28.

24 Hans Grundig, Künstlerbriefe aus den
Jahren 1926 bis 1957, Rudolfstadt, 1966, p.
99 (letter to Lea Grundig on 7/12/1946).

25 Hans Grundig, *Zwischen Karneval und
Aschermittwoch. Erinnerungen eines Ma-
lers* (Berlin (East), 1957), 294.

26 In the Greek sense of "belonging to the
burial".

27 Helen Ernst was a graphic artist and a
close friend of the Grundigs since the
1930's, member of the German Communist
Party, arrested twice in 1933 for illegal pol-
itical activities, emigrated to the Nether-
lands in 1934, arrested by the Gestapo in
1940, 1941–45 in the Ravensbrück con-
centration camp and in the outer camp
Barth, Member of the United Socialist Party

Elias Canetti refers to the phenomenon of the individual who always creates distances around himself out of the deep fear of contact, but completely looses this fear in crowds and is therefore attracted to them.[13] In the same year, the 31 year old Werner Heldt noted "some observations about the masses", arriving at the insight that a "regression to a primitive emotional stage, in which very small children and dreamers can live without disease" is required in order to arrive at this reality of a "collective hallucination", a mass psychosis.[14] Immediately after his return from prisoner of war captivity, he painted *View from a Window with Dead Bird,* a view onto the deserted city. He had returned, without having returned home, like Beckmann in Borchert's "Outside at the Door". Artists like Heldt saw themselves as "shipwrecked ... driftwood of a broken civilization, citizen of a fantastic dream city which stretches out between the tops of hills of rubble and moraines ... eye and body witnesses of a world inundated by catastrophe ...".[15] In dream-like sequences, his pen-and-ink drawings from between 1946 and 1949 imagine a *Berlin on the Sea* (compare figs. 64, 68, 69, p. 76f.), the sea having overwhelmed the war like a deluge. The houses become rocky cliffs on which the flood breaks. His memories of the Mediterranean seashore of his temporary exile on Majorca in the 1930's come into play.

Just as Werner Heldt sees an allegory for nature's triumph over "what human hubris constructed"[16] in his *Berlin on the Sea* cycle, Wilhelm Rudolph presented Dresden, destroyed on February 13, 1945, as a landscape, which through the "effects of time, rain, snow, wind and frost, had transformed itself into a crumbling rocky mountain range. ... Nature wins back the broad city zone"[17] (figs. 78–99, p. 81f). In comparing the comments of both Werner Heldt and Wilhelm Rudolph on their graphic cycles of the destroyed cities of Berlin and Dresden, the relationships between the glance onto the destruction and the unbroken will to exorcize the ugliness and negativity of the destruction through its transformation into the sublimity of nature's beauty are revealed. The sight of nature raw and unconquered arouses feelings of dizziness, groundlessness and powerlessness.[18] The Dutch artist Armando, who in 1979 had settled in Berlin, the "lions' den", examined how the "unbeautiful beautiful, the terrible-beautiful" can become art, "with the result, I hope, of the sublime, *the sublime as the artistic taming of the horrible*" in his painting cycle *Guilty Landscape*.[19] The question remains: how can the artist do justice to the entanglement of beauty, shame and guilt, without "affirming the despicable way of the world as bold nature".[20]

The extreme change in roles from *Self-Portrait as Mars* (1915), in which the Nietzscheian Otto Dix presented himself as the embodiment of the merciless Dionysi-

an principle of chaos and destruction, as perpetrator and war god, to *Self-Portrait as Prisoner of War* (1947; fig. 61, p. 74) drastically demonstrates the changed perception of war by a generation who in 1914 had still experienced the coming "holy" war as the storm that would cleanse the putrefaction of the rotting civilisation. The 57 year old Otto Dix, who went to war at the last summons in 1945 as Volkssturmmann and was released from prisoner of war captivity in France in spring of 1946, appearing shockingly aged, "himself a anonymous vegetable without feeling among dazed, anonymous comrades".[21] His eyes, drawn to narrow slits, are dull and register nothing, the face is careworn and shot through with deep wrinkles. The barbed wire barrier surrounding him makes him seem like Christ on the stake.

Dix painted *Job* (fig. 60, p. 74), half naked, covered with repulsive ulcers, in his hand "a shard for scraping himself with, while he sat amidst the ashes",[22] with sharp frosty color tones in the dry, recalcitrant al prima technique, which in the late work of the 1930's replaced the old master's technique of varnishing. Job, stunned, staring into the sky with his mouth half-open, at odds with his God, became, in 1946, the symbol for the Germans unconscious of any guilt, over whom the tragedy had descended like a natural disaster. Hannah Arendt, on her first visit to Germany (August, 1949 to March, 1950) since her emigration, observed symptoms "of a deeply rooted, stubborn and occasionally brutal refusal to confront (themselves – trans. note) with what had actually occured and come to terms with it. ... The average German does not look for the cause of the last war in the deeds of the Nazi regime, rather in the events that lead to Adam and Eve's expulsion from paradise. ... The persisting claim that there is a cleverly thought-out plan for revenge, serves as the soothing argument for the evidence that all people are equally sinners. The reality of the destruction surrounding every German is dissolved into a brooding, but hardly rooted selfpity"[23]

Hans Grundig's *Self-Portrait* was also created at the end of the year after his return to Dresden, his home city, in January, 1946, before which he had spent five years between captivity in the Sachsenhausen concentration camp, service at the front in the Dirlewanger punishment division, defection to the Red Army and a year-long residence in Moscow. After seven years of not having painted, he felt "like a beginner and have to struggle with the dry, stubborn material like before".[24] He too gave up the old masterly 1930's style of varnishing, with which he had interpreted the NS regime as a regression back to barbarism (for example *Struggle of the Bears and the Wolves*, 1938). The ghosts and demons, the "raging, two-legged wolves", have disappeared. But his glance is still captivated by the "Infernal wandering ... in a horrible, inhuman

of Germany after 1945, died in Schwerin in 1948 (compare: *Helen Ernst. 1904–1948. Berlin – Amsterdam – Ravensbrück. Stationen einer antifaschistischen Künstlerin*, exhibition catalog, "Das Verborgene Museum" (Berlin, 1994); Christel Beham, close friend of the Grundigs in the inner emigration, unskilled worker, concentration camps Hohnstein and Buchenwald because of illigal political work, according to a witness' statement in court for the benefit of Lea Grundig in 1938 "we saw him, our beloved friend Christl, for the last time" (Lea Grundig, *Gesichte und Geschichte* (Berlin (East), 1960, p. 1982); Fritz Schulze, painter and Hans Grundig's student colleague at the Dresden Art Academy, member of the German Communist Party and belonged to the local Dresden group ASSO, executed by the Nazis.

28 The report on the first meeting of the main committee of "Victim of Fascism" in the central organ of the GCP by the Deutsche Volkszeitung from 7/3/1945 is symptomatic: "Millions of people are victim of fascism. Victim of fascism are those who have lost their home, their apartment, their possessions. Victim of fascism are the men who had to become soldiers and fight in Hitler's battalions Victim of Fascism are the Jews, who were persecuted and murdered by fascist racism, the Jehovah's witnesses and the 'employment contract traitors'. But we cannot stretch the term 'victim of Fascism' so far. They have all suffered and endured hardship, but they have not fought!" Quoted from: Olaf Groehler, "Der Holocaust in der Geschichtsschreibung der DDR", Ulrich Herbert/Olaf Groehler, *Zweierlei Bewältigung. Vier Beiträge über den Umgang mit der NS Vergangenheit in den beiden deutschen Staaten* (Hamburg, 1992), 42f.

29 Hans Grundig, letter to Lea Grundig, see Hüneke, 122.

30 Hermann Müller, Horst Strempel, in: *bildende kunst*, vol. 4/5, 1947, quoted by Günter Feist, "Das Wandbild im Bahnhof Friedrichstraße. Eine Horst-Strempel-Dokumentation 1945–1955", in: Eckhart Gillen/Diether Schmidt (Ed.), *Zone 5. Kunst in der Viersektorenstadt 1945–1951* (Berlin (West) 1989), 92f.

31 Wolfgang Borchert, *Das ist unser Manifest*, 1947.

32 Barnett Newman, "Surrealismus und Krieg", *Schriften und Interviews, 1925–1970* (Bern/Berlin, 1996), 103f. The initial attempts of the Berlin "Fantasten" (Heinz Trökes and Mac Zimmermann, among others), for whom Surrealism "actually lay in the streets" to paint "an ironization of what we saw outside" (for example *The Moon Gun* by Trökes), remained a West Berlin exception.

desert".25 Like Nussbaum, the artist, marked by his experiences, penetratingly fixes the observer at a distance. He builds himself up before the observer, standing between light and shadow, thus blocking entrance into his atelier. The canvases are empty. Enlightened by experience, he stands before a new beginning which is still overshadowed by the gravity of self-exploration, by the pause of reflection on what had happened.

With the religious solemnity of an icon painter, Grundig painted two versions of *To the Victims of Fascism*, a gripping, silent epitaph honoring the dead.26 He chose the form of the predella, the place of Christ's grave within the medieval polyptichs, which hid the promise of resurrection. He inscribed the second, Dresden version (1946/49; fig. 59, p. 73) in dedication to his friends Helen Ernst, Christel Beham and Fritz Schulze27 on behalf of the circle of resistance fighters in Dresden in which he and his wife were active. As a survivor, he expressed his solidarity with his dead comrades by giving his own Sachsenhausen concentration camp prisoner number to the dead lying in the foreground. Remarkable and unique within the context of antifascist painting in the Soviet Occupation Zone/GDR is the fact that Grundig included the Holocaust of the Jews in his memorial painting. In contrast to the political prisoners from the GCP and GSP, the Jews were not taken into consideration in the East German national memorials and monuments, because they had "not fought".28 The political prisoners in both versions wear uniforms bearing red triangles. Grundig lay a yellow star of David over the triangle in the second version. "I wanted to present this annihilated, wonderful humanity in the most precious way humanly possible. I felt that they had to be layed on pure gold. I did it."29

Horst Strempel also took up the tradition of portraying the passion in his triptych *Night over Germany* (1945/46; fig. 57, p. 71). A contemporary art critic interpreted the central figure of the man in front of the landscape of concentration camp barrack roofs as the one crucified. "The tatooed arms of children reach upwards. The captured one hangs from the barbed wire, his dimensions larger than life."30 Instead of Christ's burial, the predella shows prisoners in bunker cells, waiting to be liberated, communicating with knocks. Their struggle in the underground symbolized the later resurrection out of the ruins. The color scale corresponds to the temporal atmosphere: "... our sky is purple at night The moans at night of those starving is purple."31 Like all artists who decided on the GDR as an antifascist alternative to the "capitalist" Federal Republic, the antifascist and communist Strempel soon realized that in the GDR, each look into the past, any question about guilt and involvement, were unwanted.

It is clear that Auschwitz can neither be explained

nor made comprehensible with traditional images of Christian iconography and its forms of pathos and stylized gestures. Expressionism had failed already in the trenches of the first World War which had brought forth Verism. Surrealism was overtaken by the horror of the second World War. Barnett Newman wrote in 1945, in an essay unpublished at the time, after having seen the first photographs of Buchenwald and Bergen-Belsen after the liberation of the extermination camps to have been published in the U.S.A.: "... Surrealism is dead. ... No painting can surpass the photographs of German atrocities. ... The contorted corpses are the work of Ernst's demons. The destroyed architecture, the rubble, the gruesome corpses are surreal reality. ... Whoever had dismissed surrealist works as the esoteric toy of a decadent, unworldly know-it-all, now cannot deny that these things held up to us the 'hyperreal' mirror of an approaching and henceforth contemporary world. ... Any new art has a prophetic quality in the beginning. ... That is what the professional revolutionaries, the left-wing politicians have never understood What they want is an official art which reflects their official politics. ... Focussed on trade, they scorn ideas, and their business takes on the form and structure of a political academism, while the artists interested in ideas have a constant revolutionary vein."32

Eckhart Gillen

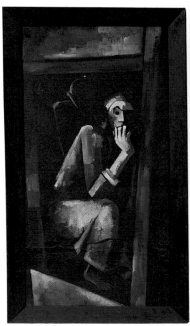
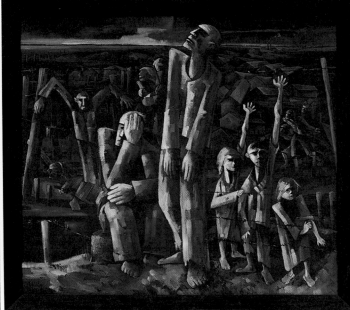
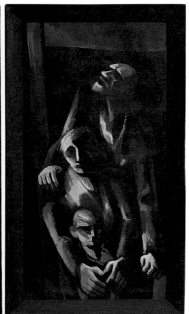
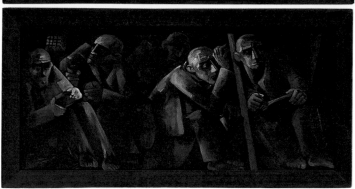

57 **Horst Strempel**
Night over Germany
1945/46
Oil on canvas
Triptych: middle panel 150 x 168 cm,
side panels each 150 x 78 cm,
Predella 79 x 166 cm
Staatliche Museen zu Berlin,
Nationalgalerie

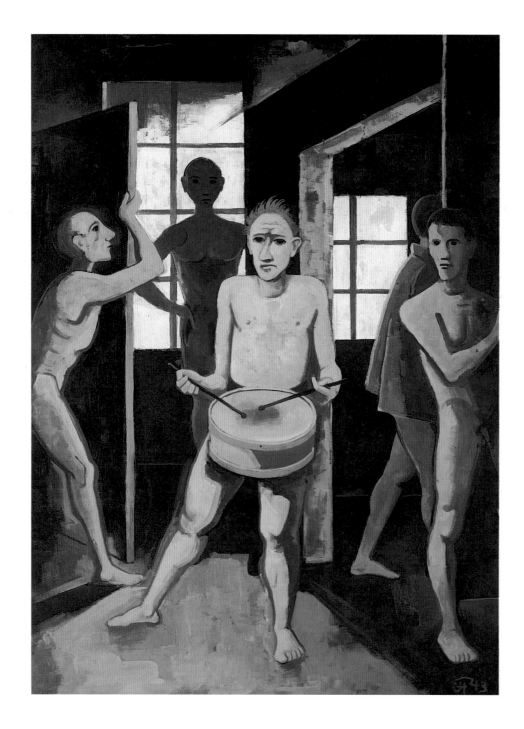

58 **Karl Hofer**
The Black Room
1943 (2nd version)
Oil on canvas
149 x 110 cm
Staatliche Museen zu
Berlin, Nationalgalerie

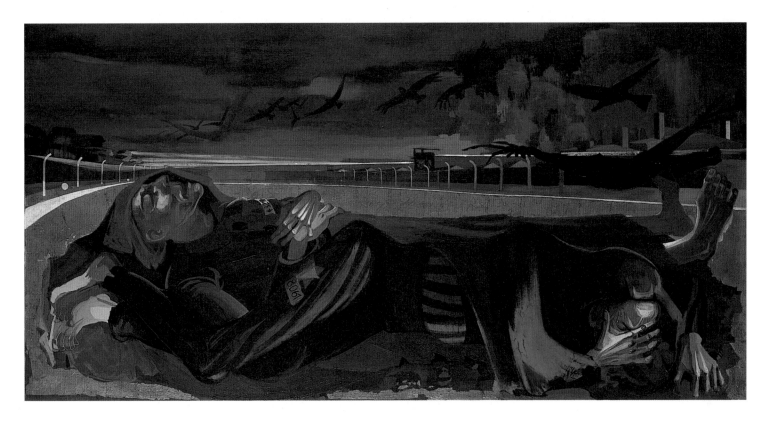

59 **Hans Grundig**
To the Victims of Fascism
1946/49 (2nd version)
Oil on fiberboard
110 x 200 cm
Staatliche Kunstsammlungen Dresden,
Galerie Neue Meister

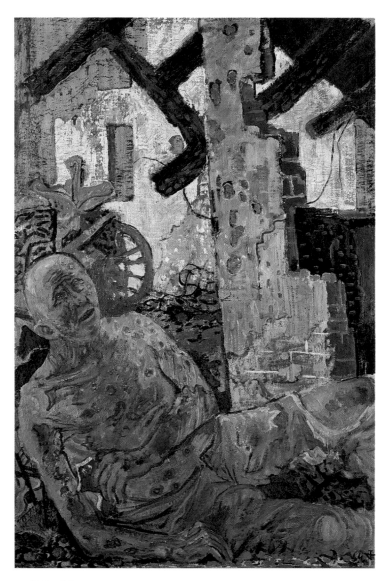

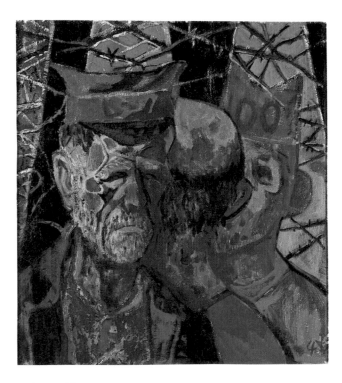

61 **Otto Dix**
Self-Portrait as Prisoner of War, 1947
Oil on plywood
60 x 54 cm
Galerie der Stadt Stuttgart

60 **Otto Dix**
Job, 1946
Oil on canvas
120 x 81 cm
Otto-Dix-Stiftung, Vaduz

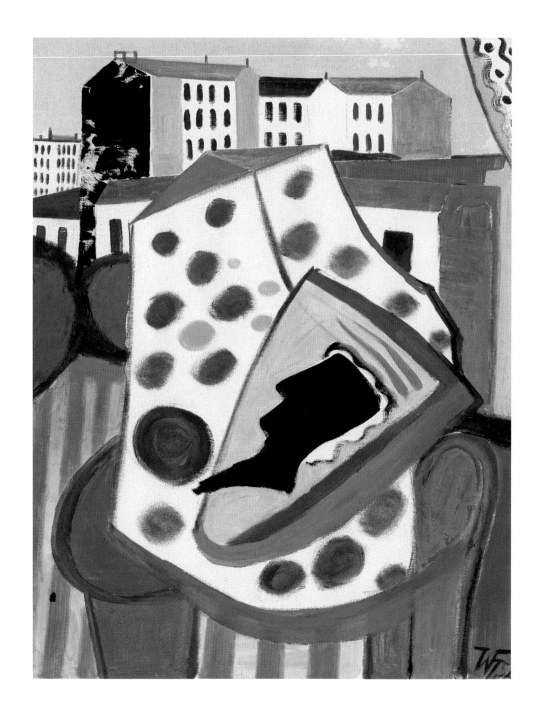

62 **Werner Heldt**
Une gifle aux Nazis (still life)
1952
Oil on canvas
100 x 70 cm
Private collection

left
63 Werner Heldt
Bomb Crater, 1946
Watercolor on paper
33.5 x 25 cm
Jürgen Kühn, Bonn

right
64 Werner Heldt
Berlin on the Sea, 1946
Watercolor on paper
12.5 x 20 cm
Private collection

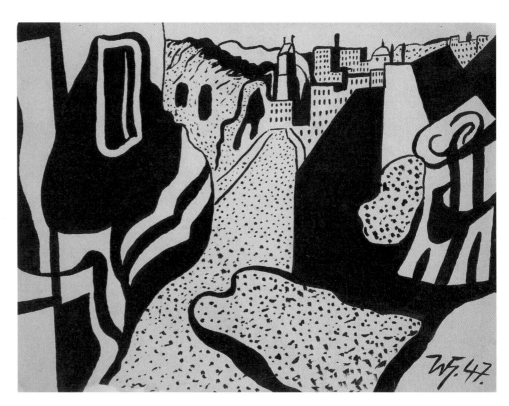

right, middle
65 Werner Heldt
City Detritus, 1947
Ink on paper
29.5 x 38.5 cm
Galerie Brusberg, Berlin

66 Werner Heldt
City Detritus, 1947
Ink on paper
30 x 42 cm
Private collection (no fig.)

68 Werner Heldt
Berlin on the Sea:
Ruins on the Canal
1947
Charcoal on paper
37 x 29 cm
Galerie Pels-Leusden, Berlin

67 Werner Heldt
Untitled (House at precipice)
1947
Brush and ink drawing on
paper
33.2 x 27.4 cm
Berlinische Galerie, Berlin
Landesmuseum für Moderne
Kunst, Photographie und
Architektur

69 **Werner Heldt**
Berlin on the Sea, 1949
Ink on paper
32.4 x 48.8 cm
Staatliche Museen zu Berlin,
Kupferstichkabinett

70 **Werner Heldt**
Houses with Lute, 1953
Charcoal and watercolor on handmade paper
24.3 x 42.5 cm
Berlinische Galerie, Berlin
Landesmuseum für Moderne Kunst, Photographie
und Architektur

left:
71 **Werner Heldt**
*Dead Girl (Drawing from
Dream),* 1945
Watercolor on paper (Field
post paper)
29.3 x 19.4 cm
Berlinische Galerie, Berlin
Landesmuseum für Moderne
Kunst, Photographie und
Architektur

right:
72 **Werner Heldt**
Houses Still Life, 1948
Ink on paper
37.0 x 50.7 cm
Berlinische Galerie, Berlin
Landesmuseum für Moderne
Kunst, Photographie und
Architektur

right:
73 **Werner Heldt**
Heads in the Sea of Ruins, 1946
Ink on paper
21 x 24.5 cm
Private collection, Hannover

bottom:
74 **Werner Heldt**
March of the Zeros (Meeting)
around 1935
Charcoal on Ingres paper
46.8 x 63 cm
Berlinische Galerie, Berlin
Landesmuseum für Moderne
Kunst, Photographie und
Architektur

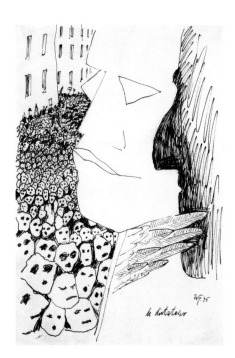

top:
75 **Werner Heldt**
le dictateur, 1945
Nib pen and ink drawing, 32 x 20 cm
Berlinische Galerie, Berlin
Landesmuseum für Moderne Kunst,
Photographie und Architektur

bottom left:
76 **Werner Heldt**
From the 1848 Cycle, 1935
Charcoal on brown paper, 37.8 x 54.8 cm
Berlinische Galerie, Berlin
Landesmuseum für Moderne Kunst,
Photographie und Architektur

bottom right:
77 **Werner Heldt**
Turmoil, 1935
Charcoal on Ingres paper
47 x 62 cm
Private collection

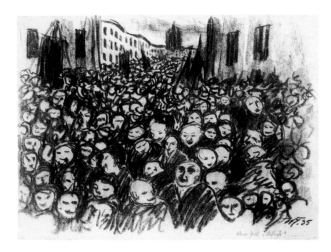

Wilhelm Rudolph: Dresden Destroyed

[1] *Verbrannt bis zur Unkenntlichkeit. Die Zerstörung Dresdens 1945,* Stadtmuseum Dresden (Dresden 1994).

[2] Wilhelm Rudolph, *"13. Februar 1945". Zeichnungen von Wilhelm Rudolph,* exhibition catalog, Staatliche Kunstsammlungen Dresden (Dresden 1955). The catalog in the library of the Kupferstich-Kabinetts contains a handwritten dedication to Wolfgang Balzer, who exhibited these drawings for the first time in 1950: "Dedicated in memory and recognition of his courageous undertaking of the first exhibition of the destruction of Dresden in the year 1950, the efforts of which at the time, brought him and myself only lack of understanding, indignation and even attack."

[3] Wilhelm Rudolph, Henner Menz, *Wilhelm Rudolph: Dokument-Werk 13. Februar 1945. Gemälde, Zeichnungen, Graphik* (Dresden, 1966).

[4] See: text by Matthias Kühn, in: Wilhelm Rudolph, *Zeichnungen "Um den Mai 1945",* exhibition catalog, Kupferstich-Kabinett der Staatliche Kunstsammlungen Dresden, Erwerbungen 50 (Dresden 1985).

[5] Wilhelm Rudolph, letter to Werner Hofmann, in: *Kunst in Deutschland 1898-1973,* exhibition catalog, Hamburger Kunsthalle, Städtische Galerie im Lenbachhaus (Munich, 1973).

[6] Lothar Lang, *Malerei und Graphik in der DDR* (Leipzig 1978) 27.

[7] It is worth noting that the trained lithographer Rudolph took up this technique only once again, briefly, after 1945, when he printed his drawings of the devastated houses.

[8] Werner Schmidt in: *Fünf Städte mahnen. Zum Gedenken an die Zerstörung Dresdens am 13. Februar 1945,* exhibition catalog, Kupferstich-Kabinett der Staatliche Kunstsammlungen Dresden (Dresden, 1970) 4. The 1970 exhibition placed Wilhelm Rudolph's drawings in the international context. It united works by artists from Dresden, Leningrad, London, Rotterdam and Warsaw.

Allied air force bombers destroyed Dresden on February 13, 1945. 12,000 houses with about 80,000 apartments sunk – reduced to rubble and ashes covering an area of 15 square kilometers. Over 35,000 people were killed. The center of one of Germany's most beautiful cities, with its magnificient Renaissance and Baroque structures, was destroyed, while the military facilities on the outskirts of the city remained undamaged.[1] The aerial warfare, once started from the German side, had caught up with its initiator.

Wilhelm Rudolph (1889-1982) lost almost the entire body of artistics work created up until 1945, as did nearly all artists then living in Dresden. His apartment at Körnerstraße 7 sank into ruins. Rudolph took on his greatest artistic challenge, the fate of Dresden, with relentless self-discipline. He began to draw among the still smoldering remains just a few days after the great destruction, in order to admirably capture the annihilation of his native city. Rudolph observed life sharply and exactly. He directly and immediately seized on experiences and events. This was the basis for his decision to record the inferno after the bomb attack: "The survivors stood before the horrible fact of the modern war which had the absolute blindness of a natural disaster."[2]

He had already finished 50 drawings at the time of the Red Army invasion on May 8, 1945, working on watercolor board which he had been able to salvage. The force of his experiences compelled its own drawing structure. A danse macabre of extraordinary character arose from the ambitionless, bristly and conflicting, even hasty, driven reed pen strokes – at first in a chaotic density indebted to the immediate experience. Wilhelm Rudolph drew the ruins of the reknown cultural structures with the same merciless hardness and facelessness as he did the apartment buildings. His theme became the destruction of the city as a community and not the downfall of famous architectural structures. He roamed through the city like a foreigner and a loner, noting down only street and place names on his drawings. The pen stroke took on its chaotic quality from the landscape of rubble. Nothing remained of the splendor of the *Gründerzeit* architecture. The windows became black hollows. The physiognomy of a city – a facade or a church – was captured in the same graphic structure. Rudolph did not strive for individuality. He went back to some streets several times. He later collected 150 drawings into the series *Dresden Destroyed,* which was purchased by the Kupferstich-Kabinett in Dres-

den in 1959 (fig. 78-99, p. 81-83). "The 150 sheets create a self-contained whole."[3]

Wilhelm Rudolph created further groups of work as well, which he brought together in *Dokument-Werk 13. Februar 1945* no later than 1966. This included a bundle of 117 drawings, most of them palm-size, with predominantly figural portrayals of prisoners-of-war, wood collectors, refugees, German prisoners-of-war, people returning home and Red Army soldiers, who invaded Dresden with their horses and carts.[4] Watercolored pen-and-ink drawings and sometimes also pure watercolors followed between 1946 and 1949. He named them *Dresden as Landscape.* In these watercolored sheets he showed how the landscape became leveled down from the effects of time with the eery images of crumbled walls and chimneys. "Nature wins back the expansive municipal area. The sandstone ... glowed in beautiful yellow and red colors in the flames ... but still, even in death, they preserve their creator's splendid striving for form"[5] Already in 1946, Rudolph had cut single subjects into wood or printed them as lithographs, which were among the first acquisitions of the Kupferstich-Kabinett in Dresden. A portfolio containing 15 woodcuts and five lithographs under the title *Dresden 1945* appeared in 1955. Lothar Lang gave an account of a series containing 35 woodcuts *Dresden 1945 – After the Catastrophy* and a portfolio called *Out* with 47 woodcuts.[6] The eikon Grafik-Presse in Verlag der Kunst again published a portfolio with 45 woodcuts from the years between 1945 and 1947 in three copies, likewise under the title *Dresden 1945* which was followed by another with 27 woodcuts. Unlike the drawings in *Dresden Destroyed,* the thematic range in the printed graphic works is surprising. The ruin motif is complemented by portrayals of low-flying aircraft attacks, people fleeing, animals, firewood collectors, people bombed out of their homes, war cripples, and wanderers. They reveal the artist's powers of sharp observation. The event as an entirety determines the character of the content.[7]

The series *Dresden Destroyed* can be counted among the most significant achievements in the art of drawing of the middle of the 20th Century. It is a "graphic document that allows the facts of reality itself to speak, thereby doing justice to the force of the historical phenomenon."[8] The drawings are not dated. Only a relative chronology can be recognized, apart from some sheets showing snow-covered rubble.

The documentary character of these drawings originates in local experience. The manner of expression, in contrast to earlier drawing techniques, however, allows us to recognize a change. In a so-to-speak monotone, hammering rhythm, a larger sequence of sheets first reveals the absurdity of the total destruction. While

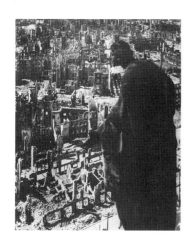

Richard Peter sen.
Wind Rose III. South, 1945
Kupferstich-Kabinett, Dresden

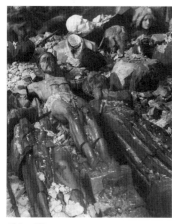

Richard Peter sen.
Sculpture Collection, 1945
Kupferstich-Kabinett, Dresden

9 Introduction by Erhard Frommhold in:
Wilhelm Rudolph. *Gemälde, Zeichnungen,
Holzschnitte*, exhibition catalog, Staatliche
Museen zu Berlin, Nationalgalerie (Berlin
(East), 1977) 17.

10 Friedrich Reichert, F*oto Schaarschuch,
Dresden. Bildbericht 1927 bis 1955*, pub.
Stadtmuseum Dresden, 1997.

11 Richard Peter, *Memories and Images
of a Dresden Photographer*, pub. Werner
Wurst (Leipzig, 1987) 58.

12 Richard Peter, *Eine Kamera klagt an,
Dresden 1949*. The first edition of 50,000
copies was out-of-print after a short time.
New editions appeared in 1980 and 1995.

Rudolph renounces personal commentary, instead trans-
posing the event with a nearly selfless, self-denying
objectivity, into a motor language of signs, he is able to
derive "a world condition from the regional totality".9 The
drawings of the houses and Baroque palaces, the
Gründerzeit villas and streets, the Frauenkirche or other
striking structures no longer reveal their creator's striving
for form or the self-esteem of the men who had commis-
sioned these buildings, rather, they all became illustrations
of February 13, 1945. Wilhelm Rudolph raised the regional
containment of Dresden's destruction to an experience
that reaches beyond the local event. There are other works
in the history of art which take the modern war of
annihilation as theme. Picasso dedicated his 1937
painting *Guernica* to the first victims of aerial warfare;
Ossip Zadkine left a memorial to the destruction of Rotter-
dam by the German Army in 1940 with his bronze
sculpture *City without Heart*. The figures – pairs and
groups – in Henry Moore's *Shelter drawings* lose all
individuality, as do the rubble in Rudolph's drawings.

Dresden's fate left traces in the works of other artists
as well who came from the city on the Elba. Let the
drawings by Bernhard Kretzschmar, Willy Jahn or Albert
Wigand be remembered here. But photographers have also
reacted to the event. Edmund Kesting assembled his
photos into a shattering death dance cycle. The photog-
raphy of Albert Schaarschuch belongs among the
numerous documentations.10 Just after February 13,
Walter Hahn photographed the first clear-up operations
and the burning mountains of corpses which had been
piled up at the Dresden Altmarkt by the rescue squads.
The photographer Richter Peter returned to Dresden on
September 17, 1945 and his first photos emerged that
same year. "For four years, I strode across the desert of
rubble, eight kilometers long and three and a half kilo-
meters wide ... Thousands of pictures thus emerged from
tenacious, unceasing work ... I only knew that they would
become historical and would be viewed by people in the
foreseeable future. As documentation of a time in which
absolute evil celebrated its infernal triumph, as evidence
of the last will and testament of a megalomaniacal Hero-
stratos and the crowd of disciples he infected who then
canonized their master even after his megalomania had
long been obvious."11 He was able to publish a selection
of his photos in the book *Dresden. Eine Kamera klagt an,*12
in 1949.

The photographer has artistic means at his disposal
which the painter does not have which chiefly lay in the
technical process of producing pictures. His possibilities
of artistic design consist in the selectivity of composition,
in perspective, in meaningful individual forms. While
Wilhelm Rudolph transferred the event and his own inner
turmoil into a leveling, nearly abstract graphic stroke,

Richard Peter, using the creative power of the camera,
gave expression to the image of single objects and the
unimaginable and absurd in the situation.

Richard Peter saw the symbolic form which stands
for total destruction, particulary in details. The knoted iron

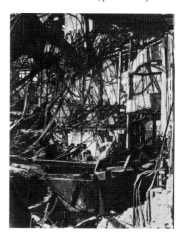

Richard Peter sen.
*The destroyed
Theater of the
Opera in Dresden*
1945
Kupferstich-
Kabinett, Dresden

constructions in the Semperschen Opera House recall
abstract structures, the wire glass softened or melted in
the embers and the bizarre concrete parts of the modern
department store illuminate the surreal moment in the
situation. These images are supplemented by the vivid
photographs from the air-raid shelters, which had been
improvisationally closed immediately after the destruction
and opened later to reveal the victims. Richard Peter saw,
unlike Wilhelm Rudolf, the same visual structure in the
rubble of the Albertinums with the remaining fragments
of the sculptures, as shown by the burned and suffocated
bodies in the air-raid shelters. The total annihilation levels
down here as well.

Hans-Ulrich Lehmann

78-99
Wilhelm Rudolph
Cycle: *Dresden - February 13, 1945*, 1945/46
Reed pen in ink
Kupferstich-Kabinett Dresden

78 *View of the Southern Suburb*
30.8 x 43.7 cm

79 Devastated Bridges on the Elbe: Albert- und Carolabrücke
30.9 x 40.6 cm

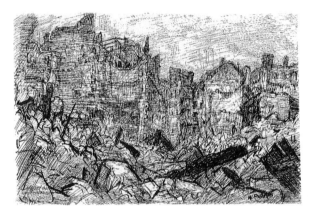

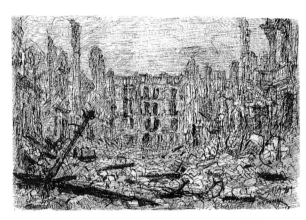

80 *Scheffelstraße*
34.5 x 51.1 cm

81 *Seidnitzerstraße*
34.5 x 51.2 cm

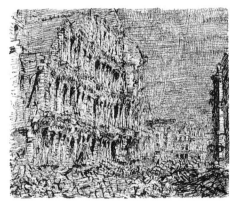

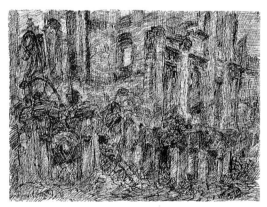

82 *Zirkusstraße*
28.7 x 33.7 cm

83 *Neumarkt, Hotel Stadt Rom*
29 x 38.4 cm

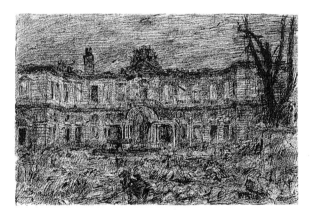

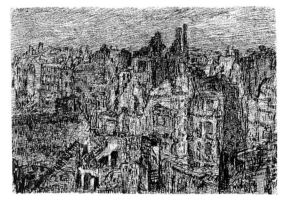

84 *Palais Johann Georg*
29.7 x 44.3 cm

85 *View from the Academy to the Neumarkt*
30.1 x 43.4 cm

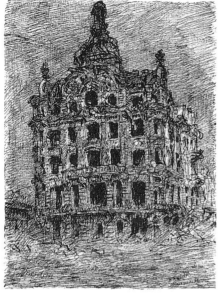

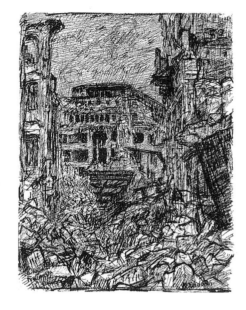

86 *Pirnaischer Platz*
39.2 x 29 cm

87 *Frauenstraße*
38.5 x 29.5 cm

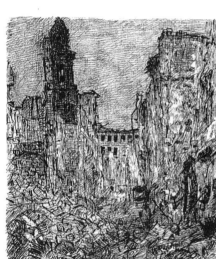

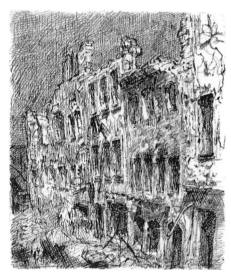

88 *Kleine Brüdergasse*
34.2 x 29.1 cm

89 *Münzgasse*
34.9 x 29 cm

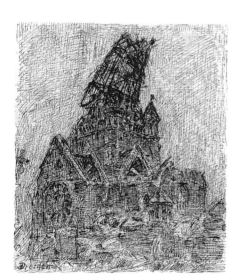

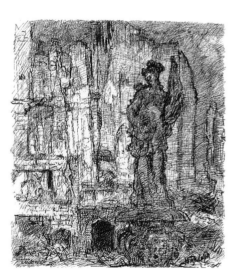

90 *Jakobikirche*
33.8 x 28.8 cm

91 *Jüdenhof*
33.3 x 28.9 cm

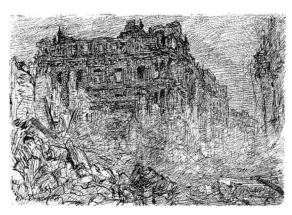

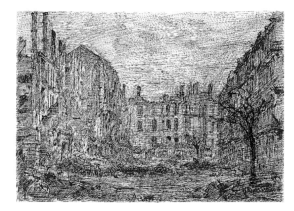

92 *Waisenhausstraße*
30.5 x 43.2 cm

93 *Gutzkowstraße*
31 x 43.8 cm

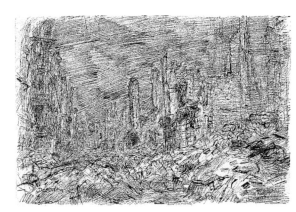

94 *Zöllnerstraße*
30.1 x 43.3 cm

95 *Christianstraße*
29.4 x 43.7 cm

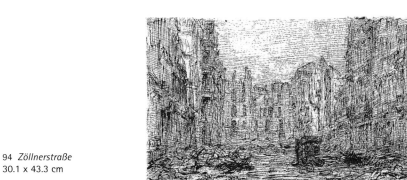

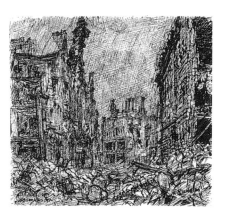

96 *Christianstraße - Struvestraße*
28.5 x 36.3 cm

97 *Waisenhausstraße*
30.6 x 32.5 cm

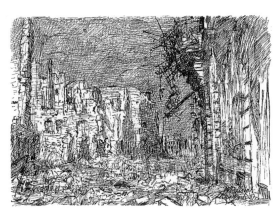

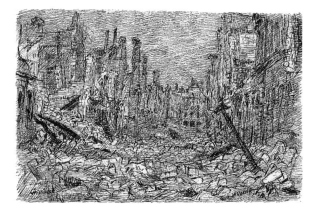

98 *Kaulbachstraße*
29.3 x 40.5 cm

99 *Christianstraße*
34.5 x 51.2 cm

Atlantis –
To New Shores

On behalf of Max Horkheimer, Theodor W. Adorno arrived in Frankfurt/Main in November 1949 to sound out the possibilities of the Institute for Social Research, closed by the Nazis in March 1933, returning to the city of its origins.

In 1934, after an interim period in Geneva, Max Horkheimer had succeeded in continuing the Institute's research activities on the premises of the renowned Columbia University in New York City. Adorno had worked as a philosophy lecturer at the Institute in Frankfurt from May 1931 to September 1933, when his authorisation to teach was withdrawn. In February 1938 he accepted an invitation from Horkheimer to work with him in the USA, whereupon he left Oxford where he had enrolled "as an advanced student" in June 1934. On his return to Europe in 1949, during a stay in Paris he was unexpectedly overcome by this encounter with the Old World: " In a historical sense, what is still here may be condemned ..., but its very presence, a sort of incongruous existence, awakens in me a slight hope that traces of humanity still survive despite what has happened." (Letter to Horkheimer, 20 October, 1949). This first résumé of his sobering experiences as a sort of "intellectual minister", extracts of which are quoted here, was published in May 1950 in the left-wing Catholic Frankfurter Hefte (Vol. 5, May 1950, pp. 469-477), edited after 1946 by Eugen Kogon and Walter Dirks. At first, Adorno seemed pleased by the general craving that followed on a period "of intellectual starvation", but at the same time he noticed symptoms of a mental paralysis within the "colony" of West Germany, a kind of "obsessive internalisation" (p. 469), which, in his view, diverted people from the everyday misery and led them on a search for "security in the provincial" (p. 471). According to Adorno, the unrealistic, inessential character of the debates among the intellectuals in the "colony" was evidence of the fact that between the two "conflicting 'tickets' of totalitarianism" "people were no longer political subjects" (p. 476). Reference to the eternal values of culture, which were obsolete in any traditional sense, was encouraging a state of oblivion, void of historical consciousness: "Meanwhile, reminding people of Auschwitz is considered boring and resentful." (Der Monat, 1950)

E.G.

... In view of all the agitation and turbulence, I often cannot help getting the impression of something vague and unreal, a game the mind is playing with itself, a threat of sterility ...

That my suspicion of a threatening 'sterility' is not exaggerated is best illustrated by comparing the present situation with that after the first war. At that time, Expressionism was prevalent. It has been declared dead since the years of economic stabilisation, let us say since 1924. But even at the time, there was a justified suspicion that the glorious overthrow of chaos by a new order and objectivity was in many ways a mere cloak for reaction, for a rehash of that juste-milieu that was even claiming to be progressive. It is not all that important that Expressionism brought forth great and lasting works of art, whose concept was perhaps incompatible with that of Expressionism itself. ... One way or the other, Expressionism at least meant a great mental effort towards ridding the ego, isolated in a fossilised world, of all the constraints of convention and concretisation and helping it achieve a pure expression of itself. In terms of its strength and steadfastness, there was nothing comparable to that effort either in Germany or in the other European countries. ... Although the Expressionist ego, that set itself up as absolute in its brave struggle against order, may since have passed on, may since have been exposed as null and void, the art that fills the vacuum these days seems imitative or helpless, or both, compared to what it ought to express. It is an eerie traditionalism without binding tradition. Pre-fascist terms such as "attitude", "commitment", or the "soldierly man", may now be reappearing detached from that political goal to which they owe their dubious existence, but they are being made into fetishes. What is being celebrated as the appropriate ideal of mankind is a heroism per se. However, one ought to ask what this heroism actually stands for, or if the concept of an introspection persisting heroically in itself is worthy of the dignity and essentiality that it so imperiously claims for itself ...

The spirit of the post war era seeks shelter in the intoxication of recognition, in what is traditional and past. But that is indeed past. The traditional aesthetic forms ... from the time between the two wars no longer have any inherent force. They have been proven false by the social catastrophe from which they emerged ...

The Swiss writer Max Frisch called the neutralisation of culture that is promoted by blind preservation "culture as alibi", Not one of the least of education's functions today is to allow the horror, and one's own responsibility, to lapse into oblivion and be repressed. Culture, as an isolated realm of existence lacking any exact relation to social reality, is capable of glossing over the return to barbarism. In doing so, it continues National Socialism's attempt to deceive us about the *rigor mortis* of authority ...

In seeking reasons for all this one is forced to think of the political situation. The period of Expressionism after the first war, of which I have spoken above, was linked with the major political movement of the time. It shared the hope for an immediate realisation of socialism. The distinct possibility of a totally changed future situation sharpened people's eyes for the given situation. One did not need to conform because one knew that things could be totally changed at any moment, that the nightmare of the fossilised conditions could be swept away. This state of mind was in no way completely developed and fully articulated. Especially among the important artists, those who repudiated the existing order, the fraudulent harmony, the cliché of the mere imitative, the relationship to politics was hidden and latent. Open-minded political art was already showing symptoms of that rehashed realism which is now being raised to a philistine norm beyond the Iron Curtain. Then, however, it seemed for a time as if a brief tremor had shaken the surface of the social structure and had been registered in the attempts of those artists and theoreticians who devoted themselves to a non-concrete artistic practice. Without perhaps being aware of the social moment, they followed their impulses, expressing in them their non-conformism: the repudiation of compliance. This has not happened again after the second war. Society has split into rigid blocs. People experience what is happening as something that is being done to them and not as an objective for their own spontaneity ...

Theodor W. Adorno

Josef Albers – Thinking in Situations

1 In his essay on Josef Albers' wall painting, Neal Benzra quotes in this context a comment of Albers from a lecture at Black Mountain in the late thirties on the relationship between form and surroundings as a "meaningful social-philosophy, namely that of true democracy: every part has a serving function, and at the same time is served by others." Neal Benzra, *neue Aufgaben jenseits des Ateliers: Josef Albers' Wandbilder und sein bildhauerisches Werk,* 75, see also *Josef Albers,* (ed.) Jochen Pötter, exhibition catalog, Kunsthalle Baden-Baden (Cologne 1988).

2 Wieland Schmidt, *Josef Albers,* exhibition catalog, Kestner Gesellschaft, Hannover 1973; Jürgen Wissmann, *Josef Albers,* exhibition catalog, Kunsthalle Recklinghausen (undated).

3 On the occasion of the presentation of the Conrad-von-Soest Prize Albers wrote in his public thanks and acceptance: "It is good to hear that I am now publically counted to my fellow citizens from Westfalen, and encouraging to think that my work is also known and seen there." In: *Westfalenspiegel,* 1959, issue 2, p. 17.

4 1948 Gallery Herrmann, Stuttgart – along with Arp and Bill – and 1949 in the Gallery Rosen in Berlin – with Bill.

5 Karl-Ernst-Osthaus Museum, Hagen 20/1/1957 – 2/17/1957; Museum der Stadt Ulm 8/9/1957 – 6/10/1957; Kunstverein Freiburg 16/3/1958 – 13/4/1958; Westfälisches Landesmuseum für Kunst und Kulturgeschichte, Munster 10/1/1959 – 7/2/1959.

6 See in this context the articles in this catalog by Eckhart Gillen from the Darmstadt discussions, p. 18.

7 "Don't go along with the pack. Think for yourselves." This admonishment is one that Albers often gave to his students. Eva Hesse (see fig. 186/187, p. 182 and fig. 188/199, p. 183) was also a student of Josef Albers and enjoyed with him the possibility of developing here own language of form.

Josef Albers remained long unrecognized as a fine artist in post-war West Germany. First in the 1950's interest in his work began to grow, which then quickly spread to wide popularity. Albers, who left Germany with his wife Anni immediately after the closing of the Bauhaus, was, especially through his teaching activity at Black Mountain College in North Carolina, able to quickly integrate himself into American society. He was recognized for his work as a teacher, as a fine artist, and for a number of architectural projects which he realized with a minimum of possible material.[1]

The encounter with the geographical enormity of North America and with the colors of Latin America, which he visited several times with his wife, proved to be decisive in the artistic develop of Josef Albers. Between 1939 and 1949 he was primarily interested in double-centered constructions in which two identical forms, suggesting space through circles and lines, were so joined with one another that they could not be exactly fixed and decoded. By means of simple surface forms, spaces emerge that can be variously read. In the exhibition "Deutschlandbilder" *Kinetic VII* from 1945, with two parallelograms (fig. 101 p. 86) and *Variant* from 1946/52, in which the dissolution of the square is already suggested (fig. 100, p. 86), are shown as examples of double-centric construction.[2] Albers provoked "thinking in situations", consciously renounced the subjective content of a personal hand signature and spontaneous gesture in the application of color. In every work he transferred the ambiguity back to the viewer.

This occurrence, which Albers described as "the discrepancy between the physical fact and the psychological effect" culminated in the studies for *Homage to the Square* – here exemplified by two earlier works (see fig. 102 and 103, p. 86) – a fascinatingly simple motif with which Albers worked for more than twenty years. Despite the serial aspect which forms the basis of his work, Albers by no means closed out the factor of spontaneity in color-selection; for him "the content of art" is "the visual formulation of our reaction to life." The principles which are revealed by his work support a position of measured continuity, close out the spontaneous gesture, and are not documents of path-breaking automatism. Albers position implies a calm and clear consciousness of the possibilities of artistic means and their reception.

In 1953 Josef Albers accepted a position as guest professor at the Hochschule für Gestaltung in Ulm and thereby documented his willingness to again turn his attention to the land from which he had once been forced to emigrate.[3] At this point he already had a number of single exhibitions to his name, among others in New York, Chicago, and San Francisco. Up to this point his work was mostly unknown in Germany, and with the exception of two group exhibitions[4], cultural institutions first addressed themselves to the work of this former "Bauhaus member" in 1957/58, however then with nine exhibitions in two years.[5]

Bauhaus masters like Albers were considered to be "pre-historic" relics and witnesses of a past era in art history, about whose works there was little information after twelve years of censorship. Their loss however, was clearly felt in the cultural desert after 1945. But the conceptual approaches of the Bauhaus were not the ones taken up by the coming generation of new artists, but rather it was the painting of the French "informel" which served as a means of compensation for their own interrupted tradition of painting. Through the use of tachist forms they simulated an avant-garde for over a decade, wishing for, and trying to conjure up, international recognition through the "world-language" of abstraction.[6] Through Tachism it was possible to maintain the image of the genius-artist, drawing his inspiration from diffuse sources. Josef Albers, with his transparent principles of design and form, hardly came close to this image. As much as abstraction had to fight against prejudices in the post-war years, so too as the vehemence with which it entered the debate, and its rejection of its opponents, factors that made it more visible than Albers with his fully unemotional works could ever have been. His enlightened position and demand for autonomous seeing, which he transmitted as first and foremost to his students, was only picked up on and further developed in the 60's after the Group ZERO had held its first exhibition and Pop Art had started to radically change the habits of seeing. The modernity of his oeuvre is reflected in the monographic exhibitions of the 70's. To "open one's eyes and learn as much from color as from life" are the calm messages of Albers', with which he provided inspiration and challenge to generations of artists.

Regina Schultz-Zobrist

100 **Josef Albers**
Variant, 1948/52
Oil on masonite
40 x 59 cm
Josef Albers Museum Quadrat
Bottrop

101 **Josef Albers**
Kinetic VII, 1945
Oil on masonite
56 x 71 cm
Josef Albers Museum Quadrat Bottrop

103 **Josef Albers**
*Hommage to the Square
(Tempered Ardor)*, 1950
Oil on masonite
45 x 45 cm
Josef Albers Museum Quadrat Bottrop

102 **Josef Albers**
Hommage to the Square, Sudden Promise
1957
Oil on masonite
122 x 122 cm
Josef Albers Museum Quadrat Bottrop

104 Willi Baumeister
Two Epochs II, 1947
Mixed technique on canvas
81.5 x 100 cm
Archiv Baumeister

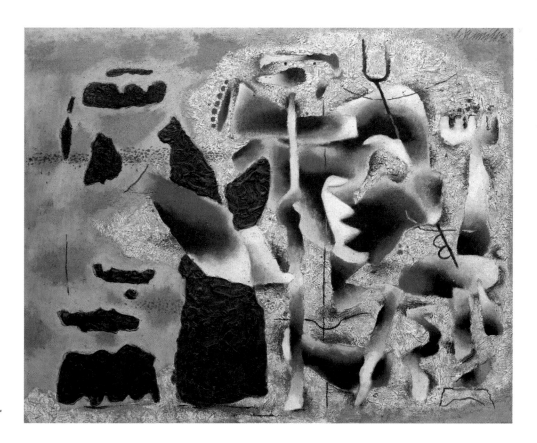

105 Willi Baumeister
Atlantis, 1949
Oil on cardboard
80.5 x 99 cm
Wilhelm-Lehmbruck-Museum,
Duisburg

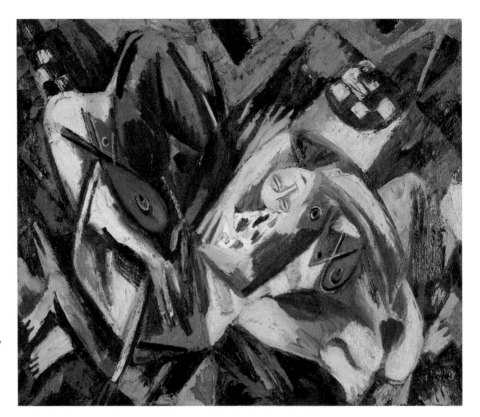

106 **Ernst Wilhelm Nay**
Wailing Women III
1944
Oil on canvas
81 x 100.5 cm
Private collection

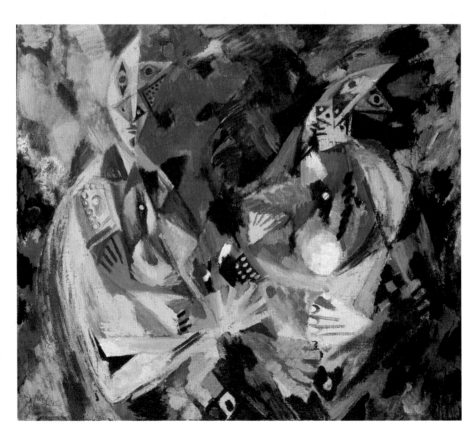

107 **Ernst Wilhelm Nay**
The Magician's Family
1945
Oil on canvas
85 x 96 cm
Private collection

108 **Ernst Wilhelm Nay**
Small Figural Form Painting
1948
Oil on canvas
45 x 65 cm
Museum am Ostwall, Dortmund

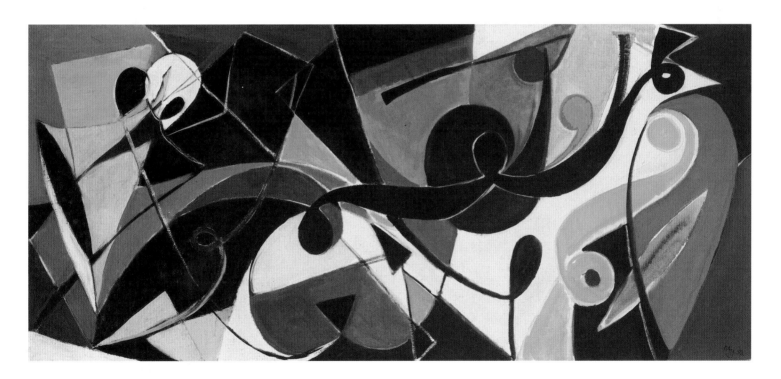

109 **Ernst Wilhelm Nay**
Large Reclining Woman (The Night)
1950
Oil on canvas
94 x 202 cm
The Günther Franke Collection

The Artist's Identification with His Time: The Painter Ernst Wilhelm Nay

To the question posed by our mailman, many years ago; what do his abstract paintings mean?, Nay answered, "There are people who take care of the important everyday work, you are one of them. Still others ponder about the world and the present time and then organize their thoughts, they are the intellectuals. And then there are people like me, who try - with our talents - to form something new, visual, in which we recognize ourselves and in which our time, our country and our environment is reflected - those people are artists."

In simple form, Nay was explaining the identification of the artist with his present. It's not a matter of pictures from history. Even if original artworks always infallibly document their own time, seldom in the history of art have there been works which make immediately recognizable, personal historical statements of the highest, artistic-timeless quality. Goya's impressive *Witches' Sabbath* from 1818 would be a perfect example, in which, after participating in the Inquisition Tribunal, he expresses the horror of the persecution of witches as artistic synonym. Picasso's *Guernica* from 1937 was likewise created out of this same personal sympathy as a monument to the destruction of this city during the Spanish Civil War.

Often, however, signs and traces of reflection on historic reality remain undiscovered in art, because they are hidden and difficult to interpret. I want to mention a formal phenomenon as example, which suddenly turned up in Nay's so-called *France paintings,* which were painted during the war in 1943/44. In these abstract images of figures he always painted the faces' eyes closed - delineated by a dash, as, for example in the painting *Wailing Women* (fig. 106, p. 88), giving the impression of skull and crossbones. Actually, this iconographic feature, as a reflex to the nearness of death, is evidenced only in the paintings from these war years. Already just after 1945, different ornamental eye forms, no longer reminding us of a memento mori, appeared in the *Hekate* paintings. Reflections on historical reality in Nay's world of images are neither illustrative nor demonstrative. Beyond an intended program they come into effect only metaphorically - in the formal inventions as well as in their stylistic spirit.

A significant change in Nay's work become perceptible through the drama of the powerful, expressive and sometimes also aggressive appearing *eye paintings* from 1963/64, which developed after the *glass paintings,* worked out in light colors from the 1950's. Looking for an explanation of this change in certain events would be too simple a conclusion, yet it cannot be denied that in the 1960's, the world underwent a crucial transformation. The increasing threat of the Cold War, the rise of terrorism, the Kennedy assasination, the Viet Nam War and - for us Germans - the erection of the Wall on August 13, 1961, brought the greatest shock after the end of World War II. The familial sorrow, the social, political and economic consequences of this division now became perceivable everywhere in the East and West of our country.

As a witness to the times, I want to report on Nay's consternation and his interpretation of this historical turning-point, which he expressed in many conversations in the studio in Cologne and also during our many visits to Berlin. Nay deplored this division calling it an unrestitutable spiritual loss comparable with an amputation. In the separation of East from West Germany, he saw the decline of the cultural collaborative quality of the different people from the individual landscapes of our country. He feared one-sided developments that would lead to an impoverishment, a provincialization of spiritual life which could cause immeasurable damages in East and West. He named Saxony as an example, a place which had produced so many significant artists, considerable art connoisseurs and collectors, and he sympathized with the West for its loss of such a tremendous potential of imagination. Without lament or sentimentality, an inner sadness arose in this conversation, accompanied by the horrible realization that there was nothing one could do to change the situation. Those robbed of their freedom in the East, the censorsip of art and its degradation for the purposes of political propaganda, reminded Nay harrowingly of the dictatorship he lived through himself during the Nazi time. No one knew at that time either, how long the situation would continue.

Age and fate did not allow Nay and many of the people he spoke to at the time – such as Adolf and Ruth Arndt, Will Grohmann, Hans Uhlmann, Hans Scharoun, Günther Franke, among others – to live to witness the unification. The spiritual consequences of this long division to which Nay attached such great importance are still to be felt today.

Elisabeth Scheibler-Nay

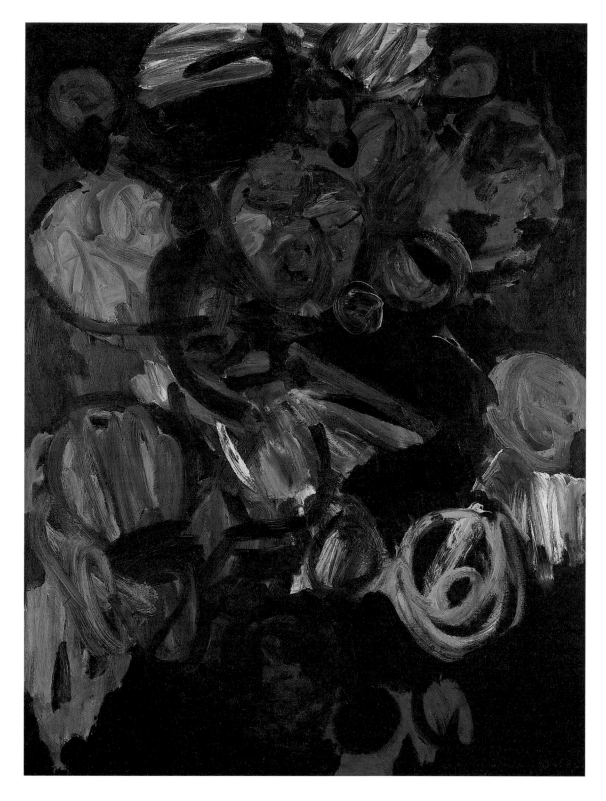

110 **Ernst Wilhelm Nay**
Night Song, 1961
Oil on canvas
200 x 150 cm
Private collection

Two Sculptures in Space
by Norbert Kricke

Norbert Kricke's concept of sculpture became more dyna-mic in the early fifties. The sculptures of 1951/52 proceed from a single line that ultimately turns back to itself.[1] Among them is the 1952 *Sculpture, White: Temple*, one of the few of Kricke's works that bears a title. Jutting upward in vertical emphasis, the line breaks off into sharp angles, pushing forward as a diagonal or a horizontal, cutting through the vertical trajectory and finally return-ing to its point of origin. Continuous tempo change, resulting from the line's fragmentation, characterizes the flow of movement. The sculpture's whiteness robs it of material substance. During this period, Kricke consciously employed color to heighten or diminish the feeling of motion.

The sculpture's fixation to a base, its constructive static, is optically toned down. The uninterrupted line brushes the base only as much as is absolutely necessary, creating the impression of floating movement, in a space with neither beginning nor end.

Three years later, in 1955/56, the sculpture in space *Hornets* arose (fig. 112, p. 93). Its aesthetic language is more sophisticated. Rather than a single line turning back on itself, a bundle of lines appears and concentrates into a knot, only to fan from this core out into the room, tentatively pulling it in. "Our space has a thousand qualities. They are the ones that we give it. Nothing is without space and movement. Every thing has its time. And these are connected to an endless number of times and spaces." This insight of Kricke's could hardly be conveyed with the single free-standing lines of the sculptures of 1951/52. *Hornets*, in contrast, leads the viewer beyond its material elements to a sweeping experience of space, characterized by openness. In this way, it picks up the thread of the sculptures after 1950. Here again, movement is the dominant impression. Circling, curving, entangled in itself, it leads out into the room. Sculpture is no longer a form bound to visual appearances, consciously traced by the viewer, but a form of impulse.

Ernst Gerhard Güse

1 "My problem is not mass, not shape, but space and movement—space and time. I want no real space and no real movement (a mobile), I want to represent movement. I seek to give form to the unity of space and time." Norbert Kricke, qtd. in Carola Gie-dion-Welcker, *Plastik des XX. Jahrhunderts. Volumen und Raumgestaltung* (Stuttgart, 1955) 197.

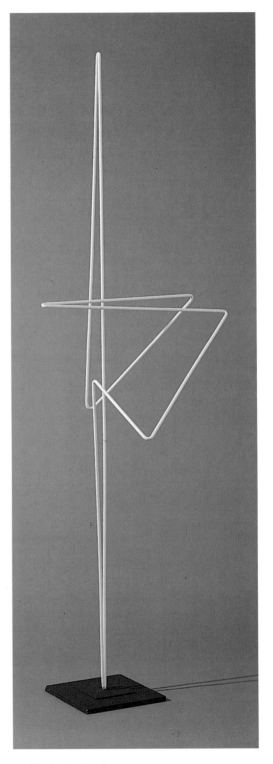

111 Norbert Kricke
Sculpture in Space, White: Temple, 1952
White Steel
203 x 67 x 46 cm
Wilhelm-Lehmbruck-Museum,
Duisburg

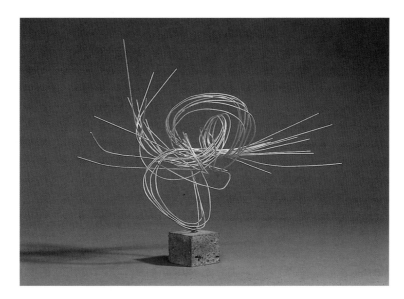

112 **Norbert Kricke**
Room sculpture "Hornisse" (Hornet)
1955/56
Nickled steel
37 x 49.5 x 26 cm (with pedestal)
On permanent loan by
private owners in the
Wilhelm-Lehmbruck-Museum,
Duisburg

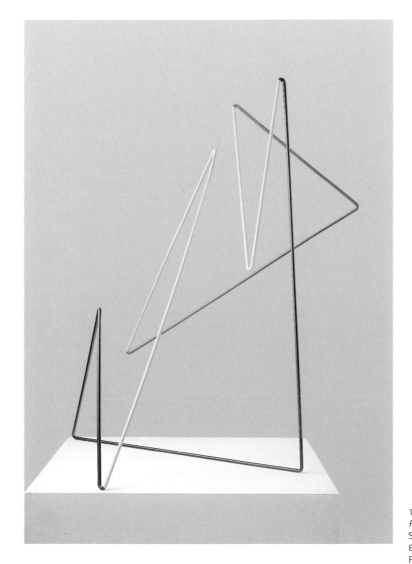

113 **Norbert Kricke**
Room Sculpture, 1952
Steel wire, black, red and yellow
84.5 x 78 x 38 cm
Property of the Verein der Freunde
der Nationalgalerie, Berlin

HAP Grieshaber

1 Ludwig Greve, "malgré tout. Grieshaber mit seinen Freunden", Deutsche Schillergesellschaft Marbach/Neckar ed., *Marbacher Magazin,* Fall, 29/1984, 2

2 Wilhelm Boeck, *HAP Grieshaber Holzschnitte* (Pfullingen, 1959) 15.

3 HAP Grieshaber recalls the exhibition: "... There were over 100 paintings, drawings, woodcuts and books from the underground which Dr. Valentien Sr. had then exhibited in his large rooms. ... As far as I know, it was the only public exhibition of outlawed art outside of the political exhibitions in the Third Reich.
The gallery had invited the participants of the Bibliophile Society's annual meeting in Stuttgart to the exhibition. Besides that, each bibliophile was given a block print - not one from 100 prints, rather each was an original out of the Reutling prints: woodcut, zink engraving or india ink sheet. Naturally, everything was camouflaged as Arabian drawings by the Bedouin and the Fellah of Mataria and a Shams or declared as Greek Folk painting, that is, anonymous. We were helped by Greeks. The Greek Minister for Public Relations, by officially reporting on the deep reverberation which the exhibition found in Greece and expressing gratitude for the Swabian philohellenism, issued us our passports to a journey through the stupidity ... We had no other help except that from the Greek side. The Director of the Stattsgalerie was, like everyone else, deeply involved in blood and soil (NS idea of unification of race and soil) ... Dr. Valentien remained alone. The exhibition was reviewed by the 'Schwäbische Merkur' (Dr. Röcker had the honor), the 'Münchner Neuesten Nachrichten' and the 'Athener Presse', which provided the background for these reviews. I also heard from Dr. Valentien, that the Commanding Squad Leader of Silesia was there and he said that it was the Reich's most courageous exhibition ...".
HAP Grieshaber, Dank verjährt nicht, in: *Blätter der Kulturgemeinschaft des DGB Stuttgart,* vol. 2, May 1971. For thorough reading on this camouflaged exhibition, see also: Ludwig Greve, 1f.

4 On the history of the Bernstein schule: Günther Wirth, Grieshaber Bernstein Karlsruhe, exhibition catalog, Landratsamt Esslingen, Kunstverein (Singen, 1993).

5 See also: Petra von Olschowski, *HAP Grieshaber. Vom Mappenwerk zum Wandbild - Die Neubestimmung des Holzschnitts.* 1952, Master's thesis, Universität Stuttgart (not printed) 1992/1993, 33f.

Shortly before the Nazi's seizure of power, Grieshaber's artistic creativity began, although not in his homeland, rather, in Greece and Egypt. He was already a citizen of the world at the time and preferred the anonymity of being the foreigner over membership in the "Reich's House of Visual Art".[1] The carefree drawing, painting, philosophizing and discussing in mediterranean freedom certainly came to an abrupt end: a culture political publication, the *Deutsche Zeitung* which Grieshaber co-published in Athens, incurred the displeasure of the German Embassy, who offered the artist the choice of going home or disappearing into a Greek prison.

HAP Grieshaber
Holzhauer, 1946
woodcut
57 x 42 cm
Wilhelm Boeck,
*HAP Grieshaber,
Holzschnitte,*
Pfullingen, 1959
cat. no. 193;
Margot Fürst,
*Grieshaber,
Die Druckgraphik
Werkverzeichnis*
vol. 1
Stuttgart 1986
cat. no. 52/5

Having returned to Reutlingen, it was a matter of surviving without being taken in by the cultural policy which, in the meantime, had been forced into Party line. Grieshaber created a world of images which were to counteract the Third Reich's propaganda images with series of woodcuts and bibliophile prints which appealed to Christian traditions such as *The Passion* or *The Church of the Virgin Maria in Reutlingen* and with a series of pictures which drew from his "stock of memories of the Orient".[2] such as *Journey through Egypt* and *Modern Greek Diary.* There being, however, no market for this art, he thus went back to what he had learned in Ernst Schneidler's commercial art and book printing class at the Stuttgart School for Arts and Crafts, and worked as compositor, printer, etcher, engraver and cartograher, occasionally even as construction worker and paperboy. He dared an exhibition in Stuttgart in May, 1938, camouflaged by the title *Arabian Folk Books, Greek Folk Painting, Drawings by unknown Orientals.*[3]

From 1940 until 1945, he had to serve the regime, which he ardently rejected, as soldier, and was taken prisoner-of-war in Belgium. After his release in June, 1946, he renovated his summer cottage on Achalm, a prominent volcanic mountain in the Swabian mountains. Building materials, food and fuel were just as troublesome to obtain as paper and paint. He sometimes used filter paper from hospital stock for printing. Themes such as *Plough in the Snow, Kindling Wood Collector, Refugee Family, Hunger,* printed either in black-white or sparingly in color, documented a new beginning characterized by need. In 1951, Grieshaber was appointed lecturer at the Bernsteinschule. There, in the former hermit cloister near Sulz on the Neckar River, friends from before the war found each other again and met young artists back from war service; East European refugees seeking shelter and work. Grieshaber proved himself a dynamic teacher: his credo went "Work is the best way to freedom and brotherhood".[4] His stand for freedom and human dignity developed globally.

The large cloister rooms inspired him to work in larger formats. While graphics and woodcuts were traditionally of a more hand-held format, Grieshaber now gave this print art an entirely new magnitude. His wooduts had nothing more in common with graphic prints which were published in portfolios or in bilbiophile books. They could dominate the wall and the artist was gradually able find his way into exhibitions with these prints, which had otherwise excluded him because graphic was considered "cabinet" art. His work now hung in parity with paintings by Baumeister, Nay and Beckmann.

In the woodcut *Pain Picture* from 1952 (fig. 114, p. 95) we see – arranged in two vertical format picture fields – a female figure on one and a male figure on the other. The first bends forwards, her long, black hair falling freely in front of her body. A child's arm juts out of the veil of hair, its hand reaches for the woman's breast. A child is apparently concealed in the hair, held forward in both hands by the mother as if in protest. The figure on the right discloses itself less easily. A figure cut in angular forms is kept behind a partition-like lattice of black contours and appears to be kneeling towards the middle of the picture.[5] The face reveals only a pair of large, threatening eyes. Two circular badges on the left of the chest and a yellow object in the form of a rifle show distinctly that this figure is a soldier.

This woodcut emerged during Grieshaber's first months at the *Bernstein.* There, he met the painter Riccarda Gohr, whose life story became the key to his *Image of Suffering.* Riccarda Gohr, who later became Grieshaber's wife, came to "Bernstein" as a refugee from East Prussia. Her's was a very "German" fate. She had to give up an artistic career in the 1930's after having been

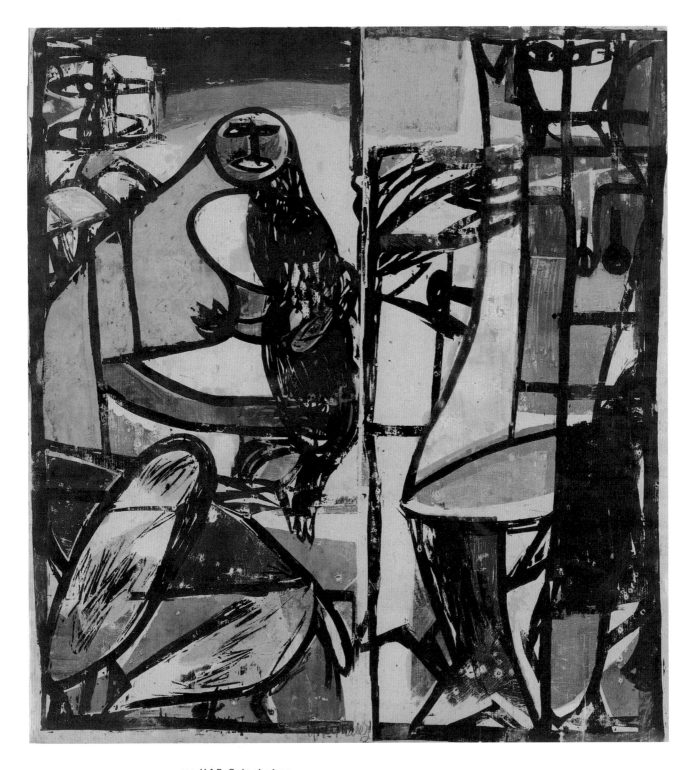

114 **HAP Grieshaber**
Pain Picture, 1952
Diptych, wood cut
151 x 133 / 162.5 x 140.8 cm
Galerie der Stadt Stuttgart

HAP Grieshaber, Study for *Germany,* 1952
woodcut, 100 x 195 cm, Staatsgalerie Stuttgart

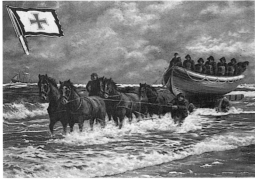

Lifeboat *"Fürst Bismarck",* donation postcard of the
German Society for the Rescue of Shipwreck Victims (GSRSV)
1930's/1940's
(painting after a photograph by H. v. Perckhammer)

outlawed as "degenerate". For the sake of usefullness, she was to learn a nursing profession and became a midwife. Her instructor was one of the notorious doctors from Ravensbrück. Towards the end of the war, she and her daughter Nani, then hardly a year old, were caught up by the advancing Red Army and she suffered repeated rape.[6] Seven years after the war ended, Grieshaber dedicated his first largely structured woodcut to her life history. The portrayal is not played out according to event, rather, abstracted from the individual characteristics of those caught in the situation. There is no "dramatic action" between soldier and woman, they are isolated from each other and each is portrayed in their own picture field. The woman's movement, her frontal, expressive face, the fierce gesture of drawing the child into her hair, are expression of her horror and protest. An episode from the fate of Riccarda Gohr becomes the metaphor for the defenseless victims of rape of every war. And the soldier? Does he wear a Soviet uniform? Or a German? Grieshaber's woodcut gives no clear information about the soldier's nationality. "Military" as such is meant: the uniform, of any nationality at all, as symbol for violence and horror. The woodcut *Germany* (fig. 115, p. 97) is unusual, first of all, because of its impressive size – and that it is printed from a single piece of wood. Grieshaber had now truly endowed the woodcut with a new dimension[7] and conquered the wall for himself. A scene containing many figures develops over the entire width of the immense picture format:

A team of horses driven by men pulls a wagon loaded with a rowboat. Men and sheep can be recognized in the boat. A conspicuous Hanse Cross, similar to the Iron Cross, is seen in the background of the picture center. What does this cross mean as iconographic symbol? The connection to the loaded boat, which must be a rescue boat (or it would not have the garland-shaped rescue rope on its hull) suggests: Grieshaber's subject is animated by one of the boats from the "German Society for the Rescue of Shipwreck Victims" (GSRSV), which, drawn by horses, was employed as a beach rescue boat. They included the Hanseatic Cross in their flag.[8] Grieshaber could have had one of the many thousand-fold distributed contribution cards before his eyes. For him, the theme of the rescue boat in alert was a fitting metaphor for the situation in which Germany found itself at this time:[9] the shipwreck

of the Third Reich: "all available powers are summoned to the rescue" – "we all sit in the same boat" – "Action is necessary" – "It has to be done immediately".

This hits upon precisely that spirit which Grieshaber radiated at "Bernstein" and with which he endeavored to rouse his students and friends. Ludwig Greve, one of the fellow occupants at "Bernstein" describes this most aptly: "An unbelievable freedom prevailed in the empty church when we talked like the argonauts about our journeys and hopes, sitting in the gallery in the evening. In his own realistic-fantastic way, Grieshaber developed plans for an art which was supposed to bring about nothing less than 'solidarity' between people; there had to be a mobile printing house, he had already worked out the costs, so that the students – that there were none didn't occur to us – could try out their trade in the factories where they were needed. After we had slept off our excitement, we saw hanging in the cloister entry the draft of his *Germany* woodcut, in which all of the dramatic figures that we had talked our heads off about were included; horse and wagon, procession of people, be they refugees or farmers. It was the time of summoning. There must still be people in the defeated country who would be able to transform an empty cell."[10] Wilhelm Boeck's interpretation points in a similar direction. For his work index of Grieshaber's woodcut, he queried the artist who had created *Germany:*... The collective German situation is symbolized in the idea of the wagon, as it was represented anew in the most lasting way to the artist, conveyed by the refugees among the members of the Bernsteinschule."[11]

The artist took on the subject – a trivial postcard with the superficial, glorifying statement of the rescue men called to action – and created, with the encoded image language that he found, an encompasing "symbol" for what demoralized Germany now urgently needed. Grieshaber, who was always ready for any personal commitment and in word, image, deed and sacrifice strove for a new society, for reconciliation, justice and humane ways of life, had allegorically summarized what moved an idealist generation in reconstructing society in the year 1952, with his woodcut *Germany.*

Constrained in a narrow, vertical format, a crouching figure develops in *Armoured Pan* from 1952 (fig. 116, p. 99). Broadly sweeping, heavy, black silhouette lines draw a body with legs drawn up to the chest and propped up by its arms. The hands hold a flute reaching horizontally over the picture surface. The head is a starkly contoured, abstract form. The broad, simple sweeps of the black scaffold of countours stand in peculiar contrast to the inorganic and metallic appearing brown and gray plates, which cover the figure like angular iron parts. Forceful black points – to be interpreted as screws or rivets – reinforce the metallic character of these picture elements.

6 Reported by Margarete Hannsmann. The author obtained this and other information through detailed conversations with Margarete Hannsmann, author and the artist's companion of many years. I wish to express my gratitude to her here. Riccarda Gohr, born in Breslow, daughter of the painter Richard Pfeiffer in 1907, studied at the art academy in Königsberg.

7 See: Rudolf Mayer in: Margot Fürst, *Grieshaber. Die Druckgraphik,* vol. 1 (Stuttgart, 1986) Introduction, 26f.

8 The Hanseatic Cross is red and is used as a flag on white background with black outline. It originated, as did the Iron Cross, in the Tatzenkreuz of the German Order.

9 The reference to Germany as a nation comes not only from the picture title, but also from the black-red-gold-flag which is seen in the woodcut draft instead of the GSRSV emblem.

10 Lutz Greve 42.

11 Wilhelm Boeck 44.

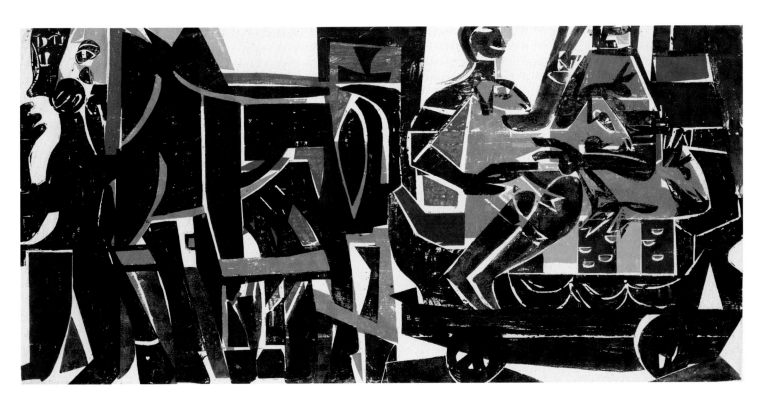

115 HAP Grieshaber
Germany, 1952
Wood cut in eight colors
105 x 200 / 99 x 197 cm
Staatsgalerie Stuttgart,
Graphische Sammlung

We need not search long in Grieshaber's work for the figure of Pan. It turns up again and again, even often in autobiographical connection. The forefather of the Pan portrayal emerged in 1939 and became the artist's signet.[12] Reduced, cut as a stamp, it served to identify the sender on Grieshaber's letters and postcards. Pan the Greek god of nature, became the artist's magic hat. In the figure of Pan, Grieshaber himself steps into his world of images. Just as he seldom wrote letters in the first person, rather in the third person – "Your old man sends greetings" or "In this country, there is a lot for your old man to do ..." – with his pictures, he concealed himself again and again behind the mythical god. In this context, it is characteristic that self-portraits are the greatest exception in Grieshaber's work. Considering the numerous animals with which Grieshaber surrounded himself on Achalm – he had horses and peacocks, monkeys and parrots, sheep and dogs – it is a seductive play of thought to place the artist on a level with the god of shepherds and animals. On Achalm, Grieshaber felt like Pan, in harmony with nature and its creative powers. *Armoured Pan* with its metallic forms, though, does not recall the arcadian god of shepherds. In May, 1952, Grieshaber visit-

HAP Grieshaber, *Berolina*
1952, Woodcut, 149 x 100 cm
Boeck 119; Fürst 52/11

HAP Grieshaber
Pan, 1939
Woodcut
42 x 35 cm
Boeck 115
Fürst 39/1

ed Berlin, the "front city" of the Cold War.[13] *Berolina* emerged after this journey, a large format woodcut recalling the Berlin blockade of 1948/49 and the allied airlift, which supplied the west sector of the city for 13 months.

A sitting female figure is portrayed wearing a coquettish hat. A large bird with a long, red beak threatens her at the level of her hips. The fuselage of an airplane with portholes, landing gear and lowered passenger steps is in the background. A letter from May 21, 1952, in which Grieshaber gives account of his Berlin journey, reads like a description of this woodcut: "... In Berlin, a vulture works on the liver of an oldish maid. The old dear has plush in her room ... "; some sentences further on: "... one has to help the old dear: Can we manage it? An unknown old dear is more important than a known name".[14] In another

letter, Grieshaber wrote referring to Berlin: "... A reknown bird works on the liver of an oldish lady there. Also saw a lot of blackredgoldpheasants in the folk-complete-decay (trans. note: Grieshaber's word play for East German parliament) ...".[15]

The continuation of the Cold War, the surrounding of West Berlin, the hostility between East and West and the suffering of the population evoked strong emotions in Grieshaber. Although he did not take Berlin, as the people close to him knew, for the hopeful city of the future, rather, he found it more "imperial-conservative"[16],

HAP Grieshaber, Pan stamps on a letter of HAP Grieshaber

the "oldish maid" to be exact, as he put it, but she is threatened, her liver will be pecked open by a vulture, like Prometheus chained to the rocks. That is why, he wrote, "the old dear must be helped." He "... dreamt about making a film about surrounded, confined Berlin ... where politics make an absurd impression, there you could dare to shake things up."[17]

Armoured Pan emerged in this context. It reflected the feelings Grieshaber had when he crossed the East-West border. He had to put on his armour in face of the "blackredgoldpheasants in the Volkskommenheit", whereby he meant, in plain English, the functionaries of the East German Parliament. "Think of the 'Armoured Pan', he said to his companion on several occasions while crossing the zone border."[18] The artist had to have been so consterned because he found the instruments of violence, surveillance and spying similar to those he knew from 12 years of Nazi rulership, which he, constantly under threat, had to spend in inner emigration.

The plates of armour, with which "Grieshaber-Pan" now had to protect himself, are at once old and new warrior arsenal – Grieshaber had them constantly before his eyes at the military training area in Münsingen, not far from Achalm, in the form of abandoned and stripped army tanks.[19]

How is it, that Grieshaber, who until now had moved within a contained circle, was able to influence an entire school at "Bernstein" and that he turned to the great

12 Margot Fürst, 39/1.

13 See letter from 5/21/1952 in: Grieshaber Malbriefe. Margot Fürst ed. (Stuttgart, 1967) 95.

14 Grieshaber Malbriefe, 95f.

15 Grieshaber Malbriefe, 96.

16 Reported by M. Hannsmann.

17 Grieshaber Malbriefe, 96.

18 Reported by M. Hannsmann.

19 Grieshaber had inherited forest property in the vicinity of the military training area, which he later exchanged with his brother for the property on Achalm. Thus, the area was familiar and he often visited also out of interest in the preservation of the mountain landscape. Reported by M. Hannsmann, see footnote 6.

20 Rudolf Mayer, "Grieshaber La Danse de Morts à Bale", opening address on 1/20/1967 at the Kunsthistorischen Museum in Magdeburg,: *Grieshaber 60*, exhibition catalog, Städtische Kunstgalerie (Bochum, 1969) 26f.

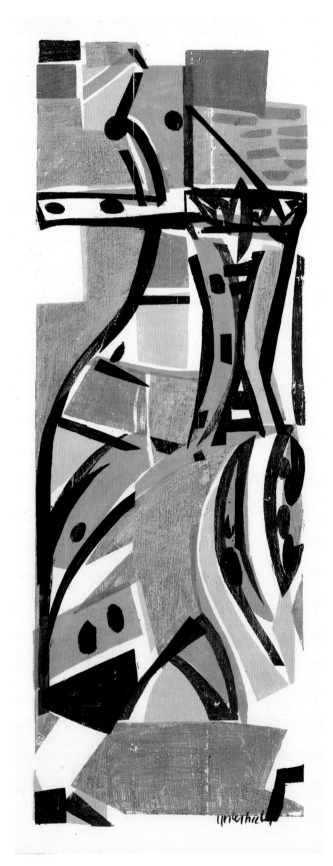

116 **HAP Grieshaber**
Armoured Pan, 1952
Wood cut in five colors
stretched on canvas
148 x 50 / 160 x 60 cm
Galerie der Stadt Stuttgart

"collective German issues" with pictures such as *Germany, Image of Suffering* and *Armoured Pan* which reached far beyond the homeland borders? The answer is to be found in his pre-war biography: During those years; between 1933 and 1945, he did not allow himself to buckle over in surrender. He preserved his principle of liberty and never betrayed his artistic ideas. Thus, he could provide the post-war generation with moral and artistic guidance and authority. He gave them orientation and became the driving force of a reconstruction intellectually and spiritually based on the principle of liberty. Grieshaber sensed his obligation to this role and acted accordingly up to his last woodcut. He experienced the arising East–West conflict as a new threat which he tried to counter by advocating the connections in the culture shared by East and West, without being appropriated by either the political authorities here or the dictators over there. On behalf of the many "border trespassing" actions which he set in motion, only his woodcut series *Death Dance* is mentioned here, which was cut in the West and despite the Wall, printed in Leipzig and finally, in 1966, published in Dresden after two years of work in the VEB Verlag der Kunst.[20] As did no other artist, Grieshaber contributed to building a bridge between East and West – he had had practise after all, having worked as a bridge builder during the 12 years of Nazi rulership. And now, at the very end it must be said with one sentence at least: Grieshaber was the most significant woodcutter of our century.

Freerk Valentien

Against the Inability to Mourn

[1] Alfred Döblin, letter from 6/4/1953 to Hans Henny Jahnn, who had likewise moved back to Paris again as an emigrant, quoted from: "Sie reden und schreiben hier nur von der Einigung Deutschlands ... Alfred Döblins zweiter, letzter Gang in die Emigration", *DIE ZEIT*, 9/28/1990, p. 68.

[2] Johannes Hübner, letter to Dominique Fourcade from April, 1970, *Im Spiegel. Johannes Hübner zu Gedenken*, Lothar Klünner ed., (West Berlin, 1983) 35.

[3] Peter Rühmkorf, *Die Jahre die Ihr kennt. Anfälle und Erinnerungen*, (Reinbek, 1972).

[4] Walter Dirks, "Der restaurative Charakter der Epoche", *Frankfurter Hefte*, Eugen Kogon and Walter Dirks eds., (vol. 5, 1950, facsimile edition) 992.

[5] Alfred Döblin, letter to Arold Zweig, Mainz, 10/6/1952, see footnote 1.

[6] *Karl Hofer, Malerei hat eine Zukunft. Briefe, Aufsätze, Reden.* Andreas Hüneke ed., (Leipzig/Weimar, 1991) 265.

[7] Bernard Schultze, "1962 im Rückblick auf die fünfziger Jahre", *Wegzeichen* (Heidelberg, 1962).

[8] Telephone conversation between the author and Raimund Girke on 2/10/1997.

[9] *Raimund Girke, Texte 1960-1995*, Kunsthaus Zug, 1995.

[10] cf. p. 162f. of this book.

[11] The paintings "often have a double - sometimes a triple meaning and at the same time can refer to the object itself, my private experiences and to political events (...) My main weapons are humor and exactness. One can enter the fires of the soul only with the cold of precision, and only under the guise of a joke can one speak with impunity about what one saw." (Conrad Klapheck, *Konrad Klapheck*, exhibition catalog, Kestner-Gesellschaft, Hannover, 1966, 18, 21).

[12] Friedrich Kittler, *Grammophon, Film, Typewriter* (Berlin, 1986) 293.

The lyricist Johannes Hübner, member of the circle of artists around the West Berlin painters' cabaret "The Bathtub", recalled the currency reform of 1948 and the beginning of the Cold War as the decisive caesurae: "The Americans pulled the jackals from yesterday and the day before yesterday out of the garbage heaps of history and brought them back to wealth and power; in East Germany just a little later, a grim Stalinism invoked the name of Rosa Luxemburg. So great was the euphoria during the first three postwar years, so black was the disappointment now. I was seized by a desperate nihilism.[2]" The new calendar in West Germany did not go "'before the liberation – after the liberation', rather 'before the currency – after the currency'".[3]

Accounts of misery, war and wreckage were no longer wanted in either of the two states that succeeded the Third Reich. "This path had already opened in 1945 with the harmless word 'reconstruction'. Fear and the need for security and comfort were stronger than courage, truth and sacrifice, and that's how we live in the age of restoration", wrote Walter Dirks in 1950.[4] Many artists in both parts of Germany felt like emigrants in their own country. Alfred Döblin, for example, who had emigrated from Berlin to Paris in 1933 and had fled to the U.S.A. after France became occupied, returned to Germany as early as November, 1945, as the only world-famous author. A French citizen since 1936, as "cultural officer" in Baden-Baden he was responsible for printing rights in the French occupation zone until the end of March, 1948. He tried to promote the intellectual "re-education" of the Germans in democracy in over 70 radio pieces and with the magazine "The Golden Gate". While he "often encouraged the emigrants to return during the first years, I warned them against it in the last years ... because the ... mental state of this folk after 12 years of Hitler was becoming clear".[5] Profoundly disappointed, he left Germany for the second time in April, 1953, this time for ever, with the remark "how complacent it all seems " *(Journal* 1952/53)

Most of the emigrants shunned returning to Germany. Of the few who came back, nearly all decided on the GDR, which they saw as the antifascist, "better" Germany. Yet the "decreed antifascism" had revealed its repressive features as early as the 1940's. Artists soon realized that any glance into the past was unwanted. Karl Hofer noted with foreboding as early as February 23, 1946, in a letter to Gerhard Marcks: "Its keeps getting worse

and more dogged here. Art should again and must and had to again, and for the folk, close to the folk, the whole Nazi crap with different signs."[6]

There were loners like Bernard Schultze on both sides of the boundary between the systems: "By the fact of being a stranger in this society and yet forced to participate in it, a nearly uncrossable barrier formed, behind which I live (...)."[7] Painting titles such as *In Tearing* (Georg Meistermann), *Sodom, Acheron, Nero* (Emil Schumacher), *In the Maelstrom, Black Trace* (Gerhard Hoehem), *Aggressive, Blood and Decay, Nuked* (Bernard Schultze) indicated the atmosthere in a generation of West German artists disappointed by the Wirtschaftswunder.

Raimund Girke was born in 1930 in Heinzendorf, Lower Silesia. He and his family were driven from their homeland when it became Polish in 1946, to Osnabruck. In 1956, shortly after his art studies ended as master student of Georg Meistermann at the Dusseldorf art academy, he painted a *Memory of a Landscape* (Illus. 140, p. 118), which was to have emerged "out of the little existence as refugee"[8]. The painting takes a key position in his oeuvre as the turning point from the Informell painting expressing personal memories and emotional vibrations to a clearly structured "objective form"[9], which connects colors from natural earth pigments with "Landscape" abstracting horizontal layers, for example in paintings such as *Heavy Colors* and *Disturbed Order* (Illus. 141, p. 118).

The austere, figurative paintings of a "Black Period"[10] of the East Berlin school, such as Harald Metzkes' *Man with Geiger counter* (Illus. 114, p. 102) and the view from Manfred Böttcher's master student atelier on Pariser Platz near Brandenburger Tor onto the *Rubble Tips (Chancery of the Reich Ruin)* in the historic no-man's land of the divided city (Illus. 118, p. 102) which Böttcher painted in 1958, correspond with the *Tired Heroes* (1957; Illus. 121, p. 103) – prostheses in a Dusseldorf window display – by Konrad Klapheck. His typewriter painting (Illus. 120, p. 103) associates the rigid marching convoys of the National Socialist Party convention, the rows of columns of totalitarian architecture and the anonymity of bureaucratic mechanisms.[11] The painting title *Will to Power*, according to Friedrich Kittler[12], alludes to the nearly blind Friedrich Nietzsche's attempt to formulate the reevaluation of values on "the hammer" (keyboard) of the 1882 typewriter designed by Malling Hansen from Denmark. His writing took on the terse "telegram style" because of his problems in operating the machine.

Eckhart Gillen

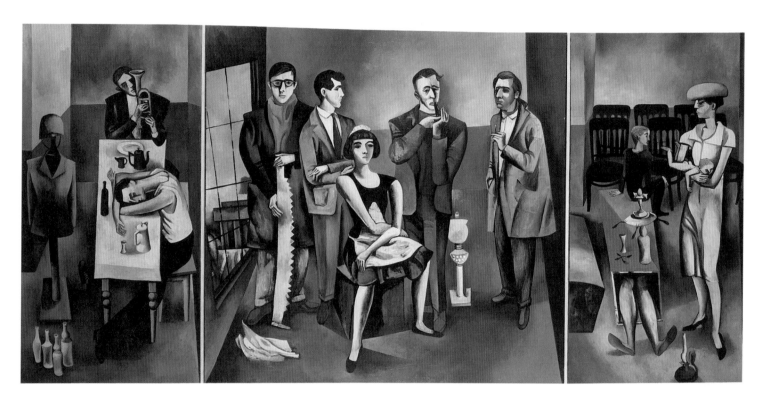

117 Harald Metzkes
The Friends, 1957
Oil on canvas
120 x 243 cm
Collection of the artist

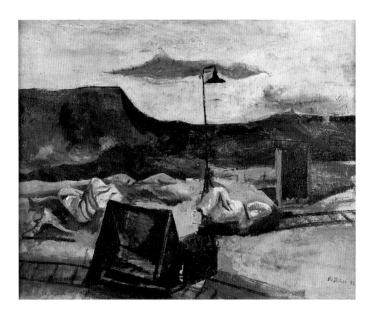

118 **Manfred Böttcher**
Rubble Tips (Ruins of the Reichskanzlei)
1958
Oil on canvas
65.5 x 80.4 cm
Kunstsammlungen zu Weimar

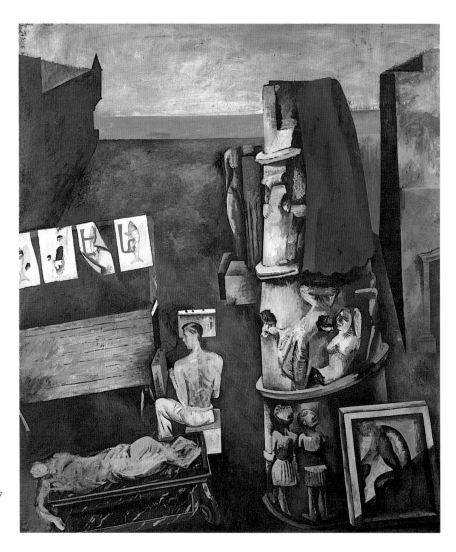

119 **Harald Metzkes**
Man with Geiger Counter, 1957
Oil on canvas
180 x 150 cm
Galerie Brusberg, Berlin

120 **Konrad Klapheck**
The Will to Power, 1959
Oil on canvas
90 x 100 cm
Collection of the artist

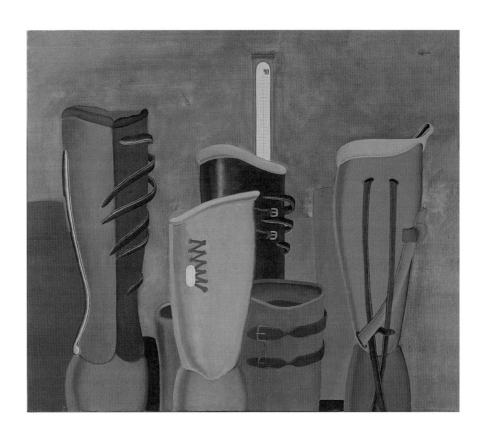

121 **Konrad Klapheck**
Tired Heroes, 1957
Oil on canvas
70 x 80 cm
Private collection

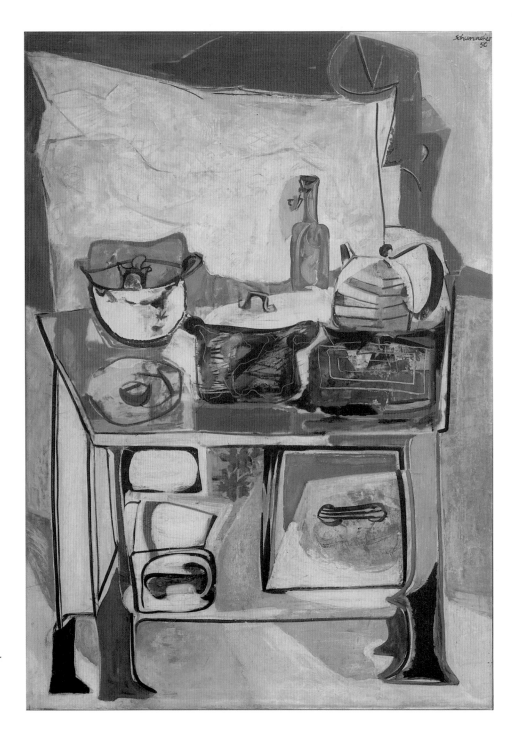

122 **Emil Schumacher**
The Stove, 1950
Oil on canvas
130 x 90 cm
Kunsthalle Recklinghausen

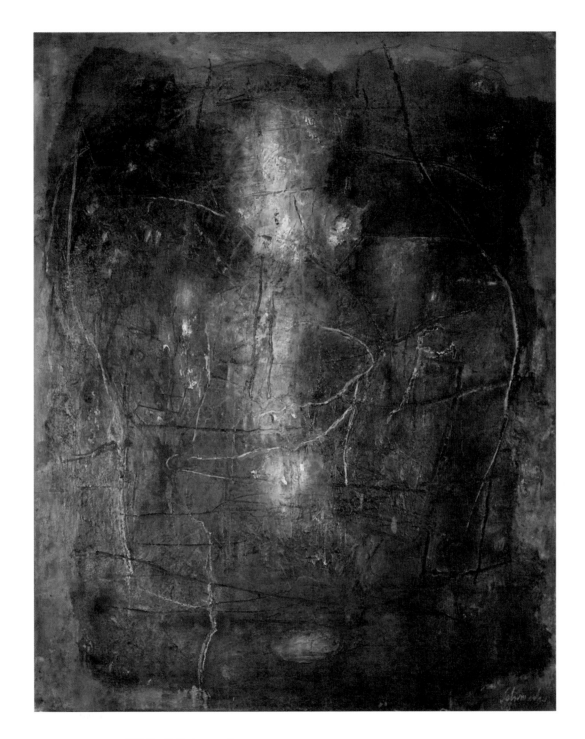

123 **Emil Schumacher**
Green Gate, 1958
Oil on canvas
170 x 132 cm
Kunst- und Museumsverein im
Von der Heydt-Museum Wuppertal

Gerhard Altenbourg's Human Show:
Ecce Homo

"The essential remains mysterious
and will always remain so,
it can only be felt
but not grasped."
Albert Einstein

Altenbourg drew three larger-than-life figures in 1949 and 1959 and captioned them with the words of Pontius Pilate passed down by the Apostle John: *Ecce homo,* transposed freely by Luther as "Behold, man!". Altenbourg had interpreted these words entirely personally: As the son of God, Jesus suffers for all people, therefore, also for him. Father Friedhelm Mennekes was so moved by the "enigmatic religious dimension of sin and atonement" in these depictions, that he had them placed like a triptych over the altar in Saint Peter's in Cologne for some time.[1] Altenbourg never hesitated in choosing figures and scenes from holy and mystic writings as metaphors, to open perspectives on other levels of meaning and to create intellectual distance to the here and now of the world. He took the figure of Christ in his passion as symbol, in order to render visible the human experience of suffering in word and image.

Altenbourg had returned from the war in a completely disturbed and bewildered state, only a few years before he made these drawings. He was far removed from Ernst Jünger's fatal and fateful pathos "to be allowed to go to war for the glory of the country" and to heroize war as a "short yet violent school".[2] He was forced to witness how people get away with laying waste to life and land.

It became clear only at the end of the war how deeply disturbed and shattered were the outer and inner world, the moral and spiritual standards. A brutalization had set in, which still continues into the present. The memories of gruesome events of the war also determined Altenbourg's view of life and artistic work. Upon his return home he began to write; lyrical texts and particularly an extensive prose work he named *In the Fire Oven,* a title rich in association.[3] In this work, he tried to describe his memories of being a soldier. Even the text's outward form reveals his agitation: cut-off sentences, single words, rows of dots again and again in between to express his thoughts and his pain when he ran out of words. The memories plaguing him also began to turn up in the drawings. With pastel crayons, he tried to evoke the heights of the Lysy-Gory Mountains and the vast water landscape of the Vistula River.[4] Other earlier works in color give away

nothing about the events of the war. Altenbourg first began portraying them at the end of the 1940's, as he found his own way of expression through drawing devastated and wounded humanity.[5] Altenbourg wanted to make visible the condition of the soul, in contrast to Otto Dix, who thirty years earlier had captured his memories of trench warfare with eery precision. Altenbourg learned to let his hand and drawing tool glide over the paper, obeying unconscious impulses, checked only by his eye, to form figures and heads from lines which he compared with "strands of nerve fibers" and "root fibers". Details are only indicated here and there, for instance, a military medal, pieces of clothing or a weapon. Faces and gestures always predominate, often calling to mind the artist himself, for example, the glance of the eyes and the flapping movement of the arm around an emaciated body. He never intended to draw directly from nature, but rather to transform: "Corporeality is transposed into a structural association, an association of signs (in a battlefield)." Thus, he wrote elsewhere in the "tatauierte Litaneien": "You have to be able to resolve; to learn to see the covered, the uncovered, the broken through as a tearing away, a flaying that concerns ourselves. Ecce homo, skinned, pealed, drawn, stripped, nailed; a glance into the labyrinth which we always like to mask", a mask to camouflage the evil drives lurking in human beings. There we discover Freud and Lautréamont: "IF I WANTED TO KILL, I WOULD KILL."[6]

The three *Ecce homo* sheets comprise the first pinnacle of the then nearly 25 year old artist's "Human show"[7]. The autonomy of his artistic handwriting can already be seen in these works. In this two year creative period, Altenbourg intentionally avoided anything echoing forms in nature in order to establish the world of black-white. He worked in the way of the earliest artists, who found thousand-fold signs to bring forth delimitations, material properties, and affects of light and shadow.[8] Despite the largely abstract drawing language, the *Ecce homo* sheets contain concrete communications, which Altenbourg had discussed in the conversation with Siegfried Salzmann.[9] At this point, I would like to add a few general remarks.

The first sheet of the *Ecce homo* group[10] (fig. 124, p. 107) is covered with three different depictions. The side we don't see today was worked on first. It shows a map of Germany drawn by Altenbourg at about the age of ten. A little later, but still before the war, he drew a military training ground with soldiers, a tank, an armoured scout car, vehicles and artillery on the side we see today. This portrayal of military armament, undertaken in naivety and innocence, became gruesome reality through the deployment of this technology in WWII for Altenbourg too when he was assigned to already retreating fronts as defense grenadier against enemy tanks in the last year of the war.

1 "Gerhard Altenbourg (Rugo Collection)." Exhibition at the Kunst-Station St. Peter (Cologne, 1989); Friedhelm Mennekes, *Triptych* (Frankfurt/M., Leipzig, 1995) 167-170.

2 Ernst Jünger, *Das Wäldchen 125,* Foreword (Berlin, 1925).

3 Typed manuscript with handwritten entries from various years in Altenbourg's estate, 41, fragment.

4 See work number 45/1 *Sunset on the Vistula* and 45/2 *Evening Mood in the Lysa Gora,* unpublished. In 1946, "a dark, dismal picture full of horror and terror with the title *The Last Crossing* was created. It is a declaration and a tearing free from those days when comrades daily made "death's last journey". (From one of Altenbourg's diaries).

5 See work number 49/37 *Clearly from the Kinship of the Sinister* or 49/52 *Soon it is Over,* but most importantly the lithographs *Don Quixote, The Whinnying of Destruction, But the Pour le merite* and *Pensioner of the Cross.*

6 Gerhard Altenbourg, *tatauierte Litaneien* (Berlin, Paris, 1962) 1, 10, 15.

7 Ibid., Scars torn open while wandering through that hilly landscape, in: *Gerhard Altenbourg. Werkverzeichnis 1947-1969,* Dieter Brusberg ed., exhibition catalog, Galerie Brusberg (Hannover, 1969/70) 34; reprinted in Brusberg, *Der Gärtner,* Anneliese Ströch and Dieter Brusberg eds., Brusberg Bücher 2 (Frankfurt/M., 1996) 196.

8 In the same time around 1950, Altenbourg began to recompose his writing script and to transform it into an art script.

9 Siegfried Salzmann, "Behold, man!," *Gerhard Altenbourg, Arbeiten 1947-1987,* exhibition catalog, Kunsthalle Bremen 1988 30-36.

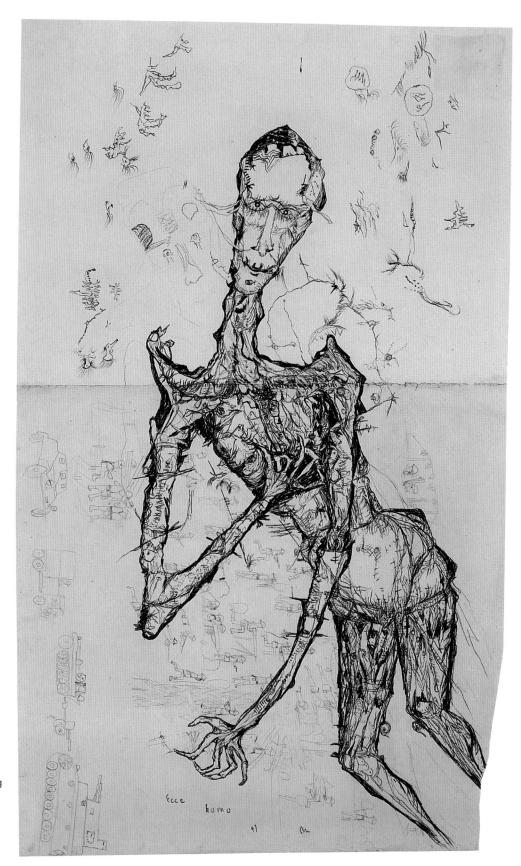

124 **Gerhard Altenbourg**
Ecce Homo I
(The Dying Warrior), 1949
Black crayon, lead, strong mural
paper, glued together
131.5 x 88 cm
Lindenau-Museum, Altenburg

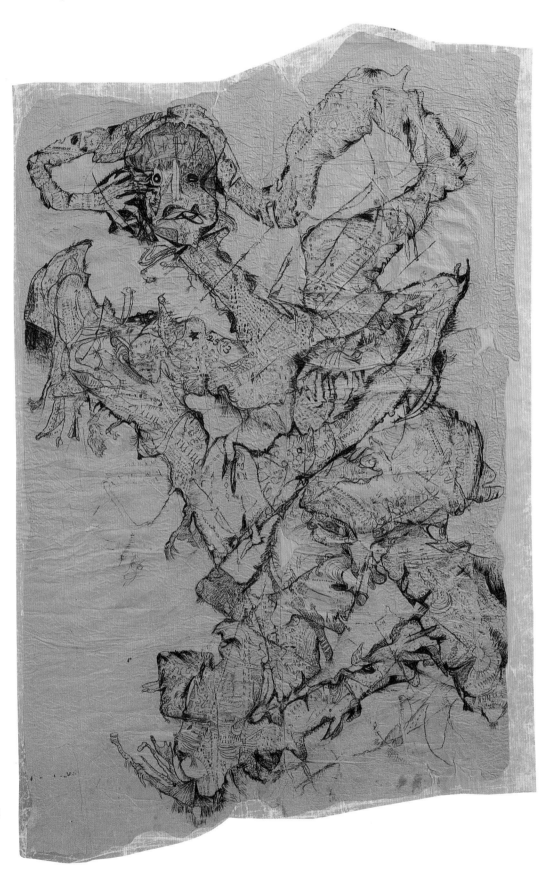

125 **Gerhard Altenbourg**
Ecce Homo, 1949
Paper on cotton
200 x 120 cm
Diözesanmuseum Köln

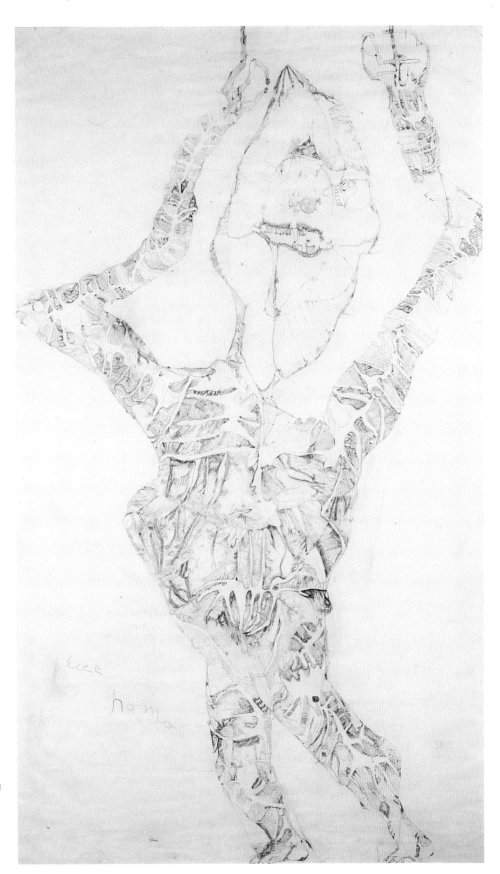

126 **Gerhard Altenbourg**
Ecce Homo (as marionette)
1950
Chalk on paper stretched on
canvas
281 x 158 cm
Galerie Brusberg, Berlin

When he came across the sheet again after the war, he transformed it into a landscape of life. He nearly doubled the size by adding another sheet and he drew a large human figure over the light pencil drawing of the military scene with deep black crayon. He named it: *Ecce Homo I* (The Dying Warrior).

The second *Ecce homo* depiction is also determined by war memories.[11] (fig. 125, p. 108) The body is densely covered with the abstract short forms, with which military personnel customarily use to indicate landscape features and troup units on maps. The star with the number "253" on the shoulder is striking; it is only an approximation of Altenbourg's regiment number[12]. He loved such approximations because they allow relief from reality. This figure is also striking because of its eccentrically moving limbs and its almost expressionist, zigzagging outline. In the third *Ecce homo* drawing[13] (fig. 126, p. 109) the outer demarcation is also decisive. In a nearly unbroken line, it seems to flow in loops around the body, creating hollows filled with dark signs which distinguish the light surfaces between. They build up the body and hold it together as a bandage-like framework with constantly changing widths. All three figures resemble each other in the body posture and the patterns of sign painting on the skin, which could signify wounds or scars. This association was also initially intended by the artist. Yet, other elements of expression have also found their way in, unnoted, which seem to contradict the title. For example, the look in the eyes, which does not express weakness or dimness but rather alertness and energy, indeed almost cheerfulness, or the arms thrown upwards, a gesture which turns up repeatedly in Altenbourg's work bearing the most diverse meanings. It must not mean submitting in the sense of surrendering oneself, but rather the contrary, setting up a defense in order to maintain one's own position in the face of onslaught by an anti-intellectual and levelling-down environment. It is no longer a matter of portraying a soldier, as indicated by the little cap, which is not part of a uniform, but rather a civilian head cover which women had inventively sewn together out of wool or fabric remnants during the crisis of the postwar years - Altenbourg had also worn one.[14] *Ecce homo* is therfore a link between Then and Now, a self-portrayal from 1949/50. That was a time which "was for me overshadowed by illness, past hardships (war, which I had to live through as infantrist and anti-tank offense, 1944/45) and an uncertain future".[15] He always felt "stretched between the poles, between Arcadia and the stormy cliffs, which signalize failure; between the shudder caused by crime, in front of the smirk of destruction. In shivers and screams, fading. Radiant light".[16]

Looking back, it would seem that rather than weakening Altenbourg's strengths, resisting and bearing physical and mental pain had renewed and increased his energy. It was as if he had used the effort in struggling against his adversaries as the driving force for the concentration with which he created his cerebral life work. He was able already in his early drawings to transpose his personal experience into the universal. This can be seen in the impact which these three large figures still have on people who either remember the events of war differently or who didn't experience them. The physician Ernst Jürgen Kirchertz, who unexpectedly found himself faced with the third version of *Ecce homo* at an exhibition, described this effect most impressively: "Directly in front of me there is this chalk drawing *Ecce Homo*, overwhelming in its dimensions alone, 2.85 meters by 1.60 meters, thus larger than life, vast, inescapable - a frightening vortex, an immediate attack upon the small individual existence and therefore threatening at the same time. I reacted to this image physically - how often does that happen! - and gradually calmed myself by trying to understand what had happened and to comprehend which of my own fears of powerlessness, of being annihilated had been roused."[17]

Annegret Janda

10 Work number 49/142.

11 Work number 49/141.

12 Altenbourg belonged to the 6th Grenadier Regiment 453.

13 Work number 50/66.

14 See also work number 54/11 *Der Gärtner* (The Gardener).

15 Altenbourg to Lothar Lang, 4/26/1965, *Selbstbildnisse*, ed. Lothar Lang, exhibition catalog, Kunstkabinett des Instituts für Lehrerweiterbildung Berlin-Weißensee (Berlin, 1965) 27.

16 Gerhard Altenbourg, *Werkverzeichnis* 35.

17 E. J. Kirchertz in a lecture on the occasion of the exhibition "Gerhard Altenbourg. Arbeiten aus 35 Jahren" in Galerie Brusberg (Hanover, 1983).

Injury to the Color Fields:
Günther Uecker's Early Work

An assessment of Uecker's move from East to West, from socialism to capitalism, as a major break in his life and work would not be unfounded. Growing up as a farmer's son from Wustrow, where he remained until his eighteenth year, he explored, like a seismograph, the garden of his family's house, in which art played no role. Amazed by the world around him, he was obviously not satisfied simply observing his surroundings up close. As if under compulsion to make himself sure of the world with a drawing pencil, to bring it into closer focus, he established a contact to it like someone who spontaneously reacts to the rays of light by which he is animated. In this respect nothing has changed, apart from the way it is done when he, the melancholic, is traveling from continent to continent, always underway and taking leave, and painting and drawing.

Even as a child, the wish to relate to that which touched him with a drawing pencil was so strong and his reflex so immediate that he was intimately attached and faithful to outward appearance. He found himself in drawing, escaped the demands with which he was outwardly confronted, and craved to experience the inner life of the outer world. Whether he drew the paths along which he walked, or the animals, including a dog, whose existence was for him a delight, one always sees something of the affection, the curiosity, the unbroken openness, but also the yearning for a kind of haven of speechless contemplation, lending protecting from the outside world. Driven from his home because the Russians declared the island a military security zone, he began studying art, the only thing he could ever imagine, first in Wismar and then at the Art Academy in Berlin-Weißensee from 1949 to 1953.

Distant from religiosity, to which he later came when he concerned himself with Buddhism, Islam, Hinduism, and the Old Testament, he studied Marxism, read Lenin, and hoped for a socialist future, internalizing to a certain degree the horror image repeated about capitalism as being the "exploitation of people through other people." In any case, he rose to the level of "Special Organizer" for the decoration of party events before legally entering the West, prior to the erection of the wall and the outbreak of the cold-war. Certainly because he had become aware of "the tendency of education in the GDR toward brainwashing"[1], because he had become disquieted by doubts and his inner rejection of the Korean War, and because he could no longer uphold the circle of lies that were so easy to confuse for truth. He who had been an official "agitator", and as he put it, thereby more "adept at lying", had recognized the changes that had taken place in himself, and the degree to which communication between the functionaries and the people, who were just left nodding their heads, had broken apart. Everything that he said appeared to him as a kind of parroting recitation for the sake of survival.

It was hardly to be expected that the breaking out, the new beginning without his parents, would automatically bring about a liberation from the prison of the authoritarian spirit. There were new obstacles and adversities to be faced, and an orientation had to be found. Still convinced of the socialist idea, although not of the praxis he had known up until then and worried about whether or not he could survive unscathed in the unjust and decadent west, he left West Berlin after a brief visit on his way to Düsseldorf where he knew Otto Pankok was teaching. A person worthy of real respect, whose work had been forbidden under the Nazis, and who was neither a "yes man" for the system, nor inhumane, nor conformist, but rather someone who embodied an element of humanity that, despite all forms of totalitarianism, does not disappear. He was an anti-fascist, and of the independent sort. The possibility of studying with him seemed to offer to Uecker a chance to prove himself without "falling prey to the rapacity and corruption of capitalism" which he feared. He didn't want the friends he had left behind to have the impression that he had run away only to disappear in another world. Uecker understood his departure more as a discovery trip into unknown territory with an uncertain outcome. Without abruptly giving up his old ideals – they were the only ones that he knew, and that had been funneled into him – he turned to Pankok with the request that he be admitted into his painting class. The teacher, however, asked him where he was from, what he had done before, and advised him that it would be best if he "go back to where he came from." As an outsider, dirty and living on the street with criminals and those prostituting themselves, feeling totally alone in the world, the rejection by Pankok, who he had seen as his last savior, came as a great shock. As Pankok saw how deeply shaken he was by the rejection, he went into the secretariat to sign him up, giving him a mattress with the words that he could sleep in the classroom. From that point on, he became a kind of substitute father, one who invited him to his home in order to offer "a sort of family" and a sense of security, "something like a bridge, as a person."

In discussions with his warmhearted professor, who from the first minute "with his beard and apron had appeared almost biblical" to Uecker, he noticed how radically different the two Germanys really were, not only

1 Heinz-Norbert Jocks, "Kann Fruchtbarkeit auf Asche gründen...", Günther Uecker im Gespräch mit Heinz-Norbert Jocks, *Kunstforum International*, vol. 117, 1991, 304-315, 306.

2 From a personal discussion with Günther Uecker in May, 1997.

because of their different political systems, but rather through the use of a language that only appeared to be the same. His manner of speaking was so formed by the GDR terminology of social change in the sense of historical materialism, that Pankok, despite his best intentions and efforts, couldn't really understand him. And when he went into the city and spoke with others he felt like a "foreigner" in West Germany, alien and uneasy, surrounded by people who where "mostly reactionary, and who were carrying on National Socialism in the secrecy of their homes, but would deny it before they had a foot out the front door." Among these people, who had once voted for Hitler, he doubted the wisdom of his decision. Up until his thirty-second year he was torn as to whether or not he had make the right decision, plagued by nightmares and fears not only that he had deserted the moral side of Germany but that he would have to go back. Under these circumstances it was no easy task to find an orientation, especially because he had begun to feel himself in conflict with his former aesthetic notions. For example when he visited a Kandinsky exhibition in West Berlin and found himself very uncomfortable that he was so deeply touched by exactly the abstract art which had been denounced as the "scum of a degenerating society", an indication of social decline and even as "devils work". The crisis resulted in a feeling that on one hand he had fallen prey to the temptation of original sin, on the other that he still had to somehow escape it until he could later give himself over to it.

At the Art Academy in Düsseldorf, where one could go into the countryside by bicycle to practice drawing people, plants, and trees in the classical tradition, he mistrusted all of those who for the sake of security were studying to be art-teachers. Gradually he began to distance himself from figurative work, beginning to experience the drawing pencil, as soon as he took one in hand to draw a nude, as a kind "sharp tool" with which he would "poke around in the eye or vagina." This was so disturbing to him that he literally got "a chill up his spine." Instead of following what was in vogue at the time, he looked for like minded people, including Strzeminski, Malevich, Rodtschenko and Tatlin, and remained innerly oriented toward the East. He also studied Goethe's color-theory, Newton, and Rudolf Steiner. That he was unable to glean anything from the informal, from that which was the focus of general attention, is explained by his polemic against a painting that would compensate for war experiences, and against it's affirmation of unmediated subjectivity. Painting began for Uecker, who was a good friend of Yves Klein, where everything autobiographical came to an end, like an attempt to reach a kind of spiritually unreachable, which, however, is raised like an icon as an image of adoration. As to the question re-

garding how painting was supposed to overcome the subjective, he looked for answers from 1956 to 1958 in experiments where he applied self-prepared paint to canvases with his hands. That he still stood in the tradition of figuration is shown by a painting that reveals, underneath the black overpainted surface the form of head. Black is for Uecker more than simply a negation of using color, but rather, as it appears in his *Call Against War* (1981), an expression of the "drama of lost being," "the gate to lost mourning," and thereby also a protest against militarism itself. Further his monochrome *allover* contains an admission of his failed painting and of his despairing dialogue with colors like yellow or red. Here he practices their structuring with fingers. There, with the help of a home-made nail-comb, he scratched filigree lines, relief like, into thick layers of colored paint as if he intended to plow the fields of his childhood garden. From this point it was not a great leap to the famous nail which he left behind, with which he wrote art-history, as a dangerous, structure-giving tool, because its aggressive force was for him, more expressive and true. Sometimes the color appears like a body injured by the nail, like a field by a harrow, the reason why this is brought into middle view. Sometimes the picture is so nailed in quarters that it appears like a head topped by a crown of thorns. It is self evident that the white appears opposite the black as a dissonant counterpart, pointing to Zen Buddhism. A thinking in dichotomies, the essence of which is variation, is here being cultivated.

Heinz-Norbert Jocks

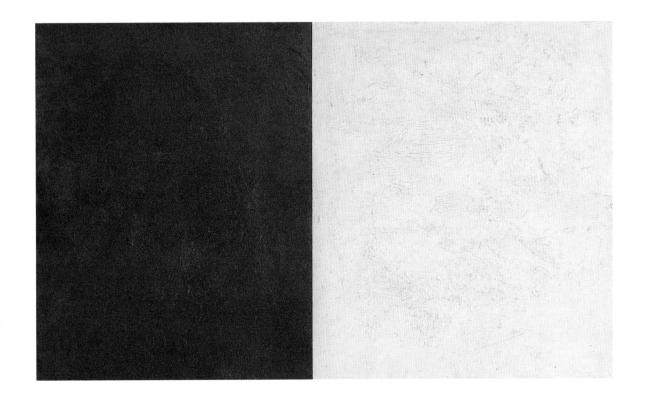

127 **Günther Uecker**
Black-White, 1956/57
Oil on masonite
125 x 200 cm
Collection of the artist

left:
128 **Günther Uecker**
Portrait, 1957
Oil on masonite
85 x 61 cm
Collection of the artist

right:
129 **Günther Uecker**
Black Lung, 1957
Oil on cardboard
90 x 76 cm
Collection of the artist

113

left:
130 **Günther Uecker**
White Horizontal, 1958
Oil on masonite
51.5 x 45 cm
Collection of the artist

right
131 **Günther Uecker**
Vertical Structure White, 1958
Oil on canvas
44.5 x 40 cm
Collection of the artist

left:
132 **Günther Uecker**
Silver Spiral, 1957
Oil, silver leaf on cardboard
73 x 75 cm
Collection of the artist

right:
133 **Günther Uecker**
Vertical Horizontal, 1958
Oil on canvas
60 x 46.5 cm
Collection of the artist

left:
134 **Günther Uecker**
Oval, Gray, 1957
Oil on canvas
80 x 62 cm
Collection of the artist

right:
135 **Günther Uecker**
Painting Nailed Over, 1957
Nail relief, nails, oil (finger
painting) on wood
64 x 75 cm
Collection of the artist

left:
136 **Günther Uecker**
Gray Structure, 1957
Oil on cardboard
67 x 50.5 cm
Collection of the artist

right:
137 **Günther Uecker**
The Red Painting, 1957
Oil on canvas
61 x 59 cm
Collection of the artist

138 **Günther Uecker**
Informal Structure, 1957
Nails, plaster on canvas on wood, white
100 x 70 cm
Staatliche Museen zu Berlin, Nationalgalerie

139 Günther Uecker
Painting Nailed at the Edges, 1957/1959
Oil on canvas, nailed edges
144 x 133 cm
Collection of the artist

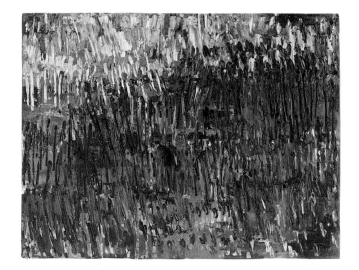

140 **Raimund Girke**
Memory of a Landscape
1956
Oil on cotton
50 x 65 cm
Collection of the artist

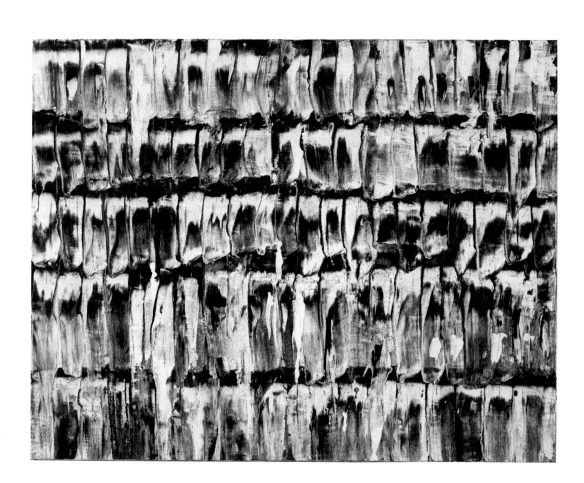

141 **Raimund Girke**
Disturbed Order, 1957
Mixed technique on canvas
100 x 125 cm
Collection of the artist

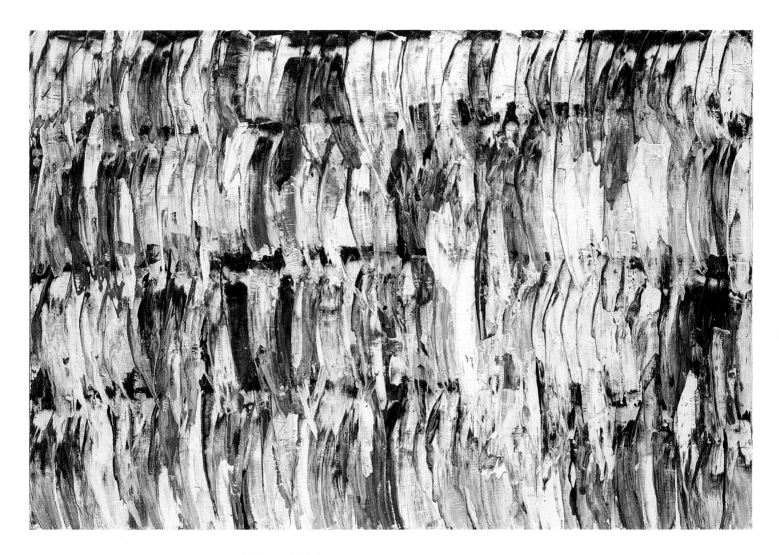

142 **Raimund Girke**
Large Vibrations, 1958
Mixed technique on canvas
125 x 180 cm
Collection of the artist

Manifestations of a New Generation

»... a generation of junk, hastily and fearfully fucked into existence before the war or in the first days of the war. ... Feeling guilty for being there, guilty of having done this or that ..., burning tanks fall out of the sky, shrapnel ... – and afterwards, when it ended? ... Now, the musty atmosphere of collective guilt, now the gray images come ..., the devastation has secretly and soundlessly happened once again amidst a wild, furious reconstruction.«

Rolf Dieter Brinkmann, born 1940, diary entry, appeared on December 21, 1972, Rolf Dieter Brinkmann, *Rom, Blicke* (Reinbek bei Hamburg, 1986).

1 *Zwanzigjährige haben das Wort* (Munich, 1959).

2 "Johannes Gachnang in a conversation with Georg Baselitz on 11/6/1975", *Georg Baselitz. Tekeningen/Zeichnungen,* exhibition catalog, Groninger Museum (Groningen, 1979).

3 Dpa-report from 10/2/1963.

4 Pamela Kort, "Die Malerei der Bewahrung", *Baselitz. Wir besuchen den Rhein,* exhibition catalog, Dresdener Kunstverein (Dresden 1997, 56). The exhibition shows portraits done from old photographs of his family from the years 1996/97.

5 Tom Holert, "Bei sich, über allem. Der symptomatische Baselitz", *Texte zur Kunst,* vol. 3, no. 9 (March 1993) 87f.

6 Robert Ohrt, "Der rebellische Fürst. Ein Motiv aus der populären Kunstliteratur, aufgefunden bei Andreas Franzke über Georg Baselitz," *Texte zur Kunst,* vol. 1, no. 3 (Summer, 1991) 143.

7 Statement by Georg Baselitz, quoted by Franz Dahlem, see: *Georg Baselitz. Gemälde, schöne und häßliche Porträts,* exhibition catalog, Städtische Galerie in the Prinz Max Palais, Karlsruhe, Neue Galerie der Stadt Linz, 1993, 61.

8 Quoted by Heinz Peter Schwerfel, "Georg Baselitz in conversation with Heinz Peter Schwerfel", *Kunst heute,* no. 2, (Cologne, 1989) 50.

9 Axel Hecht/Alfred Welti, "Ein Meister, der Talent verschmäht", *art* 6/90, 62, 64.

At the end of the 1950's, swastikas scrawled on the Jewish cemeteries and synagogues of numerous West German cities disturbed the busy calm of the public preoccupied with reconstruction. After all, they believed that the "incident" in German history had been "cleaned up" once and for ever with the wiping out of the very last swastika when the war was over. The generation of those who were 20 at the time heard and learned nothing in the schools about genocide, world war or the National Socialist system. "German History did not start until after 1945." Asking questions about the period before had the effect "as if you bump against a rubber wall. It yields for a moment, doesn't hurt anyone and then stands again exactly as it had before."[1]

An historically unprecedented generation clash broke out in the Federal Republic's "Fatherless Society" (Alexander Mitscherlich, 1963) over the parents' complicity in Nazi crimes. The painter Georg Baselitz felt the situation to be a rupture with all ties, after his double resettlement from Oberlausitz to East Berlin and finally to West Berlin. "You found yourself suddenly in a very alien, chilly environment... When the traditional ties are gone, when there are no more teachers, no more fathers, that's what I mean by rupture."[2]

In 1963, a West Berlin State Attorney had the paintings *The Naked Man* and *The Night of the Senses* (fig. 143, p. 121) removed from Baselitz' first one-man-show in Galerie Werner & Katz. All that the press saw were "distorted, dehumanized nude figures of men, male infants and embryos".[3] Society reacted with pornography trials, which were actually political trials. From the "tachistic foaminess" which dominated the art academies during the time he studied, Baselitz came up with body parts, an over-sized "tear sac" or hacked-off feet, whose titles such as *Old Home Town - Sheath of Existence - Fourth P.D. Foot* (1960-63) expressed being cut off and the impossibility of returning to the place of childhood. The foot as remaining body part stuck in the hollow of a felled treetop, the "old home town", cannot be rejoined: "(limb - 'member' / 're-member' = remember); it is a doppelgänger, who simply won't disappear."[4] The dismembered bodies "remind the social body of its potential to endanger and they negate the integral structure of the Fascist body armour in a postwar Germany highly sensitive to just that. Considering what society was imagining, it is not at all difficult to diagnose the agitation from official places in the Baselitz case as a late paranoid defense

reaction, necessary for the protection of a stable unity... Around 1960, challenging the Fascist fathers was still being expressed in the forms of blasphemy and genitals. Shortly afterwards, the politicization of this challenge began... ."[5]

The children born during and after the war compulsively, again and again, pulled out the things the parents didn't want to see, like the Hitler youth wearing shorts in the painting *The Night of the Senses* pulled out his penis. "And who did he pull by the dick in front of the painting, if not the tormented, pathetic Germans whose night of the senses is now down the toilet?"[6] (Trans. note: "The Night of the Senses" is the translation of the German title, which literally means "the big night down the toilet"). His "kick in the Germans' balls"[7] was not aimed, "because the evil was much too complex. At whom should I have aimed? The art academy, the politicians, the man in the street?"[8] The "obscene" genitals were merely a symbol for the obscenity of the swastika, still hidden at the beginning of the 1960's, which turned up, concealed, in *Constructivist* (1968) by Sigmar Polke and in *Clean* (1966) by Hans Peter Alvermann, in this case aimed directly against the Fascist petit-bourgeois father.

The painter placed himself in the devastated home town as tattered army private with knapsack and painting tool, breaking through walls (compare *The Shepherd,* 1965, [fig. 147, p. 126]), wounded and snagged by hand and foot traps, as representative of an abandoned generation. It was certainly no coincidence that in these years in no-mans-land West Berlin, Baselitz took on the name Deutsch-Baselitz, the place where he had spent his childhood.

The initial attempt at artistically working through the burden of memory - to get rid of it by means of objectivization - came inevitably to a critical border. Around 1969, Baselitz began to turn the themes upside down, and with this trick, directed the observer's glance to his skillfulness, to the painting as artifact, to distract him at once from the painter's personal motives. His material remained the working of the memory from the unconscious, as shown by his first exhibition in Dresden, Saxony of portraits painted from old photographs of his family. He contented himself with the transposition to the picture, because the connection to the motif takes place in the mind. "What finally ends up on the surface is quite unimportant." The work was successful, as he said, "in the sense that the painting itself is the undertaking, not the representation of the object". They "are inventions without comparison in reality, without truth."[9]

Eckhart Gillen

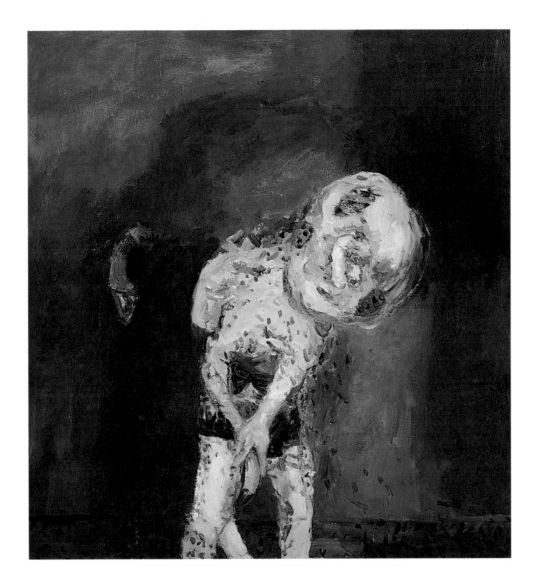

143 **Georg Baselitz**
The Night of the Senses, 1962
Oil on canvas
185 x 165 cm
Stedelijk Van Abbemuseum, Eindhoven

144 **Georg Baselitz**
The Hand –
The Burning House
1964/65
Oil on canvas
135 x 99
Private collection

145 **Georg Baselitz**
The Heart, 1964
Oil on canvas
165 x 190 cm
Private collection

Georg Baselitz: The Poet

Edvard Munch, *The Sun,* around 1912
Oil on canvas, 163 x 205.5 cm
University's main hall, Oslo

Georg Baselitz painted *The Poet* (fig. 146, p. 125) in Florence in 1965. Although it differentiates itself from *New Types,* and from *Heros,* where the formats are full of figure images, *The Poet* belongs in this sequence. The small central figure is surrounded by a broad ring of concentric circles and radial lines. This structure of straight or circular lines could be read as a spider's web, in which the poet is caught helpless. But the small landscape in the middle of the painting and the large duck head in the lower right corner evoke a more spatial idea, so that the network appears like a tunnel, through which the poet is catapulted forwards. The cage-like bars enclosing the figure may have been the ground for showing the work for the first time in the exhibition "Labyrinth", which united works from the 16th Century to the present within the framework of the 1966 Berlin Festival Weeks. *The Poet* seemed unfinished to me at the time, because of the primarily linear elements and the unelaborated surfaces. It gave the impression of being a quickly thrown together brush drawing or a framework for a yet-to-be painted work. Compared with the other paintings in the exhibiton, this seemingly unfinished anti-painting had the effect of a provocation. Many years later, Georg Baselitz said in a conversation with Dieter Koepplin during Easter, 1991: "But there was something else in the painting that was much more important to me, namely, that I used a canvas that has remained for the most part unpainted. So I had exerted myself to manage with as little painting over as possible... The painting was turned out very, very quickly."[1]

In the meantime, the work has finished painting itself. The primed surfaces with the hasty brush strokes have grown together to a vivid portrayal, which through the predominant red tones - like a bloody tattoo - suggests the individual's isolation and disconnectedness in the world. The open structure and absense of elaboration allow every contact of brush to canvas to be perceived. The spontaneity of paint strokes and the staccato of the lines still convey the excitement of the creative moment to the today's observer. The painter is the poet, the painting-poet, who elucidates and compresses the essence of art historical models and personal experience into a painting which had never existed before.

The circling brush stroke of the sucking crater or the urging elevation is also found in Edvard Munch's work. To the surrounding forms in Munch's pictures, Georg Baselitz credited: "a nervousness, an aggressivity, a tension ... which you can compare with those in pictures of the mentally ill, something insanely naive and gripping".[2] With this description, Baselitz aptly characterized his own painting as mad and for that reason, a rousing invention. Munch's great picture *The Sun* on the facade of the main hall at the University in Oslo, has a radial picture construction similar to that in *The Poet.* In Munch's painting, there is the shining void of the sun's disc, in Baselitz', a night sky over a devastated war landscape, which also turns up in the other *Heros* paintings, with a house ruin and baren trees. This Saxon homeland lies in the far distance, reduced like a reflection in a curved mirror. The painter-poet appears with his lengthened feet, forwards on the run. Entangled in the world, he falls into a stagger, spreading his arms out to gain balance and probing the constricted space searchingly with his amorphous hands. He is burdened by his memories of the country life and his experiences in the foreign world, to which he exposes himself in his vulnerability. Just as the painting is an anti-painting, so is the hero an anti-hero, who suffers in and because of the world. The position of suffering is emphasized by the cross, formed by the spread arms and the vertical of the over-sized male member. Torment and sexual excitement reflect the poet's inner streif.

The painting obtains its enormous tension from this conflict between the psychic and formal powers. The picture elements are founded on conflict: The plane of the drawn circular forms contrast with the arching space of the sky in the center. The round picture construction breaks off at the right-angle border. The lineal and flat forms intensify reciprocally in the struggle with each other. The oppositional powers charge the painting with such tension, that it threatens to burst. That this conflict is carried out in the painting without making it burst is what gives the picture its animation and greatness. The exertion of the centrifugal powers to break asunder is countered by the substance of the accentuated center. Surfaces and drawings permeate each other, the enigmatic and the superficial blend in the painting plane, and the circles pulsate in waves between extention and contraction. In this way, all impulses and hazards are exposed and at the same time, held in balance by the texture of the forms. The outer space of the ring of rays can also shift in significance into the inner space of a projected world in the poet's head. "You make up a painting, you don't get it from outside" (Georg Baselitz).[3]

Günther Gercken

[1] Georg Baselitz, "Da ich kein Historien-maler bin". Gespräch über "45" mit Dieter Koepplin", *45 (Reihe Cantz),* (Ostfildern bei Stuttgart, 1991) 9-33, 23, 25.

[2] Georg Baselitz, "Erfundene Bilder", *Edvard Munch. Sein Werk in Schweizer Sammlungen,* exhibition catalog, Kunstmuseum Basel (Basel, 1985) 145/146.

[3] Georg Baselitz, *Hamburger Rede,* 2/23/1997, unpublished.

146 **Georg Baselitz**
The Poet, 1965
Oil on canvas
162 x 130 cm
Annemarie and Günther Gercken,
Hamburg

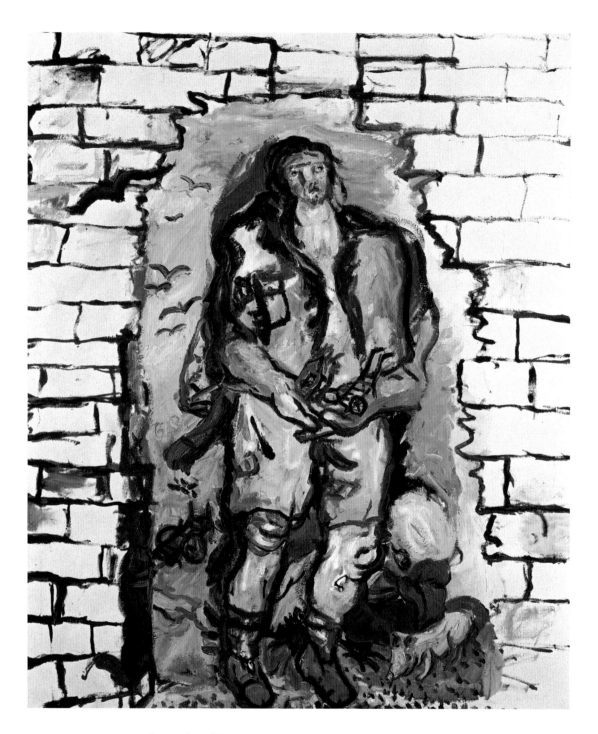

147 **Georg Baselitz**
The Shepherd, 1965
Oil on canvas
162 x 130 cm
Galerie Hauser & Wirth, Zürich

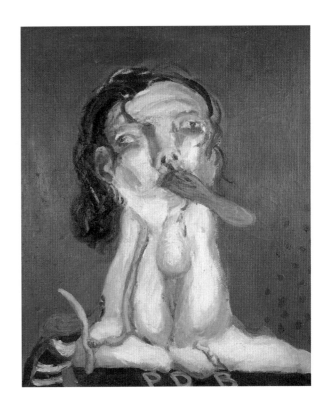

148 Georg Baselitz
P D B, 1965
Oil on canvas
104 x 85 cm
Private collection

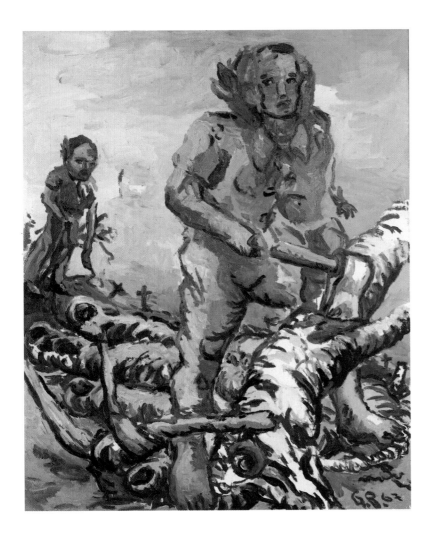

149 Georg Baselitz
Portrait E.S. in Secret, 1967
Oil on canvas
162 x 130 cm
Stober Collection

AGIT. PROMETH. –or–
The Night of the Senses
1st and 2nd Pandemonium by
Eugen Schönebeck and Georg Baselitz

No one wants to remember or discuss the manner in which the legendary manifestos by both artists were set forth in the world, particularly not the protagonists themselves. I came to Berlin in spring of 1963, too late to witness the making of myth, but at just the right time – in autumn of the same year – to see the Georg Baselitz exhibition at the newly opened Galerie Werner & Katz on Kurfürstendamm. Two paintings were already missing, I thus found no further hint of a scandal. Being Swiss, however, I was surprised at the fierceness with which the culture battle was led. Two years later in the same rooms, I saw the works of Eugen Schönebeck in a broader overview for the first time.

For want of real facts, I'll tell my own story in their place, and because it is about the entire history of the tribulations of two Saxons in Berlin, I choose as the starting point of my observations a work in the possession of the Dresdener Gemäldegalerie, namely, Ferdinand von Rayski's *Wermsdorf Forest* from 1859. In a different context, the work had already taken its place in the history of art. I will begin then with a short description of the painting.

In the center, a little under the horizon, stands a single mighty tree shown without its crown – not in its entirety that is – surrounded by birch trees. In accord with the atmosphere of the forest, the observer finds himself standing before the picture at the end of winter in the waning sun: thin shadows fall away from the trees. The trees depicted here bear no leaves, consistent with the season suggested. The central tree with it's knotty branches, divides at the first third of its trunk into two strong limbs, which grow upwards into the sky. Since it is a German painting we are talking about, the tree is probably an oak. A second horizon, placed a little above the first, indicates a hilly landscape in the background. The central tree determines the painting's composition, but also the situation in the forest. The semi-circle of birch trees surrounding the oak are given less status but form the setting as

Ferdinand von Rayski, *Rest from hunting in Wermsdorf Forest,* study of the forest, around 1859, Oil on canvas, 105 x 114 cm Staatliche Kunstsammlungen Dresden

well as the repoussoir of the whole. Other oak trees stand among the birches, in the depths of the background. They express the painting's actual theme less strongly and corresponding to their humbler significance. They are also less elaborated. The painting, rather than the landscape, emphasizes as idea, the mighty tree stands for itself alone!

This painting by Rayski appeared in 1972 in the catalog designed by Franz Dahlem for the Baselitz exhibition at the Hamburger Kunstverein, as a black-white illustration with no further explanation. Artists from the Dresden School were at that time not known to me, consequently, neither was the painting described above. Baselitz had this painting in mind as he set into the world *The Upside-down Forest* in 1969.

During my later visit to Dresden in the Gemäldegalerie, Penck also didn't want to show it to me. Its presence as illustration may have been sufficient. At that time my overriding interest was in contemporary painting. As such, the painting remained concrete and is rather worth mentioning in connection with the course of Baselitz' work. While searching for historical facts about the 1st and 2nd pandemoniums (fig. 150, p. 129 and fig. 152, p. 131), with which apparently no one is willing to come forth, I'll have to think up my own story, irrespective of all that I've heard over the years. Some anecdotes can already be checked and the contents of the manifestos were publicized on various occasions, as were the works of Lautréamont and Artaud, the minds who had inspired the matter. Their works were available and could be read in good German translation at that time.

The *Wermsdorf Forest* brings me to the Adorno quote about truth, which the artist has a lifetime to formulate because this privilege belongs to him alone. "Even someone believing himself convinced of the noncomparability of works of art will find himself repeatedly involved in debates where works of art, and precisely those of highest and therefore incommensurable rank, are compared and evaluated one against the other. The objection that such considerations, which come about in a peculiarly compulsive way, have their source in mercenary instincts that would measure everything by the ell, usually signifies no more than that solid citizens, for whom art can never be irrational enough, want to keep serious reflection and the claims of truth far from the works. This compulsion to evaluate is located, however, in the works of art themselves. So much is true: they refuse to be compared. They want to annihilate one another."[1] In the logical conclusion, there can also only be one artist who survives. The actual story surrounding them both, about the manifestos which the artists jointly produced, can neither be told nor written down in the comprehensive sense of the "whole" truth. The only reality upheld by the truth lies in the drawings and paintings from that time

[1] Theodor W. Adorno, *Minima Moralia. Reflections from Damaged Life* (London, 1996) 75.

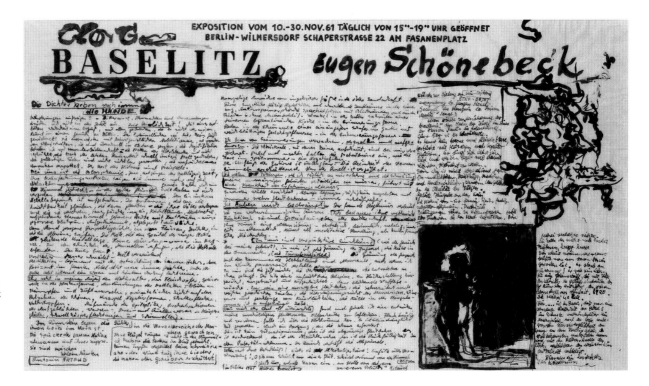

150 **Georg Baselitz**
Eugen Schönebeck
Pandemonium I
Manifesto (1st Version),
1961
Ink, tracing paper
59 x 102.7 cm
Ludwig Forum Aachen

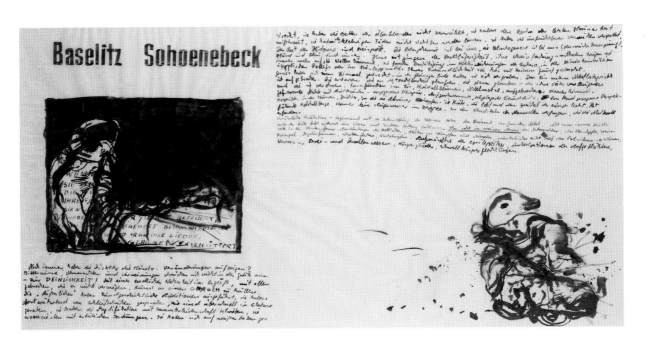

151 **Georg Baselitz**
Eugen Schönebeck
Pandemonium I
Manifesto (2nd Version),
1961
Ink, tracing paper
52.3 x 104.7
Ludwig Forum Aachen

129

and only there can it be found and perceived. The intentions of both artists in the two illustrated texts were interwoven into a strong, great whole, an outcry and an attempt to break through with word and image, black Indian ink trickled onto paper – named Pandemonium. Incunabula of recent German art history? Two young artists recall unequivocally their own origins and culture and contradicted, in a kind of late vintage surreal fragment, not only all outward influences of the spirit of the age but also the Abstract's Informel. They chose what was at that time the most difficult of all possible means. The

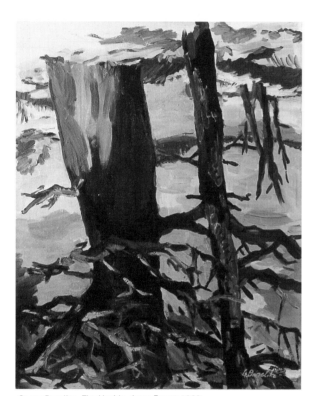

Georg Baselitz, *The Upside-down Forest,* 1969
Oil on canvas, 250 x 190 cm, Museum Ludwig, Cologne

physical as well as the psychic efforts necessary were so intensive that over a shorter or longer time it had to come to an altercation. They separated just as the 2nd Pandemonium was finished. Two strong personalities, each needed fresh air and the room to define his own space. If one were to reflect on the drawings and paintings from that time within today's contexts, one can come to the realization that Schönebeck attempted to capture in his paintings the iconography which the manifestos and their visions delivered in words. As a drawer, Baselitz undertook writing to free himself from the confines and unintelligibility of text, to establish new positions on another shore and to discover new ideas.

With the discovery of the graphics and frescoes of the mannerism artists in Florence, Baselitz succeeded in this step to painting *A New Type* (1965) – a first go – but he was already underway to a new painting for our time: *The Upside-down Forest* (1969).

From the heroic times before 1968, Schönebeck's unusual portraits of Pasternak, Majakowski, Siqueiros, but also of a Soviet soldier or of Mao Tse-tung remain intact for us and show again the great beauty with which the whole dream could have been formed. *The Basic Human* (1964; fig. 185, p. 149) was ahead of its time, because even then the painting revealed the pain over the loss of utopia, which was soon to be replaced by the general rhetoric used in societal discourse. The means of painting was not enough in coping artistically with the new situation.

Finally, by mentioning three other pairs of artists, I want to mitigate this exceptional case in Berlin, with the good intention of being then able to discuss it in other contexts. To this I want to add, van der Leck and Mondrian, as well Meyer-Amden and Schlemmer, not to forget Chaissac and Dubuffet. Should there be a rule to these juxtapositions, it would go as follows: The first named in each pair already had the idea in his head for a new language of images, but realized it in the dialect of his culture, which in turn his friend and opponent took on and in some years was able to transform into a very specific world language. The strategic games intimated are manyfacetted and as we know, the dialect has especially now received increased attention, so that new realizations need to be considered. While searching for the artistic truth, once again torn between cause and effect, we are left with a warning in the ring from Kurt Schwitter's mother: "Don't let them take you by surprise, boy!" Schwitters, another exceptional case for the next round.

Johannes Gachnang

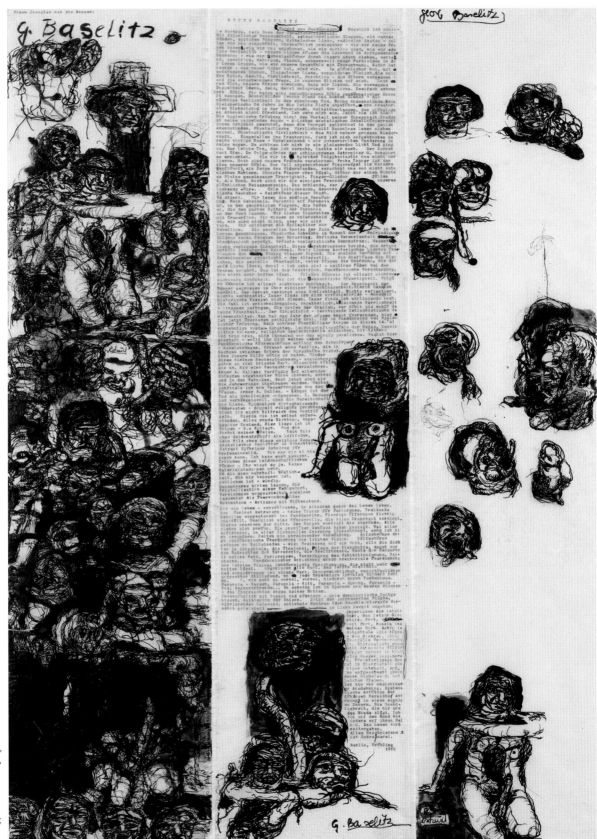

152 **Georg Baselitz**
Pandemonium II
Manifesto, 1962
Ink, typewriter, ball-point pen,
tracing paper on three stripes,
left half of a paper sheet (cut
through in 1962; right half
presumably in Eugen
Schönebeck's possession)
88.5 x 20.4 cm; 98 x 20.4 cm;
88.6 x 20.4 cm
Ludwig Forum Aachen

131

153-169
Georg Baselitz
17 drawings
for the *Pandemonic*
Manifestos

153 Untitled, 1962
Ink, tracing paper
11.2 x 11.5 cm;
34.3 x 20.9 cm;
16.3 x 21 cm
20 x 21.1 cm
Ludwig Forum Aachen

154 Untitled, 1962
Ink, typewriter,
tracing paper
53 x 21.2 cm;
19.9 x 9 cm;
28 x 8.1 cm;
11 x 9.5 cm
Ludwig Forum Aachen

155 Untitled, 1962
Ink, pencil,
tracing paper
30.9 x 18.2 cm;
14.9 x 17.8 cm;
27.3 x 25.6 cm
Ludwig Forum Aachen

156 Untitled, 1962
Ink, tracing paper
11.2 x 11.5 cm;
16.3 x 21 cm;
34.3 x 20.4 cm; 20 x 21.1 cm
Ludwig Forum Aachen

157 Untitled, 1962
Ink, tracing paper
41.9 x 29.4 cm
Ludwig Forum Aachen

158 Untitled, 1962
Ink, tracing paper
42.1 x 29.5 cm
Ludwig Forum Aachen

159 Untitled, 1962
Ink, tracing paper
77.8 x 42.1 cm
Ludwig Forum Aachen

160 Untitled, 1962
Ink, tracing paper
63.8 x 38.8 cm
Ludwig Forum Aachen

161 Untitled, 1962
Ink, tracing paper
27.3 x 18.6 cm
Ludwig Forum Aachen

162 Untitled, 1962
Ink, pencil, splashes of white paint,
tracing paper
56.2 x 29.2 cm
Ludwig Forum Aachen

163 Untitled, 1962
Ink, tracing paper
36.5 (27.1) x 41.7 (40.4) cm;
33.5 x 33 cm
Ludwig Forum Aachen

164 Untitled, 1962
Ink, tracing paper
70.1 x 43.3 cm
Ludwig Forum Aachen

165 Untitled, 1962
Ink, tracing paper
72.3 x 42.1 cm
Ludwig Forum Aachen

166 Untitled, 1962
Ink, tracing paper
71.2 x 33 cm
Ludwig Forum Aachen

167 Untitled, 1962
Ink, tracing paper
71.8 x 33 cm
Ludwig Forum Aachen

168 Untitled, 1962
Ink, clear film
60.6 x 48 cm
Ludwig Forum Aachen
(no illustration)

169
Untitled, 1962
Ink, clear film
59 x 48.7 cm
Ludwig Forum Aachen
(no illustration)

170 **Georg Baselitz**
Figure with Animals, 1964/65
Blue-black chalk on beige paper
75 x 57.4 cm
Staatliche Graphische Sammlung,
München

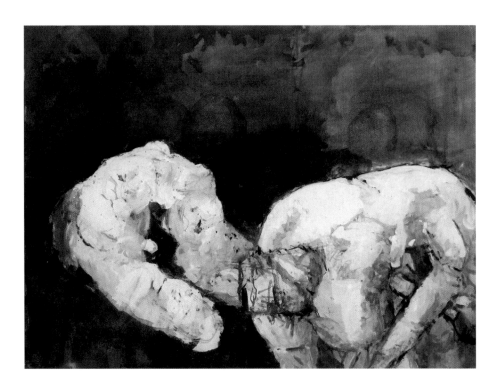

171 **Georg Baselitz**
Sex with Dumplings, 1963
Gouache, opacque white,
pencil on paper
47.5 x 63 cm
Galerie Hauser & Wirth, Zürich

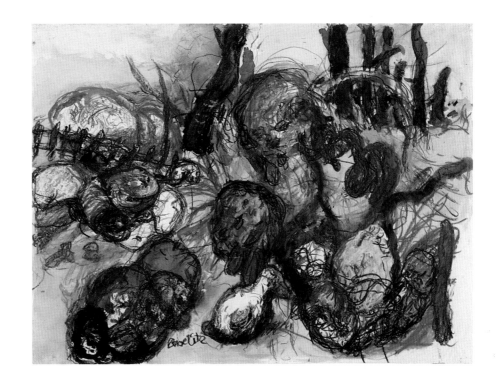

172 **Georg Baselitz**
Saxon Landscape, 1962/63
Watercolor, pencil, charcoal,
tempera on paper
48.3 x 62.2 cm
Staatliche Graphische Sammlung,
München

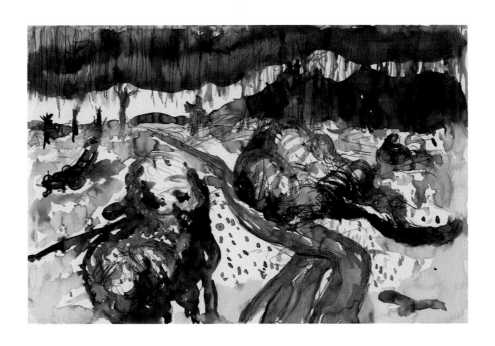

173 **Georg Baselitz**
Duck Pond, 1964
Watercolor, pencil, charcoal,
tempera on paper
41.8 x 61.6 cm
Staatliche Graphische Sammlung,
München

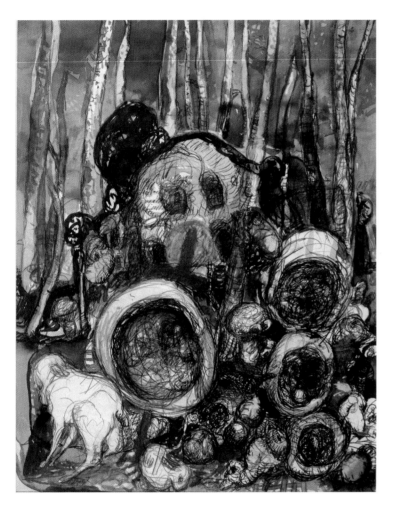

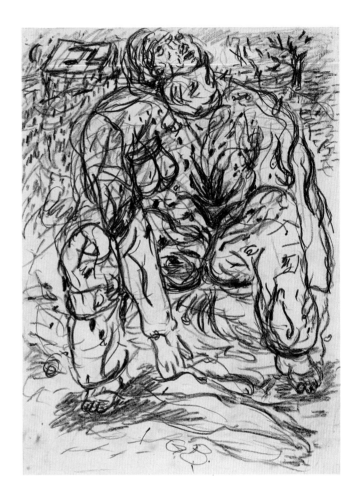

174 **Georg Baselitz**
The Forest, 1964
Pencil, watercolor, ink, opacque
color on paper
63 x 48 cm
Galerie Hauser & Wirth, Zürich

175 **Georg Baselitz**
Untitled (Person sitting) 1965
Graphite on paper
45 x 32 cm
Staatliche Graphische Sammlung,
München

"Words are Swingling Swine":[1]
The Unfinished Work of the Painter
Eugen Schönebeck

Eugen Schönebeck, *Woman,* 1961
Ink on paper, 39.7 x 29.7 cm
Courtesy Silvia Menzel Beratung und
Betreuung von Kunstsammlungen, Berlin

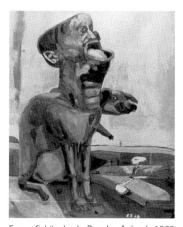

Eugen Schönebeck, *Dresden Animals,* 1963
Oil on canvas, 160 x 132 cm
Whereabouts unknown

A Search for Traces

The painter Eugen Schönebeck is a legend, a myth in German art of the postwar period. It is nourished both by the denial of Schönebeck, the man, who gave up painting thirty years ago and renounced public access to his person, and by the inadequate and imprecise accounts of his circumstances and origins. Conversely, the paintings and drawings are so radical and of such superior quality that his quantatively modest oeuvre could not remain unnoticed.

What is known can be quickly recounted, but the fundamental questions remain, for the work of Eugen Schönebeck is to the present day hard to grasp. With only seven paintings sparsely distributed in public institutions and otherwise in partially inaccessible private collections, his work having been shown only twice comprehensively,[2] an uneasy feeling prevails in the otherwise well-informed art world that only a fragment, rarely discussed, is known.

Born in Heidenau near Dresden in 1936, Eugen Schönebeck first makes a detour as painter apprentice. Upon coming of age, he begins his studies at the Hochschule für Bildende und Angewandte Kunst (HfBAK) in East Berlin. He attends a class for large-scale painting where he is introduced to the propaganda art of social realism but leaves after only one semester and moves to West Berlin. There he begins to study at the Hochschule für bildende Künste, at first under Hans Jaenisch, then taking Hans Kuhn's course on mural painting. Here Schönebeck becomes acquainted with the period style of the fifties and works in the abstract. In 1957 he meets Georg Kern who studies with Hann Trier and who had also transferred from the HfBAK. With Trier, who calls himself Baselitz as of 1961, he develops a closer friendship as well as friendships with Antonius Höckelmann and Peter Zinke. The two young students see themselves as outsiders and, on the basis of this romantic feeling, plan to publish a type of manifesto and to organize an exhibition.

That is how an exhibition came to be held in West Berlin in November 1961, three months after the wall was erected, described in retrospect as being "the perhaps most significant event (for German painting) of the period",[3] though it had little or no echo in those days. Baselitz and Schönebeck showed their most recent work in the midst of newspaper clippings and poems on one rented floor of a condemned building on Schaperstrasse. A large placard with texts and drawings was sent out and

posted primarily in galleries as announcement for the *Exposition* (cf. figs. 150f., p. 129). It was only a few months later that the actual *Pandämonium* (Pandemonium) was published (fig. 152, p. 131), so that the *1. Pandämonisches Manifest* (1st Pandemonian Manifesto) came into being

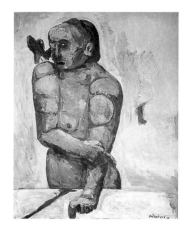

Eugen Schönebeck, *Figure with Bird II,* 1964
Oil on canvas, 162 x 130 cm
Private collection

only later. The texts are dominated by elements of existential paranoia and nihilistic suffering, of a sense of nothingness charged with feelings. In the dark paintings and primarily in the ink drawings, the gentle shedding of abstraction is the visible sign of Schönebeck turning away from the style of the period, as, for example, in the work *Frau* (Woman) of 1961. Exploring the "new figurations,"[4] showing a surprising parallel in principle questions to the Munich group SPUR, Schönebeck, with the help of literature by Antonin Artaud, Lautréamont, and Samuel Beckett, makes the absurd and the exalted his own. With the help of art by Jean Fautrier, Chaim Soutine, and Jackson Pollock, he lays bare the figure. The history of modernism, its problems, and minor figures are explored intellectually and sensualistically far off from the common course.

Schönebeck's intensive portrayal of the present led from the abstraction of landscape to the depiction of the human figure, at that time a reviled subject virtually ignored. In the six years of intensive work, four phases or work groups can be determined in the paintings, and, nearly parallel to these, in the drawings. The first phase 1961-1963, the skinning of deformed bodies placed centrally against a flat dark background, depicts as its central theme the exaltation of the body as a reflection of the soul, as a portrayal of negative existence and of the worldly demon. The second phase 1963-1964 includes three figural paintings based on Odilon Redon and two depictions of animal-humans as well as four crucifixions. In the former, a mythic-symbolic extension of the body is visible, which communicates in the crucifixions, created at the same time and placed out-of-doors, a heightened empathy. The third phase 1964-1965 is formed by half-

1 In the original: "Worte sind Schwengelschweinchen." This is Schönebeck's variation of A. Artaud, quoted by Baselitz at the end of his text in the second manifesto of the Pandemonium: "Alles Geschriebene ist Schweinerei" (All writing is crap). The more common *Schweinerei,* based on the word pig(gishness), has connotations of scandal, disgrace, mess, etc., while *Schwengelschweinchen* is a made-up compound. *Schweinchen* is the diminutive of pig, while *Schwengel* is a word not found in modern German dictionaries. In historical or regional language dictionaries it is found to be used for a variety of meanings, often for

length portraits in which the cubistic segmentation of color planes has almost ornamental features. T-shaped constructions have been placed in front of the face, suggesting a type of control from outside or making the hindrance to their existence obvious. At the same time, this barrier, a bar between portrait and viewer, heightens the interest in what is being depicted. The group of works 1965-1966, finally, is a segmental painting based on Schönebeck's experiences in the East. With revolutionary heroes pointing like ethos formulas far beyond their own person and at the same time standing isolated without a following, he ends his public presence - then silence. The fading of the driving ardor, the loss of an idealistic hopeful faith in the „free zone of art," may have been the reason for this denial, for his faith was quickly crushed by Schönebeck's experiences with an art scene much disliked by him and by a profit-oriented art market that mostly did not care about content. Arising out of this awareness, a bridge was spanned between hope and mourning.

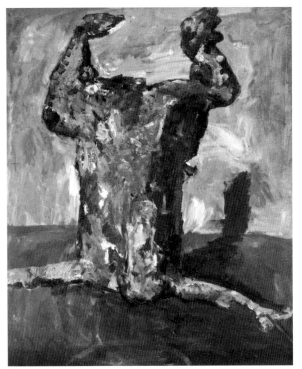

Eugen Schönebeck, *Bait,* 1963
Oil on canvas, 162 x 130 cm
Private collection

The strain, though, broke an irreconcilable artist's soul. Injured, it continues to live today as denial. The quiet elegy recounts the foundering of the "utopia (previously lived artistically) by an outsider who declares his love to a society that he does not accept and that does not accept him."[5]

The Theater of Cruelty (A. Artaud)

In *Verlust der Mitte*[6], 1948, Hans Sedlmayr harshly criticized the surreal chaoticism of depictions of the human being tormented and deformed since Goya. Schönebeck's art is to be understood, though, in exactly this context. He continues the tradition of the "aesthetics of ugliness"[7] and verifies, drawing from Hegel, "the internal essence of nature that exists here - pure self."[8] Looking back to German idealism, Schönebeck's *Nacht des Malers* (Night of the Painter) of 1961 possibly interprets the negation of the subject as described in Hegel's *Nacht der Welt* (Night of the World): "The human being is this night, this empty nothingness that contains everything in its simplicity, a richness of infinitely many ideas."[9] Turning outwards again this dialectic characterizes the relationship to past art that continues to have an effect to the

present day, at first scorned as retrograde, today recognized as unexpected progress - and marks here the figurative introduction to Schönebeck's work.

The surrealistic round of language in the first manifesto entitled *Methods for Creating (Being-Objects) Être-Objet* turns against abstraction and proclaims: "Conditions lead to insight but not tendencies that are too cocksure." The actual *Pandemonium,* the meeting of the evil spirits and demons, came into being in the spring of 1962, with the second manifesto. Schönebeck shows his reverence here to Mikhail Vrubel, Gustave Moreau, Fred Deux, and Dado. The final sentence is: *"Worte sind Schwengelschweinchen",* a variation of a quotation from Artaud. At the same time *Pandemonium* stands for the end of the male camaraderie. An exhibition does not take place.

Bearing the imprint of Tachisme, Schönebeck works on dim figures having no credible talent nor will to survive. With crude descriptions of kafkaesque creatures the inner pain erupts and disfigures the "economic miracle's" advertising aesthetics of clean-pored body surfaces to atrophied, crippled, deformed creatures gone mad. As if the physical suffering were not enough, *Gehängter* (Hanged Man), 1962, *Köder* (Bait), and *Gefolterter* (Tortured Man), both 1963, illustrate being dependent on and at the mercy of the anonymous, "lonely crowd"[10] of society. They are assigned a role in which victims and perpetrators, the animal from the human being, cannot be distinguished. The body communicates the suffering in and due to the world. It forms the cutting line between our being and our environment, society.

That which shines through with *Ginster* (fig. 181, p. 145) - the choice of title having no conscious connection with Siegfried Kracauer's novel of 1928 - has notable parallels to Schönebeck's complete oeuvre and is possibly related to the rediscovery of the New Objectivity painting beginning in 1961 (Berlin, Haus am Waldsee). The level of awareness, which can be summarized as "behavioral teachings of the cold" for the "attempts to live between the wars" in the 1920s, is symbolized by the protagonist Ginster, who "moves the dilemma of the self-confident subject into the ramp light of comedy", a tragicomic "hero, a new objective self-less appearance, ... greeted by contemporary criticism as a 'sociological Chaplin.'"[11] Schönebeck's postwar depiction of the human being is born of the same intellectual attitude as Kracauer's between-the-wars depiction, and the two may be seen as comparable characters if one considers the theory of roles in *Homo Sociologicus* (1958). It is not possible to transform the *Homo Sociologicus* "into a specific individual either ... He remains a pale, half, strange, artificial person ... an inhabitant of a world that is not the world of our real experiences, but does have considerable

something that swings back and forth: e.g. bell clapper, tail, penis, etc. (Trans.)

2 Cf. *Eugen Schönebeck,* exhibition catalog (Berlin: Galerie Abis, 1973/1974); and *Eugen Schönebeck, Die Nacht des Malers,* ed. Carl Haenlein, exhibition catalog (Hanover: Kestner-Gesellschaft, 1992).

3 Kynaston McShine, "Berlinart: An Introduction," *Berlinart 1961-1987,* ed. Kynaston McShine, exhibition catalog, (Munich: Prestel, 1987) 14.

4 Hans Platschek, *Neue Figurationen: Aus der Werkstatt der heutigen Malerei* (Munich, 1959).

5 Walter Grasskamp, *Der lange Marsch durch die Illusionen: Über Kunst und Politik* (Munich, 1995) 78.

6 Hans Sedlmayr, *Art in Crisis: The Lost Center,* trans. Brian Battershaw (Chicago, 1958).

7 Karl Rosenkranz, *Ästhetik des Häßlichen* (1853; reprint, Darmstadt, 1973).

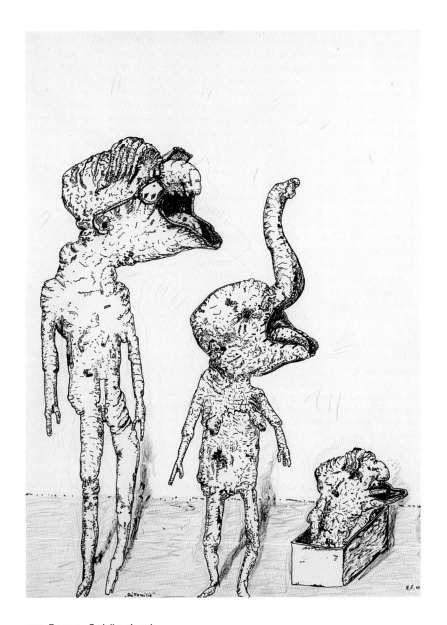

176 **Eugen Schönebeck**
The Family, 1963
Ink nib pen, graphite and wax
crayon on paper
60.8 x 43 cm
Berlinische Galerie, Berlin,
Landesmuseum für Moderne Kunst,
Photographie und Architektur

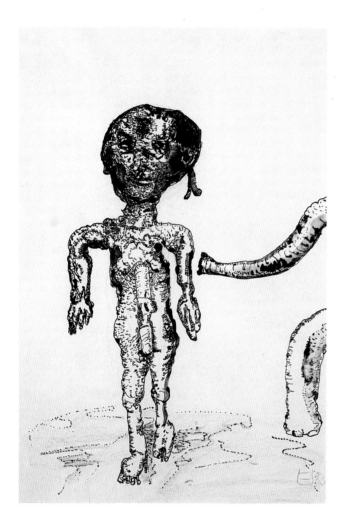

177 **Eugen Schönebeck**
Untitled, 1963
Nib pen, ink, and red chalk on paper
45.6 x 30.2 cm
Berlinische Galerie, Berlin,
Landesmuseum für Moderne Kunst,
Photographie und Architektur

178 **Eugen Schönebeck**
Untitled, 1963
Ink nib pen, washed and graphite
on paper
60.7 x 43 cm
On loan from the
Federal Republic of Germany

179 **Eugen Schönebeck**
Untitled, 1963
Nib pen, ink, and ball-point pen
on paper
60.7 x 43 cm
Berlinische Galerie, Berlin,
Landesmuseum für Moderne Kunst,
Photographie und Architektur

180 **Eugen Schönebeck**
Untitled (Crucifixion), 1963
Nib pen, ink
on paper
42 x 29.5 cm
Berlinische Galerie, Berlin,
Landesmuseum für Moderne Kunst,
Photographie und Architektur

Francis Bacon
Fragment of a Crucifixion, 1950
Oil and cotton wool on canvas
139 x 108 cm
Stedelijk Van Abbemuseum, Eindhoven

8 Georg Wilhelm Friedrich Hegel, *Sämtliche Werke,* vol. XX, Jenenser Realphilosophie: Jenenser Philosophie des Geistes (1805/1806; reprint, Leipzig, 1911), p. 181. Cf. also Slavoj Zizek, *Grimassen des Realen: Jacques Lacan oder die Monstrosität des Aktes* (Cologne, 1993) 45-54.

9 In the original: *"Der Mensch ist diese Nacht, dieses leere Nichts, das alles in ihrer Einfachheit enthält, ein Reichtum unendlich vieler Vorstellungen."* (Trans.) Hegel.

10 David Riesman, *Die einsame Masse: Eine Untersuchung des amerikanischen Charakters,* trans. Renate Rausch (Hamburg, 1958). American original: *The Lonely Crowd: A Study of the Changing American Character* (New Haven: Yale University Press, 1950).

11 Helmut Lethen, *Verhaltenslehren der Kälte: Lebensversuche zwischen den Kriegen* (Frankfurt/Main, 1994) 185f.

12 Ralf Dahrendorf, *Homo Sociologicus* 15th ed. (Opladen, 1977) 82

13 Lethen 186.

14 Oskar Bätschmann, "Ausstellungskünstler: Zu einer Geschichte des modernen Künstlers", *Kultfigur und Mythenbildung: Das Bild vom Künstler und sein Werk in der zeitgenössischen Kunst* (Berlin, 1993) 1-35, 23.

15 Susan Sontag, "Der Künstler als exemplarisch Leidender", *Kunst und Antikunst: 24 literarische Analysen* (Frankfurt/Main, 1982), pp. 91-101. American original: "The Artist as Exemplary Sufferer", *Against Interpretation* (New York, 1962).

similarities to it."[12] Schönebeck's creatures also reflect the models of society experienced autobiographically and shaped by the individual. This sociopolitical reference is paradigmatic for all phases of Schönebeck's work. For that which is formulated with Ginster and takes on a central position in Schönebeck's work with the human figure "is a circumstance that is conspicuous when seen from the angle of exterior control: Ginster does not act - 'he behaves' ... His resistance does not lie in protest, but 'in his manner of receptivity.'"[13]

Social Contract

This is also the case in the four crucifixions forming the central group that are rich in symbolism. In the *Kreuzigung* (Crucifixion) of 1963 (fig. 182, p. 147), in allusion to Artaud's *Van Gogh, the Suicide of Society* (In the original: *Van Gogh, le suicidé de la société.* Trans.) the flesh and blood under the van Gogh-related head shows not a ray of paschal hope. The passion figure of the Christian religion, the human sacrifice of the Son of God - aside from the motif of the thieves suggested by the T-shaped crosses - refers to a "secondary show place" rich in tradition. Honoré de Balzac was not the first "to declare Christ as the most admirable model for the artist whose life stands under the yoke of the maxim that a great man must be unhappy: ... 'Un artiste est une religion' - an artist is a religion."[14] Since Dürer, a reproach of a society that provokes the suffering of artists is lodged in Christomorphic self-depictions. Van Gogh is synonymous with this. The "exemplary sufferer"[15] is effusive about his flesh and shows himself naked. With the act of sacrifice, he guarantees in the end that there is the other one. He finds unity with the world in the "mandate of the symbolic sacrifice that society has transferred to him ... the more innocent he is, the more his sacrifice weighs."[16] As in comparable depictions by Francis Bacon and Antonio Saura, Schönebeck's crucifixions are neither about Christian crucifixions nor explicit self-portraits. Rather, they manifest the artist's observations that reveal him and the anonymous other as a martyred element of the community.

Narratively this "negative dialectic" supports Schönebeck's depiction of the human being, a position that can be understood as provocative counterpart to the propagated culture of repression and joyful hedonism. These are the psychosocial emotions of the individual in an absurd world, positioned in the middle of the pictorial square. Like the ideology, the iconography is fixed, established in the paradox of the *Homo Sociologicus,* between morality and alienation[17] - in the two world systems of Germany and particularly of Berlin. *The Family* of 1963 (fig. 176, p. 141) is anchored as a significant example in this role. It characterizes the despicable traditional domestic picture from which no new developments can

emerge. The methods of countering this, as concrete as they are cynical, evinced in aspects of the anti-institutional liberation in the commencing student protests, are the anti-affirmative visual shock of implacability. This is meant to halt the unreflected course of history and lead to new sensations via the empathy evoked by the anguish of the world. The paradoxical "social contract" - free choice and the attending moral obligation - were put in the picture by Schönebeck, were, so to speak, nailed to the cross or identified in the images as mechanical exterior control and "speech defects."

The Constructed Human Being

Schönebeck leaves the world of ugliness and anguish in the year 1964. With *The Real Human* (fig. 185, p. 149), a synonym for the socio-political revolution and directives for a new future, the format changes into the symbolically monumental and the bold. *The Real Person* is caught in a geometric system of inherent pictorial formalism and establishes no positive relationship to technology, unlike the figures in works of artists favored by Schönebeck: Fernand Léger, Alexander Deinekas,[18] or the Mexican muralists. On the other hand he is characterized by his attributes. The T-shaped knob (of a spade?) above his left shoulder signals action, work, change, underwrites renewal and culture: "Worker, take up the pen!"[19] Yet it is not the picture of a cultural revolutionary that is called up, rather it is an immobile human being degenerated to the technical and (remote-controlled) person-machine, whose small head seems to be will-lessly subordinated to the massive body. Together with the T-shaped cross the bar coming into the picture from the right and leading over a locking mechanism for the arm seems to support the head from which eyes look almost fearfully beyond the picture to the right. Schönebeck paints a transparent critical depiction of the "Real and New Person", whom the functionaries of the propaganda machinery and of the Bitterfeld planning culture had euphorically called out to the world. Decisive for their point of view is perhaps a drawing on which he is working at the time: a "constructive depiction of the human being", an ideational subject and ideal object. For as a late consequence of the radical Russian avant-garde and in the sense of the behavioral teachings it is true that: "the human being is by nature artificial."[20]

Myths of the Revolution

Against this background the heroic person is central in the last well-known paintings and block-like drawings of the year 1966. He takes on a less ambivalent stance. For in the interwoven relationships of "proletarian culture and art",[21] of the Russian, Mexican, and Chinese (cultural) revolutions, which also stand for far-reaching changes in

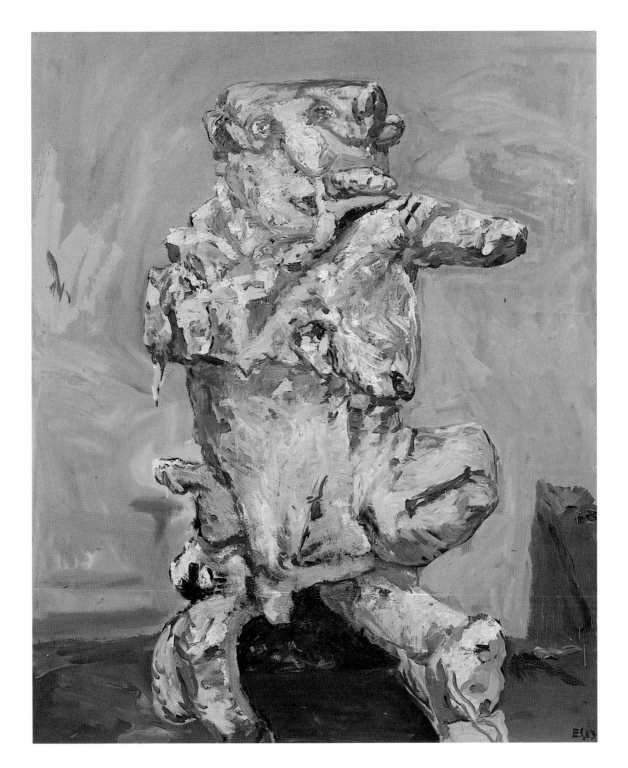

181 **Eugen Schönebeck**
Ginster, 1963
Oil on canvas
162 x 129 cm
Private collection

Fernand Léger, *The Construction Workers*
1950, oil on canvas, 300 x 200 cm
Musée National Fernand Léger, Biot

Eugen Schönebeck, *Siqueiros,* 1966
Oil on canvas, 162 x 130 cm
courtesy Silvia Menzel Beratung und
Betreuung von Kunstsammlungen, Berlin

the visual media, the painter Schönebeck positions himself above the middlemen. In the act of looking the afterimages, which are divided into partial color planes, become archetypes (In the original: „...Nachbilder zu Vorbilder." Trans.). In the intellectual bourgeois disposition of poetic and political sublimations of the past an impressive humanistically communist gallery, which Schönebeck could paint without any political doubts, is presented: Mayakovski, Mao Tse-tung, Pasternak, Siqueiros, Trotsky, Lenin, Yevtushenko. They lit the revolutionary fire in which history is illuminated and in which, nourished by utopia, the present remains alive. Beyond the idea of a better society incarnated in the depiction of the human being the selected heroes stand, so to speak, as living monuments, as social figurations, in front of the viewer. In the drawings, in which pencil hatching merges to chiseled portraits, as in *Ho Chi Minh and Mayakovski of 1965/1966* (figs. 183/184, p. 148), Schönebeck also strove for a reflected identification with the photographic prototype.

Thus pacification of the cold war was offered in exchange for the ideological misuse by the standard bearers of a socialist realism that had long since been exposed for its name juggling and its inhuman state art. In the impersonal objectified sham-aesthetics - a transfer picture of the fetishism with consumer goods - it was not the subject that was central to the service of humanity, but the object to the greediness of the masses. In the West as well as in the East the same ideals were exalted. Schönebeck's portrait gallery is unique in that it can be derived from the terrible exclusivity of the German problem and specifically from the Berlin case and be grasped only with Schönebeck's authentic crossing of systems. In the interlinking of the formalistic and social realistic demands, the freedom of the homeless individual *à rebours*[22] was guaranteed. In the linking of both aesthetic mass phenomena the "alternative other" of the individual, the heroic genius of the masses, had to be presented as example for the masses, to be "depicted in his greatness as extremely lonely".[23] It is the human being's constitutive lack of equilibrium that requires an act of balance with which the painter - in social figurations relayed through the depiction of the human being - also realizes himself. Thus his heroes no longer require barriers or supports.

Berlin Things - German Tragedy

Eugen Schönebeck's works reflect society's lack of individuation and testify to an artistic position that saw and sought art as a counterbalance, as a politically subversive power against the negative image of the educational and creative task. Against this background the problem of German history before and after 1945, in particular of its two art histories, indicates that Schönebeck's solution

could not be the goal, but that it does embody a more honest and at the same time more painful inclination to tragic resignation than to give oneself up by continuing. "The unaesthetic democracy",[24] as a general model linked to the West and as a Berlin counter-model, offered a solution to the "German Tragedy" neither in active artistic deed nor in renunciation. Schönebeck could only counteract this in the service of the genre and of humanity by relentlessly and doubtfully treating it as an unreasonable Commedia dell'Arte: negative in its image and positive in its being, utopian and yet localized, classically oriented, but not conventional. Thus these pictures would not have been thinkable in the East either. They stand for an alternative without alternative, for a subversive desire without real subversion.

In the regressive traditional disposition of painting, the "politicization of aesthetics," as rehabilitation of suppressed human creativity, was to outlive the exploitation of humanity by humanity. Suffering and hope circumscribe the field of tension in which all motifs are embedded and which turns against the demagogical "aestheticization of politics" by demiurges.[25] Thus Schönebeck's early works were and are expression of the abstract identity, the late components of a positive industry of identity, which take the political dimension of human deeds and visual art seriously. They demand that one question and take a position. Neither the course of history nor the recipient should withdraw from their personified aura, which, if not quite cultic, is nevertheless politically charged.

Gregor Jansen

16 Zizek 71.

17 Dahrendorf 84.

18 Cf. Christos Joachimides, "Wer ist Eugen Schönebeck?", *Eugen Schönebeck,* exhibition catalog (Galerie Abis Berlin, 1973/74) n.p.

19 The appeal of the first Bitterfeld conference in April 1959 was: "Take up the pen, buddy, the socialist national culture needs you!"

20 "The principles of his (Helmuth Plessner's) anthropology of 1924 read lapidarily. 'The human being is by nature artificial. He is born in an 'excentric' position to his environment and requires the artificiality

of a second nature, of the cultural context ..' " Lethen 80.

21 Leo Trotzki, *Proletarische Kultur und Proletarische Kunst* (1924; reprint, Berlin, 1991).

22 Cf. the parallels to the work of Jean Hélion, for instance, the piece *Á rebours* (Against the Grain), 1947.

23 Zizek 168f.

24 Walter Grasskamp, *Die unästhetische Demokratie: Kunst in der Marktgesellschaft* (Munich, 1992) 127-35.

25 Cf. Boris Groys, *Gesamtkunstwerk Stalin: Die gespaltene Kultur in der Sowjetunion* (Munich/Vienna, 1988) 39f.

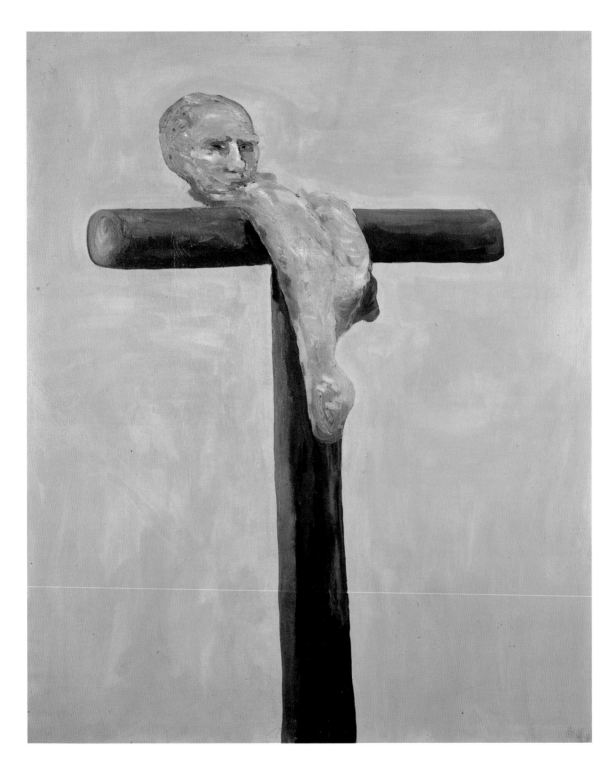

182 **Eugen Schönebeck**
Crucifixion, 1963
Oil on canvas
162 x 130 cm
Collection of Dr. Rabe, Berlin

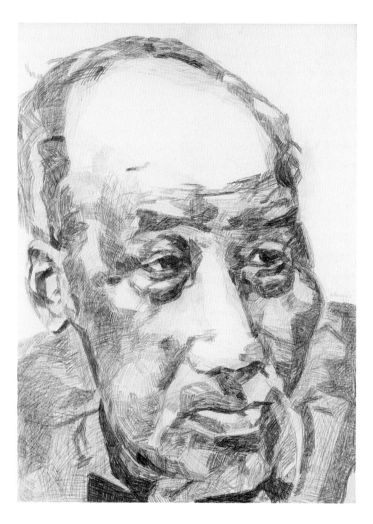

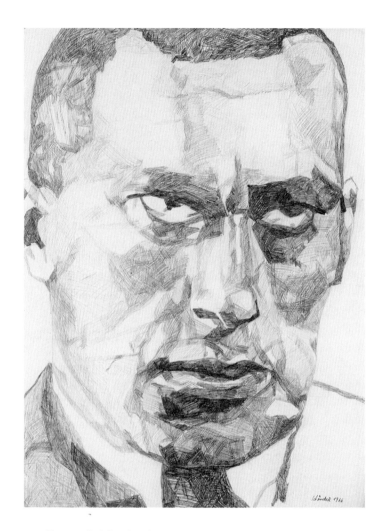

183 **Eugen Schönebeck**
Ho Chi Min, 1965/66
Pencil and paper
85.7 x 60.7 cm
Verlag Gachnang & Springer,
Bern–Berlin

184 **Eugen Schönebeck**
Mayakowski, around 1966
Pencil on paper
85.7 x 61 cm
Verlag Gachnang & Springer,
Bern–Berlin

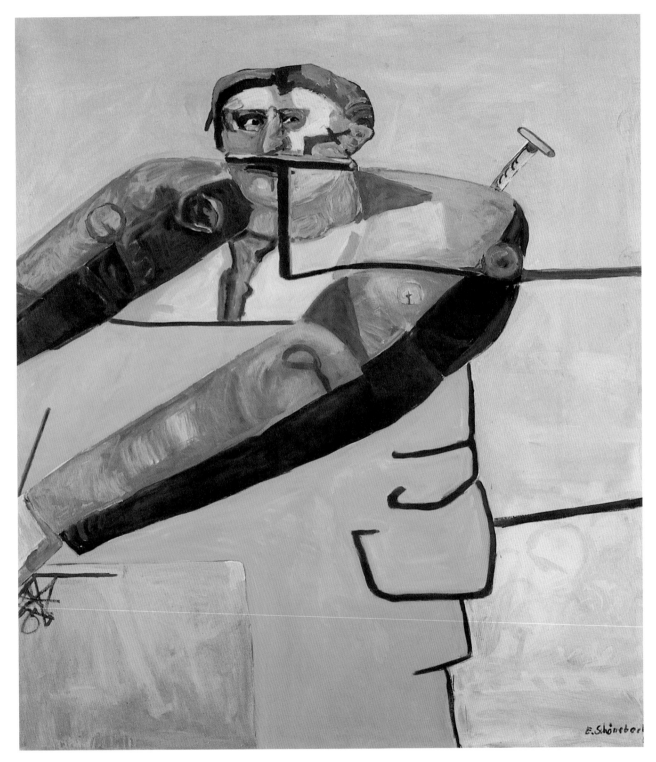

185 **Eugen Schönebeck**
The Real Human, 1964
Oil on canvas
219.5 x 188.5 cm
On loan from the Wittelsbacher Ausgleichsfonds
Sammlung Prinz Franz von Bayern to the
Bayerische Staatsgemäldesammlung München,
Staatsgalerie Moderner Kunst

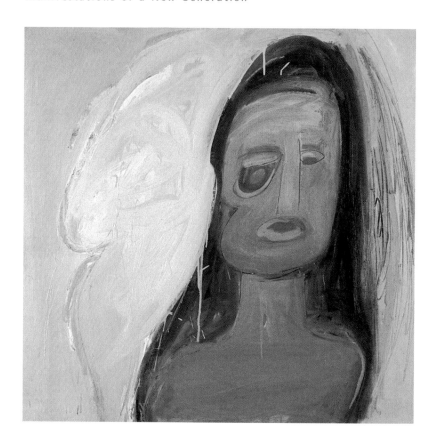

186 **Eva Hesse**
Self-Portrait, 1961
Oil on canvas
91.4 x 91.4 cm
Collection of Ruth and
Samuel Dunkell

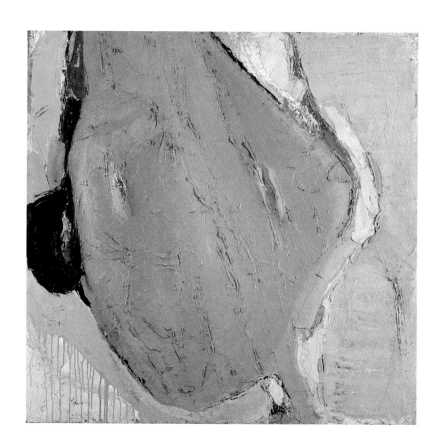

187 **Eva Hesse**
Untitled, 1963
Oil on canvas
ca. 100 x 100 cm
Collection of Ruth and
Samuel Dunkell

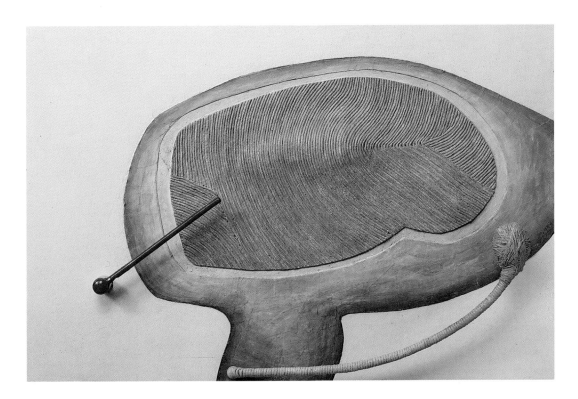

188 **Eva Hesse**
Legs of a Walking Ball, May 1965
Relief: Band, Emaille, Tempera,
Metal and Papermaché on
masonite
45.1 x 66.9 x 10.8 cm
The Estate of Eva Hesse, courtesy
Robert Miller Gallery, New York

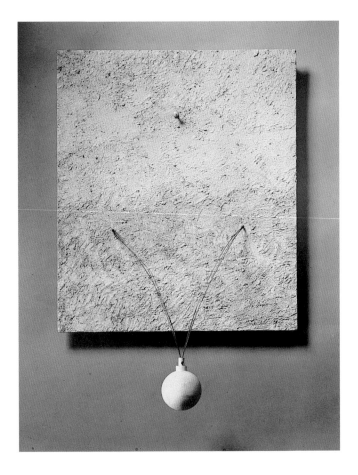

189 **Eva Hesse**
C. Clamp Blues, July 1965
Relief: various painted materials,
metal wire and plastic ball with
rattle on pressed chip board
65.1 x 54.9 x 3.8 cm
Private collection

Between Passion and Manifesto:
SPUR from 1958–1965

JANUAR-MANIFEST

1. Wer in Politik, Staat, Kirche, Wirtschaft, Militär, Parteien, soz. Organisationen keine Gaudi sieht, hat mit uns nichts zu tun.
2. Boykottiert alle herrschenden Systeme und Konventionen, indem ihr sie nur als mißratene Gaudi betrachtet.
3. Jeder echte Künstler ist zur Umänderung seiner Umwelt geboren.
4. Preise, Stipendien, gute Kritiken, alles wirft man uns nach; aber eins ist sicher: brauchen kann man uns nicht.
5. Unbrauchbarkeit ist unser höchstes Ziel: Gaudi ist unpopuläre Volkskunst.
6. Die ganze Welt ist der Bereich, in dem sich der schöpferische Impuls, der allein der Gaudi vorbehalten ist, entfalten kann.
7. Alles was anwendbar ist, ist nicht für den Menschen. Ohne den Künstler gäbe es schon jetzt keinen Menschen.
8. Wir sind gegen den Fasching, weil der Fasching die Gaudi kommerziell engagiert. Der Mißbrauch der Gaudi ist das größte Verbrechen.
9. L'art pour l'art ist beendet, ebenso l'art pour l'argent und l'art pour la femme. Jetzt beginnt l'art pour la Gaudi.
10. Schöpferisch sein heißt: durch dauernde Neuschöpfung mit allen Dingen seine Gaudi treiben.
11. Mensch sein heißt homo ludens und homo gaudens.
12. Seit der Herrschaft des dialektischen Materialismus und des Determinismus ist die Gaudi kein integrierendes Moment der Kultur mehr: wir fordern ihre Befreiung aus der Unterdrückung durch die herrschenden Ideologien und den Rationalismus.
13. Dem Satz „Wissen ist Macht", der das Zeitalter der Wissenschaft eingeleitet hat, wird der Satz folgen „Gaudi ist Macht", der das Zeitalter der Gaudi einleitet.
14. So wie Marx aus der Wissenschaft eine Revolution abgeleitet hat, leiten wir aus der Gaudi eine Revolution ab.
15. Die sozialistische Revolution mißbrauchte die Künstler. Die Einseitigkeit dieser Umstürze beruhte auf der Trennung von Arbeit und Gaudi. Eine Revolution ohne Gaudi ist keine Revolution.
16. Es gibt keine künstlerische Freiheit ohne die Macht der Gaudi.
17. Alle unzufriedenen Kräfte sammeln sich in einer Organisation der Antiorganisateure, die sich in einer umfassenden Revolution verwirklichen.
18. Wir fordern allen Ernstes die Gaudi. Wir fordern die urbanistische Gaudi, die unitäre, totale, reale, imaginäre, sexuelle, irrationale, integrale, militärische, politische, psychologische, philosophische ... Gaudi.
19. Durch die Realisierung der Situationistischen Gaudi werden alle Probleme der Welt gelöst: Ost-West-Problem, Algerienfrage, Kongo-Problem, Halbstarkenkrawalle, Gottesläsierungsprozesse und sexuelle Verdrängungen.
20. Wir engagieren die ganze Welt für unsere Gaudi.

(München, Januar 1961)

GRUPPE SPUR

Sturm
Prem
Fischer
Kunzelmann
Zimmer

The January Manifesto
(Gaudi Manifesto)
Flyer of the group SPUR, January 1961

[1] Lothar Fischer was on a scholarship at Villa Massimo in Rome at the time.

[2] Only in 1975 were the various accusations against the group finally rejected by the German Federal Constitutional Court.

[3] *Gruppe SPUR.* 2nd ed. (Munich: Galerie von de Loo, 1988) 16.

[4] *Gruppe SPUR,* 20.

[5] Margarethe Jochimsen and Pia Dornacher, eds., *Heimrad Prem. Retrospektive und Werkverzeichnis.* (Munich, 1995) 34.

In 1958, several young graduates of the Academy of Fine Arts in Munich founded the internationally focused artists' group SPUR (German 'track'): with their politically provocative artistic activities, flyers, manifestos—most significantly, the January Manifesto of 1961—, and the seven editions of SPUR magazine, the sculptor Lothar Fischer and the painters Heimrad Prem, Helmut Sturm, and, somewhat later, HP Zimmer, repeatedly clashed with church and state. Along with Dieter Kunzelmann, who would later co-found Kommune 1 in Berlin, they drew up the January Manifesto (also known as the "Gaudi Manifesto") for the exhibit Engagierte Kunst (Involved Art) in Munich. The manifesto would ultimately become the reason for a ban of SPUR's members in the Haus der Kunst. SPUR magazine, which first appeared in 1960, was also held by the organs of justice to be offensive and illegal. The district attorney's office attacked the magazine as early as 1961. The sixth edition met with particularly sharp criticism. It had been produced in southern Sweden with the help of Jørgen Nash, brother of the Danish painter Asger Jorn, after the ban on SPUR members' exhibits and their rejection by Bavaria's church, state, and general public. Because the group viewed the situation of the sixth edition's production as a kind of voluntary emigration, it is titled SPUR in Exile.[1] The group's first court case followed the May 1962 confiscation of all editions of SPUR magazine. Kunzelmann, Prem, Sturm, and Zimmer were charged with the circulation of obscene writings and blasphemy.[2]

The general public of the late fifties and early sixties viewed the artists belonging to SPUR as potential revolutionaries, unwilling to bow to the yoke of antisexuality and to live and work in a society shaped by the attitudes of the petty bourgeoisie. SPUR's weapons were irony and rebellion. Its members aimed to brazenly challenge postwar Germany's double standards and, most of all, to provoke the public into the recognition of those standards. They confronted the growing consumer society, a society of followers, with spontaneity and emotion in the form of words and images that unavoidably led to conflict. Sturm points out how important it is to attempt

to grasp the "backwardness of Germany's cultural situation in those years. We were so undernourished that even abstract or Cubist painting was seen as a sign of rebellion."[3]

The attempt around 1960 of SPUR's painters to come to terms with analytical Cubism is documented in Prem's and Sturm's joint work, and described in literature with the three titles *Passion, Kreuztragung* and *Sturz.* Reserved in its use of color, the canvas proffers fragmented bodies and isolated heads, clearly expressive of fear and terror, suffering and pain. They surround the central figure, recognizable as that of a woman, her arms spread wide and mouth torn open. Decisive for this work in so-called *Facettenstil,* as Lothar Fischer notes, was "the confrontation with the Baroque ... What was important to us was the faceting of single forms, the overlapping levels, the image density, the painting as a moving

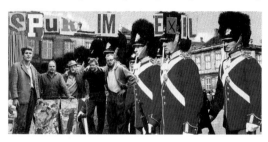

Collage postcard from Southern Sweden: SPUR group at Jørgen Nashs' place, sent to Otto van de Loo in Munich, summer 1961.
The photo on the left depicts (right to left) HP Zimmer, Heimrad Prem, Dieter Kunzelmann, and J. Martin. From the archives of Galerie van de Loo, Munich.

cosmos."[4] The circular arrangement of its elements recalls a whirlpool's movement and has a suction-like effect, much like that of the baroque ceiling paintings found in southern Germany. It is well known that Prem, after a visit to the Walderbach cloister church near his birthplace Roding, had intended to complete a series of paintings of the stations of the cross. This is likely the source of the titles *Sturz, Passion* (fig. 190, p. 153), and *Kreuzigung.* They should be understood as fashioned after images of the Passion, the stations of the cross, or the apocalyptic fall.

In attributing elements of the painting's visual language to either Prem or Sturm, one may safely assume that Prem essentially composed its figured, compact, concentric center, while Sturm completed the areas surrounding it. Sturm generally exhibits a more intense, expansive, energetic confrontation with the painting's space, often dynamically pushing beyond the picture's frame. During this period, Sturm was heavily influenced by the work of Emilio Vedovas, while Prem, in contrast, focused more on Max Beckmann and his immediate post-WWI works such as *Die Nacht* (The Night) of 1918/19.

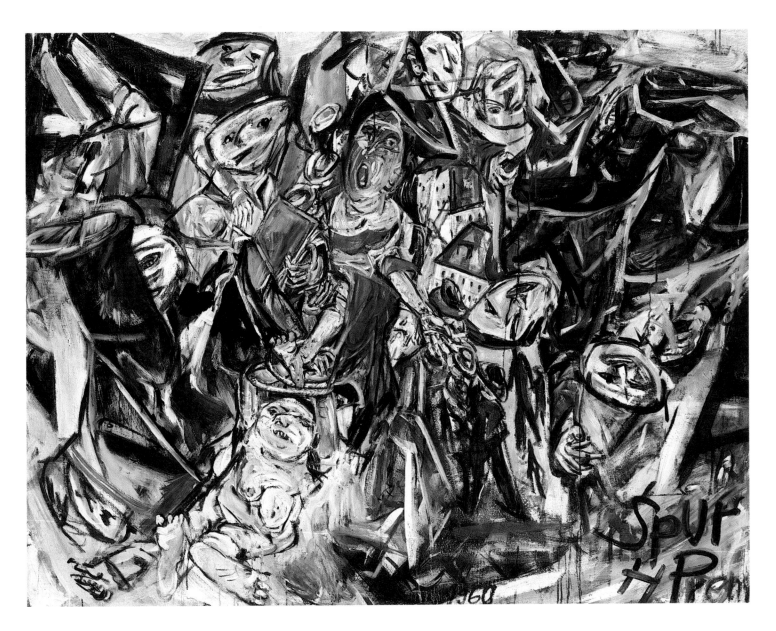

190 **Heimrad Prem and
Helmut Sturm**
Fall (Passion), 1960
Oil on canvas
150 x 190 cm
Staatliche Museen zu Berlin,
Nationalgalerie

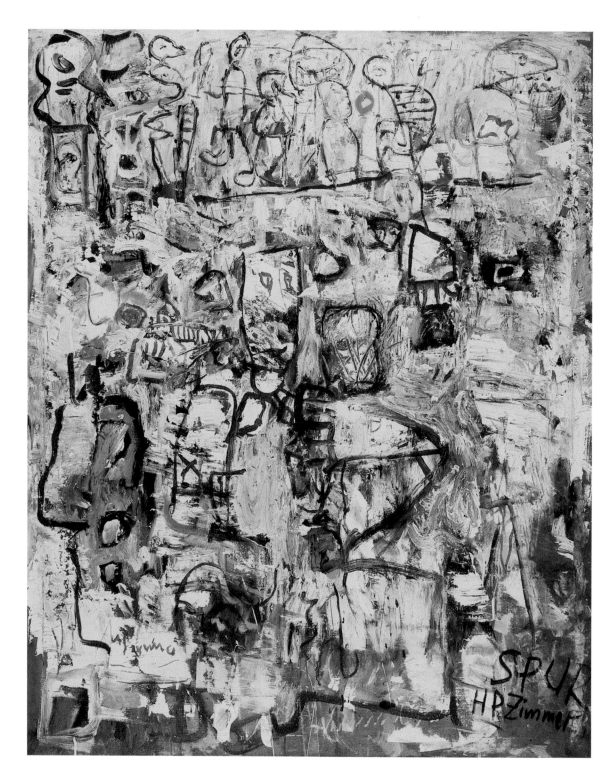

191 **H.P. Zimmer**
High Society, 1959
Oil on canvas
140 x 110 cm
Collection of Gudrun and Peter Selinka,
Ravensburg

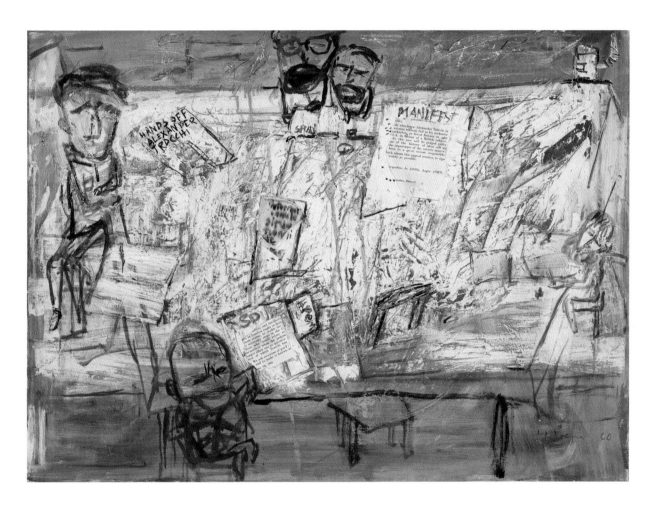

192 **Heimrad Prem**
Manifesto, 1960
Oil on canvas
60 x 80 cm
Private collection of Otto van de Loo,
Munich

HP Zimmer, Untitled, 1960
Created for the SPUR exhibition in Essen
Galerie van de Loo, Munich

SPUR in Munich, 1958
Left to right: Helmut Sturm, Heimrad
Prem, Lothar Fischer, and HP Zimmer

6 HP Zimmer, *Selbstgespräch,* Bilder 1958-84 (Munich, 1984) 33. (Quote trans. K.D.)

7 Zimmer, *Selbstgespräch,* 15.

8 Roberto Ohrt, *Phantom Avantgarde. Eine Geschichte der Situationistischen Internationale und der modernen Kunst.* (Hamburg, 1990).

In works with themes from the religious sphere, Prem regards the Christian Passion as a metaphor for his conception of the artist shunned by society. Sturm, on the other hand, comments: "At the start of the sixties, when we were trying to go beyond the picture frames with provocative activities or participation in demonstrations, often risking our heads and necks to do so, many artists and art critics wrote us off as crackpots and laughed at us. The aggressiveness and explosiveness of the faceted paintings are a result of this situation."[5]

Compared to the faceted style, SPUR member's pre-1959 works are downright quiet. Dull colors reign and initially lend the paintings a rather monotone appearance. HP Zimmer's 1959 work *Die oberen Zehntausend* (High Society) (fig. 191, p. 154) consists of sketchy figures that come forward in a kind of pattern from the background. Similar to the figures of Jean Debuffet (who knew Zimmer personnally and held him in very high regard) which were inspired by children's drawings, the canvas portrays, mostly along its upper border—at the top of the heap, so to speak—a row of simply constructed figures. In Zimmer's works one inevitably discovers tightly packed groups of figures and endless crowds, as documented in numerous of his post-1965 paintings, subsequent to SPUR's heyday. Of the group's members, he is the one most concerned with the theme of the figure, because "painting without figure is really only a nihilistic activity, no matter what the figures look like. Anybody who doesn't want ordinary figures creates his own."[6] Thus, it is less important to look for single figures in Zimmer's work than to perceive the modulations which take place within each painting. Figures suddenly appear on the canvas and disappear again. In retrospect, this painting cannot be used to substantiate possible social criticism.

In the same year that Zimmer created *Die oberen Zehntausend,* Asger Jorn told him "about a group centered in Paris, whose theoretician is supposed to be a certain Guy Debord ...They call themselves 'International Situationists', want to know if we'd like to join up, he could get us in ... we were curious and said that we could be interested"[7] SPUR's members, always open to new contacts, hoped that by joining the Situationistic Internationale (S.I.), a group of artists, architects, and writers, to forge connections to international movements. Through S.I. and Jorn's foreign ties, the young graduates of the academy in Munich hoped to flee the city's cultural wasteland. They joined the S.I. at its third conference in 1959.[8] When, in 1962, Debord demanded a ban on the paintings of the Situationist artists, it led to the expulsion of many

members. Debord's goal was essentially to do away with all art within the organization. Consequently, SPUR's membership in the S. I. as the German section was limited to the period from 1959-1962.

Heimrad Prem's 1960 work *Manifest* (Manifesto) (fig. 192, p. 155) resulted from the influence of S.I.'s flyers and writings, and shows the group SPUR, together with Jorn, at work composing one of their many manifestos. Grouped around a square table, in a mass of color made up of materials like glass and paper, the faces of the individual painters can be discerned: Prem is front and left, sporting a beard and a kind of plastic tag bearing the artist's signature. Zimmer's distinctively long face can be seen to his left. Sturm is the figure at the table's upper edge, in the middle left, wearing glasses and a beard. Beside him is Jorn, his pipe resting before him on the table. Seated on the right, finally, is the SPUR-sculptor Lothar Fischer. The canvas's collage of textual excerpts, arranged on the table like single sheets of paper, refer to the Scottish author Alexander Trocchi, who had been imprisoned for drug-related offenses. "Hands off Alexander Trocchi" reads the clearly visible writing in the painting's upper left, alluding to a headline from a flyer distributed by the Situationists and SPUR on October 7, 1960, protesting Trocchi's imprisonment and simultaneously making a plea for public tolerance of the artist's creative and political freedom.

The works described here indicate three different positions of the artist at society's edge: the painful position of the outcast, the critical position of the observer, and the committed position of the political activist. Art's function is not discursively examined here, as it is in the manifestos. And more importantly, it is not seen analogous to them.

Pia Dornacher

Heimrad Prem:
Only Struggle Strengthens Me

The painting *Only Struggle Strengthens Me* (fig. 193, p. 159) by Heimrad Prem from the year 1962 was originally part of a much larger wall frieze. It is filled with countless figures, objects and flat bodies laying over each other. Only through this overlapping does a kind of foreground, middleground and background emerge. Legs and the bodies to which they belong can hardly be discerned. This painting is characterized by forms, partially fleshed out and further elaborated linearly here and there. Heads and bodies are fashioned by organic forms. In contrast, angular shapes form the basis for arms, legs and elongated objects. Collectively, the work

gives the impression of a mosaic composed of many pieces.

Such color surfaces, with their drafted lines, points and four-sided figures first began to appear around 1962 and became increasingly more frequent. Before this point his paintings had been marked by a more linear and color-reduced brush stroke.

Red is the prevailing color in *Only Struggle Strengthens Me*. It spreads out over the entire canvas in different grades. Prem even painted red sprays of blood in great detail. The artist also used the colors white, green, black and yellow for an intentionally arranged color composition. The deepest underlying layers of paint appear to be strongly thinned out, while the upper layers are applied increasingly opaquely. The last application is nearly like paste, Prem had partially scratched into the moist paint.

A concrete subject is not immediately apparent. Recognizable horseshoes, horse's tails and individual shoes in the lower area offer clues and associations to horse and rider. The warriors with speers gradually crystallize. Bloody punctures suggest battle.

In this depiction, Prem follows the example set by Paolo Uccello (1397-1475) with his three-part panel painting of the Battle of San Romano.[1] The individual panels hang today in Paris,[2] Florence[3] and London.[4] Although Prem traveled to London in 1960 and to Paris in 1961[5] with the SPUR group,[6] it cannot be proven that he saw the original painting. It is the opinion of Lothar Fischer, however, member of the SPUR group, that Prem knew the panels, from reproductions.[7]

The reception of Uccello's portrayal of battles in 20th Century art is noteworthy. The Cubists and Futurists in particular were fascinated by the treatment of space and surface expessed in Paolo Uccello's work. After WW II, Fernando Botero (*1932) valued above all the heightening of the form and the colors, which were not nature-oriented in Uccello's work, and was inspired by them again and again to create new picture compositions.[8] Even Prem, who took Uccello as his model for *Only Struggle Strengthens Me*, was apparently only interested in formal and color design. The historical battle became a minor issue.

[1] Willi Bleicher, "Willis Wilder Wille", *Gruppe SPUR. 1958-1965. Lothar Fischer, Helmust Sturm, Heimrad Prem, HP Zimmer*, exhibition catalog, Städtische Galerie Regensburg et al (Regensburg, 1986) 30.

[2] Right panel: Paolo Uccello, *The Battle of San Romano* (around 1440), Musée National du Louvre, Paris.

[3] Middle panel: Paolo Uccello, *The Battle of San Romano* (around 1450/55), Galleria degli Uffizi, Florence.

[4] Left panel: Paolo Uccello, *The Battle of San Romano* (around 1450), National Gallery, London.

[5] The Munich artist group SPUR (1957-1965) consisted in core of the painter Heimrad Prem (1934-1978), Helmut Sturm (*1932), HP Zimmer (1936-1992) and the sculptor Lothar Fischer (*1933). They engaged themselves against academism, provoked with scandals, published flyers, manifestos and a magazine, with which they agitated the public. In the time of Tachism, the group created figurative representations in intensive coloring, for the first time again in Germany since the war.

[6] *SPUR group. Biography,* unpublished manuscript, around 1964, Archiv Fischer, Baierbrunn, 1f.

[7] Conversation with Lothar Fischer on 2/1/1997.

[8] Volker Gebhardt, *Paolo Uccello. Die Schlacht von San Romano. Ein Bilderzyklus zum Ruhme der Medici* (Frankfurt/Main, 1995) 64f.

[9] Conversation with Lothar Fischer on 2/1/1997.

[10] Bleicher, 30.

[11] SPUR Group. Biography, 1; conversation with Fischer on 2/1/1997.

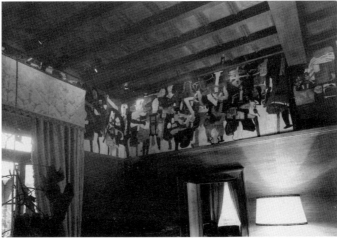

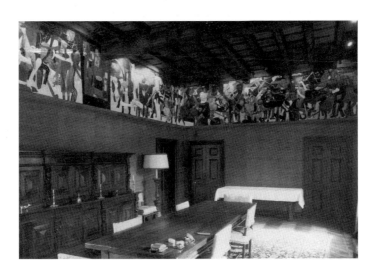

Wall frieze by Heimrad Prem in the Villa Paolo Marinotti, Milan (Two parts)

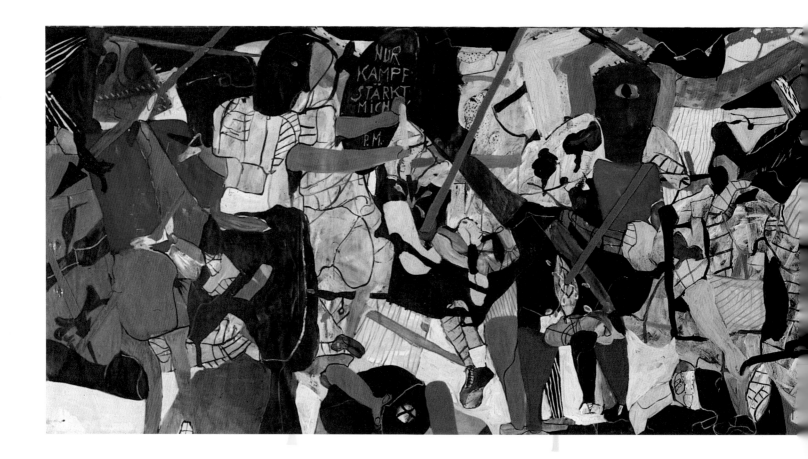

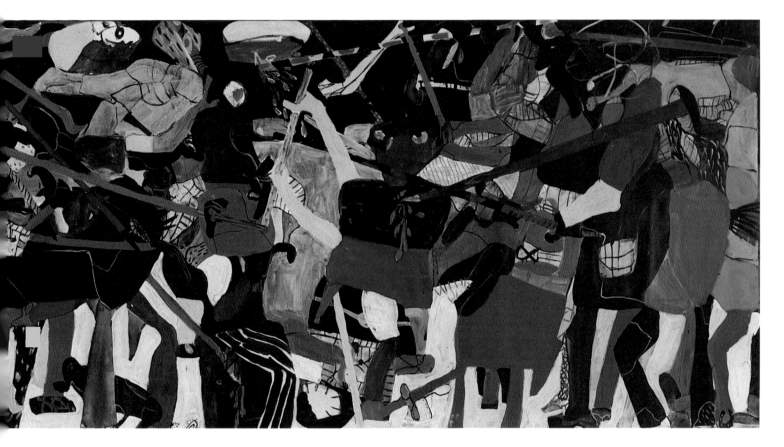

193 **Heimrad Prem**
Only Struggle Strengthens Me, 1962
Oil on canvas
130 x 507 cm
Galerie Christa Schübbe,
Düsseldorf/Mettmann

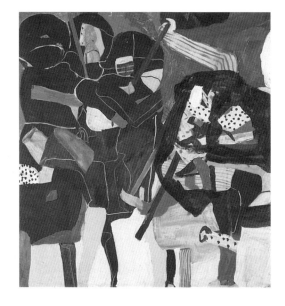

12 Conversation with Fischer on 18/10/96. Between October 1961 and January 1962, there was a contract between Marinotti and the SPUR group addressing payments and painting acquisitions ("Memorandum für die Gruppe 'Spur'", 10/10/1961, un-published manuscript, Archiv Fischer, Baierbrunn). Payment entries were also documented by the group's cash-book, which was managed by Christel Fischer (Archiv Fischer, Baierbrunn). Prem received 6,000 DM from Marinotti for the frieze (Letter from Heimrad Prem in Munich to Margarethe Jochimsen, then Freiburg, i. Br., 10/12/1962).

13 The photograph was printed in: HP Zimmer, Selbstgespräch. Bilder 1958-84, (Munich, 1984) 80.

14 Letter from Heimrad Prem to Margarethe and Reimut Jochimsen, then Freiburg i. Br., July, 1962. Prem painted the work for three months in total.

15 SPUR group. Biography, 2.

16 Along with Prem, Sturm and Zimmer, the temporary SPUR member Dieter Kunzelmann and, in a separate juvenile trial, the minor aged Uwe Lausen, were accused. The trial was heard again in the second appeal on November 7, 1962. The prison sentences were set at five weeks with probation.

17 SPUR - Conversation, Gruppe SPUR. 1958-1965. Eine Dokumentation, pub. by Galerie van de Loo (Munich, 1979) 2, Florian Rötzer, "Revolte als Spiel und Gaudi," eds. Margarethe Jochimsen/Pia Dornacher, Heimrad Prem. Retrospektive und Werkverzeichnis, (Munich/New York, 1995) 29f.

18 Roberto Ohrt, "Interview mit Helmut Sturm", Gruppe SPUR. 1958-1965. Lothar Fischer, Helmut Sturm, Heimrad Prem, HP Zimmer, SPUR-Buch zur Art Cologne 1991, ed. by Galerie Christa Schübbe, (Düsseldorf/Mettmann, 1991) 131.

19 It only became public half a year later, that Maunz had taken part in the formulation of the Nürnberg Racial Laws, "and then we naturally understood, why they left the lid on" (Ohrt, 131).

20 Letter from Prem.

Horse, cavalrymen and battle on horseback, as independent theme also turned up in the works of other SPUR members, particularly at the beginning of the 1960's. Because of the ornamental possibilities of structure through saddle and bridle, for Lothar Fischer there is no "motif more fertile"[9]. The horse as formal surface element was Prem's prime interest while designing the wall frieze.

An inscription is to be found next to the figural depiction, in the left third of the painting. The red letters read: "Only Struggle Strengthens Me P.M." This programatic motto is also the title of the entire frieze. The painter hadn't chosen it himself, it was given to him rather, by his patron, Paolo Marinotti (P.M.)[10] As early as 1959, Prem, together with the artists of the SPUR group, had met the art collector and industrialist Dr. Marinotti from Milan through the Danish painter Asger Jorn (1914-1973). Jorn was one of the founders of the international artist group COBRA (1948-1951).[11]

Marinotti described himself as "Krypto-SPUR" and saw himself as the financial foundation of the group. Between 1962-64 he was significant patron of the artists.[12] A photograph from 1964 showing Marinotti in bathing trunks even carries the caption "Spur (Spur: trace, track) protecter".[13] But Marinotti's importance was not only financial. He opened a forum in his house for the SPUR members, where they met other international artists. He owned the Palazzo Grassi in Venice, directly on the Canal Grande and he made the house available for events. From July until October, 1963, the exhibition "Visione Colore" was presented there, where, among others, Jean Dubuffet, Asger Jorn, Pierre Alechinsky, Maurice Wyckaert, Sam Francis, Alan Davie, Enrico Baj, Horst Antes and the SPUR group showed their work.

It has been documented that Prem began work in July, 1962. He wrote in a letter: "In some days I'll travel to Marinotti in Milan. I have been commissioned to paint a room there, that means, the entire upper half of a dining room."[14] His stay in Milan was also confirmed in the SPUR group's "Biography". Prem was to have envisioned "a wall frieze in the Villa Marinotti in Milan".[15]

The commission came at just the right time for Prem because he and a few other members of SPUR had been charged by the Munich District Court in May, 1962, with allegedly having published sacriledge and pornography in the SPUR magazine.[16] By way of this court case, the group, whose ambitions first and foremost concerned artistic provocation and less the changing of society, came into the political discussion.[17] In the time of the Economic Miracle and rearmament, an averted critical discussion about the National Socialist past and an ignorance towards the guilt of the - often to this day - politically responsible, the conflict between the generations began to intensify long before the Student Movement of 1967/68. Questioning the generation of the fathers' values by the youth expressed itself not only in the political arena, as in the Easter Marches (Peace Movement), but rather also in the cultural fields or in youth protests, such as the Schwaben Riots in June, 1962.

The SPUR magazine's breaking of taboo was indeed officially prosecuted as blasphemy and pornography. Still, Helmut Sturm assumed that these charges by the District Attorney were to be held up more simply. It was just as

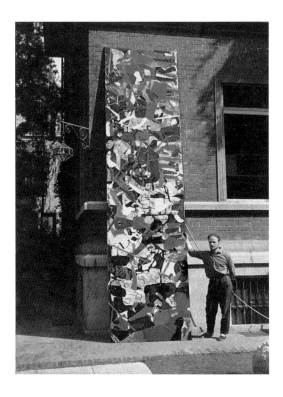

upper left:
Heimrad Prem, Untitled
(Only Struggle Strengthens Me, part of
the painting in the dining room), 1962
Oil on canvas, 130 x 119 cm
Sammlung Selinka, Ravensburg

lower left:
Heimrad Prem with the titled part of the
wall frieze, 1962

right:
Heimrad Prem, *Struggle Strengthens Me,*
1962
Oil on canvas, 145 x 110 cm
Private collection, Munich

21 "Die SPUR", *Momenti 3,* Centro Internazionale delle Arti e del Costume Palazzo Grassi, (Venice, 1967). The painting was dated 1965.

22 Christa Schübbe had discovered the painting. HP Zimmer had also painted a dining room in Marinotti's house in Milan in 1965 (see Zimmer, 85f.). It was painted over in 1981 during renovation in the villa. (Conversation with Christa Schübbe on 3/3/97).

23 Letter from Prem.

24 Heimrad Prem, "ARSch VIVA. Aufsatz eines Stipendiaten", *Zeitschrift SPUR,* Nr. 2 (Munich, 1960) 4f.

25 Heimrad Prem, "Ohne Malverbot", *Zeitschrift SPUR,* Nr. 4 (Munich, 1961).

26 Heimrad Prem, "Mein Problem/Selbstfindung", ed. Joseph Berlinger, *Grenzgänge. Streifzüge durch den Bayerischen Wald,* (Passau, 1985) 149.

27 Heimrad Prem, "8 Sätze", *Heimrad Prem,* exhibiton catalog, Galerie van de Loo (Munich, 1963).

28 *Duel,* 1962, Private collection of Otto van de Loo, Munich: Illus. in: Jochimsen/Dornacher, 93.

29 *Struggle Strengthens Me,* 1962, Private collection, Munich.

30 *Only Struggle Strengthens Me,* 1972, Private collection, Munich; Illus. in: Jochimsen/Dornacher, 233.

31 Heimrad Prem, diary entries (1963-1967), from a transcription typed by the author. As corrections in his orthography were important to the artist, the diary was transcribed.

32 Prem, 149.

much about the struggle against "nihilistic, anarchistic, Communist tendencies," he said[18]. The trial was forced through by the Bavarian Minister of Culture Maunz, who had felt directly attacked by SPUR[19].

Prem described the situation for the group at the time as without hope. Because of the criminal prosecution, SPUR was then excluded from exhibitions in the Haus der Kunst in Munich and from art prizes and grants in Germany. He wrote, "for living, it is more favorable for us in Italy"[20]. The work in Italy offered Prem a way to break out of the constrictions of the Munich art scene.

The entire frieze fit between the wood encasement of the wall and the timberwork of the ceiling. Small parts of the painting even ran above the curtain suspension. A painting of about 60 square meters, in several parts, arose and surrounded the entire room. The segment discussed here filled out the width of the room above the doors. Prem appears to have used particular care in this segment. Interestingly, the artist had signed precisely this painting with "H. Prem '62" on the lower right. The work was separatly, however, wrongly dated and a few years later, reproduced in the book "Die SPUR"[21]. For decades, the painting was thought to be missing, until it turned up again in the middle of the 1990's.[22]

The large part of the frieze discussed here could first be fixed to the wall shortly before completion, because the photograph shows the artist with the nearly finished painting. Afterwards, it was altered again on both sides and adjusted to the adjacent canvases. According to his own words, Prem painted the various parts of the frieze in relative isolation from each other,[23] which explains why the single parts appear to be so differently executed and other parts give the impression of being only slightly homogeneous.

Even when the frieze's theme *Only Struggle Strengthens Me* was given by Marinotti, it is informative for Prem's biography.

The components of struggle turn up again and again, not only in the paintings, but also in the writings. In his role as artist, Prem saw himself as an outsider in society, wherein he must have felt this confirmed by his experiences in the SPUR trial. "The artist causes unease, because he disturbs the sleep of his environment."[24] He called for a "madhouse" in which the "useless", the artists, could be accommodated. He himself had had to struggle extremely hard to study art against the initial resistance of his father, who had planned a career for his son as house painter.[25] Throughout his life, the artist felt himself torn between feeling and reason. For him, feeling and reason were two incompatible components, even rivals, which "struggle" with each other.[26] He described the canvas as a "battlefield", on which "structures and atoms of material resolve"[27].

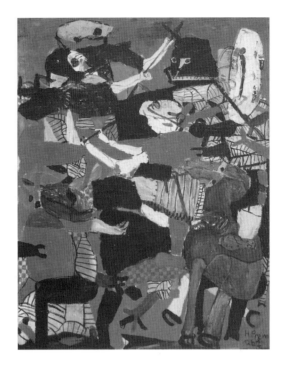

Only Struggle Strengthens Me is not the only work in 1962 in which Prem was occupied with the theme of the struggle. Alongside *Duel,*[28] the painting *Struggle Strengthens Me* should be named, which immediately generates a connection in the title.[29]

In 1972, ten years after the frieze, Prem took up the theme again and entitled anew a painting *Only Struggle Strengthens Me.*[30] It dates from the year in which he slowly recovered from a suicide attempt in June, 1971. His diary reads: "... you have to struggle in order to live. Since you die at the end anyway, or even very suddenly, suicide is at least theoretically more logical than continuing to live pointlessly."[31] Prem appeared able to justify his existence only by struggle. A life without struggle didn't exist for him. "I struggle, therefore I am",[32] was how Prem reformulated the French philosopher Descartes' maxim.

The wall frieze designed for the Villa Marinotti acquired, in this way, an existential significance for Prem. The theme ran like a red thread throughout the artist's biography - until he ended his life in 1978.

Ilonka Czerny

A Break with Socialist Idealism

1 Christa Wolf, *Kein Ort. Nirgends* (Berlin/Weimar, 1981) 95.

2 Heiner Müller, *Krieg ohne Schlacht. Leben in zwei Diktaturen*, (Cologne, 1992) 363.

3 Ursula Feist, "Leid-Erfahrung. Der Dichter und Bildkünstler Roger Loewig", Günter Feist/Eckhart Gillen/Beatrice Vierneisel eds. *Kunstdokumentation SBZ/DDR 1945-1990, Aufsätze, Berichte, Materialien* (Cologne, 1996) 639f.

4 Quoted by Marianne Streisand, "Der Fall Heiner Müller. Dokumente zur Umsiedlerin", *Sinn und Form,* 43, vol. 3, 1991, 430. Heiner Müller's piece "Die Umsiedlerin oder Das Leben auf dem Lande" was originally performed at the student stage of the Academy for Economy in Berlin-Karlshorst on 9/30/1961, directed by B. K. Tragelehn within the framework of an international student week. With his piece, which took place in a village in Mecklenburg, Müller drastically staged the contradictions in the development of Socialism with the example of the forced collectivization carried out between 3/4 and 4/14/1960.

5 Müller, 171.

6 Siegfried Wagner to Ulbricht, with copies distributed to Kurella, Honecker, Verner, Hager, "Zu einigen ideologischen Problemen nach dem 13.8.: Hermlin-Junge Autoren; Cremer-Junge Künstler; September volume NDL; Aufführung 'Umsiedlerin'" (Stiftung Archiv der Parteien und Massenorganisationen der DDR im Bundesarchiv (SAPMI-BArch, DY 30/IV 2/2026/1, 181-184).

7 Letter of 4/8/1964, SAPMO-BArch, NYY 182/932, 188-190. Cremer was not spared the unregular contact from the Min-

"Following Canetti's schema, it can be understood how the East Germany's population constituted itself as a self-contained mass, by means of a frontier that was equated with the threat of death against those who tried to cross it. From this view, the Wall appeared to be what it was from the beginning: the cattle fence around an unwilling heard of people who had been forced into confinement and subjugated by models and special laws. Only in this lasting state of emergency was it possible to mobilize the masses internally, to hold them constantly in check as reserve, to control their forms of movement and their language. Hindered from breaking away by the border, an entire population became a mass available for summoning either to be silent or to attend parades and meetings. The border: it was the invention of an absolute insider, the magic trick of the artificially drawn horizon like in theater … The masses of East Germans, as homogeneous as they may even have been, were formed overnight, thereby confronted with themselves. Their isolation compelled what Canetti called the repetition, the perpetual production of the same world of things and thought, a fateful indentity which only endured itself in paranoid suspicion."

Durs Grünbein, "Wir Buschmänner. Eine Erinnerung an Elias Cannetti's 'Masse und Macht'", *Wir Buschmänner, Galilei vermißt Dantes Hölle. Aufsätze* (Frankfurt/Main, 1996) 205f.

In Christa Wolf's narrative of a fictional encounter with Karoline von Günderrode, Heinrich von Kleist comes to the astonishing realization: "He, on the other hand … had not lived in an actual community, rather, in his notion of a state."[1] In his autobiogrpahy, Heiner Müller trouches on these thoughts in the last chapter, "Recollections of a State": "Perhaps it was precisely the unreal in the GDR's construction of a state which made it attractive to artists and intellectuals … The GDR … was a dream that history made into a nightmare, like Kleist's Prussia and Shakespeare's England."[2] His comparison of the GDR with Heinrich von Kleist's dream of the state as an entire work of art describes the fatal consequences of German Idealism. Concrete perception was extinguished for the benefit of an idea, utopia as a design of order, a plan sketched by intellectuals, carried out by the state as authority of the Weltgeist, performed by the "working people". Reforms and revolutions, redemption and liberation were always a subject of authority, achieved in the form of a dictatorship of education, conceivable only as a forced

utopia, protected by a Wall. Like the classical state utopias of Bacon or Campanella, which were only imaginable on islands or in cities screened off by walls, the "real, existing Socialism" could also only work "in a country" isolated from the "normal" outer world, respectively, by wall and barbed wire. The Wall became the symbol for history closed down and silenced, for time held still. As an isolated society, Socialism in the GDR was to have unfolded "on its own basis". For the idea of a general human happiness, many individuals had to renounce their right to happiness. Should they not have understood that, the United Socialist Party felt obligated "to force them to their happiness".

In the year the Wall was built, Roger Loewig drew in red and black ink, how the tanks drove up and how all the movements between the guards and the guarded froze (figs. 194-196, p. 165). Only these three drawings eluded the confiscation of his artistic and literary works when his apartment was searched after his arrest in August, 1963, because they happened to be elsewhere at that moment.[3]

On August 13, 1961, the case snapped shut. The artists as individualists were taken in hand: "Now we have the Wall, and we will crush in anyone against us", Walter Ulbricht said in 1961 according to a statement by Heiner Müller, while many artists thought at the time, "now that the Wall is there, we can talk openly about anything".[4] Siegfried Wagner, born in 1925, the director of the Department of Culture in the Central Committee of the USP (United Socialist Party) and whom Heiner Müller identifed as a former Nazi SA man,[5] summarized the situation on the art front on October 5, 1961: "Some people, Cremer among them, want to take action against what in their oppinion are the dogmatic manifestations in cultural policy. They believe that now they can act with all severity, by which the security measures of the regime will not allow the opposition to have the possibility of an usufruct. The other group, to which Heiner Müller and Tragelehn apparently belong, tries to test how far they can use the field of art to spread oppinions directed against the Party and state."[6]

In this estimation of the intellectuals after the Wall was built, the critical but antifascist GDR-loyal artists were divided into two camps and each was used to play against the other. Fritz Cremer, of antifascist and Communist conviction, professor and director of the sculpture department at the Academy for Applied Art in Vienna from 1946 to 1950, was appointed to the Deutsche Akademie der Künste (DAK) and came to East Berlin with the intention of contributing "to overcoming and surmounting the German past of militarism, fascism and revanchism".[7] In his position as permanent Secretary of the visual art department at the DAK (as of January, 1961),

istry for State Security, who did not shy away from blackmailing attempts (nude photos) (see: BStU, MfS AP 4420/92, vol. 2, p. 113 Cont'd.; 4421/92, vol. 1, 63-65; 89-92; 98-100, 118, cont'd.). An "operative plan" for constant conservation developed against Cremer, Dessau, Graetz, Grzimek, Mermlin, Sandberg and Uhse, which as of 1966 was carried out under the term "traitor" (AP 4420/92, vol. 2, 18).

8 Neue Kunst braucht keine Musterknaben, Interview with Fritz Cremer, *Sonntag,* 7/9/1961, quoted in: *Bittere Früchte. Lithographs by master class students of the DAK in Berlin 1955-1965,* Akademie der Künste (Berlin, 1991) 21.

9 Over the glued-together newspaper cut-outs of critiques, Cremer drew a dying Pegasus, Illus. in: *Kunstkombinat DDR. Daten und Zitate zur Kunst und Kunstpolitik der DDR 1945-1990,* ed. Museumspädagogischer Dienst Berlin (Berlin, 1990) Illus. p. 44.

10 The DAK, founded in 1950, as the institution to procede the Prussian Academy of Art, enjoyed absolute autonomy. Alfred Kurella said at the 14th Conference of the Central Committee of the USP: "We can dissolve the entire shop and found it anew; but I believe that that isn't right. So we have to conquer it from within". (SAPMO-BArch, DY 30/IV 2/906/3, p. 101-117).

11 Department meeting on 3/21/1967, quoted in *Bittere Früchte,* 41f.

12 Quoted in *Erste Phalanx Nedserd. Ein Freundeskreis in Dresden 1953-1965,* exhibition catalog, Kunsthalle Nürnberg, 1991, 85.

13 Quoted in *Bittere Früchte,* 29. The discussion took place in the course of the conflicts around the exhibition "Young Artists - Painting".

14 Heiner Müller, 481.

15 Jan Faktor, "Siebzehn Punkte zur Prenzlauer-Berg-Szene" (1992), *Die Leute trinken zuviel, kommen gleich mit Flaschen an oder melden sich gar nicht... .* (Berlin, 1995) 132.

16 1964: 5th Congress of the Association of Visual Artists with reprisals against the three congress speakers Fritz Cremer, Bernhard Heisig and Hermann Raum; 1965: the notorious 11th Plenum of the Central Committee.

17 "We thought it was really good to build the Wall, according to our political conviction at the time, it was right ..." (Penck, 1984, quoted in *A. R. Penck,* exhibiton catalog, Nationalgalerie (Berlin (West) 1988) 91. Heiner Müller: "Even agreeing with building the Wall was a taboo, if it was clearly formulated" (Müller, 131). "Penck was a concept that touched

he defended the master class students as a basically loyal new generation, who were also, however, equiped "with much sincere scepsis", who had seen the world in which they had lived go down "literally in ruins" or "had been born in the ruins". Convinced that the GDR needed precisely the "so-called difficult young artists" and "not the paragons, the boring, pleasing onces"[8], he provided them with their first public presentation with the exhibition "Young Artists – Painting", which opened on September 15, 1961. In an introduction, which Cremer conceived as a page to be included in the yet-to-appear catalog, he justified the programatic of his exhibition with the attempt "to tear open what until now was all too narrowed, buried and partly already decrepit".

The exhibition triggered a storm of indignation and criticism with faked letters from working people, a press campaign[9] and discussion, which was directed first and foremost against the works of the master class students and their teachers[10] who were responsible for them. Considering the poetic-naive still lives, interiors, landscapes and portraits, this attack was incomprehensible. As a result of the event, Cremer resigned as Secretary and in February, 1962, Otto Nagel also resigned as Academy President. For the catalog which appeared on the occasion of the second part of the exhibition "Young Artists – Graphic, Sculpture" on March 9, 1962, the visual arts department had written a critique to replace Cremer's introduction. No new master class students were taken on in 1962, 1964 and 1965. Another master class student exhibition was not organized again until 1967, which, according to Cremer, was only the pitiful expression of a "false cultural policy", a "conventional exhibition of the 19th Century." He appealed to his colleagues to win back "the students' lost trust in the academy, which we had at the time I tried to make this exhibition".[11] ("Young Artists – Painting", 1961, – author's note.)

Along with the Berlin master students, Manfred Böttcher (see fig. 118, p. 102), Achim Freyer, Harald Metzkes (see fig.117, 119, p.101f.) and Horst Zickelbein, the art circle around Jürgen Böttcher at the Dresden adult education center, to which Peter Graf, Peter Herrmann, Peter Makolies and Ralf Winkler (alias A. R. Penck) were connected, attracted negative attention. As a merry contribution to "Bitterfelder Weg", the new culture political integration of art and life, professional and layperson's art propagated since 1959, Jürgen Böttcher shot a film in the style of "nouvelle vague" about the three worker artists Graf, Herrmann and Makolies: "They want to express what their friends and colleagues feel. They want to be what they are: three from many."[12] The DEFA documentary film, in which Ralf Winkler collaborated with texts and Manfred Krug spoke, without having been named in the credits, disappeared immediately into the Central Committee's

safe. Only 27 years later could the film be screened for the first time, in East Berlin in 1988, although it had fulfilled Alfred Kurella's demand on the young artists in the academy discussion of October 19, 1961 to the letter: "... connect yourselves to the people Take their wishes into consideration, their opinions ... learn together with them."[13]

The film, the opening of the exhibition "Young Artists – Painting" on September 15th and the premiere of Heiner Müller's *Umsiedlerin* on September 30th, could only have been signs of a conspiracy in the eyes of the functionaries: "there's someone behind it, probably even Trotzky would be at the bottom of it".[14]

Although none of the artists criticized at the time supported a political opposition of whatever nature, they were treated as enemies of the state. Everyone had to learn to live with the fear, that "spared no sector of society, not even the 'liberated' or split off sectors"[15]. Ralf Winkler (A.R. Penck) alone, set an example until 1980 for many younger artists through his freedom from fear and his sleepwalking balance along the "border between the allowed and the not allowed". In Penck's painting *Passage* from 1963 (fig. 208, p. 177), his I-figure still balances like a tightrope walker with supreme ease over the abyss, while in the second, the night version (fig. 209, p. 177), it falls from the burning footbridge with arms raised in fright. Between 1963 and 1966, the art political situation worsened dramatically, for Penck as well.[16] Despite his basically positive attitude to Socialism in the GDR,[17] he was systematically excluded and pushed off into the underground. On the occasion of his exhibition in the West, in Galerie Hake (Michael Werner) in Cologne, he settled on the pseudonym Albrecht Penck, the geographer and Ice Age explorer (1858-1945), thereby also deciding on a strategy of subversion. As cultural Ice Age explorer, oriented by Marxist thought, he wanted to analize societal forces and structures. "What I have in mind is a kind of physics of human society."[18]

Manfred Kempfer, a Berliner, painted *Warning* (fig. 197, p. 166), the expression of an oppressive standstill amidst a rhetorically raging "scientific-technical revolution" and sign of his isolation in the inner emigration he himself chose. He was one of the artists who lived in the East and studied in the West (Master School for graphic and book design in Friedenau), for whom the building of the Wall meant the rupture in all contact to contemporary art, artists and gallerists.[19]

The USP, having begun with the claim to a "political avant-garde", refused the alliance with the artistic avant-garde and unconditionally maintained the national cultural legacy of classical Humanism as the real unity of truth, beauty and harmony. According to Walter Ulbricht in 1962, as Socialism in the GDR developed, the working

Socialism. Nearly a Communist artist" (Penck, 1978, quoted in *A. R. Penck*, exhibition catalog, Nationalgalerie (Berlin [West], 1988) 80. See Jürgen Schweinebraden, "Erinnerungen 1956-1980", Feist, et al, 676f.: Penck was a member of the Young Pioneers, the FDJ, the FDGB, the Society of German-Soviet Friendship and candidate of the VBKD, when he was 17, he wanted to join the SED and wrote running petitions with suggestions for improvement.

18 Joseph Beuys had follwed a similar approach with his statement: "You have to quasi be able to see ideas!" (Joseph Beuys im Gespräch mit Knut Fischer und Walter Smerling (Cologne, 1989) 13.

19 See Jürgen Schweinebraden, "Innere Emigration als Isolation and Chance. The Produktivität der Verweigerung", Manfred Kempfer, *Bilder 1959-1989,* exhibition catalog, Galerie Pankow (Berlin, 1992). Kempfer was only able to exhibit in the EP (= the only private) Galerie Schweinebraden, in 1974 and 1980.

20 Heiner Müller, 315.

21 *Gerhard Richter. Text. Schriften und Interviews,* Hans-Ulrich Obrist ed. (Frankfurt/Main/Leipzig, 1993) 9.

22 Müller, 99.

23 Henry Schumann, "Leitbild Leipzig. Beiträge zur Geschichte der Malerei in Leipzig von 1945 bis Ende der achtziger Jahre," in: Feist, et al., 510f. VBKD = Association of Visual Artists of Germany.

24 Heinz Schönemann, "Zwölf Bemerkungen zur Kunst Wolfgang Mattheuers", *Wolfgang Mattheuer,* exhibition catalog, Museum der bildenden Künste (Leipzig, 1978) 25.

25 Eckhart Gillen, "Der entmündigte Künstler", Feist, et al., 12f. and "Wir haben ständig in einer Nachkriegszeit gelebt. Antifaschismus und Geschichtspessimismus am Beispiel des Malers Bernhard Heisig," *Jahrbuch der Burg* (Beeskow, 1997).

26 Hannah Arendt, *Eichmann in Jerusalem. Ein Bericht von der Banalität des Bösen* (Munich, 1964) 163.

27 Freya Mülhaupt, "Regisseur großer Bildstoffe. Der Maler Bernhard Heisig", *Kunst in der DDR,* Eckhart Gillen/Rainer Haarmann ed. (Cologne, 1990) 380f.

28 Meeting report by Dr. Werner on 12/13/1976, Signed by R. Sandner, 12/14/76. Akte Kober, BStU 000084.

29 Axel Hecht/Alfred Welti, "Ein Meister, der Talent verschmäht. Georg Baselitz. 'Avoid Harmony at All Costs'", *art,* 6/90, 70.

people began "to write ... the third part of 'Faust'". For Ulbricht, the figure of Faust embodied the continuity of middle-class emancipation. It was Heiner Müller's opinion, that this "Humanism", as reckless domination and exploitation, was the nature of barbarism because it aims at exclusion and selection. "When it is a matter of the emancipation of humanity, then the enemy is humanity's enemy, therefore, not human."[20]

Gerhard Richter had not left the GDR in March, 1961, moving from Dresden to Düsseldorf, in order to escape the materialism, "that rules here much more exclusively and inanely, rather, I had to escape the criminal idealism of the Socialists."[21] He resolved from then on "to think and to act without the help of an ideology. I have ... no idea, ... no belief, that shows me direction, no vision of the future, no contruction that offers a supreme meaning."[22]

In Leipzig, in late autumn of 1965, a generation came up at the "7th VBKD exhibition of the district of Leipzig",[23] comparable with the exhibition "Young Artists" of 1961, including Bernhard Heisig and his students Hartwig Ebersbach, Wolfgang Mattheuer and Werner Tübke, who countered the idealist genre paintings of a wholesome, timeless and innocent society with the ghosts of the past and present. With the painting *Cain* (fig. 201, p. 169) Wolfgang Mattheuer opened the series of his "Problem paintings", which shifted the societal conflicts in the "real existing Socialism" to the metaphorical level of biblical and mythological allegory, in order to articulate the critical potential, present in the audience at his exhibition, – even if it was encoded in parable – thereby averting real protest actions. Today, these paintings may be read as seismographic recordings of the quake which signaled the noiseless implosion of the system in 1989. In spite of that, no one in the GDR would have imagined seeing a symbol for the division of Germany in the murderous struggle between brothers on a hill over a city of highrise buildings. For the art historian Heinz Schönemann, *Cain* had "the bullet-head of the Congo-Müller, he wears GI-boots on his feet"[24].

Like those already before him – Heiner Müller (December 1, 1961), Willi Sitte (February 2, 1963), and Hermann Raum – Bernhard Heisig, on June 10, 1964, in the "Möwe", the "club of the people who create culture", had to practise public self-criticism of his speech for the 1964 5th Artist Association Congress.[25] He destroyed the tenth version of his *Paris Commune* and four more versions from the time 1965-1970, by painting over them. The original version of the The *Unteachable Soldiers' Christmas Dream* from 1964 (fig. 199, p. 168) was his artistic breakthrough to a confrontation with his own war trauma, with his conflict as perpetrator (member of the Waffen-SS) and at the same time, victim. In the count-

less further variations over more than 20 years, such as *The Persistence of Forgetting* from 1977, the veterans, without understanding, are assigned only to the western part of the country and belittled by banners carrying the cheap propaganda against the western reunification hypocrisy: "We are still all brothers and sister..." His constant uncertainty which resulted from both the Party's criticism of the painter's "historical pessimism" (the art historian Karl Max Kober, who "looked after him" had cooperated informally at the same time) and the self-criticsm demanded of him, was expressed in Heisig's haunting, aggressively charged paintings. They never came to rest in completion, rather, were changed and painted over for years and decades. Perhaps illustrating the declaration after 1945 that people were "inwardly enemies of the regime at any time"[26] Heisig withdrew from the USP in December, 1989, giving back his national prizes with the explanation that he had known nothing about the abuse of power and corruption at the top of the USP.[27] The IM (informal Stasi collaborator) report from 1976 over Heisig's position on Wolf Biermann's expatriation revealed how lastingly the "sever censure" and the humiliation of the self-criticism demanded of him in 1964 still continued to effect him 12 years later: "Heisig, as Dr. W. (alias Karl Max Kober - author's note) found out from the subject himself, had received two anonymous calls, in which he was asked if he wanted to sign. ... Heisig declined. ... He had spoken of the disciplinary actions of that time and had said to Dr. W, that he already knows what it's like to go through that grinder. Suddenly one has no more friends. Ulbricht had only then said: Don't make him into a martyr. So he was left in peace again. This experience was probably the reason why Heisig did not hand in a statement regarding Biermann."[28]

Seen in this light, the controversial interview with Georg Baselitz about artists from the Leipzig school becomes more understandable: "They had placed themselves in the service of the 'good cause'. On the added on, so-called historically right way, they betrayed the fantasy, the love and the craziness."[29]

Eckhart Gillen

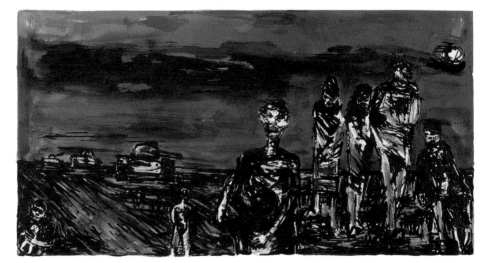

194-196 **Roger Loewig**
Three Drawings from
the series *From German History
and Present*
1961

194
Tank, Tank, Tank
Ink on paper
42 x 60 cm
Collection of the artist

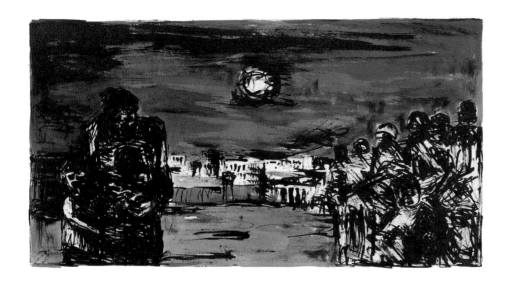

195
Guard and Guarded
Ink on paper
42 x 60 cm
Collection of the artist

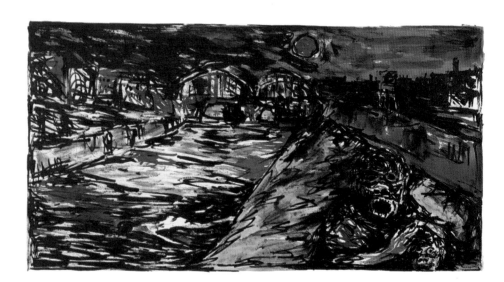

196
Woman Shot Dead, in the Canal
Ink on paper
42 x 60 cm
Collection of the artist

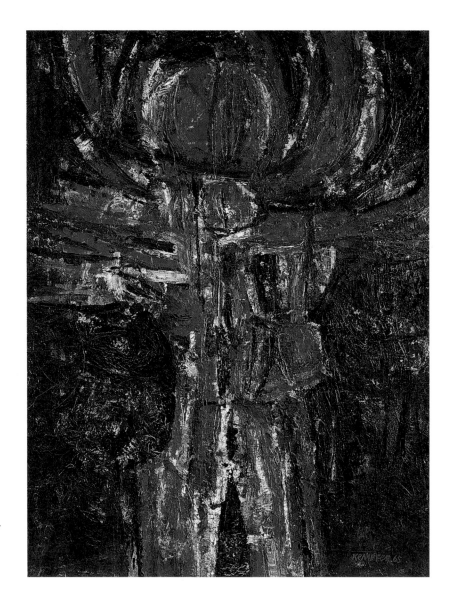

197 **Manfred Kempfer**
Menetekel (Warning), 1965
Oil on canvas
115 x 85 cm
Collection of the artist

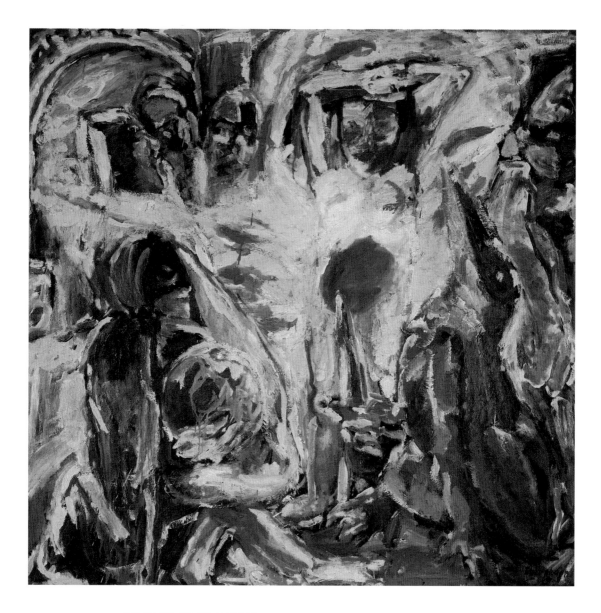

198 **Hartwig Ebersbach**
Burning Man I, 1966
Oil on plywood
145 x 145 cm
Museum moderner Kunst
Stiftung Ludwig, Vienna

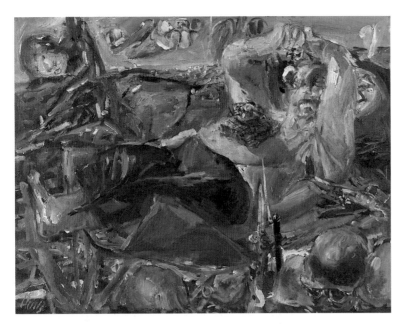

199 **Bernhard Heisig**
The Unteachable Soldiers'
Christmas Dream, 1964
Oil on masonite
41 x 52 cm
Monika and Karl-Georg Hirsch

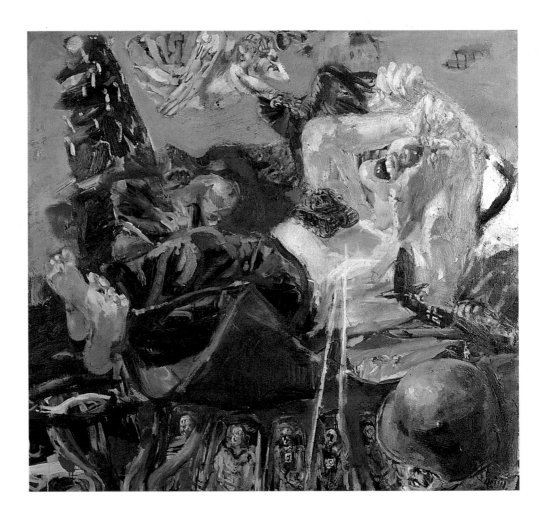

200 **Bernhard Heisig**
The Unteachable Soldiers'
Christmas Dream, 1974/75
Oil on canvas
100 x 107 cm
Kunstsammlung der
Städtischen Museen Jena

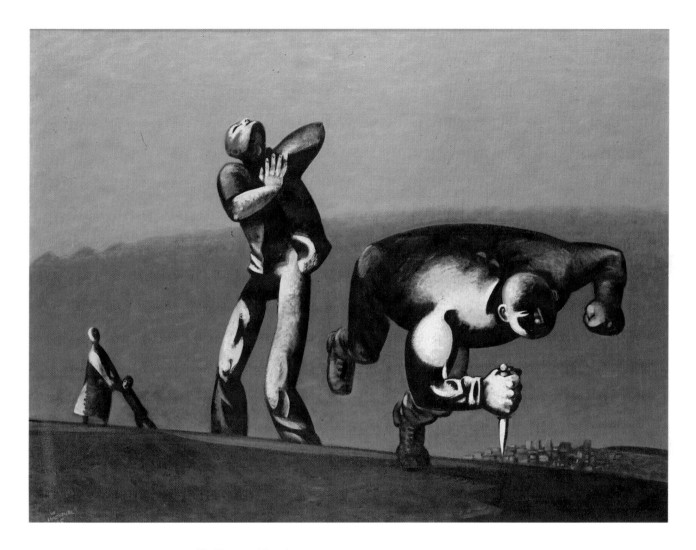

201 **Wolfgang Mattheuer**
Cain, 1965
Oil on canvas on masonite
95.5 x 118.5 cm
Staatliche Galerie Moritzburg, Halle

Werner Tübke: Reminiscences
of JD Schulze III

Werner Tübke, *Reminiscences of
JD Schulze VII*, 1967
Mixed techniques on canvas on wood
122 x 182.5 cm
Museum der Bildenden Künste Leipzig

The First World War provoked a protest of the artistic imagination. The horrors of the Second, the German crimes, and the moral disaster lamed artists and lead to a silence of historical denial. Cases of dealing openly with what happened are very rare, even in the anti-fascist GDR. The most comprehensive example is as problematic as it is moving: the series of painting from the Leipzig painter Werner Tübke entitled *The Reminiscences of JD Schulze*. The fictive main character, with his common German name of "Schulze", stands for the uncountable "pencil-pushing" murders and representatives of Nazi "justice," who without scruple or regret continued after 1945 to work in both East and West Germany. The cycle of works was completed between 1965 and 1967 and includes variations and excursions, made up of 11 main works, 15 watercolors, and about 65 drawings and studies in which the artist continually reminds himself of his motif and of his capacity to feel pain. They are based primarily on photos and film documents from the concentration camps. The immediate impetus for these works was the Frankfurt Auschwitz Trial from 1963 to 1965. Decisive is the fact that these works were privately initiated without public funding and were later, as the work grew, sponsored by the *Kulturbund* (Culture Association).

Tübke is no didactic artist whose "message" stands in the foreground. The memories involved in his work opened Pandora's-box, catapulting the artist into a morass of conflicting feelings and associations.

Tübke combined his analysis with painful self-examination, losing his way in confusion while working in the labyrinth of bourgeois normality and crime. With his choice of subject, more than bringing reality into play, he brought forth the contents of consciousness. His entire life he has tried to deal with a multi-layered and contradictory world-historical event through correspondingly complicated and heterogeneous artistic forms. He dissolves the single work into cycles, series, and panoramas, then changes his style and examines thereby the different aspects and meanings of his subject. He combines realistic elements with reflection, the fictive, the contemporary, and historical with inner and outer perspectives. Tübke has a preference for interpreting history through history, which means through historical consciousness and images. However in the *JD Schulze* cycle (see fig. 202/203, p. 171/173), this technique reaches its limits. The mirror breaks again and again, refusing to deliver the key figure and answer. The contradictions and chaos are the result

of Tübkes search for truth. The cycle knows only changing perspectives and feelings. There are no final formulations or solutions. The style of these works changes violently. Cold academic precision and controlled technique are followed by frantic, expressive, almost pathological elements. Succeeding distanced portrayals are traumatic and claustrophobic scenes. After the clarity of Bruegel comes the excess of Ensor. Sovereign narrative is interrupted by stuttering and dissonant passages. Virtuosity stands next to despairing catastrophe. Cold and feverish heat, torture and desire, intermingle with one another. Tübke buries himself so far beyond redemption that the threat of a collapse of consciousness or death by suffocation through the deluge of feeling and history is not far off.

For Tübke The Last Judgement consummates world history. At the beginning of the cycle stands the *Requiem*, a still-life, a highly sensitive choreography of figures writhing in the pain of death, expressively draped bodies whose emotion appears through a kind of surrealistically exaggerated precision wrought with penetrating loneliness. Their only echo is their shadows against a brightly lighted prison courtyard. The few accessories - a neglected, sawed off "Tree of Life," a kneeling mourner turned away from the viewer, a wreath, and an emblematic dove of peace - strengthen the stillness of death. Following the miniature-like eulogy of the *Requiem* in the cycle, are hate and violence. Many studies were never ended and remain only in a germinal stage. Others, like the small version of the theme, portray cruelty and torture with the clarity of the old masters. The seventh version even attempts to address and overcome the trauma, thereby combining two major motifs of his work. He penetrates the horror of the past stored in the unconscious with scenes at the beach, images of a happy and contented present. Two seductive female nudes hold - picture to picture - the horror before them. The most important version is the third variation in monumental format. Here the erupting violence is raised to the level of world theater, anchored in a great historical allegory. An all powerful judge figure holds court like an evil deity in the ruins of a fortified tower. Tübke does not personify the judge but rather chose a marionette dressed in red hanging from strings, a mechanical soulless puppet with robot hands, a balloon head with grotesquely sketched features. Like a lord of the Middle Ages he presides over the gruesome atrocities. The symbol of the strings summarize the image - all that they created and hold together. The painting is composed of the most divergent segments, and terraces, out of landscapes, architecture and interiors, become an unreal, dissonant, pictorial space. The individual scenes fall apart and yet commensurate with one another at the same time into a pulsating whole. The evil judge, whose figure could be

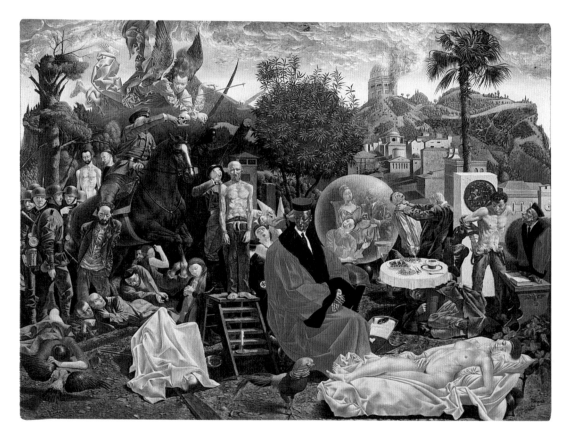

202 **Werner Tübke**
Reminiscences of JD Schulze II, 1965
Oil on canvas
40 x 53 cm
Staatliche Galerie Moritzburg, Halle

taken from a Bruegel parable, divides the world - compare here the Berlin drawing *The Ass in the school* (1556) - into a sphere of hellish terror and its victims and a right sphere made up of the paradisiacal world of the perpetrators. The eyes of the statist monster fall on the scene of victims in a concentration camp, a box frame in which one sees prisoners, corpses, and caskets labeled with the names of Jewish victims. Here the branches of the "Tree of Life," into which a knight has climbed, extend themselves. Tübke shows violence and cruelty as an insoluble union of cause and effect, of perpetrators and victims, of horror and lust. The scenes intertwine, flowing into one another, overlapping almost palimpsest-like. Like a cancerous tumor, the horror scenes spread out, only to disappear, before reappearing again in more malignant form. One recognizes an SA member on the right side, under him a figure resembling Himmler who is executing a blood drenched victim, further below there are marching soldiers, a group of tortured prisoners, a figure removed from a cross, and finally a woman keeling over a corpse covered with cloth. This bizarre and horrid garden is a vile and depraved paraphrase of the famous *Garden of Lust* from Hieronymus Bosch.

Meticulous realism is transformed into a conjuring of the Old Masters as if in a dream. And Tübke's quoting of old German subjects and style-forms is not accidental: Altdorf's magic heaven, in which a twisting windtunnel looms above and an angel, surrounded by a colored aura, sits holding a scale. On the left side is a skull, and on the other, lighter side, a dove. Tübke uses a style cultivated by the National Socialists in the thirties in order - as successor to Dix - to show its bankruptcy. He presents, in a so-called "healthy" artistic language, sickness: the criminal fantasies and atrocities of the regime.

Left of the judge the horror, to the right the idyllic world of the perpetrators. A model for the sunny southern landscape, rolling hills and manicured gardens, was the hotel mountain at the Caucasus resort Suchumi, a luxurious refuge for soviet bureaucrats. The terrace scene to the right of the foot of the judge unfolds an odious bourgeois interior, that again, and not accidentally reminds one of Dix, and this time, Dix of the twenties. Two adults are flirting while a boy dressed in a sailors outfit - here the artist draws on his own autobiography and origins - lays on the floor reading. At the bottom right of the painting extremes converge: bourgeois lust recalled through erotic images, with the cruelty and horror of the Third Reich. Inciting is the contrast between the beauty spread on the canvas and the macabre images of the tortured, suffering, and dead. These spheres touch each other at the balustrade. Here we encounter a wreath for the dead, a relief with Picasso motifs, and homage's to the great ambassadors of humanity. Finally, again Bruegel

Pieter Bruegel, *The Ass in the school*
1556, Ink, quill
232 x 307 mm
Kupferstichkabinett
Staatliche Museen zu Berlin –
Preußischer Kulturbesitz

like, comes the artist's own childhood, disparate, mysterious, and not yet overcome. An archaic relief with the plundering of Europe is a weathered reminder of the ancient world. A praying monk in his cave recalls the hidden or lost world of Christianity.

These are slivers, associations, the remains of dreams, ideals, and counter-worlds that touched the spiritual life of the artist, that could not prevent the worst, and in remembrance, could not put the pieces fully together once and for all. The detailed, but at the same time large-scale work is painted with watercolor brush and egg-tempera on a white plaster background. Subtle drawing is combined with biting color. The groups and forms are left sketched and free-floating. Tübke refuses to moralize or deliver an agitational message. The contingent and ambivalent work, the opposite of anti-fascist propaganda, met, in 1965, with official rejection but also found admirers and defenders who saw in it a hidden critic of the GDR system. The painter was accused of using encoded messages, psychopathic Surrealism, and alienation, and showing inadequate support for the party. Finally it came to serious discord with the party. Tübke was expelled from the Art Academy in Leipzig. Pieces from the cycle of works were later shown in Italy, in 1971. As the Italian catalog came through the mail to Leipzig the package was refused and seized by the police who labeled it "filth and rubbish." A year later the East Berlin gallery devoted itself to the cycle in a studio-exhibition. Today, the third largest version can be viewed at the National Gallery on Kemperplatz.

Eduard Beaucamp

This essay is based on an article that has been published in the "Frankfurter Allgemeine Zeitung", 1/22/1994.

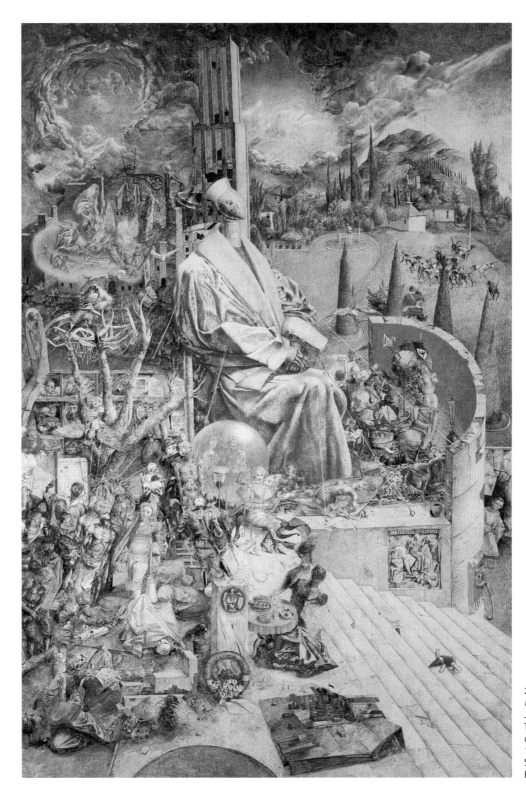

203 **Werner Tübke**
*Reminiscences of
JD Schulze III*, 1965
Tempera on canvas
on wood
188 x 121 cm
Staatliche Museen zu
Berlin, Nationalgalerie

ICON AND COSMICON:
On A. R. Penck

A Divided Country:
Immendorff visits Y

A.R. Penck was the icon painter of the Cold War in the Electronic Age whose second phase is now ending with the worldwide networking of computers. Now that the walls have been razed, the mine-fields cleared, and the radio signals decoded, the allegorical meaning of his painting has come to light. It was not the world of cave men that was traced here. At most, in primitive recurrence, the luckless shadows of the Parthenon frieze come through in his canvases, the anthropoid ghosts of total war. The spear-carriers, the hunters and gatherers, had long since been replaced by the bureaucrat with a table of dogma, the ideologue with a traffic arrow, and the soldier of world revolution. These figures were the new cast in his paintings, ordered into groups in a game of positioning. The *World Picture* of 1961 first captures them in an exemplary fashion, and still today one senses the horror preserved here, the ominousness of their heavily armed encounter. Since then, with paintings which only remind decorators of Lascaux, Penck has tried to describe the status quo as a dangerous confrontation. For three decades, Ice-Age research was his project (which the name of the German glacialist Penck stands for). The Ice Age from which his pictures came ended yesterday — a geopolitical Ice Age. Caught in the pack ice of blocs, boxed in between immobile masses (of population, weapons technology, architecture), he tried to develop, from nothing, a pictorial alphabet with which the dead-end situation could be described—as state of the art.

The series of experiments leading to *Standart* betrays his scientific longing. The pictogram style he later developed betrays his desire to clarify complex relationships no one still understands, let alone can represent. His iconography owes itself to the pretence of the cybernetics of those years: to grasp the dynamics of competing systems and informational cycles in terse formulas. His analytic work, whose building blocks are logic and systems theory, is unique in post-war German art. His mission is not exhausted in laments about the crisis of representation or in Expressionist rhetoric: he was already wary of mimetic painting early in his career. The transition from a traditional image of humans to the no man's figure of his stick figures follows the disappearance of humans on new shores. His warnings extended the political horizon to the planetary. His pictorial formulas translate the "Dialectic of the Enlightenment" into nothing but no man's dances before a still nameless catastrophe.

It is not an accident that art criticism, blinded by his archaic gestures and the jungle colors following the period with black figures, was quick to lock him in the cage of the *Neuen Wilden*. At the end of a century of sublimation, which has been a dream of flourishing capitalism ever since the graves of humanism have had place names everyone knows, his art is systematically confused with Stone-Age symbolism and cave painting. One needs no drugs to recognize oneself in the labyrinth of his symbols, finally holding nothing but a cartridge, a button, or a fragment of a hand-axe which has turned back into nature.

Durs Grünbein

204 **A.R. Penck**
World View I, 1961
Oil on masonite
122 x 160 cm
Kunsthaus Zürich,
Vereinigung Züricher
Kunstfreunde

205 **A.R. Penck**
World View II (Large World View), 1965
Poster paint on masonite
172 x 260 cm
Museum Ludwig, Cologne

206 **A.R. Penck**
A Possible System (A=I), 1965
Oil on canvas
95 x 200 cm
Museum Ludwig, Cologne

207 **A.R. Penck**
„L-Korso", 1977
Acrylic on canvas
144 x 180 cm
Collection Sanders,
Amsterdam

208 **A.R. Penck**
Passage, 1963
Oil on canvas
94 x 120 cm
Ludwig Forum
Aachen

209 **A.R. Penck**
Passage by Night, 1966
Oil on patterned fabric
(table cloth)
100 x 130 cm
Private collection, Essen

210-227 **A.R. Penck**
Standart-Model, 1973/74
Museum Ludwig, Cologne

210 *S-Model No. 1*
Three-part carton object
connected with pins
41 x 66.5 x 15.5 cm

left: front side
right: back side

211 *S-Model No. 2*
Five-part cardboard object
46 x 43 x 39.5 cm

212 *S-Model No. 3*
3 cardboard objects
placed on and in each
other, partly connected
with pins
59 x 38 x 28 cm

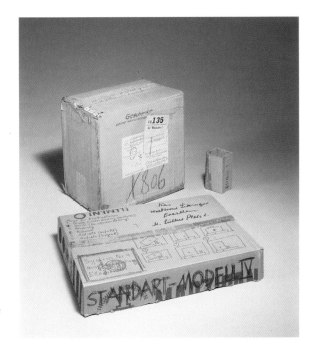

213 *S-Model No. 4*
Carton object from three
moveable elements
40 x 38 x 28 cm

214 *Hanging felt heart,*
mounted in six-sided,
cut cardboard box
39 x 3.5 x 23.5 cm

215 *S-Model No. 7*
System break through
carton, glued with
cardboard and felt objects
37 x 42.5 x 31.5 cm

216 upper left
*S-Model No. 8; Function of Form/Function of Recognition/
Function of Separation*
Carton with felt object
17 x 42.5 x 31.5 cm

217 upper right:
Model Probabilistic
Carton with green felt snake, carton flap, fixed to carton
punched twice with holes by pins
10 x 52.5 x 40 cm

218 lower left
S-Model No. 10
Alternative machine, 6-part
cardboard object
60 x 51 x 22.5 cm

219 lower right:
*Model No. 6 „Pyramid cube
sphere cycle No. 6"*
Carton with cardboard ob-
jects, paper, red silk band
and ball of wool
23 x 33 x 27 cm

220 *Decision Model*
(Antenna box)
Carton stuck and glued with
various cardboard objects
47 x 31 x 30 cm

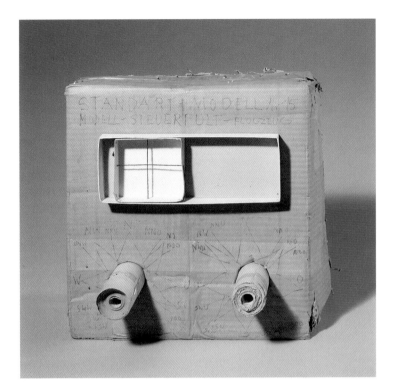

221 top:
S-Model No. 15
Cardboard object with roll
of carpet cut, stuck-through
and glued on
with cardboard,
41 x 42 x 30 cm

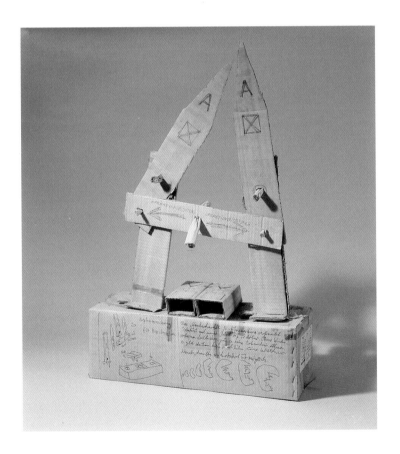

222 lower left
Standart Identity Machine
Carton, with various
moveable or glued on
cardboard objects
90 x 58 x 21.5 cm

223 lower right:
2 Books:
drilled through once
and twice
25 x 25 x 10 cm

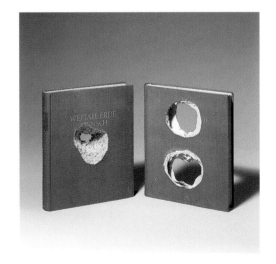

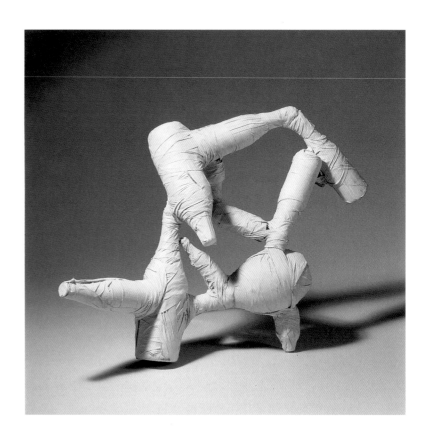

224 upper left:
2 light bulbs, one bottle
wrapped with
sticking plaster
15 x 23 x 13 cm

226 lower left:
Narcotic Center
Carton with two tin cans, a
bottle, soap, a ruler, brush,
painted blue–white
33.5 x 41 x 31 cm

225 upper right:
11 bottles wrapped with
sticking plaster
48 x 68 x 20 cm

227 lower right:
Carton, newspaper wrapped
with cord
97 x 22.5 x 22.5 cm

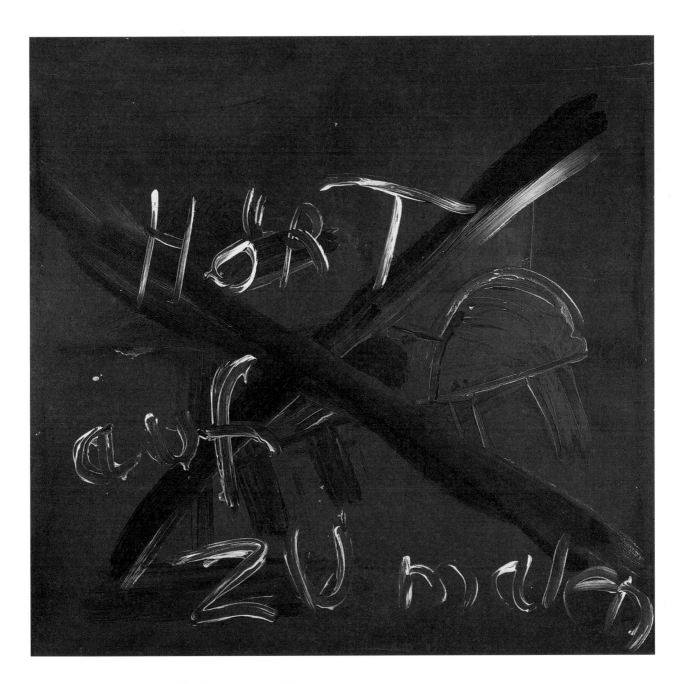

228 **Jörg Immendorff**
Quit painting, 1966
synthetic resin on canvas
135 x 135 cm
Stedelijk Van Abbemuseum, Eindhoven

229

230

229-234 Jörg Immendorff
Brecht Series, 1976
6 paintings, synthetic resin on canvas
each 110 x 90 cm
Stedelijk Van Abbemuseum,
Eindhoven

229 *Brecht Series*
(Questions of a Reading Worker), 1976

230 *Brecht Series*
(Questions of a Reading Worker), 1976

231 *Brecht Series*, 1976

232 *Brecht Series*, 1976

233 *Brecht-Series*
(A Great Man every Ten Years.
Who pays the Expenses?), 1976

234 *Brecht-Series*
(Questions of a Reading Worker), 1976

IN WELCHEN HÄUSERN DES GOLDSTRAHLENDEN LIMA WOHNTEN DIE BAULEUTE? WOHIN GINGEN AN DEM ABEND, WO DIE CHINESISCHE MAUER FERTIG WAR, DIE MAURER?

231

DER JUNGE ALEXANDER EROBERTE INDIEN. ER ALLEIN? CÄSAR SCHLUG DIE GALLIER. HATTE ER NICHT WENIGSTENS EINEN KOCH BEI SICH? PHILLIP VON SPANIEN WEINTE, ALS SEINE FLOTTE UNTERGEGANGEN WAR. WEINTE SONST NIEMAND? FRIEDRICH DER ZWEITE SIEGTE IM SIEBENJÄHRIGEN KRIEG. WER SIEGTE AUSSER IHM? JEDE SEITE EIN SIEG. WER KOCHTE DEN SIEGESSCHMAUS?

232

233

ALLE ZEHN JAHRE EIN GROSSER MANN. WER BEZAHLTE DIE SPESEN?

SO VIELE BERICHTE, SO VIELE FRAGEN.

234

WER BAUTE DAS SIEBENTORIGE THEBEN? IN DEN BÜCHERN STEHEN DIE NAMEN VON KÖNIGEN. HABEN DIE KÖNIGE DIE FELSBROCKEN HERBEIGESCHLEPPT? UND DAS MEHRMALS ZERSTÖRTE BABYLON, WER BAUTE ES SO VIELE MALE AUF?

Immendorff Times Penck
X Penck Times Immendorff

Opening of Jörg Immendorff's exhibition "Malermut rundum" (Painter-Courage-Orama) on Aug. 14, 1980 in the Kunsthalle Bern. Johannes Gachnang (Director) is accompanied by A. R. Penck on string bass.
Jörg Immendorf *Café Deutschland IX / Stilkrieg,* 1980
Synthetic resin on canvas
280 x 350 cm
Collection of the Artist.
Painting on the right: cf. fig. on p. 187

Let me start by comparing situation West briefly with situation East around 1977. At the time they were still separated by the Wall (Wall of disgrace x antifaschist protection Wall), which divided not only a city, but a country, if not even an entire continent. Two different societal systems, from which the actions of the two artists sprung and the illucidation of which should contribute to the deeper understanding of the whole. It should be mentioned that in this kind of observation, the political aspects inevitably let the artistic aspects recede into the background.

We begin in the West because in this case the initiative came from Jörg Immendorff. At the beginning of the 1970's in Dusseldorf and in the Rhineland, he increasingly isolated himself through the political themes he brought directly into his paintings and by the way he manifested himself as artist towards society. No one in the better, that is, the West side of the art world wanted to seriously discuss what he proclaimed in image and word. Thus, Immendorff felt compelled to keep a look-out for suitable allies who would help to understand art and politics as a symbiosis, to jointly draw up guidelines which had to be defended.

Immendorff marked this departure with the painting *Self-Portrait in Atelier* (1974), in which the artist self-critically challenges himself to go into the street. Yet even in this case it is necessary to stress that the paintings created in the atelier, although inspired by the events in the street, were hardly accepted by the street. *The Brecht Series (Questions of a Reading Worker)* (1976; figs. 229-234, p. 184), an artistic confrontation in six paintings with the poem "Questions of a Reading Worker" by Bertolt Brecht, shows the intelligent endeavor to call to life a forum suitable for coming discussions and to awaken interest in the current political concerns. On the occasion of the Venice Biennial 1976, it soon became evident that despite the international art crowd gathered there - who presented themselves in the shipyards on Giudecca to talk about contemporary art - there was only little interest in discussing the subject.

Immendorff's efforts in Venice therefore, did not fare any better than those of Malevich, who had attempted to bring across his artistic intentions and strategies to his colleagues at the Dessau Bauhaus fifty years earlier. Lack of language skill in both places could not have been the sole deciding factor in the misunderstandings and failure. In short: Babylon had to be rebuilt after having been destroyed many times and with that, Immendorff's way to Dresden was charted.

The situation in the East presented itself necessarily as calm, to the extent that you could judge from the Western side. A.R. Penck's activities remained discretely controlled under the surveillance of the State Security Service to prevent a possible fire from spreading to epidemic proportions. Penck understood this kind of vacuum as a consequence within the framework of the regime's experimental phase in connection with his brainwork. For this, he designed suitable strategies to use and at the same time, to subvert a comic situation imposed on him. In the West, one hardly got reports about these kinds of undertakings. Here, the primary interest was in his painting, which appeared to be concepts transposed by means of painting and therefore meant to define the goal of a greater system. This kind of delivery in Penck's case brings to mind, for the most part, the radical inventions in the area of language of Russian artists such as Malevich and Rodchenko or Chlebnikov, to briefly refer to the creative powers from Eastern Europe.

It is interesting that an American artist like Donald Judd had never declared himself to the Bauhaus, but had always stressed the pioneer achievements of the Russian Constructivists in connection with his own work.

Moreover, in 1976/77, no significant work series were completed in Immendorff's atelier in Dusseldorf nor in Penck's in Dresden. In both places, the signs pointed to change: In thought, Immendorff was already on the way to his hommage to Bertolt Brecht's 80th birthday in 1978. Immendorff initiated both activities. He tried, transcending borders and ideologies, to create a platform, to find a point of departure for the cooperative work on the great subject of art as a social concern. His intention in the artistic process, was to jointly overcome the Wall - that which separates - and personal isolation. The first meeting between both artists took place in East Berlin on May 1, 1976. They committed themselves and secured each other's solidarity and decided on joint actions for the near and distant future.

The two artists set the exhibition "Immendorff Times Penck, Penck Times Immendorff" on the program at the Galerie Michael Werner in Cologne for the end of 1976. As if the authorities in the East had gotten wind of this trespassing of Wall and frontier, they prevented for the first time the actually illegal but until now tolerated transport to the West of Penck's sheets painted with emulsion paint. Incidentally, 13 years after the lash against Base-

Jörg Immendorff
Café Deutschland VI / Caféprobe, 1980
Synthetic resin on canvas
280 x 350 cm
Galerie Michael Werner, Cologne

litz in the West, art works were again withdrawn in Berlin. This time, three works were confiscated. The sender was reimbursed in 1993, following the transformed political situation. As chronicler of the time, Immendorff had captured this unexpected incident in an excellent manner for art as well as for history with the painting *Café Deutschland - Border* (1977). Thus, he painted Michael Werner, among others, being frisked by the (East German) People's Police. By the way, also an art dealer, Werner was not only capable of achieving the unusual for German art in this case. What is more - for many years right up to today, he worked on and participated in the entire presentation of this art together with the artists in a far-sighted manner.

The exhibition was not cancelled because of this disturbance, but was postponed for a short time. Immendorff engaged his colleague Penck to paint three new paintings for the joint project, in an abstract manner if possible, in order not to provoke unnecessary difficulties. With the second attempt, Penck's contribution[1] passed unqueried through the German-German border. The exhibition itself could finally be opened on January 12, 1977 and was to be seen for four entire weeks. Out of interest and reasons of solidarity, I saw all of it personally, and began to address the new situation that had arisen, which seemed to promise a different future and diverse perspectives for myself and my work. I discovered where the common house could stand. "Café Deutschland" was its name, and this metaphor served Immendorff for a long time into the future as artistic workshop. All his friends were invited, and as artist he set all of them into the picture!

Also, in the case of the Cologne exhibition, Penck merely had the paintings delivered, without even having the possibility of seeing them presented there. On a later visit to East Berlin (Café Lindencorso), he would hear reports of these events, see photos, to form his own picture based on this meager information of how the matter presented itself in the given setting. The first exhibition that Penck was able to see after his expulsion from the GDR and simultaneous reception in the FRG in August, 1980, was that of his friend Imendorff's: "Painter-Courage-orama", which I, a bit later - with Penck on bass - had the honor of opening in the Bern Kunsthalle. One year later in the same place, the first presentation of Penck's work on Western ground took place. He had not only conceived it but had also, together with myself, worked it out to the last detail. He had had to wait twelve years for this event, during which his conceptually oriented colleagues in the West, in various exhibition places, had worked to conquer first the walls, then single rooms, ultimately entire institutions through which they controlled the understanding of art.

And if you recall Penck's exhibitions in the 1970's, you are still amazed today with what precision they were thought out and prepared. With the realization of each concept, those responsible and therefore appointed had in most cases an easy time, certainly only then when the concept was understood. I resolved the job twice to the artist's satisfaction, first for the Bern Kunsthalle, (1975), later in Rotterdam for the Museum Boymans-van-Beuningen (1979).

The exhibition in January/February 1977 in Cologne made, to my knowledge, no great waves in the public. The paintings, as well as the tackled initiative, met with resistance caused by the strained situation between the two German states. Once again, the local cultural pages in the press was still not ready to take up the East-West problematic thematized by the paintings nor a corresonding plea to take it further constructively on another level. On the contrary, in the following Summer on the occasion of the "documenta 6", those responsible let themselves be blackmailed and took Penck's paintings down from the walls, placed them in depot without comment, no doubt to make room and to spare the official artists of the Leipzig School trouble with the functionaries. The exhibits of this circle were added on short notice to the exhibition in Kassel because of soft political pressure. Subsequently, it was no surprise when Lüpertz and Baselitz showed their solidarity with Penck and ordered those responsible to take their works down, too. Immendorff had not been invited to documenta, and for that reason his name is missing in this connection. Once again, politics were done at the cost of art, and no one noticed that in the East, the postwar joy of experimenting - slowly choked by the functionaries - now finally came to a standstill.

After the diverse, not infrequently exciting events in the course of 1977, the situation in the Dusseldorf and Dresden ateliers was so charged that the pent-up energies simply had to burst into series of paintings. Immendorff found his credo in the theme "Café Deutschland" which he used as chronicler and critic of his time, but which he also understood as forum for his own and his friends' public visibility. In the center of the discussions on the state of art, the illustrated example of the East-West problematic of Penck and Immendorff stood in the Dusseldorf atelier. The first works in this painting series appeared, even to the specialists, as very unusual. The works contradicted, rather mocked the Zeitgeist in the artistic sense, i.e., all aesthetic criteria established by the Conceptualists and Structuralists, but also the rhetoric of their proponents. Despite any reservations, one had to admit that they bore the aura of the painting- never-seen. At the same time, a harsh realism forced the sceptics to take a position, art always ranks before politics on the respective agenda as regards this kind of work seeking the

[1] There were three untitled canvases which Penck painted abstractly and only in black, two of which were 2.85 x 2.85 meters.

image - even when for a long time the opposite was maintained from the side of the critic. Immendorff's achievement consists above all in that he has always succeeded in breaking with the aesthetic consensus in the sense of the 1917 avant-garde (Dada). Parallel to this, he tried to proclaim an international question in the midst of his art and to interpret the division of Germany and Europe in a topical as well as modern image and to resolve this question artistically. Of course this was basically an impossible venture whose failure was presaged and precisely for that reason is of such inestimable worth.

In Dresden on the other side of the Wall, the *Chameleon* series arose as counterpart, and with this - as the title already suggests - in a kind of exercise in style (exercice de style) the confines of the discourse in the East as well as in the West were once again to be intellectually provoked and opened up, which succeeded initially, at least on the Western side. At the same time, in the East, the last round of the end game was kicked off, only to be played out ten years later. At the time, I first heard Penck express the wish for changes, with London and the East End as actual goal. That was new - to date he had

solidarity visit was illustrated in word and image; the book by Fred Jahn appeared the same year in Munich and was rated by Penck's circle of friends as "Czech children's book". Immendorff painted 41 gouache pictures in the unheated atelier, on which his host Penck commented in writing. Subject: The situation in East and West and how one can find themself as artist in the larger entirety and overcome borders. Still another year later after the completed "transition" in the West, Penck noted laconically: "A new life begins, the work continues." Immendorff had found the platform he sought, set forth important themes, although it has to be stressed, that people are first and foremost much more interested in the artistic and political concerns of the two protaganists beyond the borders rather than in their own countries. It is therefore no surprise that shortly after the encounter in Dresden, preparations for the exhibitions in the Basle (Immendorff) and Rotterdam (Penck) museums began. Thereby, the energy generated was finally directed into two independent aims - each artist dealing with a personal artistic discourse without, however, losing sight of the friend and ally.

Johannes Gachnang

Warm-up.
From left to right:
Christian Lindow, Jörg Immendorf,
Michael Werner, A. R. Penck,
Albert Oehlen

Game between Switzerland and Germany on Aug. 15, 1980 in Bollingen near Bern.
1st row, from left to right:
Christian Lindow, Michael Werner, Albert Oehlen Jörg Immendorff, Markus Lüpertz, A. R. Penck, Franz Fedier, (referee).
2nd row, from left to right:
Anselm Spoerri, Rémy Zaugg, Anatole DuFresne, Eberhard W. Kornfeld, Ralph Gentner, François Grundbacher, Johannes Gachnang (Coach Switzerland).

vehemently supported the standpoint that the essential problems of a German artist in the East as well as in the West had to be the same. Everyone had to simply tackle and resolve the entire thing with all the means available to him, so that in the last consequence a valid painting, seen as orientation, is what determines the situation and not the other way around. "The painting must assume the function of the potato", was how Immendorff's motto to his colleagues went.

Immendorff went on the road at the beginning of 1979 and visited Penck in his Dresden atelier. This visit is legendary today and documented thanks to the first music record "Gostritzerstrasse" by Penck and his friends. The

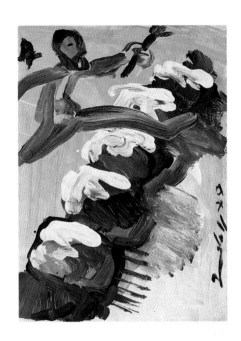

235 **Jörg Immendorff/**
A.R.Penck
Immendorff Visits Y, 1979
42 works on paper (including title page)
each about 14.8 cm x 29.6 cm
Dürckheim Collection

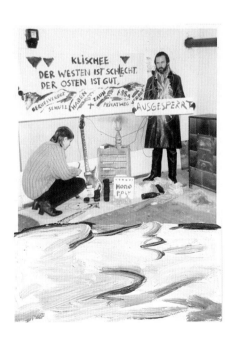

195

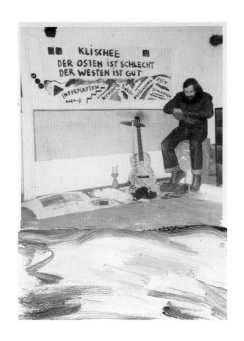

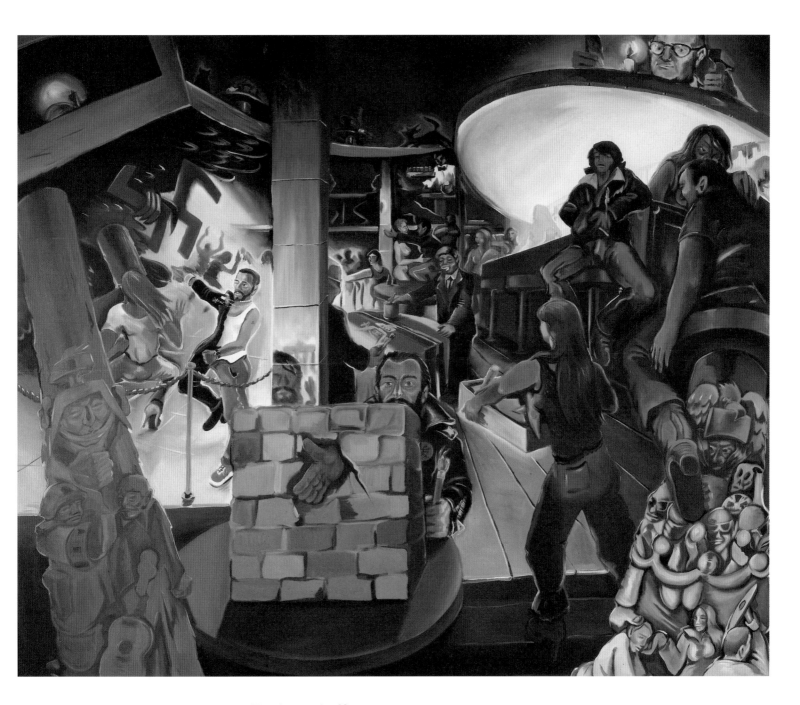

236 **Jörg Immendorff**
Café Deutschland I, 1978
Oil on canvas
278 x 326 cm
Museum Ludwig, Cologne

Phenomenology of Repression

"Establish a better morality in the human race through self-discipline and all walls will disappear."

Joseph Beuys, August 7, 1964[1]

Wolf Vostell during preparation Brock, standi

The "Festival of New Art", which took place in the Audimax at the Technical Academy in Aachen on July 20, 1964, made up an outstanding event within the numerous manifestations of action art in the 1970's. The presentation attained its significance not only because of its large numbers of participants and artistic variety. Featured artists included Eric Andersen, Joseph Beuys, Bazon Brock, Stanley Brouwn, Henning Christiansen, Robert Filliou, Ludwig Gosewitz, Arthur (Addi) Køpcke, Tomas Schmit, Wolf Vostell and Emmett Williams (Ben Vautier had to cancel at the last minute). The uproar, violent physical confrontation and the premature closing as well as the political reference to July 20th, the anniversary of the attempted assassination on Adolf Hitler, and the court penalties which followed gave the event a special status in art discourse.

Although ignored for a long time by the art historical establishment, the "Festival" was nonetheless present everywhere - however, as more than a "famous-notorious" event situated between folly, aggression and scandal, represented by the "heroic icon of the bleeding artist."[2] In recent times, on the other hand, the research also extending to contemporary "anti-art" devoted its energies to meticulously decoding the "chaos of the Modern" with the traditional means of art theory. That "Fluxus", the new field of work, is again able to partially evade such relevant pressure to decode and reconstruct, at the same time giving rise to continued methodical questioning, will also become clear in the analysis of the Aachen Festival presented here. The extensive descriptions of the event already published represent a fund of knowledge which is constantly being corrected and complemented.[3] The notion of an interpretation never coming to a conclusion appears to be deciphered from a fundamental Fluxus principle.

Like some other "provincial" Fluxus activities, the Aachen event also came to pass because of the special presence of individual, involved contact people: Valdis Āboliņš,[4] the architect student and Asta (student parliament) officier for culture, stimulated by the up-and-coming Fluxus scene in the Rhineland, had contacted Tomas Schmit in Spring, 1964 and asked him if he could take over the artistic organization of the "presentation of the

newest actions" at the TA in Aachen. The artists to whom Schmit shortly thereafter wrote were insured absolute freedom in the design of their contribution and the special date was not left unmentioned. Chosen at first for coincidental, academy-internal reasons, July 20 was then seen by the organizers as a "glorious coincidence", which would give "the cause an excellent background."[5]

For the artists, the reference to July 20 certainly had no general programatic character and each defined it differently according to outward requirements. Āboliņš later maintained in an interview, that he saw a connection to July 20 within the framework of Fluxus art and for that reason had invited people on this date.[6] Yet, according to the charges brought against the protagonists on the part of the "July 20, 1944 work group" there was absolutely no connection or statement about July 20th mentioned in the various writings and statements from Beuys (respectively, his lawyers) to the prosecuting attorney's office. It was merely Beuys' opinion that the Fluxus-program would fit on this day just as well as on any other special holiday, because the content "(is) always carried by an earnest feeling of responsibility towards human and artistic questions alike". In Āboliņš' and Schmit's corresponding statements, however, a reference to July 20th was once again confirmed (it was left up to the individual to establish his own).[7]

What distinctly emerged from the response letters from the artists and their statements for the Festival program and particularly from the actions performed, is that various participants had consciously integrated aspects relatable to July 20 in their works for the Festival.[8] A dispute about the performance authorization ensued, when the academy administration believed to have found an incompatibility between new art and July 20. The protagonists were only just able to push the event through with a lot of effort, publicity pressure and intervention by means of renaming the event a "commemoration". Thereby, the planned afternoon and outdoor actions certainly could no longer be realized. The confrontation had, how-

[1] See footnote 7. for reference to Beuys' position on the Berlin Wall.

[2] Peter Moritz Pickshaus, "Man darf die Kartoffeln nicht mit dem Messer schneiden. Joseph Beuys, Aachen, 7/20/64", *Kunstzerstörer. Fallstudien: Tatmotive und Psychogramme*, Peter Moritz Pickshaus ed. (Reinbek bei Hamburg, 1988) 356. Heinrich Riebesehl's reknown photograph of Beuys during the Aachen action is meant, in which the artist's nose is bleeding while he lifts a crucifix. The photograph was hung in large format in one of Beuys' work rooms.

[3] Especially in Pickshaus, 341f.; Uwe M. Schneede, *Joseph Beuys. Die Aktionen* (Ostfildern-Ruit bei Stuttgart, 1994) and Adam C. Oellers/Sibille Spiegel, *Wollt ihr das totale Leben? Fluxus und Agit-Pop der 60er Jahre in Aachen,* exhibition catalog, Neuer Aachener Kunstverein 1995, 8-87; see also: Source material and complementary documentation on the occasion of the exhibition: "Wollt ihr das totale Leben?", Neuer Aachener Kunstverein 1995 (Archive copy in the Aachener Hochschul- und Museumsarchiv). As source material, photo series by Peter Thomann, Heinrich Riebesehl and Horst Winkler as well as a small color series in the Joseph-Beuys-Archiv Schloß Moyland are presented alongside the not always exact statements from contemporaries. Original written documents are to be found mainly in the Archiv Hundertmark (Cologne).
Remnants of original film and sound recordings (among others, also an interview with Beuys, Brock, Vostell and Āboliņš from 7/3/64, which will be often quoted from here) are owned by the Technical Academy in Aachen and by the WDR-Archiv (the broadcast "Prisma des Westens" from 9/7/64, moderated by Dieter Kronzucker).

| Brock at a lectern | Brock performance | Joseph Beuys at the piano |

273 "Festival of New Art" on July 20, 1964 hosted by the Tecnical Academy in Aachen
b/w, 24'55
Production: Medien-Archiv Joseph Beuys, Nationalgalerie, Staatliche Museen zu Berlin and Berliner Festspiele GmbH
Concept/Investigation: Hannes Heer and Adam C. Oellers
Cutter: Gabriele Draeger

4 The Latvian Valdis Āboliņš (1939-1984) studied at the TA in Aachen from 1961 until 1970/71 *Miss Vietnam mit rohem Hering im Mund. Valdis Āboliņš,* exhibition catalog, Neue Gesellschaft für Bildende Kunst (Berlin, 1988).

5 Letter from Tomas Schmit, 5/19/1964 (see Oellers/Spiegel, 15).

6 Interview from 7/23/1964.

7 As for the criminal charges (of "public nuisance" and defamation) compare Oellers/Spiegel, p. 82 f. As proof of Beuys' political attitude, Āboliņš quoted however, Beuys' known recommendation to raise the Berlin Wall (from his "Course of Work - Resume" in the program to the Aachen event) and interpreted that Beuys wanted to say (in bitter irony): the "Wall has become everyday reality, like a piece of furniture, which should indeed be well proported". When this recommendation came to an inquiry from the Ministry of the Interior, Beuys wrote a memorandum for the Dusseldorf Academy, which - referring to today's unification - contained that absolutely visionary sentence presented as motto in the text presented here (compare Joseph Beuys, exhibition catalog Kunstmuseum Basel 1969, 15). The records of the trial are to be found in the Dusseldorf State Archives (File Nr. 2 Js 595/64; Rep 89, Nr. 164-166). Foreign students had also protested against the "Festival" to the TA principal.

8 Compare Āboliņš' Introduction in the program, which explained the political and

ever, intensified the curiosity within and beyond the student body, a Fluxus event had seldom attracted such attendance, around 800 people.

The spatially as well as temporally precise course of the evening,9 planned by the artists two days in advance and even rehearsed partly with various students as co-protagonists, was conceived from the start as simultaneous performance. The multi-level nature of the event referred not only to the simultaneous performances of the individual artistic contributions, but also to the simultaneity of the various medial forms of presentation within the artistic concept itself. The very entrance into the event - the seamless transition from the beginning of the infamous Goebbels speech (Do you want the total war?) recorded repeatedly on tape to the introduction speech from Bazon Brock at the podium (which he later continued standing on his head) - is a characteristic example of the enormously suggestive confrontation of two realities: the dynamic-aggressive thematization of taboo historical events with the customary world of the usual academic lectern address. While this form radically differs from official commemorations10 and triggered unrest and protest, the concept of large audience participation, which came mostly from Vostell, developed in the course of the evening into a fiasco. His performance *Nie wieder/never/jamais* presented a spacial as well as social interlocking of artists and audience: Numerous sheaves of grain were placed in the auditorium and were later picked to pieces, carried onto the stage, respectively, thrown at the protagonists. Two protagonists went through the audience rows, while they lead a boxer hound to the podium - a "police dog" (German Shepard) had originally been planned for this action. It was reported that the students had again and again pushed the barefoot man leading the dog from the podium down between the rows of benches, at the same time, however, calling "cruelty to animals".11

The activity in the auditorium had to do with the performance of eight men standing on the stage with their backs to the audience, who were supposed to fall into the

yellow pigment powder covering the stage every time the audience blew their whistles. Vostell himself sat facing the audience with gasmask and a blue lamp, which he switched on to signaled the audience to enter a process of reflection (explained on a piece of paper). The audience was to use the whistles provided, to slam the desk top, respectively when not whistling, to feel their own heartbeats. The medium of contemporary technology12 advocated by Vostell, for Aachen also, was meant entirely to serve a reappraisal of historical references. The radio placed at the front of the stage, decorated with bloody bones and the light impulses and commands to whistle were features of a dirigistic mechanism in which the human is robbed of his decision-making ability and made into an object of power with no will of his own. The students had only partially played along in this symbolic act of submission. Their disruptive behavior and constant counter whistling may have been, however, less the expression of their qualified resistance against repression as art, and much more the usual habits of students to fool around within the framework of cultural entertainment.13

It would prove difficult to integrate the contributions of the individual artists who performed in Aachen into the conceptual scheme of performance art. Nam June Paik had already conveyed the openness and variety of the concept and the Fluxus movement's claim of internationality in his design for the event's poster.14 Surely, the notion of happening as a form of performance which occured in scenes and intensively involved the audience is to be associated more strongly with Vostell and Robert Fillious. Fillious' performance, on the other hand, was spontaneously, nearly playfully left to the development of the evening and was thus only described in fragments. Performances with all sorts of "old junk" were to belong together with "L'Autrisme". We have photos of scenes with a ship's bell and dance numbers (with a student and with Tut Køpcke, among others) and with Christiansen playing hits on the piano. Performing with window display dummies (later damaged by the audience), dressing up in old

Beuys with chisel

Robert Filliou with mannequins

Tut Køpcke and Filliou

Brock's performar

artistic parallels within the subject July 20 and the statements in the program by Christiansen and Køpcke. Oellers/Spiegel, 19, 24, 27. For the actions by Brock, Filliou and Vostell 35, 36, 38f.

9 Compare with the diagrams by Vostell and Schmit (Oellers/Spiegel 40f.) and the film footage of the preparations.

10 The students associated fitting ways of celebrating - such as laying wreaths - with July 20, which at the TA did not count as an official commemoration day. The "proper" clothing of many students had less to do with this date but much rather with the attitude towards cultural events at the time. The official TA celebrations to commemorate the June 17, 1962, for example: apart from the teaching staff, noticeably many student societies were represented during the memorial procession; some students staged a realistic GDR border crossing with barriers and People's Police (*Aachener Volkszeitung*, 6/17/1964).

11 Statement by Johannes Cladders.

12 See also his statement in the program ("shunting station as municipal theater - highway with holiday traffic through the audimax") respectively, the interview from 7/23/1964 ("I conceived the sounds of a real airplane, that means, my idea was to place a real airplane in the TA") as well as the airplane in his picture *Never jamais* from 1966 (Oellers/Spiegel, 71).

13 An overestimation of the student disturbance as "resistance" can be found, for example, in the article by Günther Rühle (*Frankfurter Allgemeine Zeitung*, 11/28/1964, see Oellers/Spiegel, 12, respectively Jürgen Becker/Wolf Vostell, *Happenings* (Reinbek bei Hamburg, 1965) 374. The audience as well as the artists themselves were indeed reproached by critical contemporaries with insufficiently coming to terms with the fascist thematic

cronies' clothing as well as the performance of one woman protagonist, who sat in the auditorium sewing little dresses with baby carriage, plastic doll and baby bottle, were in fact part of the action *Ban the Bomb*.[15]

If we take the repeated staging of small scenes, text and music pieces – strongly alienated or taken from the banal everyday events – as a basic characteristic of an Anglo-American Fluxus orientation, then several artists had certainly gone in this direction (or at least had meant to). Emmett Williams' prematurely broken off work "An Opera", a scenic spoken piece, was originally meant to be stretched out over two hours. Three readers with cardboard plaques, on which the role of each is written *(Narrator – Naked Man – Woman)* as well as the author himself ("Music"), read stories from everyday life with help from cue cards. Williams signaled each change in reader by hammering monotone on the drum.

The presentation of text and written contributions was also an essential structural element in Addi Køpcke's

and Ludwig Gosewitz's actions as well as in those from the two Danes Eric Andersen and Henning Christiansen. Gosewitz advocated postal communication as a medium of action art, by involving the audience and using overhead projectors,[16] while Andersen and Christiansen foregrounded a stuctural aspect more strongly within their planned group and audience activites.[17] There is hardly any source material available about audience performances planned together with Køpcke. But there are photographs showing Andersen standing behind the uppermost row of benches with a megaphone next to Christiansen who is holding up the picture of a notorious hanging scene from WW II.[18] The board inscription assigned to Christiansen *Climb up*[19] is also to be seen in a color photo from the Beuys Archives: Køpcke appears to be tracing over the yellow writing with red chalk. The arrow pointing upwards was added later. The audience itself streaming onto the stage wrote on the board *(Crying Shame, Incest,* among other things).

The flowing transition between concept and performance, between collecting ideas, announcement and change are even more strongly visible during the performance with Addi Køpcke than with Andersen and Christiansen. From the wealth of announced form suggestions, his aphorisms and sentences – regularly ending with the question "What is it?" – are all that remain in the recipient's memory. Banal sentences and everyday habits alternate with poetic-literary and critically reflective text passages[20] or were spoken

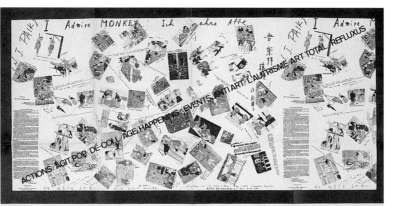

237 a Nam June Paik, Poster for the "Festival of New Art" on July 20, 1964, TA in Aachen
Offset, 84.5 x 59 cm, Galerie und Edition Hundertmark, Cologne

Beuys with a deck of cards, stove burners, and box of fat Wolf Vostell with a radio

(see Dorothee Sölle et al, *aachener prisma*, vol. 13, issue 1, Nov. 1964 also in Götz Adriani, Winfried Konnert and Karin Thomas, *Joseph Beuys. Leben und Werk* (Cologne, 1981) 131f. The actions were even called "Degenerate Art" in the ensuing debate before the student parliament (according to interview from 7/23/1964).

14 In all statements, they insisted on the classification as "international artist group". Bazon Brock mentioned in his speech the artists' geographic origins and described each country (France, Britain, The Netherlands, Denmark, Poland) as having suffered under German Fascism. In Beuys' action sketches in his catalog contribution on the subject of the "Berlin Wall" (see footnote 7), "the mid-European happening" and "the European happening" appear as integrating concepts (see footnote 35).

15 On "L'Autrisme" (according to Brock's announcement: "Das Andere, das Fremde, das Unverwechselbare") see also Oellers/Spiegel, 36.

16 Oellers/Spiegel, 36f.

17 Oellers/Spiegel, 33, 35f.

18 Photo by Peter Thomann, respectively, WDR - Film.

19 The idea turns up for the first time from him in an answer card and then in statement (Oellers/Spiegel, 52, 24).

20 Køpcke distributed pieces of paper on which were written "Draw a football". To his question: "Was the knife invented for cutting food or for killing?", the audience chanted "shut up", to which a student reacted furiously in the later discussion. Along with Køpcke, (to the audience's confusion), other artists also "constantly" distributed objects or paper: Vostell, Gosewitz, Brock ("bloom-newspaper"); stereoscope glasses were also handed out.

over by loudspeaker announcements. Køpcke's confronting the trivial with the meaning-laden disturbed, respectively, transformed the basic pattern of perception, the convention of interpreting texts and sentence, not without a measure of irony and humor. He also transferred this penetration of perception levels to images (by confronting a "Playboy" photo with a diagram of a battle formation[21]), although an historical principle of violence and oppression may also appear behind such a juxtaposition of war and sex.

Beuys' various performances (or his corresponding statements) show his specific ambivalence and mark a position of transition in the integration in the Fluxus movement's elaboration of personal performance concepts, still more distinctly than in Dusseldorf in 1963.[22] Beuys later increased his distance to the Fluxus scene (and to the neo-Dadaists), describing his connection as only "superficial, organisational", while at the same time developing his own Fluxus concept.[23]

On the other hand, Beuys also stressed the positive aspects among the Fluxus artists.[24] He described their demands for audience participation in the processes, their freedom of opinion and their pluralism of method, finally their "provocative statement", as an impetus, a process of resurrection which can address all possible powers (suppressed feelings, soul). Johannes Stüttgen's methodic-dynamic analysis also distinguishes itself from a purely formal Fluxus-reference. Recognizing and fulfilling the broadening of the Fluxus concept through Beuys (charging with spiritual content - the political stations - the social sculpture) is only possible, according to Stüttgen, in the framework of expanding art theoretical reception itself.[25]

The estimation that Beuys maintained a distanced relationship to the Fluxus scene, accords with the interpretation that the Beuysian application of the term "Fluxus" - a "propagandist trade mark of the movement"- was merely a means to disseminate his own ideas.[26] Such straight formation of theory or the phases of artistic de-

velopment stood in contrast to his still largely open work concept of the early 1960's, which probed in diverging directions. His own concept appears to have become concrete only in the performances following his personal experience during the Aachen Festival.

During the Aachen performance, the classic Fluxus thought was present not only in some of the action sequences, handling the piano – for example, shaking in various objects, painting over the music score, or generating vibrations with an electric chisel[27] – or by showing colorfully patterned cards. Autobiographical references[28] and personal positions also express[29] a still seemingly playful and superficial preoccupation with the most banal things and insane scene arrangements.

The new concept of social sculpture, described as an expansion of Fluxus, becomes very clear in the margarine action, which involves the processes of warming, melting and pouring into a "fat box". Beuys took a packet of Rama margarine from one of his boxes of materials and dropped it into the partially filled, already warmed box of fat. The meaning of this part of the action is revealed by the fact that his utensils, newly arranged, were later taken on in the vitrines of the Ströher Collection (in the Auschwitz vitrine, among others (compare p. 267). Because of the uproar, Beuys was no longer able to realize his *Fat Corner Model*, a work equally programatic.

Further performances or props are to be grouped around the performance mentioned above: first, the copper rod wrapped in felt and held up by Beuys,[30] then the battery of newspapers, the indicator and the rosebush, furthermore, a scene unknown until now, showing Beuys calling into the audience and then receiving an imaginary message.[31] Finally, the notorious scene after the brawl in which a crucifix is held high which, together with the handing out of chocolate, developed a new programatic referring to Christian motifs. Beuys reports of a fiery dispute, intended to be provocative and therapeutic, with a student who felt offended by the religious content of the

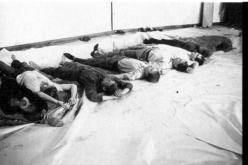

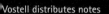

Vostell distributes notes | During the Vostell performance *"Nie wieder/never/jamais"* | Køpcke with "F

Crucifix Scene.[32] In contrast to the unambiguity of the Christian reference,[33] the preparedness for aggression[34] as described by Beuys in 1981 has to be modfied to the extent that the props used also appear[35] as all-embracing concepts in sketches and multiples, and that, instead of the mentioned "like lightening" counter reaction, there were rather perceivable moments of reflection. It could perfectly well be a matter of transformation, a change in consciousness during the course of the evening: from a more trivialized, yet typical Fluxus action (for example, according to the principle *"panem et circenses"*) to the inner impression of Christian experience of suffering (Passion) and charity.

In talking about the course of the brawl, which had developed as a result of a spilt splash of acid, Beuys said that he had already used the acid (HNO3) in his first scene with the rose ("I poured a drop of acid in the liquid, because I needed to produce a small amount of smoke").[36] He explained further that the scene ended afterwards and the bottle was locked in the tool box behind the piano. Then, as the audience mobbed the stage, objects (lamps, manuscripts, photos) were stolen from the box, including the bottle of acid, which someone took out, played with and must have knocked over. The climax of aggressions and disturbances were then triggered by a piece of clothing allegedly damaged by the acid.

21 See photo Thomann (Battle at Masurian Lakes, 1914).

22 Thomas Kellein, "Zum Fluxus-Begriff von Joseph Beuys", Volker Harlan, et al. eds., *Joseph Beuys-Tagung Basel, May 1-4th, 1991* (Basle, 1991) 137 f. as well as quotation Hans van der Grinten, "Diskussion X", 143f.

23 Quoted from Adriani et al, 69.

24 Volker Harlan, et al eds., *Soziale Plastik. Materialien zu Joseph Beuys,* 2nd expanded edition (Achberg, 1984) 23, 55f.

25 Johannes Stüttgen, "Fluxus und der Erweiterte Kunstbegriff", *Kunstmagazin*, 20, II/1980, 53f.

26 Under the headword "Fluxus", *Joseph Beuys*, exhibition catalog, Kunsthaus Zürich, 1993, 260.

27 Cf. Schneede, 46f. as well as Oellers/ Spiegel, 33f.: on the left, a score entitled "Kukei", on the right, a sheet of music from the Satie sonata played and painted brown (see also Joseph Beuys. *Braunkreuz,* exhibition catalog, Nijmeegs Museum Commanderie van Sint-Jan (Nijmegen, 1985) fig. p. 111).

28 The use of children's things and toys, in Dusseldorf two tin musicians, in Aachen a playpen, a humming top, tracing back to phenomena which had already appeared in some drawings from the "4 Büchern aus: Projekt Westmensch" (Nr. I 146 (125); Nr. II 79 (66)) or in "Fluxusobjekt" from 1962 (Achenbach Collection, Dusseldorf). These phenomena paraphrase the existence of own progeny as "Fluxus event" (also in Vostell, see *Aachener Volkszeitung* 9/27/1966).

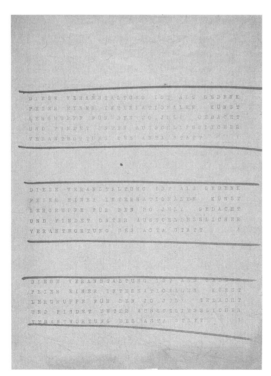

237 b Sticker for the "Festival of New Art" on July 20, 1964, TA in Aachen
Galerie and Edition Hundertmark, Cologne

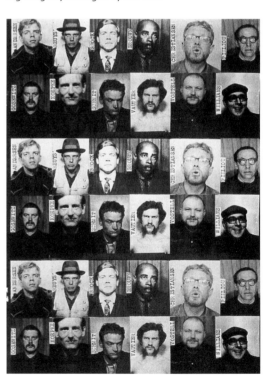

237 c Cover of the program booklet for the "Festival of New Art", Staatsgalerie Stuttgart

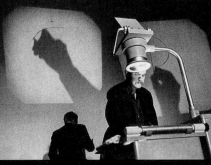

Franz Erhard Walther with spray can Henning Christiansen and Eric Andersen Ludwig Gosewitz

29 Following the chaos and damage, in contrast to Vostell's consternation, Beuys is reported to have bemusedly responded: "That's Fluxus". In a later interview, his statements about the equal thought correlation between causal sense and acausal sense (nonsense) point toward the Fluxus theory. Beuys, however, at once expands such a formation of counter concepts into a transcending "exploration of counter space - warmth - time - immortal intrinsic nature of humans" ("Krawall in Aachen. Interview mit Joseph Beuys", Kunst, 4/4, October-November 1964, 95f.). According to Walter Biemel, the artists reproached one another in their Hotel (Hotel "Drei Türmchen") the following morning, to the effect that bad and faulty contributions had led to the failure.

30 See illustration of the rod in Oellers/Spiegel, 78. For the action which was not documented in pictures, compare Schneede, 48.

31 The scene filmed took place parallel to Brock's action. Beuys moved up to the stage ballastrade, put his hands to his mouth as if calling to the audience; somewhat later, he holds an object to his ear like a telephone receiver. During Brock's speech (delivered from a headstand), Beuys, with bowed head, turned to the speaker.

32 Interview from 7/23/1964.

33 See Kreuz + Zeichen. Religiöse Grundlagen im Werk von Joseph Beuys, exhibition catalog, Suermondt-Ludwig-Museum and Museumsverein Aachen, 1985, 76f.; Schneede, 53.

34 Schneede, 48.

Today, it is no longer possible to exactly differentiate between deliberate upstarts, the play instinct of undisciplined students and Fluxus groupies. In this sense, some artists who were not officially taking part also sought to give themselves voices. During the performance by Franz Erhard Walther, who walked barefoot over the desks and sprayed pine fragrance into the audience, possibly suggesting (no doubt more coincidental) a closeness to the Vostellian scenes,[37] Timm Ulrichs' conduct must clearly be seen as a disturbance. He accused the actors of plagiarizing his ideas; the majority of the eggs stamped with "Total art" which he meant to distribute to the audience, had already been trampled and crushed at the entrance by Bazon Brock. Ulrichs knocked Brock over during his head-stand speech, distributed manifestos and made announcements over the microphone until he was finally barred from the auditorium.

Ultimately, the audience's storming of the stage was a particular hindrance which was caused as much by the mobbing of numerus (hobby) photographers and cine-filmmakers as by the corresponding incitement over the loudspeaker.[38] Beuys assumed that the people had "to some extent planned the aggressions", he stated that some students had confirmed this assumption, but that he couldn't concretely prove it.[39] Other motives for the disturbances were discussed in the off-the-record part of the interview: talk is heard of the generally known student tendency to fool around during Asta's film screenings, the shortage of women students at the TA, the car as status symbol, respectively, the general lack of consciousness among the students.

The artists agreed in their estimation that in the given situation, even without the violent assault on Beuys, it still would have been impossible to properly follow through with the rest of the program. This would have affected above all the pieces by Emmett Williams and Stanley Brouwn, which demanded the silent, "greatest concentration". Brouwn's action, planned for the end of the evening and until now unknown, is described as

follows: It was planned to eat at three different tables, while various contacts were to be touched with knife and fork, in turn triggering off topical radio programs.[40]

It was therefore not the case that the simultaneity of the actions itself was what gave rise to the audience's undisciplined tumult. Rather, it was more likely the simultaneous mixture of integration and exclusion of the audience, of intensive audience participation and stringent abstinence. Besides that, the students, during later discussions, repeatedly complained about a lack of explanation because the pieces' extreme polarity between the obvious and the enigmatic called for a yet unknown intellectual agility.[41]

As a result of the event, the notion that an artwork treatable as self-contained and concluded is put into question and finally made impossible by action art, remains unfamiliar to the artists as well as to the later observer. The categories of nonfinito or of destruction, which until then had referred to the epochs of classical art or to phases in the disintegration of culture, appear - in so far as the artist has been unwilfully confronted with them – to be a possible creative means of design of the avant-garde for the first time. However, one can only approximately determine to what extent these "counter impulses" have fallen on fertile earth with artists and audience or have continued to have effect.

Bazon Brock analyzed the event to prove his theory of mediatization of the modern audience. He said that "the freeze-frame image of art, ... the students' petrified notion of art" was "to be destroyed".[42] Brock legitimized his quotation from a Goebbels speech – which the students critized as an historical image possibly having a Nazi propaganda effect - by showing a film of a small action: While he layed out wooden matches on his leg, lit one in his mouth and then collected them together again, he told the story of the notorious Pirate Jack Cow, who had the sailors of a captured ship line up before him, asked them their names and then sent them into the sea. The

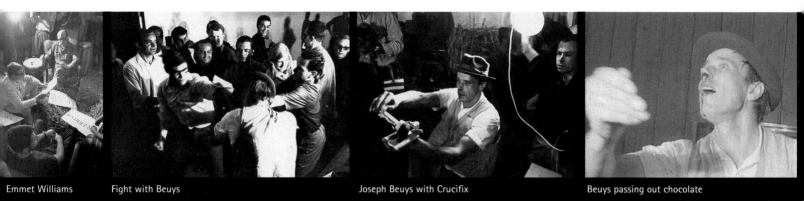

Emmet Williams Fight with Beuys Joseph Beuys with Crucifix Beuys passing out chocolate

35 Compare, among others, the sketches from the undated notebook with the title "Und jetzt zu den Ereignissen des heutigen Abends", appearing as illustrations, Klaus Fabricius, *Joseph Beuys. Aprovechar a las ánimas/Fer profit a les ánimes*, exhibition catalog, Museo de Arte Contemporáneo (Seville, 1993) 178, 179; see also Nr. 6 in: *Kreuz + Zeichen*, 77, dated "around 1964"; as well as Schneede, 53, dated "around 1965".

36 According to the interview from 7/23/1964.

37 According to Schneede, Beuys had spoken against F. E. Walther's participation; he spoke positively in the later interview (7/23/1965) ("I know him, a very nice and talented person in himself", who staged his "own happening"). There was talk of other "tag alongs" in the interview (Willem de Ridder from Fluxus Amsterdam).

38 According to a tape-recorded discussion (the instigator on the loudspeaker is unknown). Asta (student parliament) later found a "scapegoat" in the photographers, who was supposed to have "blocked" everything (according to interview from 7/23/1964).

39 Interview from 7/23/1964.

40 According to Vostell in the interview from 7/23/1964. The group of students cooking in the audience, however, had nothing to do with this action.

41 In an interview from 7/23/1964, Brock answered that culture is no casually passing, subordinate matter which for that reason must be explained. He continued, that it is not to be classified under natural sciences, nor an airplane, whose passengers certainly don't demand an explanation of how it functions.

ship's captain, standing among his men, finally answered with the name Jack Cow, who at the mention of the frightful name, then took flight himself. That Jack Cow would foreverafter run off in horror at the mere mention of his own name, Brock took for an error in history - reducing the name's spellbinding effect.[43]

In contrast to Brock, Vostell and Beuys present themselves again as characteristic polarities in the end. The two artists reacted in different ways to the central accusation of provocation, made again and again by the students and the press. In the interview, Vostell said that through the performance the audience was forced to analyze themselves that he had even performed his action, "in order to test the audience's self-control". What's more, he declined, however, to give a qualitative judgement on a matter already hacked to pieces.

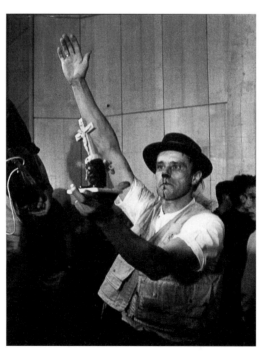

Heinrich Riebesehl, *Joseph Beuys at the Festival in Aachen*

In contrast to Vostell's self-contained, deductive concept,[44] Beuys worked on the audience to attain an increasingly open position by integrating new proccesses of perception. Discussions among students following the crucifixion and the brawl showed that Beuys had developed the approach to a social task in art; he spoke explicitly of a therapeutic effect of his work. Beuys assumed that even the students who had hit him had the potential and ability to learn and to receive the healing effect of his work. He took the punishment (advised by the student body) for "senseless" - "I can imagine that they had neither control nor knowledge of the emotional centers awoken by our happenings".[45] He learned of this necessity for such emotional provocation in Aachen, primarily from the confrontation with the natural scientists and their training. Already at that time, he had set his integral concept of life as art against their causality thinking.

Beuys appeared shocked by the discussion that followed in the student parliament, "how little consciousness is there, that for example, mechanical engineering, metallurgy and process engineering are, in the end, indeed currents of cultural life, which will not always be schizophrenically split." "Technology is part of cultural life ... That is certainly also our idea ... We do not want to separate. Indeed, we do want to integrate life. Life is art. All of life is art. The human being is art." Taking up from Vostell, who had called on the technicians to break away from self-limitation, to imagination and speculative methodic (for example, in experimental physics), Beuys said that we need chaos and experimentation as antithesis to methods of crystallization, the measurable, provable science, in order that new ideas may arise. Opposite crystallines, Beuys named "the amorphous" as "absolute chaos".[46]

The particpating artists may have reached a kind of programatic crossroads in action art, between social integration and art-inherent display through the Festival in Aachen. And the audience was also lead to its limits of reception at the time. Even if the conscious as well as

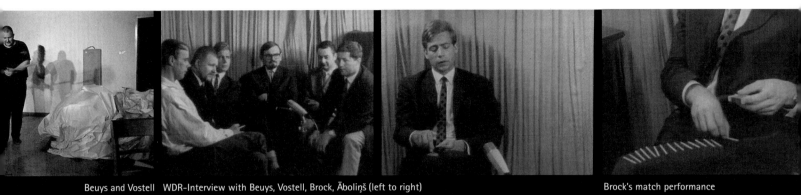

Beuys and Vostell WDR-Interview with Beuys, Vostell, Brock, Āboliņš (left to right) Brock's match performance

the unconscious influences on the "spectator's" biographical development are much more difficult to read, a multifarious search for continuing examination remains recognizable beyond a superficial refusal that even reached into the student and ecology movements.[47]

Thus, July 20, 1964 may still have had a certain political signal effect after all: In face of the art-brawl, Vostell was certainly surprised that the students had until now never reacted so sharply to the "real scandals" (racial, political and military issues). Yet at the same time, Beuys assumed that "human beings, who remain quite unmoved ... by the most atrocious descriptions", through these so-called "primitive media" are, he continued, still "to be moved in" their "centers".[48]

Such gatherings of critical opposition and artistic avant-garde, characteristic of the pre-1968 generation, certainly came about less and less frequently with the broadening of the protest movement, as the students in the FRG turned much more to theory and pure politicization (unlike France), while the artists again concentrated above all on their own art and gallery scenes. The culmination point from July 20, 1964, in which artists and mass audience, politics and history had come as close to each other as seldom before, had at the same time opened up the borders of communication between the anarchic concepts of the avant-garde and the classification systems or categories of thought in contemporary society. In the follow-up, it was only Bueys who deemed it necessary to transform the political "march through the institutions" propagated by the students into an artistic marching through.

In conclusion, the "Festival of New Art" should, however, not be assigned its historical status based on the empirically guaranteed facts alone. Remarkably, the event in Aachen had lead to a strong process of internalization for a large number of the active as well as passive participants, so that it is still surrounded by a sphere of the mysterious. This may be described with the help of its special threshold function in which the completely

new principle of "chaos as evolutionary or formational principle" could already be experienced immediatly and intuitively but still awaits its intellectual elaboration which could only take effect later on in the future.

Adam Oellers

42 Interview from 7/23/1964. On the subject of mediatization, compare also Brock's lecture at the Neuen Aachener Kunstverein on July 20, 1994.

43 Compare the TA film studio's film and sound recordings. The later rerecorded presentation took place after the interview from 7/23/1964 (Bazon Brock, *Ästhetik als Vermittlung* (Cologne, 1977) 173, 661. The use of wooden matches is considered a "political playing with fire" (in analogy to Struwwelpeter).

44 Despite it's large scale and fullness in detail, Vostell's action in Aachen was painstakingly conceived (see footnote 9), the direction sheets distributed to the audience followed each other temporally and logically (Oellers/Spiegel, 71). Only Vostell's statements in the program were more strongly aphoristic. His key sentence, however, is also about the development of art to life ("art as space, space as environment, environment as event, event as life").

45 Interview from 7/23/1964. Beuys' belief in the "learning effect" was later partially confirmed (see Pickshaus).

46 Interview from 7/23/1964. Vostell chose "Décollage" (as "form of dismantling"). Simlar statements from Beuys can also be read in a later interview (see footnote 29).

47 The artistic avant-garde program continued in the TA itself as well as in the student-founded gallery (Galerie Aachen) which was oriented towards Fluxus art (see Oellers/Spiegel) 13, 194f.

48 Interview from 7/23/1964, respectively, "Krawall in Aachen", see footnote 29.

Wolf Vostell: German View

1 Albert Schulze-Vellinghausen, *magnum*, 21, December, 1958, 58.

2 "Interview with Mercedes Vostell", *Sprache im technischen Zeitalter 55*, July-September, 1975.

3 *Newsweek* 7, December, 1964, 73.

4 With an article by the SDS-group "Culture and Revolution" bearing this title, a discussion began in *Die ZEIT* on 11/29/1968 over "Art as Product", which was closed with the text "Social Work instead of Art" by the Heidelberg Cultural Revolution Work Circle.

5 *Die Zeit* 29 Nov. 1968

6 Vostell had adapted the term from the headlines in *Le Figaro* from 9/6/1954: "peu apres son décollage un superconstellation tombe est s'engloutit dans la riviere Shannon", which spoke of the take-off ("décollage") of a Super-Constellation airplane and its immediate crash. "An urgent necessity arose, to include what I saw and heard, felt and learned, in my art. ... to use the term for the torn, open forms of mobile fragments of reality – events. mobile coll/age is dé-coll/age. ... mobile collages are events. events are changes. ... what had especially shocked me in the Figaro reportage, like in every other disaster, was the double meaning of the word dé-coll/age THE AIRPLANE WAS (dé-coll/age) DE-COLLAGED. A term with contrasting events." Starting from the lexical meaning of dé-coll/age, Vostell developed his techniques of tearing off, smearing, wiping out, distorting, blurring, pressing over each other, television, smearing, car accident, airplane crash,. earthquake (Wolf Vostell, THE CONSCIOUSNESS OF THE dé-coll/age/1966, in: *Vostell. Retrospektive 1958-1974*, exhibition catalog, Neuer Berliner Kunstverein in cooperation with the Nationalgalerie Berlin (Berlin (West), 1975) 305).

7 "Die Fluxus-Leute. John Anthony Thwaites, Gottfried Michael Koenig and Wolfgang Ramsbott interview Jean-Pierre Wilhelm, Nam June Paik, Wolf Vostell and C. Caspary", *magnum*, 47, April, 1963, 32. At the preparation of his first exhibition in Paris, in 1960, Vostell met the Nouveaux Réalistes Dufrene, Villeglé, Hains and Rotella.

8 The title of a Pontus Hulten exhibition in 1969, in the Moderna Museet, Stockholm. When the exhibition was taken on by the Münchner Kunstverein in 1970, it radically questioned the forms of traditional art agenting in Germany.

The first Dada restrospective "Dada – Documents of a Movement", which Ewald Rathke organized at the Dusseldorfer Kunstverein in September, 1958, prepared the way in Germany for Neodada, Pop Art, and New Realism. The critical impulse of Dadaism hit a nerve in West German postwar society: "Between then and now, the perfidious slime of Nazi jargon was stuffed into our ears. We are still deaf among ourselves and only listen to advertising slogans. ... We ourselves had to blow up the gates ... by renouncing the horrible comfort of an idiom that consists only in clichés and shams. Not least does this retrospective make its appeal to this situation."[1]

For Wolf Vostell, the Dada retrospective was a stimulating experience that affirmed his artistic maxims: "For the first time in my life I saw that my artistic ideas had begun in an earlier direction in art. Art as life principle, art ... as critical behavior research Social consciousness as a subject of art."[2]

The following edition of the "Magazine for Modern Life" (*magnum* 22, February, 1959) devoted itself to "Dadaism in our time" and described the economic wonderland of the Federal Republic as Dadaist real montage. We live in an "assembled world" and are all crazy and free, "that is the Dada in us". Andy Warhol's Pop-philosphy of cynical indifference is already discernible here: "Everything is art and nothing is art. Because I think everything is beautiful"[3] With his affirmative aesthetic, Warhol confirmed Karl Marx's reknown recognition in *German Ideology* (1845/46), in which the consciousness is a social product already from the start. Quoting Marx's idea of turning against the idealist illusion that the individual is his own master in his own consciousness, Hans Magnus Enzensberger introduced his 1962 essay "Consciousness Industry" to open the debate in the 1960's around the criticism of "art as product of the consciousness industry."[4] As speaker for the work circle "Culture and Revolution" in the League of Socialist Students (SDS), Michael Buselmeier turned against the naive belief that one could change society through art. He conceded, however, that it was possible "through art, to make one or the other person more attentive to what happens to and around him".[5] He had thus precisely formulated the objective of Wolf Vostell's critical art. Vostell, at this time, worked with the Dadaist techniques of montage, collage and the neodadaist finding dé-coll/age as "production principle that avails itself of destruction and autodestruction",[6] in order to undermine the hardened structures in the manipulated consciousness.

The discovery of the "myth of the everyday" (*Mythologies*, 1957) through Roland Barthes' analyses of advertising and fashion prompted the discovery of the city with its torn posters on walls and crushed cars. "A torn poster looks very similar to a Tachist painting." Vostell asked himself: "Why is reality sometimes more interesting than its fiction?"[7] Life should infect art and art should transcend life through its poetization. This romantic program flowed into the slogans of Paris in May, 1968: "Power to the Imagination!" and "Poetry must be made by everyone!"[8] The motto of the 1950's "For another art" (Michel Tapié) was superceded by the 1960's motto: "For another life".

On December 18, 1964, three months after René Block opened his small West Berlin gallery with the exhibition "Neodada, Pop, Décollage, Capitalist Realism", one of the demonstrations initiated by the SDS, in which around 600 German and African students protested against the presence of the Congolese Prime Minister Moise Tschombé, became the "beginning of our cultural revolution" (Rudi Dutschke). Despite police cordons and closed-off districts, the demonstrators, by positioning themselves cleverly at the Schöneberg weekly market in front of the town hall, managed to hit Tschombè's car with tomatoes as he was driving away. The goal of "breaking the rules", a mixture of dadaist provocation and political manifestation, replaced the time of the Easter Marches and resolutions. Wolf Vostell "for the first time, no longer saw a difference between life and art" in the new forms of action, for example, the "going for a walk demonstration" on December 17, 1966.[9] It was the revolt of a fatherless generation[10] against a society that was not ready to face the responsibility for the past. The children of the war only heard repeatedly: "We really didn't know anything." In a "country of peace", they demanded a new "reference to reality".[11]

The Adolf Eichmann kidnapping came like a shock into this situation. Eichmann was the former SS-Obersturmbannführer who was kidnapped by the Israeli secret service on May 23, 1960. His trial followed in Jerusalem in 1961. In the same year, Wolf Vostell, as layout chief, was given the task of redesigning the appearance of the Cologne magazine *Neue Illustrierte*. He now came into daily contact with hundreds of agency photos of current events, such as war, accidents, and catastrophies. In the magazine's photo archive, he was confronted for the first time with pictures of concentration camps, torture, and mass murder, which at that time were still taboo for publication. This experience changed his art lastingly – and his philosphy of life.[12]

The *Black Room* was Vostell's first environment, a montage of three assemblages on pedestals in a black

room: *Auschwitz-Floodlight 568*, *German View* and *Treblinka* (figs. 239-240, p. 210). All three consisted of things Vostell had found, "that means, objects 'marked by life'"[13] such as: barbed wire, children's toys, television, films, motorcycle part, crucifix, floodlight, newspapers, radio, pieces of wood, etc. Vostell dé-collaged them out of their previous context in order to 'collage' them into a new art object that established a continuing connection to the outer world over the "living pictures" of the television and transistor radio. The sur-realist combination of things that don't belong together and the body language of the materials entered into a provocative contact with historically stigmatized names like Auschwitz and Treblinka.

The architect Rolf Jährling's legendary Wuppertal Galerie Parnass showed *Black Room* in 1963 for the first time within a retrospective. On opening night, Vostell took visitors for a bus ride and confronted them with "9 DÉCOLLAGES" on various sites in and around Wuppertal.[14] The art consumer became actor in the framework of a "musical score" conceived by the artist as action setting. "The content and intent must be determined by each particpant and observer. But even when the events don't let themsevles be determined, they lead to the realization that the things don't let themselves be determined."[15]

On December 20, 1963, in the chamber of the Frankfurt City Council Meeting in the Römer, the greatest proceedings against mass murder in the history of German legal history – the so-called Auschwitz Trial – began against 21 former concentration camp guards. After 20 months and 182 days of negotiation, in which 359 witness from 19 nations gave statements, judgement was passed on August 9, 1965.

Wolf Vostell reacted to the trial with the painting *We were a Kind of Museum Piece* (fig. 242, p. 212), finished at the end of 1964 in Cologne. The title is a quote from Pjotr Mischin's statement as witness on October 29, 1964, the 105th day of negotiation. Vostell used a newspaper clipping with the report by the trial observer Bernd Naumann under the headline "We were a kind of museum piece".[16] The article is only readable in the places untouched by paint, or where the paint is transparent. With a bit of effort, one can make out parts of sentences such as "Forced to do outdoor sport in 20 degrees below zero". The sentence, from which the article headline and painting title were taken, is obscured in the work: "We were very few (Soviet prisoners-of-war, author's note), we were such a kind of museum piece in this large international camp." The newspaper fragment was eclipsed by a series of current events photos, which Vostell had painted over with spray-paint. The agency photos, reproduced million-fold, which vivify the violence and aggression of the significant events in postwar history, pushed

9 Wolf Vostel, *Aktionen, Happenings und Demonstrationen seit 1965* (Reinbek, 1970).

10 See Alexander Mitscherlich, *Auf dem Weg zur vaterlosen Gesellschaft* (Munich, 1963).

11 Hans Werner Richter, *Bestandsaufnahme* (Munich, 1962) 564 f.

12 Author's conversation with Vostell on 8/20/1996.

13 Wolf Vostell, *Das Schwarze Zimmer*, quoted from Vostell. *Das plastische Werk 1953-87*, Mult(h)ipla (Milan, 1987) 55.

14 *Treffpunkt Parnass Wuppertal 1949-1965*, Will Baltzer, Alfons W. Biermann ed., (Cologne, 1980) 224 f.

15 Wolf Vostell, 2/9/1966, quoted from: Vostell. *Bilder, Verwischungen, Happening-Notationen*, exhibition catalog, Kölnischer Kunstverein (Cologne, 1966).

16 *Frankfurter Allgemeine Zeitung*, 7/30/1964, 8. See also: Bernd Naumann, *Auschwitz. Bericht über die Strafsache gegen Mulka et al., vor dem Schwurgericht Frankfurt* (Frankfurt/Main, 1965).

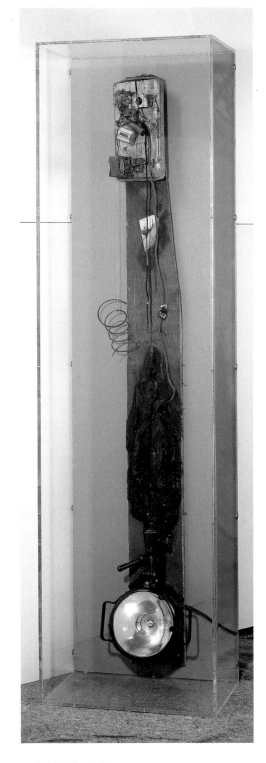

238 **Wolf Vostell**
Auschwitz-*Floodlight* 568
(from the cycle *Black Room*), 1958
Dé-coll/age, Wiping, Wood, metal, Hair, asphalt, floodlight
205 x 57 x 31 cm.
Collection Rafael Vostell

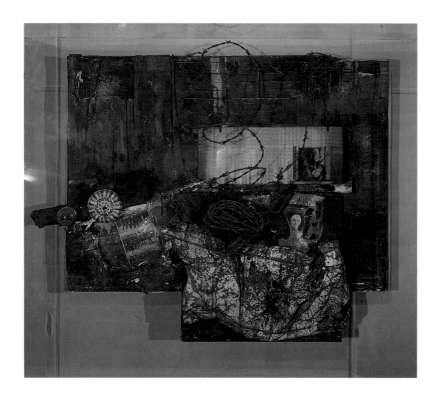

239 **Wolf Vostell**
German View
(from the cycle *Black Room*)
1958
Dé-coll/age, wood, barbed wire, tin,
newspaper, bones, television set with base
and cover
197.5 x 129.5 x 81.5 cm
Berlinische Galerie, Berlin,
Landesmuseum für Moderne Kunst,
Photographie und Architektur

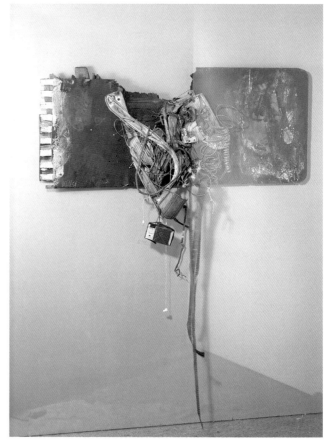

240 **Wolf Vostell**
Treblinka
(from the cycle *Black Room*)
1958
Dé-coll/age, motorcycle part, wood, film and
transistor radio
200 x 140 x 80 cm
Collection David Vostell

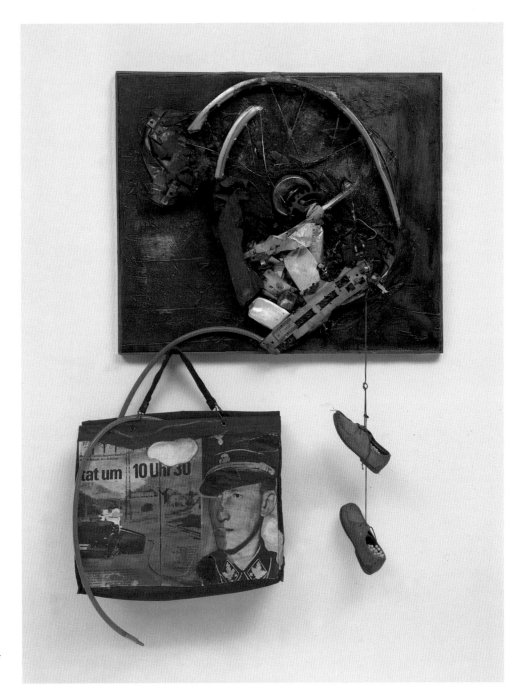

Exhibition
»Hommage à Lidice«, 1967
241 **Wolf Vostell**
Hommage à Lidice, 1959–67
Mixed Media
110.5 x 120 x 20 cm,
150 x 160 x 30 cm with cover
The Czech Museum of
Fine Arts, Prague

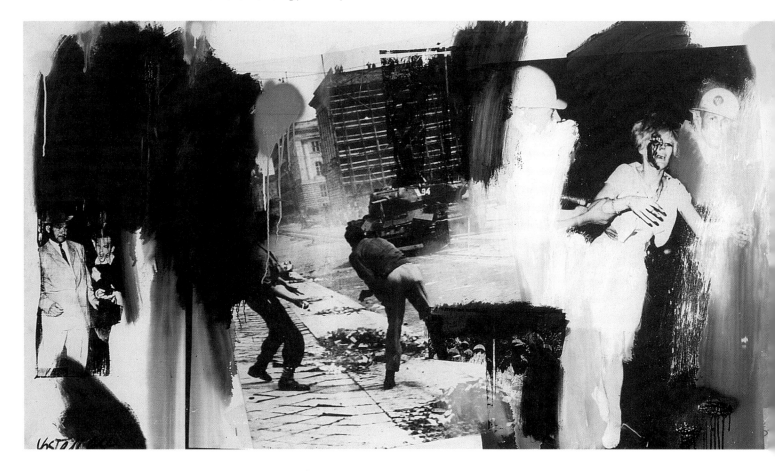

242 Wolf Vostell
We were a Kind of Museum Piece
1964 silk screen, spray paint on canvans
120 x 450 cm
Berlinische Galerie, Berlin,
Landesmuseum für Moderne Kunst,
Photographie und Architektur

17 *Kursbuch*, vol. 1, 1965, quoted from
*Bewegung in der Republik 1965-1984. Eine
Kursbuchchronik*, vol. 1, Ingrid Karsunke
and Karl Markus Michel, eds. (Frankfurt/
Main, 1985) 13, 17.

18 As magazine layouter, he was familiar
with photo-sensitive canvas, emulsions and
acids that oxidize on the canvas. "Then I
printed on the wiped away canvas photos
or added paint mechanically with spray-
paint. There are three mechanical proce-
dures on the canvas: blurring, silk-screen
and spray-paint, which is sprayed on bold-
ly". (Interview with Jürgen Schilling, in:
Wolf Vostell, exhibition catalog, Kunstverein
Braunschweig, 1980, 12).

the memory of Auschwitz into the background, letting it
shrink down to a sober newspaper account. The uncon-
fronted, unresolved past collides with an surmountable
present.

Vostell, as phenomenologist and realist, integrated
the picture documents about the world which shaped
contemporary history into the museum context of fine
arts. But he did not stop at a distanced quoting of photo
documents as Andy Warhold had done (*Jackie*, 1964 and
Race Riot, 1963 for example). Displaying and processing
the documentary materials should direct the gaze of the
experienced media observer to the shocking details, which,
having been blurred and painted over, intentionally
frustrate the observer's curiosity. "Blur, in order to see
clearly! The observer's imagination can elaborate the
absence with assumptions about the what-had-been-
there-before, thus, a constant state of tension arises"
(Wolf Vostell). The absence of gruesome pictures docu-
ments from the concentration camps ignored the cogs in
the death machinery, which as soulless "beasts", relieved
the conscience of the "innocent" who had simply gone
along. In a critical essay reporting on the Auschwitz Trial
in the media, Martin Walser wrote in 1965 about "our
Auschwitz": "Historical research was complicit in the reve-

lation, moral and political enlightenment of a population,
which apparently could not be made to recognize what
happened by any other means." At the same time, Wal-
ser saw that this enlightenment was jeopardized by the
ways and means through which the hangman's assistants,
henchmen and thugs of the system became stars. "The
more incomprehensible the detail, the more distinctly it
is described to us. ... And the more tangible the deed, the
easier it is to detach from the conditions of the system,
from our history from 1918 to 1945. ... I believe, that we
will soon have forgotten Auschwitz again if we become
acquainted with it only as a collection of subjective bruta-
lities."[17]

For Vostell, the uncovering, softening and subver-
sion of hardened, ossified structures of thinking and
perceiving materialized in the aggressive processing of the
documentary, material he began with, dé-coll/age, paint-
ing over and blurring from the effect of acid on the photo-
sensitive canvas.[18] This corresponded to the diagnosis
made by Alexander and Margarete Mitscherlich of the
West German society in their study *The Inability to Mourn*
(1967) and in which they saw a connection between the
"political and social immobilism and provincialism" in the
Federal Republic and the "stubbornly maintained defense

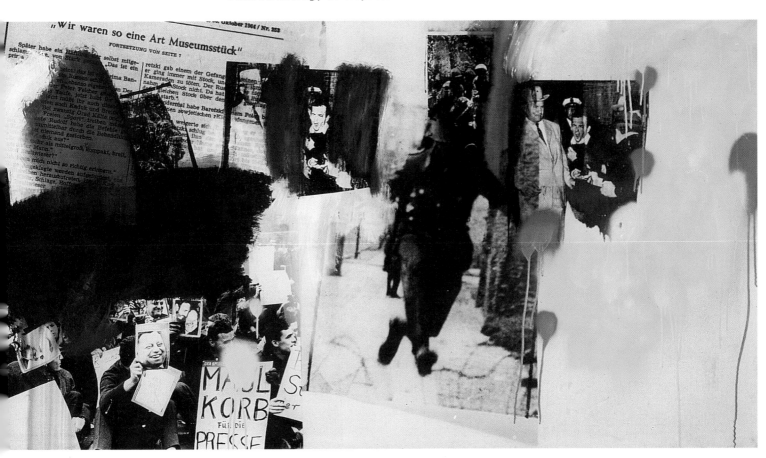

of memories, especially the blocking of emotional participation in the events of the past now denied".[19] In this sense, Vostell's visual manifestations intended "to train an aware audience, to trigger a positive protest."[20]

The painting *We were a Kind of Museum Piece* was shown for the first time in the exhibition "Phenomena and Realities" in the Galerie René Block from February until April 1965 in West Berlin. Parallel to this exhibition, Vostell and Block jointly realized his first Berlin happening, *Phenomena*, at the Sperber car dump on Sachsendamm on March 27 - a staged battle field of the motorized society. This simultaneity of exhibition and happening showed the equivalence in stagings of pictures and events, as he had two years earlier in Wuppertal. On the one hand, the over-painting, which looks like a bag of paint "home run" with color streams coursing down, refers to "happenings, psychograms or happening scores that have become static."[21] On the other hand, the happenings are paintings that are performed and brought to life. "My paintings are ... idea fields realized in the imagination of the observer and in that way they find confirmation."[22]

Vostell practised the unity of art and life concretely in 1970: The Dusseldorf "Lidl" group oriented around

Jörg Immendorff and Chris Reinecke, participated in the exhibition "Now. Artists in Germany today" (Kunsthalle Cologne, 4/14 - 5/18/1970), and was banned from the house on March 2, 1970 by the head the culture department Kurt Hackenberg because a member of the group had used swastika symbols. Vostell was the only one among numerous exhibition particpants to have protested against this cultural/political decision and took down his environment *Thermo-electronic Chewing Gum.* On the occasion of the exhibition "happening & fluxus" 1970/71, Vostell planned the installation of a pregnant cow, that was supposed to give birth in the Kunsthalle. Since the animal protection laws in Germany have always proved to work much better than those protecting humans, it wasn't very long at all until officials from the town clerk's office "liberated" the cow and brought her back to her stall.[23] Absolutely everything "that stinks", according to Hackenberg's words, had to leave the exhibition. Vostell: "A society that stinks, cannot bear a stinking exhibition."[24] In March of 1971, Vostell left Cologne for West Berlin.

Eckhart Gillen

19 Alexander and Margarete Mitscherlich, *Die Unfähigkeit zu trauern* (Munich/Zürich, 1977) 9.

20 Quoted in *magnum* 47, April, 1963, 67.

21 Peter O. Chotjewitz, in: *Kunst*, no. 19-21, 1966, p. 339.

22 Quoted from Vostell, 2/9/1966, 16.

23 Michael Euler-Schmidt, "In Köln und von Köln aus", *Vostell*, exhibition catalog, Rheinisches Landesmuseum Bonn, et al., Rolf Wedewer ed. (Bonn, 1992) 98.

24 Louis F. Peters, "Tatort Köln: Verbotene Kunst der sechziger Jahre. *Die 60er Jahre. Köln's Weg zur Kunstmetropole. Vom Happening zum Kunstmarkt,* Wulf Herzogenrath and Gabriele Lueg ed., exhibition catalog, Kölnischer Kunstverein, (Cologne, 1986) 565.

Not a Monument,
but Rather Food for Thought

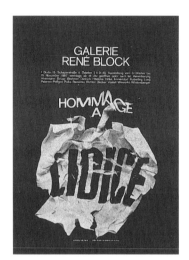

Poster "Hommage à Lidice", 1967
Galerie René Block, Berlin

When the few women who had survived the gruesome years in concentration camps returned after their liberation to their Bohemian homeland, full of joy in anticipation of seeing their husbands, children and houses again, they could no longer find their village. There, where it had once stood, grew large fields of young wheat instead. And however they searched, they didn't find their children. And however they waited, their husbands didn't come back. Only the wheat grew and ripened. And as they looked over the fields, they noticed that the wheat grew higher and wilder in one place and even had a different color. They interpreted this as a sign and began digging up the wild wheat. Thus, in a 12m x 10m grave, the women found the mortal remains of the 172 men who had never left the village.

What sounds like a timeless legend, a story which could have been played out in many wars in the past, becomes contemporary through two words: concentration camp. And when the name of the annihilated village is mentioned - Lidice - the reality, cruelty and senselessness of this Nazi crime also become clear. What made this crime so particularly heinous was the senselessness of being driven by the delusion of having power over the life and death of other people, and having to demonstrate this power. As in the case of Lidice, it was a matter of revenge for the murder of Reinhard Heydrich, who was sent by Hitler on a mission to Bohemia as "Protector of the Reich". As Thomas Mann said in his radio address "German Listeners", broadcast in June, 1942 from the BBC to Germany:

"Since the violent death of Heydrich, that is, the most natural death that a bloodhound like him can die, the terror rages everywhere, more sickly unrestrained as ever... The Führer, bowed in grief over the loss of his beloved fellow killer, gives the directives he thought up during sleepness nights. A slaughtering and shooting begin, a raging against defencelessness and innocence, true to the way of Nazi pleasure. Thousands must die, men and women. An entire village, which was to have sheltered the perpetrators, is exterminated and razed to the ground. Back home, he is honored with a pompous state funeral, and another fellow butcher says over his grave, that he had a pure soul and was a person of the highest feeling for humanity. All of that is insane ... power is one and all to the insanity. The insanity unconditionally needs the power in order to realize itself..." Lidice, which had never been a place of active resistance, became the world-

Hans Peter Alvermann
• Born 1931 in Dusseldorf
• Lives in Marburg
Hans Peter Alvermann studied at the Dusseldorf Kunstakademie from **1954–58**. His first solo exhibition was at the Schmela gallery in Dusseldorf in **1962**. Together with W. Gaul he drew up his Quibb Manifesto in **1962–63**. After further exhibitions, at the Parnass gallery in Wuppertal in **1964**, the Kleine Galerie in Schwenningen and the Haus am Lützowplatz in West Berlin in **1965**, and the Galerie Aachen in **1966**, Alvermann abandoned the art scene in order to devote more of his energies to political activities. The exhibition catalog published by the Wuppertal Kunst- und Museumsverein in **1970** provides a survey of the objects he produced between **1959–66** and includes a catalogue raisonné. Combining a socially critical attitude and a surreal leaning towards the absurd, Alvermann attempted to draw attention to political shortcomings with the help of absurdist provocation. In **1996** he was represented at the "Face à l'Histoire" exhibition at the Centre Georges Pompidou in Paris.

Klaus Peter Brehmer
• Born 1938 in Berlin
• Lives in Hamburg
After training as a process technician between **1956–59**, Klaus Peter Brehmer attended the Werkkunstschule in Krefeld from **1959–61** and the Kunstakademie in Dusseldorf from **1961–63**. His works contain elements from commercial art and advertising, and were first shown at the René Block gallery in West Berlin in **1964–65**. Brehmer produced chains of motifs using Hitler postage stamps. He has been teaching at the Hochschule für Bildende Künste in Hamburg since **1971** and has been represented at numerous exhibitions including "documenta 5" in Kassel in **1972**, "Art into Society" at the ICA in London in **1974**, "documenta 6" in Kassel in **1977**, "Art Allemagne Aujourd'hui" at the Musée d'Art Moderne de la Ville de Paris in **1981**, "Um 1968. Konkrete Utopien in Kunst und Gesellschaft" at the Städtische Kunsthalle in Dusseldorf in **1990** and other venues.

H.J. Dietrich
• Born 1938
• Lives in Frankfurt
H.J. Dietrich studied at the Werkkunstschule in Wuppertal from **1956–61**. His first solo exhibitions took place in Wuppertal and at the Amstel gallery in Amsterdam. After further exhibitions at the René Block gallery in West Berlin in **1965** and the Autosalon in Cologne in **1966**, together with Vostell and Tsakiridis, Dietrich retired from the art scene to work in an advertising agency.

Gotthard Graubner
• Born 1930 in Erlbach, Ober-Vogtland
• Lives in Dusseldorf and Berlin

wide symbol for resistance after its destruction. Spontaneously, villages in Mexico, Brazil, Panama, Peru and in the U.S.A. renamed themselves after Lidice in solidarity.

A "Lidice-Shall-Live" committee was founded as early as 1942, in the English town of Coventry, which had been badly destroyed by German bombs in 1940. It was initiated by MP Barnett Stross. Two pledges stem from this initially English, later international "Lidice" committee: the planting of a rose garden which today boasts 27,000 rose bushes from all over the world, and the

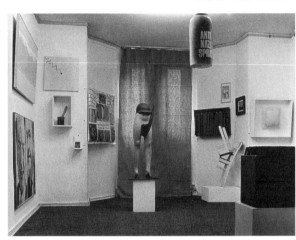

Exhibition "Hommage à Lidice", 1967
View of the exhibition room in the Galerie René Block with works by Koberling, Dietrich, Beuys, Brehmer, Polke, Immendorff, Alvermann, Höke, Rot, Rühm, Paeffgen, Graubner, Wewerka and Uecker

foundation up of a museum showing works of art from every part of the world.

This second call, sent out in 1967, was heard and responded to by many artists. The hundreds of art works donated at the time, stand today in the depot of the small castle in Nelahozeves, waiting for the completion of the Lidice Museum. Our story begins with the appeal to the artists.

Flashback: West Berlin, 1967, a city caught between the Cold War fronts. A new generation, born during the war and after 1945, has grown up. They are up in arms against their fathers and grandfathers those who suppressed their past rather than coming to terms with it, against the portrayal of East/West - black/white in politics and the press, against the spreading of a multinational "capitalist imperialism" in "third world" countries, against the Shah of Persia and for Fidel Castro, against South Viet Nam, but for Mao. Student unrest erupts. A new political consciousness emerges and manifests itself in an extra-parliamentary opposition (APO).

Artists also sought new ways to articulate themselves. Although they felt sympathy for each other in the beginning, it very soon became clear, that the political "avant-garde" tolerated nothing else but itself in art. Art was required to subordinate itself and illustrate, or take the form of "polit-happenings", which entertained the masses at the many "sit-ins". All other art was bourgeois. Private ownership of art was disqualified as elitist. While the first artfair in Cologne was successfully held in 1967, a tendency to negate art ownership caught on in the new Berlin society.

But it was the artists, in fact, who had already long reflected on the democratization of the art market, through the invention of the multiple; art works manufactured industrially in large numbers, which could be offered at bargain prices. But that is another story.

1967 was a politically sensitized time in which this

Gotthard Graubner began studying at the Hochschule für bildende Künste in West-Berlin in **1947–48** but changed to the Kunstakademie in Dresden in **1948–49**. He left the GDR in **1954** and studied at the Kunstakademie in Dusseldorf until **1959**. He also exhibited for the first time in Dusseldorf at the Schmela gallery in **1960**. He became professor at the Hochschule für bildende Künste in Hamburg in **1969** and at the Kunstakademie in Dusseldorf in **1976**. In **1973** he became a member of the Akademie der Künste in West Berlin, from which he resigned in **1992** when the East and West German academies were amalgamated. Graubner became famos for his expansive cushion works. He represented the Federal Republic of German at the "XI Biennial" in Sao Paolo in **1971** and at the **1982** "Venice Biennale", and participated in "documenta 6" in Kassel in **1977**. Venues for his solo exhibitions have included the Kunsthalle in Bremen in **1989–90** and the Saarland Museum in Saarbrücken in **1995**.

Karl Horst Hödicke
•Born in 1938 in Nuremberg
•Lives in Ireland and Berlin
After his studies at the Hochschule der bildenden Künste in West Berlin from **1959–64**, Karl Horst Hödicke became a founder member of the Grossgörschen 35 artists' cooperative in West Berlin. His first solo exhibitions took place there in **1964**, the year of its foundation, and at the René Block gallery. Hödicke's expressive-subjective painting won him the Mannheim youth art prize. He lived in New York from **1966–67**, after which he had a one-year scholarship to the Villa Massimo in Rome in **1968**. He has been professor at the Hochschule der Künste in West Berlin since **1974** and in **1980** became a member of the Berlin Akademie der Künste. Alongside exhibitions at the Kunstsammlung Nordrhein-Westfalen in Dusseldorf in **1986**, the Neue Berliner Kunstverein in **1993** and the Kunsthalle in Emden in **1997**, Hödicke was also represented in the London touring exhibition "A New Spirit in Painting" in **1981**, the "Zeitgeist" exhibition at the Martin Gropius Building in West Berlin in **1982**, and the "German Art in the 20th Century" exhibition at the Royal Academy of Art in London in **1985**.

Bernhard Höke
•Born 1939 in Braunschweig
•Lives in Frankfurt am Main
Bernhard Höke began his studies in **1958** at the Werkkunstschule in Braunschweig and continued at the Hochschule für bildende Künste in West Berlin until **1962**. His first solo exhibition took place at the "situationen 60 Galerie" in West Berlin in **1964**. In **1965** he began editing the *edition et,* Berlin. After various environments presented at the Academy of San Marino, the Cologne Art Market and the Galerie nächst St. Stephan in Vienna in **1967**, Höke retired from the art scene in **1972**.

Bernd Koberling
•Born 1938 in Berlin
•Lives in Berlin and Iceland
Bernd Koberling studied at the Hochschule für bildende Künste in Berlin from **1958–60** and lived in England from **1961-63**. A founder-member of the Grossgörschen 35 artists' cooperative, he had his first solo exhibitions there

appeal came from - by then - Sir Barnett Stross. It only had to be passed on further and made concrete. The only means at a gallerist's disposal is an exhibition and the en bloc handing over of the art works donated for Lidice.

Because the exhibition space in the gallery on Schaperstraße was very small, I requested small works. In addition, all the works had to fit into a VW bus to be transported to Prague. I had spoken with 21 artists and received 21 art works. Friends of the gallery, art collectors as well as exhibition organizers were invited to facilitate the publication of an exhibition catalog by donating money. Although most of the people I spoke to reacted positively and particpated with a small donation (50 to 100 DM was requested), some Rhineland collectors felt so offended - by this wallowing in the mud of the past - that they ignored the gallery afterwards. And it was good that way.

With this kind of exhibition, one is certainly caught in the middle. The conservative – as a rule financially strongest – art audience took the gallery for a red cell, because its artists openly sympathized with the political goals of the students (indeed, Ulrike Meinhof often visited exhibitions). On the other hand, the emerging "left scene" saw this very gallery as an elitist bourgeois undertaking, whose artists supported the prevailing system. (This opinion intensified and was expressed in the violent thwarting of a Beuys/Christiansen Fluxus concert on February 27, 1969 in the West Berlin Akademy der Künste, during which much was damaged and many people were hurt.)

They reacted likewise to the exhibition "Hommage à Lidice" when it took place in Berlin in October, 1967. Praise from the mainstream press (Der Tagesspiegel)[1] with reservations in view of the exhibited artists and work (Die Welt)[2] up to certain malice and ridiculing the works on the part of left-wing critics.[3] The art historian Jindrich Chalupecky in Prague, who absolutely wanted to show the exhibition in his Spála-Gallery, was similarly "caught in the middle". He was supported by his progressive gallery advisory council, but turned down by the executive committee of the Central Association of Artists. After lists

Above: Appeal to the artists of the world by Sir Barnett Stross, Chairman of the British Commitee "Lidice Shall Live" in 1967, at the 25th anniversary of the destruction of Lidice by the National Socialists.
Galerie René Block

Below: The art historian Jindřich Chalupecky's letter to René Block concerning the ban of the Lidice exhibition in the Spála-Galerie in Prague.
Galerie René Block

in 1965–66. He spent the year 1969-70 in Rome on a Villa Massimo scholarship. Between 1981-88 he was professor at the Hochschule für Bildende Künste in Hamburg. Since 1988 he has been professor at the Hochschule der Künste in Berlin. In addition to solo exhibitions at the Kunstverein in Braunschweig, the Arhus Art Museum and L.A. Louver in Venice in 1986, and the Kunstsammlung Nordrhein-Westfalen in Dusseldorf and the Museum of Contemporary Art in Oslo in 1991, Koberling has been represented in exhibitions of German and Berlin art such as the London touring exhibition "A New Spirit in Painting" in 1981, the "Zeitgeist" exhibition at the Martin Gropius Building in West Berlin in 1982, and the "German Art in the 20th Century" exhibition at the Royal Academy of Art in London in 1985.

Konrad Lueg
- Born 1939 in Dusseldorf
- Died 1996 in Dusseldorf

Konrad Lueg studied at the Dusseldorf Kunstakademie from 1958-62 together with Sigmar Polke and Gerhard Richter with whom in 1963 he organised a »demonstration for capitalist realism« by displaying their works in a Dusseldorf department store. After exhibitions at the Schmela gallery in Dusseldorf in 1964, the René Block gallery in West Berlin in 1966, Galerie h in Hanover, the Patio gallery in Frankfurt am Main (with Richter) in 1966, the Friedrich gallery in Munich and the René Block gallery in West Berlin in 1967, and at the Denise René gallery in Paris in 1968, Lueg opened his own gallery under the name of Konrad Fischer in Dusseldorf in 1968 devoted to minimal and concept art.

C.O. Paeffgen
- Born 1933 in Cologne
- Lives in Cologne

C.O. Paeffgen graduated in law in 1959. He is a self-taught artist. His first solo exhibition took place in 1965 at the Benjamin Katz gallery in West Berlin. In addition to solo exhibitions at the Kunstmuseum in Dusseldorf and the Karl Ernst Osthaus Museum of the City of Hagen in 1979, the Bonn Kunstverein in 1981, the Museum Abteiberg in Mönchengladbach in 1983, the Staatliche Kunsthalle in Baden-Baden in 1987, and the Kestner Gesellschaft in Hanover in 1993, Paeffgen was also represented in the "Jetzt" exhibition at the Kunsthalle in Cologne in 1970 and "Kunst nach 1945" at the Nationalgalerie in West Berlin in 1985.

Chris Reinecke
- Born 1936 in Potsdam
- Lives in Dusseldorf

Chris Reinecke studied at the Ecole des Beaux Arts in Paris from 1958-61 and continued at the Kunstakademie in Dusseldorf from 1961-65. Following her first happenings and exhibitions in Dusseldorf in 1966 ("Frisches, ein Abend"), in Aachen ("Aachener Kleider"), on the banks of the Rhine in Dusseldorf ("Mehlkleid") and at the Art Intermedia gallery in Cologne in 1967, together with Jörg Immendorff, Reinecke took part in activities and performances by the Lidl group between 1968-70. She then gradually retired from the art world.

of signatures by protesting artists were displayed in the Spála-gallery's window, the culture functionaries, gnashing their teeth, finally agreed to tolerate the exhibition.

It opened in Prague on July 3, 1968 and was received positively by the audience, among whom was a delegation of women survivors from Lidice.

It was to be seen for only a short time. The invasion of Warsaw Pact troups forced a premature closing. Chalupecky just managed to bring the art works into safety - but the connection to Prague was broken, and the works were assumed to be missing for a long time.

Thirty years later, in June 1996, they were all rediscovered in the small castle in Nelahozeves, where Antonin Dvořák was born, every work accounted for and in remarkably good condition. Expanded by 31 works donated by artists, the exhibition reopened in Prague in March 1997, in the museum "House of the Black Mother of God" and accompanied by an extensive and informative catalog.

The task now at hand is to complete the museum begun in Lidice.

It doesn't take any great courage to organize such an exhibition, as Baron Herbert von Buttlar, however, wrote in his 1967 catalog text.[4] Yet, a certain sensitivity for the occasion and a certain feel for an appropriate treatment of the subject are required.

This required sensitivity towards art works contradicts, on the other hand, the event that today seems unimaginable: squeezing the 21 unpacked artworks into an old VW bus to bring them to Prague without customs papers. It was like bringing a Trojan Horse behind the "Iron Curtain".

Joseph Beuys had later artistically legitimized this action, by using this very VW bus in the work *The Pack/Das Rudel* (1969), to let 32 sleds break out of its interior like bloodhounds.

René Block

[1] Heinz Ohff, "Geschenk an Lidice", *Der Tagesspiegel*, 10/25/1967.

[2] Lucie Schauer, "Hommage à Lidice", *Die Welt*, 11/3/1967.

[3] Katrin Sello, *Christ und Welt*, 11/17/1967; H.D. Budde, *Die andere Zeitung*, 11/23/1967.

[4] *Herbert von Buttlar, Hommage à Lidice*, exhibition catalog, Galerie René Block Berlin (Berlin 1967).

Gerhard Rühm
•Born in Vienna
•Lives in Cologne
Although he studied at the Staatsakademie für Musik in Vienna, as of **1954** Gerhard Rühm devoted his attentions primarily to his literary activities. After a first solo exhibition at the Würthle gallery in Vienna he worked in a literary cabaret with Achleitner, Bayer and Wiener from **1958–59**. In **1964** he moved to West Berlin. In **1978** he was appointed to the Hochschule für Bildende Künste in Hamburg where he was professor until **1996**. Rühm had solo exhibitions at the Ruppertinum in Salzburg in **1987**, the Gesellschaft für aktuelle Kunst in Bremen in **1988** and the Frankfurter Kunstverein in **1989**, and was awarded the Austrian state prize in **1991**. In **1996** a book was published containing Gerhard Rühm's complete Visuelle Poesie.

Stefan Wewerka
•Born 1928 in Magdeburg
•Lives in Cologne and Berlin
Stefan Wewerka was conscripted into the army in the last year of the war in **1944–45**. After the war he studied architecture at the Hochschule für bildende Künste in West Berlin from **1946–51**, became a member of the German architects' association in **1954**, and planned and supervised the construction of various buildings. His first solo exhibitions were in **1958** at the Galerie nächst St. Stephan in Vienna, the Boukes gallery in Wiesbaden and the Studio Baumeister in Cologne. In **1965** he had a guest professorship at the Washington University in St. Louis, USA. Solo exhibitions followed at the Von der Heydt Museum in Wuppertal (with Dieter Rot) in **1971**, the Museum Folkwang in Essen in **1972**, and the Städtische Kunsthalle in Dusseldorf in **1973**. Wewerka was professor at the Werkkunstschule in Cologne from **1974–93**.

Lambert Maria Wintersberger
•Born 1941 in Munich
•Lives in Walbourg, France
Wintersberger trained as a decorative artist, stained glass artist and mosaicist from **1958–61**, then studied at the Accademia delle Belle Arti in Florence from **1961–64**. In West Berlin he was part of the group of Berlin Realists that formed out of the circle around the Grossgörschen 35 gallery where his first solo exhibition took place in **1965**. Wintersberger taught at the Dusseldorf Kunstakademie from **1974–77**. A retrospective exhibition of his work was shown under the title "Bilder 1965-68" exhibition at the Badische Kunstverein in Karlsruhe, the Stadtmuseum in Mühlheim, and the Kunsthalle in Wilhelmshaven in **1985–86**.

Biographies of Joseph Beuys, Jörg Immendorff, Blinky Palermo, Sigmar Polke, Gerhard Richter, Dieter Rot, Günther Uecker and Wolf Vostell are to be found in the appendix to the catalogue.

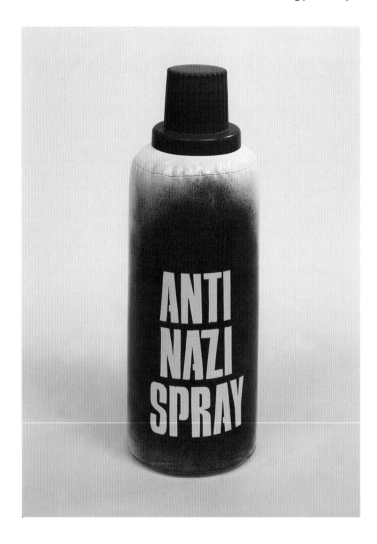

Exhibition "Hommage à Lidice", 1967
245 **Jörg Immendorff**
For all the Dear Ones in the World (Lidl-Landscape), 1967
Oil on plywood 8.8 x 76.2 x 9.8 cm
The Czech Museum of Fine Arts, Prague

Exhibition "Hommage à Lidice", 1967
246 **Hans Peter Alvermann**
Waiting for Nürnberg II, 1966
Steel helmet, sickle, symthetic hair, metal construction,
burlap, plaster, paint, wooden board 106 x 42.6 x 47 cm
The Czech Museum of Fine Arts, Prague

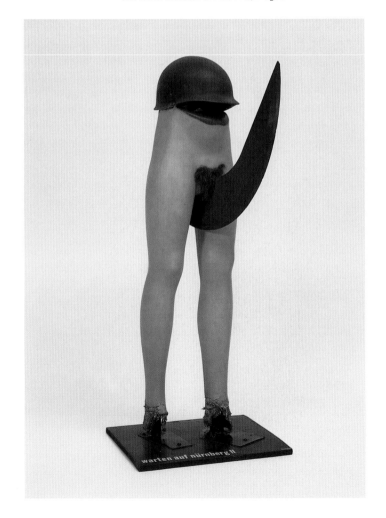

Exhibition
"Hommage à Lidice", 1967
243 **Bernhard Höke**
*Anti Nazi Spray,*1967
Plastic sprayed with varnish
72 x 20 x 20 cm
The Czech Museum of Fine Arts,
Prague

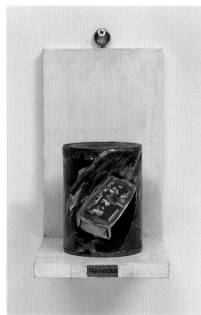

Exhibition
"Hommage à Lidice", 1967
244 **Chris Reinecke**
Matchsticks, 1967
Tin can, Oil on paper band
10 x 7.5 x 7.5 cm
The Czech Museum of Fine Arts,
Prague

Exhibition
"Hommage à Lidice", 1967
247 **C.O. Paeffgen**
Untitled, 1967
Synthetic foil, metal rod, acrylic
gloss paint on wood
50 x 70.2 x 12 cm
The Czech Museum of Fine Arts,
Prague

Exhibition
"Hommage à Lidice", 1967
248 **Karl Horst Hödicke**
Blue Pane, 1967
Wood, glass, adhesive band
54.8 x 48.8 x 7 cm
The Czech Museum of Fine Arts,
Prague

Exhibition
"Hommage à Lidice", 1967
249 **HJ Dietrich**
Untitled, 1967
Acrylic on canvas, loudspeaker, switch, battery, electrical
equipment
50.5 x 50.3 cm
The Czech Museum of Fine Arts, Prague

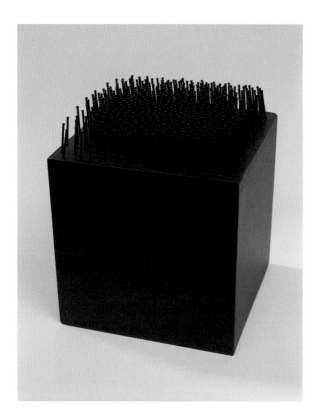

left: Exhibition
"Hommage à Lidice", 1967
250 **Günther Uecker**
Black Block, 1967
Masonite, iron nails, sprayed with
varnish
35 x 35 x 35 cm
The Czech Museum of Fine Arts,
Prague

right: Exhibition
"Hommage à Lidice", 1967
251 **Gotthard Graubner**
Molly, 1966
Cushion painting: canvas, painted
gauze, cotton wool, wooden crate
35.5 x 30.3 x 12 cm
The Czech Museum of Fine Arts,
Prague

Exhibition
"Hommage à Lidice", 1967
252 **Gerhard Rühm**
*Paper cut-out in Form of an Excla-
mation Mark,* 1967
Paper cut
15 x 21 cm, (with frame) 30 x 41 x
4 cm
The Czech Museum of Fine Arts,
Prague

upper right: Exhibition
"Hommage à Lidice", 1967
254 **Joseph Beuys**
For Lidice, 1962
Bones, metal container, paint, glue
46.4 x 27.4 x 17.1 cm (with wooden
box)
The Czech Museum of Fine Arts, Prague

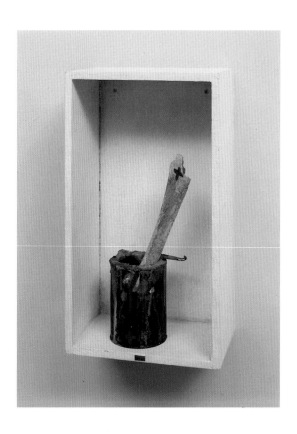

Exhibition
"Hommage à Lidice", 1967
253 **Stephan Werwerka**
Chair, 1967
Wood, varnish
82 x 42 x 44 cm
The Czech Museum of Fine Arts,
Prague

right: Exhibition
"Hommage à Lidice", 1967
255 **Dieter Rot**
Untitled, 1967
Oil on canvas / gauze, cardboard, glass
35 x 20 cm
The Czech Museum of Fine Arts, Prague

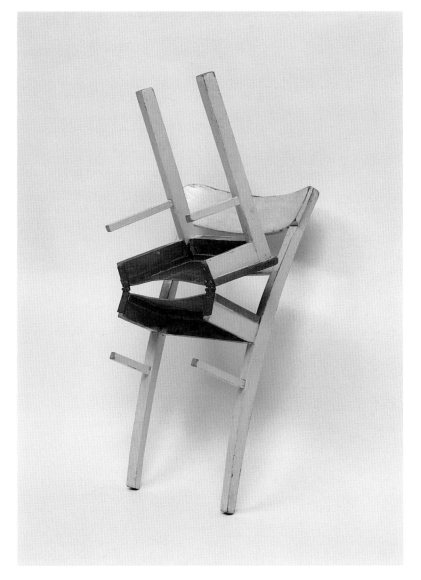

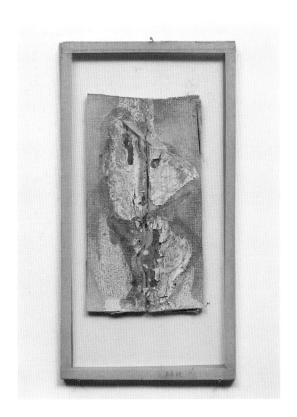

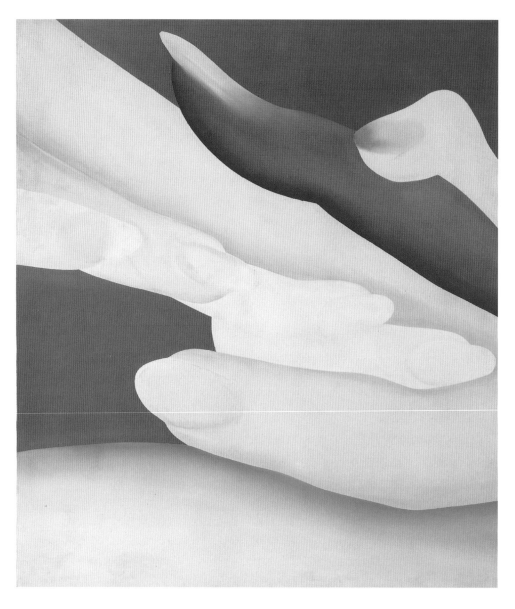

Exhibition
"Hommage à Lidice", 1967
256 Lambert M. Wintersberger
Caresse, 1967
Oìl on cotton
184.2 x 156 x 4.5 cm
The Czech Museum of Fine Arts, Prague

Exhibition
"Hommage à Lidice", 1967
257 Bernd Koberling
Landscape, 1967
Oil on structured foil on canvas and cotton
76.5 x 161.4 cm
The Czech Museum of Fine Arts, Prague

Exhibition
"Hommage à Lidice", 1967
258 **Konrad Lueg**
Meadow of Flowers, 1965
Acrylic and synthetic resin on canvas
101.5 x 137 cm
The Czech Museum of Fine Arts, Prague

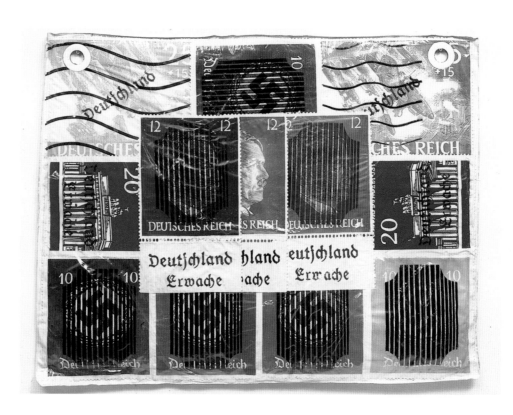

Exhibition
"Hommage à Lidice", 1967
259 **Klaus Peter Brehmer**
German Values, 1967
Plastic foil, foam material, cardboard
88 x 110.5 x 4.5 cm
The Czech Museum of Fine Arts,
Prague

223

260 **Gerhard Richter**
Family, 1964
Oil on canvas
150 x 180 cm
The Olbricht Collection

Exhibition
"Hommage à Lidice", 1967
261 **Gerhard Richter**
Uncle Rudi, 1965
Oil on canvas
87 x 50 cm
The Czech Museum of Fine Arts,
Prague

224

Werner Heyde im November 1959, als er sich den Behörden stellte.

262 **Gerhard Richter**
Herr Heyde, 1965
Oil on canvas
55 x 65 cm
Private collection, Wolfsburg

263 **Gerhard Richter**
Aunt Marianne, 1965
Oil on canvas
120 x 130 cm
Private collection, Stuttgart

264 **Gerhard Richter**
Stukas, 1964
Oil on canvas
80 x 80 cm
On loan from the Wittelsbacher
Ausgleichsfonds, Sammlung
Prinz Franz von Bayern to the
Staatsgemäldesammlung München,
Staatsgalerie Moderner Kunst

265 **Gerhard Richter**
Corridor, 1964
Oil on canvas
150 x 135 cm
Städtisches Museum
Gelsenkirchen

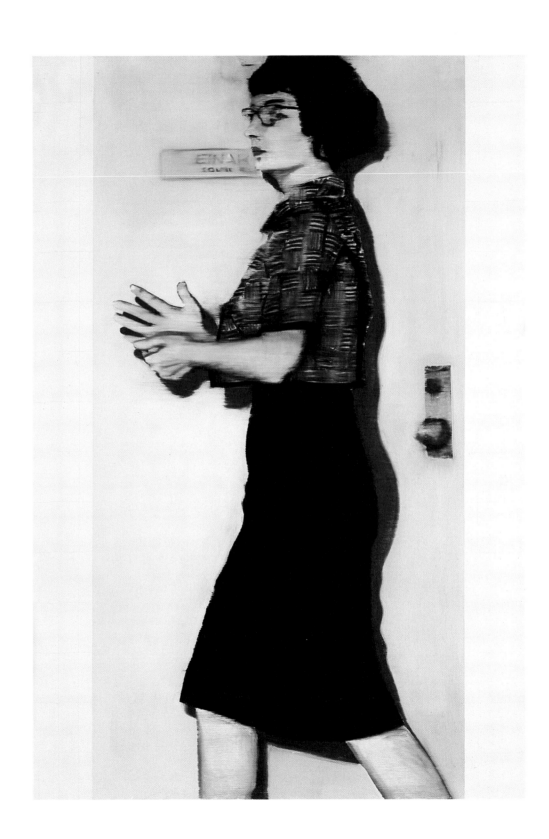

266 **Gerhard Richter**
The Secretary, 1963
Oil on canvas
150 x 100 cm
On loan from the
Federal Republic of Germany

Remembrance of the
Bitching Sheet

Sigmar Polke's *Bitching Sheet* (fig. 267, p. 229) was shown for the first time in the exhibition "Jetzt. Künste in Deutschland heute", in the Kunsthalle Cologne (February 14 to May 18, 1970). The catalog still had not listed this work (instead, the painting *Modern Art* and *Self-Portrait as Astronaut* as well as the montage; the photos of people from many groups and races connected by cords in the middle to a photo portrait of Polke). Yet Polke brought in the *Bitching Sheet* and suggested that it replaces another work intended for the exhibition. How could one have resisted this proposal! The beautiful photograph[1] showing Polke glancing backwards, the sheet draped over his shoulders like a royal mantle, had been taken before the *Bitching Sheet* was mounted. The Kunsthalle's technicians hung up the giant sheet in Polke's presence by (if my memory serves me) simply nailing it on, but only from the top. Polke wanted it to hang down loosely. Now we could read what Polke had written on the soft pink fabric with tar: nothing but swearwords. Polke decided quickly to have the sheet turned around. Now the observer could only guess what was there. The glossy paint had seeped through the fabric, the writing could only be decoded in parts as if from a piece of blotting paper. But anyone could lift the sheet and read at least some of the swearwords distinctly. I can still see in my mind's eye how entire school classes disappeared behind the giant sheet and read the frowned upon words to each other, giggling. School students often came to the exhibition, which was very well attended anyway, and "Jetzt" was the first encounter with contemporary art for many young people.

Some baffling lines appear in Gottfried Sello's review of the exhibition in the newspaper *Die Zeit* on February 20, 1970: "The avant-garde is being wooed, even then, when they ... are simply fooling about ... Sigmar Polke is invited and brings, among other objects, a painting on which four-letter words are written. Yet the painting is turned to the wall in order not to harm the younger audience. Even when it is presented in front view, it would be out of place." Should a work like that be denied?

Helmut R. Leppien

The author was Director of the Kunsthalle Cologne at the time.

1 See p. 239 of this volume.

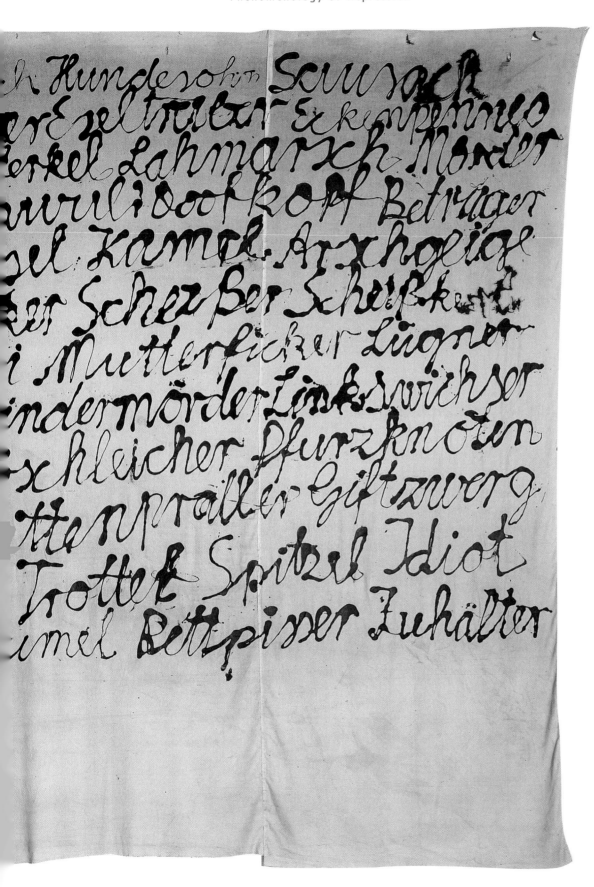

267 **Sigmar Polke**
The Great Bitching Sheet, 1968
Tar on flannelette
400 x 437 cm
Courtesy of Thomas Ammann,
Fine Art AG, Zürich

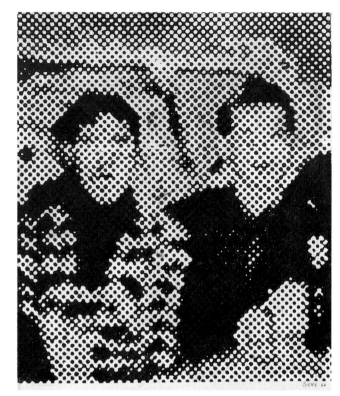

268 **Sigmar Polke**
Family III, 1966
Dispersion on canvas
71 x 60 cm
Marieluise Hessel Collection

Exhibition
"Hommage à Lidice", 1967
269 **Sigmar Polke**
Double Portrait, 1965
Oil on canvas
100 x 151 cm
The Czech Museum of Fine Arts,
Prague

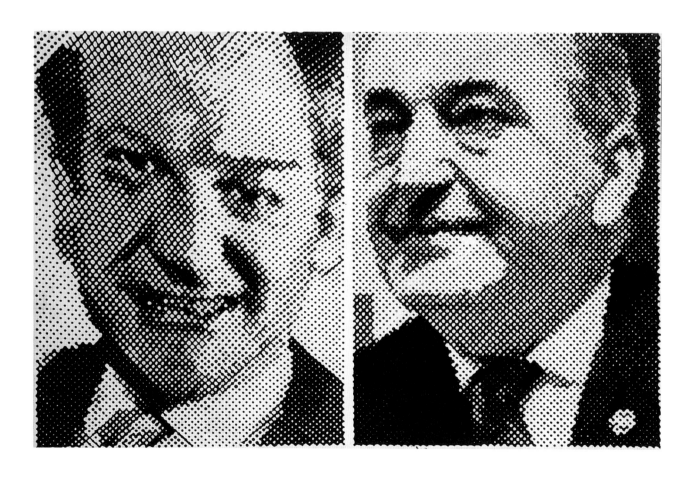

270 **Sigmar Polke**
Bedroom, 1965
Dispersion on canvas
160 x 125 cm
Städtisches Museum Abteiberg,
Mönchengladbach

271 **Sigmar Polke**
Doll, 1965
Dispersion on canvas
125 x 160 cm
Stober Collection

Gerhard Richter: Capitalist Realism and His Painting from Photographs, 1962–1966.

1 Gerhard Richter generously gave me information indentifying the persons in this and the following pictures described in a telephone conversation on 5/16/1997.

2 On his work method, see Richter's notes from the years 1964-1965: *Gerhard Richter, Text. Schriften und Interviews,* pub. Hans-Ulrich Obrist, (Frankfurt/Main/Leipzig, 1993) 29.

3 *Herr Heyde* was shown in an exhibition at the Galerie René Block in Berlin in 1966; compare the essay by René Block in this volume.

4 The source of the photo model used by Richter for this painting could not be determined. Reports on the Werner Heyde case appeared in (among others), *DER SPIEGEL,* no. 48, 1966, 66 f.; *DER SPIEGEL;* no. 23, 1968, 40 f.

5 The prostitute Helga Matura was murdered in 1966. Her fate was reported in various magazines over a long period of time. Ingrid Misterek-Plagge investigated the models for both of Richter's 1966 paintings of Helga Matura. Ingrid Misterek-Plagge, *"Kunst mit Fotografie" und die frühen Fotogemälde Gerhard Richters,* (Hamburg, 1992) 218-223.

6 For example, see: Dieter Helms, "Umsetzungen", *Frankfurter Allgemeine Zeitung,* 3/17/1966; Heinz Ohff, "Der vertauschte Naturalismus. Ausstellung Gerhard Richter - Galerie René Block in neuen Räumen", *Der Tagesspiegel,* 12/13/1966; Hans Strelow, "Der sorglose Realist des Kapitalismus. Gerhard Richter, Träger des Kunstpreises 'Junger Westen 67'", *Rheinische Post,* 1/31/1967.

7 According to Richter in a conversation with Dieter Hülsmann and Fridolin Reske in 1966, quoted from Richter, *Text,* 53.

8 The cycle *October 18, 1977* is discussed in the catalog contributions from Ulf Erdmann Ziegler and Kai-Uwe Hemken.

9 Misterek-Plagge.

10 Most of the time, the category of photographic model cannot be determined from a painting, unless Richter also transposed photo captions or text quotes in the painting, as in the painting, *Herr Heyde.*

Three women, two children and a dog in front of a flat meadow landscape: This photograph, which served as Gerhard Richter's model for this painting, shows Richter himself at the age of about eight in Waltersdorf where he grew up. Richter kneels holding his dachshund Struppi in his arms, his sister next to him, and behind the children, to the left is the grandmother. His mother is in the middle with a friend on her right.[1]

Like the painting *Family* from 1964 (fig. 260, p. 224), much of Richter's work from 1962 to 1966 show individual persons or groups of persons. In some of the other paintings, everyday objects are to be seen, a chair or chandelier, for example. Parallel paintings from this time show army planes dropping bombs (fig. 264, p. 226). In face of the disparity between the subjects, the single connecting moment is the medium of the photographic model, which Richter transposed to the canvas with efficient, skillful technique.[2]

In the painting *Aunt Marianne* from 1965, (fig. 263, p. 225) one sees an infant lying on pillows and a young woman standing behind and leaning towards him. The artist himself and his aunt Marianne are portrayed. Gerhard Richter was about six months old when the photograph was taken. It later served him as a model. Richter's memories of his aunt from the maternal side go back to his early childhood. As he said himself, his perception of her as a "frightening presence" connects to the fact that she suffered from schizophrenia. Richter's aunt was placed in the mental institution in Großschweidnitz bei Löbau before WWII and was supposed to have died there. The report of her death at the time, according to Richter, prompted no one in the family to look into its cause.

The 55 x 65 cm format painting *Herr Heyde* (fig. 262, p. 225), also from the year 1965, shows the back of a person in uniform in front of the profile of a man wearing a hat and glasses. It can be read in black and white at the bottom of the painting: "Werner Heyde in November 1959, as he gives himself up to the authorities." Richter used a newspaper clipping as a model and transferred not only the photographic subject onto the canvas, but the caption as well. Prof. Werner Heyde, one of the National Socialist regime's leading euthanasia doctors, had worked after the war as a neurologist and court advisor in Flensburg under the name Dr. Fritz Sawade. When his true identity was revealed, he gave himself up to the police in Frankfurt/Main in 1959 and

was taken into custody. He hanged himself in his cell on February 13, 1964, after four years of imprisonment while awaiting trial. Today, the name Heyde is remembered only by few. By the 1960's, Richter's painting had become an issue in the ongoing discussion surrounding the case.[3] After Werner Heyde's suicide, the trials against those holding high official positions, doctors and professors in Flensburg who had covered for him, provided for further headlines.[4]

Herr Heyde and *Aunt Marianne* are carried by black, white, and various gray tones, as are most of Richter's paintings from the years between 1962 and 1966. After transposing the photo motif onto the canvas, Richter smudges the oil paint while it is still moist. His painting language betrays no emotion and no critique. The painting of his aunt, assumed to have been an euthanasia victim, and the painting of Heyde, one of the people chiefly responsible for the more than 100,000 euthanasia victims during Nazi times, are not differentiated from each other in the technique of portrayal. The subjects of his paintings were often prominent topical figures, as in the case of Werner Heyde or the murder victim Helga Matura.[5] The art critics, however, took no particular notice of these paintings at the time.[6] Richter's painting technique during those years remained constant and appeared to be independent of the subject. Consequently, the figure portrayed came to be seen more as arbitrary and peripheral. Richter himself contributed to this estimation: "If I would paint believably and correctly, as if illustration would be the important thing, then I would only be using it as a pretext for a painting."[7]

Richter was seen as the German representative of a new objective – but not politically engaged – painting. Painting from photography stands in the foreground as a subversive gesture against painting traditions, in comparing his work with American Pop Art. Art history long maintained this view of Gerhard Ricther's work; first the exhibition of the painting cycle *October 18, 1977* in the Museum Haus Esters in Krefeld[8] stimulated a new examination of early painting from photography. They enquired into the sources of the newspaper clippings in order to reconstruct the original context of the photographs.[9] In comparison with the numerous paintings which Richter painted from magazine photos in the early 1960's, relatively few are based on photos from his years in the GDR.[10] Until now, there has been no appropriate study on these paintings in the literature on Richter's work. The exhibition "Deutschlandbilder" shifts them into the foreground for the first time. Three of the seven exhibited works – *Family, Aunt Marianne, Uncle Rudi* (fig. 261, p. 224) – arose from family photos in an album which Richter had brought with him from East Germany.[11] This album marks a continuity between Richter's 29th year in the

GDR and the following years in the FRG. It points to memories of the family that remained behind, of friends and acquaintances as well as places and landscapes, and experiences which were not easily erased with the change from East to West, but rather attained new

Konrad Lueg and Gerhard Richter at their performance piece *Life with Pop. A Demonstration for Capitalist Realism* in Möbelhaus Berges in Dusseldorf, October 11, 1963
Photograph by Reiner Ruthenbeck

meaning and probably additional importance with the building of the Wall. The Richter paintings already described here appear at first to have nothing to do with all of that. They give the impression of indifference, although Richter was in no way without opinion nor was he apathetic – as revealed by the action he staged together with Konrad Lueg (Konrad Fischer).

On October 11, 1963, Lueg and Richter invited people to an event in Möbelhaus Berges (furniture store) in Dusseldorf. *Life with Pop* stood in large red writing on the yellow invitations cards, and underneath, in smaller print: "a demonstration for Capitalist Realism".[12] Lueg and Richter had placed a green balloon through the punched-out "o" in the word Pop and added the following explanation on the other side of the card: "Instructions: 1. Inflate! Read the print! 2. Explode! Note the noise! Pop!" Irony, as they indicated with these lines, determined the entire event.

The owner of the furniture store was the one to have suffered the most. He wanted to used the affair as publicity for his business and had placed two announcements of the event in the press. Beforehand, Lueg and Richter had shown him a photograph from the Swiss art magazine *Art International* of the exhibition "New Realists" in the Sidney Janis Gallery in New York, in order to illustrate to him their plans.[13] In New York, "New Realists" was considered to be the "most provocative art event of the season".[14] On October 5, 1963, this photograph illustrated Möbelhaus Berges' announcements in the Dusseldorf local newspaper *Mittag*. The caption under the illustration read: "The exhibition 'Life with Pop' will be something like this."

An object entitled *The Stove with Meat* created in 1962 by Claes Oldenburg is shown in that photograph. Oldenburg took an old stove and arranged kitchen utensils

and food on it, which he had formed from plaster-soaked fabric and then painted, and placed the oject on a low platform. His procedure – associated with Marcel Duchamp's Readymades – of putting an everyday object on a pedestal, became the central motif of Lueg's and Richter's action. The two artists arranged a living room in a windowless room on the third floor of the furniture store, complete with cabinet, tea-trolley, gas stove, standard lamp and a side table with television, as well as two arm chairs and a couch placed around a table in the middle of the room. Each piece of furniture stood on pedestals of varying heights and at unusually great distances to each other. In this way, Lueg and Richter wanted to "effect" a "... being exhibited", as they remarked in the account they drew up shortly after the action.[15]

With his object *The Stove with Meats,* Oldenburg distanced himself from the New York School's noble notion of art. He activated and thematized the relationships of tension between "high and low", between art's elite claims and the everyday's image worlds and objects. Lueg and Richter's strategy was conceptually thought through like Oldenburg's, whereby they transformed their living room design into a parody of the societal situation in the FRG at the time, by way of the pedestal. The historical context of the event must be pointed out here.

On Friday, October 11, Konrad Adenauer handed in his resignation as Chancelor to President Heinrich Lübke, effective October 15. This was a condition of the FDP (Free Democratic Party) for the continuation of the coalition with the CDU/CSU (Christian Democratic Union, Christian Social Union) after the governmental crisis, which the *SPIEGEL*– Affair had set off in 1962.[16] The fact that the date of Adenauer's resignation had been fixed many months earlier, lets us doubt Lueg's assertion that the action had nothing poltical to signify[17] as well as Richter's reference to a "nice coincidence".[18] One of the artists themselves delivered the powerful piece of counterevidence. Lueg and Richter had placed the paper-maché figure of the American President John F. Kennedy next to a rolled carpet in a passage way leading to an anteroom of the living room, decorated as a waiting room. In addition, copies of the *Frankfurter Allgemeine Zeitung* from the same day[19] lay on each chair in the waiting room, and the tea-trolley in the living room was equiped with Winston Churchill's just published memoirs. Not to forget the running television: at the point in time of the action, the first station's news broadcast was followed by a report about the Adenauer era. The political event became a kind of platform for the artists' "demonstration" by way of topical reporting as element of the action. Lueg's and Richter's living room arrangement was a memorable picture of the rigid, immobile Federal German society at the beginning of the 1960's. They described the withdrawal into

11 In the meantime, Richter had taken some photos from the album and added them to the *Atlas. Atlas* is the name of his collection of materials, which he began in 1969 and continues collecting, mainly photographs which have partially served as painting models. Gerhard Richter, *Atlas der Fotos, Collagen und Skizzen*, pub. by Städtische Galerie im Lenbachhaus, Munich, current new edition (Cologne, 1997).

12 For a reconstruction, see Susanne Küper, Konrad Lueg and Gerhard Richter: "Leben mit Pop - eine Demonstration für den kapitalistischen Realismus", *Wallraf-Richartz-Jahrbuch,* vol. LIII, Cologne, 289-306.

13 *Art International,* 1/1963, Illus. 24.

14 David Bourdon, Andy Warhol (Cologne, 1989) 135. Janis, who to date had represented the Abstract Expressionists, contributed decisively to the break through of American Pop Art with his support of the new objective directions in art.

15 Printed in: Obrist, 15-17.

16 Daniel Koerfer, *Kampf ums Kanzleramt. Erhard und Adenauer* (Stuttgart, 1987) 702 f.

17 Stella Baum in a conversation with Konrad Fischer, see Stella Baum, "Die Frühen Jahre. Gespräche mit Galeristen", *Kunstforum International,* vol. 104 (1989), 277.

18 Richter used this formulation in a conversation with me on 7/25/1990 in Cologne.

19 *The Frankfurter Allgemeine Zeitung* reported on the awarding of the Honorary Citizen of the City Berlin to the retired Chancelor on 11/10/1963.

20 In a 1986 conversation with Benjamin H.D. Buchloh, Richter explained that in 1962/63, he had been chiefly concerned with American Pop Art, Marcel Duchamp and Joseph Beuys. Obrist, 128-131.

21 Lueg and Richter had asked Joseph Beuys to lend his clothing for their action, whereupon Beuys personally installed his own suit in their living room arrangement. Small slips of paper with brown crosses were attached to the pants and jacket. On the one hand, this aspect of the event is to be seen as an homage to Joseph Beuys and Fluxus. At the same time it poses the question of the effect had by Beuys' work in face of the societal situation of the time vivified by Lueg and Richter.

22 According to Richter in our conversation in Cologne on 10/26/1989.

23 Notes from the year 1962. Richter, *Text*, 9. The Berlin gallerist René Block invited Gerhard Richter to an exhibition and showed a total of 14 paintings, including *Stukas* (fig. 264, p. 226) and *Family* in his new gallery on Frobenstrasse. Block entitled Richter's work as "Capital Realist Paintings" on the exhibition poster in support of the title of Lueg's and Richter's action. When I asked Richter about this in our conversation on 7/25/1990, he answered, that he couldn't prevent Block from associating his work with the slogan "Capitalist Realism". "I never thought that I would make 'Capitalist Realism', not even during the furniture store times", Richter maintained, adding that the term is perhaps quite apt, after all.

24 Obrist, 31.

25 Gerhard Richter 1990 in a conversation with Ingrid Misterek-Plagge, Misterek-Plagge, 330.

26 Uwe M. Schneede, *Gerhard Richter in der Hamburger Kunsthalle* (Hamburg, 1997) 8 f.

27 In the conversation with Benjamin H.D. Buchloh, Richter answered the question about his criteria for choosing photographs: "Definitely the content - which I had earlier denied - because I had always maintained that it has nothing to do with the content, it was only a matter of painting from a photo and demonstrating indifference." He said later on in the same conversation: "I looked for photos that revealed my present time, what concerns

the domestic idyll characteristic of that time. Sitting in the arm chair and lying on the sofa, they demonstrated for "Capitalist Realism" and made fun of everyone whose interests are limited to their own four walls. They caricatured the part of the population that followed the political event in television or the newspaper – only at safe distance.

It was hardly possible in the GDR to express an individual, critical opinion without being taken into custody or deported. This had not been Richter's least reason for having left the country. Against the background of his experiences, he could only face the lethargy in what was for him the new part of Germany without comprehending. The cooperative event with Konrad Lueg was part of a phase in Richter's work, in which he had to orient himself anew after having left the GDR. He examined Western art[20] and the political and societal situation at the same time. During his reconnoitre, he occupied himself mainly with the role art played in Federal Republic society[21] and where he could begin with his painting. The questions occupying Richter at the time couldn't have been expressed more concisely as in the photograph showing Lueg and Richter in their living room in Möbelhaus Berges.

"We wanted to show what is", said Richter.[22] By taking up the slogan "Capitalist Realism", they indirectly drew an extremely provocative – at the same time ridiculing – comparison to Socialist Realism. To this day, Richter still rejects any form of rigid determination, any "ism" and noted in 1962:

"... the social is a form and method, which is correct according to today's understanding. But if it raises itself to social-ism, to order and dogma, then it gives up its best and most original and can become criminal."[23]

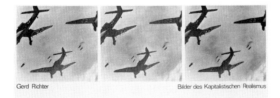

Poster for Gerhard Richter's exhibition in the Galerie René Block 1964

With regard to the action, it cannot be a matter of indifference. The ironic, partly even cynical attitude of the two artists points much more to their critical consciousness and their own consternation. But how can it be explained that the paintings described here offer no opinion? How can there be no mind set when the motifs and themes demonstrably concern Richter personally? The seeming incompatibility of form and content recalls works

by Andy Warhol, who had already used photography as models for his paintings before Richter. After initially transferring the photo onto the canvas manually, Warhol began to use silk screen as mechanical help in 1962. Photographs of spectacular car accident victims were the basis for a painting series from 1962/63; in 1963 Warhol

Andy Warhol
White Burning Car II
1963
Screen printing with acryl and liquid textile on canvas
269.5 x 208.5 cm
Museum für Moderne Kunst, Frankfurt/Main

varied the photograph of an electric chair in an entire sequence of varying paintings. He often printed the same subject repeatedly next to each other on the canvas. Emotionality or other forms of statement are not in evidence. Warhol always remained distanced in his work and with his own means, reflected on the mass medial dissemination of photography and the observer's glance dulled and numbed by the daily presence of comparable "images". The same superficial allure radiates from Andy Warhol's "crash" paintings as from his portraits of famous American stars.

Richter, unlike Warhol, continued to transfer the photo to canvas manually and then worked over the portrayal by guiding a dry brush over the still moist paint in order to blur the sharp contours. To explain his procedure, Richter noted in 1965:

"I blur to make everything equal, everything equally important and equally unimportant. I blur so that it doesn't look like artistic-craftsmanship, but rather technical, smooth and perfect. I blur so that all the parts shift into each other. Maybe I also blur out the 'too much' of unimportant information."[24]

The blurring of the photographic subject transferred to painting matured in 1964 as Richter's characteristic technique. The 1962/63 works from photographs, such as *Pall-bearer*, *Stag* or *Neuschwanstein Castle*, however, having a distinct experimental character with regard to the reworking with paint, testify to Richter's struggle for a painting language that accords with his own intentions. The painting *Table*, from an illustration in the Italian architecture magazine *domus*, has a particular significance in this context. The painting-parallel and foreshortened table takes up nearly the entire surface of the painting. A darker background in the lower area and a smaller, light zone in

me." Richter, *Text*, 134, 136. In a recent essay, Stefan Germer treated Richter's "private" pictures separately (Stefan Germer, "Familienanschluß. Zur Thematisierung des Privaten in neueren Bildern Gerhard Richters", *Texte zur Kunst*, Nr. 26, June, 1997, 108-116). He disregarded, however, that a reference to the artist as person exists in any case, regardless of whether the subjects are public or private. Richter united "public" and "private", as well as "abstract" and "objective" portrayals as diverse facets of his vision of reality.

28 Benjamin H.D. Buchloh was the first point out the reference in Richter's painting to Readymades. Benjamin H.D. Buchloh, "Ready-made, photographie et peinture dans la peinture de Gerhard Richter", *Gerhard Richter*, exhibition catalog, Centre National d'Art et de Culture George Pompidou, Musée National d'Art moderne, (Paris, 1977) 11-58.

29 "Painting must be worked off against the historical reality: first, by creating a distance to the photographic interpretation, it opens the recent appropriation shown in the paintings", wrote Stefan Germer about the cycle *October 18, 1977*. His interpretation is also valid for Richter's painting from photographs in the early 1960's (Stefan Germer, "Ungebetene Erinnerung", *Gerhard Richter. 10. Oktober, 1977*, exhibition catalog, Haus Esters, Krefeld; Portikus (Frankfurt/Main, Cologne, 1989) 51). Renewed appropriation over distance is also known as a characteristic moment in the writings of Uwe Johnson, with whom Richter shares not only vital biographical dates. Johnson said in a lecture in Frankfurt/Main in 1979: "I don't mean that literature's task would be to consider history with reproach. The task of literature lies much more in telling a story, in my case it means not telling it in such a way as to lead the reader into illusions, but rather to show him what the story is. If that is an enlightenment, not a social activist enlightenment, it doesn't demand that the reader immediately transforms himself, but rather that he takes on the story, thinks about it, and draws his own conclusions." Uwe Johnson, *Begleitumstände. Frankfurter Vorlesungen*, (Frankfurt/Main, 1980) 206.

30 See Richter's notes from the year 1964, Obrist, 18.

the upper part of the painting suggest speciality. Richter worked over the subject by moving a brush or cloth soaked in solvent in circles over the painting, so that the various gray tones merged in the center of the canvas. He introduced a process of destruction implicit to painting, which

Gerhard Richter, *Table*, 1962, 90 x 113 cm
Private Collection, Frankfurt/Main

he guided with his hand movements. Traces of wiping remain and flow towards the center, dry at the edges and fade away. Illusion is evoked and the same moment dissloved, in that an abstract surface lays itself over the perspective space of the painting like a veil.

It makes no difference if it's a simple object portrayed, like a designer table, or a person of public interest at the time the painting was created. With photographs, Richter had always transposed onto the canvas opinions, ideas and histories that had grown around the figure portrayed. Personal memories of his aunt or of his uncle from the maternal side *(Uncle Rudi)*, who his parents had extoled as an exemplary person,[25] left their traces just as did the societal gossip about the prostitute Helga Matura or conjecture on Lee Harvey Oswald's character.[26] The criteria for selecting the purely private as well as the publicly known subjects were subjective.[27] Richter looked for photographs, whose subject occupied him personally, only the working over leads to a generalization and objectivization. Richter endows the painting either with fleetingness or he lets it freeze, each according to how it is blurred. In this respect, one analogy to Andy Warhol's painting strategy emerges, in that Richter – as his action with Konrad Lueg already showed – and Warhol both took up Marcel Duchamp's Readymade principle.[28] Both Richter and Warhol transformed the *objet trouvé*, the photograph, without expressing their personal opinion. But while Warhol followed the strategies of media and advertising, intensifying and emphasizing them with help of his technique, Richter proceeded in the opposite direction. The example *Table* made his intention and the effect

of the bluring especially clear. Richter brought the photographic subject and the painting technique into play as competing picture means, so that each claim to reality is canceled by this conflict. On the one hand, Richter held the observer's own view of the portrayal like a mirror before their eyes, while at the same time, his paintings opened the possibility of distance and a renewed examination of the object.[29]

Richter had *Table* as number 1 in his work catalog, although he knows that this painting was not his first from a photograph.[30] Without a doubt, it bore a programatic significance for the early paintings from photographs. But doesn't this painting's program reach further?

Richter's color charts from 1966 mark the first break with regard to the initial painting from photographs. The artist turned away from objectivity and towards abstraction. Since then he maintained his work in constant vacillation between those initially opposing means of painting language. Gerhard Richter had turned ambiguity and doubt into a constructive principle of image and work. The scepsis that characterizes Gerhard Richter's work with regard to painting in general (he knew only too well how perfectly painting manipulates), and his defiant, unwavering striving for recognition of reality with the means of painting, were set forth in the painting *Table* from 1962.

Susanne Küper

Sigmar Polke's Images of Germany

Sigmar Polke, *Chocolates*
1963, pen and watercolor on paper
29.6 x 21 cm, private collection

Sigmar Polke, *Socks,* 1963
Oil on canvas, 70 x 100 cm
private collection, Cologne

1 The full quote from 1951 reads: "Writing poetry after Auschwitz is barbaric, eroding also the knowledge which voices why it became impossible to write poetry today" (Theodor W. Adorno, *Kulturkritik und Gesellschaft. Gesammelte Schriften,* vol. 10/1, (Frankfurt/Main, 1977) 30.) (Translated here, the text is also published in English). Adorno had used the word "barbaric" numerously in his essays "Taboos about the Teaching Profession" and "Education after Auschwitz", Adorno, *Stichworte. Kritische Modelle 2,* (Frankfurt/Main, 1969), in connection with the call for educators to make the new generation aware of the barbarism which had caused Auschwitz, so that there will be no second Auschwitz.

2 Quoted from Friedrich W. Heubach, *Sigmar Polke, Sigmar Polke. Bilder, Tücher, Objekte. Werkauswahl 1962-1971,* exhibiton catalog, Kunsthalle Tübingen, 1976, 130.

"Writing poetry after Auschwitz is barbaric."[1] With this maxim, Adorno made all creative, self-critical people aware that it is not possible to continue working on a culture in the accustomed language which had lead to the Holocaust. New artistic forms would have to be found, from which no passed down associations could be made. Joseph Beuys, professor at the Dusseldorf Academy since 1961, sought this alternative in new forms of sculpture, in the staging of installations and actions even involving the artist himself. He also called upon his students to invent different, immediate means of artistic expression and to consciously disassociate themselves from the traditions of that culture which had made Auschwitz possible; to follow Adorno's dictum. Sigmar Polke was a student at the Dusseldorf Academy at the time - he painted despite any restriction, however, responded to Beuys' call with Polke-esque satirical Pop Art. He confronted himself with the "here and now", with the trivial "purpose in life" flaunted by postwar society in the economic wonderland of divided Germany.

Polke, who had spent his childhood on the East side of the Iron Curtain, could observe the glaring contradiction of the societal realities in both parts of Germany with the necessary distance and expose the phenomena with irony. His drawings were critical; quick sketches on topical German issues arising in the atmosphere of the Economic Miracle. They were parodies on the excessive consumerism. Stressing nonartistic materials; poster-paint, felt or ballpoint pens on limp packing paper or in graph-lined school notebooks, for instance, he caricatured the new German illusion of being able to buy any happiness on earth with the Deutschmark. He found models for these works in the glossy catalogs of department stores. For the Germans in the East, the "artifical paradise" remained an unreachable dream, for the others in the West living in permanent abundance, it had soon become taken for granted. His subjects ranged from German gluttony in the form of endless chains of plump sausages to variations on neckties, socks and shirts up to luxury travel to the dream destination under palm trees. In childish writing, he named what we see anyway on the paper, thereby throwing that audience whose standards of art he parodies with the drawings into a state of thorough insecurity.

He satirizes the peculiarities of his own compatriots with loving irony. He characterizes the society to which he also belongs through the reality of the every day things. The potato, for instance, the favorite food of the Germans,

must play the role of metaphor for an entire philosophy. Sometimes as the building block for a *Potato Pyramid in Zwirner's Cellar,* and sometimes the formal model for certain politicians - *Potatoheads (MAO & LBJ)* (LBJ –Lyndon B. Johnson), until the artist ultimately brought the potato into play in a philosphical-satirical treatise as analogy to the characterization of his own profession: "Yes, if there is something at all which applies to everything that is always said about artists: joy of innovation, creativity, spontaneity, productivity, creating entirely out of themselves, then it is the potato: how it lies there in the cellar and spontaneously begins to sprout, innovating sprout for sprout in sheer inexhaustible creativity, completely withdrawn behind their work, soon disappearing behind their shoots and in that, the most wondrous thing is created! - And such colors!: the nearly trembling frost-bite-purple of its sprout tips, the spaceless, pale white of its shoots sometimes showing an earthless pained green, and then that timeless motherly wrinkled brown of the self-consuming fruit. ... Everything that the public always expects from the artist, of which he is able to fulfill so little - the potato exhibits in abundance!"[2]

Together with Gerhard Richter and Konrad Lueg, he founded "Capitalist Realism" in 1963 with the same consciousness-transforming objective with which he produced the trivial drawings. As artist collective, they organized provocative exhibitions under the same demonstrative slogan, for example, in a Dusseldorf furniture store. In contrast to American Pop Art, which placed the triviality of the consumer world on the pedestal of the illustrious in high gloss and large format, they questioned the aesthetic claims of traditional art perception not only through content but also through the unprecious materials of their paintings and exhibition objects.

Other Dusseldorf Academy art students also sought contemporary new forms of expression. Following the model of Marcel Duchamps, they took up Readymades; things available from everyday life or banal objects that are found and endowed with new significance in a new context. The two IMIs, for instance, Rainer Giese and Klaus Wolf Knoebel, used fiberboards from a builder's yard and composed them to sculptural structures in space-filling installations. Sigmar Polke and Gerhard Richter used photographs as an authentic slice of the real world on which to base their paintings. They did not choose artistic and therefore artificially arranged photographs, but rather snapshots, family memories, which they either produced themselves or found in newspapers. For both artists, it was a matter of transposing the passed down reproductions of reality by means of painting, in such a way that the reproductions place themselves in question through the language of image alone. Artistically, however, they both went completely different paths. While

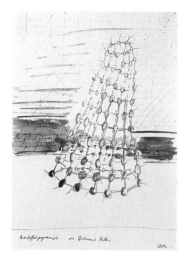

Sigmar Polke, *Potato Pyramid in Zwirners Cellar*, 1969
Pen, water color and rapidograph-ink on paper
29.7 x 21 cm, Private collection

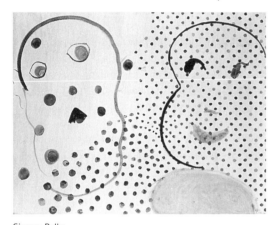

Sigmar Polke
Potatoheads, MAO + LBJ, 1965
Dispersion on canvas, 90 x 110 cm
Collection Frieder Burda

Sigmar Polke, *Raster drawing (Interior)*, 1965
Rubberstamp, brush on paper, 43 x 40 cm
Private Collection

Richter copied in painting the photographic models in the shades of their grey tones and let the contours dissolve into blurs (see *Uncle Rudi*, fig. 261, p. 224), Sigmar Polke took up the raster screen as a relevant means of expression for many-leveled statements reflecting time. (*Family III*, fig. 268, p. 230). Thereby, he formed a connection, in many respects metaphoric, to the present, because it represents the encoded language of the media, in which all images are transmitted to the current news reports.

The raster point cliché is the dissolution of an image in single more or less densely distributed points, only through which the print-technical reproduction of photographs is possible. In photography they are so tiny that you can only see them with a magnifying glass. For printing newspapers, on the other hand, the points are course and large enough to be seen with the naked eye. In both cases, they copy reproductions of reality which themselves have been transformed once before, that is, second-hand pictures. The subjects of Sigmar Polke's pictures are the displacements that can be manipulated on various levels of meaning as well as the layering of societal structures. He breaks down the chosen image material in its binary system according to the principle of a researcher - in points and nonpoints. At first, each point appears neutrally for itself, yet some of them lead their own life. And many individual points disturb the eye! Caution is called for, because the artist is cunning and knows the media manipulators' tricks. You have to look very closely at his pictures; behind the appearance of the resolved illustration's precision, revealing nuances are concealed, suggesting displacement.

Polke takes no position of judgement, yet he questions by means of irony. He often chooses banal things from the everyday world for picture subjects, like in the drawings, for example, pictures from the postwar modern living milieu. His *Interiors* range from sober objectivity to the kitchy, pompous, flashy designer furniture of the nouveau riche (*Bedroom*, fig. 270, p. 231). In all cases, the screen pictures contain faulty places, spots which severely disturb the appearance of order.

They create at once unrest and distance to the accustomed vision. They signal signs to the brain, challenge the observer to place these signs in a larger context and to transform them into recognizable images. By getting involved, the observer himself becomes actively integrated in the creative process of image making and compelled to reflect on image reality. Then, for example, the observer can develop amazing statements out of the point variations of the painting *Double Portrait* (fig. 269,

p. 230). Two men of around fifty years of age, perhaps politicians, are portrayed. Both have a friendly, smiling facial expression, which in the younger of the two could freeze into a grimace. Polke had applied the points in two different ways. The lighter half of the face is formed by black points on white background, while a black grid pattern is painted on the shadowed half. Facial features, shadows around the eyes, mouth and nose are marked by densifying the black network. The direct glance into the camera stiffens the strained grin in tension. In an analogy to life, Polke paints the two sides of this gentleman in negative and positive points. Both appear in systematically arranged patterns, which are however, partially frayed at the edges and diffusely overlapped. The portrait of the second man is placed further towards the background. Nothing of his true personality is divulged. He glances sideways, smiling non-commitally out of the picture with that smug expression of pride over the recovered prosperity. The facade is flawless!

With the title *Double Portrait*, Polke already gives away the intended generalization of his statement. For him, it was obviously not a matter of portraying two individuals, rather the stylization of a certain species of human and its exchangeability. The painting from 1965 thematized the prototypes of the successful, correct Germans from the heyday of the Economic Miracle: dark suit, white shirt, tie, decoration on the lapel, short haircut, receding hair-line. The men's ages suggest that they were professionally active before the Nazi Regime. They embody that legendary generation of fathers who held the political and economic reins in the 1950´s and 1960´s - witnesses of the Hitler Regime and as such participants, who later evaded that discussion about their share of responsibility with sons and daughters, pointing the blame elsewhere. In art, the content defines the form, and the screen cliché appears here as the fitting solution to the extent that it refuses smoothness and illusion.

The painting was Polke's contribution to the art project "Hommage à Lidice", which the Berlin gallerist René Block bequeathed as a sign of atonement to the younger generation of the reconstructed Czech town Lidice and its new citizens: In memory of the crime committed there by the German SS.[3]

"Just like in Squire Sancho, folk wisdom and life smarts are paired in Polke with a shot of superstition and realism, with which he tracks down the human inadequacies in the powers that be and the greatness and abjectness in the people. He is therefore able to encounter them with an ironic superiority which is sometimes full of tenderness."[4] The tenderness testifies to a great sympathy for the weaknessess of his fellow man, who he captures in his paintings and to whom he declares himself to some extent in his drawings and paintings. The dis-

Sigmar Polke, *Don Quichotte*, 1968
Dispersion on canvas
80.3 x 60.5 cm
Private collection Frieder Burda

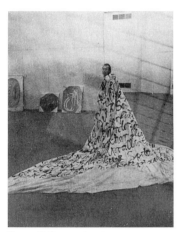

Sigmar Polke wearing the
The Great Bitching Sheet

3 See essay by René Block in this volume.

4 Harald Szeemann, "Halonen am Firmament der Bilder", *Sigmar Polke,* exhibition catalog, Kunsthaus Zürich, 1984, 10.

5 Lucius Grisebach, "1971-1985. Von der 'Kargen Kunst' zum 'Hunger Nach Bildern'", *1945-1985. Kunst in der Bundesrepublik Deutschland,* Nationalgalerie Berlin, 1985, 24.

6 The four-part work *Vitrine Piece* is provided with the following text: THE PAINTING; PAINTED ON THE COMMAND OF HIGHER POWERS: I STOOD BEFORE THE CANVAS AND WANTED TO PAINT A BOUQUET OF FLOWERS: THEN I RECEIVED THE COMMAND FROM SUPREME BEINGS: NO FLOWER BOUQUET! PAINT FLAMINGOS. FIRST I WANTED TO CONTINUE PAINTING; THEN I KNEW THAT THEY REALLY MEANT IT SERIOUSLY.

7 Arnold Hauser, *Ursprung der modernen Kunst und Literatur,* (Munich, 1979) 23 f. See also: Sandro Bocola, *Die Kunst der*

crepancy between the illusions which these people take for reality and the actual reality often makes for situation comedy. Polke is alert when it's about tracking down signs of the time in the political landscape. With sensitive antennae, he registers the positive as well as the negative atmospheric energies. Just as the fool in Shakespeare's dramas glosses over the realities with satirical to cynical sayings, Polke interferes with the same intention in his painting. With the drawing *Your Parcel to the Poor Relatives Behind the Wall* for instance, he succinctly showed the psychological attitude of his satiated fellow citizens towards their brothers and sisters in Germany's other part. Pack it up, tie it tightly, send it away! We're doing something for them. The conscience is soothed. He doesn't say everything, yet the choice of the word "parcel" is statement enough in his dimension.

The art of the late 1960's was intended to make people think. It was less about the work "which follows from artistic work as endproduct, but rather about 'situations' and 'hidden structures', which should become recognizable through the work."[5] The art work serves not only to glorify the illustrious, but was much more expression of a sociological or philosphical dispute. With his painting *Higher Powers Commanded: Paint the Right-Hand Corner Black!* from 1969 (fig. 272, p. 243) Polke thematized the traditional cult surrounding the artist - who until now had been the epitome of the creative genius - as being closer to God. Polke shows - as in the *Vitrine Piece* from 1966[6] - that he accepted his role as executor of universal powers, just as he respects that his paintings have their own life.

In the 1960's the notion of art was fundamentally put into question and the definition of new value structures was attempted. Art was judged according to its "social relevance". What Arnold Hauser set out in his discourse about works and the effect of Mannerism in surmounting the Renaissance for the 16th Century, could have been just as valid for the renewal of art following the times of crisis in the 20th Century: "What most strikingly characterizes Mannerism as anti-classical art is the abandonment of the myth that the art work forms an organic, indivisible and unalterable whole and is from one cast. ... The unclassical Mannerist art work, in contrast to this synthetic portrayal, aims at the analysis of reality. It is oriented neither towards the capturing of something essential, nor to the condensing of individual moments of reality into a substantial being, nor to the extraction of a spiritual core ... It moves with preference along the periphery of the area of life to be represented, ... to indicate that the being it represents possesses a center nowhere and everywhere."[7] In the expanded interpretation, art in the 1960's was able to function as connecting link between different disciplines and thereby to expand the

angle of vision and above all perception. *Quit painting,* the call which Jörg Immendorf painted on a kind of banner in 1966 (fig. 228, p. 183), had already been followed by many artists who had staged political actions and consciousness raising experiments even by involving themselves.

Polke completed *The Great Bitching Sheet* (fig. 267, p. 229) in 1968, the year of revolt. He sprayed a tirade of provocative four-letter words in childlike writing all over a pink flannelette larger than 16 m². They were not some would-be-revolutionary slogans, but rather the worst four-letter words from the adult taboo-department that could occur to a child out of defiance, anger and desperation. The artist had obviously greatly enjoyed displaying these obscene words in public unpunished, thereby provoking, if possible, those adults who were already adult at the time he was a child and who, in response to such obscene words, would surely have smacked him. He wrapped himself in his *Bitching sheet* as if it were ermine, before its mounting in the exhibition "Jetzt. Künste in Deutschland heute" in the Cologne Kunsthalle in 1970, and had himself photographed in confident, theatrical pose. He conveys himself again with this ambivalence of earnestness and enigmatic "loveable", mischievous playfullness, which keeps him from being seriously harmful.

"Making visible that there is something that one can think but not see or make visible".[8] Jean-Francois Lyotard's demand on modern painting corresponds to Polke's intention in dealing with the sensitive issue of the recent German past. The painting *Doll* from 1965 (fig. 271, p. 232) for instance, at first only exudes an austere, off-putting atmosphere. It shows a cut off bedstead, which calls to mind a hospital or similar institution. We see an untouched, properly made bed. Like the *Double Portrait,* it stems from the beginnings of Polke's raster paintings, in which he merely paints or stamps single black and white points on the canvas, which appear to stand out from the respective contrasting background. A couple of spots upset the regularity of the point pattern, occasionally the raster points are so condensed to form a black surface, as in the bed cover, for example. The doll, dressed as a girl, lies stiffly and rigidly next to a bright object and stands out against this surface. Little concrete indications of place and time can be seen, however the painting conveys an atmosphere of coldness, of unlovingness, of abandonment and hurt. The doll clues us in on an absent child, who must have put it there on the place which possibly serves for the moment as home. Dolls are the most important companions for children. They confide their troubles to their dolls, share their fears, always carry them around with them. The abandoned dollmodel, offers us a presentiment of the child's fate: "Making visible that there is something that one can think but not see or make visible."

In an interview for this essay, Sigmar Polke described *Doll* as one of his most important paintings. He showed it in the exhibition at the Rotterdam Museum Boymans-van Beuningen in 1984, hung together with his icon on Auschwitz: *Camp* from 1982. No people are to be seen here, either, only the no-man's land between the concentration camp's barbed-wire fences and the bowed lamps of the surveillance facility, which have been long imprinted on the memory. "The painting in 'Camp' is not painting at all. It is a reproduction. This couldn't be painted at all. ... I have used the narrative form and the objective of a photograph as reproduced tragic. ... It is the reproduction of a feeling. You feel that, because it is imposed on you as German as guilt. For others it is a question of survival and annihilation. The concurrence of art as artificiality and unexperiencing and unexperienceable can be found in *Camp.9* We all have in our mind's eye the documentation of the concentration camps in the most horrific images, for which no one finds words and which leave the observer at the same time helpless, traumatized and paralyzed. Polke knows these events as do most observers of his paintings: only from what they have read or been told. While painting, he therefore experiences what has been conveyed to him emotionally. "The camp, the fenced-in space, the borders - everything is there right up to the smallest model, even up to working with the burnt coal. Painting with the embers, the canvas glows, steams. ... Something happens to the painting."10 It is transferred physically and mentally to the observer. The painting brings us right up to the place of the event with few, yet unmistakeable accents, as a memorial and warning of profound sorrow and contemplation. Polke concentrates on the representation of what is atmospheric, what is inescapable. The tales of suffering are hidden in the black clouds of soot, they exude their stench out of the burn holes in the damaged canvas, and they scream out of the blazing fire in the distance, which bathes the sky in gold. Polke offers no direct view of the inferno, yet he sharpens the senses. With empa-

thetic respect for the dignity of the people tormented, he blocks the voyeuristic glance with that striped wool blanket as it was used in the camp. Sigmar Polke is conscious of the psychological reactions to admonishing gestures. By introducing emotions into the picture and therefore vividly preparing the viewer for this place void of people, every individual can decide for himself, to what extent he allows himself to get involved and project his own images from his own memory.

With the painting *Degenerate Art* from 1983, Polke positioned himself among those artists whose works were outlawed by the Nazi rulers. Joseph Goebbels described the works, which were to be chosen for the exhibition "Degenerate Art" as "German decline art". In his speech at the opening of the Haus der Deutschen Kunst in Munich, Adolf Hitler gave a crass description of the "confused dabler" such as Beckmann, Kandinsky, Klee or Kirchner, who produced such degenerate works: "And these most atrocious dilettants dare to present this to our society today as art of our time, that means, as the expression of that which forms the present time and leaves its mark on it."11 Polke used a photograph of the Hamburger exhibition site from 1983, the Kunsthalle on Spittaler Straße, as model for the painting "Degenerate Art". He dissolved in raster points the throngs of people waiting along the bulding wall, in such a way that - observed in detail - patterns and signs arise which evoke swastikas. Yet the picture as a whole conveys the impression of an endless line of people standing densely pressed together, who patiently remain in front of the supposed entrance, idle hands buried in coat pockets. It is an anonymous, homogeneous mass, in which no individual is distinguishable. We don't know who stands in line here roused by malice, craving for sensation, or who is in the know of the realistic political situation and uses the opportunity to see the masterpieces of the Modern possibly for the last time. Basically, the image of lines of people from that time stimulates diverse, often frightening associations. The artist bedded them as historical reality into a tender, masterly space of color, removed from reality. But beware: the color connections are poisonous! Polke chooses the materials according to their specific qualities and endows them with metaphoric meaning. He demands much from the observer's knowlege and capacity for empathy. A remarkable fascination arises from the painting; sensations are stimulated by the painting alone, fluctuating between undefinable fear and enjoying the beauty of the color effect. A fine veil of brownish varnish spreads itself across the painting, which is more thickly applied in some places and here and there trickles over the canvas, going off in drops. The artist can influence the chemical physical state of the paint during the drying process in such a way as to reveal cracks in the surface:

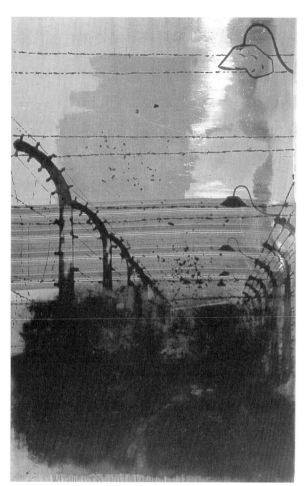

Sigmar Polke, *Camp,* 1982
Acrylic, pigment burned holes, deko material, wool blanket, shutter frame
450 x 250 cm,
Museum of Fine Arts, Boston
Donated by Charlene Engelhard

Moderne. Zur Struktur und Dynamik ihrer Entwicklung. Von Goya bis Beuys (Munich, 1994) 328 f.

8 Amine Haase, "Verlust oder Vision", *Kunstforum International,* vol. 119, 89.

9 Bice Curiger in conversation with Sigmar Polke. "Ein Bild ist an sich schon eine Gemeinheit", *Parkett* Nr. 26, December 1990, 16/17.

10 Curiger, 17.

like the arterial network under the skin, a fine web of tentacles runs across the canvas, placing the waiting throng of people on crumbling ground. In contrast to *Camp* which is void of people, the artist refers here to evene's opportunity to perceive the cracks in the social

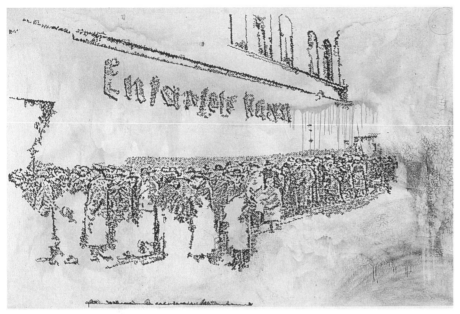

Sigmar Polke, *Entartete Kunst*
(Degenerate Art), 1983
Dispersion and varnish on canvas
200 x 300 cm
On loan in the Kunstmuseum Bonn
Collection Grothe

system and to act accordingly. But a prerequisite is to detach oneself from this passive throng - similar to distancing oneself from his pictures while viewing them - in order to recognize the structures of the system. In 1986, Sigmar Polke was nominated as the only German artist to design the Federal Republic of Germany's pavillion at the Venice Biennial. This specific site represents a big challenge for any artist because of its history. Even prior to WW I, this site was used as the official art pavillion of the German Empire and served the Nazi regime's Fascist architecture, following its reconstruction according to neo-objective classical style. Hitler instrumentalized the German pavillion on Italian soil in order to manifest his imperialist claim to power, in which State art played an important role. Walter Grasskamp refers to it in his catalog contribution on Hans Haacke's work *Bottomless* from 1993 as "ruin of significance" - that building which became the "showcase for the aesthetic liberalization of the Federal Republic".[12] However, the national ghost of the past still lingers on its walls and constitutes a provocation for artists and visitors alike. Polke, who in the 1960's had as painter already bowed down to the command from "higher powers", set about, as "explorer, inventer, discoverer, transformer" capturing on film the invisible powers at the places contaminated by German tragedy. Before he could bring the art works into this house, the place had to be demystified. Atmos-

pheric room shots emerge in film and photos, in imaginative experiments, for example, with double and multiple exposures and in alchemistically manipulated development prossesses. They shook the temple of art in convulsive raptures and seemed to blow it up and to throw the spirits in panic. "Exterior and interior, first heaven and limbo appear superimposed in a kind of short-circuit kinetic; the overall view evokes shifts in color tones on a terrain that has become unstable."[13] An impressive selection of these "Polkograhies"[14] are published in the book *Sigmar Polke. Athanor - Il Padiglione,* the exhibition catalog of the XLII. Biennial in Venice.[15] They were not shown there, however, but were preliminary works in advance of the whole project.

Polke, the cynic, prepared the visitor mentally with regard to whose pavillion he would enter with his raster painting *The Policeman and the Pig,* which hung in the exterior area right next to the official lettering BUNDES-REPUBLIK DEUTSCHLAND. Polke, the painting explorer and artist trained in the all-embracing humanist sense, had taken no one less than his countryman Albrecht Dürer[16] as model for his Venetian painting in the internal area of the building. Dürer's journey to Italy had taken the heaviness out of German art, had animated it, the Venetian colors had inspired him. And Polke? He conceived a completely new exhibition program likewise for Venice, with paintings, which "distinguish themselves demonstratively from the contemporary production, which as a whole has a program of the 'Still-not-seen': with its chemical motors, with the built-in susceptibility and ability to transform, selectively reacting to warmth, light and humidity - to the environmental influences".[17] Within this framework of his overall design, he self-confidently and at the same time ironically introduced the first German artist's light quotations into the modern sense; Albrecht Dürer's ribbon of virtues from the wood-cut *The Wagon of Triumph of Emperor Maximilian I.* from 1522. They hover like airships in a cosmic landscape, nestled in graphite dust and silver, as an elevated relic of normative German values from humanist pre-history. Yet Polke, who flirts with the role of the *Call of the Present,* pulls the observer again and again back to the ground of reality with cleverly distributed raster paintings in the BUNDES-REPUBLIK DEUTSCHLAND pavillion.

The idea of transposing reality with the means of painting alone has always driven Polke on to new inventions since the 1960's. He wants to be understood in the language of painting alone, because painting, for him, is another form of thinking. He brought the "things of reality found" onto the canvas with the points, the canvas itself becomes "evidence of reality" with the decoration fabric. This fabric, patterned with ornaments and images possesses, in the Polkeian sense, the reality of personal

11 From the Führer's speech at the opening of the Haus der Deutschen Kunst in Munich. Peter-Klaus-Schuster ed., *Nationalsozialismus und 'Entartete Kunst'. Die 'Kunststadt'* (Munich, 1987) 250.

12 Walter Grasskamp, "Niemandsland", *Hans Haacke. Bodenlos,* ed. Klaus Bußmann and Florian Matzner, Exhibition catalog, Venice Biennial 1993 (Stuttgart, 1993) 42 f.

13 Dierk Stemmler, "Die Fotografien", *Sigmar Polke. Athanor. Il Padiglione, XLII. Biennale di Venezia 1986,* Commissioner for the FRG's Pavillion, Dierk Stemmler ed. (Düsseldorf, 1986).

14 This expression was coined by Paul Schimmel, curator of the exhibition "Sigmar Polke Photoworks: When Pictures Vanish", which was shown from December 1995 until March 1996 in the Museum of Contemporary Art in Los Angeles and was used as headline for his catalog contribution.

15 See footnote 13.

reference. They symbolize the aestethic of postwar society and emulate the classical Modern with their modernist design and replace the need for art in petty bourgeois life. Polke's transporter of image (the canvas) becomes trans-

of that smiling scientist, who watches over the harm done to man and nature up to their extermination, collects the results and fills the organizers with them.

Anne Erfle

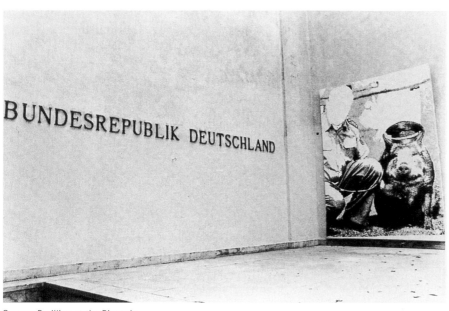

German Pavillion at the Biennale
Venice, 1986

Sigmar Polke, *Dürer Ribbons I-VIII*
VI Ratio, 1986, Graphite, silver, sepia
on canvas, 190 x 200 cm
Bayerische Staatsgemäldesammlung
Munich

16 Albrecht Dürer was the first German artist to have travelled to Italy and to have taken on the dialogue with Humanism and Italian art. For that reason, he was refered to even during his lifetime as "Apelles Germaniae".

17 Laszlo Glozer, "Mutmassungen über Polke in Venedig", *Parkett* Nr. 30, December 1991, 75.

porter of meaning because it embodies illusions, but at the same time exudes an unbearable stench. The painting *The Living Stink and the Dead are not Present* from 1983 (fig. 324, p. 329) tells its story as well. Polke sketchily paints many sober loose-leaf organizers from the company LEITZ, on three pieces of variously patterned fabrics sewn together suggesting an ideal world of wild life in Africa up to the island paradise of the South Seas. The organizers stand in an intimated book cabinet, well arranged, numbered and labeled with *Healing* and *Recovery.* Two of them carry the dates "1970" and "until 8/23/72" as the artist's personal reference. On one side, the organizers are framed by the clearly defined head of a smugly grinning man, to go by his clothing we can assume he is a doctor. On the other side, they are framed by a form made of plant-like intertwined lines, which could be identified at the same time as both the proboscis of a monstrous insect and as a gasmask. That remains open, as often is the case with Polke, and in the intentional ambiguity, refers to the numerous mechanisms of extermination which humanity has introduced in our century. The existential threats no longer exist behind the barbed-wire walls of camps, they rampage uncontrollably and diffusely, overcoming every barrier and penetrating every area of life, even the paradisical harmony of Paul Gauguin's South Sea landscapes. Polke sullied this picture base of illusions with spots and added the context of reality. In his cynical way, he aptly presents the activity

Höhere Wesen befahlen: rechte obere Ecke schwarz
malen!

272 **Sigmar Polke**
Higher Powers Commanded: Paint the
Right-Hand Corner Black!
1969
Varnish on canvas
150 x 125.5 cm
Stedelijk Van Abbemuseum,
Eindhoven

Blinky Palermo

When he changed to Joseph Beuys' class at the Dusseldorf Art Academy, the painter, first Palermo to his friends and then later in signature, began to engage himself with new forms of painting. He shared the desire with many of his contemporaries to go beyond the traditional art styles. Their teacher Beuys, gave them the freedom to discuss and formulate the expanded concept of art. Palermo's refusal of every traditional structure as represented in the standard composition and framed painting is characteristic of his earlier work.

Starting in the mid-60's, Palermo wrapped left-over wood and other found objects with canvas as if with a second skin, which he then painted. These wall works, which he continued creating until the beginning of the 1970's, are to be understood less as objects, rather much more as paintings in which the painting's theme dominates and determines its form of the painting. The found object no longer plays a role as significant or individual objet trouvé. It is transformed and integrated into an aesthetic process.

The two T-works from 1966, respectively 1967, belong to Palermo's early work phase. They avail themselves of the iconography of archaic-cult context - a characteristic that also remains central in the artist's later work. The decisive roots for this are to be found in Joseph Beuys, whose language of forms, according to Beuys himself, was to have aroused great fascination in Palermo.[1] The language of forms is reflected in, among other things, the cross-form suggested in Palermo's T-works, whose intentionally awkward, nearly humble fashioning stands in contrast to its conspicuous presentation.[2] Palermo's work differentiates itself from the objects by Beuys, however, in that they are not relics from past rituals. While Beuys' forms are imbedded in and subordinated to a comprehensive theory - most of them even originate from a concrete historical context of action, - Palermo never took such a basis for his work. Still, an intellectual relationship to the Beuysian notion of action cannot be denied. Palermo's object paintings are also meant to illustrate deadlocked societal conventions and habits of vision, at the same time aiming at new ways of giving form.

In the case of the large *Composition Red/Orange* (fig. 273, p. 245) this may be substantiated by Palermo's concrete political commitment: The work was created for a solidarity exhibition dedicated to the town of Lidice near Prague. 1967 marked the 30th anniversary of its barbaric destruction as a so-called act of retaliation by the Nazis.[3] The exhibition, which took place at the initiative of the galerist René Block, included the participation of numerous artists and after its run in Berlin, was seen for a short time in Prague. The proud *Composition Red/Orange* reflected not only the situation of loss and mourning, but also the unbroken will to completion and reconstruction.

In the same year, 1967, three weeks after the death of Benno Ohnesorg in West Berlin, with whom the entire student movement emerging in the FRG reached its first high point, Joseph Beuys founded the German Student Party on the lawn in front of the Dusseldorf Art Academy. One of its aims included the unity of Europe and the world: "Dissolution of the independence of East and West", world economy, world law, world culture.[4] Palermo also participated in the foundation of the party and pursued all of Joseph Beuys' actions closely and with great interest, however from the sideline.

In the same way, Palermo's works are to be seen as political in a further sense, even when the immediate historical occasion is seldom conveyed. "He was most political", said Beuys about his former student, "but he ...declared a poetic stance. He was therefore political-musical, one could say ... There you see a couple of structures and regulation formats, which he placed in some spacial concept, in order for us to sense ... how he conceives the arrangement of a world which takes shape from art."[5]

Palermo's works have an aura of nearly magical enigmatism - in all clarity and simplicity. This component of art work, which became increasingly suppressed in the course of the Enlightenment since the 18th Century and which no longer has a place in the program of the Modern, is merely vaguely outlined by notions of the auratic and spiritual.

First of all, the spiritual in Palermo's works arose out of the apparent and thoroughly reverent devotion to the poor and worthless, whose aesthetic transformation resembles a metamorphosis. The process of production becomes a kind of process of healing. Moreover, the conscious setting on a specific site - the so-to-say sacral staging on the white wall - contributes to the complete effect of the painting. In this way, the artwork unfolds its intimate monumentality and conveys the apparent unreachable distance despite all earthly presence.

A completely new way of treating paint determines the fabric painting group of works as of 1966. Direct inspirations may certainly have come from the artist friend Sigmar Polke, who in 1966 first painted on fabric, and from Gerhard Richter, whose color pattern paintings declared the industrially produced paint as painting. Palermo's paintings, on the other hand, are exclusively made out of industrially produced and dyed fabrics, which the

1 "Über Blinky Palermo. Gespräch zwischen Laszlo Glozer und Joseph Beuys", *Palermo. Werke 1963-1977,* exhibition catalog, Kunstmuseum Winterthur, 1984, 100.

2 See text by Mario Kramer in this volume on the significance of the cross-form in Joseph Beuys' work.

3 See text by René Block in this volume.

4 "Protokoll der Gründungsversammlung vom 22. Juni 1967", prepared by Johannes Stüttgen, *Um 1968. Konkrete Utopien in Kunst und Gesellschaft,* ed. Marie Luise Syring, exhibition catalog, Städtische Kunsthalle Düsseldorf (Cologne, 1990) 167.

5 *Palermo,* 102.

Exhibition
"Hommage à Lidice", 1967
273 **Blinky Palermo**
Composition Red/Orange, 1967
Oil on canvas wrapped around
wood
272 x 159.7 x 2.4 cm, width of
beams: 5 cm
The Czech Museum of Fine
Arts, Prague

artist found in a department store, sewed together and stretched on frames - usually in the format 200 x 200 cm.

The making of paintings and the artistic treatment of paint begin at a point when all aspects of color have already been determined, shifting to choice and purchase of colored fabric, to assignment and proportioning - a reduced form of the composition - to the sewing together as well as the montage, which the artist leaves to his wife.

The essential means of expression of the fabric paintings is paint, which touches not on painting, but on coloring. Palermo places increasing value on paint in the further course of his work. The artist endeavors to emancipate color from substance, from material and the form which limits color.

Because the eye is not capable of registering color without form, it searches for the borders of color. The eye finds it only unsatisfactorily at the edges of the square, because the conventional frames are missing. After all, the glance is concentrated on the horizontal lines, on which the variously colored fabrics are sewn together. The horizontal lines are experienced by the observer as soothing, because they affirm his landscape-conditioned experience of reality. The mostly broken colors of the fabrics used are also related to nature - some even evoke illusionistic effects. The material qualities also inform the scenic and organic character of the works. The open surface structure of the cotton fabric emanates an aura - softer, milder and more lively than it would have been if completely painted over.

The *Quietspeaker* from 1969 appeared like a conceptual answer to the fabric paintings and as a transition to a stronger spacially conceived work. Clearly, the question of materiality at first played an important role: In the upper part of the work, the artist had set in an industrially dyed piece of unworked cothing fabric. This materiality appears even to be enhanced by means of assemblage with the small fabric painting, picking up on that same cotton fabric through which this kind of process reveals itself explicitly as art work. In contrast to Beuys' ideas, the material or its symbolic content was of no significance to Palermo - nor was the work's object character. Rather, Palermo used material paint to experiment with the effect of color: if the fabric work's paint appears to be materially bound to the object, it merges paradoxically with the space in the upper part of the work as pure material. This also confirms: for the painter, the dealing with paint itself remains central. The Beuysian notion of artistic "Transsubstantiation of the material" corresponds to Palermo's "Transsubstantiation of the paint".

In the spatial two-partedness, in the actual separateness of the work, a moment of divergence - a motif - reveals itself. This can be observed in Palermo's work from the beginning on, and is expressed as early as the T-works in its conflicting composition of directions.

From the realm of the "in between", which is defined by the spatial separation of the two parts of the work, the observer can orient himself according to the definitions of above and below. He also experiences the act of observing as a temporal sequence of a before and after. However, the in between remains a vacuum, a negative space. The wall, as common ground and connection, attempts in vain to relate the two parts of *Quietspeaker*. The internal division remains dominant.

Palermo's paintings join to a whole, but they do not join at all to a unity or uniformity. Wholeness applies to the outer design, unity, to the inner content. Seeing the whole and at once missing the unity imparts to the observer the sense of being torn, of being abandoned and of being lost. This principle of polarity appears as a metaphor for a great yearning for completeness and the feeling of lost unity in a contradictary world, as it was experienced not only by Palermo. One cannot doubt the fact that such a romantic world view, which also determines the conception of the artistic work was foremost stimulated by Beuys. Palermo's modified and independent transference of these thoughts to painting is likewise incontestable.

Palermo's works operate in an undissolved state of what indeed belongs together, but is unbound without being divided. They are articulated parallel to a State which has been divided by a Wall for some years and parallel to a superficially healed but internally torn West Germany of the 1960's. At the peak of the so-called Economic Miracle, the artist felt frightened by the excessive relationship of his contemporaries to the reconstruction of the cities and to the world of merchandise, the reckless and unscrupulous shaping of their environment and leisure time. He was "someone, who valued poverty more than wealth", said Joseph Beuys.[6] Palermo's sometimes austere art was an art of protest and the silent attempt at an alternative plan.

Bernhart Schwenk

6 *Palermo*, 102.

274 **Blinky Palermo**
Green T, 1966
Casein on cotton over wood
206.5 x 205.5 x 3 cm,
width of beams:
5 cm
Kunstmuseum Bonn

275 **Blinky Palermo**
Fabric Painting, 1969
Lengths of fabric
200 x 200 cm
Private Collection

276 **Blinky Palermo**
Quietspeaker, 1969
Part 1: Dyed cotton fabric, 47 x 176.5 cm
Part 2: Dyed cotton fabric over cotton, stretched on
wooden frames, 41 x 93.8 x 4.5 cm
total dimensions: 98 x 176.5 x 4.5 cm
Museum für Moderne Kunst,
Frankfurt/Main (former Karl Ströher Collection)

Work Samples: *Seven works of glued packing paper II*
The idea of this form of work was to make a whole out of parts, and to divide the whole again to be able to handle it openly: either seeing the parts next to each other and have the idea of unity, or, to think of the parts as a block lying on the floor. Working the edges, cutting, dividing, packing, piling, layering, covering over, ordering, the material process of beveling, among other things, I assume all go back to my early experiences in my parent's bakery. I grew up with these things and the experiences with forms and handling are definitely deeply engraved. I assumed the experiences surfaced again because I didn't want to have anything to do with the art forms popular at that time. (1980)

from: "Lebenslauf · Werklauf",
Franz Erhard Walther. Mit dem Kopf sehen. Werkentwicklung, Werkbeispiele. 1957 - 1997, exhibition catalog, Kunstsammlung Gera, Orangerie (Gera, 1997) 12

277 Franz Erhard Walther
Seven Works of Glued Packing Paper II, 1963
Packing paper, paste, vegetable oil
each 100.5 x 74 cm
Collection of the artist

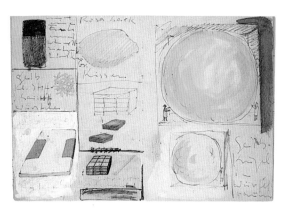

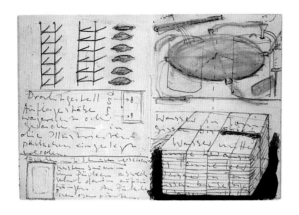
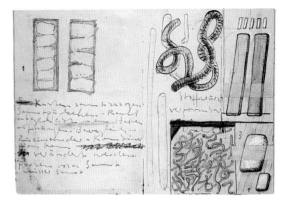

Franz Erhard Walther
16 double pages from a
sketchbook with drawings and
notes about *Glued Packing Paper*
and other projects, 1962/63
Mixed technique and glued
applications on paper
each double page: 20.9 x 29 cm

278 **Imi Knoebel**
Room 19, 1968
77-part, fiberboard, wood,
canvas stretchers of various sizes
total dimensions: approx. 420 x 510 cm
Collection Dia Center for the Arts,
New York
courtesy of the Menil Collection,
Houston

Number of elements	Height cm	Width cm	Depth cm
4	221	65	64
2	33	261	49
3	91	73	91
3	91	57	91
2	6	261	32
1	6	261	64
3	161	97	5
4	6	261	32
2	6	261	64
1	6	261	128
4	5	196	97
8	5	161	132
1	4	130	160
1	4	140	160
1	4	150	160
1	4	160	160
1	5	131	161

Number of elements	Height cm	Width cm	Depth cm
1	161	228/258	5
6	161	131	5
4	261	161	5
1	29	16	3
1	41	12	3
12	8	15	12
4	0,5	46	10
1	4	9	61
2	16	33	33
1	0,5	21	30
2	0,5	14	17

and different frames

Imi Knoebel: Room 19

Room 19 (see fig. 278, p. 254) has long been considered both by critics and by Imi Knoebel himself as the key to his Œuvre. The layering and stacking of frames, boards, slabs and box elements on walls and floors, as well as the laconic elementary geometric forms, the change from open to closed forms and the row-assembly of identical objects have appeared again and again as basic principles of his creative production.

At first glance the complex of works appears to be an art depot with stored materials stacked tightly against one another. The room can be understood in a trivial sense as a storage space but as repository in an emphatic sense as well. The expanded image of such a space comes very close to Beuys' notion of a fund or reserve. Like the "depots" of his teacher, those of Imi Knoebel – layers and piles of grates, panels and cubes – create aggregates that bring forth a sense of stored energy. Most directly, the cubes arranged tightly next to each other create the impression of batteries that, although without outward expression, are internally loaded with tension.

If the image of stored energy in Beuys' works relates itself to the specific texture and substance of the materials and their storage in a closed space, Knoebel's pieces of wood, fiberboard, and cubes, renounce this kind of material expressivity. In his works, the association with accumulated energy comes not so much through the symbolic value of materials like metal or felt, nor through allusions to energy systems as is the case with Beuys, but rather alone through the stacking, layering, and the use of obviously neutral materials without any reference to iconographically or symbolically mediated meaning (apart from the frames of the traditional easel painting and the cubes on the pedestal of a traditional sculpture.)

Compared with the expressive content of Beuys' materials, Knoebel's fiberboard appears, even in its silence, as without a moment of eloquence. Although the fiberboard work is just as impoverished as the felt, the cardboard, or the paraffin of Beuys, it refuses to speak of its poverty. It is simply dumb. Dumb like fish that cannot speak. It hardly shows signs of aging, only the skin browns slightly under the sunlight, becoming leather-like. Apart from this the surface of the fiberboard shows no signs of time out of which the history of its use could be read. The discreet character of the material and sealing of the surface make up primary elements of the closed quality of Knoebel's work.

In art as in life: as figures closed to the outside world but radiating with life energy, Imi Knoebel and Imi Giese, who also worked on *Room 19*, quickly made a name for themselves at the Dusseldorf Art Academy. As Johannes Stüttgen (class spokesperson in the Beuys-class around the time of late sixties) reported: "They always wanted to push us into the political corner. This you already know. I have also had to say that at every full assembly – and you were always there – and at every discussion, even when you didn't say a word, you were always consistent, and when I was standing at the microphone defending the German Student Party and saw you at the back of the atrium it always gave me great power in my work, real energy. You were like batteries for us just by being there..."[1]

The introvertedness of Knoebel's work makes up at one and the same time the quieter, but no less intense, side of the "Great Refusal" of political activism which at this time had permeated the Beuys circle at the Dusseldorf Academy. This rejection of immediate comprehension and disclosure of meaning gave rise to a hermetic body of work, which to this day has maintained a moment of resistance against consumerism and the bureaucratic administration of art and artists.

Room 19 is hermetically sealed, although on the other hand it presents itself to the viewer as a show-room. That which is presented refuses obstinately to disclose information about itself. Speechless and closed, the objects withdraw into their cave in which they have been arranged. Near as they are to each other, they appear to conduct a silent discussion, only to be understood by those capable of hearing into the hermetic space. Looking closer, one can recognize the calculated proportions and progressions between the specific object sequences. Chance and order, chaos and system, enter, in these groups of geometric objects, into a subtle connection with each other. One that removes itself from a first glance, just as *Room 19* as a whole is formed by this historically characteristic removal from immediate perception. The dialectic of presentation and veiling repeats itself in other aspects of the work. Usually remaining unseen by the user or observer are the frames of paintings, the pressed wood plates, used on the backsides of cabinets, shelves, and chests of drawers. Knoebel brings both out of this hidden realm into the center of the exhibition space – a kind of social liberation of the "poor material" which is made the center of attraction. The frame, in itself a mere aid without meaning of its own, steps into the position of the once privileged mark on the canvas just like the pedestal made of fiber, which represents itself, and must no longer serve as a mere carrier for the elevation of a sculpture. Here to be borne in mind is the implicit critique of established hierarchies, Hegel's dialectic of Master and Slave which he saw as the motor of history.

1 *"Der Ganze Riemen" IMI & IMI 1964-1969*, "Johannes Stüttgen im Gespräch mit IMI (W.) Knoebel, January 6, 1982, *IMI Knoebel*, exhibition catalog, Van Abbemuseum (Eindhoven, 1982).

2 Regarding the topic of the distance to the rest of the Beuys-class which IMI Knoebel and IMI Giese cultivated in *Room 19* the artist remarked: "At the beginning Immendorf and Palermo were still in, but not for long. We worked completely independently, also from the class. We really set ourselves apart. With regard to our work, there was a real break with the others. Through the discipline of our work we thought we had to be unusual and cool, and to stay clear headed, be consistent, and not let ourselves be distracted by personal matters. This was not at all directed at Beuys, but against the whole class - maybe to build up our image." From "Der ganze Riemen", see note 1.

3 Heinrich Pachel "Zu den Arbeiten von W. Knoebel/IMI", *Blockade '69*, exhibition catalog, René Block Gallery (Berlin, 1969).

4 see note 1.

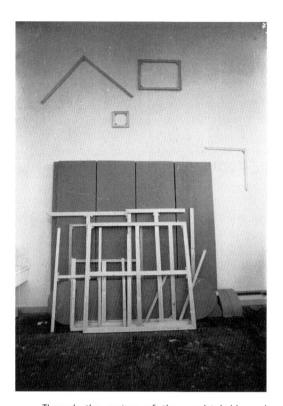

Imi Knoebel, *Room 19* in the
Kunstakademie Dusseldorf, 1968.
Photo: Imi Knoebel

Through the gesture of the unmistakable and
unavoidable objects, which simultaneously opens them-
selves to the viewer and close themselves before on
looking eyes, a certain uneasiness is communicated to the
viewer which brings forth the question as to the sense
and meaning of the mute collection. One's view is pulled
toward the relation between the things. But also here the
game of hide-and-seek is set forth. The geometry of the
relationships between the parts, the sub-divisions and the
progressions of fields are difficult or impossible to discern.
Sometimes they are hidden to the point irrecognizability.
Predominant remains the impression of a more accidental
order which could have resulted from the practical
necessity of stacking and piling the boards and boxes
standing around. The impression is strengthened by the
fact that Knoebel's storage space is coherent but not over-
whelming in its construction. Other groups of stacked
boards and frames appear to be imaginable through and
through and possible of being carried out.

Evidence of its variability was given by Knoebel to
every new exhibition of *Room 19,* which was differently
constructed, but always with the same materials: at the
first presentation of *Room 19* at the group exhibition
"Public Eye" in 1968 at the Kunsthaus in Hamburg the
majority of the objects remained unpacked, stacked on
the floor in alliance with the brooms and pails of the
cleaning woman. In later exhibitions in Lucerne, Eindhoven,
Winterthur, Bonn, and New York, the artist combined the
material in specific relation to the respective rooms. A

second and expanded version of the work, *Room 19 II,*
to which a few boxes and a series of frames were added,
was installed in 1992 for the Hessian Landesmuseum
Darmstadt. The most compact version of the work was in
New York at the Dia Art Foundation in 1987. There are
photos from 1968 showing the different groupings of
elements of *Room 19.* Here the open structure of the
surfaces and bodies becomes most clear. Through the
neutrality of the materials and the precision of their
execution Knoebel's work sets itself consciously apart
from most of those coming out of the Beuys-class and
from that of the American minimalists, with which it was
associated by critics shortly after its appearance.[2] The
categorization of Knoebel's work as a kind of "German
imitation" of minimalism was rightly criticized by
Knoebel's close friend Heinrich Pachel in the catalog for
the group exhibition "Blockade '69" which took place at
the Berlin gallery René Block and consisted of a series a
single exhibitions. "What appears to be anonymous,
cannot deny its producer. Coldness and aloofness at first
glance are achievements of very personal thought
processes, experiences in artistic work. The conceptualism,
functionalism, and constructivism of American mini-
malists doesn't exist in Knoebel's work." In contrast to the
"expensive materials" and the expensive production costs
involved in the "industrial manufacture" of minimalist
objects, Knoebel limited himself to the handwork of the
artist and "poor" materials. He frees his work of every
sense of "meaning... as is the case with the combined tasks
or the demand to believe in the unseeable of some mini-
malist works."[3]

The crude material of the wood strips, rough fiber-
boards, and pre-industrial technique, which is more ex-
periential, intuitive, and bodily, than it is derived from a
concept, brings *Room 19,* despite its geometry, regular
form, and precise execution, closer to the constructive
works of Beuys than to American minimalism or its Euro-
pean parallels. More than anything this work stands in
the tradition of Kasimir Malevich, whose black square on
a white background, with its painterly execution and ir-
regularities disappointed the American minimalists, just
as it fascinated Knoebel due to its synthesis of the spirit-
ual-intellectual with the bodily-material.

"Fascinated by the black square," Knoebel asked
himself the question during the work on *Room 19:* "I first
stood before it asking myself how I can get in. Or how
can I take this on, how can I grasp it! That was much more
important than how to get beyond it."[4] An installation of
part of *Room 19* in *Room 19* demonstrates this drawing
near the square on various levels. A small square frame,
of 30 x 30 cm, hangs high on the wall, similar to the way
Malevich hung his *Black Square On White Background* at
the legendary 1915 St. Petersburg exhibition "0.10" in the

Imi Knoebel, *Room 19* in the
Kunstakademie Dusseldorf, 1968.
Photo: Imi Knoebel

corner under the ceiling, the place where icons are normally hung in Russian homes. The configuration of Knoebel's quadrate remains ambiguous. Is it the white wall bordered by frame reinforcement which is defined? The quadrate would be a purely optical phenomena, a field raised from the continuum of the wall by the frame which would disappear with its removal. Knoebel also experimented in his light-image projections with such immaterial picture-fields created purely through the defining power of a frame. With a slide projector, pictures in the form of pure light were shown on a wall. However with his "light projection sizes" the artist determines only the measurements of the immaterial and entirely unseeable picture on the wall as in the exhibition "Blockade '69". Or does the quadrate consist of the material body of the picture frame, which has physicality and is graspable, changing between the picture surface, relief, and object?

All other variations of *Room 19* are based on this quadrate, either in its material or immaterial mode. The frame over the quadrate shows the expansion of the quadrate to a rectangle, while both of the angles open the square to the surrounding wall and room. Together the large fiber board panels leaned against the wall form another square, divided again in six vertical strips. Left of the middle point, through the subdivision, there appear two equal strips, and on the right side four. The width of two smaller strips equals the distance of one large strip. Behind the six panels stand another two arranged in a constellation next to the quadrate of six strips. The two

equally sized panels form another quadrate, the outer edge of which is identical to the one made of six strips. The subdivision of the two square surfaces then produces a series of parts, which have in relation to the quadrate the measurements 1/2, 1/2, 1/4, 1/4, 1/8, 1/8, 1/8, 1/8. The method of creating systematic segments of significant physical wholes which simultaneously produce divisions and connections is also used by Blinky Palermo, with whom Knoebel studied, in his "strip-pictures."

The frames which are stacked in front of the panels are related to each other through a play of structure comparable to that which arises out of a quadrate as starting point. The first frame outlines the form of a negative square, which is itself further divided into four squares. The L- and T-shaped frame fragments placed behind it "denote" the immaterial quadrate surface of the missing picture in changing constellations. In *Room 19 II* the potential of the different forms was first systematized through using all of the possible combinations including single wood strips, L-forms, T-forms, F-forms, U-forms, and more complex ones, all the way to whole square frames with crosses of differing form stacked one in front of the other and attached on the inside of the frame. Similar progressions in the measurement proportions are present with the stacked panels and three dimensional boxes, sometimes freer, sometimes more systematically related to each other. Even the panel and boxes with round edges emerge out of quadrates. Every rounded edge indicates the segment of a circle written in a square.

Out of the subdivision and arrangement of the quadrate on the surface in the room, a variegated pattern emerges, so complex that an overview becomes impossible. The interplay of chaos and order, intuition and precision, produces a transitory constellation of forms that reach from the immaterially imagined, the two dimensional surface and the transparent relief, to the closed space-enclosing cube. The phasing of the gradations of reality, the transitions between the imaginary and material, the proportions of the elements in relation to the human body (from the smallest building block like children's toy, to the large panels), and the play of the visible and invisible patterns brings about a space which is at once real and imaginary, fixed and flowing in one, precisely constructed and transparent, a space that corresponds to the image we have of our bodies. This too is materially given but can be had only imaginarily. As enclosed and imperceptible as the pictureless picture frames of *Room 19* work on the viewer, they open a perceptual space that itself works like the extension of ones own body. In this space, the arranged objects enter of their own accord into a relationship with each other, speechlessly communicating – like the hidden relation in our bodies between the toe and thumb, or the eye and the stomach, of which we are rarely aware, but which bears our consciousness. The passable image of the silent body imparted to us by *Room 19* corresponds to the experience of our own bodies, that which we are, and that which we don't yet have, unless it be at the convergence point between preconscious physical presence and imaginary construction. As Heinrich Pachel observed in 1969, "Knoebel's pieces are so successful as mediating objects precisely because they function without the aid of suggestion or Association."

Art Nourishes Life

I.

As a classical museum in the tradition of the 19th century, the Hessisches Landesmuseum in Darmstadt contains works of the visual arts from antiquity to the present as well as scientific collections. In this it is consistent with the origins of the museum as a chamber of art and wonders. Thus the visitor is rather surprised when, on the top floor, he is suddenly confronted with the immense block of works by Joseph Beuys, who much appreciated the context of this museum even though he repeatedly criticized the lack of space. This, the heart of Beuys's oeuvre of the fifties and sixties, comes from the former collection of Karl Ströher who, between 1967 and 1969, acquired the three-dimensional work of Beuys made up to that time. Since April 1970, that is now 27 years ago, this work has been located here, spans more than 300 works, and certainly is amongst the most impressive oeuvres in art after 1945. The body of works was purchased in 1989 by the Kulturstiftung der Länder (Cultural Foundation of the Länder), together with the Land Hessen for the Darmstadt collection.

Part of this ensemble is also a display case with the title *Auschwitz Demonstration*.[1] It was installed in this form by Beuys in 1968. The objects in this case stem, however, from the years 1956–1964 and mostly stand in connection with other works and actions by the artist. One of the earliest links is to Beuys's participation in the competition for a monument in Auschwitz in 1957.

In the following essay Beuys's contribution to this competition, as well as the designs that were created to this purpose and that are to be presented in the exhibition "Deutschlandbilder" will be examined more closely. Subsequently, it will remain to be demonstrated what significance the showcase Auschwitz Demonstration has in the context of the competition, and, finally, how Beuys's works in this complex of themes are to be interpreted.

The years 1956–1960 Beuys describes in his "Lebenslauf Werklauf" (Life Course / Work Course) as "Beuys works in the fields" and the years 1957–1960 as "Recovering from the field work."[2] The formulation "field work" marks a radical change in Beuys's life, a time in which he was exposed to the threat of depressive states of exhaustion, but also the after effects of his five severe war injuries. In addition to this came financial need, which, due to the lack of commissions, did not improve. At this point in time, Beuys lived on the farm of the van der Grinten brothers in Kranenburg for several months and he maintained a close professional friendship with Hanns

Lamers, a sculptor from Cleves. In this crisis, thus Beuys "war events were no doubt continuing to have an effect, but also current events, for basically something had to die. I think this phase was one of the most essential for me, in so far as I also had to completely reorganize my constitution; I had for too long dragged a body around with me. The initial process was a general state of exhaustion, which quickly however turned into a real process of renewal ... Sicknesses are almost always also a psychological crisis in life in which old experiences and thought processes are rejected or are recast into really positive changes."[3] And at another point Beuys says: "Nothing is without pain – without pain there is no consciousness." Asked in 1980 by André Müller what he had felt after the end of the war when he had recognized the full extent of the horror, Beuys said: "That was a shock, certainly, and an irreversible one." And he continued: "Actually, this shock after the end of the war is my primary experience, my fundamental experience, which is in fact what led me to begin to really go into art, that is, to reorient myself in the sense of a radically new beginning."[4]

In my opinion one can go so far as to describe the entire early oeuvre by Joseph Beuys as a type of catharsis, a freeing from spiritual conflict – by means of an artistic statement.

II.

In 1958 Beuys participated in the international competition for a monument in the former concentration camp Auschwitz-Birkenau, for which 426 artists entered designs. The international jury consisted of such renowned artists as Hans Arp, Henry Moore, and Ossip Zadkine. Hans and Franz Joseph van der Grinten, from whom I have this information, remember that the deadline was March 15, 1958.[5] Beuys had made about two dozen thematically related sketches and reworked photographs for this. Thus the foldout drawing in the display case entitled *Auschwitz* is also a preliminary sketch that Beuys had drawn onto visual material from the competition brochure. Beuys to this: "I explained my plan for a monument at Auschwitz in a series of letters to the Auschwitz committee."[6]

One can also understand Beuys's design on the basis of the works on paper exhibited here. The *Monument for Auschwitz* from 1958 shows a sketched composition overpainted with watercolor and mordant, mounted on a light brown envelope.[7] Three arched shapes determine the dynamics of the drawing. A perspective consisting of four elements is spanned between these. Three dark gate structures, repeating a form consisting of two pillars and an upright irregularly shaped quadrangular slab, lead the eye to a radiant mark lying far off in the distance. The monument lies in a barren, undulating, expansive landscape bathed in warm colored light. One can compare this

1 The present essay is a revised version of a lecture written before the numerous commemorations for January 27, 1995, the 50th anniversary of the freeing of Auschwitz. The lecture was intended for the Beuys Symposium at the New School for Social Research in New York in April 1995, and it was held once more on November 9, 1995 at the Museum für Moderne Kunst in Frankfurt/Main, and on 10 March 1996 at the Art Station St. Peter in Cologne.

2 Printed in: *Joseph Beuys, Werke der Sammlung Karl Ströher*, exhibition catalog, (Kunstmuseum Basel, 1969) 4-7.

3 Quoted from Götz Adriani, Winfried Konnertz, and Karin Thomas, *Joseph Beuys* (Cologne, 1973; rev. and enl. ed., 1994) 40.

4 Joseph Beuys, *Penthouse*, 106 (1980) 98.

5 Franz Joseph van der Grinten, "Beuys' Beitrag zum Wettbewerb für das Auschwitzmonument," *Joseph Beuys Symposium. Kranenburg 1995*, ed. Förderverein "Museum Schloß Moyland e.V." (Basel, 1996), 199.

6 Joseph Beuys in *Haagse Post* (3 May 1980) 69.

7 See Franz Joseph van der Grinten and Hans van der Grinten, *Joseph Beuys: Wasserfarben/Watercolours 1936-1963* (Frankfurt/Main, 1975), fig. 71, and accompanying text 48-49.

Joseph Beuys, *Monument for Auschwitz*, 1958
Pencil, watercolor, opaque color, mordant, 17.8 x 24.6 cm
Museum Schloß Moyland

Joseph Beuys, *2 Mining Lamps 1 on/2 out*,
1953, bronze, plaster
Hessisches Landesmuseum Darmstadt

8 Franz Joseph van der Grinten and Hans van der Grinten, *Joseph Beuys: Wasserfarben/Watercolours 1936-1963* (Frankfurt/Main, 1975), fig. 47, and accompanying text, p. 39; cf. the two drawings Untitled *(Mining Lamp)*, n.d. (1958) *Joseph Beuys: Kleine Zeichnungen*, ed. "Förderverein Museum Schloß Moyland e.V." (Kranenburg, 1995) cat. no. 162, p. 190 and cat. no. 163, p. 191.

9 *Joseph Beuys - The secret block for a secret person in Ireland*, ed. Heiner Bastian, vol. 2 of the exhibition catalog to the exhibition in the Martin-Gropius-Bau, (Munich, 1988), fig. 121. I am indebted for this information to Dieter Koepplin who has studied this block of drawings in depth.

10 See Eva Wenzel and Jessyka Beuys, *Joseph Beuys: Block Beuys* (Munich, 1990), figs. pp. 194-95, no. 9; also cf. the figs. in *Getlinger photographiert Beuys 1950-1963*, exhibition catalog (Städtisches Museum Kalkar, 1990), fig. 32.

11 *Transit Joseph Beuys: Plastische Arbeiten 1947-1985*, exhibition catalog (Krefeld: Kaiser Wilhelm Museum, 1991), fig. 18, p. 54.

12 Quoted from van der Grinten, "Beuys' Beitrag zum Wettbewerb für das Auschwitzmonument", p. 200.

to the drawing *Untitled* from 1958 on letter-sized paper on which Beuys had already typed his name, address, and the date "15.3.1958" (fig. 279d, p. 272). In an illusionistically heightened foreshortening, three reinforced concrete gates rising above a camp gateway and railroad tracks were to lead towards a silver bowl which was to reflect the light refracting in it. Placed 375 m apart, the gates were to be 5, 9, and 25 m high. The silver plate was to have a diameter of 6.50 m.

There are preliminary works to this bowl shape: One design variation can be seen in the watercolor *Untitled (Lamp)* from 1956 (fig. 281, p. 273).[8] In the cycle of drawings *The secret block for a secret person in Ireland* one finds a pencil drawing already made in 1954 entitled *Sun Reflector* (fig. 280, p. 272), which preformulates such a radiating monument in the hills.[9] The pentagonal reflector shows the radiation of the crystal with a halo. And *2 Mining Lamps 1 on/2 out*, to be found in an adjacent display case in Darmstadt, were made as early as 1953.[10] They lead directly to the small model made of pewter and zinc *Untitled, (Table with Crystal)* from 1953/57 (in a private collection since 1958) that is also one of the models for Auschwitz (the table legs are a later addition).[11]

Beuys's idea was that a long pathway was to lead visitors under several gate structures, the question remaining open whether the gates were to pass over the railway tracks that lead to the large concentration camp, or stand parallel to them. In the distance the eye was to fall on an immense *Mining Lamp / Sun Disc* placed at a slant and having a silvery shimmer. In his explanation Beuys described his concept in the following manner: "The first emblem must be seen from very far off, thus it rises far above the watchtower. Its height and planar extension are planned in such a way that it radiates outwards. The second and smaller stand has the task of conveying the expression of the large emblem to the interior of the camp, also aiming in the direction of the monument. Both concrete emblems are to underscore the atmosphere of the concentration camp, heighten and summarize it. Thus these two sculptural bodies are subordinated to a dynamic function and have at the same time an atmospheric value. In regard to the monument it was important to seek a metaphor that rises to the multi-layered significance. The sculpture is a light, bowl, crystal, flower, and

monstrance. The morning sun is to refract in it in manyfold ways and radiate into the far distance from the gleam of the polished silver."[12]

What Beuys intended is shown most clearly with the sheet of paper entitled *Entwürfe für Mahnmal Auschwitz* (Designs for Monument Auschwitz) from 1957 (fig. 279e, p. 273).[13] In a juxtaposition of three photographs and five drawings which are mounted on the same sheet, the rhythm of the path and the respective proportions become visible in the perspective foreshortening. The three gate structures are drawn very precisely onto the photographs, while above all five drawings with their strong more painterly coloration make obvious that the gates of reinforced concrete should have been painted red – which would have further emphasized their guillotine-like shape. The sequence of drawings has less the character of a concrete preliminary sketch than one of tracks that a wounded animal leaves behind.

As a further comparison drawn from the oeuvre of drawings, the watercolor *Death and the Girl* of 1957 should be named.[14] Another yellowed envelope clearly shows the stamped name of the sender "Comitée International d'Auschwitz," who had initiated the competition. A second stamp includes the name and the address of a Hermann Langbein, an Austrian resistance fighter who died in October 1995 and who was, among others, one of the most important witnesses in the Frankfurt Auschwitz trial of 1963–1965. Beuys here combines a classical art historical vanitas motif with the presence of Auschwitz.

For better visualization Beuys prepared two wood models of varying scale for the competition. These are also in the Darmstadt block of works, as parts of different work groups.

The smaller nutwood model from the year 1957, of which the title is not known, later came to be part of the sculptural cabinet ensemble *Scene from the Stag Hunt* of 1961.[15] Today it stands in one of the upper cabinets, together with *Hare on a Motorbike* made of chocolate, a metronome, and a graduated cylindrical laboratory glass. The conspicuous sequence of the numbers 125921 above the doorway of the gate structure is autobiographical in character as it represents Beuys's date of birth (May 12, 1921). Of course, the stencilled numerals also remind of a brand mark as well as of the identification numbers tatooed onto the skin of concentration camp prisoners.

The same numerals also appear on a large-scale untitled collage made only a few years later, in 1963 (fig. 282, p. 273).[16] Beuys obviously uses partial plans of the concentration camp Auschwitz-Birkenau from the application material. On the upper left side the numerical sequence 125921 appears, stencilled as well as handwritten above. It thus also becomes an identification number for the designs. 16 crosses painted in brown –

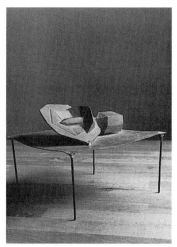

Joseph Beuys,
Untitled *(Table with Crystal),* 1953/57
Pewter, zinc, table: 10.5 x 20.7 x 17.6 cm,
Crystal: 15.8 x 10.1 x 4.5 cm,
Total height: 15.9 cm, private collection

Joseph Beuys,
Scene from the Stag Hunt, 1961
Detail with nutwood model of gate
Hessisches Landesmuseum Darmstadt

13 Franz Joseph van der Grinten, "Beuys'
Beitrag zum Wettbewerb für das Ausch-
witzmonument", fig. 79. An additional
inscription with the five drawings on the
right-hand edge indicates the height: 8 m,
16 m, and 25 m.

14 *Joseph Beuys, Arbeiten aus Münchner
Sammlungen,* exhibition catalog (Munich:
Städtische Galerie im Lenbachhaus, 1981),
cat. no. 87, fig. 11.

15 Cf. Wenzel / Beuys, *Joseph Beuys. Block
Beuys,* figs. 51, 55.

16 *Joseph Beuys, Ölfarben 1949-1967,* ed.
Götz Adriani, exhibition catalog (Kunsthal-
le Tübingen, 1984), fig. 107.

so-called *Braunkreuze* (brown crosses), a fixed expression in Beuys's work – are distributed across the sheet. In connection with the ground plan they become a cemetery, but they also fly across it like a flock of birds. Finally one can also think of the view from an airplane when a soldier controls the throwing of bombs through an aiming telescope with a hairline cross.

The larger of the two gate models is made of pine, was later sawn apart by Beuys and, by exchanging the pieces, given a new form. Today it lies in the display case adjacent to ours and is entitled *Signs of Transformation,* 1957.[17] In looking at the two wooden models and the thematically related drawings it becomes clear that the scaffold-like archways on the slim pillars were to have an asymmetrical shape.[18] The basic shape reminds of a slanted house roof. It circumscribes an irregular quadrangle that is formed by two wedge or arrow forms extending from the gate pillars. Due to the irregularity, an additional third wedge shape of the same size is created along the upper edge. Thus the three wedges in turn surround an irregular quadrangular interior shape. On a black-and-white photograph, the front of the small gate model can be seen. The interior form is clearly contrasted by the darker coloration from the three wedge shapes. [19] In comparison to this, the larger wood model entitled *Signs of Transformation* has, on the side that is now facing upwards, two red arrow forms heightened by color as well as relief which, placed together, form a large triangular shape. The object also has the numerical sequence 125921 on the bottom.[20] Beuys used both wooden models in 1965 as sculptures in his performance *und in uns ... unter uns ... landunter* (and in us ... under us ... landunder) within the framework of the happening *24 Hours* in Wuppertal.

For 24 hours Beuys performed on a kind of pedestal and thus became a sculpture himself. Handling the two wooden parts of the large gate model corresponded to the display of the double or community spade of 1964. One of these Beuys held in front of his chest at the level of his heart.[21] The blade of the spade, hand-forged by Beuys himself, was heart-shaped, the two wooden handles came graphically to be the aorta or the arteries of the heart. The sawn-apart gate model stands here in formal analogy to the heart-shaped spade. Both spades are also in a display case in Darmstadt today.[22]

III.

The works related to the competition – watercolors, collages, drawings, objects – thus reemerge in various places in Joseph Beuys's oeuvre. In the Darmstadt showcase mentioned at the beginning *Auschwitz Demonstration* there is also a work whose origins lie in this

Joseph Beuys, *Death and the Girl,* 1957
Thinned paint on yellowish envelope, stamp on the right,
17.6 x 25.2 cm, private collection

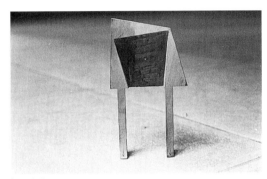

Joseph Beuys,
Title unknown, 1957, nutwood
Hessisches Landesmuseum Darmstadt

competition: the ground plan of the concentration camp Auschwitz, which was included in the application papers. Not only with this element, but with the display case as a whole, Beuys refers to the themes that are evoked by "Auschwitz".

Furthermore it seems noteworthy to me that all the objects in this showcase that are significant in terms of content, having as their central theme death and suffering, originate in that above mentioned period of Beuys's physical and psychological crisis, from the years 1956 to 1957.

As of 1967 Beuys chose, for the presentation of small-scale objects, used horizontal display cases from various ethnological museums such as, for instance, the Naturmuseum Senckenberg in Frankfurt/Main or the Glyptothek in Copenhagen. The showcases in Room 5 of the Darmstadt block of works, to which *Auschwitz Demonstration* also belongs, originated from the Bayerisches Nationalmuseum in Munich. With the showcase ensemble *Auschwitz Demonstration* that is presented here we are dealing with one of the few showcases in Beuys's work which has been given its own title. The flat display case was installed by Beuys in that particular constellation and order only in the summer of 1968 on the occasion of the exhibition "Sammlung 1968 Karl Ströher",

Joseph Beuys, *Signs of Transformation*,
1957, pine
Hessisches Landesmuseum Darmstadt

17 Cf. Jörg Schellmann ed., *Joseph Beuys. Die Multiples: Werkverzeichnis der Auf-lagenobjekte und Druckgraphik 1965–1986* (Munich, 1992) ill. pp. 158–61.

18 This form goes back to an earlier design for a table from 1953. This also came to be part of the Darmstadt block of works later on. Cf. Wenzel / Beuys, *Joseph Beuys. Block Beuys*, fig. p. 151.

19 Dieter Koepplin was able to take this detail shot at the time that the Beuys block of the former Karl Ströher collection was installed in Basel in 1969.

20 This can be seen on a performance photograph; cf. Uwe M. Schneede, *Joseph Beuys: Die Aktionen* (Ostfildern-Ruit, 1994), fig. p. 99.

21 Cf. Uwe M. Schneede, *Joseph Beuys: Die Aktionen*, fig. p. 101

22 Cf. Wenzel / Beuys: *Joseph Beuys. Block Beuys*, fig. p. 131.

23 Thus the objects *Fish*, 1956, and *+- Wurst* (+- Sausage) from the showcase *Auschwitz Demonstration* can be seen in a still completely different context in an earlier shot in a four-storied glass display case in the exhibition *Schilderijen, Objecten, Tekeningen* at the Stedelijk Van Abbemuseum, Eindhoven in 1968; cf. Adriani et al., 1st ed. (Cologne, 1973), p. 115, fig. 152, and p. 101, fig. 135; in the current paperback ed. (Cologne, 1981), pp. 218/219, fig. 103. The objects are at this point of time still individually titled. For the installation of the display case in the Ströher exhibition see figs. in: Adriani et al., new ed. (Cologne, 1994), p. 96, and in Beuys, *Block Beuys*, 401.

which typically enough took place in the former "Haus der deutschen Kunst" in Munich.[23] Beuys thus responded to a place in which in 1937 the *Große Deutsche Kunstausstellung* (The Great German Art Exhibition) took place parallel to the exhibition *Entartete Kunst* (Degenerate Art) in the adjacent Royal Gardens. The building designed by the architect Paul Ludwig Troost (first stone laid in 1933, opened in 1937) is furthermore considered a typical example of architecture of the Nazi period.

The showcase contains 14 objects from the years 1956 to 1964, appearing completely heterogenous at first. Together with the adjacent cabinet on the right it forms a type of double object. Even the viewer who passes by relatively quickly, driven on by the almost claustrophobic feeling of room, will notice the contents specifically of these cases. Having a table height of 85 cm, both display cases are somewhat lower than the others in the room, thus ensuring a very good overview from the top. Although the view into the display case is equally possible from all four sides due to the glazing all around, the best view is, in my opinion, from the corridor. Several objects are very clearly directed to this side.

An analysis will now illustrate the relation of the individual pieces to one another but also to other Beuys works and performances.[24]

A vertical rectangular metal plate fills the lower right space of the display case, parallel to its edge. It shows a sketchy, very delicate relief with a wide edge, its recognizable wood grain glimmering gold in contrast to the dark patina. The seams of the cast make clear that it is a bronze or brass cast of a wood relief. The work is entitled *Fish* and being from 1956 is the oldest object in this cabinet. Only the title lets one suspect the spindle-like body of a fish and an oval form.

The metal relief goes back to a wood relief of the same name from 1956 (today in a private collection),[25] which one year later apparently served as printing block for a woodcut of which seven prints are known. In the literature this work is entitled *Der Wels* (Sheatfish) or *Laichender Wels* (Spawning Sheatfish).[26] Conspicuous motifs in the wood relief and woodcut are an oval egg shape and a rod that could also be interpreted as a harpoon.[27]

In addition to the relief there is a work entitled *Akku (Wurst) / Storage Battery (Sausage)* of 1963 in the display case. A perfectly round metal disc lies flat on the bottom of the showcase, but appears more to be floating, lighter than the plate with the fish motif. The disc has a dirty coloration, greasy spots form irregular islands. On it is a collection of various pieces of sausage: an old piece of blood sausage, long past being edible, with a smooth black surface. In addition, two endpieces of a blood sausage standing on their cut edge and reminding of the toes of a hoofed animal. In the lower section of the disc are three

further endpieces of hard sausage. They carry metal fillings and square yellowed cardboard labels. Furthermore there is a large gray pasteboard which is the only object projecting over the edge of the disc. It looks like a price or descriptive sign. All objects on the disc are connected to one another with strings. Due to the perfectly round hole in the middle of the disc the object at first looks like a record. Underneath the hole is a clouded mirror which nevertheless lights up, through the reflection of the window.

There is a surprising counterpart for the object *Storage Battery (Sausage)* in an oil on paper from 1961 entitled *Druidic Measuring Instrument* which seems like a painterly preliminary drawing for the later object.[28] The circular disc with the pale round hole, collecting all details on its surface, reminds – as does the gray appended shape – of the object with the pasteboard sign. In the literature the work is sometimes entitled *Celtic Sun Disc*. The term "Akku", short for "Akkumulator" (storage battery) describes an instrument for storing electric energy in the form of chemical energy. "Akkumulieren" (accumulating) means to pile up, collect, and store, a process which Beuys transfers to nutritive substances. The measuring instrument of the Celtic priests, the druids from the pagan period, becomes the storehouse for life energy in the sixties – here Fluxus forces are clearly of influence.

The following double object entitled *Heat Sculpture* of 1964 consists of a used mobile electric stove with two rusted cooking elements of different sizes on which two grayish yellow brick-sized wax blocks are deposited. On the left-hand side the stove is missing both feet, so that the whole object stands at a slant. The stove reminds of improvised living, of a cooking corner in a single room, perhaps with no kitchen being available. But one has the impression that the stove has not been used for cooking for a long time, but rather that it was placed in a workshop as a worn-out utilitarian object. The control knobs are switched on, the left one turned to the first marking, to 1, the right-hand one only to 1/2. The right-hand wax bar lies directly on the plate, the left one additionally on a perfectly round disc placed underneath, also made of wax. The impression is created that this bar is already in the process of melting due to the higher temperature level of the left-hand control knob. But the stove is obviously not functional. The factor of things being put out of action seems to me to be of prime importance in all objects exhibited here. And the hard wax in its box shape emphasizes precisely this disuse of the stove. Both bars were cast in a box-shaped bread or cake form. The stove may originally have served for the heating process that has obviously taken place.

The subtitle of the double object *Heat Sculpture* indicates its use in one of the most spectacular joint performances by the Fluxus artists on July 20, 1964 in

View from the hall

View of back

Joseph Beuys,
Auschwitz Demonstration,
1956-1964
Hessisches Landesmuseum
Darmstadt

Aachen, in which Beuys also participated.[29] In the thirty-page program for the event Beuys published his "Lebenslauf Werklauf" for the first time.[30] The complexity of this Fluxus evening is described elsewhere.[31]

Beuys used the electric stove that came from the kitchen corner of his Dusseldorf studio in a performance sequence.[32] Beuys held his flat hand testingly over the stove elements several times, even when they were not turned on, thus heat was suggested rather than in fact created. But later, in continuation of the sequence, blocks of fat were melted in a box of zinc. It is today an independent action sculpture and is to be found in the neighboring display case in Darmstadt.[33] His participation in the Aachen Fluxus performance was one of Beuys's first public demonstrations in which he introduced such new plastic materials. It had to do with the relationship of heat, cold, energy, and the related processes of transformation.

In a further performance by Beuys another object, namely sunlamp goggles – today also part of the Auschwitz display case – was supposed to be used, but because the audience stormed the stage, it never got to that point. The commotion escalated when a young man, a student, hit Beuys several times in the face with his fist. Beuys seemed to be prepared for this and very present-mindedly pulled a crucifix, which swung back and forth on a pneumatic pedestal, out of his box of stage props. With a bloody nose, Beuys held it in his left hand, the right hand demonstratively held high. It was also on this occasion that Heinrich Riebesehl made the famous photograph which formed the perhaps most lasting public image of Beuys at that time and contributed to the creation of his myth. Afterwards he distributed chocolate bars to the audience. But the performance had to be stopped. The scandal in the end was not the absurd performance by the Fluxus artists, but the demonstration of absolute intolerance by the student audience.

The wooden tubs placed next to the stove fill the left-hand display case with their volume and parallel orientation. They form a double object, but the contents has differing titles and various dates of origin. The high

cylindrical wooden vessels are painted on the outside with old dull blue-green paint and have a base mounted in metal which lets one conclude that their original function was as sieves. As utilitarian objects they belong more to the rural region and seemingly to the past. Both are filled with grass to differing heights.

The front tub holds a completely mummified body of a rat, rolled up in foetal position, as if imbedded in a landscape. The dry hard skin has no trace of fur anymore, it appears naked. The title is *1. Ratte* (1. Rat), meaning First Rat or First of All: Rat, dated 1957. In the second tub, in behind, there is a fold-out measuring stick. The lower two sections are folded out, the upper three run in a zig-zag form. The original object is a commonly sold 2-meter measuring stick with yellow lacquer and metal joints. At the top as well as the bottom it is broken off. In this mutilated state, and the way it is shaped, it is useless for measuring. The lower end is glazed with brown paint and leads into a small felt wrapping. It also carries traces of brown paint. The reddish brown color, a fixed concept in Beuys's work, has a complementary effect next to the blue-green of the tubs. The upper end of the measuring stick, which is sawn off at the 42 cm mark, leans against the glass pane of the display case. It measures the height of the case and thus makes the spatial volume clear. With the striking title *Lightning* the measuring stick becomes figurative, and one tends to perceive it as something essential. In addition, the landscape-like aspect of the grass and of the total composition is underscored. Lightning creates, so to speak, a link between sky and earth. The measuring units run, following the movement of lightning, from top to bottom. The object is dated 1964.

The yellow color of the wooden measuring stick can also be interpreted as a ray of light. Lightning as a phenomenon of nature and unloading of cosmic energy is filtered out upon hitting ground. The reddish brown overpainted glazing of the lower end also reminds of dried coagulated blood. The place where lightning strikes is like a wound.

From the perspective of lightning as discharge of

24 In doing so I will follow the example of Eva Beuys' catalogue raisonné presented in 1990, and begin on the right, then proceed clockwise: Wenzel / Beuys, *Joseph Beuys. Block Beuys*, fig. pp. 156f., pp. 182-87.

25 Wenzel / Beuys, *Joseph Beuys. Block Beuys*, fig. p. 358 bottom.

26 Cf. Schellmann, fig. 12, p. 510.

27 A comparison of motifs is suggested particularly by a very painterly oil on paper, 1958, having the same name and stemming from the van der Grinten collection, which also shows the fish as a spindle-shaped body. Cf. Franz Joseph van der Grinten and Hans van der Grinten, *Joseph Beuys. Ölfarben/Oilcolors* 1936-1965 (Munich, 1981) fig. 22.

28 Cf. van der Grinten/van der Grinten, *Joseph Beuys. Ölfarben*, fig. 73.

29 The full title is *Wärmeplastik Aus: Actions/AgitPop/De-collage/Happening/Events/ Antiart/L'Autrisme/Art Total/Refluxus July 20, 1964 in Aachen.*

30 *Beuys. Werke der Sammlung Karl Ströher*, see note 2 above.

31 A detailed description of the Aachen festival is given in the contribution by Adam C. Oeller in the present volume. A comprehensive account of Beuys's action is in: Schneede, 42-67.

32 Cf. this and the following scenes with the illustrations in the article by Adam C. Oellers in this volume.

33 Cf. Wenzel / Beuys, *Joseph Beuys. Block Beuys*, fig. pp. 200-2; there described under no. 12a: *The 20th July Aachen Fettkiste*, 1964.

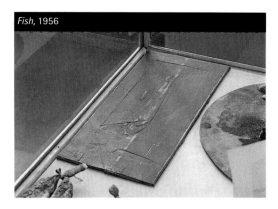

Fish, 1956

Storage battery (sausage), 1963

heat energy, the number 42 can also be read as a temperature of 42° centigrade. It would indicate a most dangerous fever and thus an extremely critical state for the human body.[34]

The adjacent object, the rat, represents an in-between region of transformation. On the one hand there is a dead and almost skeletonized animal, moreover a rat, which is feared as carrier of sicknesses and is generally perceived as a repulsive disgusting animal. On the other hand there is the embryonic position, the careful embeddedness that is almost moving. Its coloration and textural appearance corresponds suddenly with the bleached-out cookie on the crucifix diagonally across which is still to be discussed. All of a sudden one perceives the most unworthy animal in its particular beauty. Death and birth are addressed in it at the same time.

The object *Lightning* is linked to the context of this display case in a special way. The upper end was not simply broken off, it was sawn off at precisely 42 cm. It thus points without a doubt to the year 1942 in a new type of chronology. The measuring stick becomes a measure of time, a ray of time, beginning in the year 1942, which is considered the actual beginning of the systematic extermination in concentration camps such as Auschwitz-Birkenau. As of spring 1942 the railway transport cars were rolling. At the ramp to Birkenau the new arrivals were selected by the SS doctors. At least 900,000 Jews, 70,000 Poles, 21,000 Sinti and Roma, and 13,000 Soviet prisoners, thus historians are now able to document, were murdered at Auschwitz.[35] It was the largest extermination camp during the Holocaust.

The most significant object in the display case, on first impression, is the plate crucifix with the title *Cross* from 1957. On an old, in part very dusty, shallow soup bowl with visible finger prints, a naked figure of Christ was formed of brown modeling clay. Due to the strong craquelé of the dried-out material, the face is unrecognizable. The plate has the very simple decoration of old utilitarian china. From the plate edge two smaller pieces were originally broken off and carefully re-

attached. It is exactly at this glued point that a bleached-out and dried-up cookie lies today. One is tempted to take the concept "the Body of Christ" literally, and in the context of Christian iconography the cookie becomes a host. A strange offering that is served on this plate as a meal. Beuys has also described the object in his notes as *Plate Christ with Cookie* or as *Cross on Soup Bowl.*[36] The white electric cord of the stove, not previously described, forms a bow that surrounds the plate crucifixion like an aureole. The plug is wrapped with aluminum foil as if insulated. But the conductive material obviously takes over the function of the plug. Electricity becomes tangible, rises to the surface. The electrical flow of energy seems to run in the opposite direction from the stove. Two tears in the cloth covering the base of the display case in the vicinity of the cord were repaired with adhesive plaster.

The plate crucifix is with certainty the most irritating element in this ensemble. It claims the presence of the mystery of Golgotha in Auschwitz. An alienating idea for Christians as well as Jews.

This object was also used by Beuys in a performance that in its complexity cannot be presented comprehensively here. It is the performance *Manresa* at the gallery of Alfred Schmela in Dusseldorf in 1966.[37] The central sculpture of the performance is the halved felt crucifix which is supplemented by a chalk sketch drawn directly on the black wall. It was described as *Element I.* In one sequence of the performance Beuys held the plate crucifix in the middle of the halved felt cross. In juxtaposition to the rather spiritual contents of this scene stood a rather mechanical physical experience. In a wooden box designated as *Element II* was an electric apparatus: a high-voltage high-frequency generator with which a high-voltage alternating current could be produced through low-voltage direct current. During the course of this sequence Beuys set off the experiment. The plate crucifix was now placed on one of the appliances. The machine changed the 12 volt tension of a car battery, which Beuys had brought along to 50,000 volt. Sparks flew and Beuys

34 Lightning was illustrated numerous times as a separate work: Adriani, et al., 1st ed. (1973), p. 72, fig. 92; *Joseph Beuys,* ed. Caroline Tisdall, exhibition catalog, The Solomon R. Guggenheim Museum (New York, 1979), p. 140, fig. 209. Beuys also presented the object separately as can be seen in the shot by R. Kaiser from the exhibition Beuys at the Städtisches Museum Mönchengladbach in 1967, *Joseph Beuys: Skulpturen und Objekte,* ed. Heiner Bastian, vol. 1 of the exhibition catalog to the exhibition in Martin-Gropius-Bau, Berlin-West (Munich, 1988) fig. 53, p. 99.

35 Data based on: Alfred Stirner, "Auschwitz-Häftling Nr. 107.907," *Die Zeit* (January 27, 1995).

Heat sculpture, 1964

1. Rat, 1957

produced electricity with a cylindrical light bulb, a Geissler tube which lit up the whole event. With the illuminated bulb he electrified the crucifix. With this gesture a light connection was created between the region of his heart and the Christ on the plate.

Beuys creates in this performance a connection between two basic forces – spirit and matter – and between two historical principles and philosophies – the Christian and the scientific. This connecting link would then be the sought-for *Element III.*

With the title of the performance *Manresa* he furthermore referred to Ignatius of Loyola who had experienced his enlightenment through retreat and mystic contemplation at this Spanish village. Beuys had occupied himself very intensively with Ignatius. It was the single-mindedness with which this inspiring ecclesiastic led his life out of a deep crisis to a positive change that was important for Beuys.

Beuys also describes the Christ impulse as a concept of substance, and he relates it to the reality of the human being today who now has to exert his own powers in order to attain a holistic world view and a comprehensive humanity.

He calls Christ, following Rudolf Steiner, a "spiritual heat element" and speaks in this context of a "social warmth," in a generic sense also of "heat sculpture," which in our context creates a connection to the title of the same name of the stove object. And thus – particularly with knowledge of the Aachen and Dusseldorf performances – the present day link created in the display case between the cooking elements and the *Plate Crucifix* with the electric cord, the concept of substance and transsubstantiation being referred to very centrally, seems logical as well.

The Christ impulse becomes an energy store and giver of strength and it has the effect of being igniter and motor. This can also be seen by comparing the series of small sacred heart pictures, made in Naples in 1971, in which Christ is described as the "Inventor of the nitrogen synthesis," "Inventor of the steam engine," etc.[38]

Beuys uses the trivial kitschy Christ picture. In

reference to this he says to Martin Kunz in 1979: "So what I actually said was that one misunderstands Christianity if one does not go beyond the old faithful maudlin sentimentality of the traditional church culture and analyze it for its evolutionary determination. It is concretely true that Christ as inventor of the steam engine does not say anything other than that Christianity has continued to develop in the evolution of science ..."[39]

The interpretation that a real transformation took place during the crucifixion inspired Beuys already in his early works to a fusion of bodily gesture and the Latin symbol of the cross. Christ himself becomes the cross.[40]

Next to the plate crucifix in the display case *Auschwitz Demonstration* is the already mentioned ground plan from the application material. Deviating from the other objects placed along the glass walls, it is set diagonally like a fence or a small paravent into the space of the showcase. Its folds indicate its original function as a foldout, as part of a book or a brochure, obvious from the torn edge. The title of this yellowed piece-of-paper-turned-object from the year 1957 is *Auschwitz.* On the front is a black-and-white photographic panorama that shows the deserted camp from an elevated site. In the foreground the fence of the rectangularly laid-out camp with its endless rows of long barracks can be seen. To the right, outside the fence, is a ditch and following that an empty street. On the label the illustration is described as "(4) Overall view of Section B II of Camp Brzezinka. On the left is the access road, next to that the railway tracks with loading ramp." On the black-and-white illustration as well as on the unprinted white page to its left Beuys has sketched gate structures alongside the railway lines in strong perspectival foreshortening. On the reverse of the foldout the following more exact designation is printed: "Ground plan of the prisoner-of-war camp AUSCHWITZ O.S. Scale 1:2000," and a more detailed description follows: "(3) Ground plan of the camp Brzezinka, on which the railway tracks that lead to the gas chambers and crematories can be seen. To the left of the railway tracks is the women's camp (WCC), calculated

36 Friedhelm Mennekes, *Joseph Beuys: MANRESA: Eine Fluxus-Demonstration als geistliche Übung zu Ignatius von Loyola* (Frankfurt/Main, Leipzig, 1992), fig. P2, p. 72; Klaus Fabricius, *Joseph Beuys: Aprovechar a las ánimas/Fer profit a les ànimes,* exhibition catalog, Museo de Arte Contemporáneo (Seville, 1993), fig. 67, p. 164.

37 Description and illustrations to the action in Schneede, 146-65.

38 *Beuys zu Ehren,* ed. Armin Zweite, exhibition catalog, Städtische Galerie im Lenbachhaus (Munich 1986) fig. pp. 228-29.

Lightning, 1964

Lightning, 1964, Detail

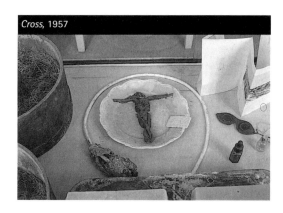

Cross, 1957

39 Joseph Beuys, *Spuren in Italien,* exhibition catalog, Kunstmuseum Luzern (1979), n.p. (14th page of the interview with Martin Kunz).

40 Several early examples can be compared: *Sun Cross,* 1947-1948; *Hand Cross,* 1949; *Symbol of the Redemption I,* 1949/1950. All of the above in *Joseph Beuys, Zeichnungen, Bilder, Plastiken, Objekte, Aktionsphotographien,* exhibition catalog, Kunstverein Freiburg (1975), figs. 2, 12, 13. *Cross,* 1950/1951, or as most logical comparison the tabernacle-like *Christ in the Jar* of 1949 in which the body is made of modelling clay. Both in Getlinger, figs. 31, 29.

for 20,000 persons and to the right of the tracks – the men's camp, calculated for 60,000 persons. Even further to the right there is section B III which is still under construction, also for 60,000 prisoners. To the right of the WCC, another section was planned for the same number of 60,000 prisoners." A frighteningly matter-of-fact and bureaucratic formulation, as it seems to me, and an alienating designation of Auschwitz as "prisoner-of-war camp." Auschwitz was a concentration camp, an extermination camp.

Behind the foldout plan on the glass wall of the display case we see a pencil drawing on hard yellowed cardboard entitled *Sick Girl, Ambulance in Background* of 1957. The foldout's shape as paravent is vivid here. The naked female figure stands with her feet more or less directly on the bottom of the display case as the drawing goes down to the lower edge of the paper. Her posture expresses helplessness. Shamefully she tries to hide her sex. The legs are slightly splayed from the knees down. Her face is almost unrecognizable, as if a mistake had been made in the drawing. To the left behind her is a type of stretcher on four wheels in perspectival foreshortening. The cardboard is signed, dated, and titled on the verso. In contrast to the numerous depictions of women in the work of Beuys from the same period, such as actresses, prophetesses, animal-women, mothers, Amazons, or shamans, this depiction of the sick girl has nothing at all heroic about it. In the space between the ground plan and the drawing of the girl, towards the right-hand edge of the display case, are four rings of coarse blood sausage arranged according to size. The sausages form narrow, vertically oval forms. The fat has sickered out, sweated out, and forms in part a white crust. Each of the sausages is – seen from the front – painted and identified with a "plus" sign on the left and a "minus" sign on the right. They become

the two poles of electrical voltage. A battery effect and a cycle of energy are indicated. The title of this group of works from 1964 is *+- Sausage.* For most viewers it probably has something gruesome, but one also senses an absurd black humor. The cloth covering the bottom of the display case is soaked in fat here and the two adjacent works on paper have absorbed the fat along their edges.

Finally one discovers in the middle of the showcase an ensemble of five smaller elements. Two small, round, tightly corked, glass medicine phials carry the title *Bottle with Fat (Solid)* and *Bottle with Fat (Liquid),* and an octagonal brown glass bottle with a black screw-on lid and a pipette are designated by Beuys as *Iodine (Bottle).* All three are dated 1962. The expiry date has in any case long been passed, and what once had a healing effect is meanwhile no longer useable, if not even unpredictable and dangerous. Next to that lie, tied together with a string and a black thin leather ribbon, dark also named by Beuys as such – *Sun Lamp Goggles* – of 1964, which remind of a small mask, and a rectangular aluminum sign with the revealing title *Non-Identification Tag (Aluminium)* of 1960. The non-identification is juxtaposed with the blindness or the visual handicap due to the protective glasses and connects this small group symbolically.

In the context of the display case with its Christian iconography emphasized by the plate crucifix, the metal relief with the Fish as a symbol for Christ belongs to the depiction of the Last Supper. The harpoon in the Fish would then correspond to the lancet wound Longinus made in Christ's side. Interesting in following this interpretation through to its logical conclusion and in the context of the "blind" glasses and the *Non-Identification Tag* is that Longinus was, according to early Christian legend, blind and thus was only able to place the lancet wound with the help of a companion and was made to see again through a drop of the holy blood (an - admittedly - very far-fetched interpretation).

Viewed purely from a formal perspective, it is remarkable what a coherent basic tone the ensemble has. I mean this in terms of color, material, as well as tone.

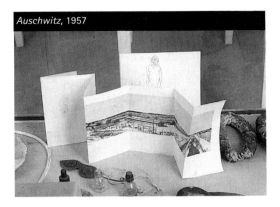

Auschwitz, 1957

Auschwitz, 1957, Detail

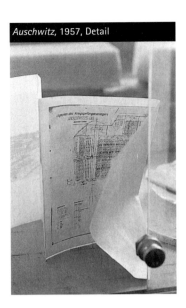

Auschwitz, 1957, Detail

The alternating play of rectangular and round forms, whether flat or three-dimensional, whether vessel or body, whether drawing or object, is conspicuous.

Although these are separate objects or groups of objects, which can each be viewed alone, they stand at the same time in loose relationship to one another. It is an additive process, not unlike a collage, with the difference though that it has no compositional principle derived from the form as a whole. The regular, highly economic arrangement prevents one seeing the objects separately, but instead it allows the eye to wander from one object to another. No object stands out in particular, everything is equal, independent of its meaning, size, or placement within the showcase.

The way Beuys treated the available space in such a display case seems to be a matter of principle. He conceives it as a total space with four walls against which the one or other object can be leaned. The display cases appear in Beuys's work like early trial runs for his later large three-dimensional spatial ensembles. The simultaneity of seeing, the synchronous view, is that which is particular to such a group of works. The specificity of the work arises from the selection of objects, their arrangement, and their relationship to one another. A total equality reigns amongst cu ltural objects (cooking elements, medicine bottles), objects of rural or everyday use (tubs, plate), tools (measuring stick), foodstuffs or natural materials (grass, animal, wax, dust, various types of fat), and finally artistic products (drawing, Christ figure, metal relief). The various semantic halos of the individual objects radiate onto the other objects.

IV.

Auschwitz was for Beuys a culminating point at which materialistic thought developed its full destructive potential. The word Auschwitz awakens a whole stream of pictures, memories of that which has been heard, read, and it is a symbol for the horror of World War II. It stands for the inhumanity of a place. If one recalls what happened one is overrun with the incomprehensible extent of destruction and violence and an abyss opens up. There is no real understanding. Beuys has more or less shut the incidents down. The display case is a place of the present which addresses its challenges to the present. Beuys attempts to remove a temporal division.

The term chosen by Beuys – Demonstration – which is often found in his drawings, means presenting, showing, handing an action over, more than being a posture of protest. In a way one stands speechless in front of the term Auschwitz as well as in front of the display case. What happened remains unimaginable, and such often used concepts as "working up" and "coming to terms with the past" seem inappropriate.

This work by Beuys from the sixties cannot be read simply against the background of national socialism, it must also be seen against that of the history of repression in postwar Germany. The display case's history of creation, the last object being from 1964, significantly falls into the period of the Frankfurt Auschwitz trial, which took place from December 20, 1963 to August 20, 1965 on 183 trial days in total. The particularity of this process, and the political significance that reached far beyond its legal function, was that a German court was here required to examine the most comprehensive and inhumane complex of crimes that has ever been committed.[41]

Beuys commented on the work group dealing with Auschwitz in the following manner to Caroline Tisdall: "I do not feel that these works were made to represent catastrophe, although the experience of catastrophe has

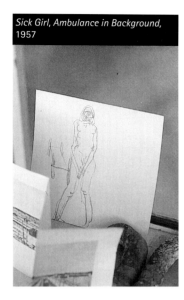

Sick Girl, Ambulance in Background,
1957

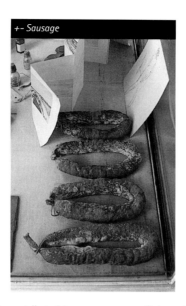

+- Sausage

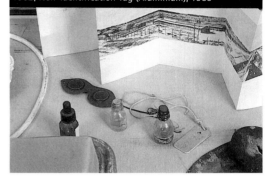

Iodine (Bottle), 1962; *Sun Lamp Goggles*, 1964;
Bottle with Fat (Liquid), 1962; *Bottle with Fat (Solid)*,
1962; *Non-Identification Tag (Aluminium)*, 1960

certainly contributed to my awareness. But my interest was not in illustrating it, even when I used the title *Concentration Camp Essen.* This was not a description of the events in that camp but of the content and meaning of catastrophe. That must be the starting point – a kind of key question – something that surmounts *Concentration Camp Essen. Similia similibus curantur:* heal like with like, that is the homeopathic healing process. The human condition is Auschwitz, and the principle of Auschwitz finds its perpetuation in our understanding of science and political systems, in the delegation of responsibility to groups of specialists, and in the silence of intellectuals and artists. I have found myself in permanent struggle with this condition and its roots. I find for instance that we are now experiencing Auschwitz in its contemporary character."[42]

In reference to "eating," Georg Jappe commented about the objects in the display case saying that they do not depict horror in a striking or episodic manner, but exemplary as decay and consumation. It is surely helpful to consider the fact that the normal word for *produits alimentaires* is in German *Lebensmittel,* that is, "means to live".[43]

Beuys sees a situation of general social emergency and demands a fundamental reflection of collective memory. The most conclusive statement in this connection is in the interview with Max Reithmann in 1982. Beuys responds to his question whether something like Auschwitz can at all be depicted:

"No, it cannot. Of course not. This exists only in order to, as I said, make an attempt to prepare a medicine. To remind of it, and in connection with the continuing performances. One has to say in any case that the whole thing belongs to performance art, even that. Simply with the continuing things, to work something up that this

terrible picture that cannot be depicted in a picture, that can instead only be depicted in its actual process while it occurred, that one cannot translate that into a picture in any way, no. That which can only be, let's say, be remembered in its positive counter image, i.e., in that which is really eliminated from the human being. That the rest of all these acts of inhumanity be overcome, no. So in that sense this Auschwitz display case is actually a toy. I do not presume to have reproduced any of the horror through this – through these things."[44]

From these few words of Beuys it is already obvious that his position to the historic events of the Third Reich is very clear and unambiguous. The accusation made repeatedly in the specialist press, most recently on the occasion of the Beuys symposium in Paris in the fall of 1994, that Beuys is dangerously close to Nazi ideology, has thus not only no basis but one must counter this emphatically.

In conclusion, another interesting reference to the New York Beuys exhibition at the Solomon Guggenheim Museum in 1979. It was developed similar to a "Lebenslauf Werklauf" in 24 stations. Beuys created with this one of his most comprehensive multi-media works and certainly the most impressive exhibition that he could realize in his lifetime. In the spiral-shaped architecture of the Guggenheim Museum, he began at the top with his sign of birth, the bathtub, and concluded at the bottom with the strongly autobiographical work *Tram Stop.* At the highest point of this snail-shaped building Beuys had placed as station 1 not only the work *Bathtub* of 1960, but directly adjacent the display case entitled *Auschwitz,* which contained the complete contents of the Darmstadt display case *Auschwitz Demonstration.* It was, by the way, the only display case ensemble that he brought from Darmstadt to New York. Beuys called the bathtub the "Geburtszeichen" (Sign of Birth). Seen as a figure, it is of male gender. The birth sign bathtub forms together with the subject Auschwitz the programmatic prelude for Beuys's "Lebenslauf Werklauf" in this New York exhibi-

41 The two-volume 1965 documentation of the collected interrogation records by Hermann Langbein has been republished 30 years later in an unrevised reprint by "Verlag Neue Kritik" in 1995.

42 *Joseph Beuys*, exhibition catalog (Guggenheim), see note 34, pp. 21-23. When Beuys speaks here of *Concentration Camp Essen,* he is referring to two sculptural works entitled *KZ=Essen 1* and *KZ=Essen 2,* both from 1963. Today they are part of one of the display cases in the Beuys Block of the Neue Galerie in Kassel. In *Joseph Beuys: Eine Werkübersicht 1945-1985* (Munich, 1996), figs. 72f.; and in Gerhard Theewen, *Joseph Beuys: Die Vitrinen, ein Verzeichnis* (Cologne, 1993) 29-32.

43 Georg Jappe, *Beuys Packen: Dokumente 1968-1996* (Regensburg, 1996) 283.

tion. His written "Lebenslauf Werklauf" begins respectively in the year of his birth 1921 with the formulation: "Exhibition of a wound drawn together with plaster."

It seems remarkable that even with the hundred-piece work *Arena,* which is today in the Dia Center for Arts collection in New York, the first of the sequentially numbered metal-framed pictures shows as top photograph the display case *Auschwitz Demonstration.*[45] *Arena* also has retrospective character in the work of Beuys and presents a collection of 267 original photographs.

The subject has not lost any of its contemporary relevance. To the contrary, as the dilemma of the Berlin Holocaust monument shows. Our trauma, our legacy of the Third Reich still having this effect, is expressed in a special way in the momentary struggle to find a form. In most of the designs the borderline to representationalism has long been crossed and comes close to "Betroffen-

Display case *Auschwitz* in the Beuys retrospective at the Solomon R. Guggenheim Museum, New York, 1979/80

heitskitsch" (consternation kitsch), as Dieter Bartezko formulated in the *Frankfurter Allgemeine Zeitung* in early 1996.[46]

Even Beuys who began his professorship for monumental sculpture at the Kunstakademie in Dusseldorf in 1961, makes his way to this form of display case ensemble only 10 years later, after his design for a monument in 1958 had at first failed, and in the film by Caroline Tisdall he emphasizes: "For me it is a monument."[47]

Mario Kramer

44 Max Reithmann, *Joseph Beuys: Par la présente, je n'appartiens plus à l'art* (Paris, 1988) 122.

45 Joseph Beuys, *Arena - wo wäre ich hingekommen, wenn ich nicht intelligent gewesen wäre!,* eds. Lynne Cooke and Karen Kelly, exhibition catalog (New York: Dia Center for the Arts, 1994. German ed.: Ostfildern near Stuttgart, 1994), no. 1, p. 67.

46 Dieter Bartezko, "Wie ein Schlag ins Gesicht", *Frankfurter Allgemeine Zeitung* (February 3, 1996) 31.

47 Joseph Beuys by Caroline Tisdall, directed by Christopher Swayne for the BBC in 1987.

279a **Joseph Beuys**
Untitled *(Design for Auschwitz Memorial, 3 arch forms)*, no date
Collage: Pencil and charcoal on brown paper (back side of a padded envelope), left below: glued paper drawn with charcoal
17.5 x 25 (top) 18 (bottom) cm

279b **Joseph Beuys**
Untitled, no date
Pencil on gray paper, small punctures mostly on line intersections
21.8 (1) / 20.3 (r) x 19 (bottom) / 21.6 (top) cm

279c **Joseph Beuys**
Untitled *(Design for Auschwitz Memorial, 5 arch forms)*, no date
Charcoal and blue ink on chamois colored paper
21. 4 x 20.9 cm

279d **Joseph Beuys**
Untitled, 1958
Blue ink and typewriter ink on chamois colored paper
21 x 29.7 cm

280 **Joseph Beuys**
Sun Reflector, 1954
Pencil on paper
15.2 x 21 cm
Marx Collection on permanent loan to the Staatliche Museen zu Berlin, Kupferstichkabinett

281 Joseph Beuys
Untitled *(Lamp)*, no date (1956)
Red watercolor (gouache) on grayish
writing paper with gray lines
(notebook page)
21 x 15.3 (bottom) / 14.9 (top) cm
Stiftung Museum Schloß Moyland –
Collection van der Grinten

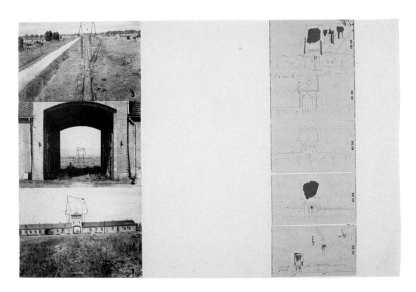

279e Joseph Beuys
Design for Auschwitz Memorial, 1957
Collage: Pencil and dark blue ink
on 3 b/w illustrations mounted over
each other along the left edge on
chamois colored paper, pencil and
red ink on 5 brownish sheets,
mounted over each other parallel
to the right edge
33.1 x 49.5 cm
figs. 279 a–e Stiftung Museum Schloß
Moyland – Collection van der Grinten

279f Joseph Beuys
Untitled *(Design for Auschwitz Memorial, sketch of the camp with gates and sculpture)*, no date
Pencil and red ink on brownish paper
(page from an account book)
6.6 x 14.3

282 Joseph Beuys
Untitled *(Plan of the Birkenau Concentration Camp)*, no date (1963)
Collage: ink, oil paint (brown cross),
black paint, opaque white on printed
paper glued on yellowish paper,
folded vertically in the middle
50 x 75.5 cm
Stiftung Museum Schloß Moyland –
Collection van der Grinten

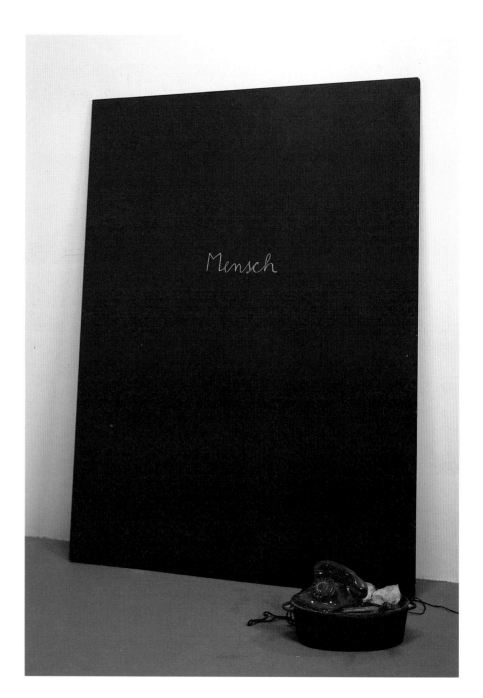

284 Joseph Beuys
Untitled *(Table Drawing)*, 1973
Pencil, dried beverage stains and
burn marks on table surface
(gray layered masonite, black
edge), framed in wood, white
polish varnish with glass plate
79 x 79 x 2 cm (Plate),
100 x 100 cm (box)
Speck Collection, Cologne

283 Joseph Beuys
Human, 1972
Installation, panel varnish on pressed wood, chalk,
cast iron, tar filled, wood and iron parts, quartz
and sandstone, telephone, cable
200 x 150 x 80 cm
Speck Collection, Cologne

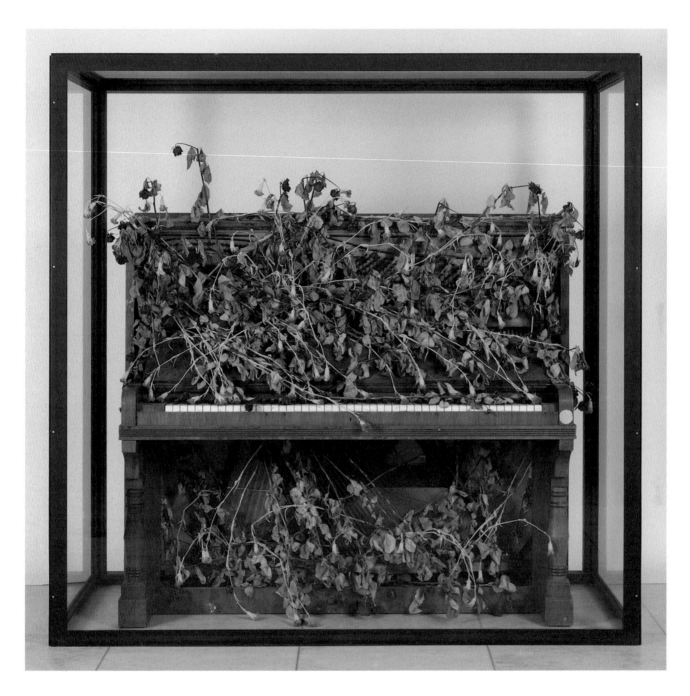

285 **Joseph Beuys**
Revolution Piano, 1969
Piano stuck with approx. 200 cloves and roses
piano: 133 x 152.5 x 66 cm
Städtisches Museum Abteiberg,
Mönchengladbach

Berlin's "Economic Assets"
Beuys's Meeting with
Eduard Gaertner and Anton von Werner

I. History

Confusion grows with new perspectives. Is the canned food standing on the metal shelves of Beuys's room-installation *Economic Assets* (fig. 286, p. 279) from the GDR, or rather the former GDR? In any case they are not HO-shelves (HO stands for Handelsorganisation and was a supermarket chain in the former GDR which supplied basic foods and household goods), as has been written, but were rather acquired from a West Berlin antique dealer. Without a doubt, the cans are not from a Berlin HO-shop. As Klaus Staeck has repeatedly stated, they were brought back by him, beginning in 1977, from visits to relatives in Bitterfeld. What he liked about these products from the anti-capitalist world, also fascinated Beuys, who first visited the GDR in 1982. The basic staple foods brought back by Staeck from the East were for Beuys commodities from a land unknown to him, exotic products of a state-planned economy.[1] For the western consumer these products possessed a kind of aura of simplicity that lent them the dignity of the authentic and genuine. In the surprising variety of brown paper and cardboard packagings, with their both practical and simple labeling reminiscent of the functional design of the twenties, these staples had, in contrast to the material and advertising efforts that make up the western commodity aesthetic, an almost "beuysian" quality.

With descriptions like *Speiseerbsen, Zwiebackbruch, Luvos Heilerde, Verbandzellstoff, Bernburger Speisesalz, Hirse, Kakaoschalentee, Gersten-Flocken, Hafer-Mark, Voll-Soja,* and *Kaffeeersatzmischung,* these products reminded Beuys of his childhood, of the time when things were simple and identical with their names. All of the eastern goods which, simultaneous to arte povera, were devoid of a corresponding modesty, or were "too trendy or conspicuously western" Beuys rejected, according to the memory of Staeck, "as mostly unsuitable."[2] Those found suitable were the "makeshift" packaging, which like all the others from the East could be saved and used again. This wide selection of GDR household goods embodied for Beuys a kind of naturalness, purity, and quality which he made his own. All of these products were inscribed by him as "economic assets," signed, and thereby mobilized as energy fields in his cosmos of forces, becoming truly "beuysian."

Beuys placed the inscribed food and household products on six metal shelves placed at different levels. On the long inner side of the shelves he placed a stereom-eteric plaster block. Its damaged corners at floor level were repaired with fat. On the upper surface, the block is inscribed with the words "Der Eurasier läßt schön grüßen. Joseph." ("The Eurasian sends greetings. Joseph.") On one of the lower shelves, immediately above the plaster block, stands a radio which is connected to the plaster. Preserving jars filled with head cheese and soup stock, as well as a key with pieces of fat and salt packages lay next to the Radio on the shelf. As a whole, these worn shelves remind one of a depot in a museum, which, in this installation, necessarily includes paintings which are supposed to have come into being in Marx's lifetime. It was further Beuys's wish, according to Jan Hoet, that the paintings be presented in gold frames as an expression of bourgeois art appreciation.[3]

What Beuys thought of as a provocation, the exhibition of the products of a state-run, planned economy on old beat up shelves in the middle of a museum devoted to bourgeois taste, became, through the collapse of the GDR and its culture of everyday life, itself musealized in an archive of social memory. Following the west-nostalgia of Beuys with regard to the integrity of the apparently so authentic eastern commodities, comes an east-nostalgia, the sad regret at the recent passing of a culture of daily life in which – according to popular lament – every thing wasn't so bad, and where the simple things in life were still important.[4] The *Economic Assets* of Beuys, once conceived for the museum as a disturbing provocation, is now suddenly delivering evidence of Krzysztof Pomian's theory of the genesis of the museum out of the ritual objects buried along with the dead in ancient Egypt. Every-day objects were removed, there for the first time, from the sphere of circulation beyond their own exchange value; raised in the burial chambers to symbolic cult value and accumulated, a development out which the museums of today have emerged.[5] After its actual disappearance, the GDR's culture of everyday life has won a lasting reality in the collection of Beuys.

II. Theory

At its first Berlin presentation on the occasion of the Beuys retrospective in Berlin's Martin Gropius Bau, its actuality could not yet have been the object of critical reflection in the exhibition catalog. Only the expanded concept of art of Beuys was at the time considered political. One saw this as exemplary in the exhibition of warehouse goods in a museum of fine art.[6] But the tradition, in this case used so drastically by Beuys, of different levels of language, the carrying over of the commodity world into the art world by Dada, Duchamp, and the neo-Dada of Pop Art, the bringing of art back into everyday life and the accumulation of the ordinary on the part of Fluxus, and finally the transformation of the old *Streubild* in the

[1] Compare *Joseph Beuys, Das Wirt-schaftswertprinzip*, ed. and photographed by Klaus Staeck and Gerhard Steidl (Heidelberg, 1990) 71. For their friendly help and information, I am thankful to Andrea Bärnreuther, Heiner Bastian, Eugen Blume, Katrin Henke, Jan Hoet, Klaus Staeck, and Volker Essers.

[2] Beuys, 8.

[3] Compare Jan Hoet and Bart De Baere, "Über Wirtschaftswerte", Beuys, 9ff.

[4] That which Heiner Müller described in 1985 as the longing of the old BRD to break out of its own mainstream conformity, has become an all encompassing German atmosphere with a particularly aesthetic quality: "Here Beuys took bags marked 'Gut gekauft - Gern gekauft,' bandages, technical felt from Zittau, or telegraph forms from Bitterfeld and applied the stamps of the companies to them, everything without any great "styling," which of course disappointed the expectations of the westerners, and perhaps caused a bit of emotional discomfort..." "I find the interesting thing about it is that it is a trend in the BRD, especially among the young, in the East - and the closest is of course the GDR - to seek naturalness and simplicity, something that in the West has been eradicated through the Americanization and comput-erization of the society. And this extends into the level of linguistic structures, so that texts from the GDR are just more condensed and syntactically more complex which gives them a moment of resistance against Americanization, against the throw-away society, and against the one-dimensionality of West German production, including art." Quoted in Ulrich Dietzel, "Gespräch mit Heiner Müller", *Sinn und Form*, vol. 6, 1985; reprinted in Beuys, 27f.

[5] Compare Krzysztof Pomain, *Der Ursprung des Museums. Vom Sammeln*, (Berlin, 1988) 20ff.

6 Thoedora Vischer, in: *Joseph Beuys, Skulpturen und Objekte*, ed. Heiner Bastian, exhibition catalog Martin-Gropius-Bau, Berlin (Munich, 1988) 298.

7 Compare Eugen Blume, "Vor dem Ausbruch aus dem Lager I", *Deep Storage. Arsenale der Erinnerung*, exhibition catalog, Haus der Kunst (Munich, 1997).

8 Beuys, 1990, 5.

9 Compare Peter-Klaus Schuster, "Grundbegriffe der Bildersprache", *Kunst um 1800 und die Folgen. Werner Hofmann zu Ehren*, (Munich, 1988) 425 ff.

10 Compare Bernhard Johannes Blume, "Der Eurasier läßt schön grüßen". For the installation *Economic Assets*-(Principle), *Von hier aus*, exhibition catalog (Düsseldorf, 1984) 59 ff.

11 Beuys, 1990, 5.

12 The following paintings were part of the original presentation of *Economic Assets* in the Ghent Museum van Schoone Kunsten: *Portrait of J.P.C. Hermolai* attributed to Tintoretto after 1561, Inv. no. 1914 – CL (Catalogus Oude Meesters 1938, 151; *Couple with Child at a Meal* attributed to Velasquez after 1667, Inv. no. 1902 - J (Catalogus 1938, 151); Henry Raeburn, *Portrait of Alexander Edgar* around 1810, Inv. no. 1902 - (Catalogus 1938, 110), Thomas Gainsborough Dupont, *Portrait of a Minister*, n.d., Inv. no. 1925 - AM (Catalogus 1938, 50).

13 According to Bernhard Johannes Blume, Beuys, 1984, 60f.

14 For the exhibition "Joseph Beuys: Natur-Materie-Form" in the Kunstsammlung Nordrhein-Westfalen in Dusseldorf organized by Armin Zweite the following works were shown as part of *Economic Assets*: Juan Gris, *Still Life with Violin and Ink Bottle*, 1913; Giorgio Morandi, *Still-Life*, 1951; Pablo Picasso, *Still-Life with Bottle and Glass*, 1913; Pablo Picasso, *Woman in Chair*, 1941; Oskar Schlemmer, *Women at the Table*, 1923; all works are found in: Werner Schmalenbach, *Malerei des zwanzigsten Jahrhunderts*. Acquisitions catalog of the Kunstsammlung Nordrhein-Westfalen, (Dusseldorf 1975). The catalog noted that for the exhibition of *Economic Assets* oil-paintings from the 19th century were displayed; (see p. 33, No. 463). The figures 215-217 show the installation in its present form with the paintings from the 19th century from the collection of the mu seum in Ghent.

plastic appearance of the archive, the store, – and especially important for Beuys – the plasticity of the depot.[7] Important in the catalog was alone the pure teaching which Beuys had developed according to Rudolf Steiner's trinity of economic life, juridical life, and spiritual life.

This trinity of economic, juridical, and spiritual life should be organized in a mutually strengthening interchange with one another. Beuys showed in his installation exactly this necessary context between economy and art, and moreover in a utopian sense. The utopian aspect of the "economic assets" of the GDR's state-capitalism was for Beuys its orientation towards basic human needs and the ecological considerations that were an obvious consideration in the package design. In this sense, the economic sector actually appears to be for the individual, as in the exceptional case of the bourgeois art of the 19th century quoted by Beuys through the paintings which were part of the installation. That which is denied to people through economic compulsion, and its resulting alienation, is, according to the German idealism, made up for in the realm of art. It is exactly this separation that Beuys sought to overcome when he tried to make clear, in the realm of art, how the economy should be, and the degree to which the economy should, through bringing forth goods that are oriented toward the individual, determine the whole of our culture. "Our culture," according to Beuys, "is not formed by culture, but rather thoroughly by economic forces. There could hardly be an objec-tion if one were to conceive of a correct notion of economy."[8]

In a mimetic form, Beuys presented such a correct concept in the form of the plaster block in his *Economic Assets*. Its geometric form is an embodiment of the rational, which threatens to harden if not animated by the flow of energy and warmth. This takes place on the plaster block through the corners made of fat used to repair damages at the floor level. The photos since 1980 show clearly the degree to which the fat has saturated through the material of the block, how, in this quasi-alchemical memorial of Beuys – a revision of Goethe's famous sphere-cube monument for Charlotte von Stein – that synthesis of the antagonistic forces of stasis and dynamism was found, which in his conception, is essential to a proper economy.[9] The true master of such an economy is the ideal-type of the new individual, the one intended on the plaster block with the inscription "Eurasier," who sublates the antagonistic principles of hot and cold, of movement and petrification in himself.[10] When he establishes a proper economy, and this means also spiritually, he can also reach a proper art, thereby overcoming the mere "L'art pour l'art" of the nineteenth century.

In this respect the *Economic Assets* from Beuys proved to be utopian in a double sense. Just as elements of a proper economic life appear in the commodities from the GDR, although they themselves are not the ideal, so also does the notion of creative individuality beyond the compulsions of economic necessity present in bourgeois art and the museum world, point to the presence of a utopian element. Insofar as the economy can be newly conceived and formed by the individual as a spiritual energy-field, can a new impulse in art also be found. No longer a mere substitute for the right state of things, art leads to a different economic life and a different spiritual life, one which proclaims the possibility of self-realization, consciousness, and that everyone can be an artist. As Beuys maintained, "it is only through art that a new concept of economy can form itself, in the sense of human need, and not in the sense of exhaustion and consumption, politics and property, but rather, more than anything, in the production of spiritual goods. The question as to what should be produced, and how it should be produced, are cultural considerations, when one thinks it through, spiritual considerations; that means that art runs through all of life right into the finest microcosm, and its products are the concrete concept of CAPITAL."[11]

III. Art

One sees that with *Economic Assets* Beuys has brought economics and art into a subtle balance. Both are for themselves and mutually "economic assets." Art emerges out of proper economies and leads, according to Beuys, to mature and responsible individuals, who in turn, themselves improve economic life. The other way around, Beuys saw exactly the privilege and distinction of art as consisting in its ability, during the present period of false economy, the period of private and state-capitalism, to reawaken and unfold peoples creative and productive capacities. Toward precisely this goal, toward peoples unfolding in every sense that would enable them to bring about such a proper economy, and toward the same goal, he uses that museum art which surrounds his storage depot, and first makes clear the concept of *Economic Assets*.

This appeal of art to humanity and its creative powers becomes all the more convincing, the more that art speaks qualitatively in the framework of *Economic Assets*. Although this appears to weaken Beuys's critic of the existing situation – an only partially valid state-capitalism meets a bourgeois art arranged according to Beuys's directions –, Beuys selected for the first presentations of *Economic Assets* on the occasion of the exhibition "Art in Europe After 1968," a room in the old Ghent Museum in which he found exclusively old masters. There were mostly portraits of women, men, and children from the workshops of Tintoretto and Velasquez, from Dutch and Flemish painters of the 17th century, as well as portraits of British aristocrats including Henry Raeburn

Joseph Beuys
Economic Assets
Details

278

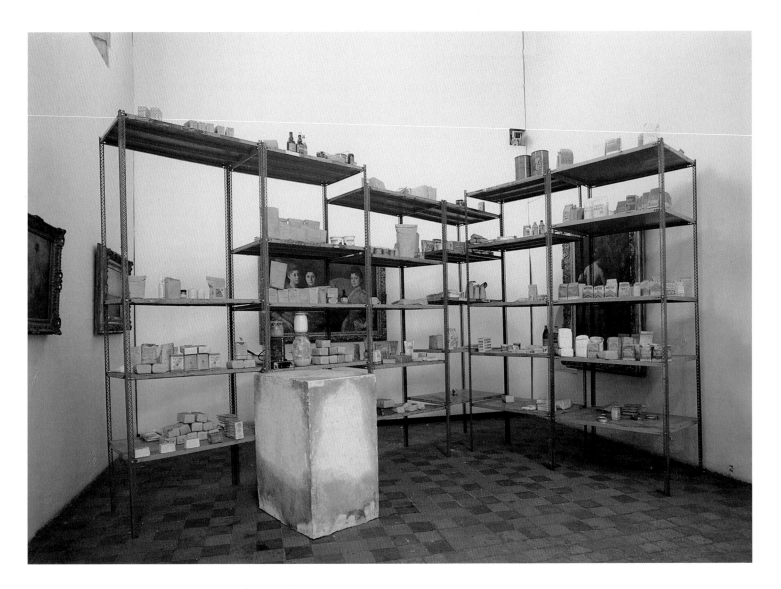

286 **Joseph Beuys**
Economic Assets, 1980
6 iron shelves, packaged food basics,
commodities from the former GDR, Poland, the
former Soviet Union, and the Federal Republic
of Germany, pencil on plaster, fat, with the
phrase "Der Eurasier läßt schön grüßen. Joseph."
(The Eurasian sends greetings. Joseph.)
on the plaster block
Shelves: 290 x 400 x 265
Plaster block: 98.5 x 55.5 x 77.5 cm
Sammlung Museum van Hedendaagse Kunst,
Ghent

and Thomas Gainsborough's nephews.[12]

Through surrounding these portraits with staple foods from the East, Beuys strengthened the humane aspect of his art and economic teaching. The viewer to whom the old masters and the bourgeois tradition of proud self-presentation speaks should not – this was to be read from the installation – allow the present form of economic life to result in a kind of resignation. Instead the energy awakened through art should be used according to the model of the Euroasian to overcome ossification and bring about living change. The person, according to Beuys the "second principle" of the economic assets, was no less present in the pictures of the old masters than the "first principle" of warmth in the fat saturated sculpture of the plaster block, and the "third principle" of the products in the form of ready-mades from everyday life on the shelves. The importance of the art of the old masters for Beuys and for his room-installation becomes clear in the light of his concern with drawing the portrait of Raeburn during the setting up of the installation; through Staeck's presentation of "Economic Assets in a photo book along with the old masters, and through the fact that Heiner Müller's palinode to Economic Assets was occasioned by this first presentation with the old masters.

The same is true of the second presentation by Beuys of Economic Assets on the occasion of the Dusseldorf exhibition "Von hier aus" in 1984. This time Beuys selected Otto Dix and those he knew from the circle of Johanna "Mutter" Ey in Dusseldorf. For the first time it was art from the 20th century which, like Beuys himself and in the sense of the title "von hier aus," agitated for and attempted to carry out changes through critic of society. The suspicion that Beuys wanted to dismiss this art, in contrast to the commodities from the East, as an empty avant-garde, is a mistake.[13] More questionable is the reversal whereby Economic Assets is raised to the level of pure art by surrounding the GDR products with classical works of modernism. A similar revaluation took place at the Beuys exhibition organized by Armin Zweite in Dusseldorf in 1991 on the basis of the high quality of the Kunstsammlung Nordrhein-Westfalen.[14] At the documenta IX in 1992, Jan Hoet exhibited Economic Assets, organized in the tower of the Museum Fridericianum as "The Collective Memory," twice surrounding by art. Once according to the directions of Beuys with works reflecting the bourgeois taste of the 19th century, and once with a musée imaginaire of the artistic breakthroughs of modernism placed in the foreground, as in the case of Gauguin with social utopia, or in the case of Barnett Newman with aesthetic autonomy. In this musée imaginaire, the Economic Assets from Beuys was raised to the level of a masterpiece of socially relevant art.[15]

After purchase of the work by the Ghent Museum, Economic Assets was, according to the wish of Beuys, mostly shown with works from the time when Marx was alive. The ambivalence of bourgeois notions of art, between religious consecration and sumptuous banality remains ever present. This is also true of the first presentation of Economic Assets in Berlin at the Martin-Gropius-Bau in 1988. For this occasion Heiner Bastian loaned out a number of portraits of artists and landscapes from the 19th century from the National Gallery. The panorama included a group portrait of the late Nazarene painters, a Munich studio interior, and Karl Haider's evening landscape inspired by the line from Goethe: "over all peaks is peace."[16]

The present meeting of Beuys with Eduard Gaertner and Anton von Werner thematizes this oscillation between bourgeois taste and the opposition, typical for Berlin, between modest sobriety and precision with Gaertner, and the pompous cult of the artist with Anton von Werner. The present danger that the beuysian Economic Assets could become either a piece of GDR nostalgia on the one hand, or become fully musealized and auratic on the other hand is thereby eliminated. Through turning back to the liberal bourgeois traditions and their conservative opponents, the not yet neutralized elements of Beuys Economic Assets are historically actualized.

Eduard Gaertner, born in 1801 as the son of an unemployed shoemaker, was an anti-academic who received his education in the porcelain industry, finding his first success as a panorama painter in the entertainment branch. Rather than being a portrayer of philistine clarity, he was a perceptive observer of the bourgeois revolution of 1848 whose idyllic and exact Berlin city scenes were wish images intended to secure bourgeois metropolitan life and its urbane forms of social contact. In contrast, the royal palace and the officials at the state reception are intentionally reduced to background motifs. In the foreground one sees the economic activity and mobility of city life, the pleasing chaos of a free moving bourgeois public life, including all of its outsiders and their highly individual dwellings. The backside of the houses express a kind of architectural collage as a form of life, at that time already threatened, in which according to Gaertner's conviction each can find one's own happiness according to one's own imagination. No less than the bourgeois demand for happiness is the main theme of Gaertner's Berlin city paintings.[17]

Characteristic of Gaertner's staging of bourgeois urbanity, something which also connects him to Beuys, is that everything individual and particular on the street takes place under the models of art in the form of a variety of public monuments. Everything is oriented and warms itself under the statues, and according to their example;

15 Compare Claudia Herstatt, "Collective Memory. Das Kollektive Gedächtnis", documenta IX, vol. 1, exhibition catalog (Stuttgart, 1992) 16 f; and further Jan Hoet, "Ein Rundgang durch Documenta IX", Kunstforum International, no. 119, 1992, 346. See as well a presentation of objects collected by Jan Hoet on a shelf from Haim Steinbach in the Neuen Galerie in Kassel with painting by Corinth, Liebermann, and Slevogt, p. 438 f.

16 For the exhibition of Economic Assets organized by Heiner Bastian in the Martin-Gropius-Bau the following paintings from the Neuen Nationalgalerie in West Berlin: Theodor Alt, Rudolf Hirth du Frenes im Atelier, 1870; Paul Graeb, Berliner Zimmer, 1865; Karl Haider, Über allen Gipfeln ist Ruh, 1912; Philipp Hoyoll, Amandus Pelz, Raphael Schall, Drei Schlesische Maler, 1835; Heinrich Reinhold, Landschaft mit Mädchen bei der Heuernte, 1818. Also selected but not exhibited was the self-portrait of Friedrich Wasmann from 1846. All works shown in Verzeichnis der Gemälde und Skulpturen des 19. Jahrhunderts, exhibition catalog, Martin-Gropius-Bau (West Berlin 1977). To the most recent presentation of Economic Assets see Harry Szeemann/ Gerhard Theewen, in: Joseph Beuys, exhibition catalog, Kunsthaus Zürich (Zürich 1993) 160 f; and further Marion Hohlfeldt, Joseph Beuys, exhibition catalog, Centre Georges Pompidou (Paris, 1994) 210.

17 Compare Peter-Klaus Schuster, Eduard Gaertner und die geistige Mitte Berlins. "Zu einer Neuerwerbung für die Nationalgalerie", Jahrbuch Preußischer Kulturbesitz, vol. XXX, 1993, 281 ff.

18 Compare Peter-Klaus Schuster, Eduard Gaertner "Die 'Linden' als Bildungslandschaft", Birgit Verwiebe ed., Unter den Linden. Berlins Boulevard in Ansichten von Schinkel, Gaertner, and Menzel, exhibition catalog, Staatliche Museen zu Berlin - Preußischer Kulturbesitz, etc. (Berlin, 1997) 29 ff.

19 Compare Dominik Bartmann, in: Anton von Werner. Geschichte in Bildern, exhibition catalog, Deutsches Historisches Museum (Berlin, 1993) 420 ff.

I Eduard Gaertner
Unter den Linden, 1853
Oil on canvas, 75 x 155 cm
Staatliche Museen zu Berlin,
Nationalgalerie

from the palace bridge to the Brandenburg Gate, – also the place where the young Marx spent his time as a student in Berlin – this was the model of the civil sphere of the autonomous bourgeois individual.[18]

With Anton von Werner this orientation of art toward society was perverted into an act of submission. The prehistory of Berlin's Richard Wagner memorial, the festive inauguration of which, on October 1, 1903, was portrayed by Werner. The marble memorial by Gustav Eberlein was made possible through the economic assets of a baritone singer who became wealthy by discovering how to produce lead-free makeup.[19] The unveiling of the monument became a social event of the Hohenzollern high society under the nimbus of the creator of the Gesamtkunstwerk, Richard Wagner. Revealed, in the painting of the Academy director Werner, before the feet of the marble statue, in the clearly ordered coat tails, medals, and uniforms, beautified by a few female robes

assets" of the German history of ideas, ones which allow themselves to be more easily reconciled in Beuys's trinitarian anthroposophical model, than in German reality.

Peter-Klaus Schuster

Anton von Werner
Unveiling of the Richard-Wagner-Memorial in the Tiergarten, 1908
Oil on canvas, 230 x 280 cm
Berlinische Galerie, Berlin, Landesmuseum für Moderne Kunst, Photographie und Architektur

and children in sailor outfits, is the delusion of bourgeois ideology, of the *Verblendungszusammenhang* of a servile German public, in contrast to its ostensibly high cultural ideals. That which is as immanent danger ever present in those artistic developments in Germany tending toward the idea of the *Gesamtkunstwerk,* that the whole is the untrue, becomes here a portent from the past also for *Economic Assets* and Beuys's idea of a universal art. His meeting with Eduard Gaertner and Anton von Werner is therefore as exciting as it is enlightening. The fantasy and rationality of economy and reality, the freedom of the individual and greatness of art, these are the "economic

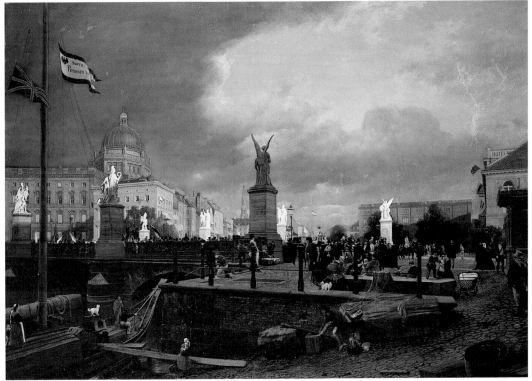

II **Eduard Gaertner**
View of the Back of the Houses on Schloßfreiheit, 1855
Oil on canvas, 57 x 96 cm
Staatliche Museen zu Berlin, Nationalgalerie

III **Eduard Gaertner**
The Schloßbrücke in Berlin, 1861
Oil on canvas, 90 x 124.5 cm
Stiftung Preußische Schlösser und Gärten Berlin-Brandenburg

Writing Time

287 Carlfriedrich Claus
Study: The Names, 1962
Nib pen, ink drawn on tracing paper,
both sides
29.5 x 20.7 cm
WI Z 275
M. Calabria Collection

288 Carlfriedrich Claus
Textvibration Study
*(Experiment to create a field),*1960
Nib pen, ink on paper
28 x 21 cm
WI 202
Galerie Gunar Barthel,
Berlin

289 Carlfriedrich Claus
Historical Allegory: Prague, 1963
Nib pen, ink, drawn on tracing paper, both sides
20.8 x 29.2 cm
WI Z 336
Private collection

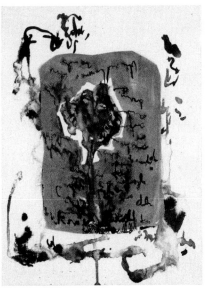

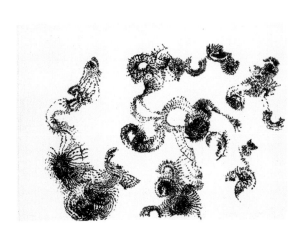

290 **Carlfriedrich Claus**
Remembered Poem of a Jewish Girl, 1959
Brush, black-brown washed ink, collage on
writing paper
29.5 x 21 cm
WI Z 142
Kupferstich-Kabinett, Dresden

291 **Carlfriedrich Claus**
Word Family, 1961
Brush, ink
21.0 x 28.5 cm
WI Z 223
Kupferstich-Kabinett, Dresden

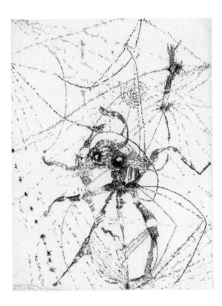

292 **Carlfriedrich Claus**
Cybernetic Reflection, 1963
Graphite, nib pen, black and red ink
drawn on tracing paper, both sides
28.5 x 21 cm
WI Z 341
Kupferstich-Kabinett, Dresden

293 **Carlfriedrich Claus**
*Note on the Simultaneity of
Unsimultaneous Historical Fields of
Vision,* 1964
Nib pen, ink drawn on tracing paper,
both sides
21 x 29.5 cm
WI Z 362
Private collection

294 **Carlfriedrich Claus**
Allegory: Doubt, 1962
Nib pen, ink drawn on tracing paper,
both sides
29.1 x 21 cm
WI Z 290
Galerie Gunar Barthel, Berlin

295 Carlfriedrich Claus
Bio-electrical Element II, 1963
Nib pen, black, green and brown ink
drawn on tracing paper, both sides
7 x 10.5 cm
WI Z 344
Gunar Barthel, Berlin

296 Carlfriedrich Claus
Water, 1966
Nib pen, blue ink drawn on tracing
paper, both sides
29.6 x 21 cm
WI Z 413
Gunar Barthel, Berlin

297 Carlfriedrich Claus
Micro-Study, 1964
Nib pen, ink drawn on folded tracing
paper, both sides
10 x 14.4 cm
WI Z 359
Hans Grüß

298 Carlfriedrich Claus
Allegorical Essay for Albert Wigand.
A Communist Problem of the Future:
Naturalization of Humans,
Humanization of Nature, 1965
Nib pen, ink drawn on tracing paper,
both sides
20.4 x 25.8 cm
WI Z 398
Galerie für zeitgenössische Kunst,
Leipzig

299 Carlfriedrich Claus
A Year of Musical Density, 1964
Nib pen, black, blue, orange ink
drawn on tracing paper, both sides
10.5 x 14.9 cm
WI Z 369
Hans Grüß

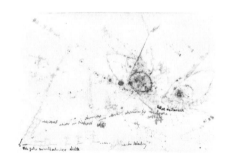

300 Carlfriedrich Claus
Who is, at the moment, I?, 1965
Nib pen, ink drawn on tissue paper, one side
24 x 20.2 cm
WI Z 399
Hans Grüß

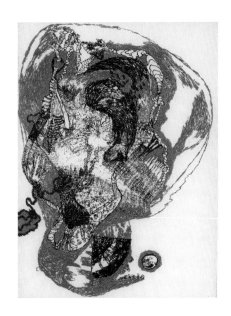

301 Carlfriedrich Claus
Thinking Process between Death and Life, 1967
Nip pen, ink drawn on tracing paper, both sides
21.1 x 20.9 cm
WI Z 441
Kupferstich-Kabinett, Dresden

302 Carlfriedrich Claus
Untitled, 1967
Nib pen, blue, green, pink and yellow
ink drawn on tracing paper, both sides
7.2 x 10.4 cm
WI Z 433
Hans Grüß

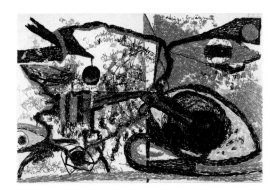

303 Carlfriedrich Claus
Sketch: Consideration, 1966
Nib pen, black and red ink
drawn on tracing paper, both sides
14.2 x 20.7 cm
WI Z 423
Galerie Gunar Barthel, Berlin

304 Carlfriedrich Claus
Consonant Isle, 1967
Nib pen, black, brown ink
drawn on tracing paper, both sides
4.3 x 6.4 cm
WV Z 443
Galerie Gunar Barthel, Berlin

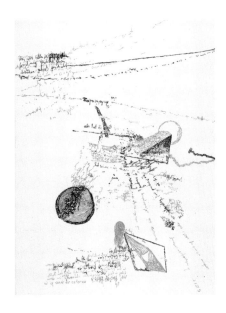

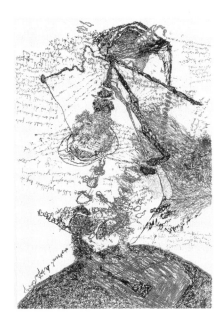

305 Carlfriedrich Claus
On Objectivization of Bioinformation, 1969
Nib pen, black and black-brown ink
drawn on tracing paper, both sides
21 x 14.8 cm
WI Z 497
Galerie Gunar Barthel, Berlin

306 Carlfriedrich Claus
Anti-contemplative Meditation, 1969
Nib pen, ink drawn on tracing paper,
both sides
21 x 13.9 cm
WI Z 502
Dr. Karl Fritz, Annaberg

307 Carlfriedrich Claus
Psychic Situation Reflected in Eyes, 1969
Graphite, pen, black and black-brown ink,
manually blurred on tracing paper, both sides
29.3 x 20.9 cm
WI Z 490
Kupferstich-Kabinett, Dresden

308 Carlfriedrich Claus
Untitled, 1969
Graphite, nib pen, ink drawn on tracing paper,
both sides
10.5 x 8 cm
WI Z 509
Galerie Gunar Barthel, Berlin

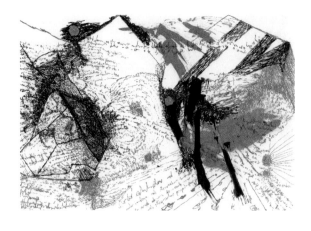

309 Carlfriedrich Claus
*Conjunctions, Unity and Struggle
of the Opposites in Landscape,
referring to the Communist
Problem of the Future:
Naturalization of Humans,
Humanization of Nature,*1968
Nib pen, brush, ink drawn on
tracing paper, both sides
20.5 x 29.1 cm
WI Z 459
Galerie für zeitgenössische Kunst,
Leipzig

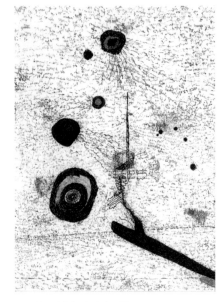

310 Carlfriedrich Claus
*Sensitivity as Source of Friction.
(In Memory of My Mother),* 1969
Nib pen, black, brown and blue ink drawn
on tracing paper, both sides
29.5 x 20.8 cm
WI Z 494
Kupferstich-Kabinett, Dresden

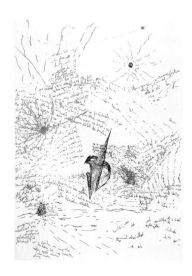

311 Carlfriedrich Claus
Untitled, 1970
Nib pen, ink drawn on tracing
paper,
both sides
21 x 14.7 cm
WI Z 524
Galerie Gunar Barthel, Berlin

288

Reading Carlfriedrich Claus's Sprachblätter

1 The first exhibition of his complete oeuvre was in 1990, entitled *Carlfriedrich Claus. Erwachen am Augenblick. Sprachblätter*, ed. by Klaus Werner, with commentaries by Carlfriedrich Claus and a catalog of his works, exhibition catalog, Städtische Museen Karl-Marx-Stadt, Westfälisches Landesmuseum für Kunst und Kulturgeschichte (Münster, 1990).

2 "The most exact autobiography, because 'written' involuntarily and simultaneously, can be deduced from my works since the early 1950s. The contests and interactions in my life of experiment with papillae lines are expressed in these works directly, are "there". An experimental existence in experimental work: the conditions under which they take place are contained in the results. Presence" Carlfriedrich Claus. *Denklandschaften*, exhibition catalog (Institut für Auslandsbeziehungen, 1993), 125 (includes the most comprehensive biographical data to date).

3 Cf. *Schrift und Bild*, exhibition catalog, Stedelijk Museum Amsterdam; Kunsthalle Baden-Baden (Frankfurt/Main, 1963).

4 Carlfriedrich Claus, "Sicht-, hörbare Phasen umfassenderer Prozesse. Notizen zu franz mon, artikulationen", in *nota* 4/1960, 42 ff., reprinted in *Claus*, exhibition catalog, 1990, p. 88, cf. note 1.

5 Cf. *Claus*, exhibition catalog, 1990. For details on the *"Lautprozesse"* cf. Christian Scholz, *Untersuchungen zur Geschichte und Typologie der Lautpoesie*. I-III, (Obermichelbach 1989), part 1, in particular 259-266; Scholz, "Anmerkungen zum lautpoetischen Schaffen von Carlfriedrich Claus", *Claus*, exhibition catalog, 1990, cf. note 1, 52-58; Klaus Ramm, "Kehlwelten. Schreiblandschaften", *Claus*, exhibition catalog, 1993, cf. note 2; Ramm, *Die Stimme ist ganz Ohr. Radioessay zu den Lautprozessen von Carlfriedrich Claus*, Bayerischer Rundfunk, 1993.

6 Carlfriedrich Claus, *Notizen zwischen der experimentellen Arbeit - zu ihr* (Frankfurt/Main, 1964) 17; reprinted, *Claus*, exhibition catalog, 1990, cf. note 1, 106.

Everything in his oeuvre is a sign, is of fundamental significance. His is a highly complex work resulting from a continuous and exhaustive research effort, thus it is not easily comprehensible. Yet whoever penetrates the cryptic depths of this realm of script, speleologically, as it were, will be able to decipher messages of great intellectual clarity.

The official representatives of cultural policy in the GDR treated Claus's work with a total lack of understanding, so that for decades he was defamed and sometimes kept under close observation. Even in the 1980s, as his growing importance abroad gradually forced them to acknowledge his achievements, he was still a source of great irritation to certain functionaries.[1]

Claus is an artist, though he does not like to call himself one, and a scholar. As such, he personifies the polyhistor, a species rarely found today. Sometimes he retires for months into isolation, the isolation of the self, in order to create and preserve that "thought atmosphere", that fragile stillness he requires during phases of intense concentration. Yet the image of the remote thinker (preferably ascribed to Germans) in the dusky quiet of his cloister, a kind of Jerome in his study chamber, is not applicable to Claus. On the contrary, he has always paid close attention to social processes and already had links with the international art scene in the 1950s through his correspondence with Ernst Bloch, Will Grohmann, Daniel-Henry Kahnweiler, Raoul Hausmann, Michel Leiris, Franz Mon, Pierre Garnier and others, a fact that also helped him to strengthen his powers of resistance to the psychological pressures imposed on him by the authorities of the time.

It would indeed be an attractive undertaking, though not at all one he would approve of, to describe Carlfriedrich Claus's life, the merciless regime he has imposed on himself, often regarding both his body and soul as instruments of his experimental work, his whole poetic existence. More than any other artist, Claus retreats behind his work.[2]

In the early 1940s Claus first came into contact with the works of Kandinsky, Klee, Picasso, El Lissitzky, and other artists of the classical modern era condemned at the time as degenerate, in books owned by his parents. Yet although he was fascinated by them, his creative beginnings were not so much in the fine arts as in experiments with language, which he got involved in around 1951 and which form the basis of the special status he

holds as regards Visual Poetry — even though he has been ranked among the avant-garde of that international movement since 1963.[3] The fundamental uniqueness of Claus's work lies in the fact that from the very beginning his experiments with written language went hand in hand with experiments with spoken language. Often his non-semantic scriptural traces constitute visual analogies to his *Klangtexte* or tonal texts.

As his early Lautgedichte or tonal poems illustrate, Claus did not imitate the trends of neo-dadaist Lautpoesie prevalent at the time in the western countries. His *Lautprozesse* were not first set down in writing, but emerged orally. His *Denkgänge* or thought walks, undertaken between 1956-58, were outdoor experiments involving speaking aloud and screaming, and making body contact with the ground. On the basis of the feed-back thus achieved, more intense relations with natural elementary processes, new kinds of emotions emerged that released the unconscious. At that time Claus was also inspired by the corroboras of the Aborigines which entailed "primarily 'tonal poems'". His early phonetic experiments aimed at releasing language from its semantic bonds also found confirmation in the "'non-articulated' cries that spur ecstasy in the Shamans of Siberia or Mongolia, and in the meaningless series of sounds, the murmured formulae of Lamaist meditation ...".[4] In 1959 Claus recorded these experiments on his legendary tape full of "multi-layered articulations and dynamic co-articulations that cluster and isolate: 'spiritual speech exercises'". Here the transition was fulfilled from *Klang-Gebilde,* sound structures, to emotional *Lautprozesse:* tonal processes in which Claus created an evocative tonality that sounds up from the depths of the unknown or the "no longer conscious", as if out of a lost realm, the realm of the archaic. Through his self-experiments he became aware of the fact that beyond the "semantic threshold" sounds send out their own messages.[5]

Concurrently the artist also realised that script not only transports information but itself sends out signals, back to the brain's speech centre. In a treatise in which he subtly examines these speech-writing experiments, reconnoitring new terrain in the fields of psycholinguistics and the philosophy of language, Claus reflects on the discovery "of a fundamental clash, a basic struggle or battle between the intellectual speech that I allow to wander around inside me ... and the precipitate, speech turned into writing. For this precipitate not only stimulates thought ... it suddenly radiates purely graphic signals back to the cortex, signals that battle to enter into liaisons with one another, above and beyond the existence that has been quasi forced upon them as phonetic-semantic vehicles."[6] In the end, Claus realised, this linguistic figure gave birth to its own contradiction,

7 *Buchenstäbe? Nein –: Darstellung einer Vokal-Konsonant-Verbindung vor dem Atemstrom*, color illustration in *Claus*, exhibition catalog, 1990, cf. note 1, pp. 100 and 101.

8 Cf. *Claus*, exhibition catalog, 1993, pp. 131f.

9 Cf. *Claus*, exhibition catalog, 1990, note 1, Z 142: "Rel. to verso concealed by mont. The artist's documents give the title: *Asche ihre Hand Regen ihr Auge blickt her aus Auschwitz Regen immer Asche.*"

10 Cf. *Claus*, exhibition catalog, 1990, Z 146 and Z 147.

11 *Claus*, exhibition catalog, 1990, Z 202. See also Carlfriedrich Claus, "Die Vibrationen im Klangbilderraum" in *movens*, (Wiesbaden, 1960) 76, reprinted in exhib. cat. 1990, p. 91.

12 *Claus*, exhibition catalog, 1990, Z 200.

13 *Claus*, exhibition catalog, 1990, Z 274 and Z 275.

14 Claus, "Sicht, hörbare Phasen ...", 43.

15 *Claus*, exhibition catalog, 1990, Z 273, Carlfriedrich Claus, *Diary*, 3.4.1970.

16 Claus's particular fascination with the phenomenon of papillae lines — the fact that there are no two people with the same lines on their fingers tips, that matter produces very simple forms that are never repeated — dates from his childhood and his interest in criminalistics. Later, this phenomenon of the papillae became central to Claus's philosophical thought. Implicit in his use of the term is the astonishing assumption that our identity, our subject, is more present in the papillae lines (also in the voice), "in the constant and demonstrable personal code of the cells in general, that is to say, in the 'genetic fingerprint'", than in consciousness. Indeed probably the whole human body is more subjective than consciousness. Cf. Carlfriedrich Claus, letter to N. and A. Arias-Mission dated 15.10.1988 in *Aggregat K*, reprinted in *Zwischen dem Einst und dem Einst* (Berlin, 1993) 61.

17 "Carlfriedrich Claus", Henry Schumann, *Ateliergespräche* (Leipzig, 1976), 28f.

namely, a tendency towards purely graphical figure formation.

As early as the mid-fifties, Claus had already conceived of the self-materialisation of spoken language. In his view, language constitutes itself as an independent objective construct during the speech process. It materialises through the "tongue as its shapes the stream of breath". For the forms that emerge during this process Claus found such poetic metaphors as "breath tree", "breath growths", and "breath being". He also made several attempts to render moments in the act of speech visible in drawings.[7] Thus it was quite consistent that in 1982 in Leipzig (in his *figura 3 zyklen*) the artist combined an exhibition of four of his *Sprachblätter*, or language sheets, entitled *Bewusstseinstätigkeit im Schlaf* (Activity of consciousness while sleeping) with the premiere of a tonal process by him of the same title.[8]

At the same time as his "spiritual speech exercises" Carlfriedrich Claus also devised a heterogeneous world of script and signs. From the typography of the letter-fields produced with the aid of a typewriter and the acoustics of the spoken sounds, he advanced to a psychographic form of writing in which the written signs often dissolve into illegible non-semantic abbreviations that form themselves into independent structures, as for example in *Azurgedicht* (Azure Poem) or *Erinnertes Gedicht eines jüdischen Mädchens* (Remembered Poem of a Jewish Girl, 1959; fig. 290, p. 285).[9] One motivation for the latter work was undoubtedly the memory of Jewish friends to whom the Claus family had stayed faithful during the NS era with the result that they were thus put under enormous psychological pressure. Though still a child, Carlfriedrich Claus began to learn Hebrew then and became absorbed in the Lurianic Kabbala, to which he has constantly returned throughout his life.

Claus also integrated natural forms into his drawing repertoire. His *Steindistrikt* of 1958, for example, embraces the inorganic in the form of a fine-grained crystalline structure. However, he inclined more towards the living, the organic, and was particularly stimulated by the unusual morphology of lichens, as reflected in the circular structures of his *Lichensätze*.[10] Between 1959-1961 Claus wrote numerous, mostly non-semantic vibration texts in which the circling movement of the planes and strands of script create a dynamism. Here the sheets are densely covered with characters, producing an oscillating effect. This is particularly evident in his *Textvibrationsstudie (Versuch der Herstellung eines Feldes)*[11] (Textvibration Study (Experiment to create a Field), fig. 288, p. 284) and in *Der Beginn (der Thora)* (The Beginning (of the Thora)) the whole surface of which is filled by the six tiny angular characters of the first Hebrew word of the Thora (Bereshith: in the beginning).[12] By contrast, the work *Ha*

Shem (the name), written in black and red ink on both sides of a transparent sheet, is based on horizontal layers in which the word is constantly repeated and the letters shifted. *Studie: Die Namen* (Study: The Names, fig. 287, p. 284) also belongs to that same intellectual world.[13] Claus's remark about the Kabbala has a bearing on his own work: "The individual Hebrew letter, here sound is the essential creative force (Sefer Yetzira = the book of cosmic cycles)."[14] In Jewish mythology, which Claus views from an atheist standpoint, as in the written Hebrew language, and particularly in the letter mysticism of the Kabbala, Claus discovered traces of a utopian surplus, an anticipation (in Ernst Bloch's sense) which he tried experimentally to expand into psycho-physical realms. His comments on *Hebräisches Alphabet im Athbasch-Aspekt* (1962) illustrate this clearly.[15]

Driven by lingual thought impulses, and with a highly trained hand, Carlfriedrich Claus allows traces of script to descend onto the ravenous white where they mingle and coincide, or cluster together to form word nests, rhizomes, configurations, or a dense black flow creating a turbulence of papillae lines, as in *Erscheinungen from the Word 'Wasser'* (Erscheinungen aus dem Wort "Wasser") (1967) in which it is possible to make out indistinct faces. Other sheets too contain linear papillae structures.[16]

From the text (textus = fabric, mesh) that he weaves with his brush emerge fine-limbed "Insekten-Buchstaben" (insect letters) or individual legible words, some in Hebrew, some in Chinese. Within the respective complex realm of relations, these have a directly semantic function, as do the iconic signs of for example the hands and the eyes, which, depending on their form, signal either meditation or strength of will and purposeful concentration "Willensenergie-Konzentration". Between 1978-82, the eye recurs in many different forms in his complex of *Karate Sheets* (Kara-te-Blickbewegungen, Kara-te-Introspektion etc.).

Many have been inclined to see Claus as preoccupied with the *écriture automatique* of the surrealists, especially as he often stretched script to the limits of the psycho-grammatical and the legible through his emotive propulsion and rapid acceleration of the writing impulse or else through his obliteration of existing configurations by means of a finger dipped in ink. Yet his works have little to do either with psychic automatism or with purely informal art. For even during the exhilarating processes, which in his case are always imbued with lingual thinking, Claus works in a highly conscious manner and with a determined will. Even in those instances in which he rebelliously crosses out or destroys a fine, visually stable structure in a matter of seconds, this happens deliberately and can be substantiated semantically. In this context, Claus once said: "I concentrate solely on the content, the process of its formation, its multi-layered

18 Cf. Claus, *Notizen,* note 6, passim.

19 *Claus,* exhibition catalog, 1990, note 1, Z 247, note by Carlfriedrich Claus: "A happy day yesterday: the birth of the first being made up of fore- and background, recto and verso! The prospect of further developing this 'occult' method is fantastic! Inclusion of time as a constitutive element: suddenly there emerges from the other side: a Janus figure, ethereal being: disappears again - but still: remains visible."

20 Carlfriedrich Claus, *Historische Allegorie* (Prag, 1963), reprinted in *Claus,* exhibition catalog, 1990, Z 336, this also includes a later note by Carlfriedrich Claus.

21 *Claus,* exhibition catalog, 1990, comment on Z 334. At that time, cybernetics was being hotly debated in the GDR and rejected by the dogmatic Marxists. By contrast, Claus pursued Georg Klaus's theory in depth. Cf. *Kybernetische Reflexion* (Cybernetic Reflection) (1963) in *Claus,* exhibition catalog, 1990, Z 341. Also Claus, *Notizen,* 8.

22 Albert Wigand (1880-1978), an artist ignored for decades, was highly regarded by Claus, especially for the simple poetry of his paintings. Thanks to Claus, Wigand made important contacts in the early 1960s with a small circle of artists and art lovers in Dresden.

23 *Claus,* exhibition catalog, 1990, cf. note 1, Z 398, pp. 210-211; also in Carlfriedrich Claus, "Texte zu Sprachblättern" in *Aurora - Sprachblätter Experimentalraum Aurora Briefe* (Berlin, 1995).

24 *Claus,* exhibition catalog, 1990, "articulation of the forms by human hand capturing, perceiving, embracing, consuming the light that breaks out of tradition those of the past and the future but whence suddenly this extension into the boundless, the flood before the light, the undecided macro- and microscopic, the tohu-bohu of that intertwining that is distress in the face of the 'tehom' for who we are is articulated in the stars in the iris, the flow of the jordan in the body visible of what category the dawn the cellular electricity the paths that the iris weaves out of the non-homogenous light and water, light leaped through the watery word the path that separates light from dark defining the one by the other appears each second anew and different the path of the rays of sight links dream taking the opposite and straight path of the rays of sight continuing the structure of what was begun a leap of expectation in which each movement of the hand is fixed."

dialectical emergence as a visual field of tension, that is to say, on its disappearance, its multiple destruction. It is natural that within a phase of negation, negative emotions of great intensity often well up."[17]

Claus is also not to be associated with so-called scriptural painting or with artists such as Georges Mathieu or Cy Twombly, whose writing on pictorial carriers has to do mainly with self-expression through rhythm and gesture and evades recognisable messages. There are similarities between his work and Henri Michaux's psychedelic drawings and Mark Tobey's fine linear webs, but these are of a purely formal nature. The main distinction between his work and theirs is its emergence from a lingual thinking that is always directed towards fundamental socio-utopian goals. For this reason it is difficult to compartmentalise him among the tendencies in contemporary art.

Claus has provided precise descriptions of those chance finds and border-crossings that have contributed to the development of his *Sprachblatt* (language sheet).[18] For example, his realisation that when using his left hand (as a right-hander) his psychic reactions changed, giving rise to productive inner tensions. On the basis of this, he developed his process of two-handed writing and writing in reverse. In 1960, when he turned transparent sheets over and continued writing on the verso, Claus was quick to notice the "auto-active effect the verso structures had on the recto, and vice versa". This "exciting possibility of a dialectic specifically immanent to the page" led to the fully fledged form of the *Sprachblatt* with its four aspects: recto, translucency of the recto, verso, translucency of the verso. The first time he deliberately used the transparency of the sheet for the overall optical composition of a work was in 1961.[19] This new procedure quickly led to a significant broadening of his thematic range. The wonderful but unfortunately lost work *Paracelsische Denklandschaft* (Thought Scene According to Paracelsus) is a case in point: a mesh of translucent arteries and microcrystals that are easily associated with mountains and plants. It is an iconic work in which Claus touched on central areas of his philosophical thought, principally, the Archeus-Vulcanus problem contained in Paracelsus' teachings about nature. Encouraged by Ernst Bloch, this was something he returned to again and again, reflecting on the possible existence or emergence of unknown forms of consciousness in inorganic matter (mention ought to be made in this context of the important work *Embryo-Blick aus Gestein*).

Claus's attractively opulent *Historische Allegorie: Prag* (Historical Allegory: Prague, 1963; fig. 289, p. 284), with its almost topographic appearance and its recognisable pictorial signs, displays an extremely wide allegorical range. His own commentary on this work offers orientation in reading the wealth of events and ideas it contains.[20] In the Middle Ages, Prague was one of the most important centres of medieval Jewish mysticism (Rabbi Loew, Avigdor Kara), on which Claus reflects in several of his works, among them the 1963 *Notizen zum Golemproblem, aufgefasst als Probleme einer subjektvermittelten Kybernetik. Oder: angedachter Aspekt der antizipatorischen Chiffre Sepher ha-Jerira* (Notes on the Problem of the Golem, Seen as a Problem of Cybernetics Transferring a Subject. Or: An Aspect of the Anticipatory Code Sepher ha-Jerira).[21]

In traditional use, allegory is a graphic rendering of concepts that in themselves are non-intuitable, so-called abstractions, and serves dry academic art and the emblems of power. Claus, however, uses it as newly defined by Ernst Bloch: not as static and intact but as a flexible, open form. In Claus' work the allegory encounters its utopian function.

A key work in Claus's oeuvre is the 1965 *Sprachblatt Allegorischer Essay für Albert Wigand. Ein kommunistisches Zukunftsproblem: Naturalisierung des Menschen, Humanisierung der Natur* (Allegorical Essay for Albert Wigand. A Communist Problem of the Future: Naturalization of Humans, Humanization of Nature, fig. 298, p. 286).[22] In this work a pyramidal stereometric form clearly emerges for the first time, rising up out of the landscape and symbolising the rocky, the mineral, that is to say, the inorganic in the realm of Nature (this is even more striking in the crystalline Spinozan world of his 1972 *Entstehung einer Denklandschaft,* Development of a Thought Scene). The swelling, tumescent forms made up of condensed non-lexical script (similar to swarms of insects that in several other sheets function as metaphors for the vital energy of the subject) signify organic, breathing material or human consciousness. One experiment which in Claus's view was still pending, was to mediate between these two forms of material existence. As indicated by the precise title of the work, the artist is primarily concerned with the possibility of resurrecting nature, in reference to a problem dealt with by Ernst Bloch. In a commentary that puts a pronounced form on his world view, Claus establishes (here in brief) that only a future nationalisation of the conditions of private property could reverse man's possessive aspirations towards nature and with them the threat to our environment.[23] Thus before the emergence of the ecological movement promoted by the Greens, Claus had already turned his attention to today's merciless exploitation of the earth's resources. Claus has prefaced his commentary with a piece of poetic prose, the fruit of a reading of the completed sheet that in its disjointedness links what is otherwise very much separate.[24] The commentary as a whole concludes a utopian vision.[25]

As of 1963 Claus's traces of script begin to con-

25 *Claus,* exhibition catalog, 1990, "Resurrection of nature, of the universe, on a planet turned communist, earth, ought to have a place in the human brain which forms a conscious union with the impulse centre of the heart. Man-nature-machine-man-symbioses, a radically new technology and industry might then be achieved, which does not just conceive the whole earth as merely the basis of life but also transforms it into a complex body of insight and action in the universe."

26 Illustration in Schumann, 35.

27 "But even during the spiritual exercise, after a hypnotic rigidity, catalepsy, the motor linguistic figure sets out in anticipation: as reality, which, more real than unbroken reality and now almost with increased potency, disintegrates, breaks several more times. The fugal, peripatetic world of language, psychic fauna, and on the walls and in caves with other windings, mental fauna appear — animal upon animal out of a poisonously shimmering fine film of verbal stimulants, sense membrane, schlieric half decomposed shreds of meaning, crawling. Infernally obdurate, faltering now, the otherwise so lithe and supple second signal system ..." from: Claus, *Notizen,* 15.

28 "One tries with all one's limbs to enter into the sentence; yet in moving into it, one is moved by it, into the finest and crudest bodily extremities and beginnings; through and through, right to the very skeleton, one is excited by that which excites. This spiritual exercise, an anti-contemplative meditation, a pensive, space-shattering and space-forming dance of all the limbs, bones in the word, is the start of the real experiment: the start, then the departure of the life-like information vehicle from the semantic gravitational field into a free intermediary floatation with observation and reading possibilities from different vantage points of meaning; or else: departure, floatation and entry: into the purely graphic or tonal gravitational field." from: Claus, *Notizen,* cf. note 6, p. 15, reprinted in *Claus,* exhibition catalog, 1990, cf. note 1, p. 105.

29 Schumann, 32.

30 Schumann, 29.

dense into surreal-like shapes that conjure up animal beings, as in the highly expressive *Nach der Schlacht bei Frankenhausen, nach Thomas Müntzers Tod* (After the Battle Near Frankenhausen, After the Death of Thomas Müntzer).[26] Out of the "scripturalchemic mass" grow creatures like birds-of-prey, "mental fauna" — a process the artist once attempted to render in forceful language.[27] Anthropomorphic features appear in the form of masklike faces, rarely as full figures, as in the *Antikontemplative Meditation* (Anti-contemplative Meditation, 1969; fig. 306, p. 287). Here we see an eccentrically vibrating skeleton that casts a shadow and radiates script particles, as it were, lexical strands. The title of the work refers primarily to a rejection of contemplation as a state of passive expectation. However, the drawing contains reflections of a much wider scope. Friedrich Nietzsche's maxim that one cannot credit a thought in which "the muscles too do not celebrate a feast" is an insight that surely Claus too arrived at. His own the subtle work on the *Sprachblätter* does not take place without the conscious participation of the whole body. In a text elucidating the deeper meaning of the drawing, he speaks of the dance of the limbs and bones.[28] In the 1980s, while still researching the effect of non-verbal communication, the certainly none too robust artist went on to study body action, also aimed at activating latent psychic powers. This found its expression in *Aggregat K* (1985–88). Here, in the *Tanz des Schamanen* (Dance of the Shaman) he achieves a self-emancipatory liberation of the subliminal. The stumbling block of a false consciousness is catapulted away. In this case the artist was also attacking the social stagnation prevalent in the GDR at the time.

It has only been possible here to touch on some of the viewpoints from which the intensely rich work of Carlfriedrich Claus might be assessed. In his prismatic thinking, in his experimental art, Claus reflects not only on aspects of philosophy, history, linguistics, and mythology, but also on several of the modern sciences — something that frightens off not just homo normalis. From his youth he has been preoccupied with the philosophy of Ernst Bloch, in particular Bloch's categories of the not-yet-conscious, the ontologically not-yet-become. Claus was also inspired by Baruch Spinoza, and even more so by the German and Jewish nature philosophers, mystics, and alchemists (Paracelsus and Jakob Böhme). He has also had recourse to the Taoism of Lao-Zi. For Claus, mysticism is nothing stifling and irrational but represents a moment of wakefulness, of enlightenment, in which he beholds "treasures that cry out to be discovered among the mythic rubble". In his eyes rebellious heretics such as Thomas Müntzer and Valentin Weigel represent early "advances into the future".[29]

Whether Claus attempts through unrelenting intro-spection to alter emotions and drives, or to investigate still unknown forms of communication — the "Spirit of Utopia" reigns supreme throughout his whole oeuvre. In short, the idea of a communism lies at the centre of his philosophical thought, revealing itself to him as a distant horizon of expectation, a vision extending into cosmological realms which could one day become reality in the "organo-cosmic azure". In this way he distanced himself considerably from the concept of a dogmatic and vulgarised Marxism, and for this reason too, and not just due to his modernism, certain officials subjected him and his art to discrimination. Immediately after the fall of the Berlin Wall, exhibitions of his works were shown in numerous cities in the Western Germany and he was accorded public honours. However, he was soon confronted there too, from a quite different side, with misconceptions about his work, disparaging comments that culminated in a veritable scandal in Donaueschingen in 1995.

According to Claus, "the Sprachblatt ought not to be 'enjoyed' aesthetically or even non-verbally, it ought to be thought through, i.e., it pursues the aim of impregnating ways of seeing with lingual thinking."[30] In our era of fast visual experiences, however, people are no longer willing to be more attentive towards works of art and to read the accompanying commentaries. The large majority of those interested in art may well be fascinated by the aesthetic appearance of the *Sprachblätter,* but generally Claus's works are not understood. Thus the artist finds himself in a dilemma. One critic wrote that it would be more appropriate not to treat the "Annaberger researcher" in the aesthetic realm, and asked, But where else? One ought to bear in mind that Claus's works are not something out of, or between art and science, but represent a genre of their own.

At present there are enough artists operating in the intellectual space between art and science, and of those who pursue art as anthropology and self-examination. In their case, everything is self-referential and remains fictional. Only seldom do any of them raise the question of the meaning of life. Carlfriedrich Claus has raised this question throughout his experimental work and life. And he even proffers suggestions. What he says in connection with his work *Aggregat K* applies to the greater part of his oeuvre, namely, that its function is to be "a possible starting point for subjective processes in the recipient, who tests it critically by way of self-experiment ..."

Henry Schumann

Hanne Darboven's
Für Rainer Werner Fassbinder (1982):
A Tractate on the Duty of the Artist

In her work *Für Rainer Werner Fassbinder* (fig. 312, p. 297)[1] Hanne Darboven refers to the tension that exists in the relationship between pure art and political involvement, day-to-day politics and historical integration, nationalism and global citizenship, that is to say, between private obsession and artistic freedom on the one hand, and social obligation on the other. The most significant date in this work, October 1, 1982, turns the observer's gaze away from the individual figure of the protagonist and towards the broader historical context. By repeatedly inserting the portrait of an unknown soldier, the artist focuses on that figure who again and again suffers the consequences of a narcissistic lust for power: the "eternal soldier", that historically anonymous yet individual human being.

Cosmopolitanism has been self-evident for Hanne Darboven since her earliest childhood, growing up in Hamburg with a Danish mother in a family that had both international business operations and family connections in Russia, Scandinavia and Great Britain.[2] In 1966, when she was almost 25 years old, Hanne Darboven moved to New York where, left to her own devices, she developed a totally rational art consisting of complicated arithmetic calculations, drawings, and smooth cursive abstract script, devoid of all emotions. With her *Tagesrechnung*, the sum of the individual digits in a date, she finally found a way of illustrating the passing of time in a new and at the same time symbolic and totally rational manner. By the time Hanne Darboven returned to Hamburg in 1969 she had made a second home in New York and had her own circle of close friends there. Several of her later works bear witness to her close attachment to New York and to American culture.[3]

Yet her long stay in the United States and her subsequent regular journeys across the Atlantic also gained her a more precise and painful experience of the particular character of the Germans and the impossibility of escaping their history. Their romantic depth of feeling and their tendency to self-sacrifice had inspired her compatriots to the highest cultural achievements, but had also led to the greatest crisis in their history. Romanticism and depth of feeling are just what Hanne Darboven wishes to avoid in her work. Yet she cannot evade them completely, as she herself is part of them. With the keenest of interest, therefore, she has closely observed the political developments and major social debates in her country: the *SPIEGEL* crisis, regarded by her as the most serious threat to the young German democracy, the student movement that culmi-

nated in terrorism, the nuclear arms race between the superpowers and the NATO twin track decision that gave priority not to disarmament but to armaments, and finally, the Green Movement in which she identifies a romantic irrationalism.

Entangled in the conflict between the "purity of art", to which she feels committed, and her engagement for a democratic, open and liberal society, Hanne Darboven applied herself to a wide-ranging text work entitled *Schreibzeit,* Writing Time. Begun in January 1975, this voluminous work consisting of more than 4,000 sheets has its centre of gravity in the year 1976. After a few additions, it was temporarily concluded in October 1982. In 1995, the work was then completed with the addition of a prologue and epilogue. *Schreibzeit* is constructed like a large rhythmic collage comprising existing texts of different lengths copied down by hand, the pages of a tear-off calendar, and several photographic sections, all documenting the artist's lifeworld and the development of western civilisation. The largest section consists for the most part of uncommentated text passages that draw their expressive force from the way in which they are combined and contrasted.

A brief list of the most frequently quoted authors and the most important text passages — as they turn up for the first time in the work — ought to provide some impression of the unusual artistic, cultural, historical and political breadth and depth of *Schreibzeit:* Charles Baudelaire, Heinrich Heine, Ferdinand Freiligrath, Karl Kraus, Jean-Paul Sartre, Simone de Beauvoir, Alice Schwarzer, Friedrich Rückert, Johann Christoph Lichtenberg, Walter Benjamin, Friedrich Hölderlin, Hans Magnus Enzensberger, Paul Valéry, Arthur Rimbaud, Bertolt Brecht, Mao Tse-Tung, Lao-Zi, Jorge Juis Borges, Rainer Maria Rilke, Pablo Neruda, Rudolf Augstein, Walther Rathenau, Ulrich von Hutten, Gotthold Ephraim Lessing, Otto von Bismarck, August Bebel, Ludwig Reiners, Alfred Döblin, Karl Valentin, Louis Pauwel and Jacques Bergier. Also included are long exracts from the life and work of Henri Rousseau, *SPIEGEL* interviews with Sartre, de Beauvoir, Martin Heidegger, Franz Josef Strauss, Rudi Dutschke, and a female GDR spy who infiltrated NATO, plus *SPIEGEL* reports and essays on the Americanisation of the western world, US foreign policy, German poetry, and a guest appearance by the Chinese national ballet. The texts and notes continually reflect the breach in German history caused by National Socialism while at the same time referring directly or indirectly to day-to-day politics, up to and including the death of Ulrike Meinhof on May 9, 1976.

This monumental compendium is held together by specific central themes that run through the whole work. In the cultural realm, for example, there is the theme of the tension in the relationship between the romantic cult

1 On this work cf. Uwe M. Schneede, "Hanne Darboven", Kasper König (ed.), *Von hier aus,* exhibition catalog, Dusseldorf (Cologne, 1984) 36-40. For more details cf. Hans Dickel, "Hanne Darboven. *Für Rainer Werner Fassbinder; 1982-83.* Concept Art gegen Melodram — Ein Bilderstreit", in *Hanne Darboven,* exhibition catalog, (Kunstraum München, 1988), 5-11.

2 Cf. Ernst A. Busche, "Hanne Darboven: Zeit & Stunde", in *art,* May 1986, 62-69.

3 *New York Diary* (1976), *Sunrise, Sunset, To: New York* (1984), *New York Trucks* (1987), *Birthday Gift — Esquire Diary; Für Leo Castelli* (1987), *New York Movie Theatres* (1988), and *Für Abraham Lincoln* (1989). Her "dual citizenship" is also documented in *Ansichten 85* with parallel images of New York and Hamburg.

of the genius and a rational standpoint, as well as between "pure art" (Paul Valéry) and political tendentiousness — or as Hanne Darboven would say, propaganda art (for example in the work of Brecht or Mao Tse-Tung). In the political realm, the dominant themes are the east-west nuclear confrontation and Franz Josef Strauss' candidacy for chancellorship, understood by Darboven to have been the most serious threat to parliamentary democracy in Germany. The other major themes include the Jewish tradition in Germany and the crimes committed against the Jewish people during the Third Reich, the stigmatisation of everything national and patriotic in history and tradition by National Socialism; and finally, political morality, exemplified in Bismarck, Mao Tse-Tung, Dutschke, and Strauss. Begun with great deliberation and supported by sallies into the Brockhaus encyclopaedia — an extensively consulted source — this compilation of texts developed into a boundless research project, the artist being repeatedly confronted with the heterogeneous traces of her themes. Thus the entry "Salomon" leads unexpectedly from the Old Testament via the women's rights activist Alice Salomon, the writer and volunteer corps member Ernst von Salomon, and the Salomon islands (an entry entailing a brief outline of colonialism) to the recent German past by way of the American occupation after the Second World War. The listing of the Oppenheim and Oppenheimer families offers an overview of the history of the Jews in Germany, which in the figure of the physicist Jacob Robert Oppenheimer and the phenomenon of the atomic bomb again ends with the Second World War. Darboven's use of the encyclopaedia, an achievement of the Enlightenment, is in itself a statement of her intention, the artist's way of referring to the fact that it is above all knowledge that can protect humanity from being politically misused again.

For Hanne Darboven the conservative trends that emerged in Germany around 1980 assumed increasingly threatening proportions. The art scene was overwhelmed by a torrent of neo-expressive painting displaying nationalist themes and myths. The same applies to the later films of Rainer Werner Fassbinder such as *Lili Marleen* (1981) and the postwar trilogy *Die Ehe der Maria Braun* (1979), *Lola* (1981), and *Die Sehnsucht der Veronika Voss* (1981). With these works Fassbinder more or less abandoned his initially educative and emancipatory approach and opted for more popular and opulent Hollywood-style productions. In *Lili Marleen* Fassbinder availed himself of the fascination of fascist aesthetics in a kitschy melodramatic mode without exhibiting the detachment gained by reflection.[4] There had already been a direct link between the artist and her protagonist in 1980: Hanne Darboven had inserted a passage from Döblin's novel *Berlin Alexanderplatz* as a foreword to a

work calling for political watchfulness, *Wende 80*, and again into *Schreibzeit*. For his part, Fassbinder had transformed Döblin's novel into an expansive television series veiled in mythic darkness. In her *Für Walter Mehring* (1980) Darboven again turned to the key terms "fascism", "anti-fascism" and "opposition movement", quoting both Günter Grass, who refers in his *Kopfgeburten* to Strauss and the "guilt" of the postwar generation, and to Bernt Engelmann. In his "Neues Schwarzbuch" Engelmann had provided a detailed account of the "SPIEGEL AFFAIR or presumption in the service of personal revenge". Finally, there had been the growing weight of the Green party, who in 1982 were elected to a state parliament for the first time. On October 27/28, 1982 Hanne Darboven noted with great agitation on the concluding sheets of *Schreibzeit:* "und heute: wieder: das Märchen gegen die Technik — der Pöbel — protest-faschismus unter / mit dem Kreuz — die Öko-gesellschaft-kultur — die saubere Energie bis Bombe — Oho ... Die Protest-schwärmer der Bergprediger: heile Welt — das märchen!!!" (and today: again: fairytales contra technology — the pack — protest fascism under / in the name of the cross — the eco-society culture— clean energy to bomb — Aha ... The sermon-on-the-mount protestniks: an ideal world — fairytale!!!).[5]

With her "Weltansichten" exhibition in the German pavilion at the 1982 Venice Biennale, also mounted on boards as in the case of *Schreibzeit*, Hanne Darboven reiterated her own vision: the late 19th century advertising plaques unfold the cosmos of an intact and peaceful global culture held together by the nation-binding spirit of international trade. With the prologue to her Goethe of 1973, also written around that time, she paid reverence to the shining light of German culture.

It was in this context, and motivated by his death on June 10, 1982, that in the months from August to October Hanne Darboven produced *Für Rainer Werner Fassbinder*.[6] The work consists of 180 individual panels grouped in ninety sets of two sheets. Each panel consists of a blank printed sheet with a white lined inner area and the kind of signal red border used by the news magazines TIME or DER SPIEGEL. Each sheet bears the heading "————: SCHREIBZEIT". Further pages are attached to this blank sheet forming a collage. The work is divided into two main sections each of which has several sub-sections. The first section, made up of 18 double panels and forming a kind of prologue, contains sheets designated as "date texts" with "poems", i.e., the *Tagesrechnungen* or calculations for each day of the year 1982 and the year of Fassbinder's birth 1946, grouped in weeks. First the sum of the digits for the year 1982 is calculated, day by day, from January 1st to December 31st: 1+1+8+2=12, 2+1+8+2=13 etc., up to 31+12+8+2=53. This section is written on letter paper from the Gramercy Park Hotel

4 The publicist and filmmaker Hans-Jürgen Syberberg sees in Fassbinder's work "a Hitlerian aesthetics, born of drug intoxication, the last lurid scream of despair of a corrupt director ..." "... a mixture of Heimat film and war scenario by a porno producer, a down-and-out Hollywood director, a melodramatic postwar genius." Hans-Jürgen Syberberg, *Die freudlose Gesellschaft* (Munich, 1981) 372 and 374. In his own film *Hitler, Ein Film aus Deutschland* (1977), Syberberg uses caricature and collage to create a distance to the film's subject, yet without totally concealing the power of the Nazi aesthetic to appeal and seduce.

5 p. 3362, printed in *Schreibzeit. Hanne Darboven*, exhibition catalog, (Kunstverein Hamburg, 1983), 23.

6 The first date, August, appears with the location "am burgberg" on panel XVIII, page 9 of the calculations for 1946, the second, September, with the location "NYC" on panel IX, page 9 of the calculations for years for 1982. This would suggest that the work was begun in Hamburg. However, according to statements made by Hanne Darboven on 14.3.1997, she began the work in New York. Hans Dickel agrees, cf. note 1, p. 7. The third date, 1.10.1982, is on the green "Burgberg" postcards. The work was concluded in October 1982. Thus the date given by Dickel, cf. note 1, 1982-83, is obviously incorrect.

where Hanne Darboven stays when she is in New York. Then, on ordinary writing paper, the year 1946 is calculated in a similar manner, by day and by week. Coincidentally, the sums of the digits of the two years, from 12 to 53, are identical.

These "date texts" are paired with sheets bearing the heading *geschichtsarbeit,* history work. The upper part of the sheets are occupied by historical postcards, the lower part by cards with a green ground produced by the artist and carrying a photo of a panel explaining the Harburg "Burgberg", which is situated directly beside the house where the artist lives and works. Darboven has publicised her address, Am Burgberg, in many of her works and publications. The panel explains the Burgberg's origins in the Ice Age and its early settlement. The lexical explanation she has placed below it, "Polis, Greek, fortress, city, state", refers to an early form of civilising social order and organisation. The terms "ubiquist"[7] and "patriotism, nationalism, cosmopolitanism, decadence" are printed on the cards, as is the artist's stamp, which she uses frequently elsewhere and which describes the basis of her numerical and arithmetic work: "2 − 1,2; 1 + 1 = 1,2; etc. Written above the 18 cards twice, by hand, in a thick black felt pen is the sentence: *"Schmidt hat meine Ziege nicht gefressen / aber: Kohl frißt sie."* (Schmidt did not gobble up my goat / but Kohl is gobbling it up"), plus in each case the date October 1, 1982. That was the day on which there was a change of government in Germany, from the social-liberal to the conservative-liberal coalition, with Helmut Kohl replacing Helmut Schmidt as chancellor. The goats, which Hanne Darboven had kept since 1971, are a symbol of the binding link between man and nature, an allegory for the unity of the world; their "being gobbled up" signifies an existential threat.[8]

About half of the 18 historical postcards refer to the two world wars: *geschichtsarbeit* begins with *Gruss von der Musterung* (Greetings from the Call-up), a naively arranged pictorial broadsheet with a portrait of Wilhelm II at the centre. Then there are sailors "with their machine guns" awaiting "the command to join the fray", their military equipment and an aeroplane bearing witness to the modernity of their armaments. There is also a portrait postcard of a soldier from the Champagne region, and of a wounded soldier being looked after by medical orderlies, both dated 1915. Finally a French biplane can be seen being raised by a German warship. Militaristic tendencies even in the left-wing camp are referred to in a caricature of a photo published in the right-wing press showing Friedrich Ebert in his swimming trunks and aimed at denigrating the then Reichspräsident. In front of Ebert and his companion, who are equipped with machine guns and other weapons, is a warning sign that reads, *"Wer weiter geht wird erschossen!!!"* (Anyone who advances will be

shot). The legend is also a comment on the Kaiser's megalomania: *"Auch unsere Zukunft liegt auf dem Wasser!!! (frei nach Wilhelm dem Letzten)"* (Our future too lies on the seas —freely adapted from the Last Wilhelm). A picture of Hermann Göring talking to an airforce soldier and a postcard of Göring's house in Obersalzberg shot to ruins broaden the historical horizon to include the Nazi dictatorship, the Second World War, and the defeat and liberation of the German people by the Allies (in this case the Americans).

This military and political panorama is complemented by picture postcards from the Harz region (Blankenburg), Switzerland (the Jungfrau massive) and Japan (Matsushima). However, that even such landscapes renowned for their leisure and recuperation potential are not "innocent"[9] can be inferred from the view of the ruins of Göring's home in the beautiful Berchtesgadener Land, still marked today by having once been monopolised by Hitler and his helpers. A picture of the Graf Zeppelin and Parceval airships above the Alster in Hamburg hints at further ambiguities. A more splendid image of weightless gliding, a greater triumph of human engineering is hardly conceivable, yet the Zeppelin airships were also used for military purposes (Hanne Darboven's hometown was largely destroyed by air attacks in 1943-45). The same applies to shipping: "The Kaiser's new yacht 'Meteor'" is unmatched in elegance and smartness, yet at the same time its owner is the greatest warmonger on the seven seas. A woman in regional costume not only conjures up the notion that everyone needs a *Heimat,* it also indicates that this need can degenerate into sluggish provincialism and apolitical sentimentality, or can be abused by a triumphalist fascist spirit. Finally the 1920s Munich-based department store Hertie (Hermann Tietz) has several associations, with Hanne Darboven's birthplace, with Rainer Werner Fassbinder's main sphere of activity, and with the one-time "capital of the Movement", though primarily with bourgeois trading efficiency, the persecution and murder of European Jewry, and the "aryanisation" of their businesses. Through the link between *geschichtsarbeit* and the datentext:1982, the present assumes great historical depth.

This first section of *Für Rainer Werner Fassbinder* marks out the area between the impartial passing of ahistorical time per se and political and social history, between the present, Greek Antiquity and the prehistorical Ice Age, between neutral technology and its abuse by militarism, between "innocent" landscape and its political occupation.

The main section of the Fassbinder work consists of 72 double panels, and has three points of emphasis. The first is the record on the green postcards of the sums of the digits in the years 1946 and 1982: the sums of the digits of the days are listed individually from "No 1 / 12"

7 On the term "ubiquist" cf. note 1, pp. 7f. Dickel associates the term with the Green movement.

8 Of the three goats, all of which were called Mickey and have since died, one was stuffed and included in Darboven's work *Existenz,* a documentation of her life in the form of brief calendar notes.

9 In his extensive series *Unschuldige Landschaften* the Dutch artist Armando who lives in Berlin, refers to regions stigmatised by Nazi concentration camps. In the case of the Jungfrau massive, it ought not be forgotten that Switzerland's expressly anti-Semitic policy neglected to help persecuted Jews. The Swiss Banks only began to discuss the issue of Jewish money held by them in 1996.

to "No. 42 / 53" and their total values translated into lines of writing which, as they increase in number, render the passing of time visually perceptible. Lines of smooth wordless script also fill the rest of the white sheet, signifying the life lived and the work done by the artist. Inserted in four intervening sub-sections is the text of an essay dated August 1981 by Rainer Werner Fassbinder on his most prominent actress Hanna Schygulla. The text was included in a book published in honour of the filmstar.[10] This extract from the book ends with a short conciliatory postscript by Hanna Schygulla and a list of her films. Alternating with these numerical and textual pages is the most visually obvious and dominant detail in the whole work, the photo of a framed photographic portrait of an anonymous member of the Wehrmacht, appearing twice each time. In this reproduction of the portrait, the black wooden frame introduces a note of mourning so that one spontaneously associates the friendly smiling face of the young man with death. The large number of times the portrait appears transforms the work into an epitaph for the "unknown soldier".[11] The work is rounded off by a five-part epilogue that includes a double portrait of the film director and Schygulla accompanied by the texts "und keine worte mehr — und eine welt noch — tagesrechnung", "schreibe rechnen — rechne schreiben — tagesrechnung (and no more words — and still another world — daily sum, write adding — add writing — daily sum), plus Fassbinder's dates of birth and death.

Fassbinder's text is, above all, a pointer to his extreme egocentrism. He writes primarily about himself and very little about the actress to be honoured. When he mentions her, it is usually in a disparaging way. Correspondingly, the photo of them both used in the epilogue shows the director in front of his star, she behind him.[12] Written in the left-wing jargon commonly used at the time, Fassbinder's text includes a description of working conditions at the drama school in Munich: "Seldom have I ever heard people mocking and ridiculing others so mercilessly." Fassbinder also describes just how much he himself despised his co-players at the Action-Theater and the anti-theater. He lauds the "non-hierarchical conditions" under which they worked, yet his every sentence betrays that he alone had the right and ability to be the dominant, leading figure "because my drive to do something was insatiable (and) ... because the group wallowed in a certain boy-scout bliss ... was pervaded by a relatively brainless and unbridled feeling of somehow belonging together." "The constitution of the direction team (for *Leonce und Lena*) was convenient. It looked good on the outside, but no one impeded me in my work," he remarks cynically.[13]

That Hanne Darboven should dedicate a work to this writer, actor and film director whom she obviously views

with critical detachment, possibly has to do with the fact that originally they had several things in common, which in the course of time underwent changes and finally turned into crass opposition. In the broadest sense, both are members of the "generation of 68". Yet whereas Darboven continues to devote her energies to the cause of improving society in the tradition of German idealism, Fassbinder became overwhelmed by a cynically destructive pessimism. Neither of them had anything to do with the crimes committed by the Germans under National Socialism, yet both suffered because of those acts and their consequences. While Darboven processes the past for the present, linking it into an encyclopaedic global historical context in the tradition of the enlightenment, Fassbinder used the past as a prop for melodramatic tearjerkers. Neither of them have shied away from betraying what is their most intimate to the public — she both in her work *Existenz* (1989), in which she presents her daily private notes from the years 1966-1988, and in her frequent use of photos of her flat and studio; he in his contribution to the film *Deutschland im Herbst* (1977-78). However, whereas her presentation of her experiences, thoughts and sentiments does not go further than brief keywords while she herself retreats behind the things surrounding her, he indulged in an almost obscene kind of self-exposure, revealing his most intimate — especially erotic — obsessions. Both of them have made considerable demands of their audiences, with Darboven challenging their intellect, while Fassbinder confronted them with an oppressive and overwhelming hopelessness. She strives towards the light of insight, whereas he preferred the stultifying darkness. She invokes the spiritual, he relied on the emotional.

These differences were highlighted in January 1983 when Darboven included *Für Rainer Werner Fassbinder* in the presentation of *Schreibzeit* at the Hamburg Kunstverein in such a way as to allow the observer judge Fassbinder's life and work by comparison with her own. When all is said and done, in Darboven's eyes the former utopist Fassbinder is just another example of the vagaries and dangers of that era. *Für Rainer Werner Fassbinder*, therefore, could really only become one thing: a thoroughly ambiguous accolade, an irate obituary.

Ernst A. Busche

10 Hanna Schygulla, *Bilder aus Filmen von Rainer Werner Fassbinder* (Munich, 1981). Lothar Schirmer, the book's publisher, is a friend of Hanne Darboven's and a collector of her works.

11 This portrait of a soldier has been in the artist's possession for some time. It is placed above a depiction of a crucifix at the centre of a large wooden cross. Both cross and photo were integrated in this form into the exhibition of *Schreibzeit*.

12 The cover of the Schygulla book, cf. note 10, shows a scene from Fassbinder's 1978-79 film *Die Ehe der Maria Braun.*

13 A recent characterisation of Fassbinder confirms "his will to power over others" and describes him as "a fat, ugly sadomasochist who terrorized everyone around him, drove his lovers to suicide, drank two daily bottles of Rémy, popped innumerable pills while stuffing himself like a pig ... Gary Indiana, "All the Rage", in *Artforum*, February 1997, 11.

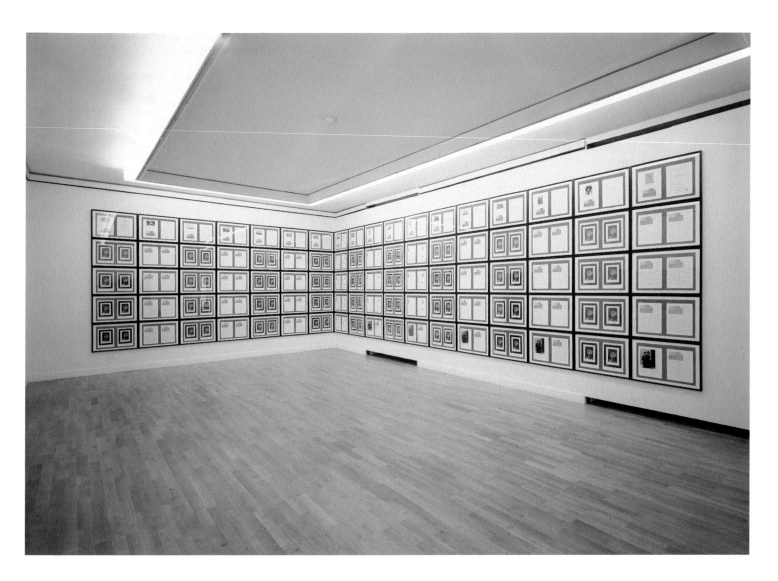

312 **Hanne Darboven**
Dedicated to Rainer Werner Fassbinder, 1982/83
Photographs and handwriting on paper
90 frames, each 50 x 70 cm
Städtische Galerie im Lenbachhaus,
Munich

geschichtsarbeit: heute

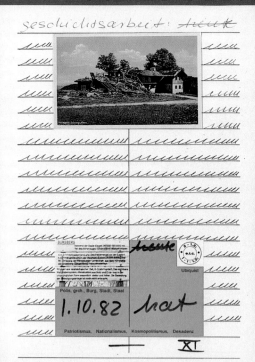

1.10.82 hat

XI

datentext: 1946 heute

index / Jahr: 1946 / Gedichte

7. Gedicht		8. Gedicht	
43. 12+2+4+6 → 24		19+2+4+6 → 31 50.	
44. 13+2 → 25		20+2 → 32 51.	
45. 14+2 → 26		21+2 → 33 52.	
46. 15+2 → 27		22+2 → 34 53.	
47. 16+2 → 28		23+2 → 35 54.	
48. 17+2 → 29		24+2 → 36 55	
49. 18+2 → 30		25+2 → 37 56.	

9. Gedicht		10. Gedicht	
57. 26+2+4+6 → 38		5+3+4+6 → 18 64.	
58. 27+2 → 39		6+3 → 19 65	
59. (28)+2 → 40		7+3 → 20 66	
60. 1+3+4+6 → 14		8+3 → 21 67	
61. 2+3 → 15		9+3 → 22 68.	
62. 3+3 → 16		10+3 → 23 69.	
63. 4+3 → 17		11+3 → 24 70.	

11. Gedicht		12. Gedicht	
71. 2+3+4+6 → 25		19+3+4+6 → 32 78.	
72. 3+3 → 26		20+3 → 33 79.	
73. 4+3 → 27		21+3 → 34 80.	
74. 15+3 → 28		22+3 → 35 81.	
75. 16+3 → 29		23+3 → 36 82.	
76. 17+3 → 30		24+3 → 37 83.	
77. 18+3 → 31		25+3 → 38 84.	

(2)

XI

geschichtsarbeit: heute

1. 10. 82 Kohl

XVII XVII

datentext: 1946 heute

index / Jahr. 1946 / Gedichte

43. Gedicht		44. Gedicht	
295. 22+10+4+6 → 42		24+10+4+6 → 49 302.	
296. 23+10 → 43		30+10 → 50 303.	
297. 24+10 → 44		(30)+10 → 51 304.	
298. 25+10 → 45		1+11+4+6 → 22 305.	
299. 26+10 → 46		2+11 → 23 306.	
300. 27+10 → 47		3+11 → 24 307.	
301. 28+10 → 48		4+11 → 25 308.	

45. Gedicht

45. Gedicht		46. Gedicht	
308. 5+11+4+6 → 26		12+11+4+6 → 33 316.	
309. 6+11 → 27		13+11 → 34 317.	
310. 7+11 → 28		14+11 → 35 318.	
311. 8+11 → 29		15+11 → 36 319.	
312. 9+11 → 30		16+11 → 37 320.	
313. 10+11 → 31		17+11 → 38 321.	
314. 11+11 → 32		18+11 → 39 322.	

47. Gedicht		48. Gedicht	
323. 19+11+4+6 → 40		26+11+4+6 → 47 330.	
324. 20+11 → 41		27+11 → 48 331.	
325. 21+11 → 42		28+11 → 49 332.	
326. 22+11 → 43		29+11 → 50 333.	
327. 23+11 → 44		(30)+11 → 51 334.	
328. 24+11 → 45		1+12+4+6 → 23 335.	
329. 25+11 → 46		2+12 → 24 336.	

(8)

XVII

geschichtsarbeit: ~~heute~~

Jägerbataillon 9
Champagne, Herbst 1915

1. 10. 82 meine

Polis, grch., Burg, Stadt, Staat

Patriotismus, Nationalismus, Kosmopolitismus, Dekadenz

XII

datentext: 1946 ~~heute~~

index / Jahr : 1946 / Gedichte

13. Gedicht		14. Gedicht		
83. 26+3+4+6 → 39		2+4+4+6 → 16	92	
86. 27+3 → 40		3+4 → 17	93	
87. 28+3 → 41		4+4 → 18	94	
88. 29+3 → 42		5+4 → 19	95	
89. 30+3 → 43		6+4 → 20	96	
90. ③1+3 → 44		7+4 → 21	97	
91. 1+4+4+6 → 15		8+4 → 22	98	

15. Gedicht		16. Gedicht		
99. 9+4+4+6 → 23		16+4+4+6 → 30	106	
100. 10+4 → 24		17+4 → 31	107	
101. 11+4 → 25		18+4 → 32	108	
102. 12+4 → 26		19+4 → 33	109	
103. 13+4 → 27		20+4 → 34	110	
104. 14+4 → 28		21+4 → 35	111	
105. 15+4 → 29		22+4 → 36	112	

17. Gedicht		18. Gedicht		
113. 23+4+4+6 → 37		③0+4+4+6 → 44	120	
114. 24+4 → 38		1+5+4+6 → 16	121	
115. 25+4 → 39		2+5 → 17	122	
116. 26+4 → 40		3+5 → 18	123	
117. 27+4 → 41		4+5 → 19	124	
118. 28+4 → 42		5+5 → 20	125	
119. 29+4 → 43		6+5 → 21	126	

③

XII

geschichtsarbeit: ~~heute~~

Auch unsere Zukunft liegt auf dem Wasser!!!
(frei nach Wilhelm dem Letzten)

1. 10. 82 frisst sie

Polis, grch., Burg, Stadt, Staat

Patriotismus, Nationalismus, Kosmopolitismus, Dekadenz

~~VIII~~ VIII

datentext. 1946 ~~heute~~

index / Jahr : 1946 / Gedichte

49. Gedicht		50. Gedicht		
337. 3+12+4+6 → 25		10+12+4+6 → 32	344.	
338. 4+12 → 26		11+12 → 33	345.	
339. 5+12 → 27		12+12 → 34	346.	
340. 6+12 → 28		13+12 → 35	347.	
341. 7+12 → 29		14+12 → 36	348.	
342. 8+12 → 30		15+12 → 37	349.	
343. 9+12 → 31		16+12 → 38	350.	

51. Gedicht		52. Gedicht		
351. 17+12+4+6 → 39		24+12+4+6 → 46	358.	
352. 18+12 → 40		25+12 → 47	359.	
353. 19+12 → 41		26+12 → 48	360.	
354. 20+12 → 42		27+12 → 49	361.	
355. 21+12 → 43		28+12 → 50	362.	
356. 22+12 → 44		29+12 → 51	363.	
357. 23+12 → 45		30+12 → 52	364.	

53. Gedicht		
365. ③1+12+4+6 → 53	1/ I / II	
	2/ III / IV	
2	3/ V / VI	
3 7+6 → No	4/ VII / VIII	
4	5/ IX / X	
5	6/ XI / XII 1946	
	7/ Jahr : 1946 / 12 → 53	
am Ende des	August, 1982	

⑨

VXIII

postdum: 1. 10. 1982 Arente,

postdum: 1. 10. 1982 Arente;

postdum: 1. 10. 1982 Arente,

postdum: 1. 10. 1982 Arente;

Rainer Werner Fassbinder "--- 1981 ---"

Rainer Werner Fassbinder

Hanna Schygulla

*Kein Star, nur ein schwacher Mensch
wie wir alle (unordentliche Gedanken
über eine Frau, die interessiert)*

"Bilder aus Filmen von Rainer
Werner Fassbinder"
Schirmer/Mosel

— 1 —

— 7 —

Rainer Werner Fassbinder "--- 1981 ---"

Erzählen will ich eigentlich vom absoluten Beginn, vom
Kennenlernen der Hanna Schygulla und mir also, den ersten
gemeinsamen Zusammenarbeiten und deren Umständen.
Das meiste läßt sich dann eigentlich im Grunde, mit den
selbstverständlichen, aber gar nicht so großen Unterschie-
den, übersetzen in unsere heutige Beziehung und Zusam-
menarbeit, auch unter dem Aspekt des mehr oder weniger
geglückten Versuchs einer offiziellen Außenwelt, frei ver-
fügbare Chiffren, käufliche Ware aus uns zu machen.
Kennengelernt haben wir uns auf einer der viel zu vielen
Münchner Schauspielschulen, von denen die meisten ledig-
lich zu dem Zweck existieren, die übermenschliche Sehn-
sucht unzähliger Mädchen und Jungen nach den Brettern,
die die Welt bedeuten, zu schüren und sie so in bar auszu-
beuten.
Meine Gründe, diese Schule zu besuchen, und die der
Hanna Schygulla, unterscheiden sich jedoch weitgehend
von denen unserer Kollegen.
Die Bühne, das Theater, Schauspieler zu werden um jeden
Preis, waren unsere Gründe nicht. Schauspielunterricht (der
im übrigen recht teuer, in keinem Verhältnis zu den Ein-
nahmen junger Menschen war, versteht sich), bestehend aus
Sprach- und Atemunterricht, Rollenstudium und einem
Etudenabend, der einmal in der Woche, jeden Mittwoch-
abend, stattfand, wo sich alle Mitschüler trafen, um gemein-
sam etwas zu versuchen, was man sich als freies Improvisie-
ren zu einem vorgegebenen Thema vorstellen muß.
Speziell diese Abende waren Lehrstunden tiefster Ver-
zweiflung einerseits und von brutalstem Sadismus anderer-
seits.

— 2 —

— 8 —

Gedankenstrich (te): heute,

— 69 —

Gedankenstrich (te): heute,

Tage 5 =
Träumung
d)

10+6+8+2 → 26

heute 26

R.W. Fassbinder
† München
10.6.1982

Polis, grch., Burg, Stadt, Staat

Patriotismus, Nationalismus, Kosmopolitismus, Dekadenz

— 70 —

Paintings by Peter Herrmann, Gustav Kluge, and Mark Lammert

Facing the Deceased

"German Art"—what could sound darker? The theme exerts pressure in all directions. It makes indefinite demands of the chosen works and the artists represented by them but also of the viewers who have no way of knowing what is meant: art from or about Germany—or German art, whatever that might be. But the importance of the question is not lessened by the uncertainty regarding answer. Especially now, as the tone of debates about German war guilt, *Wehrmacht* crimes and the Neonazis becomes ever shriller, as do the voices in quarrels surrounding a national Holocaust memorial. The painful question is whether it is even possible for art to reply to the demand for the mediation of an acceptable historical understanding, a demand that essentially goes beyond the artistic sphere. Precisely the discussion surrounding this monument, but also the submissions for it, and finally, the praise for unmasking oneself, arrogantly and ignorantly, as conqueror, shows that artists must urgently ask themselves what it means for art to follow the premises of the politicians rather than its own conscience, its particular and realizable responsibility. It is the question of the justification for using artistic means in the affirmation of totalizing historical constructions, smoothing over insolubility, difference and conflict with memorials of monumental design.

Maybe it is the acute need for awareness that is to thank for the fact that in the exhibition (literally) in question, a number of modern artists are represented who still, and particularly now, in answer to current questions, work in the tradition of panel painting, creating "German art" that distances itself not only from the daily political scene, but also from the modish and the temporal.[1] Among them are Peter Herrmann, Gustav Kluge, and Mark Lammert. These three painters belong to different generations (Peter Herrmann is sixty, Gustav Kluge fifty and Mark Lammert thirty-seven), and went through different schooling in different places and different societies: Herrmann is self-educated, having received his formative impressions in the Dresden Circle surrounding Jürgen Böttcher (Strawalde), and left the GDR in the eighties. Kluge went from East to West as a child, studied in Hamburg and lives there today. Lammert moved to Berlin-Weißensee and there, in his late twenties, experienced the demise of the GDR. For this reason, and others, it may seem inappropriate to consider these artists at one stroke. Yet they are bound by a certain lack of pretentiousness, a rejection of arty chatter, at precisely the point when the problem of the aestheticization of remembrance is at the fore.[2] Thereafter, their respective pictorial languages and thematic worlds diverge.

1.

Peter Herrmann's path to becoming a painter was not as effortless as it is for some others. He studied chemistry, and though he started to paint as early as 1955, he did not start his life as an artist until 1971. However, the constancy, calmness and self-determination of his development can be seen even in his earliest paintings. He fundamentally paints not what he sees but what he holds dear, friends and things, landscapes and interiors that describe an extremely personal milieu and convey "an inimitable flair, of sadness and cheerfulness, of poverty and poetry."[3] Everything brilliant falls away. The apparent naiveté of the object rendering is broken by highly differentiated color, drawn first from basic, earthy tones, later increasingly acquiring surface and light. Herrmann's confrontation with art history, with Giotto, Rembrandt, the Brücke Expressionists, and above all, with French painting, was for him less a source of motifs than of an awareness for formal, disciplined composition and spatial division. Even his use of direct citation is to be understood as a profession of loyalty within the sphere of sanctioned modes of reception.

None of this has changed. *Conversation with Henri Rousseau,* for example, treats French motifs in a series of paintings that is simultaneously a series representing Herrmann's constructed world. The artist's early-discovered images flow into that world, creating yet a third associative chain: from *The Evening* a 1980 triptych, and the 1987 *Berlin Dream* all the way to 1991's *Green Hour,* there are delicate connecting lines, their significance in the relation of life's reality and the reality of art, people and objects, space and surface, unfolding and encapsulation, private and public, all of them coalescing to become "clear and human."[4]

In most of Herrmann's paintings, numerous details (houses, lanterns, stars, lights) flow together, sometimes in confrontation, to become multifarious and melancholy metaphors of big-city life, but the paintings included here, *Death of the Father* of 1987 (fig. 314, p. 305) and the 1988 *The Homecomer* (fig. 313, p. 304), are untypically reductive and introspectively monumental. Each of them is dominated by a figure raised to symbolism, each of them compositionally more commanding and severe than other paintings. Not a hint of the feeling of space is conveyed by the large yellow backgrounds. Like the gold of Gothic representations, they shut out every kind of illusory dimensionality. First, the *Death of the Father,* a father Herrmann was forbidden to see one last time by the "authorities" of the GDR and whom he

1 Carl Einstein, *Die Kunst des 20. Jahrhunderts* (Leipzig, 1988), 7.

2 Cf. Konrad Paul Lissmann's insightful commentary on the aesthetization of remembrance, "Auschwitz als Kunstgenuß", *Freitag* (2/28/1997), 9.

3 *Klaus Werner, Peter Herrmann.* Exhibition catalog, Galerie Arkade, (Berlin, 1981).

4 Bernd Wagner, *"Zwei Augen". Gespräch mit Henri Rousseau.* Exhibition catalog, (Berlin, 1991).

302

Facing the Deceased

could therefore give nothing but remembrance, with mountainous landscapes and a village church of the homeland. Behind it, the dying father. He lies in the cross of a broken, second horizon, his soul rising gently above it. The bedcover juts out as a surface, divided into blue

Gustav Kluge
Amical Neuengamme, 1996
Oil on canvas
200 x 190 cm
Produzentengalerie Hamburg

5 Theodor W. Adorno, *Minima Moralia,* (Frankfurt/Main, 1951) 6.

6 *Gustav Kluge, Eindrehung,* exhibition catalog, Bonner Kunstverein, Kunstverein Hamburg, Badischer Kunstverein (Karlsruhe 1987), 42.

and black squares, frozen fields and meadows, beneath which the father now grows cold. No pillow supports his head. It is pressed against the bed frame, its bars locked into the landscape. Crossing and reconciliation are hindered. All paths are twisted.

As in *The Homecomer* he stands before the Wall, binding his field of movement and pulling him along. To his side, a yellow wall (of color), neither above nor behind, but suggesting a clarified beyond. This "homecomer," a Rodender, pulls the heavy load behind him with a shoulder strap, without advancing a step. It is a plough that refuses to go further and thus pulls the man into a diagonal, forcing him into a balance of seemingly futile exertion. His head, slightly tilted to the left, looks neither forward nor back. Nobody's going home here. Perhaps the figure reflects the rootlessness of the artist or the fetters of a hopeless situation, in any case, desperation. Only the

entire composition reveals the meaning beyond the subjective motivation—the transferal of an inner state to "art" that presents the German condition before the fall of the Wall, at once urgently and subtly, a defiant time, warm deathliness, a delicate and forced balancing act.

It is the personal background that makes the supra personal of the situation visible and believable. They recognize each other in a kind of pain that avoids everything loud, narrative, sensational and sentimental, thus judging not only a certain present, but as painting, the mass-media's vulgar exploitation of images in the floodlights of cameras and border zones.

2.

Similar observations can be made in regard to Gustav Kluge's works. Precisely at the point when the painter refers to concrete, contemporary historical themes—as in his 1984 *Stammheim Duet* or in the paintings *Transport* (1987) and *Escape* (1992; fig. 317, p. 311), the atmosphere, motive, composition and surface structure of his paintings take on a self-centeredness that blocks out everything hasty and sensationalistic, so much so that one might view them as a demonstration of how unnecessary is the attempt of milking often copied subjects for painted intellectualization.

For this reason, Kluge's works are always interruptions of the image stream. They are eventless, almost stiff retorts to everything entertaining. There is nothing in them that can be easily explained. In fact, it is difficult even to describe them. Even in the few comprehensible scenes, the motives are archaic, fallen prey to "faces" searching for origins, motives that can hardly be conveyed. The respective actors are sacrificed to the stranger's gaze in a way that generates more timidity than curiosity. It is the painter's reserve that recalls Adorno's pithy cultural criticism: "Progress and barbarism have become so matted together in mass culture that only barbaric ascetisicm, in opposition to this and the progress of means, is capable of reinstating the non-barbaric."[5]

Kluge's protagonists never make their appearance as the civilians of a dynamic process of development, but as the carriers of existence in a state of "passing predeath,"[6] as he once called it. Correspondingly, his figures are usually naked, free of the markings that would tie them to any certain culture and its attributes. They are charged, mythically loaded, de-individualized, their gestures, bodily positions and instruments represent existential determination, constituted beyond the subjet in color climate, image structure and the concrete constellation of the figures. This frees the painting from the temporal and lends it a validity no longer determined by the original motivation but granting the images their own, ever new motivations.

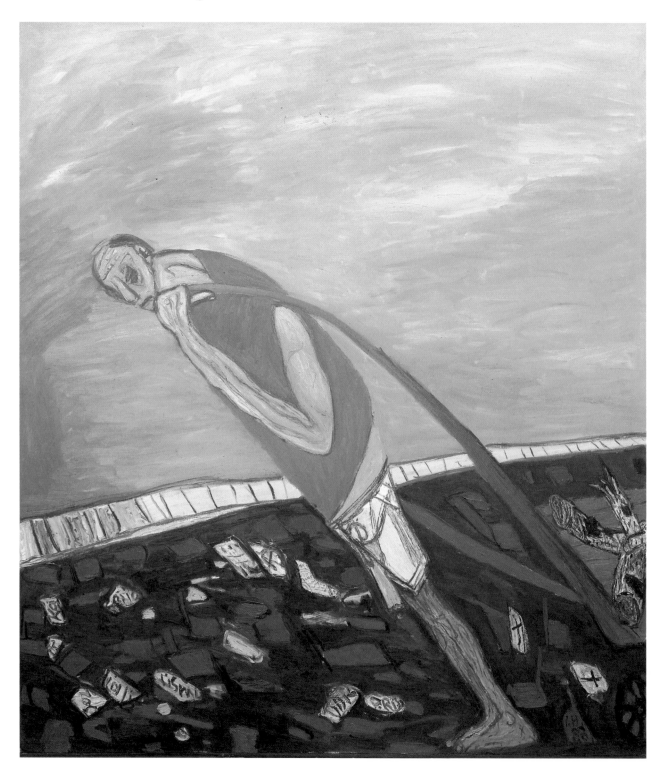

313 **Peter Herrmann**
The Homecomer, 1988
Oil on canvas
205 x 175 cm
Collection of the artist

314 **Peter Herrmann**
Death of the Father, 1987
Oil on canvas
160 x 180 cm
Ludwig Forum Aachen

305

Escape is a work that immediately calls to mind the mass shootings of the Nazis, and so viewed, it is, on the primary level, "German art." But it aims not only to appropriately memorialize horrible events. It is also an image of the inhumanity and ignobility of all mass murder, of the denial of individual death, found in every epoch and which is still occurring today in various theaters of war. Bodies lie horizontally stretched in a grave, some of them already cold, others toppled over in surrender, now and

3.

Another example of ascetic imagery, the intensification of expression and meaning by abstention, are Mark Lammert's *Chins* (fig. 316, p. 309 ff.), a series of etchings which originated in 1993 during the course of several of the Berlin Ensembles' rehearsals. It includes 42 individual engravings, all of them following the same goal—one more analysis of the image's potential. The fact that Lammert applied this thought to none other than the

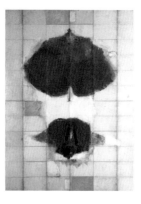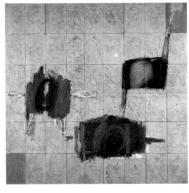

Mark Lammert, *Allied I*
Oil on the back of a map
(Mark Brandenburg), 108 x 81.8 cm
Collection of the artist

Mark Lammert, *Allied II*
Oil on the back of a map
(Russia), 160 x 160 cm
Collection of the artist

Mark Lammert, *Allied III and IV*
Oil on the back of a map
216 x 152 cm and 178 x 178 cm
Collection of the artist

Mark Lammert *Allied V*
Oil on the back of a map
(England), 136 x 105 cm
Collection of the artist

again showing movement. Near the center, a single figure tries to escape the trap, putting his arms on the grave's edge and peering to the side. Success is uncertain. The image doesn't flow. It stands still. It shows not flight but perhaps-rebellion. But it is a costly rebellion, as the fleeing person is forced to trample the dead and the dying.

With this terse representation of misery, Kluge has created a metaphor for pure violence, for violence per se, prying the horrific image of the corpse-filled pit from its historical fixation and raising it to the context of its present. The emotional responsibility of the viewer is mobilized not only towards the past, but in his life right now. The general event, the confrontation with mass death and the reaction of horror and sadness, suddenly tip into a sphere of personal uncertainty and rising dismay, resulting from the viewer's identification with the fleeing figure: the atrocity visited on the victims is made to the atrocity of the victim, the unavoidable process of dehumanization following the figure forced to walk over the corpses with the wish of escape.

Although the painting retains some concrete images, it doesn't release the viewer with a reconciliatory message of distance. One is suddenly pulled into the picture oneself, at the mercy of the terrifying double meaning of "sympathy": "Suffering is to suffer for the sake of consciousness, not for the sake of death."[7] Precisely the refusal to stoop to description, stripping the representation down to an elementary conflict, makes of the German image *Escape* – which it is – a historically anchored, unsettling and oppressive image of the times.

person of Heiner Müller suggests his questioning of the possibility of approaching a famous individual without falling into celebrity worship or monument erection. The difficulties of the problem necessarily led to radical decisions. Lammert rejected all the premises of tradition concerning portraits, premises which he himself had faithfully practiced in earlier creative phases, renouncing oil painting's demands of eternity, the physiognomical description and the psychological interpretation of the face, the representative posture of format, and the gesticular reading of the character. He forswore the dominance of the eye's expressivity and transferred his entire attention to a single point which was now to speak for the whole-the chin, the location of the will.

These portraits are no longer really portraits, but rather ascriptive gestures that arrange the image without wanting to own it. The sketches sign the plates, sowing them with fragile patterns, with the almost despondent trace of the needle. The subtlest approach, evasion, highly technically refined, the opposite of everything that has ever been shown of this man, whose signature black eyeglasses meanwhile fill glossy books.

Similarly, in the series *Alliiert* (Allied)Lammert seeks the unusable image, as it were. *Allied* stands for those basic attitudes determined by consensus, formative of Germany's intellectual climate, crippling political action and bending history into shape. The title takes aim at the technical, intellectual, military and media possibilities that coalitions have at their disposal, coalitions that embody nothing other than the preservation of their own twisted construction.

7 Gottfried Benn, "Provoziertes Leben", *Essays und Reden in der Fassung der Erstdrucke* (Frankfurt/Main, 1989) 379.

315 **Mark Lammert**
January 2, 1996, 1996
Four drawings: charcoal, silver
pencil on paper
each 31 x 45 cm
Collection of the artist

316 **Mark Lammert**
Chins, 1993
8 etchings from a 42-part series
Each sheet 53 x 39 cm
Collection of the artist

Lammert's series, then, would join irreconcilable image worlds with irreconcilable functions in exactly an "all-liiert" (all-aligned), all-attached way. The grid of the back of historical maps is turned to become a formal field organization for new images. The division beneath the topographical objectification unites, back-to-back, with a topographical objectification of sensation-driven analyses of the color red. The maps are, on the one hand, the solid ground of abstraction, for geographical reality made representable. They are raised, on the other hand, to an image basis for the painter, working on the motives of colorful reality that no longer represents anything. The result is a double image in which every view becomes the back of its own back. Each surface impedes on the other with its alliance. The map penetrates the painting with its associative offers of temporal fixedness, for the concepts of the familiar and the foreign, for precision and representationality, the painting blots out the map, insisting on the recognition of its autonomy and refusing all associative diversions. Turned around, the painting obliterates the map's historicity by using its ground as purely aesthetic material with certain color temperature, neutralizing its function of practical foldability and locking it behind glass. The original images point to the intellectual accessability of "Lebensraum", to travel and rambling, to the object of military strategies. The same structure, as an unprimed basis for a painting, resists this with its own color apparatus of imagined heights, valleys and borders. Colors occupy the map, recalling the "raison d'etre" of every map, namely, an aid to conquest, to be decorated with military drawings. Oil and turpentine so thoroughly penetrate the maps that later additions suddenly become the background.

This is the painting of history in its futility. The concept is guided by diametrical alternatives for action, bursting out in bloody red and dissolving into nomadic blotches, beneath which shines the English, Russian or French sun. This series allies art and history, landscape and topography, image and image to an originally separate and all-liiert connection, a connection as lost to the contemporary world as it is to the Germany of today.

Michael Freitag

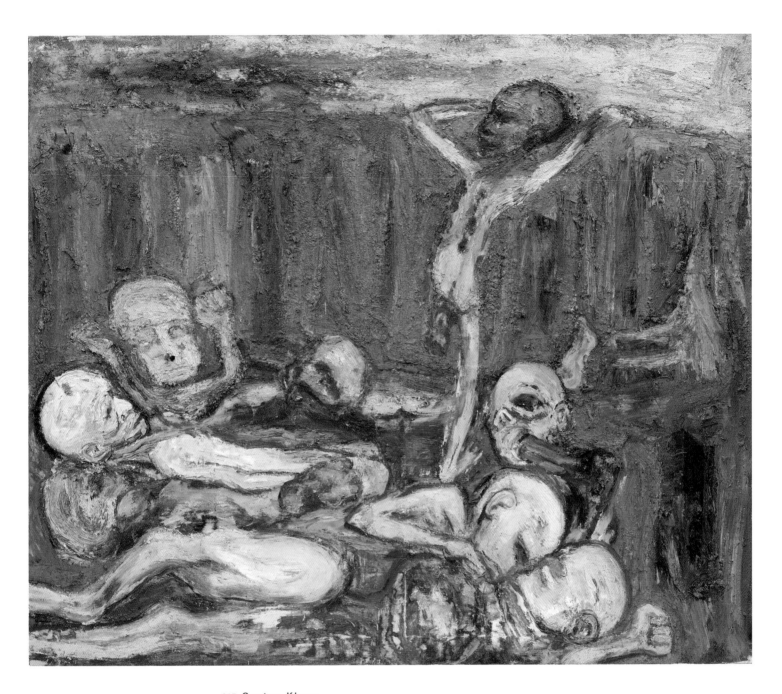

317 **Gustav Kluge**
Escape, 1992
Oil on canvas
195 x 225 cm
Private collection

Gustav Kluge: Stammheim Duet

When Gustav Kluge painted *Stammheim Duet* in 1984 (fig. 318, p. 313), he composed a sign for a dramatic and traumatic moment in German post-WWII history. On October 18, 1977, the hostages were freed from the hijacked Lufthansa aircraft "Landshut" onto the Mogadischu landing-ground and the RAF prisoners Andreas Baader, Gudrun Ensslin and Jan-Carl Raspe were found dead in their prison cells. A movement that had declared war on imperialism and capitalism and became ideologically entangled in terrorism and crime, collapsed along with its three leading members. In a hopeless situation, the three prisoners drew the final curtain themselves. *Stammheim Duet* is a political painting, but beyond that a symbol of personal sympathy for the cruel fate. Kluge's work is not an historical painting in the heroic or mythic sense. It neither glorifies, prettifies, judges nor does it aspire to a documentary account. The painter confronts us with a place and a scene in an unevasive close-up. He compels us to remember something we even then preferred to suppress or did not allow to register at the time it took place.

The site is the High Security wing in the Stammheim Prison. We look from above into a box-like room bordered by walls, which symbolizes the confinement and desolation of prison cells. The accused were sentenced by the court to life imprisonment on April 28, 1977. The proceedings, however, were not yet over, because the attorneys had filed an appeal.[1] In the early morning hours of October 18, 1977, the prisoners' hopes of gaining freedom by blackmailing the State were crushed. The news that the hostage-taking had failed drove them to the desperate act of suicide, which the RAF and their sympathizers however, interpreted as execution. In the painting, the news that the security forces had stormed the aircraft is delivered by a mailman, who resembles *The Sower* by van Gogh. The painting's two main characters, Andreas Baader and Gudrun Ensslin, are not portrayed as in a still photograph, but rather, a course of action is compressed into one single shot. Andreas Baader points the gun at himself and in the second blurred head portrayal he falls headlong, already dead. Gudrun Ensslin hangs herself with the loudspeaker wire, clasping her throat with her long, overdrawn right arm, the green stool already tipped over. In the clustered composition of figures around the vertical axis on the foreground plane – in front of the space of prison cells fleeing into the perspective depth – the painting condenses the process leading to the dramatic moment of transition from life to death. The destructive violence of the suicides is simultaneously summarized by the figures' postures as well as their corpse-like color. The escalation of the event – through time compression and spatial concentration – intensifies the observer's glance into this border situation to the unbearable. The prisoner's radical violence against themselves is the same violence they had directed against State and society.

But what is more, this painting is also witness to another aspect important to the artist. It was shown for the first time in 1984 at the Hamburger Kunsthalle in an exhibition of Gustav Kluge's works on the theme "The Twin Schematic".[2] Just as Siamese twins are bodily intergrown, so appear Andreas Baader and Gudrun Ensslin inseparably unified in an idea. This inner attitude and emotional affinity join them in a communion of fate, leading them together into death. It was a final manifesto in the struggle against the society and political system under which they suffered. They were shattered by the societal reality which they believed, in their fanatical judgement, they could change through terrorist actions. In this way, personal fate in its reciprocal relationship to State violence becomes a political event, evoking outrage as well as sympathy.

The stirring, gripping painting *Stammheim Duet*, created four years before the cycle on the same subject by Gerhard Richter, refutes the doubt, "if national and contemporary history can at all be portrayed authentically by means of painting" (Benjamin H.D. Buchloh).[3] In turn, one can naturally argue about what 'authentic' in this case means. Is this a documentary illustration or a pictorial representation of the event in its entirety? *Stammheim Duet* is certainly not an authentic rendering of what took place in the prison; it is much rather an artistic monument that goes far beyond this kind of authenticity, making us remember and relive the trauma, and mourn.

Günther Gercken

[1] Ulf G. Stuberger, ed., "In der Strafsache gegen Andreas Baader, Ulrike Meinhof, Jan-Carl Raspe, Gudrun Ensslin wegen Mordes u.a.", *Dokumente aus dem Prozeß* (Frankfurt/Main, 1977).

[2] *Gustav Kluge. Das Zwillingsschema*, exhibition catalog, Hamburger Kunsthalle "Standpunkte" (Hamburg, 1984).

[3] Benjamin H.D. Buchloh, "Gerhard Richter, 18. Oktober 1977", *Gerhard Richter, 18. Oktober 1977*, exhibition catalog, Haus Esters, Krefeld; Portikus, Frankfurt/Main (Köln, 1989), 55-59, 56.

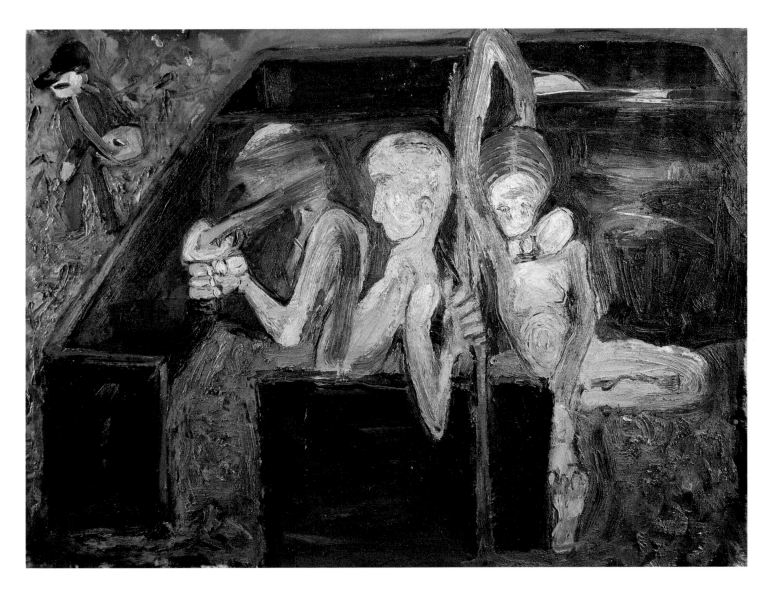

318 **Gustav Kluge**
Stammheim Duet, 1984
Oil on canvas
150 x 200 cm
Annemarie and Günther Gercken,
Hamburg

Rosemarie Trockel
"Mother" and "Father"

Rosemarie Trockel took her participation in a group exhibition in Vienna in 1994 as an opportunity to examine Sigmund Freud's work more closely.[1] She planned a thoroughly critical work for the exhibition based on the early psychoanalytic works. Trockel conceived a "pseudo-identical" position as the point of departure for her work.

Concerning Sigmund Freud, it couldn't be more obvious than to stage a pseudo confrontation and resolution of the family experience, to develop a game in which the object – the relationships to the parents and siblings – offers the most authenticity possible. Rosemarie Trockel researched and prepared with extreme thoroughness in order to rule out the possible sarcasm that could easily arise in connection with her own family history. She took up complex issues hidden within the rules of societal games and generated at once sensitization and irritation with her poetic image formulas. Her intellectual, methodic process provides her with a critical distance to each subject. Although as early as her childhood, Trockel took a more observant, less involved position to her parents and siblings, she was surprised and astounded that she could not maintain the emotional distance she assumed to have during the work on *Family Models*. The confrontation became increasingly self-reflective.

Two sisters, a self-portrait, father and mother: This work group consisted in a total of five works, from which *Father* and *Mother* are shown in the exhibition "Deutschlandbilder". Each individual family member is portrayed by a semi-sculptural portrait head made of plaster and a number of works on paper. Each head exhibits its own archetypical structure which was taken up thematically and varied in the drawings. The sculpture of the *Mother* (fig. 320, p. 317) is the largest and in its dynamic, most dominant in the family group. Its composition corresponds to the idea of a child playing with modelling clay. Rolled, stuck together "sausages" build up the physiognomy of the face, describing eye-sockets and mouth. Individual facial expression is ruled out by what seems to be clumsily finished work. The right eye contracts into a spiral, the left eye remains a simple hole which can be easily penetrated by anything passing by. Structurally, this head evokes the image of an exposed network of nerves, as if its substance consists in brain matter without the protecting skull and skin. The eight additional drawings are arranged in a circle around the central plaster, continuing the theme of the bulging excrescences and the restless, circling movement in the profile and frontal representa-

tion. Horror, helplessness and involuntary comic effect are equally readable in these faces of a woman gone completely out of control.[2]

In his "Studies on Hysteria", published together with Josef Breuer in 1895, Freud differenciated the connection between hysteric symptoms and a necessary, preceding psychic trauma. When a "normal person" is able to correct the memory of a trauma by "putting the facts right, by the individual's consideration of his or her own dignity and the like...", then the patient's memory of these experiences are absent or only exist "in an extremely abridged form".[3] That the patient has not reacted to psychic trauma, is explained by Freud and Breuer in that "... the nature of the trauma rules out the reaction, such as the irretrievable loss of a loved one, or because the social circumstances make a reaction impossible, or because it is about matters that the patient wanted to forget, which he intentionally repressed from his conscious thought, blocked and suppressed".[4]

Trockel's mother belonged to a generation, whose first self-determining phase in life began at a time of excessive demands. The situation of war forced them to confront death and loss. The tragic suicide of her fiancé, who was unable to live with the guilt of having been forced to shoot a deserter his own age, is as much a part of her personal biography as it stands for the collective experience of an entire generation, leading away from the individual history to "Model Mother".

Silence and repression are the two key words to the *Father* group (fig. 319, p. 316). Unlike the works on paper in *Mother*, which Rosemarie Trockel developed in a concentrated action over a few hours, the works comprising *Father* – a 10-part series of gouaches and one drawing – emerged from numerous work steps. It was difficult for Rosemarie Trockel to find access to the opposite-sex parent. At first, the position of the father could only be taken up by the daughter in the form of outward appearance and remained concealed until the end. Thus, the plaster mask of the *Father* is a mask in both senses. The facial characteristics were vehemently smeared away while the paster was still wet. The finger traces remain clearly visible, showing how Trockel had smeared the physiognomy in deep furrows from top to chin. For perception organs, the *Father* is only allowed two holes for eyes and a narrow, scratched-in notch for a mouth – which we notice is not suited to opening. The nose is polished away, a small plateau in its place provides for a blunt profile. Trockel made deep punctures here and there with long nails, mostly around the eyes. The distinct beard is formed 3-dimensionally and lines the lower jaw as insigne of masculinity. The 10 gouaches – Trockel uses this technique only in *Father* from the entire family group – as well as one drawing – take up the semi-sculpture's structural

1 The exhibition was organized by Galerie Metropol, Vienna. The entire installation *Family Models* was seen in the Billy Rose Pavilion of the Israel Museum, Jerusalem (catalog).

2 Edvard Munch's *Scream* from 1893 can be taken to be the iconographc basic formula for the illustration of tormentful insanity. The picture construction is completely based on circling movments, as also seen in Trockel's work.

3 Sigmund Freud and Josef Breuer, "Über den psychischen Mechanismus hysterischer Phänomene" (1893), *Studien über Hysterie,* (Frankfurt/Main, 1991) 33. Translated here from the original German.

4 Freud 34.

handicaps. Eyes, nose and mouth, which as dramatic growths and distortions escalate to absurd, frightening caricatures in the *Mother*, are almost completely missing in the faces of *Father*. In surfaces of watered-down color, the head forms of different types of men are more indicated than carried out. On the other hand, each of them is provided with a recognizable beard. The traces left behind in the plaster in *Father* by Trockel's fingers are repeated in the linear brush strokes in the gouaches and reappear very clearly in the programatic drawing, from which a face emerges from the densely set parallel lines. If a person is concealed behind this structure of lines or if the prison itself has become a person, remains unresolved.

The *Father* has lost his face – a loss of face in the physical as well as the figurative sense. The obscured or flat, featureless heads are clearly incapable as partner in an interhuman dialogue; communication no longer takes place. The complete withdrawal and consequent renouncing of individual needs are the most striking characteristics of the *Father*. His concealment leads to a loss of personality, its representation becomes the only possibility remaining to the daughter. But here also, as in the *Mother*, an involuntary comic effect sets in. The emphasized beards give the impression of being glued-on assertions of virility – ridiculous and gratuitous in faces that have renounced more necessary elements. Rosemarie Trockel's *Father* stands for the state of mind which Freud characterized as melancholic. He suffers from "an extraordinary reduction of his I-feeling, an enormous impov rishment of the ego".[5]

Father and *Mother* represent, in the model forms which Rosemarie Trockel had elaborated for them, the typical pattern of male and female repressive behavior. The female behavior – the penetration of pain increasing unto insanity – can be traced back and found in the mythological and dramatic subjects of Western antiquity. The male pattern of reaction – the inability to deal confrontationally with pain and also with guilt – manifests itself in "heroic" silence: real men don't verbalize.

Wars connect individual fates to parts of a collective basic experience. The possibility of individual reappraisal unfolds in the nonascertainable scale of violence and death. Hannah Arendt's observation that when the Germans talk of the war they experienced, they speak more about a fateful scourge than about an event they caused themselves, elucidates the mechanism of evading confrontation.[6] The possible reevaluation of the disaster of common responsibility in a prolonged catastrophe falls into the (loop)hole sanctioned by society, which also allows the individual to drastically distance him/herself from his/her own experience. In this way, guilt and death

were carried like a virus in a postwar life that had become too quickly normalized by middle-class thinking and passed down mutely and without reflection to their own children.

Based on Sigmund Freud's knowledge, Alexander and Margarete Mitscherlich wrote in their analysis about the nonexistent behavior of mourning in the Germans, of the phenomenon which Trockel vividly defined. "Self-evacuation", a "quasi-stoic" position and the manic compulsion to eliminate all the relics of the past, lead from the easy identification with the victors to the "automatically functioning mechanism of de-realisation". According to the authors, the compulsion of the "manic making undone what was done" made the colossal collective effort of the reconstruction feasible.[7]

Rosemarie Trockel limits her sympathy for the generation of parents. She recognizes their potential to suffer, but also refers resolutely to their inability to confront and come to terms with themselves. The distance she achieved is revealed in the comic accent which resonates in the works *Father* and *Mother*. Through her work, Rosemarie Trockel developed these models of all fathers and mothers out of the awkward child's view of his parents. In this process, her identity as daughter is equally transformed into a representative of her own generation in "Model Daughter." She steps out of her entanglement in powerlessness and avoidance by taking over the task of critical confrontation neglected by her parents.

Regina Schultz-Zobrist

5 Sigmund Freud, "Trauer und Melancholie", *Trauer und Melancholie, Gesammelte Werke*, vol. X (Frankfurt/Main, 1969), 431. Translated here from the German works by Freud.

6 "The average German looks for the causes of the last war not in the deeds of the Nazi regime, but in the events which lead to the expulsion of Adam and Eve from the Garden of Eden." Hannah Arendt, *Besuch in Deutschland* (Berlin, 1993), 26. See essay by Eckhart Gillen in this volume.

7 Alexander and Margarete Mitscherlich, *Die Unfähigkeit zu trauern* (Munich, 1977), 40. Translated here from the German.

319 **Rosemarie Trockel**
Father, 1994
Plaster mask with 11 linear hung drawings
Mask: 39 x 29 x 29 cm;
Drawings: 33 x 28 / 38 x 35 / 43 x 31.5 / 34 x 23 /
40.5 x 30.5 / 51.5 x 37.5 / 35 x 28.5 / 31.5 x 25 /
36.5 x 27.5 / 35.5 x 28.5 / 40.5 x 32 cm
(On permanent loan to the Neue Galerie am
Landesmuseum Joanneum, Graz)

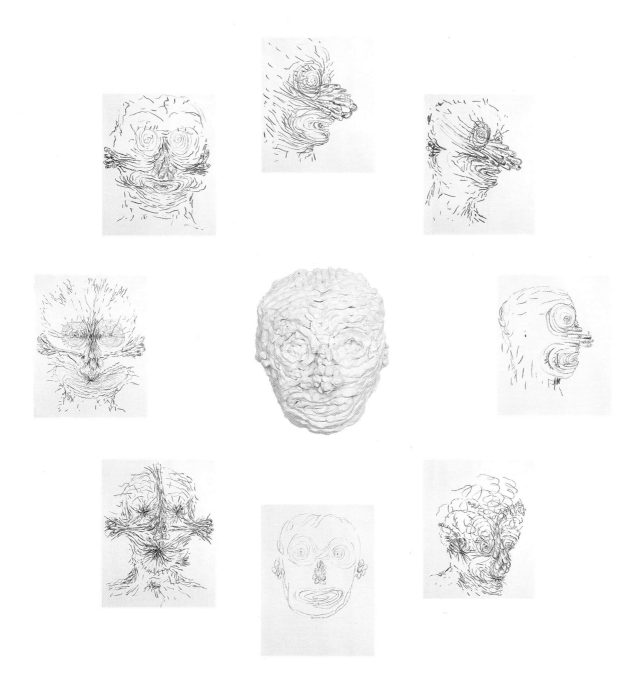

320 **Rosemarie Trockel**
Mother, 1994
Plaster mask with 8 drawings hung in a circle
Mask: 44 x 32 x 27 cm;
Drawings: 3 of 37.5 x 33 each / 40.5 x 30 /
40 x 30.5 / 38.5 x 30 / 38 x 30.5 / 36 x 30 cm
Collection of Dr. Michael and Dr. Eleonore Stoffel

Manet-PROJEKT '74

"PROJEKT '74" was an exhibition billed as representing "aspects of international art at the beginning of the seventies." It was staged in the summer of 1974 by the Wallraf-Richartz-Museum in Cologne (now Wallraf-Richartz Museum/Museum Ludwig), on the occasion of its 150th anniversary. The exhibition reportedly cost more than $300,000. It was promoted with the slogan, "Art Remains Art." The Kunsthalle in Cologne (like the museum, a city institution) and the local Kunstverein (a private institution with subsidies from the city) joined the Wallraf-Richartz-Museum in presenting this exhibition.

Invited to participate in the exhibition, Haacke submitted a general outline for a new work. Manet's *Bunch of Asparagus* of 1880, in the collection of the Wallraf-Richartz-Museum, is on a studio easel in an approx. 6 x 8 meter room of "PROJEKT '74". Panels on the walls present the social and economic position of the persons who have owned the painting over the years and the prices paid for it."

Dr. Evelyn Weiss, the modern art curator of the Wallraf-Richartz-Museum (1986, senior curator and deputy director of the Museum Ludwig) and one of six members of the 'PROJEKT '74' organizing team, responded that this plan was "one of the best projects submitted," but that it could not be executed in the exhibition or printed in the catalogue.

This decision was reached in what was described as a "democratic vote" by the organizing team. The vote was three to three. Voting for the work's exhibition were Dr. Evelyn Weiss; Dr. Manfred Schneckenburger, then director of the Kunsthalle (organizer of *Documenta* in 1977 and 1987); and Dr. Wulf Herzogenrath, director of the Kunstverein. The votes against the work were cast by Dr. Horst Keller, director of the Wallraf-Richartz-Museum (now retired); Dr. Albert Schug, the museum's librarian; and Dr. Dieter Ronte, the personal aide of Prof. Dr. Gert von der Osten, who was head of the Cologne municipal museums and co-director of the Wallraf-Richartz-Museum until his retirement in 1975 (Ronte was the director of the Museum of Modern Art, Vienna and is now the director of the Städtisches Kunstmuseum, Bonn). With the exception of the director of the private Kunstverein, all team members were subordinates of Prof. von der Osten.

Dr. Keller objected to listing Hermann J. Abs' nineteen positions on boards of directors. Information about his social and economic standing was provided in the work because, in his capacity as chairman, he represented the Wallraf-Richartz-Kuratorium (Association of the Friends of the Museum), when it acquired the Manet painting. In a letter to the artist, Dr. Keller elaborated on his position. After explaining that the museum, although financially carried by the city and the state, depends on private donations for major acquisitions, he continued: "It would mean giving an absolutely inadequate evaluation of the spiritual initiative of a man if one were to relate in any way the host of offices he holds in totally different walks of life with such an idealistic engagement ... A grateful museum, however, and a grateful city, or one ready to be moved to gratefulness, must protect initiatives of such an extraordinary character from any other interpretation which might later throw even the slightest shadow on it ..."

He also remarked, "A museum knows nothing about economic power. It does indeed, however, know something about spiritual power."

Dr. Keller and Prof. von der Osten never saw or showed any interest in seeing the work before they rejected it. Instead, on July 4, the day of the press opening of "PROJEKT '74", *Manet-PROJEKT '74* went on exhibition at Galerie Paul Maenz in Cologne, with a fullsize color reproduction in place of the original *Bunch of Asparagus.*

Daniel Buren incorporated in his own work in "PROJEKT '74" a scaled-down facsimile of *Manet-PROJEKT '74,* which Haacke had provided at his request. He also attached to it a poster entitled, "Art Remains Politics" – referring to the exhibition's official slogan, "Art Remains Art" with an excerpt from "Limites Critiques", an essay Buren had written in 1970: "... Art, whatever else it may be, is exclusively political. What is called for is the analysis of formal and cultural limits (and not one or the other) within which art exists and struggles. These limits are many and of different intensities. Although the prevailing ideology and the associated artists try every way to camouflage them, and although it is too early – the conditions are not met – to blow them up, the time has come to unveil them."

On the morning after the opening, Prof. von der Osten had those parts of Buren's work which had been provided by Haacke (including a color reproduction of the Manet still life) pasted over with double layers of white paper.

Several artists, among them Antonio Diaz, Frank Gillette, and Newton and Helen Harrison, temporarily or permanently closed down their works in protest. Carl

Daniel Buren sticking Hans Haacke's *Manet-PROJEKT '74* on his own work during the exhibition "PROJEKT '74" in the Kunsthalle in Cologne, July 1974. Photo: Barbara Reise

Facsimile (Detail) of *Manet-PROJEKT '74* as part of the work of Daniel Buren in the exhibition "PROJEKT '74", Kunsthalle, Cologne July 1974 (with double layers that had been pasted over by the Wallraf-Richartz-Museum), Photo: © Haacke

Andre, Robert Filiou, and Sol LeWitt had previously withdrawn from the exhibition, after hearing that *Manet-PROJEKT '74* would not be admitted.

In response to a question by Prof. Carl R. Baldwin, who was preparing an article on the incident for *Art in America,* Dr. Keller wrote in a letter of September 25, 1974: "In any event, it is not an uncommon practice for a museum to paste over an artist's work, when an artist has expressly disregarded an agreement previously reached with a museum…"

Hermann J. Abs, still an honorary president and member of the Deutsche Bank's advisory board, has lately represented German interests at international art auctions. In 1983, he successfully bid for an old German illuminated manuscript, the Gospels of Henry the Lion, at Sotheby Parke-Bernet in London. The manuscript was acquired by the German consortium for the price of DM 32 million ($ 11.7 million). As the "secret head of the Department of Culture" of the City of Frankfurt (this is how Hilmar Hoffmann, who had been Department head for twenty years, referred to him).

In 1982, Abs was appointed by Pope John Paul II to the advisory board of the Institute of Religious Works, the agency that manages the Vatican's finances. The appointment drew strong protest and an immediate call for Abs' resignation by the Simon Wiesenthal Center for Holocaust Studies in Los Angeles

Hans Haacke

Edouard Manet
Bunch of Asparagus, 1880
Oil on canvas
46 x 55 cm
Wallraf-Richartz-Museum,
Cologne

On loan of the Wallraf-Richartz-Museum in Cologne the original by Edouard Manet was part of Hans Haacke's *Manet-PROJEKT '74* for two months during the exhibition "Deutschlandbilder".

Das Spargel-Stilleben

1880 gemalt von

Edouard Manet

Lebt von 1832 bis 1883 in Paris. – Entstammt einer katholischen Familie des franz. Großbürgertums. Vater Auguste Manet Jurist, Personalchef im Justizministerium, später Richter (magistrat) am Cour d'appel de Paris (Berufungsgericht). Republikaner. Ritter der Ehrenlegion. – Großvater Clément Manet Bürgermeister von Gennevilliers an der Seine, vor Paris. Familie besitzt dort ein 54 Hektar großes Landgut. – Mutter Eugénie Désirée Fournier, Tochter eines franz. Diplomaten, der die Wahl Marschall Bernadottes zum schwedischen König betrieb. Karl XIV. von Schweden ihr Pate. – Ihr Bruder Clément Fournier Artillerieoberst. Demissioniert während der Revolution 1848. – Zwei Brüder Manets im Staatsdienst.

Manet besucht renommiertes Collège Rollin (Mitschüler Antonin Proust, späterer Politiker und Schriftsteller). Entgegen dem väterlichen Wunsch nach einem Jurastudium fährt er für kurze Zeit zur See. Fällt bei der Aufnahmeprüfung zur Seekadettenanstalt durch.

1850–56 Kunststudium im Privatatelier von Thomas Couture, einem erfolgreichen Salonmaler. Studienreisen nach Italien, Deutschland, Österreich, der Schweiz, Belgien, Holland, Spanien.

Finanziell unabhängig. Nicht auf den Verkauf seiner Bilder angewiesen. Wohnt in großen standesgemäß eingerichteten Häusern in Paris, mit Dienerschaft.

Stellt ab 1861 mit wechselndem Erfolg im Salon und in Kunsthandlungen aus. 1863 Beteiligung am „Salon des Réfusés" (Salon der Zurückgewiesenen). Bilder werden wegen Verstössen gegen die Konvention von der offiziellen Kritik bekämpft. Kritische Unterstützung durch Zola, Mallarmé, Rimbaud.

Heiratet 1863 nach dem Tod seines Vaters Suzanne Leenhoff, seine ehemalige Klavierlehrerin, die Tochter eines holländischen Musikers. Léon Edouard Koëlla, ihr 1852 geborener Sohn, ist ein illegitimes Kind Manets; wird von ihm adoptiert.

Stellt 1867 aus Protest gegen die konservative Jury 50 Bilder in einer für 18 000 Francs selbstfinanzierten Baracke auf einem Grundstück des Marquis de Pomereu in der Nähe der Weltausstellung in Paris aus. Anhänger unter jüngeren, besonders impressionistischen Künstlern.

Als Nationalgardist 1870 bei der Verteidigung von Paris im Deutsch-Französischen Krieg, Meldegänger im Regimentsstab. Während der Pariser Kommune bei seiner Familie in Südfrankreich. – Antiroyalist. Bewunderer des Republikaners Léon Gambetta, des späteren Ministerpräsidenten.

1871 umfangreiche Bilderkäufe durch den Kunsthändler Durand-Ruel, einem Freund impressionistischer Malerei. Findet Anerkennung in den für künstlerische Neuerungen aufgeschlossenen Kreisen der Pariser Gesellschaft. Zahlreiche Porträtaufträge. 1881 Gewinn der 2. Medaille des Salons. Auf Vorschlag Antonin Prousts Ernennung zum Ritter der Ehrenlegion.

Während seiner tödlichen Krankheit Behandlung durch früheren Leibarzt Napoleon III.

1883 Gedächtnisausstellung in der Ecole des Beaux-Arts Paris. Katalogvorwort von Emile Zola. Verkaufserlös zugunsten der Erben 116 637 Francs.

Das Spargel-Stilleben

1880 für 800 Francs gekauft durch

Charles Ephrussi

Geboren 1849 in Odessa, gestorben 1905 in Paris. – Entstammt jüdischer Bankiersfamilie mit Bankunternehmen in Odessa, Wien und Paris. Familiäre Beziehungen zur franz. Hochfinanz (Baron de Reinach, Baron de Rothschild).

Studiert in Odessa und Wien. – 1871 Übersiedlung nach Paris.

Eigene Bankgeschäfte. – Kunstschriftstellerische Arbeiten u. a. über Albrecht Dürer, Jacopo de Barbarij und Paul Baudry. 1875 Mitarbeit an der „Gazette des Beaux Arts", 1885 Mitinhaber, 1894 Herausgeber.

Mitglied zahlreicher kultureller Komitees und Salons der Pariser Gesellschaft. Organisiert mit Gustave Dreyfus, der Comtesse Greffulhes und der Prinzessin Mathilde Kunstausstellungen und Konzerte, u. a. von Werken Richard Wagners. – Zweites Vorbild für Marcel Prousts Swann.

Sammelt Kunst der Renaissance, des 18. Jahrhunderts, Albrecht Dürers, Ostasiatische Kunst und Werke zeitgenössischer Maler.

Zahlt Manet statt der vereinbarten 800 Francs für das „Spargel-Stilleben" insgesamt 1000 Francs. Aus Dankbarkeit schickt im Manet das Stilleben eines einzelnen Spargels (1880, Öl auf Leinwand, 16,5 x 21,5 cm, Paris Musée de l'Impressionisme) mit der Bemerkung: „Es fehlte noch in Ihrem Bündel".

Ritter (1882) und Offizier (1903) der Ehrenlegion.

Gravure von M. Patricot „Charles Ephrussi" aus „La Gazette des Beaux Arts", Paris 1905

321 Hans Haacke
Manet-PROJEKT '74, 1974
10 panels, each 80 x 52 cm, and a color reproduction of the *Asparagus* still life by Edouard Manet, 83 x 94 cm (dimensions of the original with frame). All panels are under glass and framed in black. Color photo: Fotofachlabor Rolf Lillig, Cologne
Private collection, Belgium

Das Spargel-Stilleben

zwischen 1900 **und** 1902 gekauft durch

Alexandre Rosenberg

Geboren 1850 in Preßburg (Bratislava), Slowakei.- Entstammt jüdischer Familie. Emigration nach Paris im Alter von 9 Jahren.

1870 Gründung einer Kunst- und Antiquitätenhandlung in Paris.

Heiratet 1878 Mathilde Jellineck aus Wien. Sie haben drei Söhne und eine Tochter.

Fortführung der Firma nach seinem Tode 1913 durch den 1881 in Paris geborenen Sohn Paul Rosenberg. Spezialisierung auf die Kunst des 19. und 20. Jahrhunderts.- Gegenwärtig Paul Rosenberg und Co. in New York, geführt durch den Enkel Alexandre Rosenberg.

Das Spargel-Stilleben
von unbekanntem Datum an im Besitz von oder in Kommission bei

Paul Cassirer

Geboren 1871 in Görlitz, Selbstmord 1926 in Berlin. - Entstammt wohlhabender jüdischer Familie. Vater Louis Cassirer gründet mit 2 Söhnen die Firma Dr. Cassirer & Co., Kabelwerke in Berlin. - Bruder Prof. Richard Cassirer, Berliner Neurologe. - Vetter Prof. Ernst Cassirer bekannter Philosoph. Kunstgeschichtsstudium in München. Mitredakteur des "Simplizissimus". Eigene literarische Arbeiten.

Gründet mit Vetter Bruno Cassirer 1898 in Berlin Verlags- und Kunsthandlung. 1901 Trennung. Weiterführung als Kunstsalon Paul Cassirer, Victoriastraße 35, in vornehmer Berliner Gegend.

Mit der Künstlervereinigung „Berliner Sezession" Kampf gegen offizielle Hofkunst. Trotz Unwillen des Kaisers Handel und publizistische Förderung des franz. Impressionismus. Enge Beziehungen zum Pariser Kunsthändler Durand-Ruel. Verhilft den Deutschen Malern Trübner, Liebermann, Corinth und Slevogt zum Erfolg.

1908 Gründung des Verlags Paul Cassirer für Kunstliteratur und Belletristik. Publikationen des literarischen Expressionismus. 1910 Gründung der Halbmonatsschrift „Pan" und „Pan"-Gesellschaft zur Förderung von Bühnenwerken, u. a. Wedekind.

Aus erster Ehe eine Tochter und ein Sohn (Selbstmord im 1. Weltkrieg). Heiratet 1910 in zweiter Ehe die Schauspielerin Tilla Durieux.

1914 Kriegsfreiwilliger. Erhält Eisernes Kreuz in Ypern. Wird Kriegsgegner.

Zeitweilig in Haft (beschuldigt, unrechtmäßig franz. Bilder verkauft zu haben). Flucht in die Schweiz und Aufenthalt in Bern und Zürich bis Kriegsende. Verhilft Harry Graf Keßler zu franz. Kontakten für Verhandlungen mit Frankreich im Auftrage Ludendorffs. Verlegt mit Max Rascher pazifistische Literatur.

Nach der Revolution 1918 in Berlin Eintritt in die USPD. Verlegt sozialistische Bücher, u. a. von Kautzky und Bernstein.

Grund für Selbstmord 1926 vermutlich Konflikt mit Tilla Durieux.

Weiterführung des Kunstsalons Paul Cassirer in Amsterdam, Zürich und London durch Dr. Walter Feilchenfeldt und Dr. Grete Ring, eine Nichte Max Liebermanns.

Das Spargel-Stilleben

für 24 300,– RM gekauft durch

Max Liebermann

Maler, lebt von 1847 bis 1935 in Berlin. – Entstammt einer jüdischen Fabrikantenfamilie. Vater Louis Liebermann Textilindustrieller in Berlin. Besitzt ebenfalls Eisengießerei Wilhelmshütte in Sprottau, Schlesien. - Mutter Philipine Haller, Tochter eines Berliner Juweliers (Gründer der Firma Haller & Rathenau). - Bruder Prof. Felix Liebermann, bekannter Historiker. - Vetter Walther Rathenau, Industrieller (AEG), Reichsaußenminister (1922 ermordet).

Liebermann besucht renommiertes Friedrich-Werdersches Gymnasium in Berlin zusammen mit Söhnen Bismarcks. – Kunststudium im Privatatelier Steffeck, Berlin, und auf der Kunstakademie Weimar. Längere Arbeitsaufenthalte in Paris, Holland, München. – Freiwilliger Krankenpfleger im Deutsch-Französischen Krieg 1870/71.

Heiratet 1884 Martha Marckwald, zieht nach Berlin zurück. 1885 Geburt der Tochter Käthe Liebermann.

Erbt 1894 väterliches Palais am Pariser Platz 7 (Brandenburger Tor). Baut 1910 Sommersitz am Wannsee, Große Seestraße 27 (seit 1971 Clubhaus des Deutschen Unterwasserclubs e.V.). Finanziell unabhängig. Lebt nicht vom Verkauf seiner Werke.

1897 Gesamtausstellung in der Berliner Akademie der Künste. Große Goldene Medaille. Seine durch Realismus und franz. Impressionismus beeinflußten Bilder werden von Wilhelm II. empört abgelehnt. – Malt Genreszenen, Stadtlandschaften, Strand- und Gartenszenen, Gesellschaftsporträts, Künstler, Wissenschaftler, Politiker. – Ausstellung und Verkauf durch Kunstsalon Paul Cassirer in Berlin. Werke in öffentlichen Sammlungen u. a. Wallraf-Richartz-Museum Köln.

Professorentitel 1897. – Präsident der „Berliner Sezession" (Künstlervereinigung gegen Hofkunst) 1898–1911, Rücktritt wegen Opposition jüngerer Künstler. – 1898 Mitglied, 1912 im Senat, 1920 Präsident der Preußischen Akademie der Künste. Rücktritt 1933. – Ehrendoktor der Universität Berlin. Ehrenbürger der Stadt Berlin, Ritter der franz. Ehrenlegion. Orden von Oranje-Nassau. Ritter des Ordens Pour le mérite und andere Auszeichnungen.

Besitzt Werke von Cézanne, Daumier, Degas, Manet, Monet, Renoir. Deponiert seine Sammlung 1933 im Kunsthaus Zürich.

1933 von Nazis aus allen Ämtern entlassen. Ausstellungsverbot. Entfernung seiner Bilder aus öffentlichen Sammlungen.

Stirbt 1935 in Berlin. Frau Martha Liebermann begeht 1943 Selbstmord, um sich drohender Verhaftung zu entziehen.

Das Spargel-Stilleben

vererbt an

Käthe Riezler

Geboren 1885 in Berlin, gestorben 1951 in New York.

Tochter des Malers Max Liebermann und seiner Frau Martha Marckwald.

Heiratet 1915 in Berlin Dr. phil. Kurt Riezler. 1917 Geburt der Tochter Maria Riezler.

Dr. Kurt Riezler, geboren 1882 in München, Sohn eines Kaufmanns. Studium der Klassischen Antike an der Universität München. 1905 Dissertation : „Das zweite Buch der pseudoaristotelischen Ökonomie".

1906 Eintritt ins Auswärtige Amt in Berlin. Legationsrat, später Gesandter. Arbeitet im Stab des Reichskanzlers Bethmann-Hollweg. 1919/20 Leiter des Büros des Reichspräsidenten Friedrich Ebert.

1913 unter dem Decknamen J. J. Ruedorffer Veröffentlichung der „Prolegomena zu einer Theorie der Politik", 1914 „Grundzüge der Weltpolitik in der Gegenwart". - Später Publikationen zur Geschichtsphilosophie, zur politischen Theorie und Ästhetik.

1927 Honorarprofessor, stellvertretender Geschäftsführer und Vorsitzender des Kuratoriums an der Goethe Universität in Frankfurt am Main.

1933 Entlassung durch Nazis.

Umzug der Familie nach Berlin in das Haus Max Liebermanns, Pariser Platz 7. - Erben 1935 seine Kunstsammlung, die Liebermann 1933 dem Kunsthaus Zürich in Obhut gegeben hatte.

1938 Emigration der Familie nach New York. Sammlung folgt dorthin.

1939 erhält Dr. Riezler eine Professur für Philosophie an der New School for Social Research in New York, einer von Emigranten gegründeten Universität. Gastprofessuren an der University of Chicago und der Columbia University in New York.

Käthe Riezler stirbt 1951. Dr. Riezler emeritiert 1952, stirbt in München 1956.

Top-left panel

Das Spargel-Stilleben

vererbt an

Maria White

Geboren 1917 in Berlin. – Tochter von Prof. Dr. Kurt Riezler und Käthe Liebermann.

Emigriert 1938 mit ihren Eltern nach New York.

Heiratet Howard Burton White.

Howard B. White, geboren 1912 in Montclair, N. J., studiert 1934–38 an der New School for Social Research in New York, wo Dr. Kurt Riezler lehrt. 1941 Rockefeller Stipendium. Promoviert 1943 an der New School zum Doctor of Science.

Unterrichtet an der Lehigh University und am Coe College. Gegenwärtig Professor im Graduate Department of Political and Social Science der New School for Social Research. Lehrt Political Philosophy.

Veröffentlichungen u. a. „Peace Among the Willows – The Political Philosophy of Francis Bacon", den Haag 1968. „Copp'd Hills Towards Heaven – Shakespeare and the Classical Polity," den Haag 1968.

Maria und Howard B. White leben in Northport, N. Y. Sie haben zwei Kinder.

Ölbild von Max Liebermann „Tochter und Enkelin des Künstlers" (Maria Riezler im Bild rechts), um 1930

Top-right panel

Das Spargel-Stilleben
1968 über Frau Marianne Feilchenfeldt, Zürich
für 1 360 000,- DM erworben durch das

Wallraf-Richartz-Kuratorium und die Stadt Köln

Dem Wallraf-Richartz-Museum von Hermann J. Abs, dem Vorsitzenden des Kuratoriums, am 18. April 1968 im Andenken an Konrad Adenauer als Dauerleihgabe übergeben.

Das Wallraf-Richartz-Kuratorium und Förderer-Gesellschaft e. V.

Vorstand

Hermann J. Abs
Prof. Dr. Kurt Hansen
Dr. Dr. Günter Henle
Prof. Dr. Ernst Schneider
Prof. Dr. Otto H. Förster
Prof. Dr. Gert von der Osten (geschäftsführend)

Kuratorium

Prof. Dr. Viktor Achter
Dr. Max Adenauer
Fritz Berg
Dr. Walther Berndorff
Theo Burauen
Prof. Dr. Fritz Burgbacher
Dr. Fritz Butschkau
Dr. Felix Eckhardt
Frau Gisela Fitting
Prof. Dr. Kurt Forberg
Walter Franz
Dr. Hans Gerling
Dr. Herbert Girardet
Dr. Paul Gülker
Iwan D. Herstatt
Raymund Jörg
Eugen Gottlieb von Langen
Viktor Langen
Dr. Peter Ludwig
Prof. Dr. Heinz Mohnen
Cai Graf zu Rantzau
Karl Gustav Ratjen
Dr. Hans Reuter
Dr. Hans-Günther Sohl
Dr. Dr. Werner Schulz
Dr. Nikolaus Graf Strasoldo
Christoph Vowinckel
Otto Wolff von Amerongen

Hermann J. Abs bei der Übergabe des Bildes

Bottom-left panel

Das Spargel-Stilleben
erworben durch die Initiative des
Vorsitzenden des Wallraf-Richartz-Kuratoriums

Hermann J. Abs

Geboren 1901 in Bonn. – Entstammt wohlhabender katholischer Familie. Vater Dr. Josef Abs, Rechtsanwalt und Justizrat, Mitinhaber der Hubertus Braunkohlen AG, Brüggen, Erft. Mutter Katharina Lückerath.

Abitur 1919 Realgymnasium Bonn. – Ein Sem. Jurastudium Universität Bonn. – Banklehre im Kölner Bankhaus Delbrück von der Heydt & Co. Erwirbt internationale Bankerfahrung in Amsterdam, London, Paris, USA.

Heiratet 1928 Inez Schnitzler. Ihr Vater mit Georg von Schnitzler vom Vorstand des IG. Farben-Konzerns verwandt. Tante verheiratet mit Baron Alfred Neven du Mont. Schwester verheiratet mit Georg Graf von der Goltz. – Geburt der Kinder Thomas und Marion Abs.

Mitglied der Zentrumspartei. – 1929 Prokura im Bankhaus Delbrück, Schickler & Co., Berlin. 1935-37 einer der 5 Teilhaber der Bank.

1937 im Vorstand und Aufsichtsrat der Deutschen Bank, Berlin. Leiter der Auslandsabteilung. – 1939 von Reichswirtschaftsminister Funk in den Beirat der Deutschen Reichsbank berufen. – Mitglied in Ausschüssen der Reichsbank, Reichsgruppe Industrie, Reichsgruppe Banken, Reichswirtschaftskammer und einem Arbeitskreis im Reichswirtschaftsministerium. – 1944 in über 50 Aufsichts- und Verwaltungsräten großer Unternehmen. Mitgliedschaft in Gesellschaften zur Wahrnehmung deutscher Wirtschaftsinteressen im Ausland.

1946 für 6 Wochen in britischer Haft. – Von der Alliierten Entnazifizierungsbehörde als entlastet (5) eingestuft.

1948 bei der Gründung der Kreditanstalt für Wiederaufbau. Maßgeblich an der Wirtschaftsplanung der Bundesregierung beteiligt. Wirtschaftsberater Konrad Adenauers. – Leiter der deutschen Delegation bei der Londoner Schuldenkonferenz 1951-53. Berater bei den Wiedergutmachungsverhandlungen mit Israel in Den Haag. 1954 Mitglied der CDU.

1952 im Aufsichtsrat der Süddeutschen Bank AG. – 1957-67 Vorstandssprecher der Deutschen Bank AG. Seit 1967 Vorsitzender des Aufsichtsrats.

Ehrenvorsitzender des Aufsichtsrats:
Deutsche Überseeische Bank, Hamburg – Pittler Maschinenfabrik AG, Langen (Hessen)
Vorsitzender des Aufsichtsrats:
Dahlbusch Verwaltungs-AG, Gelsenkirchen – Daimler Benz AG, Stuttgart-Untertürkheim – Deutsche Bank AG, Frankfurt – Deutsche Lufthansa AG, Köln – Philipp Holzmann AG, Frankfurt – Phoenix Gummiwerke AG, Hamburg-Harburg – RWE Elektrizitätswerk AG, Essen – Vereinigte Glanzstoff AG, Wuppertal-Elberfeld – Zellstoff-Fabrik Waldhof AG, Mannheim
Ehrenvorsitzender:
Salamander AG, Kornwestheim – Gebr. Stumm GmbH, Brambauer (Westf.) – Süddeutsche Zucker-AG, Mannheim
Stellvertr. Vors. des Aufsichtsrats:
Badische Anilin- und Sodafabrik AG, Ludwigshafen – Siemens AG, Berlin-München
Mitglied des Aufsichtsrats:
Metallgesellschaft AG, Frankfurt
Präsident des Verwaltungsrats:
Kreditanstalt für Wiederaufbau – Deutsche Bundesbahn

Großes Bundesverdienstkreuz mit Stern, Päpstl. Stern vom Komturkreuz, Großkreuz Isabella die Katholische von Spanien, Cruzeiro do Sul von Brasilien. – Ritter des Ordens vom Heiligen Grabe. – Dr. h.c. der Univ. Göttingen, Sofia, Tokio und der Wirtschaftshochschule Mannheim.

Lebt in Kronberg (Taunus) und auf dem Rentgerhof bei Remagen.

Photo aus Current Biography Yearbook 1970 New York

Bottom-right panel

Das Spargel-Stilleben
erworben mit Stiftungen von

Hermann J. Abs, Frankfurt	Klöckner Werke AG., Duisburg
Viktor Achter, Mönchengladbach	Kölnische Lebens- und Sachvers. AG., Köln
Agrippina Rückversicherung AG., Köln	Viktor Langen, Düsseldorf-Meerbusch
Allianz Versicherung AG., Köln	Margarine Union AG., Hamburg
Heinrich Auer Mühlenwerke, Köln	Mauser-Werke GmbH, Köln
Bankhaus Heinz Ansmann, Köln	Josef Mayr K. G., Hagen
Bankhaus Delbrück von der Heydt & Co., Köln	Michel Brennstoffhandel GmbH, Düsseldorf
Bankhaus Sal. Oppenheim jr. & Cie., Köln	Gert von der Osten, Köln
Bankhaus C. G. Trinkaus, Düsseldorf	Kurt Pauli, Lövenich
Dr. Walter Berndorff, Köln	Pfeifer & Langen, Köln
Firma Felix Böttcher, Köln	Preussag AG., Hannover
Robert Bosch GmbH, Köln	William Prym Werke AG., Stolberg
Central Krankenversicherung AG., Köln	Karl-Gustav Ratjen, Königstein (Taunus)
Colonia Versicherungs-Gruppe, Köln	Dr. Hans Reuter, Duisburg
Commerzbank AG., Düsseldorf	Rheinisch-Westf. Bodenkreditbank, Köln
Concordia Lebensversicherung AG., Köln	Rhein.-Westf. Isolatorenwerke GmbH, Siegburg
Daimler Benz AG., Stuttgart-Untertürkheim	Rhein.-Westf. Kalkwerke AG., Dornap
Demag AG., Duisburg	Sachtleben AG., Köln
Deutsch-Atlantische Telegraphenges., Köln	Servais-Werke AG., Witterschlick
Deutsche Bank AG., Frankfurt	Siemag Siegener Maschinenbau GmbH, Dahlbruch
Deutsche Centralbodenkredit AG., Köln	Dr. F. E. Shinnar, Tel-Ganim (Israel)
Deutsche Continental-Gas-Ges., Düsseldorf	Sparkasse der Stadt Köln, Köln
Deutsche Krankenversicherung AG., Köln	Schlesische Feuervers.-Ges., Köln
Deutsche Libby-Owens-Ges. AG., Gelsenkirchen	Ewald Schneider, Köln
Deutsche Solvay-Werke GmbH, Solingen-Ohligs	Schoellersche Kammgarnspinnerei AG., Eitorf
Dortmunder Union-Brauerei, Dortmund	Stahlwerke Bochum AG., Bochum
Dresdner Bank AG., Düsseldorf	Dr. Josef Steegmann, Köln-Zürich
Farbenfabriken Bayer AG., Leverkusen	Strabag Bau AG., Köln
Gisela Fitting, Köln	Dr. Nikolaus Graf Strasoldo, Burg Gudenau
Autohaus Jacob Fleischhauer K. G., Köln	Cornelius Stüssgen AG., Köln
Glanzstoff AG., Wuppertal	August Thyssen-Hütte AG., Düsseldorf
Graf Rüdiger von der Goltz, Düsseldorf	Union Rhein. Braunkohlen AG., Wesseling
Dr. Paul Gülker, Köln	Vereinigte Aluminium-Werke AG., Bonn
Gottfried Hagen AG., Köln	Vereinigte Glaswerke, Aachen
Hein. Lehmann & Co., Düsseldorf	Volkshilfe Lebensversicherungs AG., Köln
Hilgers AG., Rheinbrohl	Jos. Voss GmbH & Co. KG., Brühl
Hoesch AG., Dortmund	Walther & Cie. AG., Köln
Helmut Horten GmbH, Köln	Wessel-Werk GmbH, Bonn
Hubertus Brauerei GmbH, Köln	Westdeutsche Bodenkreditanstalt, Köln
Karstadt-Peters GmbH, Köln	Westd. Landesbank Girozentrale, Düsseldorf
Kaufhalle GmbH, Köln	Westfalenbank AG., Bochum
Kaufhof AG., Köln	Rud. Sieberslebens'che O. Wolff-Stiftg., Köln
Kleinwanzlebener Saatzucht AG., Einbeck	

The Living Stink

Via Lewandowsky,
Fear of Germany, 1989
Acrylic on canvas, 180 x 160 cm
Collection of the artist

1 Quoted in *Vom Ebben und Fluten*, exhibition catalog, Leonhardi-Museum (Dresden 1988).

2 Personal discussion of the author with Else Gabriel on 1/14/1991.

3 Hans-Joachim Maaz, *Gefühlsstau. Psychogramm der DDR* (Berlin 1990), 84.

4 Maaz, 95. The educational ideals of the new socialist individual remain: "...the cult of the Führer-cult, the mass marches, religious-like rituals and fetishes, the xenophobia, and the defining of enemies (the GDR had just made Israel one of its enemies – can this cynicism be topped?), the psycho-terror through infiltrators and surveillance, conformist idiocy, the glorification of strength, power, discipline and order, a mendacious view of women, a distorted romantization of motherhood, sexual prudery, repressive education, and brainwashing – all characteristics typical of both fascist and stalinist social structures."

"When there is no [more] good to be done," art at least takes on "the place of evil, always better than evil [itself]."
Georg Wilhelm Friedrich Hegel, Lectures on Aesthetics

Four students of stage-design at the Art Academy in Dresden, Micha Brendal, Else Gabriel, Via Lewandowsky, and Rainer Görß (who since their performance "Heart Horn Skin Shrine" in the cellar of the Art Academy have referred to themselves as "Autoperforation Artists") have renounced through the demonstrative use of their own bodies and their own biographies as material, the fight against the phantom of an ever present but unreachable state, of which one can form no image. They played for all they were worth and at great risk. "So falls the last place of refuge, ones own body."[1] Every performance was an attempt which tried to bring to consciousness the exceptional situation and the permanent amputation of the senses in the GDR without being pedantic or trying to enlighten. To their public, which had tried to make themselves as comfortable as possible under the circumstances, they demonstrated the situation without illusion by "making themselves into monkeys."[2] After the departure of A.R. Penck and other older artists from Dresden such as Ralf Kerbach, Helga Leiberg, and Cornelia Schleime a vacuum emerged. The Autoperforation Artists remained in the GDR without however contributing to the psychic stability of the system and without making themselves at home in a kind of "inner worldly Diaspora of asceticism." This generation, born after the construction of the wall, came to the sober conclusion that the GDR was a state to which applied the sad metaphor a "huge cage": "a stable and secure enclosure of perfect control and training ... oriented toward performance and obedience".[3] The state, which as a closed facility granted leave to its subjects according to its own whim, barricaded itself behind the wall as "anti-fascist shield," and legitimized its repressive dictatorship with an offensive anti-fascist policy against an ostensibly latent fascism in the western part of Germany. A real "denazification" was however even less of a reality in the GDR, which carried on the dictatorship of 1933, than in the FRG. "The fascistic way of life was taken over and carried on almost without a break."[4]

The GDR was for them like a corpse; "so dead that the only thing one could do was laugh about it."[5] Else Gabriel wrote in a text entitled "Über(M)ich" (a play on words in German referring to a text both about the author

and her super-ego) "I have developed weapons for daily combat. For example, AUTO-PERFORATION, putting holes in oneself, handy for the neutralization of too much emotion, which emerges when one removes oneself, or is removed, from the good or evil movement of the object at hand..."[6] In the generally ossified and sclerotic society of the GDR, every surplus of emotions rebounded against itself. The consequence was then the idea of "emotional inundation" or an "emotional jam-up" developed by Dr. Hans-Joachim Maaz in his psychiatric practice in Halle since 1980, as the central psychological fact of life in the GDR. The compulsion to split ones personality, and the corresponding separation from ones feelings, lead to a situation where under the mask of good behavior and discipline, there sweltered "a morass of jammed up emotions, of existential fear, murderous anger, hatred, terrible pain and bitter sadness." Without feelings as a corrective for the experience of a disturbed environment, it was possible on a daily basis to experience, but not to feel, the contradiction between ideology and reality. The emotional inundation lead to a loss of felt contact with oneself and the world, and finally to a deformation of the personality, which is then considered "normal." The person in question "remains from then on dependent on and addicted to authority."[7]

Against the generation of their parents, who kept quiet and always looked for harmony, the Autoperforation Artists developed shock techniques, transgressed limits of shame (Via Lewandowsky: "wetting slowly," 1985), gave the torturous silence a body, and continually created new unclarity, fakes, farces, and confusion. They can only be superficially compared to the catholic "wind down – work it off" rituals of the Vienna Actionists. Metaphysics, mysticism, and aesthetic "life-liturgies" (Hermann Nitsch) were beyond their horizons. Durs Grünbein has spoken of "Protestant rituals," of the love-hate of the Protestant, who recovers ethics through acrobatics: "They have to wound in order to establish order."[8] At the same time the group is characterized by "a comically astonished sense of their own situation, a clown-like self consciousness..."[9] In contrast to many artists in the GDR who tried to spread their belief in a better socialism within the real existing socialism, their public remained without consolation, alternative, or hope. They blew apart the familiar but unspoken consent of the alternative art scene. The performance group, a community of necessity, quickly dissolved itself after the fall of the GDR. Each was left alone with his or her own histories.

Since 1988 Lewandowsky has developed the principle of reproductive painting, "a form of art recycling" of found and already reproduced visual images.[10] The transformation of art through art is ironically driven to the limit through the inclusion of scientific illustrations in

5 See note 2.

6 Quoted in the exhibition catalog *Vom Ebben und Fluten,* see note 1.

7 See note 3.

8 Else Gabriel, also called Alias... *Die Kunst der Fuge,* Permanente Kunstkonferenz of 6/17/1989 in the gallery Weißer Elefant, East Berlin.

9 Durs Grünbein, "Protestantische Rituale. Zur Arbeit der Autoperforationsartisten", in: Eckhart Gillen/Rainer Haarmann, *Kunst in der DDR* (Cologne 1990), 316.

10 Via Lewandowsky, see note 1.

11 Paul Westheim, "Heimaturlaub zur Kunst", *Frankfurter Zeitung,* no. 61, 3/2/1916.

12 Durs Grünbein, "O Heimat, zynischer Euphon", in: *Schädelbasislektion* (Frankfurt/Main 1991), 111.

13 Quoted in "Permanente Kunstkonferenz" (Berlin 1990), 58.

14 "In order to get rid of the nightmare of history one first has to recognize the existence of history. Otherwise it could re-emerge in the same old way, as the spirit of Hamlet. First one has to analyze it, then one can do away with it. Very important aspects of our history have been repressed for too long." ('Ich glaube an Konflikt. Sonst glaube ich an nichts.' Ein Gespräch mit Sylvère Lotringer", in: Heiner Müller, *Gesammelte Irrtümer. Interviews und Gespräche* (Frankfurt/Main 1986) 78.)

15 *Zwischenspiele,* exhibition catalog, Verband Bildender Künstler and Neue Gesellschaft für Bildende Kunst (Berlin (West) 1989).

16 At almost the same time Salomé, who then belonged to the group "Heftige" in the self-organized gallery on Moritzplatz, was working in West Berlin's Kreuzberg district on the myth of the Nibelungen. He commented as follows in 1987 on his painting *Siegfrieds Tod:* "Through a Jewish friend I was forced to deal with Nazism, how ideals were killed in Germany. Or: how Germans love their heroes. What relationship does society have to extreme people, like now to the person Siegfried. It was clear to me that he had to die in a German prison. And so he died, shot in barbed wire. I resisted for a long time painting this scene...I also think that the landscape of the soul or the darkness of the whole history is very German. In fact I can't imagine it with any other people." (Salomé im Gespräch mit Wolfgang Storch, "Berlin im September 1987", in: Wolfgang Storch [ed.], *Die Nibelungen. Bilder von Liebe, Verrat und Untergang,* exhibition catalog, Haus der Kunst, 12/5/1987 to 2/14/1987, see p. 286 f.)

pamphlets about emergency medicine from the thirties, and the consequent mechanization of artistic production through copy machines, film, montages, and repeated projections, all the way to the manual reproduction of pseudo-authentic hand writing on canvas. Boundless German depth hardens into a linear, flatly grotesque rendering of German physiognomy which freezes through the process of combination into uncanny reproductions of "German thoroughness." The ideology of a "socialistic-humanistic image of humanity" which, succeeding the classical humanism of an earlier bourgeoisie, wanted to *Climb to the Limits* (Oil on paper, 1989), is sent to its resting place by Lewandowsky through his visual de-construction. He offensively uncovers with his mutations, monsters, deformations, and phantoms how the social relations of power, with the help of institutional medicine, social-hygiene, and compulsory education, lay their hands on the body, condition, measure and mark it. A body so conditioned loses the possibility of sensing desire for itself. A social substitute-self (Volksgemeinschaft, Party, Army,) holds the disembodied self together like a uniform. *Frozen Limbs Break Easily – Greeting, Picture-Swing* (1988) shows for example the breaking apart of this sterile, trained body armor. The bandaged cripples coming apart at the seams degenerate into an eerie *Rumpf-Stampfen* (1988) and demonstrate, with their deformed organs, against their condition.

Lewandowsky carried out a negative genealogy of the *German Family* (1990). Placed on three stools made of steel, and filtered through screens, the quintessence of those facial expressions which make up the German phenotype of the "public-servant," enlisted officer, family father, and inspector is shown. In the face of these character masks, a small hunched over and kneeling boy hides his face against the floor: *Fear Of Germany* (1989). Lewandowsky quotes Wilhelm Lehmbruck's sculpture *The Deposed,* which was executed in 1915/16, a year after the catastrophic fighting around Langemarck. It shows "a dying, against which the body struggles ... A Head ... boring itself into the ground ... as if trying to find refugee from a reality spitting out death."[11] Then too, a whole generation fell in war, among them more than a few expressionist painters and poets, whose ideals were broken, and who marched to battle with the refrain, written in 1914 by Heinrich Lersch, on their lips: "Germany must live, even if we must die!" "The sick fathers we are the mob, the walls/miscarriages" wrote Durs Grünbein in 1991.[12]

On June 22, 1989, only months before the wall came down, there took place within the framework of a "permanent art-conference" in the "capital of the GDR," a performance in the gallery "Weißer Elefant". In the gallery were assembled the left over pieces of a German schoolroom: a stuffed eagle and a buzzard, a black mirror in the form of a blackboard, and a speakers podium. As Via Lewandowsky did violence to a dead pigeon on the floor with an iron rod, a symbol of the hypocrisy of the socialist "Politics of Peace," and demonstrated the state's attack on the body on himself (shaving of pubic hair and tying himself up), Durs Grünbein read a text at the podium which described the inner repression of the new socialist person, the killing of ones self: "I killed it. I finally managed to kill it. I locked it up, starved it, broken under the torture of isolation ... I had to kill it, slowly, with German resolve. What then began was the abolition of crime in favor of the plan..." The inner insurgency was finished, sealed, frozen over. The scene sunk in a cloud of ashes, whipped up by a vacuum cleaner: "Outside the incredibly silent implosion of a landscape. With German resolve."[13] Via Lewandowsky's painting *Hoffnungistdeslebensstabvonderwiegebiszumgrab* (Hopeisthemeasureoflifefromthe-cradletothegrave) deals ironically with the state promoted view of history. In this work he confronted the West for the first time. Here one had really disposed of the past, thrown the corpses out of the house of history; in the GDR, they lay in the cellar. There one had to live with them, and deal with them without hope of escape.[14] The painting, which was shown in the exhibition "Zwischenspiele" (Interim-plays) (Oct. 22–Dec. 10, 1989) during which on November 9 the wall came down, was exactly to the point: temporary cease-fire of brother against brother! A battle unit sits on the corpses in the cellar and tries to get rid of them fast. The extremely large reproduction shows a part of Alfred Rethel's woodcut series of the Nibelungen saga from 1840. It concerns the 34th adventure: *How they threw out the dead at the last battle in Etzel's (Attila's) castle.* The conservative heroism of the Nibelungen with all of its mediaeval trappings is banalized into an enormous cartoon, on which blood-red watercolor runs. The "crocodile tears" of the sentimental successors which are shed with such pleasure, water the canvas, like a trick with a water pump in a Hollywood movie.[16]

For his first exhibition in West-Berlin at the end of 1989 in the Realism-studio of the New Society for the Fine Arts, he submitted the series "You Can't Hear the Screaming – Eight Portraits about Euthanasia"(see fig. 322, p. 326 f.)[17] The reference to the Nazi euthanasia programs contained in the title is conceived by Lewandowsky as a post-traumatic statement about the GDR, which suddenly vanished from the picture like an evil spirit.[18] Only after it was over did it become clear to him what a monstrous "brave new world" had escaped. In the face of this he lost his humor from one day to the next. The sudden disappearance of the stress helped sharpen his view into the past. In the reversal of the ancient notion of a beautiful death to the cynicism of killing "unworthy life," the GDR

322 **Via Lewandowsky**
Eight Portraits about Euthanasia,
1989
Acrylic, glue, urine, cotton wool on
canvas
Each 130 x 110 cm
Berlinische Galerie, Berlin, Landes-
museum für Moderne Kunst, Pho-
tographie und Architektur

upper row:
*One Sees That It Will Never Arrive
at Home,* 1989

There was No Other Choice, 1989

What More Do You Want?, 1989

The Dice Have Fallen, 1989

lower row:
It is Time, 1989

Talk and Answer, 1989

*The Damage Went All the Way to
the Center,* 1989

The One Born at a Lucky Hour, 1989

323 **Sigmar Polke**
Untitled *(GDR-Emblem),* 1978
Acrylic, oil on canvas
150 x 130 cm
Private collection

324 **Sigmar Polke**
The Living Stink, and the Dead are not Present, 1983
Acrylic on fabric
280 x 360 cm
Emily and Jerry Spiegel

329

[17] On Sigmar Polke's treatment of the euthanasia theme *The Living Stink and the Dead are not present* (fig. 324, p. 329) cf. article by Anne Erfle, p. 242.

[18] Already on 7/14/1933 the law for the protection against unhealthy hereditary material was passed which called for sterilization of 16 "hereditary diseases". 300,000 Germans were subjected to forced sterilization based on this law. The later command to destroy "unworthy life" came directly from Hitler. The leader of the chancellery of the Führer of the NSDAP, Philipp Bouhler, personally supervised the "euthanasia action" which killed 70,273 persons who had previously been sterilised in Bernburg/Saale, Brandenburg, Grafeneck, Hadamar, Hartheim and Sonnenstein/Pirna. Compare Ernst Klee, *Euthanasie im NS-Staat* (Frankfurt/Main, 1991).

[19] Durs Grünbein, "Alibi für Via", in: *Sie können nichts schreien hören. Acht Porträts zur Euthanasie*, exhibition catalog, Neue Gesellschaft für Bildende Kunst (Berlin (West) 1989), 27. Compare also the work by Via and Pina Lewandowsky, *Kleine Sippenhygiene* (1993), 14 home altars, diverse materials: brother-in-law, cousin, relative, mother, step-daughter, half-brother, grandfather, father, nephew, great-grandmother, son, aunt, niece, great-aunt.

[20] Professor Dr. Schmeil, *Menschenkunde* (Leipzig 1937), 108. In the spirit of Hitler's revision of the Mosaic ban on killing (cf. catalog article "Tabula rasa und Innerlichkeit", p. 16ff.) Gerhard Venzmer wrote that the ostensibly "barbaric" use of selection among indigenous peoples shows "that the savages, without knowing anything about heredity, practice a kind of eugenics..." *(Erbmasse und Krankheit. Erbliche Leiden und ihre Bekämpfung)* (Stuttgart 1940), p. 40. Already in 1948 it was possible for Venzmer to publish, with the approval of the American Military Government, *Die Wirkstoffe des Lebendigen. Von Hormonen, Vitaminen und anderen Lebensreglern.*

[21] Georg Wilhelm Friedrich Hegel, *Vorlesungen über die Geschichte der Philosophie* (Lectures on the History of Philosophy), vol. 2 (Frankfurt/Main 1971), 371.

[22] Georg Wilhelm Friedrich Hegel, *Vorlesungen über die Ästhetik* (Lectures on Aesthetics) (Frankfurt/Main 1955) vol. 1: 218, vol. 2: 236. (Translated here from the German original.)

is revealed as an asylum "of people who did evil to their own – put them asleep, anesthetized, administered, caged them with rules, ideologically bribed them, and so on."[19]

His portrait gallery shows terse faces which provoke in the viewer the question as to why, of all people, such a person would be selected out as sick. The execution of the heads is ambivalent: The clamped tongue ("Rede und Antwort"– which in English has the sense of "to justify oneself") is, to begin with, the first-aid against the danger of suffocation after becoming unconscious, at the same time however, it is the muzzle of dictatorship. The transcendence of barbarism through beauty and the analogy to a Christian burial in Hans Grundig's painting *To the Victims of Fascism* (see fig. 59, p. 73), are denounced outright by Via Lewandowsky. While Grundig, like an icon painter, uses gold leaf to render the dead, Lewandowsky uses yellow urine for the pictures background. The canvases as image carriers are placed in their steel frames like broken bones in a splint, in between which he placed a lining.

The six-hundred part work *Anti-Selection* from 1992, shown in the exhibition "Interface" in the Corcoran Gallery in Washington D.C., takes up and carries to the limit a certain strain in Nazi racial-theory in order to demonstrate its absurdity: "The over growth of mentally, morally, and physically inferior genetic material constitutes a terrible racial denigration, which, if nothing is done against it, can only lead, within a few centuries, to the dying out of healthy genes through anti-selection..."[20] Who or what is the subject that "anti-selects," makes the choice of the species-best? Nature, humanity, or the social-hygienic conditions? Lewandowsky answers the violent "anti-selection" through state propagated ideologies and educational measures with an "anti-anti-selection" which turns the principle of the selecting order on its head. The world becomes for him a domino game which he can arrange at will. The attitude of artists in Berlin, until 1989 the interface between two social systems, has turned in the nineties towards melancholic skepticism. They have nothing more to loose. Utopias and ideologies have fallen like a row of dominos. The point is now that of a sober assessment. In contrast to doubt, a condition of being torn back and forth between positions closing each other out, skepticism is "indifferent to the one as well as the other: this is the standpoint of ataraxy".[21] With heightened awareness they surprise us with their sense of paradox and the play of possibilities. Via Lewandowsky violates Hegel's verdict on the presentation of evil in art because it doesn't allow "a real beauty;" in comparison however with the hypocrisy, with which "classical beauty" was misused in the GDR for the purpose of discipline through classical facades (for example in the official "Houses of

Culture") in his pictures the actually corresponding is "the abnormality and misforming of human figures and physiognomies."[22]

"The Banality of Evil"(Hannah Arendt) was presented by Georg Herold, uncovered, in a wooden cabinet with 150 returnable glass jars, socks, and scents (see fig. 325, p. 331). He was inspired to this arrangement by a photo that came from the German News Agency on June 28, 1993 accompanied by the following text: "In the former headquarters of East Germany's intelligence agency in the Normannenstraße in Berlin, smell-samples are sorted. Agents had suspicious persons sit on a chair, from which samples were removed then and packed into glass jars for eventual use with specially trained dogs in the event of a future search for that person."

Eckhart Gillen

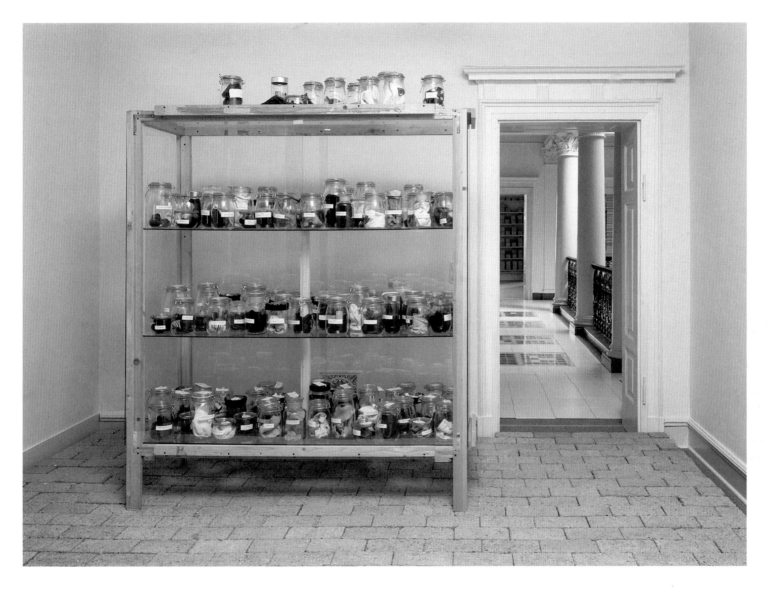

325 **Georg Herold**
Idolatrine Module (Complementary Supplements),
1996
150 preserving jars, socks, perfume, glas, wooden
display case, 5 boxes of bottling jars, frame, glass
plates
230 x 160 x 60 cm
Private collection

Diving Out One Devil With Another
Prescription of Symptoms as Therapy

Germany's Spiritual Heroes

On the November 9, 1988, Philipp Jenninger, at that time president of the German Bundestag, held a speech which later proved to be his undoing: his explanation that up until 1945 a large majority of Germans willingly supported Hitler was misunderstood as an apology for National Socialism. In the realm of art, similar misunderstandings came about with the appearance of Kiefer and Baselitz at the German pavilion at the Venice Biennale in 1981, as well as in the context of the exhibitions "Aesthetic Fascination in Fascism" in Berlin in 1987, and "History in Work – Work on History" in Hamburg in 1988. With their exhibitions in the eighties, the artists Federle, Merz, and Förg became, like Jenninger, the object of public debate.

Of course there is a significant difference between the public statements of artists and curators on the one hand, and the elected representatives of public institutions on the other. However, in reality Jenninger and the artists used the same strategy, one which Ignatz Bubis characterized as the "style of imagined common experience." When such an imagined common experience is effective – dramatists have known this since the time of Euripedes – the listener, the onlooker, the spectator is fascinated. One can understand this fascination as a kind of "active immunization," although discussions of violence in the media increasingly tend to call the immunizing effect into question, and emphasize the danger of imitation.

The concept of "fascination" (of evil, power – even of totalitarianism), which Jenninger also used, has been applied since the time of the Romantics by story tellers, writers, composers, and fine artists to describe the ambivalence and ambiguity of affect-communication. They tried to walk the thin line around which desire turns into disgust, compassion into anger, and joy into terror. The psychologists of the twentieth century maintained that the conditions for affect-communication apply to every individual regardless of education or social status. One who is not prepared to accept these multiple meanings and ambiguities risks serious psychological damage. The ostensibly harmless denial and repression of fascination dominates individuals first then, when they do not act intentionally, but rather tend to see themselves as the victims of the action of others.

However not only for affect-communication, but also for cognitive thinking, the importance of the multilayerdness of pictorial images and thought constructions should not be underestimated. The political and social utopians have thematized this. Since Plato, with his students, tried to no avail to form an ideal state in Syracuse, the founders of ideal cities and societies have found that ideal models can not be concretely realized. This means that even when one confronts people with proven and positive models, that the effects cannot be limited to the wished for imitation. Between intra-psychic, in other words, the cognitive operations and communicative action, there is a principal difference. It appears as though the difference between "thought and action," "life and spirit," "parliamentary drivel and social action," could only be eliminated through the exercise of rigid censorship, dogmatism, and blind obedience. Power becomes totalitarian when it tries to guarantee a one hundred percent agreement between program and action. Today this intention of achieving an absolute identity between thought and deed is generally understood as fundamentalist, including not only the economic and political spheres, but also religion.

That Jenninger in his speech on the occasion of the so-called "Reichskristallnacht" did not explicitly refer to the mechanisms of totalitarian, fundamentalist domination, but rather indirectly assumed them as self evident, should have been understood by exactly those Germans for whom such an occasion is not simply the absolution of an empty ritual. German history brought about, more so than that of the French, English, or Americans, the disastrous results of the convergence between conceptual gullibility and blind obedience, of being true to the letter of the law and serving according to the rules. Heinrich Heine was the first to have examined this particular susceptibility of Germans. According to his judgment, the actual relations of power have forced Germans, since the time of the Thirty Years War, to concentrate their energies on the development of speculative visions in music, philosophy, literature, and science – on the construction of castles in the sky. Their philosophers have supposedly so strongly inculcated in them the notion of the greater power of ideas in contrast to the banal political reality, to the point that one could hold philosophical and artistic constructions to be more true than reality. This "German sickness" has spread to the entire world in our century. And the therapy? Since the discovery of a small pox vaccine and homeopathy it has been referred to as "active immunization"; since Nietzsche it has been called "therapy through prescription of symptoms". Prescription of symptoms as active immunization was carried out by the former Interior Minister Höcherl as he made clear to the Germans that one could not "carry around a book of laws" and try to bring every social fact in correspondence to the letter of the law if one didn't want to fall into totalitarian dogmatism.

Prescription of symptoms as immunization against the flood of fantasy worlds was the effect of Klaus Staeck's satiric posters as he warned the Germans "that the SPD wants to take away your villas in Tessin," or that development aid was being used to buy golden bathtubs for African despots. Prescription of symptoms as immunization was also conducted by the Dusseldorf artists group "the Langheimer" as they called for the foundation of an ideal living community, the "Kloster Langheim – Lebensborn e.V." (Cloister Langheim - Life Fountain Association). Virtually all of the reactions to this cathartic strategy of imagined common experience show how difficult people made it, and make it!, for themselves when it comes to the nature of affect communication and the biology of knowledge. One who seeks to force a desirable welfare state into existence without regard for the existing economic realities, places too much faith in the power of wishing. One who seeks to force the creation of a common European currency according to the letter of the Maastricht Treaty is doomed to failure. One who takes the promises of advertising at face value will find out, at the latest when they come to the end of the check out line, that fantasy and reality cannot be magically united by Madison Avenue. And that one who tries to abolish ethnic, religious, and social discrimination by decree, is playing with fire by trying to drive out Beelzebub with the devil.

Germany's Spiritual Heroes

Anselm Kiefer brought together such "devils" as *Germany's Spiritual Heroes* (see fig. 326, p. 335f.) in the hidden room of the bourgeois home, the attic. There is stored what doesn't belong in the family room, that which as superfluos junk preserves the family history. Rummaging with anxious expectation under cover of the ceiling beams, which preserve the original charm of building, are children and scholars hoping to discover a secret: a manuscript from Hölderlin or a love letter from grandmother. The attics become memorial halls of the hidden, as well as that which is to be hidden. Their children hide their knowledge of that which according to their parents they should not yet know. Adults hide their forbidden melancholy and desires under the rough wooden beams. Richard Wagner transformed this holy place of the bourgeois imagination into theater. Bayreuth was supposed to be a quickly built wooden construction, the fassade of which would be more stimulating than the salons of the leading social circles. To play with fire in such buildings remained a metaphor not only until the introduction of electric lighting, which Wagner had in any case already used to conjure up an aura of magic around the Holy Grail at the first performance of Parsifal. The fire stele with the smoking salad bowl shape has survived up to the present day as decor for the Olympic games. The yearly celebrations of the

Nazis on the occasion of November 9, included "exalted" torch light marches, presicely staged, from the Military Commanders Memorial Hall (Feldherrnhalle) to Königsplatz in Munich. There before the classical burial tombs (of the Troostschule) the names of the "fallen" comrades of the first Nazi coup attempt in 1923 were called out, only to be then reported as present in a collective echo by the assembled SA troops gathered in military formation. Anselm Kiefer, against the backdrop of his barn temple, evoked such a bringing to the present of the memory of the dead to such a degree that one has the urge to jump up and try to prevent the blazing fires from destroying the entire structure. The intended nearness to somber memory and the risk of destruction applies however, with the exception of Richard Wagner, to none of the cultural heros called through inscription back into the present: Robert Musil not to mention Adalbert Stifter, Joseph Weinheber, or Theodor Storm have with their works and deeds hardly called up the context between creation and destruction, at the most that between misleading memory and historical falsification. Did Kiefer want to soften the reawakening of Wagner by calling up the names of others who were never understood as cultural heroes? In later reawakenings of the dead greats (*Wege der Weltweisheit*, Ways of World Wisdom) there also appear next to the artists, princes, military commanders, leading philosophers and cultural heroes equal to Wagner, like Kleist or Stefan George. The most likely answer is that Kiefer wanted to place himself as a painter in the context of fascination through the forbidden and an opening presentation of taboos. The grandiose iconographical topography of *Malerei der Verbrannten Erde* (Painting of the Scorched Earth) points to this through establishing the analogy between state-building and destroying, and artistic work. It is therefore only logical that Kiefer in other works placed the artist as such, the unknown artist, in the framework of the memorial – just a one in the twentieth century creates memorials for unknown soldiers, for those no longer called by name. When Kiefer replaced the sarcophagus in the temple crypts of the dead from March 23, on Königsplatz with a pile of pallets on a pedestal he was operating with a subtle irony. The culture-business, based on the competitive glorification of great masters, means that countless others will never be known by name. Those who remain unknown are the sacrificial victims for the possibility that others can become famous.

In the tableau *Kunersdorf* Kiefer brings together all the aspects of the theme. With the exception of a small area in the center of the lower half of the work, the picture consists of a lead foil, which with its drawing-like beauty allows one to imagine the landscape where Frederik the Great suffered his worst defeat in the Seven Years War. In the small area in the lower center is a photo

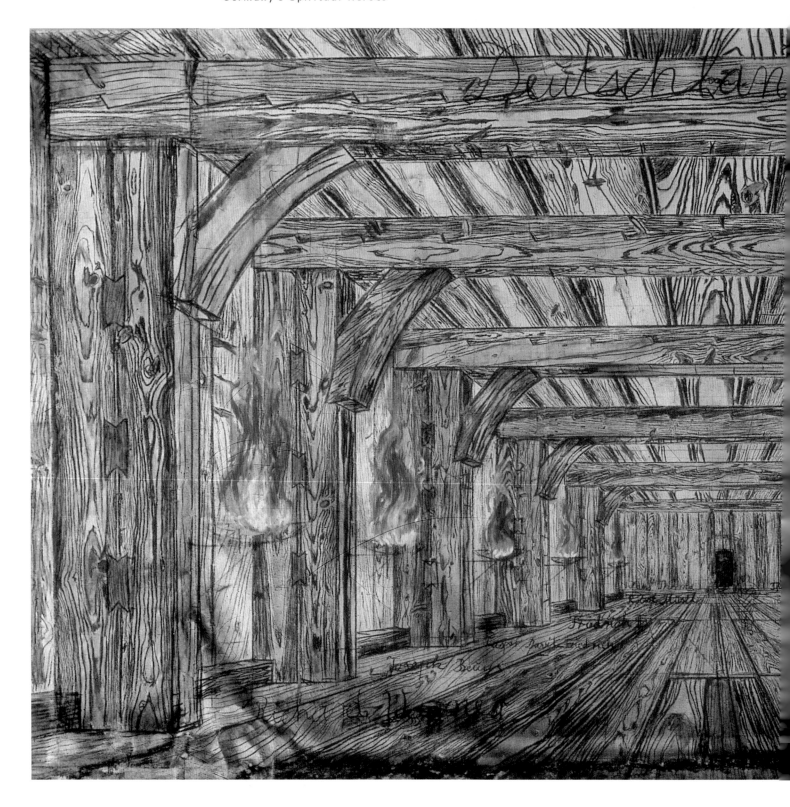

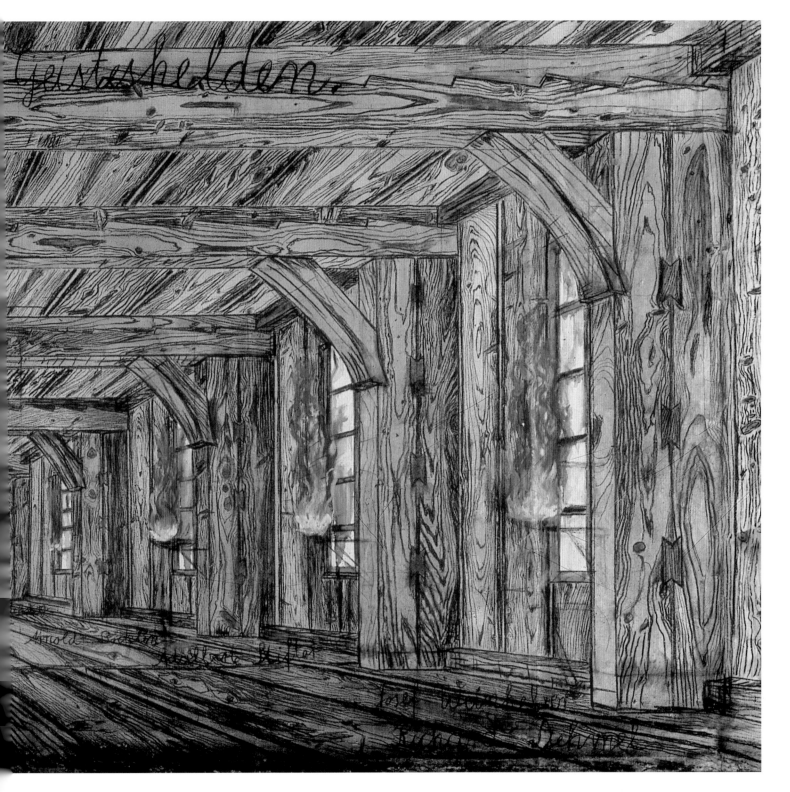

326 **Anselm Kiefer**
Germany's Spiritual Heroes, 1973
Oil and charcoal on burlap, mounted on canvas
307 x 682 cm
The Ely Broad Family Foundation, Santa Monica

Death Fugue
Paul Celan

Black milk of dawn we drink it at dusk
we drink it at noon and at daybreak we drink it at night
we drink and we drink
we are digging a grave in the air there's room for us all
A man lives in the house he plays with the serpents he
 writes
he writes when it darkens to Germany your golden
 hair Margarete
he writes it and steps outside and the stars all aglisten
 he whistles for his hounds
he whistles for his Jews he has them dig a grave in the earth
he commands us to play for the dance

Black milk of dawn we drink you at night
we drink you at daybreak and noon we drink you at dusk
we drink and we drink
A man lives in the house he plays with the serpents he
 writes
he writes when it darkens to Germany your golden
 hair Margarete
Your ashen hair Shulamite we are digging a grave in the
 air there's room for us all

He shouts cut deeper in the earth to some the rest of you
 sing and play
he reaches for the iron in his belt he heaves it his eyes are
 blue
make your spades cut deeper the rest of you play for the
 dance

Black milk of dawn we drink you at night
we drink you at noon and at daybreak we drink you at dusk
we drink and we drink
a man lives in the house your golden hair Margarete
your ashen hair Shulamite he plays with the serpents

He shouts play death more sweetly death is a master from
 Germany
he shouts play the violins darker you'll rise as smoke in
 the air
then you'll have a grave in the clouds there's room for you all

Black milk of dawn we drink you at night
we drink you at noon death is a master from
 Germany
we drink you at dusk and at daybreak we drink and we
 drink you
death is a master from Germany his eye is blue
he shoots you with bullets of lead his aim is true
a man lives in the house your golden hair Margarete
he sets his hounds on us he gives us a grave in the
 air
he plays with the serpents and dreams death is a
 master from Germany
your golden hair Margarete
your ashen hair Shulamite

Translation: Joachim Neugröschel

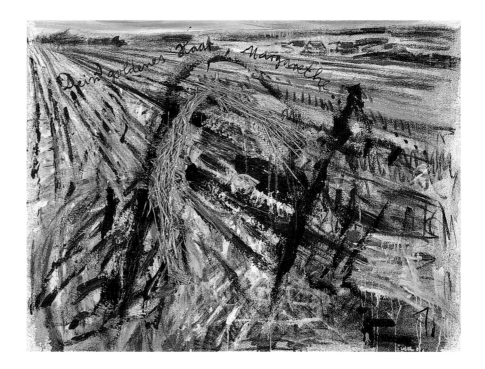

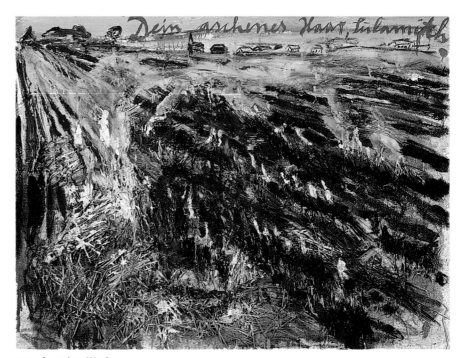

327a **Anselm Kiefer**
Your Golden Hair, Margarete, 1981
Oil, emulsion and straw on canvas
130 x 170 cm
Sanders Collection, Amsterdam

327b **Anselm Kiefer**
Your Ashen Hair, Shulamite, 1981
Oil, emulsion and straw on canvas
130 x 160 cm
Sanders Collection, Amsterdam

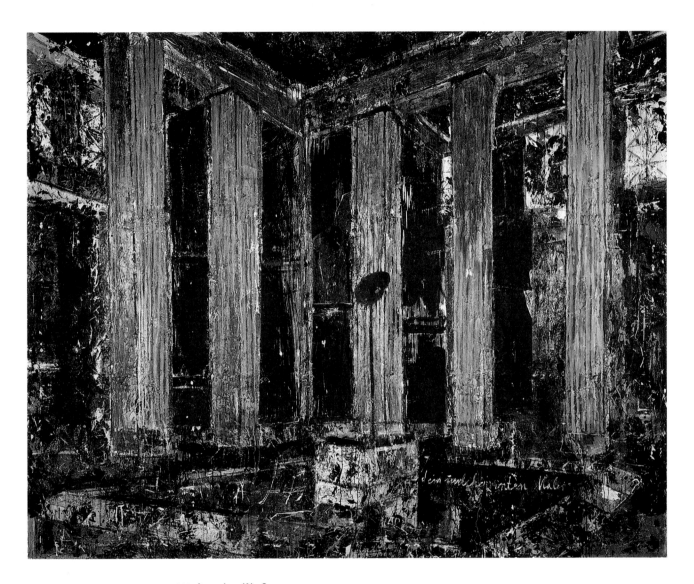

328 **Anselm Kiefer**
To the Unknown Painter, 1982
Oil paint, straw, wood cut on canvas
280 x 341 cm
Museum Boijmans Van Beuningen,
Rotterdam

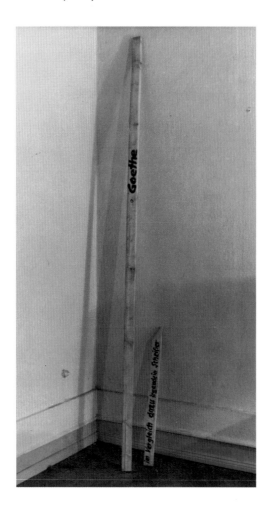

329 Georg Herold
*Goethe-Slat (In Comparison
with some other Jerk)*
1982
Two roof battens, written on
210 cm; 60 cm
Albert Oehlen, Cologne

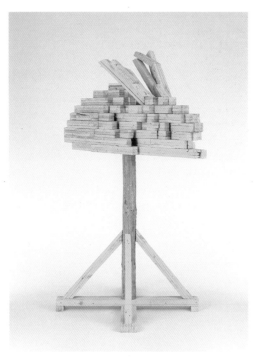

330 Georg Herold
Dürer-Hare, 1984
Roof battens
90 x 75 x 190 cm
Dr. Andreas Hölscher,
Cologne

from Kiefer's 1969 series *Besetzungen* (Occupations).
Occupied were sites of historical events and the memory
of them through the contemporary Kiefer in order, in "the
form of historical common experience," to subject not only
the perpetrators of violence, but also oneself, to recalling
memory.

Georg Herold also operates with the naming of
German cultural greats and many unknowns. His *Goethe-
Latte* (Goethe-Slat, see fig. 329, p. 338), made out of un-
pretentious materials and executed in casual construc-
tion as a roof batten, becomes a Dadaistic measure of the
"buggers", formerly bourgeois. In Germany, with the ex-
ception of the unknown solider, the unknown carriers of
mass culture have never been honored. From the per-
spective of the greats they seem like failures, the incom-
petent. The unknown worker, scientist or consumer were
not considered worthy of public monuments. "Trümmer-
frauen", concentration camp victims, and victims of the
bombing were categorized more for their memorial
potential as anonymous victims.

That an animistic totem-animal like the hare
peopled the German life-world from Dürer to Beuys, is
recalled by Herold in his roof batten sculpture of *Dürer-
Hase* (The Dürer-Hare, see fig. 330, p. 338). One can well
imagine what kind of political effect could be achieved if
one were to try to add the "Dürer Hare" to the national
coat of arms and to create monuments to this symbol as
the epitome of German self-understanding (see the fairy
tale about the race between the hare and a hedgehog).
Such a sign would at the same time bring out the small
mindedness and the reality denying attitude of a people
which believes itself in a position to beat every challenger
before the race has even started.

Inwardness based on power and teary self-emoti-
on characterize the German mentality. The wish to in-
undate millions with Beethoven and Schiller and to
reserve for oneself a special mission in the unfolding of
world wide brotherhood corresponds to the need to shud-
der at the greatness of Beethoven, while at the same time
consuming him in small bits in ones living-room. This need
is given visual expression by Dieter Rot in his throw-away-
sculpture *The Bathtub to "Ludwig van"* (see fig. 331, p. 339),
a collection of hoarded chocolate Beethoven busts filling
a bathtub is a drastic indication of consuming the greats
in a cultural and religious context. The Christians and the
Salzburgers knew already why they did not promote Ob-
late wafers or Mozartkugeln in anthropomorphic form, but
rather were satisfied with a pictorial appearance.

In Lüpertz's triptych *Schwarz-Rot-Gold – dithy-
rambisch* (Black-Red-Gold – dithyrambic, 1974; see fig.
332, p. 340) a strategy is brought to light with which since
the ancient world war emblems have been used both as
a form of retrospective memory, but also as a prospective

form of warning. The Romans adorned their temples with conquered weapons, flags, and banners. From these trophies they derived the apotropaic use of signs (paintings are in any case also sign-constructions), a further development of the Perseus shield in the polished surface of which one saw the etched figure of a destroying medusa. The use of this apotropous not only warns the

331 **Dieter Rot**
The Bathtub to „Ludwig van", 1969
Zink bathtub containing 60 heads made out of white sugar icing, brown chocolate and solid fat
57 x 188 x 70 cm
Ludwigforum Aachen

warrior against overestimating himself, but is indented to prevent the worst through preparation for it. So did the hymnal dithyrambic bringing to consciousness of Lüpertz become a kind of protective shield for the black-red-gold Republic: as the saying goes, if when leaving the house one brings an umbrella, one can be assured it will not rain. Even the apocalypse itself was reformed by Lüpertz into a dithyrambic apotropous (1973). In the series of dithyramb works from 1966 to 1974, Lüpertz activated the vitalism and spiritual euphoria even with roof tiles and asparagus beds. The dithyrambs bring out amidst veiled sublimity the banal core of social emotiveness without discriminating against it: the longing and the necessity to finally say "yes" to the world, even though no part of it deserves unreserved affirmation.

Bazon Brock

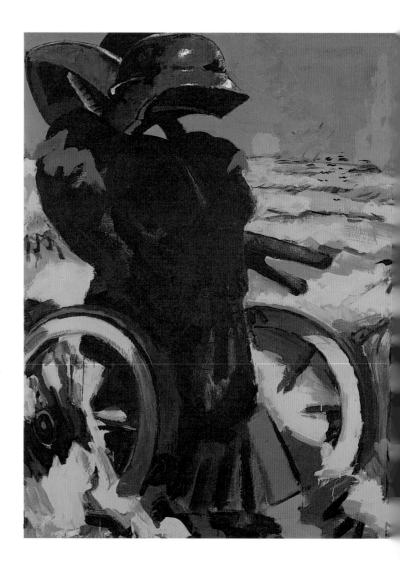

332 **Markus Lüpertz**
Black-Red-Gold - dithyrambic, 1974
Triptych: Distemper on canvas
Each 260 x 197 cm
Galerie der Stadt Stuttgart

346-1 **Andreas Slominski**
Oven for Burning Forks of Tree Branches, 1997
Metal
(no illustration)

The illustration shows:
Oven for Burning Forks of Tree Branches, 1997
Metal, glas
217 x 73 x 100 cm
Collection of the artist

Slominski or the Inconspicuous

When Andreas Slominski arrived atop the Ettersberg at the end of a peaceful foot-journey from Weimar on May 16, 1996, he discovered, on the grounds of the former concentration camp Buchenwald, in the black soil of a freshly-dug mole-hill, a one-pfennig coin. This inconspicuous item, much worn by the elements, had been issued in 1943. Under any other circumstances, the find might have qualified as a lucky penny. More than fifty years later, discovered among splinters of bone, glass ampules and the weather-worn heels of shoes, this tiny piece of metal emits an all but radioactive glow that gives the lie to the superstitious saying "finders keepers." It cannot be measured by the physicist's Geiger counter, nor neutralized as a historian's document. It can be preserved as a form of energy only in that medium we reverently, and in bad conscience, still call art.

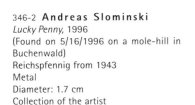

What can the luck of 1943 mean to us so many years later? The belief in predestination from which a certain shaman forged world politics? The childhood of a beautiful woman soon to be reduced to ashes in the rubble of an air-raid cellar? The defeat of an entire army thousands of miles from the site of the find? Random survival in cities about to be razed to the ground?

Fortunatus Slominski cannot get over his astonishment. The longer he regards his lucky penny, the stranger and more uncanny its returning gaze. The devaluation of all values, collapse of symbols, confusion of all meaning – these are things the recent finder of the coin knows quite well, as well as his forbears knew propaganda, church-going and the faith in that notion of artistic beauty of which the old aesthetic theories speak.

Slominski regards history with a Parsifal's gaze. He approaches the uncanny with the wariness of a woodland creature. One of the keys to his work is the awe, an almost holy awe, he brings to meaning, which, once it has been frozen into place, contributes to the semantic misery of all things. Almost literally he embraces the credo of Goethe's late years: "Once in the forest / I strolled content, / To look for nothing / My sole intent." One can note, for example, that his deceptive object remain, for the most part, within earshot of woods and fields. All the animal traps, windmills, fanciful ovens seem like objects that someone has carefully deposited in a clearing-intending, perhaps, to return for them later. Meanwhile they tease the viewer with their ostensible usefulness, enchant him with the uncertainty of their origins, as found objects or models that might inspire one to copy them. An *Oven for Burning Forks of Tree Branches* would be the perfect gadget for the "Little Hunchback" from the pages of the German Children's Book that the young Walter Benjamin could still imagine encountering. Unless I am gravely mistaken, Slominski's strategy is to make reparations to that which has been repressed (in history and landscape, craft and lifestyle) by concentrating on that which has been cast aside, the inconspicuous, even the strange. Leaping as if in flight between hot and cold symbolism, he light out into the bushes, of which there are fewer and fewer each day. The difficulty one has catching hold of him has its basis in the hunt. It is not merely personal preferences that are transforming today's artists. With a bit of luck, one can catch an occasional of him, a timid deer glancing back along the path of its own retrest from the ruined forests to the sprawling cities in whose museums and galleries it briefly pauses.

Durs Grünbein

Picking up the Shards
On Heribert C. Ottersbach

Problems of Reconstruction, Class Trip to Westwall, Government Bunker, and *Charnel-House* are titles of paintings with which at the end of the 1980's, Heribert C. Ottersbach, painter and now also sculptor, obstructed the aesthetic routes of escape in the Federal Republic that forgot history. Ottersbach, born in 1960, reattempted, after the cynical-sarcastic historical deconstructivists, to examine history dialectically with historical images. The painting *History (is what disappears),* from 1989, evokes an historic vacuum, the blind spot in the Federal Germans' consciousness, on which Ottersbach had begun to reflect in the 1980's.

The Third Reich had vaporized away "like an evil but fairytale-like, distorted, childhood memory into the mythical prehistory" and seemed to have "fallen out of all of history".[1] The GDR had suspended history in exactly the same way, with its secularized doctrine of salvation. Artists and writers acted as state-licensed endowers of identity who provided the postwar generation in West and East each with the system-conforming, critical-emancipating, respectively, socialist-antifascist consciousness. When the boundary between the two political systems fell on November 9, 1989, these trusted hegemonic agreements suddenly became invalid. Not only the GDR, but the old Federal Republic as well, stood ready for a new definition.

The 1989 collapse of the East bloc and the end of the "ideological age" that had characterized this century triggered Ottersbach to increasingly include found images in his work. He felt the year that the Wall opened to be a break, the "most exciting, important and decisive political year" for his generation.[2] An enormous fund of pictures from archives in the East and West opened up and waited to be remembered and used by the painter. Since 1989, to find and invent his images, he has helped himself to the archives, depositories, and collections whose systematology and scientific methodology, however, he undermines and transforms into something new. He finds, invents, and remembers images.[3]

Since 1992, Ottersbach has worked in series of paintings, which join together to form extensive tableaus. "My doubts about large pictures cause me to work in series. An appoach is only possible with fragments because there is no big entirety".[4]

The 40-part work *Untitled (40/I)* emerged in 1992, and *Untitled (40/II)* the following year. Following the principle that each part is of equal value, the observer is faced with fragments that collectively maintain a possible context. 40 paintings stand for 40 years of two parallel developments. Naturally, there is no leitmotif running through two-times German postwar history, but there are astounding visual analogies, fragments of a common mentality history beyond the ideologies, slogans, and the Cold War political semantics. In his panels Ottersbach envisions a fictional fund of images and memories common to all Germans. The photo material is cut up and reassembled.

For the 44-part cycle *Untitled (Youth)* (fig. 347, p. 354f.). Ottersbach used exclusively historical photographs from various archives as departure material for the paintings. After determining which part of a photograph was to be included (for example, from the well known scene-of-the-crime photo of the Rudi Dutschke assassination, he shows only the feet of passers-by and the two shoes in the bottom-left section) and numerous photocopying, the now large-grained, raster-point photos are transferred onto thin photo-documentation paper. They are then glued onto the canvas, whereby the photo paper adheres so closely to the canvas structure that the photograph makes the impression of being a sketch. In contrast to the thin veil of varnish painted over the assembled photographs in the cycles *40/I* and *40/II*, the painting makes the photograph recede, so that only bits of the raster structures remain visible as a sketch-like graphic element.

At the end of the century, painting and photography were set in a dialectical relationship to each other. Photography, once painting's opponent at the beginning of the century, becomes its background and foundation at the century's close. The painter draws his own conclusion at the end of the century from the experiences with an avant-garde which remained fixed on the utopic expectations of redemption of a distant future and lost its base, or, as "absolute"[5] painting, remained auto-referentially, exclusively occupied with itself. It was necessary to review, examine, and secure the 20th Century painting's fund of images and canon of forms.[6]

The theme in Ottersbach's vintage of shards is the fatal inter-workings between the political and aesthetic avant-gardes. The Youth Movement, which originated in the founding of the "Wandervogel, Committee for Student Trips (AFS)" in the Steglitz Rathskeller on November 4, 1901, sowed the totalitarian seeds for the 20th century as it was characterized by contrary ideologies until 1989. The Wandervogel - as the active nucleus of reformation movements in bourgeois youth and life which dreamed of a German youth front in the struggle for a German youth empire - soon led to a bewildering succession "of conflicts and splits, provisional realliances ... always with the vision of an impossible unity, which

1 Frank Schirrmacher, "Abschied von der Literatur der Bundesrepublik", *Frankfurter Allgemeine Zeitung,* 10/2/1990.

2 Unpublished text on the work "Untitled *(Youth)"* from 2/9/1996.

3 See: *Heribert C. Ottersbach,* Remembered Images *on the painting cycle* O.T. *(40/I and 40/II),* ed. Karin Thomas (Stuttgart, 1995).

4 Eckhart Gillen in conversation with Heribert C. Ottersbach, *Wider die Vollendung,* ed. Klaus Honnef, exhibition catalog, Rheinisches Landesmuseum Bonn 1993.

5 "From pure forms, polygons, circles, lines and pure colors, absolute painting (absolute = complete and unconditional) makes up the absolute work of art, a new thing, so to speak, a picture that is nothing but a picture in itself."

6 For Gerhard Richter, however, painting from photographs meant a kind of artistic de-ideologization cure after he left the GDR: The photo "as a picture that conveyed a different vision to me, without any of the conventional criterion which I had previously associated with art. It had no style, no composition, made no judgement, it freed me from personal experience". (Gerhard Richter, quoted by Ulrich Loock and Denys Zacharopoulos, *Gerhard Richter* exhibition catalog, Westfälischer Kunstverein, Münster 1985, 31.

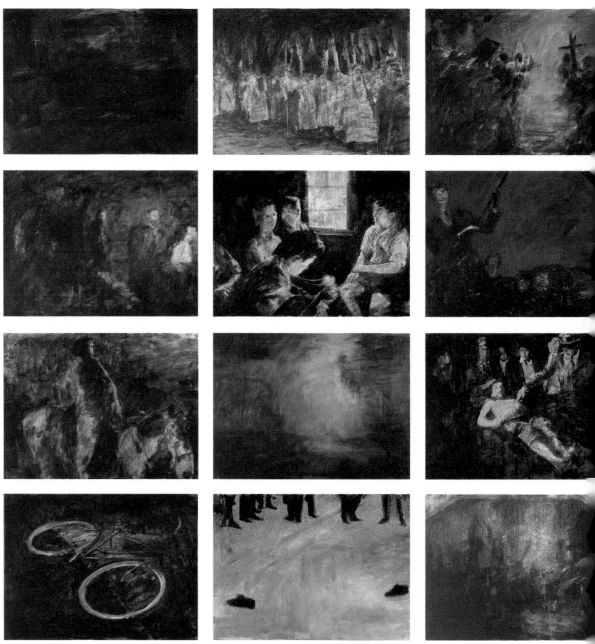

347 **Heribert C. Ottersbach**
Untitled *(Youth)*, 1994/95
44 parts in four rows, mixed technique
on canvas
Total dimensions: 200 x 727 cm
Collection of the artist

was then realized under the pressure of power and at the same time by fascination - in Hitler Youth".[7]

The political and artistic avant-garde wanted to conquer the future in double-quick pace like their model, the army vanguard. They polarized culture against civilization, community against the masses, nature against the city, etc. When Ottersbach placed a row of young Catholic women from 1920 next to a dramatically red-orange toned picture of a 1968 West Berlin demonstration showing wooden crosses and water-throwers, or Kibbutz youth from the 1920's next to student society members from the 1960's, he was naturally not interested in the history and structures, programs and political implications of youth organizations, but rather in the common gestures, the similar rituals and poses, the sub-ordinations of the individual in the collective. As a painter and visual being, Ottersbach lets himself be guided by a fine feeling for physiognomic detail in examining and selecting material for the choreography of totalitarian body language and patterns of behavior. The third row from the top, for example, shows the Führer vested with pseudo-religious decoration and following. On the outer left side, Che Guevara rides a donkey, like Christ entering Jerusalem. The third picture from the left shows the well-known photo from October 8, 1967, the day Che Guevara was executed by the Bolivian military. Journalists flew in so that they could confirm the identity of the revolutionary leader. "The photos in which Guevara appeared to resemble Christ were taken on this occasion: one reminded me of Mantegna, another reminded me of Rembrandt's The Anatomy Lesson.[8] Ottersbach decided on the Rembrandt variant, which he parodied with his artistic sensitivity. Guevara appears a third time on a poster in an American student demonstration (lower row, fourth picture from the right). This example confirms the status Ottersbach grants the aesthetic qualities of his photographic originals and their political-ideological function as propaganda, evidence, and icons of social "movements". Nearly thirty years later, Che Guevara's mortal remains were ceremonially transported like relics from Bolivia to Cuba, where they were placed in a mausoleum in Santa Clara and will be later made accessible for contemplation.[9] In the second row from the bottom, right in the middle, Dutschke, not visible in the painting, speaks in the auditorium of Berlin's Free University, 1968. Ottersbach ironically treats and also evaluates the plain black-and-white photos with painting, by bathing the scene in an unreal, Bengalese light. The teach-in thus becomes an ecstatic rebaptist community.

The last row of pictures takes the time of Ottersbach's own youth in the 1970's as a central theme: Demonstrations on Berlin's Kurfürstendamm, Gudrun Ensslin and Andreas Baader during the department store arson trial, a "Lidl" party at the Dusseldorf art academy, a pop concert ... The spectrum of images out of history spans from the origins of the Youth Movement to the end of the 1970's to the Women's Movement. The tableau of pictures is vitalized by the tension between the equalized black-and-white photos, which undercoat the painting as line drawing through the filtered out gray values, and the painting, which allows the individual elements, the particular, to come into its own. Painting conveys the zeitgeist, the stylistic gestures, the inductive, somatic memory. Photography stands for the objectivizing, deductive, documenting remembering. The painter snatches the anonymous photo-document stored away and disposed of in archives out of oblivion and shifts it into our consciousness. In his painting, it becomes the "subject of a structure whose site ... (is) filled by the presence of the now".[10] Here the historical facts become something "that only happens to us just at the moment, realizing them is a matter of memory".[11] The painter uses images from history, the collected documents, images passed down, and photographs, as material that supports the memory. But he does not order them chronologically, nor does he evaluate them with "objective" source verification methods and scientific logic. The artist finds something that arouses his interest and he makes it into his point of departure for a complex work of construction. Ottersbach proceeds analogous to psychoanalytic memory work "which strives for the redressement of repressions and displacements"[12], in the displacement, re-ordering, and rear-ranging of his subjects: "I displace the problem ... into another level, I might simply change the angle of vision, to possibly be able to better deal with the problem. My studio is a displacement point, not a point of destination."[13]

Painting is for Ottersbach, still, a site "on which the things can process themselves, be arranged, be remembered, in a way not possible in other media," because in the picture there is "perhaps a possible culmination point which, however, is only individually, not generally, perceivable ... Everything is all there at the same time ... Perhaps the motivation for my paintings is to have everything together all at once."[14]

Eckhart Gillen

[7] Jean Pierre Faye, *Totalitäre Sprachen*, vol. I (Frankfurt/Main, 1977) 258. From the start, there was a kind of uniform to differenciate themselves from the vagabonds and hawkers, a hierarchy: school boy, fellow, bachant (wandering student in the Middle Ages), and *groß*bachant, a special greeting, adopted from the *völkischen* students and already used by the *Alldeutschen*: "Heil". (259).

[8] Richard Gott, "Die Hände Che Guevaras. Wie die CIA das Idol der Revolution begrub", *Frankfurter Allgemeine Zeitung*, 7/8/1997.

[9] See: *Frankfurter Allgemeine Zeitung* from 7/14/1997.

[10] Walter Benjamin, "Theses on the Philosophy of History", *Illuminations* (New York, 1968) 260. "Benjamin wrote *Jetztzeit*, indicating that he did not simply mean an equivalent to *Gegenwart*, that is, the present. He clearly is thinking of the mystical *nunc stans*", (translator's comment to "presence of the now" from the American edition of *Illuminations*).

[11] Walter Benjamin, *Passagen-Werk*, Gesammelte Schriften, vol. V. (Frankfurt/Main, 1983) 491.

[12] Sigmund Freud, *Zum psychischen Mechanismus der Vergeßlichkeit*, (7th Ed.), Gesammelte Werke, vol. I (Frankfurt/Main, 1981) 525.

[13] Quoted from Heribert C. Ottersbach. Remembered Images *on the painting cycle O.T. (40/I and 40/II)*, ed. Karin Thomas (Stuttgart, 1995) footnote 17.

[14] Thomas, footnote 17.

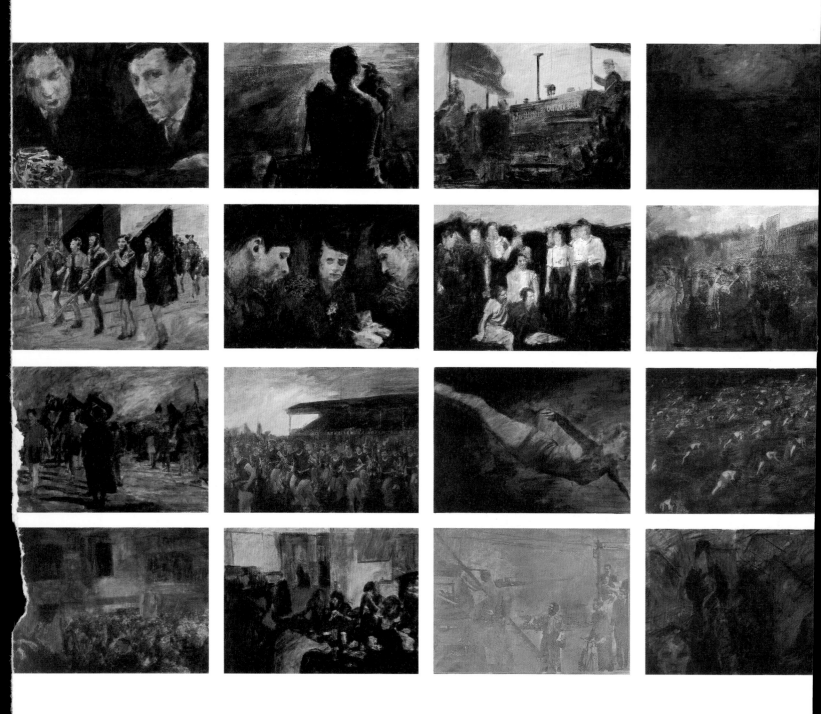

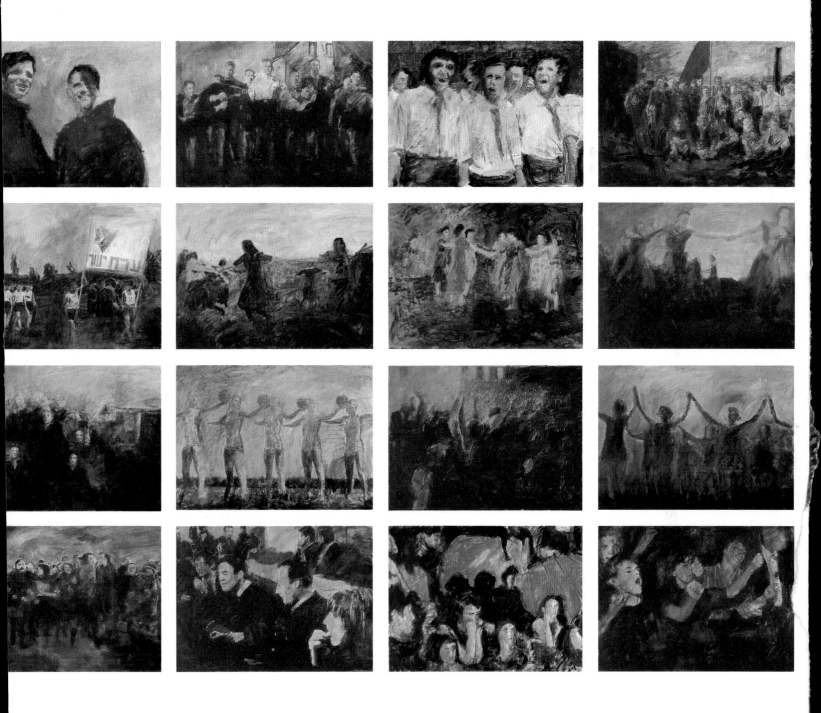

Kopfdiktate

The exact title should be:

Reinhard Mucha

"Kopfdiktate"
An exhibition from
February 19 to March 20, 1980

Museum Haus Esters
February 19 to April 1, 1990

With "Kopfdiktate," too, the *meaning of the form* "exhibition" is extremely important. On the surface, the photos and the photographed written pages (which certainly also could be read as drawings) may seem to have a central meaning. Actually, though, they represent at best a kind of anecdotal element, with all their possibilities and traps for interpretation and identification. But if the exhibition as a whole is viewed as something like a plastic event, they can generate an image that concerns us much more directly. In this picture, the photos remain marginal, on the outskirts. Of course, they are presented in the Haus Esters Museum in a special way, framed as two temporally and spatially separate exhibitions (Wuppertal 1980 and Krefeld 1990). But the way in which this is carried out (quotes from painting and architecture), **where** it is happening (in a formerly private home, designed by Mies van der Rohe), **when** it is happening (on my 40th birthday), and **for whom** (friend, relatives and acquaintances) – that is the real picture of this exhibition. The photos and the written pages have in it a purely framing function. This switch is very important and plays a part in many of my projects: the picture as framing figure – the frame as picture.

Nevertheless, the photo's motifs are not arbitrary. They are meant to suggest movement. Metaphor as vehicle—vehicle as metaphor. Scooters and shoes. Whereby the scooter, leaned up against a stack of chairs, is simply and plausibly plastic.

My project at that time, in 1980, required that the exhibition take place in the stairwell of a middle-class, turn-of-the-century home*, and in a quasi-private sphere. The same could be said today. Although the accent (and thus the confrontation) has certainly been somewhat shifted, namely, to precisely those works (among others) that were created in the years between. Without them, a repetition of the exhibition in Haus Esters would hardly be possible.

R.M. (1990)

Excerpt from a letter to Dr. Gerhard Stock, Krefeld

Reinhard Mucha

* In Parsevalstraße 13 in Wuppertal was then the home of the gallery Annelie Brusten.

348 **Reinhard Mucha**
Kopfdiktate, 1980–1990
30 showcases,
60 black & white photos, wood,
glass, lacquer, etched glass,
aluminum, felt
Each ca. 72 x 129 x 59 cm
Chairs, scooter, shoes
Museum Kurhaus Kleve
The Ackermans Collection

Dingwörter
Der Mann, der Mond, die Zeiten,
der Sonntagmorgen, der Wald,
das Holz, die Welt, der Staffelstock,
das Haus, die Sonntagskuchen.

O daß doch meine Stimme schallte
bis dahin wo die Sonne steht, o daß
mein Blut mit Jauchzen wallte solang
es noch im Laufe geht, ach wär
jeder Puls ein Dank und jeder Odem
ein Gesang.

Die Mutter wiegt das Kind. Der
Junge wagt sich raus. Die Bäume
stehen dicht. In der Nacht kommt der
Vollmond. Ich muß zum Gericht.
Die Mutter wiegt das Kind.

auf der Jagd. Jagd. Morgens
rasselt der Wecker. Die Hühner
gackern im Stall. Wer erkältet ist
muß husten. Die Nachtigall flötet
schöne Lieder. Wenn wir in der
Schule plappern gibt's Neo Straf-
arbeit.
Wir passen auf daß wir nicht krank
werden
Ich darf mich im Winter nicht auf die
Steine setzen. Mann muß sich warm
anziehen um sich nicht zu erkälten.
Man darf im Sommer kein kaltes
Wasser trinken. Ich darf im Winter

im Freien nicht baden. Wer unreines
Obst ißt wird krank. Durch Ansteckung
kann man auch leicht krank
werden. Wenn man geschwitzt hat,
darf man nicht gleich ins kalte
Wasser. Man muß aufpassen,
das man, wenn man eine Wunde
hat kein Dreck reinkommt.
Ich darf auch keinen Sand in
den Mund nehmen. Ich darf,
damit ich keine Blase hinein
kriege nicht mit Feuer spielen.

Nebel

Jedes Dingwort hat ein
Geschlechtswort. Es gibt
drei Geschlechtswörter:
der, die und das. Der
gehört zu einem mänli-
chen (Dingwo.)
Dingwort, die die zu
einem weiblichen und
das zu einem säuschlichen
Dingwort

Die Leute sitzen. Die Leute lesen.
gehn aufs Klo. Die Leute reten.
warten. Die Leute gucken aus dem
die Leute lösen. Die Leute grüßen
gucken. Die Leute gräßeln.

Seit ein paar

Wenn wir eine Bombe oder
Granate finden, dürfen wir
nicht damit spielen. Wir
müssen sofort die Polizei benach-
richtigen.

Erzählung

Vor einem Jahr war ich in einem
Garten. Dort hatte ich alles zer-
treten und den Zaun kaputt
gemacht. Auf einmal kam ein
14 Jahre alter Junge und fragte
mich was ich da mache. Natürlich
habich gedacht, er wäre der
Sohn des Besitzers und bin wegge-
laufen.

noten

Eine Klassenfahrt

Bald fährt unsere Klassenfahrt in
die Jugendherberge. Wir freuen uns
alle sehr darauf. Wir werden viel
Schönnes, viel lustiges erleben.
Wanderungen und Spiele werden
uns erfreuen, und Langeweile wird
es nicht geben. Wir werden viel
singen und lustig sein. Bin geht
es bald ans Kofferpacken. Sehr viel
mitnehmen werden wir nicht, aber
nichts Notwendiges darf vergessen
werden. Hoffentlich haben wir
schönes Wetter, damit wir in den
Wälder sein können. Wenn wir
wieder bei unseren Eltern sinde,
werden wir viel erzählen könne
viel Schönes, viel lustiges, viel singen
viel singen, viel mitnehmen
nicht Notwendiges, viel erzählen

die Jugend
Jugendh
das Ko
verpac

Hof

sprechen
denken
siegen
Malen

Hausarbeit

Der Maler/n malt die Wände an.
Ich male in der Schule ein Bild.
Auf das Bild male ich einen
Baum. Dann male ich daneben
ein Haus. So male ich immer
weiter. Ich nehme das Bild mit
nach Hause und lege es auf den
Geburtstagstisch der Mutter, und
sie sagt das Bild, dann sagt sie:
„Das Bild hast du aber schön
gemalt."
Der Müller mahlt das Mehl. Die
Mutter (malt) den Kaffee. mahlt

Verrillen

ver yer
12 12.

Der Verräter

Es war einmal ein Mann. Er verriet einmal
der Polizei das ich mich versteckt hielt
der Verräter war schon vorgelaufen
und voreilig denn die Polizei fand mir
nicht mer. Ich hatte mich nämlich
woanders versteckt der Verräter
lief ganz dicht an mir vorbei.

Hinfahrt:
ab Gerresheim 9⁵⁵ Uhr
an Westh. 11¹⁵ "
Rückf. d 14. 10
ab Westhofen 8⁰⁵ Uhr an Gerresheim 9³⁵

Was der Straßenbahnschaffner
alles sagt!

Der Schaffner sagt: „Bis zur
mitte aufrücken!"
Der Schaffner sagt zu den
Kindern: „Geht vom Eingang
weg!"
Der Schaffner sagt „Rauchen
verboten!"
Der Schaffner ruft „Fahrgast
ohne Fahrausweis zum Schaffner-
platz kommen!"
Der Schaffner fragt: „Haben
sie das Geld nicht stimmt?"

Schreiben: was die Straßenhändler
rufen! 18 S

Ich darf in der Klasse nicht schwätzen
Ich darf in der Klasse nicht schwätzen
Ich darf in der Klasse nicht schwätzen
Ich darf in der Klasse nicht schwätzen
Ich darf in der Klasse nicht schwätzen
Ich darf in der Klasse nicht schwätzen
Ich darf in der Klasse nicht schwätzen
Ich darf in der Klasse nicht schwätzen
Ich darf in der Klasse nicht schwätzen
Ich darf in der Klasse nicht schwätzen
Ich darf in der Klasse nicht schwätzen

Die Polizisten. Die Kinder. Die
Neger. Die Verkäuferinnen. Die
Straßenarbeiter. Der Obst-
händler. Der Feuerwehr-
mann. Der Schornsteinfeger.
Der Straßenbahnfahrer. Der
Lumpenhändler. Die Frauen.
Die Männer.

Im Briefkasten aber war es ganz
dunkel. Später machte ich
eines.

Ich muß in der Klasse leise sein. Ich
muß in der Klasse leise sein. Ich muß
in der Klasse leise sein. Ich muß in
der Klasse leise sein. Ich muß in der
Klasse leise sein. Ich muß in der Klasse
leise sein. Ich muß in der Klasse leise
sein. Ich muß in der Klasse nicht laut
sein. Ich muß in der Klasse leise sein.
Ich muß in der Klasse leise sein.
Ich darf beim Turnen nicht laut sein.

Häuflinge, die Buchfinken, der
Dompfaff
Im Briefkasten war es ganz
dunkel. Später machte ich
eine lange, lange Reise,

Postwarnzeichen

Man kann Karten und Briefe
im Ortsverkehr und im Fern-
verkehr schicken.
ehr. Im Ortsverkehr bekommt
eine Karte eine 8-Pf und ein
eine 20-Pf Marke.
Im Fernverkehr bekommt ein
eine 10-Pf Marke und ein Brie

Ich darf beim Turnen nicht laut sein
Ich darf in der Turnstunde nicht
laut sei.. Ich darf beim Turnen
nicht laut sein. Ich beim Turnen
nicht laut sein

Ich muß leise sein. Ich muß leise
sein. Ich muß leise sein. Ich muß
leise sein. Ich muß leise sein.

Die Schneeflocke. Der Himmel
Die Welt. Die Zeit
Der Zaun. Das Dach

Ich muß in der Klasse leise sein.

Ich darf in der Schule nicht
schwatzen. Ich darf in der
Schule nicht reden. Ich darf
in der Schule nicht reden. Ich
darf in der Schule nicht reden.
Ich darf in der Schule nicht
reden. Ich darf in der Schule
nicht reden. Ich darf in der
Schule nicht reden. Ich darf in
der Schule nicht reden. Ich darf
in der Schule nicht reden. Ich
darf in der Schule nicht reden.
Ich darf in der Schule nicht reden.
Ich darf in der Schule nicht reden.

Ich darf in der Schul nicht reden
Ich darf in der Schul nicht reden
Ich darf in der Schule nicht reden
Schie. Ich darf in der Schule nicht
reden

Ich muß mich nach dem schellen
ordentlich aufstellen. Ich muß
mich nach dem schellen ordent-
lich aufstellen. Ich muß mich
nach dem schellen
ordentlich aufstellen. Ich muß
mich nach dem schellen
ordentlich aufstellen. Ich muß

mit meinem Gesicht.

 Dingwörter

Die Schmiede, die Mutter, der Berni,
das Tor, der Amboß, der Gesele, das
Feuer, der Blasebalg, der Rauch,
die Hufeisen, der Fußboden, die
Ecke, der.

 Steigerungsform
groß-großer-am gro
klein- kleiner-am kle
dick-dicker- am dickst
dünn-dünner- am dünn

hupen, klirren, bellen
rasseln gackern husten flöten
plappern Jagd Jagd
Ich muß mich nach dem schellen
aufstellen Ich muß mich nach
dem schellen aufstellen Ich muß
mich nach dem sch schellen
aufstellen Ich muß mich nach
dem schellen aufstellen auf=
stellen Ich muß mich nach
dem schellen aufstellen Ich
muß mich nach dem schellen
aufstellen Ich muß mich nach
dem schellen aufstll aufstellen

Ich muß mich nach dem schellen
aufstellen Ich muß mich nach
dem schellen aufstellen Ich muß
mich nach dem schellen aufstelle
Ich muß mich nach dem schel=
len aufstellen Ich muß mich
nach dem schellen auf=
stellen. Ich muß mich nach
dem schellen aufstellen Ich
muß mich nach dem schellen
aufstellen Ich muß muß Ich
muß mich nach dem schellen
aufstellen Ich muß mich nach
dem schellen aufstellen Ich muß

The Sons Die Before the Fathers

How the Soul Leaves the Body
Gerhard Richter's Cycle October 18, 1977, the Last Chapter in West German Postwar Painting

I.

Gerhard Richter's paintings have the solitary quality of naming something vague, but they shift the vague to the concrete. It is a process which Richter had tried and tested over decades on very different objects. An artistic act, which absorbs what is felt, thought, and known - even what is foreseen - and never relinquishes them. Richter's standing as a painter and to a lesser extent the subject, brought the cycle *October 18, 1977* (figs. 349-363, p. 389-401) into the prominence which one now attributes to it. This prominence is founded in the paintings themselves. It is their form which triumphs. All other pictorial artistic works concerned with the RAF have remained marginal or episodic in the end.

The cycle was shown for the first time publicly in the Museum Haus Esters in Krefeld in 1989. In Novem-

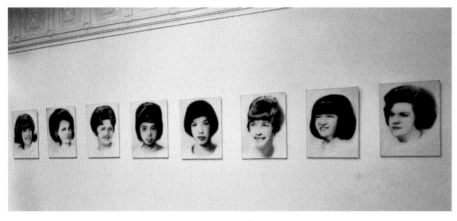

Gerhard Richter
Eight Student Nurses
1966
Oil on canvas
Each 95 x 70 cm
The Crex Collection,
Hallen für neue Kunst,
Schaffhausen

1 From Richter's notes 1964-65: "Having ideology means having laws and regulations, that means, to kill the ones who have other laws. What is that good for?" Gerhard Richter, "Text". *Schriften und Interviews,* Hans-Ulrich Obrist (ed.) (Frankfurt/Main, 1993), 33.

2 Richter, 53.

ber of the same year, Honecker's regime collapsed and one year later East Germany, the once so proud GDR, became part of the Federal Republic of Germany. In the following two years it came to light that at once ten of the people who as members of the Red Army Faction (RAF) had been on the wanted persons list in the West had lived under State protection in the GDR. This abruptly transformed the notion of what in the West – and officially in the East also – counted as political reality. The RAF had suddenly become a phenomenon for all of new Germany.

Born in 1932, Richter grew up with German National Socialism. His home town Dresden lay in rubble when he was 13. Once rich in baroque architecture and enlightened bourgeois traditions, the city – or what remained of it - was now the southwestern post of the Soviet occupied zone. When Richter was admitted to the Art Academy in Dresden at the age of 20, the GDR had already been

founded, but was to remain halfway open for a long time. Shortly before the East German State locked in its citizens until countermand with help of the "antifascist protection wall" (a border where people were shot), Richter moved to westernmost Germany, to Dusseldorf, where he registered anew at the academy there.

13 years of Nazis, 15 years of Stalinists: no wonder that Gerhard Richter was no longer receptive to doctrinaire theories.[1] But like the Federal Republic's entire cultural avant-garde – Günter Grass, Hans Magnus Enzensberger, Peter Zadek – Richter could also not accept the Adenauer State's crude slogan "No Experiments" as an alternative to the GDR: "I like the undetermined and boundless and the continuing uncertainty", Richter said for the record in 1966.[2] Virtually all of the really creative powers in the Federal Republic in the sixties and seventies belonged to one or another direction of the Left or Left intellectual milieu. And hence the contact with the Red Army Faction: Baader and Ensslin were the personification of revolutionary impatience. But then they became figure symbols of a hatred which grew out of a negative identification with the State.

Gerhard Richter was 55 years old when he began the work on the cycle. In retrospect, Richter's devotion to the RAF as subject had the effect of a prophetic act. At a time when the RAF had nearly no more resonance in Federal Germany and shortly before they returned to contemporary history as a result of the German unification. With their noble motives, evil conspiracies, internal frictions. Richter kept stressing that he doesn't know why he came to this subject at this time; but he intimated that it couldn't have been possible earlier. Gerhard Richter painted *October 18, 1977* when he was mature enough as a painter to do so.

II.

In the cycle *October 18, 1977*, several artistic methods converged which can be traced back to Richter's preceding work. The references to a) other groups of paintings, b) the gray paintings, and c) the paintings from photographic models are all very distinct.

a) By "groups of paintings" I don't mean variations on a motif (like "Cloud" or "Vesuvius"), but rather works which as a group have a common title and are inseparable: *Eight Student Nurses* (1966), *48 Portraits* (1971/72), *October 18, 1977* (1988) and *S. with Child* (1995). The following scheme emerges:

October 18, 1977 is thus structurally similar to the other existing groups of paintings. The first two groups from 1966 and 1971/72 are serially stricter only because the formats of each are identical. They have the effect of self-contained convolutions: in *Eight Student Nurses*, because all of them were victims of the same perpetra-

	Eight Student Nurses (1966)	48 Portraits (1971/72)	October 18, 1977 (1988)	S. with Child (1995)
Number of paintings	8	48	15	8
Painting format	equal	equal	unequal	unequal
Model	b/w, raster	b/w, raster	b/w raster	Color, photos
Source	Newspaper or magazine	Encyclopedia	Magazines	Private photos
People/Things	People	People	People/Things	People
Men/Women	Women	Men	Women and Men	Woman / male child
Prominence	of victims	of the work	(to be clarified)	of the painter
Persons living or dead at the time of painting's creation	dead	dead and living	dead	living
Motive admiration or sympathy	no	yes	(to be clarified)	yes
Victim of some kind of violence	yes	no	yes	no
Topicality	yes	no	no	yes

tor; in *48 Portraits*, because it quotes from a closed context, namely from the encyclopedia. The first group shows exclusively women and the second exclusively men. Both groups touch a nerve of self-doubt in the production of art whose male dominance is odd and whose inclination to bring women as "models" in an object-relationship has been registered meticulously and eagerly for thirty years. The cycle which shows Richter's third wife Sabine with their child explicates the context in obvious openness.

October 18, 1977 dissociates itself from the question, "why do men formulate image languages in which female identities become historically recognizable?" While the painting group *Eight Student Nurses* touches the context thoroughly, albeit cynically, the pattern cannot be projected on Baader, Ensslin, Meinhof, Raspe, and Meins. That is, curiously enough, a result of the gender parity in the RAF.[3]

What clearly distinguishes *October 18, 1977* from the other groups is the painter's specific emotional affinity – and in addition to him, that of his audience - to the persons portrayed and their lives. They are extremely prominent – but their prominence is neither that of the murdered nurses nor of the accomplished gentlemen from the encyclopedia. Although, there are connections. As people who were violently brought to an end, they remain in the collective memory. One recognizes them by their "superstructure" like the philosophers, musicians, and writers from the encyclopedia, and at least in the case of Ulrike Meinhof, by her work, in the classical sense of the word.

Eight Student Nurses, 48 Portraits and *S. with Child* come from the portrait genre and comment on it; that doesn't apply to *October 18, 1977*. In this cycle, there is also a pure interior (*Cell;* fig. 353, p. 392), a still life *(Record-player;* fig. 362, p. 400), and a crowd scene *(Funeral;* fig. 363, p. 401). Pictures of corpses constitute a genre of its own (in painting as well as in photography). With Ulrike Meinhof's *Youth Portrait* (fig. 349, p. 389), Richter goes back to the iconography of the student nurses. There is nothing in the image rites of bourgeois life that points to a cruel death. Or the other way around: death does not change the fact that there was a bourgeois life.

Richter's work is like a compendium of genres, e. g. portrait, landscape, still life, and interior. The painter is not fixated on the human figure, which makes the cycle *October 18, 1977* rich, heterogeneous, and charged with a history of form.

b) Back to the methods: The preoccupation with gray runs through Richter's work. Starting with *Table* from 1962. It is a painting showing a white table, half of which is, however, covered from the middle with a partially transparent application of gray (cf. illustration on p. 236). In the successive paintings, which show no comparable fields of disruption, gray means black and white (the shading, the raster, the sheen, etc.) of the photographic model. It is also not a gray tone - but various tones and shadings and the density varies considerably. From *Tiger* (1965) - a painting confronts the pedantry of the camera that follows its subject - up to the coarse schematic top view of a *Townscape M 2* (1968). With large-format studies like *Gray* (1973, Work Index nr. 334-3) Richter moves in on

[3] In a conversation with Richter, Jan Thorn Prikker remarked: "For you, the RAF is above all a women's movement." Richter: "That's right. I also think that the women played the more important role, they also impressed me much more than the men." Gerhard Richter/Jan Thorn Prikker, "Gespräch über den Zyklus *18. Oktober 1977", Parkett,* 19 (April 1989), 127-136; 130.) On the question of the roles of women in terrorism, see Susanne von Paczensky, *Frauen und Terror. Versuche, die Beteiligung von Frauen an Gewalttaten zu erklären* (Hamburg, 1978). An account attributed to Gudrun Ensslin about the Baader-Meinhof members' first training by the Al Fatah is also to be found in this book.

the detail of the representation, to the microscopic scheme of light and dark. Up to the middle of the seventies, the gray found expression in paintings called "Vermalungen" as resignation to the object. "Vermalungen" means approximately de-paintings – painting and blurring in the same act.

That is important, because it was just at the beginning of the seventies that the political paralysis in Federal German society set in. Although it was Willy Brandt who became Chancellor in 1972, this left-liberal consensus man could not or would not stem the confrontation with the radicalized and fragmented Left. The formation of the Red Army Faction coincided with this time. One might have assumed at the time that Richter was retreating into "abstract" questions in painting, but it would be more apt to conclude that he responded to the societal paralysis with a kind of ban on images (for himself). Richter must have freed himself from this around 1975/76. His work becomes colored – heavy color, effusive color – gray no longer plays a decisive role as medial Ariadne's thread until it suddenly becomes visible again in the cycle about the RAF in 1988.

c) The cycle is naturally connected with the part of Richter's work that interprets photographic models, or more precisely, in the problems which arise from the questions around their interpretations. The painter concerned himself with the private, the ghastly, the banal, the sensational, and the dangerous. It becomes clear that Richter, in the end, does not believe in a mastery of painting untouched by photography. He derides the thought of autonomy in painting and involves the observer in melancholy reflection over the "sincerity" of an emotion (for example, while looking at a landscape). It was quite clear with the colorless (or gray) paintings from photographic or printed models of the 1960's that Richter was fascinated with the compulsive nature of the photographic procedure. That was no longer the case for the cycle *October 18, 1977*, which is less surprising when one assumes that Richter's work and its reception successfully created an awareness of the "compulsive nature" of photography and therefore a return to the same subject was not necessary.

Benjamin H.D. Buchloh, a Marxist critic and friend of Gerhard Richter's, is one of the first interpreters of the cycle. Even he was undecided in reference to the question as to what role the photographic models have in *October 18, 1977*. "Our claim that Richter's paintings

Ulrike Meinhof 1958, 1969, 1970 and 1972
double page in *stern*, 5/20/1976: 74D/74E

Ulrike Meinhof
Photograph in *DER SPIEGEL*, 11/7/1977: 38

4 Benjamin H.D. Buchloh, "Gerhard Richter: *October 18, 1977*", *Gerhard Richter. October 18, 1977*, exhibition catalog (Frankfurt/Main: Portikus, 1989), 55-59; 58.

5 Richter/Thorn Prikker, 129. The conversation was inserted as supplement in the first edition of the catalog to *October 18, 1977*.

October 18, 1977 offered artistic resistance to the violence of police photography and the collective persecution can also be turned around to say that it is exactly this precision in the photographs Richter chose which allow these paintings to take effect as specific acts of memory against the general prevailing repression." Thus the police photography refreshes the collective memory.[4] Jan Thorn Prikker gave account of Buchloh's statement in this way: "I cannot ... understand when he writes that you criticize the police photos' cruel look." Richter: "No, that's absolutely not what it was about."[5]

III.

Since September 5, 1977, the German Federal government had faced the horrible decision either to sacrifice a leading industrialist named Hanns Martin Schleyer, who found himself in the hands of the second RAF generation, or to release eleven terrorists. Actually, it quickly became clear that they would not give in. The special crisis committee played on time in the hopes of raiding the hide-out. In addition, after Schleyer's kidnapping had continued for several weeks, an airplane, whose passengers were mostly German vacationers, took off from Mallorca on October 13 and was hijacked by Arab terrorists who adopted of the RAF's demands and added their own. On October 18, 1977, a few minutes past midnight, the passengers were freed in a spectacular action by the German anti-terror squad which specialized in hostage situations. Shortly before 5:00 a.m. the plane took off with the freed passengers from Mogadishu (Somalia) to Frankfurt/Main. Even before it landed, Baader and Ensslin took their own lives in the Stammheim Prison in Stuttgart; Raspe died that morning in the hospital; Irmgard Möller, who had wounded herself in the chest with cutlery, could be saved. Hanns Martin Schleyer was murdered by the RAF and was found on October 19.

When Richter names his cycle *October 18, 1977*, the title is quite clear. That means, the cycle is about the suicides on that night in Stammheim. But a complex collage of motives is concealed beneath the laconic painting titles:

Youth portrait	U. Meinhof, 1968 or earlier
Arrest (1)	H. Meins, Frankfurt/Main, 6/1/1972
Arrest (2)	H. Meins (same situation)
Confrontation (1)	G. Ensslin (about 1972)
Confrontation (2)	G. Ensslin (same situation)
Confrontation (3)	G. Ensslin (same situation)
Man shot down (1)	A. Baader (Stammheim, 10/18/1977)
Man shot down (2)	A. Baader (same picture source)
Dead	U. Meinhof (Stammheim, 5/9/1976)
Dead	U. Meinhof (same picture source)
Dead	U. Meinhof (same picture source)

Hanged	G. Ensslin (Stammheim, 10/18/1977)
Cell	A. Baader's cell, Stammheim
Record-player	in A. Baader's cell, Stammheim
Funeral	of A. Baader, G. Ensslin
	and J.-C. Raspe in the
	Waldfriedhof (cemetery) in
	Stuttgart, 10/27/1977

Of the 15 paintings six are about the deaths of Andreas Baader, Gudrun Ensslin, and Jan-Carl Raspe in the high-security wing in Stuttgart-Stammheim and the cells in which they (more precisely, Baader and Ensslin) lived. Of the other nine paintings, three *(Confrontation;* figs. 355-357, p. 394) refer to Gudrun Ensslin, one of this night's dead. It could be meant indirectly, that *Arrest* (figs. 358-359, p. 396-397) also refers to Andreas Baader because he was arrested in the same situation in Frankfurt/Main as was Holger Meins. Four paintings from the cycle, however, refer to Ulrike Meinhof, who had taken her own life in the night from May 8 to 9, thus more than one year before her three comrades. Her *Youth Portrait* not only moved the entire cycle out of the juridicial-political context but anchored it in the biography and history of the Federal Republic.

Of all those who had ever belonged to the RAF, Ulrike Meinhof - born on October 7, 1934 - was the only one to really have known National Socialism from her own memory. Her family, on her mother's as well as her father's side, had had very hard experiences with the Nazis. Her parents were members of a small Protestant resistance church. With her Protestant schooling and her progressive legacy, Ulrike Meinhof grew into a widely illuminating figure in public life in the fifties. She was a spokeswoman in the "Anti-Atom-Committee", as of 1958 in the League of Socialist Students (SDS) from which the Social Democratic Party of Germany (SPD) severed itself because of Meinhof's doings. From 1960 on she was editor-in-chief of the Left-wing magazine *konkret* in Hamburg. With her steadfast attitude, her clear diction, and her progressive femininity, she won approval from her comrades and respect from political opponents.

Unlike Christian Klar or Silke Maier-Witt later, the RAF's founding generation was very closely tied to the institutions and groups which brought about the transformation of the Federal Republic to an open society with social conscience: the League of Socialist Students, the communes, and the Left-wing unionists. In Ensslin's work for a writers' election committee, she supported the Social Democratic Party of Germany in the general parliamentary elections in 1965. Raspe had been co-founder of the "Commune II" in Berlin, Holger Meins was trained at the West Berlin film academy. A large part of the uprising's intellectuals embarked on the March through the Insti-

tutions, some in seven-league boots. When the heads of the Baader-Meinhof-Group - in the hate-version: Baader-Meinhof-Gang - turned up on the wanted posters, the young, Left-wing establishment knew who these people were. Or from the point of view of the urban guerilla, they knew whose ideas they had seized in order to interpret them high-handedly.

By including Meinhof's *Youth Portrait* in the cycle, Richter made clear that he thinks of the Stammheim prisoners as real individuals. Meinhof is two years younger than Richter - thus of the same generation. He consciously did not choose a picture showing her as revolutionary heroine (such a photo would have been easy to find). Richter chose a photograph which appeared on November 7, 1977 in *DER SPIEGEL* showing Meinhof as a woman of at least thirty. However, Richter reproduces this picture in such a way that it looks like the ideal portrait of a school girl taken by a small town photographer, an Ulrike who sympathizes with Catholicism and reads prose by the ton.

The other three pictures of Meinhof show her unmistakably as a person hanged. By serially varying the motif, Richter gives it weight.[6] He sees the unique promise *(Youth Portrait)* which she embodies and juxtaposes the horizontal portrait of the strangulated woman *(Dead;* figs. 350-352, p. 390) whose head seems separated from the torso by the dark strangulation mark. An Ulrike Meinhof is highly unlikely ever to give up, and should she do so nonetheless, she must be completely desperate.

October 18, 1977 is about failure - exclusively. It makes no difference from which context the observers come, when they find themselves amidst this group of paintings: they would never imagine that there is a programmatic remainder. Richter had painted the subject until its end. The title is metaphor.

IV.

The cycle is to be seen at the Frankfurter Museum für Moderne Kunst where it has been on loan since 1991. Unlike its first mounting in the Museum Haus Esters in Krefeld, the paintings are all hung together in one room. At first one has the impression of homogeneity. The paintings are stylistically related to each other, they are dark, colorless - a mausoleum. The painting *Funeral,* more than 3 meters wide, holds the cycle together. It is the head end. *Youth Portrait* is a portrait of conventional format, and the smallest version of *Dead,* only 40 cm wide and 35 cm high, could be an oil study in preparation for the actual painting. There is no ideal distance for viewing any of the paintings.

The difficulty in visually decoding the paintings (each for itself) depends not only on their size but also on the tone and density of the application of the paint, on the means and severity of the de-painting (or blurring),

Photographs of Andreas Baader's cell in Stuttgart-Stammheim, taken on 10/18/1977; in *stern,* 10/30/1977: 23

6 The photographic model can be found in *stern,* 6/16/1976: 150–151.

and on the extremely differing formats. The paintings with the strongest bodily presence are *Confrontation (1-3)*, in which Gudrun Ensslin is presented before witnesses for identification. The way she nearly turns frontally to the observer (actually, beholder) and then turns away, much about her becomes perceiveable - despite the prison clothing. The smallness, the swiftness, the Protestant severity, an unmistakable hint of intellectual hubris and a refractoriness which is still nourished by her feelings of security within her revolutionary group. She is no longer the classic beauty of the revolt which she still had been in the arson trial in Frankfurt/Main. In this respect, *Confrontation* is also a confrontation with her imago and thus with the question if she still exists.

The two *Man Shot Down* paintings (figs. 360-361, p. 398-399) are the direct opposite. Baader's corpse is not fully shown, but shown at least in such a way - he looks more as if he had fallen over than lain down - that one still recognizes him as the living person. Andreas Baader was the wild young man with the hard talk, fast cars, the sex appeal of the disloyal, the weakness for breaking the law and for weapons - the staging of the imaginary shimmers even through the posture of the corpse. He appears stretched out like the second hero in a Western who has to die so that the first hero can escape.

In museums vertical formats have a tendency to be inconspicuous. This applies also to the paintings *Cell* and *Hanged*, both 2 meters high.[7] In Baader's *Cell*, one sees as if through a frosted glass wall, partially rubbed down until it becomes transparent. In Ensslin's cell where she is seen as *Hanged* (fig. 354, p. 393), the view is so fleeting and faded that the distortion must be one of memory. It is that image that is so taboo, it cannot be more distinctly called up. On the other hand it cannot be driven away.

From reproductions, it is difficult to see why there are second and third versions from two motifs, namely, from *Man Shot Down* and from *Dead*. However, while encountering Richter's paintings it is evident that Baader's body is closer in the second painting, but at the same time its contours are less distinct than in the first. The second painting has a blue tinge. Comparing the two versions shows how volume disappears and leaves an imprint behind. The same goes for the *Dead* Ulrike Meinhof. There seems to be a change in perspective from the first painting to the second because the swelling on her throat, beneath the strangulation mark, is hardly clear in the first painting and quite distinct in the second. The third, the smallest painting among the *Dead,* however, shows, as did the second version of *Man Shot Down,* the reduction of the body to its materiality. Put biblically – how the soul leaves the body.

The other painting series do not have the same meaning – this reveals the richness of Richter's systematic approach. Factually, they mean chronology, sequences *Confrontation* reflects Ensslin's passage beyond the mirror. *Arrest* shows two stages in the arrests of Raspe, Baader, and Meins which took up more than one hour. The armoured car was actually first rolled into the middle of the yard and had later stood at the property's entrance.[8]

Record-player in Andreas Baader's cell is as unique as Meinhof's *Youth Portrait*. Seen together with the painting *Cell*, the image of a room emerges which in no way corresponds to the prison cliché – stuffed full of books and a record on the "stereo system". The painting is quite small but it renders the record player in realistic dimensions. The record-player is the showpiece of the seventies, the dream of any Protestant confirmand, and part of the basic furnishing of each room in a communal apartment. The logo of the record company on the record's label is no longer recognizable in the lightly faded rendering, and the record-player hovers a little to the right over a repeatedly appearing pattern that seems like an antiquated city and park landscape seen from the air.[9]

Record-player emphasizes the fact that Richter focuses on the balances between the material and immaterial, character and institution, of standstill and history. He sees those doomed to die in the living and in the dead he sees the myth which came to life on October 18, 1977. Richter takes the judicial and police pictures and reanimates them. We are startled by the whispering of the dead, agitated and in discord, as so often before.

V.

On the 41st day of the Stammheim trial, October 28, 1975, Meinhof said before the court - interrupted twice by the presiding Judge Theodor Prinzing, who apparently did not grasp the implications of her testimony: "Only one possibility remains to the prisoner in solitary confinement to signal that her behavior has changed, and that is betrayal ... That means, there are exactly two possibilities in solitary confinement: either you (she meant the court or justice in general) silence the prisoner, that means, they'll die from that, or you make them talk. And that is confession and betrayal."[10] A moment later, Prinzing ordered her to stop speaking.

The statement is a bit puzzling but one can infer so much with certainty: Ulrike Meinhof wished to speak about the group's actions and bombings. That was not part of the defense strategy. Meinhof conveyed that "her behavior", meaning her judgement of what she was on trial for, might have changed. And because a reversal was not possible in this situation, there was "exactly" only one alternative: "they'll die from that."

Which is what she did half a year later. Even though the other prisoners had tried to blame the court for her

7 When one compares the Baader motifs - *Man Shot Down* (1 and 2) and *Cell* - one sees that Richter was not influenced by the models in his choice of formats. The shot down Baader filled a double-page lead spread in *stern,* while his cell (with the bookcase) is set in only as marginalia, about the size of a pack of cigarettes (see *stern,* 10/30/1980: 20-21; 23). It looks as if Richter had in principle adopted the format of his picture models, however, the size of the paintings were determined fully independently. (In *stern* the pictures and sketches by the criminal police followed the account by Gerhard Kromschröder about the "sloppiness and contradictions" in the investigations into the Stammheim deaths. - With thanks to Henriette Kolb, Berlin.)

8 The arrest of Jan-Carl Raspe, Holger Meins, and Andreas Baader took place in the dismal back of an apartment house at 2-4 Hofeckweg, in Frankfurt/Main. 25 years later, the situation is unchanged. When the pictures appeared in *stern* in 1972, one actually thought more of a spacious industrial yard (*stern* 6/8/1972, 20/21). Richter, however, interpreted precisely the notion of dimension and consistence in the picture models. An English author sees a "multi-storey car park" in Richter's reproduction of the building. See Neal Ascherson, "Revolution and Restoration: Conflicts in the Making of Modern Germany", *Gerhard Richter,* exhibition catalog (London: The Tate Gallery), 33-39; 35.

9 There are often wavering backgrounds evoking a very uncertain picture space in Richter's colorless early work; for example: *Lovers in the Wood* (1966).

10 Stefan Aust, *Der Baader-Meinhof-Komplex* (Hamburg, 1985), 366.

death they must have known that, in some respect, they had also sacrificed Ulrike Meinhof. The embattled women had been described by Baader as "grotesque lunatics". For Meinhof's conflicts, who he called a "liberal cunt" (in a secret message to her), he had no understanding.[11]

With the kidnapping of Schleyer a situation arose in Stammheim which in retrospect is difficult to imagine. On the one hand, the prisoners on the seventh floor were officially cut off from all news. On the other hand, the nightly barricading of their cells with sound-isolating material offered a perfect opportunity to convert the house electrical equipment into a kind of shared radio, unobserved. While the civil rights activists got worked up about the law gravely restricting contact between the prisoners themselves and with their lawyers, Baader, Ensslin, Raspe, and Möller kept themselves completely informed. While the Federal Government was pretending that they would prepare the exchange for Schleyer, the prisoners fell into the role of diplomats under house arrest. The time point of Baader's, Ensslin's, and Raspe's suicides alone swept away all illusions about the enforcement of the communications restriction, right afterwards costing the State of Baden-Württemberg's Minister of Justice and the prison director their jobs.

The political scientist Wolfgang Kraushaar had very pointedly worked out why the political parity between the prisoners and the responsible politicians could never be established: "The logic of the deed - kidnapping to obtain the release of prisoners - can only be understood according to the logic of exchange of equivalents. The driver and the escorting officers were murdered in order to come into possession of an exchange value. One Schleyer should be worth just as much as eleven comrades in prison. Therein, however, you don't only offset one against eleven, whereby each individual comrade is worth 1/11 of the value of Schleyer, respectively, Schleyer is worth eleven times as much as one single comrade, but from the onset you rule out the four public servants as individuals worth exchanging. The kidnapping situation in question - which is still only meant as means to exchange - violates an elementary principle which represents the prerequisite for success. An exchange of equivalents can only then be carried out, when it remains free of violence."[12]

VI.

The RAF was everywhere. On the posters in the autobahn service areas, in the minds of the Left, in the police com-

puters - they had aimed for the future, but without mandate. The Viet Nam War, what it had all originally been about, was over. The subject of National Socialism was no longer a taboo. With the RAF, it was now nearly only a matter of the prisoner situation, the logistics of the those gone underground and the effect of "actions" on possible recruits. Since 1977, the RAF was a gigantic semantic short circuit, whose burning cables reach into the present.

This aspect is what gripped Richter. He is not interested in the desperados of the national highways, in nervous policemen with automatic pistols, in the imposing scene of the crime of the attacks, and not even in Hanns Martin Schleyer.[13] Or to be more exact, Richter finds out that the "Baader-Meinhof-Complex" is not portrayable.

The choice of his motifs has to do with the RAF's fateful strategies. The strategies were fateful because they were directed at the disfigurement of the State and the State would rather disfigure itself than give room to the armed opposition's contradictory theory-charged options. Gerhard Richter showed the limitations and severity of the "leeway" which dwindled within prison reality and the narrowing of the radicalized biographies into the inevitable raster of the victim. Arrest, identification line-up, funeral – there is no life after social death.

Benjamin H.D. Buchloh used Richter's work to reanimate the legend of the three prisoners (and not only them) having perhaps been executed in cold blood.[14] Buchloh writes, contrary to truth, that the years of imprisonment, while awaiting trial, "never even resulted in an indictment" and the "crime ... whose victims they became" was "never even investigated".[15] Actually, the circumstances under which each of the causes of death of Baader, Ensslin, and Raspe were investigated, were scandalous. Stern took up the subject three years later and, in this way, rescued it in the 1980's.[16] Photos of the dead and their cells as well as police sketches of the cells were published. Two motifs in the cycle go back to this reportage: Man Shot Down and Cell.

Richter was therefore familiar with the investigation scandal which centered around the pathologist's circumstantial evidence and he voiced his view on October 18, 1977: "The paintings are nonpartial, but in that they are unequivocal. They resist being used. Mourning is not bound to one 'circumstance'. Neither is sympathy." Thorn Prikker: "With what do you have sympathy?" Richter: "With the death that the terrorists had to suffer. They probably killed themselves, which for me makes it almost more horrible. Sympathy also with the failure, with the fact that an illusion of being able to change the world had failed."[17]

VII.

Whoever writes a tragedy, must know their characters and may not be one of them. Gerhard Richter was an extreme-

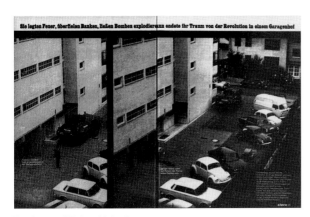

The Arrest of Holger Meins in Frankfurt/Main on 6/1/1972, in stern, 6/8/1972: 20–21

11 Aust, 303f.

12 Wolfgang Kraushaar, "44 Tage ohne Opposition", Der blinde Fleck (Frankfurt/Main, 1987), 10f. – With thanks to Wolfgang Gast in Berlin, who gave me decisive pointers for the RAF research as well as lending me books and video recordings.

13 Thorn Prikker: "Did you ever consider also painting the terrorists' victims, for example Hanns Martin Schleyer?" Richter: "Never." Thorn Prikker: "The scene in Vincenz-Statz-Strasse with the baby carriage obstacle for stopping the car. The uncovered bodies of the driver in the street, the Mercedes?" Richter: "No, never. Then, one could only paint such things. That's the normal crime, the normal misfortune that happens daily. What I chose is still an exceptional misfortune." Richter/Thorn Prikker, 130. Names given wrongly are corrected here.

ly sceptical late arriver to the "generation of sceptics". But in the 1980's he was surrounded by Leftists.

Richter could have read the name Isa Genzken in *DER SPIEGEL* in 1972. In this article about the still new phenomenon of German terrorism, it read "Newcomer Ulli Scholtze, cover name 'Peter Ursinus', left West Berlin ... on December 8. He spent the night at the home of his mother to whom he introduced Ilse Stachowiak as Isa Genzken, saying that she had come to Nuremberg for her friend's wedding."[18] The real Isa Genzken married Richter, the painter, ten years later. She was an artist.

When Richter showed his *100 paintings* in Nimes in 1996, the exhibition was divided into two parts.[19] The first part showed some paintings of Isa Genzken. Portraits from 1990, and nudes from the back from 1993, one year before their divorce.[20] Apart from those, "abstract paintings" dominate in which oil paint is intensively applied with a knife and then scratched, revealing the attempt to work the painting's deep ground so that he can freely go back to using the brush. At the end of the first part there are some vanitas motifs, wilted flowers, and the first version of *Skull* from 1983.

The second part of the exhibition begins with an Ingres pastiche, the *Small Bather* from 1994. A bit later, the same figure appears in greater detail in the new cycle *S. with Child*. The paintings of his third wife, the artist Sabine Richter, with their son Moritz, are not naive. Here, Richter had employed some of the techniques of questioning a painting physically – smearing over, blurring, scratching, applying paint with a spatula. Richter has returned to his basic position: distance, caution, ambivalence, and doubt. However, the time of teeth-knawing is past. He painted his first - ironic - self-portrait (dated 1996), an inconspicuous figure with large glasses.

In the meantime the cycle *October 18, 1977* has been bought by the Museum of Modern Art in New York where it will be received at the beginning of the next century. Richter's decision was disapproved of by many German followers of his work. The criticism pointed out that the political history of these paintings would mean nothing to the Americans, anyway. However, the context of perception will shift. Many of MoMA's visitors will recall how Rainer Werner Fassbinder had ridiculed "the third generation" of terrorists as ice-cold wind bags. Others will recognize without much lecture that the cycle deals with the extreme chapter of a history in which West German (pre-1989) society tried to cope with the legacy of National Socialism. Perhaps some of the new viewers of these paintings will recall the protests in Berkeley or the American group "Weathermen", whose (political) fortune was that the first building that they blew up was their own. Some will wonder why, in Germany of all places, what

began as resistance to the Viet Nam War could turn into such a fiasco.

October 18, 1977 will be understood in New York in its singularity because Richter's complete detachment from Pop Art manifested itself in the cycle. In New York, the pictures will be more painting and less politics, in the end. Richter's somberness is completely intelligible. It has to do with neither conceit nor cynicism, and it also has no patina of art for edification. The cycle is the core of German painting, which marks the end of the "postwar era".

Ulf Erdmann Ziegler

14 Buchloh's essay from the 1989 exhibition catalog (see footnote 4) was published under the same title in the catalog for exhibition at the Boymans-van Beuningen Museum in Rotterdam, *Gerhard Richter 1988/89* (Rotterdam, 1989), 32-43. The text appears in Dutch and English. It says in the Rotterdam catalog, unlike the first catalog where the remark on the same place is missing (p. 39): "... the events at the Stammheim Prison (events surrounding the deaths of the five members of the group, which were presented as collective suicide, but were suspected of having been, instead, a state-ordered police assassination)".
The name Holger Meins came up immediately before. However, he was not a prisoner in Stammheim. He died on November 9, 1974 from the results of a hunger strike in the Wittlich Prison. It is unclear who Buchloh counts as the fifth member, probably Meinhof. However, it is politically and historically not tenable that the deaths of Meins, Meinhof and then Baader, Ensslin, and Raspe - scattered over a three year period of time - were merely made out to be "collective suicides" by the official side. Buchloh succombs to the suggestion of Richter's cycle, which brings the biographies together in an artistic space. The museum room in Frankfurt, where the cycle is mounted, nearly becomes a cell itself. The post mortem "putting the prisoners together" which the supporters had always demanded. Richter did not, however, mean a collective end, but rather at the most, the beginning of the group as a collective political force.

15 Buchloh, 40 (Dutch), 41 (English).

16 *Stern,* 10/30/1980: 20-21, 23.

17 Richter/Thorn Prikker, 135.

18 *DER SPIEGEL,* 1/7/1972: 46.

19 *Gerhard Richter. 100 Bilder,* exhibition catalog, ed. Hans-Ulrich Obrist (Ostfildern-Ruit: Musée d'Art Contemporain de Nimes, 1996).

20 I take the biographical information from Jürgen Hohmeyers article "Selbstentblößung in Schmelz und Wut", *DER SPIEGEL,* 3/25/1996: 216-219.

Suffering from Germany – Gerhard Richter's Elegy of Modernism:
Philosophy of History in the Cycle October 18, 1977

Katharina Sieverding, *XI/78*, 1978
Color photograph, acrylic paint, steel,
300 x 375 cm
Staatliche Museen zu Berlin,
Nationalgalerie

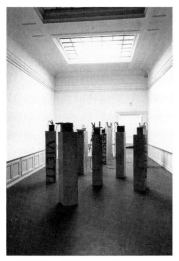

Rudolf Herz, *Discharging the Military,*
January 1996
Ensemble of 14 inscribed concrete
pedestals, car batteries, burned-out
starter cables
Badischer Kunstverein, Karlsruhe

1 Rainer Werner Fassbinder interviewed his mother Liselotte Eder in the movie *Deutschland im Herbst* (Germany in the Fall), FGR, 1977/78. Quoted in Michael Töteberg (ed.), *Rainer Werner Fassbinder: Die Anarchie der Phantasie: Gespräche und Interviews* (Frankfurt/Main, 1986), 214–15. The movie was a co-production by eleven directors, including Fassbinder, Alexander Kluge, and Volker Schlöndorff.

2 Joseph Beuys, "Das System nährt den Terrorismus am Busen: Interview mit Georg Jappe", *Kunstforum International 21*, 1977, 201-11.

"(Liselotte Eder:) I would not encourage anyone to discussion in the momentary situation. I would be terribly frightened if anyone would comment in a discussion in public even just the way Jungk did yesterday during the questioning, that he pointed out that criticism is justified and that if one represses criticism and addresses exactly those kind of things, the way they are now happening with the terrorists – I would simply be scared to hear anyone say such a thing.
(Rainer Werner Fassbinder:) Why?
(Eder:) Because I don't know what someone else would make of it ..."[1]

Alarmed by the general political climate in the Federal Republic of Germany in the late seventies – triggered by the *Heißer Herbst* (Hot Fall) in 1977 – Rainer Werner Fassbinder filmed a contribution for the movie *Deutschland im Herbst* (Germany in the Fall). Consternation on the one hand and contradictions between the ideal of a radical democracy and the desire for an authoritarian leadership of society on the other, as it is formulated particularly by Fassbinder's mother in the course of the conversation, are paired with a fear of free speech.

The political situation in Germany in the seventies could be described with Katharina Sieverding's *Schlachtfeld Deutschland* (Battlefield Germany). With the photographic work *XI/78*, made almost at the same time as Fassbinder's movie, she not only illustrated the motif "street battles" between police and demonstrators, she also visualized almost metaphorically the state of war of a form of government that perceives itself as guaranteeing free speech amongst other things, but when threatened, i.e. in that situation in which the democracy has to prove itself with respect to upholding fundamental rights, no longer wants to grant these. Fassbinder's film contribution and Sieverding's photography, like numerous other works by, for example, Joseph Beuys, Marcel Odenbach, Wolfgang FLATZ, Rudolf Herz, Olaf Metzel, and Gerhard Richter, respond to democracy's intellectual as well as political state of emergency.

Gerhard Richter's group of paintings *October 18, 1977* forms in its complexity a highlight in this series of works (figs. 349-63, pp. 389f.). The controversial discussions about this cycle testify not only to the unabating explosive nature of the subject complex Red Army Faction and Terrorism in Germany, which continues to be considered a trauma in Germany's postwar history, but also to

this artistic work's ability to penetrate the central issues of the controversies of public debate and to cause discussions to flare up. The total of 15 panel paintings created between March and November 1988 deals in essence with the death of the Red Army Faction (RAF) members Andreas Baader, Ulrike Meinhof, and Gudrun Ensslin imprisoned in Stuttgart-Stammheim. In addition, there are motifs of the accompanying incidents of that time as well as depictions of individual objects. Conceptionally the cycle has a multi-layered structure: Richter reacts amongst other things to the mass-media mythification of the Baader-Meinhof group and to the strategy of instrumentalizing images. His subject is painting in confrontation with omnipresent visual worlds, the way the mass media generally depicts them, and he criticizes history painting today by subjecting it to the philosophy of history. Richter's cycle can be understood as an expression of "historical mourning", applicable not only to the terrorists who died in Stuttgart-Stammheim, but also to the losses of a democracy, to the young Federal German Democracy's wasted historical chance of a maturing process at the moment of its being threatened.

Terror: Healing through Art

"The system nourishes terrorism in its bosom": this statement by Joseph Beuys was used to title an interview with the irksome artist and aroused an impression of sympathy with the terrorists.[2] But Beuys had a differentiated view of the relevant political problems. As director of documenta 5, which was held under the theme "Befragung der Realität" (Questioning Reality) Harald Szeemann invited Beuys to participate in the section "Individual Mythologies: Self-Portraits / Performance / Activities / Changes." In Kassel Beuys set up the *Büro für direkte Demokratie* (Direct Democracy Office), which had previously been installed at the Düsseldorfer Akademie. It consisted of, aside from conventional office furnishings, a neon sign *"Organisation für direkte Demokratie durch Volksabstimmung"* (Organization in Support of Direct Democracy through Plebiscite) mounted diagonally across the wall. Beuys's artistic contribution thus consisted of advertising his own political goals.

Beuys's model of society for the "direct democracy" was founded on a criticism of (party) democracy, which he accused of being socially heteronomous. His utopia of a society not dependent on parties was to guarantee uninfluenced development of political objectives and grass roots democratic decision making on the basis of plebiscites: "I (Beuys) understand plebiscite as meaning that the people give themselves their own constitution, that they furthermore determine their own fundamental rights and as a result of these constitute their rights."[3]

He was skeptical about the revolt of the younger

3 Quoted from *Joseph Beuys, documenta-Arbeit, exhibition catalog*, Museum Fridericianum, Kassel, eds. Veit Loers/Pia Witzmann (Ostfildern near Stuttgart, 1993), 84.

4 Beuys (1977), 211.

5 Cf. *Joseph Beuys, exhibition catalog*, ed. Harald Szeemann (Kunsthaus Zurich, 1993), 82f.; as well as Beuys, *documenta-Arbeit*, 77-144. See note 3 above.

6 Beuys (1977), 211.

7 In the original: "Wahnsystem". Albrecht Wellmer, "Terrorismus und Gesellschaftskritik", *Stichworte zur 'Geistigen Situation der Zeit,'* ed. Jürgen Habermas, vol. 1, *Nation und Republik* (Frankfurt/Main, 1979), 265-93.

8 Cf. Peter Friese and Dirk Halfbrodt (eds.), *HERZ* (Nuremberg, 1997), 43-45.

9 "… that there must be for example new economic laws, which overcome certain hindrances in all given structures, above all one must name profit as economic goal, ownership of production means, wages as an exchange procedure, just to name three very important seats of disease." Beuys (1977), 211.

10 Beuys (1993), 113.

11 In the original: *"Legitimationszwang".* Wellmer, 277ff.

12 The historical trauma of National Socialism was moreover aggravated by further factors. First of all, Germany, or rather the Federal Republic, had not freed itself from the national socialist dictatorship of its own volition, secondly, it had to a large extent not parted from the "personnel" of the Third Reich, and finally, it had not engaged in any critical historical reappraisal of the reasons, structures, and reality of the national socialist dictatorship. All these points would in essence have been necessary in order to define moral concepts in a democracy and were then finally called in by the younger generation in the sixties.

13 Wellmer, 289. Also cf. Jürgen Habermas, *Protestbewegung und Hochschulreform* (Frankfurt/Main, 1969).

14 Wellmer, 266.

15 For a description of the individual works cf. the contribution by Ulf Erdmann Ziegler in this volume; as well as Hubertus Butin, *Zu Richters Oktober-Bildern* (Cologne, 1991). Richter also made a series of painted-over book pages entitled *Stammheim: Der Prozeß gegen die Rote Armee Fraktion* (Kiel, 1986). Cf. *Stammheim: Gerhard Richter*, exhibition catalog (London: Anthony d'Offay Gallery, 1995).

generation however: "The students will have to recognize that their new protest movement, if they only show up in the old ideological corset, will have a terrible end, for in '68 this ideological corset was already tighter and more wounding than the police clubs from outside! They were not free. And the system will have to recognize that it is nourishing terrorism in its bosom, that it cannot be enough to fight a symptom here and a symptom with police force there!"[4]

Beuys's work *Dürer, I'll guide Baader + Meinhof through Dokumenta V personally* (Dürer, ich führe persönlich Baader + Meinhof durch die Dokumenta V; fig. 365, p. 403) seems to be based on this perspective: The Hamburg performance artist Thomas Peiter, who appeared at the documenta 5 as Dürer, wrote this sentence on two wooden panels primed yellow. The sentence had been directed by Beuys at the "Pseudo-Dürer."[5] Both panels served in the course of the exhibition as demonstration and protest panels for Peiter led a small crowd of spontaneous visitors through the art show daily. As provocative as just naming the terrorists Andreas Baader and Ulrike Meinhof might have been, it was only at first glance that Beuys demonstrated sympathy for the Red Army Faction. For Peiter had left out one follow-up clause, which Beuys had used to give meaning to the fictitious tour: "Dürer, I'll guide Baader + Meinhof through the Documenta V personally, then they will be resocialized!" According to Beuys the terrorists had left the democratic community: "That the free university must show clearly, that all ideologizing of any subject, of any problem, is nothing else than striving for hierarchy of power, which is, after all, inherent in the antiquated political structures, whether they be left, right, or in the center …"[6]

The RAF had succumbed to that alienation that Albrecht Wellmer described as the "system of delusion,"[7] which was founded on a system of perception sure to disappoint. This dimension of meaning was Rudolf Herz's subject in a 1996 installation entitled *Entladung der Militanz* (Discharging the Military)[8]: On concrete pedestals, on which the names of the RAF members still imprisoned in January 1996 were written, Herz placed car batteries with burned cables having no connection – symbolizing, so to speak, "ideals in neutral."

But Beuys was not concerned with the social criticism voiced by the student movement and the RAF, although he adapted the forms of the student protests. Rather, he viewed society as a sick body which art was to heal in that "misdirected" energies would be transformed and lead to social pacification.[9] At the end of documenta 5 the two panels were expanded by Beuys to an installation: He placed them on felt slippers that were filled with fat in order to indicate the "expenditure of energy" required for the process of transforming protest to

harmony. The additional rose stems symbolize the evolutionary healing process. To Beuys, the rose is exemplary for its growth: "The flower does not emerge abruptly, but only due to an organic process of growth, which is so contrived that the petals exist embryonically in the green leaves and are formed out of these."[10]

The period of bloom, the climax of social evolution, is at the same time the end. The healed body of society knows no historical continuation, no progression that develops and is formed out of the conflict with different interest groups. With his *Aktion für direkte Demokratie* (Action for Direct Democracy) Beuys seemed to be responding to a state of social deficiency, which Wellmer calls the "compulsion to legitimize"[11] What is meant is the initiation of think spaces for a public discussion on the values and norms of democracy. Instead, all fears in regard to the dangers of political monopoly were ignored with the Great Coalition in the year 1966.[12]

In September/October 1977 a climax is reached in the still young history of terrorism in Germany. The kidnapping of the president of the German Federal Union of Employers' Association Hanns Martin Schleyer and of the Lufthansa airplane Landshut, the official prohibition of contact for the terrorists imprisoned in Stuttgart-Stammheim and their death as well as the intensified man-hunt by the police determined the political events in the Federal Republic. Terrorism soon developed into an historical as well as national political disaster for the democracy. Paradoxically freedom was "defended" by a law guaranteeing a sensitive limitation of freedom. In this manner there was – if one follows the critical thoughts of Wellmer – an "unwanted interplay of terrorism and "reaction,"[13] which social criticis attempted to place in the vicinity of terrorism. In the mass media meanwhile, a disastrous atmosphere was pushed, allowing only two positions: "and that is a conceptless indignation or a cheap distancing on the one hand, and an irrational – if not political, then emotional – solidarity with the terrorists on the other hand."[14]

History, the Mass Media, and Art

With a time span of ten years from the political events, Gerhard Richter made terrorism in Germany, or rather the Baader-Meinhof group, his subject – and as becomes apparent, from a fundamentally different perspective. Only with great difficulty can one describe this group of in total 15 pieces, heterogeneity and fragmentariness being after all characteristic to this work.[15] The starting point for all works are various incidents connected with the Baader-Meinhof group. Sources for the motifs are photographic documents, which were translated into a "smudged" gray painting. Although the title names the death date of several members of the RAF (Andreas

Confrontation of Ulrike Meinhof in May 1974, photo from *stern*, 8/25/1977: 21

Marcel Odenbach, *When the Elephant Turns Ivory Trader,* 1978
Photo work, detail
Collection the artist

16 Cf. Susanne Küper in this volume for Richter paintings based on photography.

17 Cf. *stern,* 6/8/1972: 20-21.

18 Cf. the photographs of the confrontation with Ulrike Meinhof in *stern,* 8/25/1977: 20-21.

Baader, Jan-Carl Raspe, and Gudrun Ensslin) who had been in the high security tract for some years already, several incidents were chosen as subject. The group of pictures, which does not intend any dramaturgical order, no beginning nor end in the sequence, consists of the two triptychs *Gegenüberstellung* (Confrontation) and *Tote* (Dead), the diptych *Festnahme* (Arrest) and the individual pictures *Erschossener (1)* (Man Shot Down (1)), *Erschossener (2)* (Man Shot Down (2)), *Erhängte* (Hanged), *Zelle* (Cell), *Plattenspieler* (Record-player), *Jugendbildnis* (Youth Portrait), and *Beerdigung* (Funeral). Richter chose his motifs from a large collection of visual material from different sources, every photograph having been earmarked by special interests at the very latest by the time it was used in the police archives or in the print media.

The transformation of the photographic sources to motifs of panel painting takes this original functional context into account, so to speak. Richter had used this method in connection with a technique of "smudging" as early as the sixties, at that time describing it ironically as

"capitalist realism". The black and white tonality and figurative pictorial language do refer to photography as the source and thus to the reality of the documented events, but the smudging presents the subject in a form that was to free painting from the dogmas of the art academy.[16] In the case of the cycle *October 18, 1977*, however, painting seems to have been called upon to convey the photographs documenting the Red Army Faction to non-functionality. Whereas vacation photographs still possessed an "innocence" of motif, it was once and for all lost in the photographs on the RAF subject, tied as they were to specific criminalistic, political, and mass media purposes.

The interferences between painting and the mass media that have been set out in the pictorial works *October 18, 1977* are illustrated, for example, in the diptych *Arrest* (figs. 358–359, p. 396–397). On photographs obviously originating from the police archives and published by *stern* the arrest of the terrorist Holger Meins in the year 1972 is only barely recognizable.[17] In the courtyard of a modern apartment building an eerie scene

is being enacted: An armored vehicle drives alongside a building towards a person – Holger Meins – followed by the arrest of the terrorist. The two photographs were reproduced in *stern;* taken from a fixed point of view they suggest a sequence of scenes. The accompanying text instrumentalizes the shots in that it justifies the appropriateness of the measures, in other words the arrest, by demonizing the terrorists. The "victorious state machinery" seems to be at least technically equipped to keep the danger of terrorism under control. Richter took over the doubling of the shots and gave the doubled instrumentalization of the pictures – observation by the state and mass media exploitation – a critical new direction. Richter seemed to have a similar intention with the three works *Confrontation.* The police confrontations appeared like an oppressive situation beneath human dignity, against which *stern* in particular staged the bodily resistance of the prisoners.[18] In Richter's work the portrayed woman's gentleness of appearance lends Ensslin a human dignity that she was denied in the mass media photographic production.

The painterly alienation in the *Arrest* paintings illuminates the humanly oppressive situation, the superior strength of a technologically determined social form: The factualness of the event (photography) becomes in the field of painting a metaphor for social alienation. For if one follows the reports on state security in the Federal Republic, then the building up of a security system soon after the left-wing terrorism began showed streaks of an irrational automatism lacking all appropriateness of means in solving the terroristically motivated confrontation. The hysteria of the Verfassungsschutz (Office for the Protection of the Constitution), the addiction to the technological perfectionism of surveillance seemed to recognize nothing but winners and losers.

This "irrational rationality" is the subject of two works made by Marcel Odenbach in the late seventies: a video and a photographic collage. In the photographic work entitled *Wenn der Elefant zum Elfenbeinhändler wird* (When the Elephant Turns Ivory Trader), 1978, he presents, between two advertisements of a company which is selling video surveillance systems, shots of reporters in a frenzied hectic rush on a sports field on the one hand and the shot made by the terrorists of the kidnapped employer, president Schleyer, on the other. This linking of motifs opens up a disquieting meaning. The push of modern observation technology is now no longer directed against the enemies of society, but also reaches, so to speak, the representatives of public law and order. In this the true holder of social power is manifested – technology itself, as Odenbach proclaims on the basis of Herbert Marcuse's social criticism. In his photographic piece he quotes this critic: *"Die Technik ist in ein mächtiges Instrument ultra-*

19 *Marcel Odenbach. Videoarbeiten,* exhibition catalog (Essen: Museum Folkwang, 1981), 37; and Herbert Marcuse, *Der eindimensionale Mensch: Studien zur Ideologie der fortgeschrittenen Industriegesellschaft* (Munich, 1994). American original: *One-Dimensional Man: Studies in the Ideology of Advanced Industrial Society* (Boston, 1964). Re-translated into English Odenbach's German text reads: "Technology has been transformed into a powerful instrument of ultra modern rulership – all the more powerful, the more it demonstrates its capability to serve those being ruled and the politics of the rulers."

20 Odenbach, 57-61. Odenbach's numerous video works also always carry a criticism of alienation through the mass media, as is illustrated not least by the video performance *Einfach so wie jeden Tag oder sich selbst bei Laune halten* (Simply Like Everyday or Keeping Oneself in a Good Mood), which Odenbach staged in Amsterdam in 1978.

21 Cf. *stern,* 5/20/1976: 74Bf.; cf. fig. p. 376 in the present volume.

22 Stefan Aust, *Der Baader-Meinhof-Komplex* (Hamburg, 1985); paperback ed. (Munich, 1989). Richter emphasized the significance of this book generally, that is, without naming any specific aspects (cf. "Gerhard Richter /Jan Thorn Prikker, Gespräch über den Zyklus '18. Oktober 1977,'" *Parkett 19* (April 1989), 127-36, 130. The first appearance of this publication in the year 1985, having received much attention, may perhaps have been another impulse for Richter taking an increased interest in the subject.

23 Cf. Roland Barthes, "Der Mythos heute", *Mythen des Alltags* (Frankfurt/Main, 1996), 85-151.

24 Cf. for example, Gerhard Storck, "Ohne Titel (Gemischte Gefühle)", *Gerhard Richter: 18. Oktober 1977,* exhibition catalog, Haus Esters, Krefeld, Portikus Frankfurt/Main (Cologne, 1989), 11-18.

25 Cf. FLATZ: *Zeige mir einen Helden ... und ich zeige Dir eine Tragödie / Show me a hero... and I'll show you a tragedy; German and English,* trans. from German by Mary Fran Gilbert and Virginia Ann Schildhauer (Ostfildern, 1992).

moderner Herrschaft verwandelt worden – um so mächtiger, je mehr es seine Leistungsfähigkeit beweist, den Beherrschten und der Politik der Herrschaft zu dienen."19 Following Marcuse, Odenbach applies the self-regulating omnipotent as well as omnipresent active forces of technology to the current political situation determined in large part by terrorism. Technology, which controls the ruled as well as the rulers according to Marcuse and Odenbach, does not leave mass media untouched either, as Odenbach wants to document with this mounted photograph as well as in other works.20 The technology for transmitting social events does not mobilize society to form opinions but is a technical instrument causing lethargy and isolation of the individual.

Richter follows Odenbach in this argument only to a certain point. While in the case of *Arrest (1)* and *Arrest (2)* the technological superiority of the state and the strategy of the mass media to demonize are obviously critically reflected, the cycle as a whole opens further fields of meaning intersecting with one another. Thus Richter has made the person Ulrike Meinhof the center of attention in *Youth Portrait* (fig. 349, p. 389) and in the triptych *Dead* (figs. 350-352, pp. 390-391). The individual RAF members were repeatedly the subject in print media as the "portrait" of Meinhof in *stern* illustrates.21 By using private, police, and press photos the superficial impression was given that one wanted to explain an intellectual's decision in favor of force and terror by reconstructing the life story, but instead the aim was to demonize. It remains unimaginable why Meinhof, like others as well, turned to terrorism. The perfidy of this strategy is finally manifested when an x-ray of Meinhof's skull is published, linked with the question whether the "terroristic insanity" could not be determined through a medical examination, that is, whether there is not a physical anomaly in the make-up of her brain.

Richter made a variety of different portraits of Ulrike Meinhof, the publication *Der Baader-Meinhof Komplex* by Stefan Aust having played a not insignificant role.22 The publication, to which much attention was paid and which was controversially discussed, opens a different view of the political phenomena of German terrorism. The political, administrative, and personal to private aspects are described in many facets from the perspective of the terrorists, state security people, and the institutions involved. The literary form of the description is conspicuous: The heterogeneity, the catastrophe of the political occurrences, and the apparently almost fateful meeting of individual characters is in no way cast into a homogenous narrative through a determinable text aesthetic. Aust leaves the individual descriptions, which appear to originate from the most varied sources, in their variedness, so that the publication grows to a most contradictory bundle of his-

torical writing. Richter must have sensed a congenial spirit here, for he also refuses that which all other previous descriptions strove for – the mythification of the events and persons. For the transference of historical events into the mythical story lets - in the sense of Roland Barthes23 – history come to be nature and thus denies the reference to causes and general causal connections of the actions.

Aust repeatedly described the person, origins, and life circumstances of Ulrike Meinhof. Her fighting nature and her sense of injustice, which can be found in her texts as well, are juxtaposed by Aust with a sensitive personality of middle class origins, who is caught, however, in group dynamic power struggles with the choleric, authoritarian, and criminally inclined Baader. Meinhof seems to be the one person in the RAF circle who suffered not only under the political situation and political opponents, but also under the group pressure of her fellow prisoners.

Only in the case of Meinhof does Richter make the biographic dimension of terrorism his subject. He integrates a photograph of the young Ulrike Meinhof into the group of images and thus obviously the aspect of a still hopeful future of a young person. In contrast to this, her suicide as the last resort to an unbearable no-way-out situation is given visual form by repeating the almost identical motif, that of her head, three times. Making the titles of the works anonymous does document the attempt to objectify the powerful pictorial motifs, but with an almost dualistic perception it is exactly the reverse that comes into force. The distancing appears to additionally dramatize the tragedy between life and death, between the young girl and the woman terrorist.

With this confrontation Richter opens up fields of meaning that go beyond simply mourning a dead woman, as it is so often described.24 Although the three-time repetition of the dead woman's head is an attempt to refer to art historical motifs, for instance the depiction of the corpse of Christ, Richter purposely allows this venture to fail in order to avoid hero, or martyr, worship often associated with depictions of the dead. Within the framework of a large-scale project in 1988 Wolfgang FLATZ also gave expression to the mythification of public persons and the resulting superimposition of the actual tragic contexts of the *Heroes'* actions.25 Under the title *Show me a hero... and I'll show you a tragedy,* FLATZ presented a total of 39 hero portraits showing to which end each came or a tragic event connected with that person. Andreas Baader and Ulrike Meinhof are each depicted with their coarse-grained wanted-person photos. Baader's photo is commented on with the Schleyer kidnapping scene of the crime and Meinhof's with the signet designed by her for the Red Army Faction. FLATZ criticizes the forms of mythifying public persons on the one hand and the veiling of the individual motivation for the *Heroes'* actions on the other

Andreas Baader, 88 x 224 cm

Ulrike Meinhof, 106 x 240 cm

Wolfgang FLATZ,
Show me a hero ... and I'll show you a tragedy, 1988
39 photographs on canvas, transparent paint, profiled steel frame, each in two parts, varying measurements

hand.[26] In so doing he names the instruments of control used for mythification, the visualization of the heroes, and the protagonists of this tendency, the mass media.

The core of the cycle *October 18, 1977* is, as the title already indicates, the death of the RAF members Andreas Baader, Gudrun Ensslin, and Jan-Carl Raspe in the Stuttgart-Stammheim prison. Since the kidnapping of Schleyer and of the Lufthansa airplane Landshut by RAF sympathizers, solitary confinement was enforced and left its traces in the physical as well as psychological state of the prisoners. If one follows the descriptions by Aust, the conditions and the consequences of confinement were aggravated subsequent to the named events. While the will to live weakened immensely, the striving of the prisoners to give the state machinery a "lesson" became all the stronger. The apparently hopeless situation due to the delaying tactics of the state, the unbearableness of solitary confinement, the *Kontaktsperregesetz* (law disallowing contact), the physical and intellectual exhaustion of prisoners, and finally the anger at the political opponents seem to turn the state of powerlessness into one that is the "last proof of power." The trial of strength between terrorism and democracy, between terrorists and government, left only one way out, that is the interpretation of Aust: suicide. The discussion of murder or suicide is to be left aside at this point, as any definitive answer to this question, in view of the living conditions in solitary confinement, seems a simplified narrowing of the problem. In the end it has to do with proving whether one's own body, psyche, and mind is at one's own disposal or someone else's. Beyond any question of guilt for the murders, killings, and offenses, a complex of questions opens up as to the automatism of a war between a democratic state and its political intellectual adversaries and as to the mechanics of dealing with a power struggle between two opponents of different generations and world views.

Richter chose several motifs in which the death of the prisoners is the subject. These are: *Man Shot Down (1), Man Shot Down (2), Hanged, Record-player, Cell,* as well as *Funeral.* The first three named works (figs. 360-361, pp. 398–399, and fig. 354, p. 393) take up in painterly fashion that oppressive mood which Aust describes at the beginning of his publication: Those terrible seconds in which the guards found the dead prisoners in their cell are described with great rationality. Baader shot himself with a previously hidden pistol, and Ensslin hanged herself with a cable. It is exactly this "descriptive" distance from the event that makes the actual incident seem even more dramatic. An intensification is achieved solely

through motifs referred to only sketchily such as *Record-player* (fig. 362, p. 400) or *Cell* (fig. 353, p. 392). Here there is no depiction of a corpse, instead the incident, the circumstances, and conditions that could have led to the death are simply indicated: The record player can be seen not only as the place where the prosecuting attorney's office suspects Baader hid his pistol, but also as a reference to the prisoners' lack of communication and "sensory deprivation" caused by solitary confinement.[27] This is also true for the view into a prison cell, which awakens associations of the home of any middle class intellectual (including book shelves and coat stands). With our knowledge of the circumstances the ordinariness of these motifs is more frightening than the direct appellative illustration of victims, scenes of crime, and the crime circumstances would be.

In the painting of Baader, Ensslin, and Raspe's funeral at the Stuttgart Waldfriedhof on October 27, 1977, large-scale in comparison to the other works in the cycle, the scenery can hardly be recognized due to the technique of smudging (fig. 363, p. 401): A structure of light and dark strokes and planes determine the event, only the pale coffins in the middle of the painting let one guess the subject of the work. It is not without due cause that Richter chose this subject and brought it into the cycle on an oversized scale, as it summarizes the statement made by the work as a whole. In contrast to Olaf Metzel, who also links the death of the prisoners in Stammheim to a "solemn memorial installation" in a work created in Stuttgart in 1984 and who in reference to the rituals deliberately and provocatively defines public remembrance as political, Richter is both concerned with naming his melancholy understanding of history and with marking a new form of aesthetic memory work.

With the death of the terrorists a tragic course of history becomes clear, a course that apparently has its origin in the middle-class model of modernism as a concept of life and society based on rationality, liberality, tolerance, and democracy.[28] The modernization of society – based on the belief in a relentless continuation of history – seems to have been turned around with the death of the Stammheim prisoners. The Promethean liberation of the human being from the strictures of heteronomy, as pre-ordained by the concept of modernism, led in the case of left-wing terrorism in Germany and the democracy combating this terrorism to an irrationality of actions on both sides. At the end of this stands the apparently self-determined death of the prisoners. The chapter on German terrorism is comparable to a political heap of rubble. With the student protests beginning in the mid-sixties and with the terrorism of the Red Army Faction, the still young Federal Republic was subjected to its first acid test as to whether the foundations and fundamen-

26 FLATZ refers to the psychological controversies within the RAF in terms of the characterization of the personalities. Accordingly, Baader is seen as a criminal and Meinhof as an intellectual. FLATZ furthermore always makes the "tragedy" larger than the respective "hero" in terms of the painting's scale (FLATZ in conversation with the author).

27 Cf. the project by the artists Rob Moonen and Olaf Arndt entitled *camera silens* that (with associations to solitary confinement) attempts to communicate as work of art the experience of "sensory deprivation". *Camera silens: Ein Projekt von Moonen & Arndt,* 2nd rev. and exp. ed. (Hamburg, 1995).

28 Cf. Kai-Uwe Hemken "Von 'Engeln der Geschichte' und aesthetischer Melancholie: Zur Geschichtserfahrung in der Gegenwartskunst", *Gedächtnisbilder, Vergessen und Erinnern in der Gegenwartskunst* (Leipzig, 1996), 143-55.

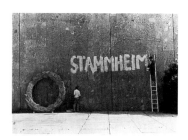

Olaf Metzel,
Stammheim, 1984
Reinforced concrete
Diameter of the wreath: 300 cm
Württembergischer Kunstverein,
Stuttgart

tal rights of the new society would be guaranteed even in the case of being threatened. From this point of view the mourning in the cycle *October 18, 1977* is not only for the dead, but also for the wasted historical chances in the development of a modern society – as expression of modernism – per se. In the case of federal German terrorism, modernism, which aims at a rational penetration of all aspects of life, now replaced the liberation of the human being with his merciless dependence on a system of authoritarian thinking and dealing (on both sides) that he himself had created. Mourning as fundamental experience and intention of the cycle thus appears more than melancholy. Melancholy is juxtaposed with a radicalized model of modernization of a society that wants to get by without criticism of its actions and without reflecting on its original goals.

Historical Mourning – Historical Consciousness

From the angle of mourning modernism and its victims, the cycle *October 18, 1977* cannot be considered traditional historical painting. Richter is indeed concerned with remembering past events, so that there are connections to the genre, but he seems to argue from the perspective of the philosophy of history, which generally addresses on various dimensions the problem of self-reflexive memory work between the individual and the masses, between private and public spheres, and between the conditions and possibilities of historical consciousness.

Richter's views seem to be close to Walter Benjamin's philosophy of history here, for already the pictorial language of the cycle's aesthetic framework reminds one of an allegory in Benjamin's sense.[29] The philosopher of history criticizes the idea of a universal history that uses past events in a purely cumulative manner and without considering their peculiarity and the language in which they are handed down. For him this form of history writing is that of the "winner" and thus that of a distanced view of things, with which the historian deals without confirming his own historicity. Benjamin, however, demands a type of "historical empathy"[30] for the past event, which is brought about by an allegorical view of things. The historical event is isolated from its historical context and transformed as symbol into the present, in the same moment of identifying with the event the recognition of one's own historical position flashes through one's mind.

Benjamin's reflexive memory work seems to make Richter's intention clearer. The cycle *October 18, 1977* obviously attempts to free the visual documents on the RAF from the strictures of instrumentalization (police archives, mass media, etc.) and to allow them to develop as allegorical symbols in the field of painting. In this state

that they not only provoke thinking about the events of that time, as by the way the vehement reactions to the cycle confirm, but also let in the same moment a "confirmation" of one's own historical positioning light up. While Benjamin wants to make his model of "historical empathy," which is shaped by the circumstances of the times, useful for the future, this intention is not recognizable in Richter's work. Benjamin's historical "objects" were far removed in time, while for Richter the after-effects of terrorism and the political defense against it can still be felt, so that a future-oriented perspective as quintessential examination is not possible. It is not the "heroic melancholy" hoping for redemption, but rather the classical form of acedia , the "lethargy of the heart," transformed through self-recognition. From this historical perspective, which attempts to grasp the historical mourning of a wasted chance of social development on the one hand and the reflexion of one's own historical position on the other, Richter's cycle is expanded to a new form of memory art, which in the end has little to do with the renewal of historical painting, as Benjamin H.D. Buchloh suggests.[31] This becomes even clearer, when one looks at the point in time in which the cycle was created. It comes together with another central event in the field of history, the battle of the historians.

One might even assume that since Richter had been collecting thoughts and material on the RAF subject for more than a decade, the historians' battle might have the effect of being an impulse for Richter. The cycle's intended dimensions of meaning pertaining to the philosophy of history suggest this. Even though Richter was concerned with another object, terrorism and "overcoming its past," and not national socialism like in the historians' battle, he does seem to address fundamental aspects of memory work – so to speak as an intellectual in the area of the visual arts, painting. Thus the relevance of historical consciousness in the late eighties, that is at the time the cycle was created, "corresponds" not only to the public debate about national socialism, the historians' battle, but also to the visual arts.

In the public controversy between the philosopher Jürgen Habermas and the conservative wing of the historians around Ernst Nolte, one argued about the "uniqueness of the national socialist extermination of Jews," but at the same time an academic discipline's conception of the world and of itself was manifested. Historiography seemed to be searching for its identity within a society in transformation.

Nolte wanted a criticism of the discussion on national socialism, which in his view had until then been led purely on the basis of special interests.[32] He wanted to place this inhuman system of oppression and the ideologically as well as racially defined mass extermination

29 Walter Benjamin, "Über den Begriff der Geschichte", *Sprache und Geschichte: Philosophische Essays* (Stuttgart, 1992), 141-54; also Ludger Heidbrink, *Melancholie und Moderne: Zur Kritik der historischen Verzweiflung* (Munich, 1994).

30 In the original: "historische Einfühlung". Heidbrink differentiates here between the empathy of historicism criticized by Benjamin on the one hand and a form of empathy, which can be derived from Benjamin's Baudelaire studies, on the other hand, 175ff.

31 Benjamin H.D. Buchloh, "Gerhard Richter: 18. Oktober 1977", *Gerhard Richter: 18. Oktober 1977*, 55-59.

32 Ernst Nolte "Zwischen Geschichtslegende und Revisionismus? Das Dritte Reich im Blickwinkel des Jahres 1980", *Historikerstreit: Die Dokumentation der Kontroverse um die Einzigartigkeit der nationalsozialistischen Judenvernichtung* (Munich/Zurich, 1995), 13-35.

into a continuum of history that has produced similar atrocities in the past or at the same time. Habermas on the other hand accused this type of argumentation of playing down the "Third Reich" – with the goal of "shaking off the mortgages of a past happily freed of its morals."[33] In so doing, the history of state or revolutionary atrocities, of which Nolte lists a few examples at random and in which according to him national socialism can be included without any difficulty, is described as a system of actions based on psychology: Fear and terror, anxiety and aggression, are so to speak fundamental anthropological constants of human existence. History is seen as a permanent continuation of comparable actions through which differences in historical contexts of actions are negated; from this point of view even atrocities can be comprehended.

Nolte furthermore brings to bear the "neutrality of interest" and independence of the (historical) science, where every question simply for reasons of knowledge-oriented curiosity be allowed.[34] Habermas exposes this as sham argument in that he interprets Nolte's conflict between intended giving of meaning and free science as a strategy to renew national identity: "The planners of ideology want to create consensus through a revival of national consciousness, at the same time though, they must ban the enemy concept of a nation-state from the sphere of NATO. For this manipulation Nolte's theory has a big advantage. He kills two birds with one stone: The Nazi crimes lose their singularity in that they can at least be comprehended as a response to Bolshevist threats of extermination (continuing to the present day); Auschwitz shrinks to the scale of a technical innovation and can be explained by the fact of the 'Asian' threat of an enemy who is still at the gates."[35]

From Nolte's point of view academic historiography was to fulfill that task which had belonged to history painting, the noblest of all genres over centuries, but has not been fulfilled since the abolishment of an almost obligatory system of pictorial language rules in the late 18th century. Current historiography addresses the viewer appellatively, setting values and norms from the perspective of an interpretation of history that orients itself on the needs of the current "intellectual situation."[36]

It can be assumed that Gerhard Richter participated indirectly in this many-layered discussion. The intellectual public seemed to be taken with this discourse between a philosopher and historians about the "public use of history" (Habermas), so that it would be natural if Richter also did more than just follow this discussion. Without wishing to presume that Richter had specific intentions, it can nevertheless be assumed, that he – inspired by the publicly carried out argumentation – reflected on this controversy with a differentiated view

of things not only as a decisive intellectual of his guild, but also wanted to take a position from the perspective of his continual interest in the Red Army Faction. The core of the RAF was, after all, that part of the "protest generation" who were the first to criticize the lacking reappraisal of national socialism and finally – in the course of ideologically hardening political hopelessness and of social frustration – sought the way to the underground. By making the Red Army Faction his subject at the same time as the dispute between the historians was going on and by using a particular aesthetic framework, Richter took a complex position, referring directly to the battle of the historians. It is not about parallelization with a view to rulership and oppression, but about basically addressing the problem of historical consciousness, without wanting to voice a concrete opinion.

With Richter a critical position could be taken in regard to conventional historiography, which concerns not only the procedure for reconstructing history and the conception historians have of themselves, but also and fundamentally the conditions and possibilities of memory work from the perspective of simultaneity of historical consciousness and historical mourning.

The already described procedure of the Benjaminesque understanding of history – isolating the historical object and transferring it to the present where it appears as symbol and no longer as document of the past – throws a critical light not only on the mass media, but also on historical methods. The simple reconstruction of the past through interpretation of handed down facts ignores the circumstances in which exactly these facts were created. What this means is not so much that the direct functional contexts should be regarded, but rather that the fact that the photographs, the written documents, etc., have to do with the language of the "winners," to speak in Benjamin's terms, should be considered. Only oral descriptions or the (later) publication of diaries, eye witness accounts, etc., can make the past (if at all) comprehensible. Richter shows this dimension of meaning in that he transforms the photographic documents from the police archives and the mass media, which from the beginning are subjected to targeted interests, into painting and thus removes their apparently documentary character.[37] They are no longer suitable as documents to transfer history. Instead, they are symbols from the past for the future – without a moralizing overtone.

Richter requires not only a problematization of the language of the handed down documents, if these are objects of memory work, but also that the interests in the reconstruction of the past be confirmed and laid open. The neutral community of historians, who have chosen to be simply administrators of that which is handed down, is a fiction. Researching the essence of history, its course

33 Jürgen Habermas, "Eine Art Schadensabwicklung: Die apologetischen Tendenzen in der deutschen Zeitgeschichtsschreibung", *Historikerstreit*, 73.

34 Nolte, 34.

35 Habermas, 71.

36 Nolte, 34f.; as well as the essay by same author in *Historikerstreit*: "Vergangenheit, die nicht vergehen will: Eine Rede, die geschrieben, aber nicht gehalten werden konnte", 39-47; and Michael Stürmer "Was Geschichte wiegt", 293-95.

37 With the exception of the use of the photograph showing Meinhof as a young woman, which obviously comes from the family life of the terrorist and is placed in juxtaposition to the official photographs.

Paul Klee,
Angelus Novus, 1920, 32
Oil painting and watercolor on paper,
31.8 x 24.2 cm
The Israel Museum, Jerusalem

and its structures, always has to be viewed from the perspective of one's own historicity, that is, from an historical consciousness. While historiography as self-appointed administrator of history claims for itself a position outside of history, from where the past is to be evaluated through its preserved documents, Benjamin allows a situation to be created through the process of allegorization, in which the "historian" must become aware of his own historicity. This historical consciousness is linked by Benjamin with historical mourning however, which as prevailing mood of the work of history lets one hope for the "'idea' of a freed future," for deliverance. This linking of historical consciousness and historical mourning with a view to deliverance is seen by Benjamin as conditional to the time, so that in the work of Richter the moment of the freed future is missing. The "uninvited memory,"[38] the weight of the past one has not yet come to terms with, as it no doubt exists in Germany's national socialism as well as terrorism, does not permit a "liberation." So that in Richter's work it is not so much the "heroic melancholy" as the "lethargy of the heart" that is meant, as is illustrated by Benjamin's parabolic narrative: "There is a painting by Klee, which is called Angelus Novus. It depicts an angel who looks as if he were about to go away from that which he is staring at. His eyes are opened wide, the mouth gapes open, and his wings are extended. That is what the angel of history must look like. He has turned his face to the past. Where we see a chain of events, he sees a single catastrophe, which continuously heaps rubble upon rubble and hurls it to his feet. He probably wants to linger, awaken the dead, and join that which has been shattered back together again. But a storm blows from paradise, it is caught in his wings, and is so strong that the angel can no longer close them. This storm carries him inexorably into the future, to which he turns his back, while the heap of rubble in front of him grows towards the sky. That which we call progress is this storm."[39]

The cycle *October 18, 1977* is not so much a renewal of history painting in the end, but in fact painted philosophy of history[40] and is thus fundamentally different from the works of other artists who have also made the Baader-Meinhof group their subject. Richter visualizes his work of mourning through modernism and at the same time reflects on the limitations of memory work in the late 20th century.

Kai-Uwe Hemken

38 Cf. Stefan Germer, "Ungebetene Erinnerung", *Gerhard Richter. 18. Oktober 1977,* 51-53.

39 Benjamin, 146.

40 The author is in the process of preparing a comprehensive exposition on this subject.

349-363 **Gerhard Richter**
October 18, 1977
1988, cycle of 15 paintings,
Oil on canvas
On permanent loan to the Museum
für Moderne Kunst, Frankfurt/Main
from the Museum of Modern Art,
New York

349 *Youth Portrait,* 67 x 62 cm

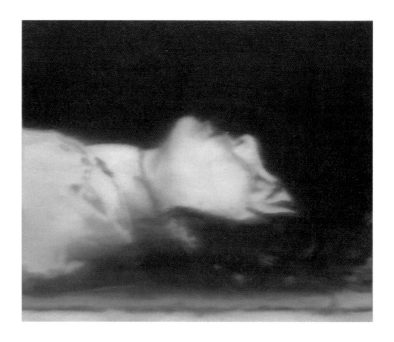

350 *Dead*, 62 x 67 cm

351 *Dead*, 62 x 62 cm

352 *Dead*, 35 x 40 cm

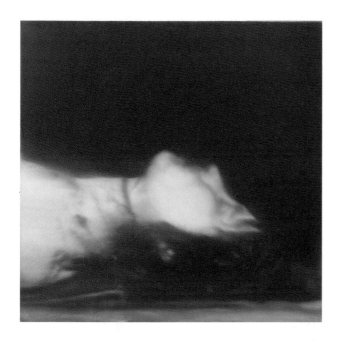

353 *Cell*, 200 x 140 cm

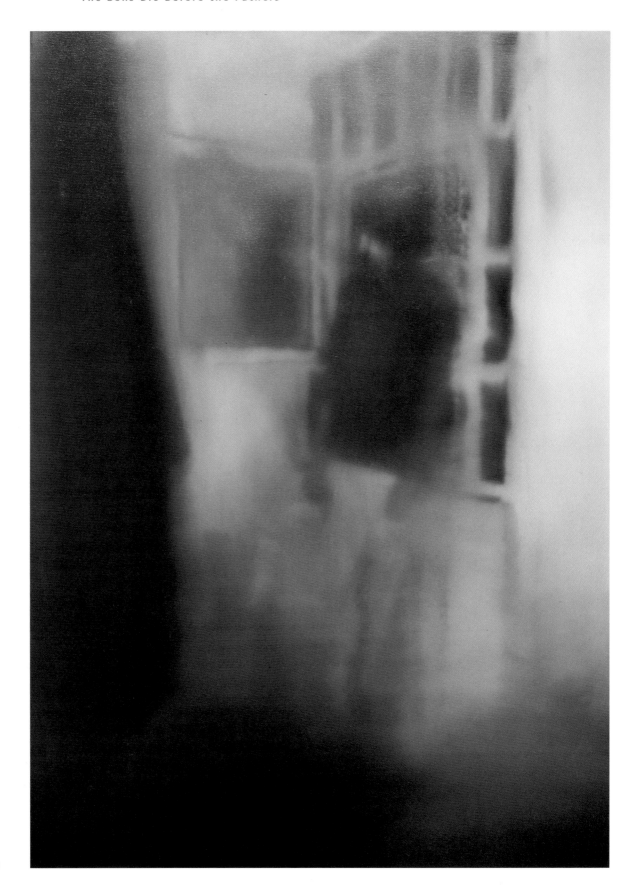

354 *Hanged,* 200 x 140 cm

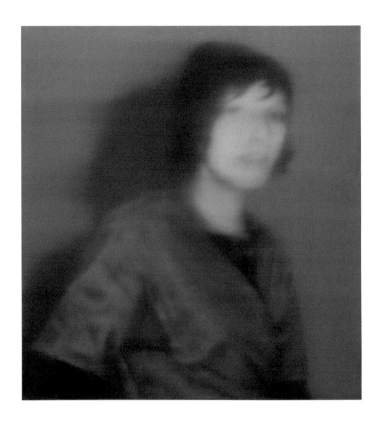

355 *Confrontation (1),* 112 x 102 cm

356 *Confrontation (2),* 112 x 102 cm

357 *Confrontation (3),* 112 x 102 cm

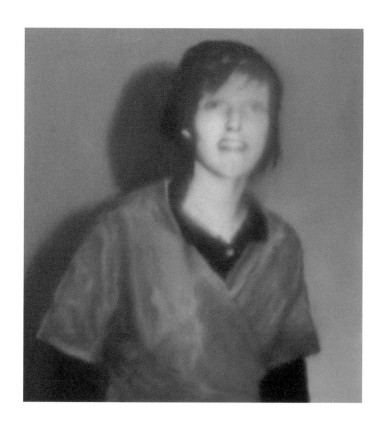 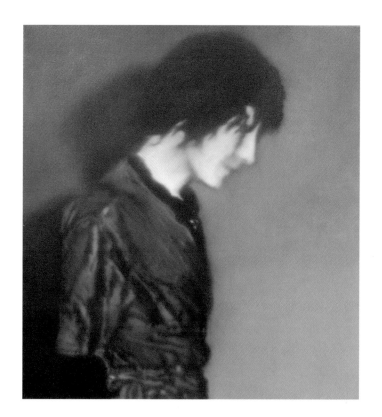

358 *Arrest (1)*, 92 x 126 cm

359 *Arrest (2)*, 92 x 126 cm

360 *Man Shot Down (1)*, 100 x 140 cm

361 *Man Shot Down (2)*, 100 x 140 cm

362 *Record-player*
62 x 83 cm

363 *Funeral*, 200 x 320 cm

364 Gerhard Richter
Betty, 1988
Oil on canvas
102 x 78 cm
The Saint Louis Art Museum

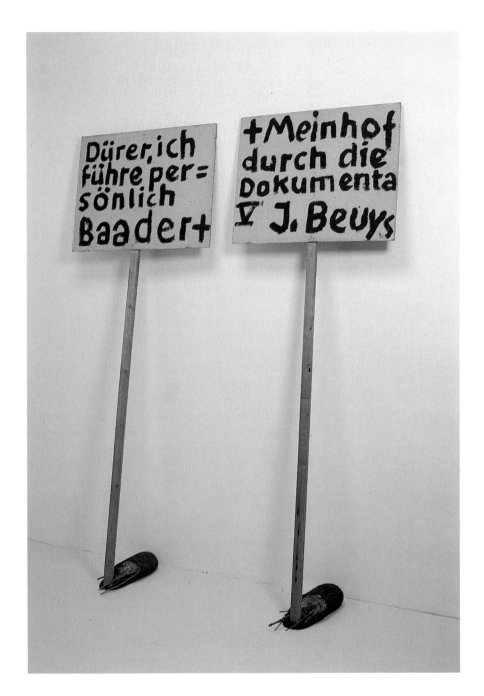

365 **Joseph Beuys**
Dürer, I'll guide Baader +
Meinhof through Dokumenta
V personally, 1972
2 wooden fiberboards,
2 wood planks, paint,
2 carpet slippers,
fat, rose stems
204 x 200 x 40 cm
The Speck Collection,
Cologne

Synchronicities

I

Streeruwitz: Is it possible for a person to make it as an artist from the German position? **Metzel:** Certainly. After all, there are enough foreign artists who pull it off here. Regardless of whether they're from America or Austria. **Streeruwitz:** Yeah, I live off you, too. I'm taking the money out of the Germans' pockets. **Metzel:** I'm not talking about a couple of writers from Austria. We'll let them pass. But there's a one-way street from the USA. **Streeruwitz:** Is there even a German mainstream? **Metzel:** Even that's remote-controlled. **Streeruwitz:** But you don't have to play along. **Metzel:** The Germans do, though. They're still thankful for the Marshall Plan. **Streeruwitz:** I'm always in favor of emphasizing the element of paranoia for the diagnosis. **Metzel:** I'm not just talking about contemporary art, but about the general cultural sensibility, too. French or Italians would laugh themselves to death over a word like *Kulturstandort*. It sees the concept of culture from an economic standpoint, and that's the way culture is treated, too. Of course, cultural spheres are economic factors, but that doesn't mean that they should be tied to balances. It's not only Americanization; group globalization sweeps everything away, too. It's just getting rid of competition. **Streeruwitz:** Yeah, but doesn't that put you into a fighting stance? **Metzel:** Fighting stance? Is it really true that after the war, the Austrians—after they had gained independence—wanted to ban the word "German" from the vocabulary? In the schools, there was supposedly not "German" class but "Language" class. **Streeruwitz:** Yes, that's how it was after the second World War. Sure, there was an attempt at emancipation, which of course was doomed to fail miserably, because the area is downright dependent upon being connected to some language, because otherwise all that would be left of Cisleithania would be a pitiful little *Würschtel*. When you consider that we could have banded together as early as 1848—maybe that would have made for more amusing history. **Metzel:** Here we go. I have here a text from a newspaper in which the government leadership is designated as a kind of trumped-up management. There's also something here about secondary Biedermeier, unthinking conformity and

social ambition in Germany. It used to be that when the *Autobahn* was closed down, it was because of rising gas prices and the oil crisis. Now it's miners who block it off. These days, if rocks and bottles fly, it's the miners protesting against foreign competition in front of the Reichstag. It used to be students. In East Germany it's even come to the point that a person who has work has to put up with disapproving stares. Then comes the idea of the 32-hour week and the question of whether there's any kind of work that would bring in more money. The whole time, only a few people realize that you can't distinguish between work, leisure and continuing education anymore. The concept of work has to be redefined, and it absolutely could have something to do with art.

II

Streeruwitz: Germany should have given itself a new name after reunification. **Metzel:** Yes. Good idea. Go ahead, make a suggestion. **Streeruwitz:** Well well. It should be *Mittelland*. Or something ugly like that. **Metzel:** Terrible. If you had to sell Germany under a different name. The others wouldn't have any fun at all. After all, they have certain expectations of Germany. **Streeruwitz:** But names are changed after marriages. Even now. Besides. It was really forced incest between two pretty sexless things. Correspondingly, it can't be much fun. **Metzel:** True. Like when one person always has to pay and the other does nothing but spend, and still nothing comes of it. Count me in. **Streeruwitz:** Sensually, nothing can work like that. **Metzel:** What is it they say about marriage: you adjust. **Streeruwitz:** Yet one half is supposed to know something about working. The other something about living. And together they're supposed to be strong. **Metzel:** Doesn't matter if it's a campsite or a garden plot. A workers' and farmers' paradise. The petty bourgeois is everywhere. But with another name, the brand "Germany" would be trashed. **Streeruwitz:** Mittelland. There's a canal in the middle of the country anyway, right? **Metzel:** Mittellandkanal. That's where VW is, and that's why it was built. We learn that in grade school. **Streeruwitz:** Now, that's really important. **Metzel:** It sure is. You said something about a new name. From the top now. So, how's that supposed to work with the atlases? Should they be dumped? Disposed of?

III

Streeruwitz: Just now. When we were talking about Araki and pornography just now, you weren't ex-

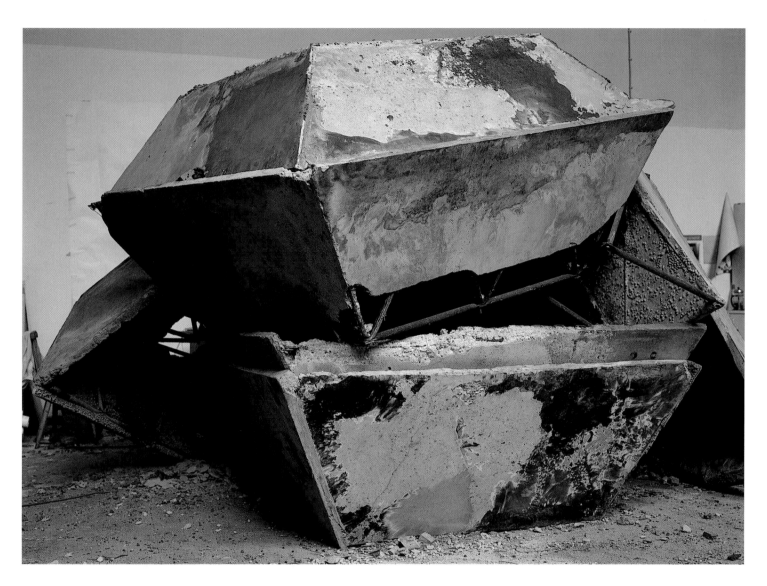

366 **Olaf Metzel**
German crate, 1997
Colored concrete, steel
ca. 360 x 380 x 250 cm
Collection of the Artist

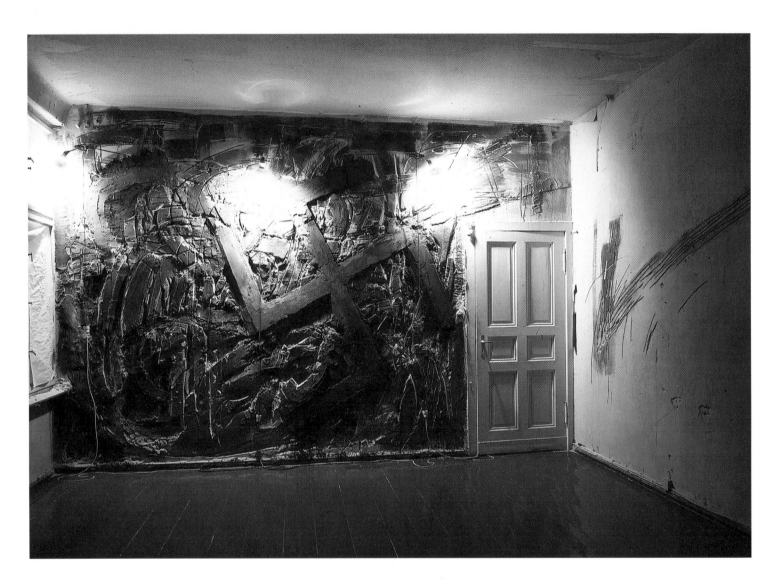

Olaf Metzel
Turk Apartment
Indemnity DM 12,000
(Basis for negotiations)
1982

actly shaking your head in distress. Human rights really wasn't your hot button. **Metzel:** That's totally normal these days. **Streeruwitz:** That doesn't make it any better, though. **Metzel:** True. But it also doesn't mean that you have to shake your head and dance around. Hi there, Mr. Mühl. Say, is he German? **Streeruwitz:** Mühl? Austrian, of course! **Metzel:** Whoever's not crazy isn't normal. That's the range of art. These days repression is different than in the sixties. **Streeruwitz:** Are you getting nostalgic on me? **Metzel:** The sixties were a cultural high point. At the end of the century, they'll be seen on a par with the twenties. From the Beatles to the moon landing. If that ever happened. **Streeruwitz:** Like I said. I'm always in favor of increasing the paranoia level. **Metzel:** Did you ever see a Sojus Capsule? They had wooden hulls. Everything was written in Cyrillic except for one sentence: "This man needs help, please open." Because they weren't sure where they were going to come down. The capsules can only be opened from the outside and they were completely incinerated when they entered the earth's atmosphere. Anybody sitting in there had his knees up to his chin. There wasn't much more space than that. And that's how they were shot up there. Real suicide missions. They were the real conquerors. **Streeruwitz:** So basically they were crouched burials in the universe.

IV

Streeruwitz: Sometimes I think that art has just disappeared. **Metzel:** Just like that. One of "Kraftwerk's" legendary titles. There was a red and white traffic cone on the cover. Now they're in a car park in Münster as part of the sculpture project. In the crash on Level 4. The best thing was that work on it was stopped by the police. There were complaints that it was disturbing the peace. Maybe that's an homage.

IV

Streeruwitz: Sometimes I think that art is just disappearing. **Metzel:** So you've finally got round to talking about my art. That's exactly what it's about. In the old entrance to the Gropius building, across from the Prussian Landtag. The Schloßbrücke sculpture groups are there. They make up a room of their own. An improvisational installation. Unbelievably heroic. It has to stay that way. It describes transitions and historical continuity. It's just the whole German business, between NVA green and NATO olive, somehow stuck away and then forgotten, never picked up.

Streeruwitz: Those are the naked guys who fight and have to learn to die. Of course, they have to learn how from a woman. **Metzel:** Bazon Brock said not too long ago that the biggest champions of culture in the last hundred years in Germany are the housewives.

V

Metzel: Did you see that poster just now? Eugen Drewermann is speaking on the international laboratory-animals day. That reminds me of the production we did together in the Cologne theater. **Streeruwitz:** Animal rights just have it easier. **Metzel:** They can give themselves a hand. The directors are teachers from the adult education courses. Somewhere along the line it must have just turned into pure self-pity. Now they only produce recognized boredom. But theater was always a reproductive art. **Streeruwitz:** But the subsidized corpse is being kept dashingly alive. Artificially in a coma. Artfully dead. **Metzel:** It's probably because you're from Vienna and I'm from Berlin. Cologne is a completely West German province. An idyll, actually. The humor there doesn't go beyond red clown noses. But the inhibited fuss about Brecht in the East is just as sickening. **Streeruwitz:** That's why they look for Brecht actors to dub porno films. Because they can come up with every kind of sigh and groan, anytime. Without even having to get in the mood.

VI

Metzel: What is it that Mr. Strauß says? **Streeruwitz:** "The worst taboo is a broken taboo." **Metzel:** Now I know what high culture is. And I'm really thankful for that. Strauß is a telling German name, after all. **Streeruwitz:** A person has to be happy to find it out again and again. And it's really sad to see that even the greats, the ones that do wonderful things, get wrinkles in their necks, too. Our Mr. Strauß is really sad about that. **Metzel:** But it's beautiful! **Streeruwitz:** That was always the problem in Germany, though. When the men get old and the fear of death rears its ugly head. Look at Goethe. Whatever they do immediately becomes more important. **Metzel:** Please! You can take care of it surgically. Much better than lifting weights. You cut open the old dried-up spots, scrape them off, and sew them up again. And just like that you're back in shape. People are standing in lines in front of these clinics. **Streeruwitz:** Yup. Should we write him a letter? **Metzel:** Fan mail. That's a different department.

VII

Streeruwitz: But look. Rolf Hochhuth used to be around, for example. He put a lot of effort into German theater. They still discussed things back then. Why isn't it like that anymore these days? Because the Pope's not doing well? Or because things are somehow going downhill with the authors, too? **Streeruwitz:** With such a boring piece, it only works once. The second time it doesn't work anymore. **Metzel:** So. You don't want to face your colleagues? **Streeruwitz:** No. And I still think that the real geniuses are the columnists. You know, this collective, the ones who answer the letters in *Bravo* and those other teeny magazines. Those are the true geniuses. And everybody should practice that. Like Beuys wanted us to. **Metzel:** You mean, the value of housewife art should be raised. **Streeruwitz:** Yes. Of course. I 'm of the opinion that poeple can express themselves and their social responsibility even with macrame. **Metzel:** What's macrame, anyway? **Streeruwitz:** It's a knotting craft, for making plant hangers. Like the ones that hang in windows. Or that swing around on the front porch. **Metzel:** You should put a candle in it for your brothers and sisters in the East. The problems that you were talking about before, with the mixed marriage. **Streeruwitz:** Forced incest. Two enemy siblings were forced on each other. **Metzel:** Sexy, huh? **Streeruwitz:** That's just what it's not. It's the failure of a culture that only has to eat well once a week, on Sunday, and not every day. **Metzel:** We used to have to hang up a flag. Then put a candle in the window. What do we do now?

Olaf Metzel and Marlene Streeruwitz

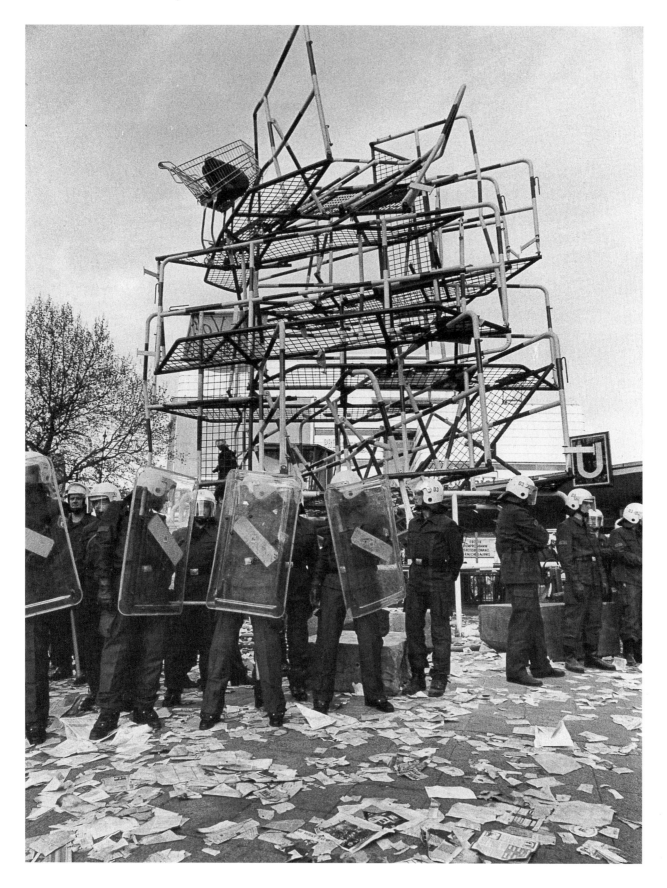

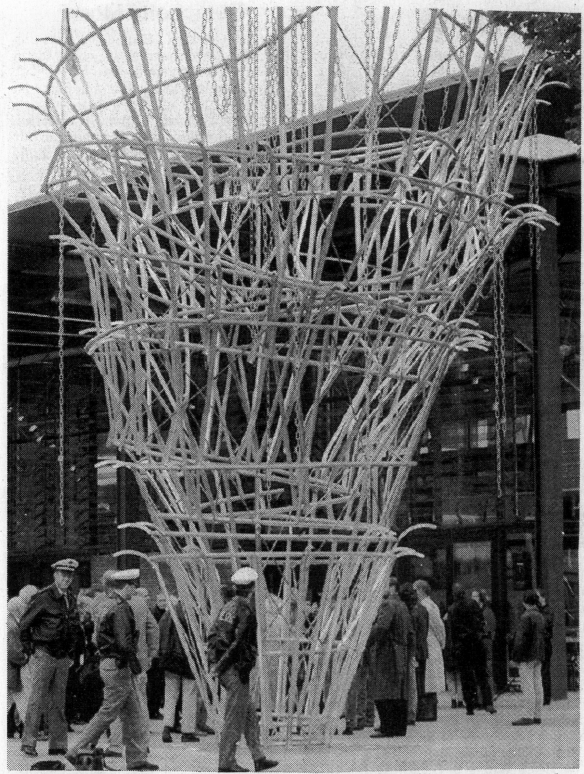

OLAF METZELS SKULPTUR „MEISTDEUTIGKEIT" *wurde gestern vor dem* *Bonner Bundestag aufgestellt. Grundelemente der sieben Meter hohen Plastik aus* *verzinktem Stahl sind Bleche von Fahrradständern.* Photo:dpa

Jochen Gerz: Exit – Materials on the Dachau Project (1972/74)

Notes on the Dachau Project

In the societal account of reality, one side consists of the actual, the actions and experiences of a person (including life in a concentration camp), and the other side consists of the cultural rendition and mediation of these actions and experiences which become binding for those who cannot change what took place in the past. This happens, among other places, in museums.

Now it appears to be true that not only the past has museum quality but also the events of the present. We are confronted with situations in which the individual does not experience his or her immediate environment as something that can be directly experienced and changed, but instead as something complete and unchangeable. Its presentation as something of the past that is irreversible is mainly a product of the cultural media – the image, the sign, and the written word. These three aspects seem to be part of an iconographic codex that is growing into something so complex that in the end it even usurps the complexity of the individually lived life. All situations, even the most private and individual ones, are organized in that matter and are assigned a place in the visual legislature.

See p. 412

1 Jochen Gerz, Francis Lévy, *Exit. Das Dachau-Projekt* (Frankfurt/Main, 1978). The most sound analysis: Monika Steinhauser, "Erinnerungsarbeit. Zu Jochen Gerz' Mahnmalen", *Daidalos*, 49 (Sept. 1993), 107ff.

2 Steinhauser, 41.

3 Steinhauser, 165.

4 Steinhauser, 137.

The installation was shown in Berlin from September 27 until 29, 1974 for the first time,[1] realized within the framework of "Actions of the Avant-garde", the Neue Berliner Kunstverein, in cooperation with the DAAD Berliner Artist Program and the Berliner Festspiele. Exhibitions in Paris, Karlsruhe, and Munich were joined. The itinerary is instructive to the extent that the spirited reactions from the public and press from city to city proved extremely diverse. Jochen Gerz had quite obviously seized on an important issue and transposed it so vividly that the work left no one indifferent. In that, nothing has changed until today. Even after the radical changes of the last two decades, *Exit* is still topical and challenging and compels the viewer to confrontation. It therefore survives as a work, interlacing the timeless and the timebound in its formal stringency.

The installation is made up of 20 tables and 20 chairs of raw wood. Over each hangs a dimmed lightbulb, allowing the ensemble of strictly alligned furniture to be just perceptible while the borders of the room seem to vanish in the dim light. The reduced light corresponds to the muted sounds. It is only after a while that one notices the dark objects lying on the tables and can make out the sounds of a running person panting and the staccato of a typewriter. Dim lighting, precise allignment of furniture, the accoustic blending of sounds of a person fleeing, and a mechanical rattle lend the installation a sinister feeling and evoke torture and interrogation. However, the suggestive effect does not become overwhelming. Collectively, the various moments of perception evoke neither fear nor powerlessness, rather, as soon as one overcomes the initial astonishment, they stimulate curiosity and reflection.

Above all, it is the dossier on each table which arouses attention and contributes decisively to an understanding of the work. The file-like, black-marbled volume contains photographs taken by Gerz in the former concentration camp, now concentration camp memorial Dachau. Without particular aesthetic ambition, the 50 reproductions show what at first glance seems unimportant. Exterior views of the memorial alternate with views into the interior of the building. We see, for example, seats, coat-hooks, a telephone, a trash can, a door knob, but most importantly, visitor information. The memorial regulations in five languages – specifically rules of behavior, requests for contributions, object labels, warnings, etc. Most of these instructions, largely formulated as a request,

distinguish themselves by their unwieldy typography. Many handwritten pages betray improvisation, from which we can infer large throngs of visitors.

It becomes clear from looking through the volume, that for Gerz it is not a matter of direct confrontation with Nazi crimes. For example, we see no reference to the victims and Gerz had also not photographed the signs from the former concentration camp now in the museum. Apart from the installation's oppressive character, the identity of the place is betrayed by only a few photographs. Among them is the photo of the broom-closet containing the stored-away sign from the execution sites or the view of watch towers and barbed-wire fences. Many of the other photographs of everyday objects, respectively, signs, however, could have been taken in one of the other museums managed by the Bavarian Administration for State Castles, Gardens, and Lakes. The Bavarian Administration of Tourist Attractions is also the very one responsible for the concentration camp memorial.

In general, however, the impression is confirmed, that Gerz obscures that which makes a memorial – a memorial, even when each photograph is provided with a registration stamp reading "Materialien zum Dachau-Projekt/1972/Nr. 1ff." ("Materials on the Dachau Project/1972/Doc. Nr. 1 cont'd.") The circle in the stamp's center is divided vertically: the left side on black background "EX" and the right side on white "IT". The stylized hand pointing from left to right indicates that the dark past reaches into the allegedly so bright present. "Exit", the stamp says, means not only exit or death but also means from there to here, from yesterday to today. The past as a condition of the present cannot be replaced by it.

In his work Gerz thematized how the museum, respectively, memorial, functions by means of language. His photo-dossier is integrated into a spatial three-dimensional ensemble whose suggestive effect permeates every mental association. The environment's ambivalence arises from the intended contradiction between the optical character and the abstract message. The room's desolate, indeed oppressive atmosphere arouses expectations which the dossiers on the raw tables do not leave ungratified, but subvert. On the other hand, taking on the documents just as Gerz had prepared them reveals the illusionistic character of the room. Whichever perspective you take, you, as observer, fall into a trap and see yourself confronted with an aporia. And such ambiguity also underscores Gerz's introductory text in his documentation. The text reads: "Because in Dachau it is a matter of a museum and not a concentration camp ..., the inscriptions couldn't be less biased. Their existence is evidence of their harmlessness. The inscriptions from the Dachau concentration camp reproduced in the museum - not photographed here

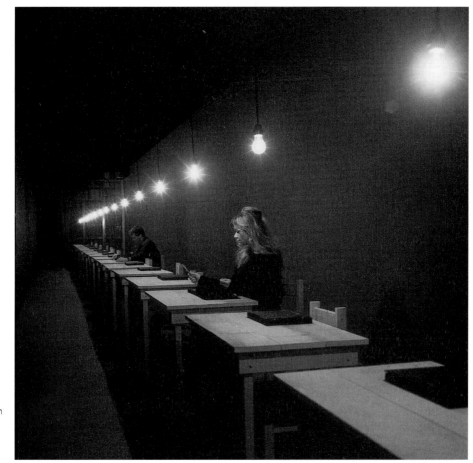

367 **Jochen Gerz**
Exit – Materials on the Dachau Project, 1972
Installation: to each of 16 tables, one chair, light bulb, dossier. One endless CD (the panting of a person running, at intervals alternating with the sounds of two electric typewriters)
27 x 3.5 m
Kunstsammlung Museum Bochum

Installation photos: Exhibition "Face à l'histoire" in Centre George Pompidou, Paris 1996.

Photographs from the dossier

This mode of "communication" may appear so inconspicuous because it is carried by a very simple system of signs and images. The language presents itself to the individual not only as something that is common to everyone but even as something the creation of which does not take the least bit of effort. Its demand on the individual does not seem to exceed that on everyone else and at the same time it forces those who use it to accept whatever it stands for. Its function is to negate the potential differences between the administration of reality and the reality of the administrated, and to immunize the administration itself. For the daily existence of concentration camp inmates, the numerous orders and directions were probably more binding than those that are usually considered restricting. In the same fashion, the linguistic organization of the Museum Dachau probably has a bigger influence on the behavior of the visitors than the detailed reproduction of the camp itself. The linguistic organization of the camp stands face to face with the linguistic organization of the museum and maybe the two complete each other – each one as a project of the other.

The comparison of the linguistic organization of that which is generally considered an extreme case of personal restriction and that which is thought to be life-enhancing is a very perceptible thing in Dachau.

Jochen Gerz, Berlin, September 12, 1974.

Jochen Gerz and Francis Lévy, *Exit. Das Dachau-Projekt* (Frankfurt/Main, 1978), 137.

– show that the script characters share the same function, in both the museum and the concentration camp. They are the medium which make both possible. The inscriptions in the Dachau concentration camp contain latently those in the Dachau Museum, and the Dachau Museum, those in the concentration camp. The inscriptions themselves are the Dachau Project."[2]

These lines disclose what concerns Gerz. He mainly demonstrates the following: the functional aspect of language, language as empty formula, as regimentation and appeal, as instrument of power. Commands and prohibitions, as they are expressed in the museum's inscriptions, even out, according to Gerz, the difference between the administration of reality and the reality of what is administered. The administration is immunized against what it has been entrusted with. In the medium of a language, as Gerz suggests, the extreme case of restricted life, torture and killing, become compatible with complexes which are normally considered life-enriching. It was mainly the situationism of the 1960's and the international circle initiated by Asger Jorn and Guy Debord "with Marxist and anarchist coloring" (Syring), which induced Gerz to take on the museum as object criticizing the culture he understands as superstructure phenomenon. After all, only life surrogates, so to speak, dead hulls, respectively, dumb artifacts were displayed. Under such auspices, the memorial in the former Dachau concentration camp was his obvious choice, all the more because for decades, the town north of Munich has for decades endeavored to extol itself as a "1200 year old place of culture with castle, palace-garden, and a unique view", to erase the evidence of the Nazi past from the town and to repress its memory.

Gerz's precarious assertion that a certain function of script characters makes the museum and even the concentration camp possible, is based on the fiction that language as a system conditions people in such a radical way that regulations and orders rule out alternative behavior. With his provocative remark, "The inscriptions in the Dachau concentration camp contain latently those in the Dachau Museum, and the Dachau Museum, those in the concentration camp" he undermines his own argument to some extent. Even if his pointed thesis - basically, the absolutism of script and character function as instrument of power - must be questioned, *Exit* loses nothing of its subcutaneous explosiveness. Gerz thematizes the obliteration of memory in a place that should keep the memory alive. His issue is not that of the concentration camp itself, but rather, how ideas which one has about this place of terror are conditioned. In *Exit,* the accent shifts from the What of the occurrence to the How of its being passed down. An abstract phenomenon is rendered visual, excluding everything living and therefore the suffering,

metaphorically continuing a process of deadening and leveling. Thus, *Exit* also recalls a certain time at the beginning of the 1970's in Germany when there was much critical reflection on how a museum passes down history. For example, the dispute over the new arrangement of the Historical Museum in Frankfurt/Main, where the inscriptions to the objects exhibited appeared degraded to mere illustration. Within this perspective, *Exit* proves itself time-bound. The installation by Gerz, however, strives not only to show how the museum as system subjugates both its contents and the visitor and disciplines the latter by instruction, thereby passing on structures which it actually means to dismantle through enlightenment. Rather, Gerz also wants to demonstrate that the museum devises and constructs history. And this is where the work transcends its own origin and in impressive aesthetic form articulates a universal problem, brought anew into current dialogue by a different token, in the discussions around Daniel J. Goldhagen's book *Hitler's Willing Executioners* and the designs for the Berlin Holocaust Memorial.

The installation triggered an intense controversy in Munich in fall, 1977. The Memorial Director felt the work, even after continued discussion with the artist and Museum Director, to be a "denigration of the efforts to prevent a repetition of the concentration camp through the establishment of the memorial and museum."[3] An understandable reaction, when one bears in mind the kind of resistance that had to be broken through in order to estabish the memorial and museum. The artist group "Tendencies" even saw in the work a "shameless offense to the victims of fascism."[4] The proposal to buy *Exit* for the State Gallery in the Lenbachhaus for the price of DM 25,000 was turned down by the town council majority of the Christian Socialist Union (ultra-conservative party) in April 1978.

Armin Zweite

Hans Haacke: The Historical "Sublime"[1]

When in a famous 1966 interview Tony Smith[2] attempted to come to terms with the radical changes imminent in sculptural production and perception, he pointed towards two seemingly unrelated examples of highly overdetermined social spaces. Both concretized the full range of these changes occurring in the public sphere: the first one being a strip of then still unfinished highway, the construction site of the New Jersey Turnpike, and the second one being a ruin of recent history, the infamous Nürnberg Stadium built by the German Nazi Government for its *Reichsparteitag.*

What both examples shared would remain somewhat obscure to an American audience that was first of all fascinated with the apparent opening of new and enlarged spaces for monumental sculptural production, promising as it seemed, the recovery of an American Sublime in the prospects of Land Art. As much as Smith might have shared that infatuation with spaces presumably untainted by avantgarde culture, his examples point with equal, if not higher intensity to the dialectical opposite of the Sublime: the insight that simultaneous collective perception, even if situated outside of the conventional spatial concepts and discursive confines of sculpture, is all the more evidently the result of the social production of space. In other words, Smith reflected upon the fact that the conditions of spatial perception operative in contemporary secular architectural structures (such as the spaces of leisure and transportation) would not only alter the formal, procedural, and material parameters within which sculpture could be conceived, but that these conditions would ultimately challenge the very possibility of traditional sculpture altogether.

Large scale spatial, mostly horizontal, expansion and the structural and morphological dissemination of the previously monolithic sculptural object were two of the most important strategies for the transformation of sculpture in the late sixties. The strategy of expanding the sculptural field into the lateral dimension attempted to overcome the increasingly obvious inability of traditional sculpture to respond to the radical transformations of the public sphere which Smith's examples had indicated. Several works that established this new aesthetic of lateral expansion (and indeed there are many) chose the road as a structural or material model.[3]

At the same time the artists of the Minimal and Post Minimal generation assumed that a new category of relatively autonomous sculpture could be legitimized through a renewal of its phenomenological dimension, i.e. an emphasis on prediscursive or extra-discursive spatial experiences. Their work either refused monumentality (such as Richard Serra's early work until 1971), it dispersed sculpture's monolithic structure (such as Andre's or Long's), or it deployed formal strategies that revealed negative or seemingly non-definable, leftover spaces (as in Bruce Nauman's cast of the negative space underneath a chair or the sculpture cast from the space between two sculptural volumes). This dialectic becomes most explicit in a work such as Serra's *To Encircle Base Plate Hexagram, Right Angles Inverted* (1970) where a remote urban space, the site and structure of a "cul de sac" in the Bronx section of New York, were incorporated into the sculptural conception precisely in order to negate all traditional claims that consider sculpture as being inherently public and monumental.

By the early 1970s, however, a younger generation of artists such as Michael Asher, Dan Graham, Hans Haacke and Gordon Matta Clark, responded critically to these Minimalist and Post Minimalist positions. Haacke and Matta Clark in particular challenged the assumption that spatial structures could operate simultaneously inside the conventions of sculptural production and outside of the spaces of social control. They proved that these supposedly prediscursive spatial realms of the phenomenological, of the abject, of negativity or formlessness, were in fact not any less historically overdetermined than the most rigorously controlled public and institutional spaces.

To radically historicize the concept of space as the intersection of social, institutional, and ideological interests, became thus one of the strategies that made the work of that generation develop a particular concept of site specificity and make it intervene with precision in its placements and discursive frames. These critiques implied ultimately that the very continuity of sculpture as a material construct and as a relatively autonomous spatial structure had to be abandoned. Textual accounts as much as functional photographic documentations took the place of the traditional sculptural object, eventually displacing sculpture altogether, if only temporarily. Urban architecture and public space appeared in Haacke's work of the seventies both as maps and archival photographic records.[4]

In the rigoros subjection of sculpture to the conditions of historicity , Haacke contributed not only to the critique of Modernist visuality, but more specifically, to a critique of phenomenological thought deployed for a relatively conventional conception of sculpture in the sixties. By removing even the last remnant of spectatorial self-determination from sculpture — which its phenomenology had always guaranteed — Haacke exchanged the phenomenological for an institutional and discursive specificity.

[1] The term "sublime" is used here in an effort at ambiguity, to range from its original aesthetic discussion in Burke and its lasting impact on American aesthetics of the 1960s to the more obscure — but certainly for Haacke, appropriate — French opposite meaning which emphasizes the condition of an ironic if not subversive insubordination to the forces of control and order in proletarian slang of the late nineteenth century. For this see Kristin Ross, *The Emergence of Social Space: Rimbaud and the Paris Commune* (Minneapolis, 1988), 16.

[2] See: Samuel Wagstaff, jr., "Talking to Tony Smith", *Artforum*, vol. 5, no. 4, (December, 1966).

[3] These range from Carl Andre's and Richard Long's horizontally organized, serial accumulations to projects that at times literally employed the materials and procedures of road construction as, for example, in Robert Smithson's *Asphalt Rundown,* (Rome, 1969), or in Lawrence Weiner's 1968 piece *A 2" wide 1" deep trench cut across a standard one car driveway.* (See: Lawrence Weiner, *Statements* (New York: The Louis Kellner Foundation/Seth Sieglaub, 1968). Andre considered the road and what he termed its "radicality of running along the earth ..." as a viable model since it seemed to correspond to both his conception of sculpture as a public, quintessentially antimonumental "place" as well as to his desire that sculpture should aspire to the condition of use value. But the model of the road and road making as place and procedure not only challenged verticality or emphasized a horizon of utilitarianism towards which sculpture was now to develop. It recognized furthermore — as had Smith's remark — that the site and structure of the road now appeared as one of the last public spaces where simultaneous collective perception — and therefore an actually existing condition of however distorted and residual, socially constructed "publicness" — could still be detected.

More recently, in 1993, Haacke once again demythified the by now academic formal strategies of spatial expansion and structural dispersal in an installation entitled *Germania* at the German pavilion of the Venice Biennale. Here the artist removed the entire travertine floor that had been originally installed by the Nazi government and he displayed the broken shards in the manner typical of a late sixties' distribution sculpture. In his new work for the exhibition *Deutschlandbilder,* Haacke engages once more with the expanded horizontal field and the road as a secret episteme of late modernist sculpture. More precisely he constructed a simulacral fragment of the infamous German Autobahn that appears here primarily as a model of historical archaeology rather than as one that prefigures the spatial and sculptural conceptions of the future.

What had in fact linked the Nürnberg Stadium and the New Jersey Turnpike in Smith's statement, was — as we realize now — a crucial moment in the transformation of public space in twentieth century history. New technologies of mass organisation and transportation altered spatial perception inherited from the bourgeois public sphere and generated radically different forms of social space: On the one hand the rise of a totalitarian public sphere in both its Fascist and in its state socialist formations; on the other hand, their historical counterparts in the various Western countries where a systematically planned and enforced Capitalist consumer culture alters public perception in a manner that — while fundamentally different — compares easily with the radicality of the changes brought about by the totalitarian models. Haacke's simulacral reconstruction of a strip of German Autobahn uncannily uncovers precisely how these totalitarian and late Capitalist spheres have been intertwined in German history more than anywhere else. The work thus assumes an unexpected archaeological and at the same time mnemonic function. Proclaimed as their invention and as one of the great achievements of the Nazi Regime, the Fascists' construction of the Autobahn was essentially a strategy to prepare for the War. Who, having grown up in Germany in the post war period, would not have heard the parental adage that the Nazis might have committed unspeakable crimes against humanity, but they also built the Autobahn and thereby took care of unemployment? Who, having lived through the sixties and seventies between the two Germanys or in Berlin, would not remember the Autobahn as the precarious passage between the two countries as it acquired a mythical status as a lifeline to "freedom" from the Stalinist state and its totalitarian control systems to traffic, trade, and communication. And who, in the Western Capitalist half of Germany, would not have realized slowly or suddenly to what degree the fanaticism of postwar German car culture

with its insistence to remain the only European nation with unlimited highway speeds, did in fact link that nation's special needs to repress and to forget its totalitarian history to a perpetual and daily *Stahlgewitter* (storm of steel) of Autobahn races and its ritual killings and self sacrificial accidents ? Yet at the same time those raging street battles articulate a fanaticism that originates in the present, deriving from the degree to which that country's successful reconstruction actually depended at least in part on a systematically enforced car culture at the expense of immeasurable and irreparable ecological destruction.

Haacke's installation of a false strip of German Autobahn inside an exhibition thus collects and condenses public images of the troubled history of post war Germany. Inevitably it contributes to the continuing debates about the "proper" ways of representing that history to the Germans, and it reflects upon the question of how a truly mnemonic, yet anti-monumental sculpture could possibly be structured at this point. Thus its horizontal expansion seems to respond directly to other recent proposals that attempt to redeem a discredited monumentality by reinscribing it into the recent forms of anti-monumental phenomenological sculpture (e.g. the Berlin proposal for a Holocaust Monument). Yet it is in this comparison that the specificity of Haacke's seemingly crude subjection of sculptural phenomenology to historically specific thought reveals its full competence. It is the work's sublime "banality" that protects it from the reinvestment of sculpture with a false claim to actually represent the unrepresentable which is in itself the most banal of all responses to the difficult but not impossible task of commemoration.

Benjamin H.D. Buchloh

368 Hans Haacke
Cast Concrete, 1997
22.5 m x 15.1 m x 26 cm

A section of Autobahn, made of cast concrete segments, approximately 15 m wide, runs in an East-West direction through the atrium of the Martin-Gropius-Bau in Berlin.

A median of cast concrete separates the two directions of the 4-lane road. The lanes are marked by white lines. Cold light falls evenly on the entire expanse.

Three Works by Astrid Klein

1 Hans Mommsen, "Das Dritte Reich: Bürde oder Herausforderung?", *Niemands-land. Zeitschrift zwischen den Kulturen*, 1/1, 1987, 16-20.

2 The battle between Germany's most prominent historians centred on the classification of National Socialism in German history. It was instigated by an article by Ernst Nolte published in the *Frankfurter Allgemeine Zeitung* on 6/6/1986 under the heading "Vergangenheit die nicht vergehen will", to which Jürgen Habermas replied in an article entitled "Eine Art Schadensabwicklung" published in *Die Zeit* of 7/11/1986. In opposition to the "apologetic tendencies in German historiography", which he diagnosed in particular in Stürmer's reflections on the problem of German identity, Habermas clings to a pluralism of western-enlightenment values: "This offers the only possibility of clearly distinguishing the ambivalances in the traditions of one's own identity-formation. And it is exactly this that is required for a critical appropriation of ambiguous traditions, that is to say, for the formation of an awareness of history that is as irreconcilable with closed and secondarily natural historical images as it is with any form of conventional, namely, unanimous and pre-reflexive shared identity." Habermas' plea for a post-national identity continues as follows: "The only patriotism that will not alienate us from the West is a constitutional patriotism. Unfortunately, a full-hearted commitment to universalist constitutional principles has only been able to emerge in the cultural nation of the Germans after — and through — Auschwitz. Anyone who wants to exorcise our embarrassed shame about this fact using a cliché such as "obsession with guilt" (Stürmer and Oppenheimer), anyone who wants to summon the Germans back to a conventional form of their national identity, destroys the only reliable basis for our commitment to the West." The term constitutional patriotism did not meet with unanimous approval. See Hagen Schulze's essay "Keine historische Haftung ohne nationale Identität", *Die Zeit*, 9/26/1986.

3 Jürgen Habermas, "Vom öffentlichen Gebrauch der Historie. Das offizielle Selbstverständnis der Bundesrepublik bricht auf", in *Die Zeit*, 11/7/1986.

4 Walter Benjamin, "The Image of Proust" in his *Illuminations* (London, 1973), 198.

5 Benjamin, 201.

Astrid Klein has been working with the medium of photography for more than two decades, her central theme being the assumed identity between reality and its photographic representation. In our century the problem of the concept of identity has been treated by all the various disciplines, its loss being either lamented or seen as an opportunity to be grasped. In Germany in particular, the loss of national and state identity as a result of the catastrophe of the Third Reich would seem to represent both an insuperable onus and a prerequisite for a free and democratic national consciousness.[1] The dialectical concept of identity draws its great power of attraction and effectiveness from a sense of loss.

The three works by Astrid Klein selected for the *Deutschlandbilder* exhibition span a period of almost twenty years. They were produced in the late seventies and in the nineties, and reflect on the problem of national identity in Germany.

In her early work *Kamikaze* (1978; fig. 369, p. 417), text and image stand side by side unrelated, mediation being inconceivable just one year after Andreas Baader and Gudrun Ensslin committed suicide in the prison at Stammheim. In their injudicious impotence, they had directed their aggression about the repression and silence of their elders inwards, as described in the text montage. Through their self-destruction the perpetrators became their own victims. Many artists of their generation were moved by this "kamikaze act" and attempted to translate the causes and motives of the RAF in a formal artistic idiom. For this they were repeatedly reproached with being terrorist sympathisers. Their sympathy, however, was not for the criminal act but for the equally desperate and romantic search for identity.

To portray the breach in German national identity, Astrid Klein conceived of the image of the flag without an emblem that fills the entire plane of a more recent work *Ohne Titel* (Untitled, 1988-97; fig. 370, p. 418). Monumental, though without a text predella, this work harks back to her earlier *Über die Zeit IV* of 1988 and represents nothing more nor less than the problem of national identity in Germany, which in the mid-eighties was at the centre of the so-called *"Historikerstreit".*[2] In 1982, when the SPD/FDP government ceded power to the CDU/FDP coalition, the "public use of history"[3] experienced a boom that was expressly promoted by the newly elected federal government. The dangers inherent in historicisation were the theme of Klein's 1984 work *Eingeebnet, eingeordnet, begradigt,* addressing the place of German hero worship, Walhalla.

A no less "determined" national symbol is the Brandenburg Gate which, in a composition dating from 1986, Klein submerged in a gigantic mountain of skulls above which the Quadriga, engulfed in dark clouds, can only vaguely be made out. The possibility of coming to terms with and atoning for the past as a prerequisite for a German identity is obscured by repression and falsification, the inability to mourn, and xenophobia.

How to acquire a democratic identity by coming to terms with the inherited burden of National Socialism is a question that is being raised again seven years after German reunification, though in a different key, so to speak. The flag openly displays its grief about the crimes committed under the German banner and the loss of national identity that is linked with them. At the same time, it clearly illustrates that even after reunification the 40-year-old rupture in identity cannot be remedied by the idea of nationality alone.

In the two works conceived for the *Deutschlandbilder* exhibition Astrid Klein achieves a new degree of abstraction by separating the discursive and the visual levels. As in her 1990-91 series of empty poison cabinets, she places the idea of emptiness at the centre of her work in order to create an image for the unrepresentable. Epistemologically, emptiness is ascribed to a term that has no correspondence in intuition. Emptiness as a concept is itself non-intuitable, especially when it refers metaphorically to spiritual emptiness or meaninglessness. By constantly searching for images for the non-intuitable, Astrid Klein creates the preconditions for filling the emptiness anew.

In the text-work *Ohne Titel* (Untitled, 1974-97; fig. 371, p. 419), which corresponds to the flag and forms a link with Klein's black script works of the seventies. Involuntary recollection, Proust's "mémoire involontaire", emerges, scarcely legible, out of the significantly enlarged fabric of recollection. Of this "mémoire involontaire" Walter Benjamin asked whether it was not much closer to forgetting than to what is usually called memory.[4] The dialectics of remembering and forgetting determine thinking, which, according to the text montage, entails both thought's movement and standstill. The object of memory can only be what Benjamin refers to secondarily as a "fragile reality."[5]

Dorothea Zwirner

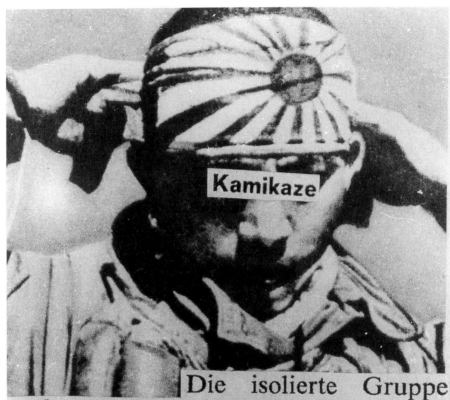

Die isolierte Gruppe muß sich eine Ideologie aufbauen, in der sie unterschieden ist von der übrigen Welt. Die Gruppenmitglieder gewinnen so die Überzeugung: Wir sind besser als andere Individuen. Was da-

bei verdrängt wird, ist die Gewaltsamkeit der Gruppenmitglieder untereinander. Wenn dann kein Ventil nach außen gefunden wird, sozusagen kein böser Feind außen identifiziert werden kann, gegen den sich Aggressionen richten, dann kommt es zur Implosion, zum Kurzschluß nach innen.

369 **Astrid Klein**
Kamikaze, 1978
photographic work
280 x 140 cm
Collection of the artist

370 **Astrid Klein**
Untitled, 1974/1997
photographic work
200 x 280 cm
Collection of the artist

371 **Astrid Klein**
Untitled, 1988/1997
photographic work
200 x 280 cm
Collection of the artist

Synchronicities

Three Works by Rudolf Bonvie[1]

The media-critiquing approach in Rudolf Bonvie's work is based on the question of what function is ascribed to perception in the age of mass media. Bonvie reacted to the consuming appropriation of the world in images with refusal strategies meant to challenge the observer to perceive critically. In his work *Compare all single column photographs that depict a person* from 1977/78 (fig. 372, p. 421), Bonvie takes stock, as it were, of Federal German history and media development by using photos from the magazine *DER SPIEGEL* from the years 1957 and 1977. Rendering the portrait representation dynamic, the altered behavior of the photographic subject in front of the camera as well as the snap shot, all attest to the media's increasingly ruthless intrusion into privacy that accompanies the alleged claim to authenticity. By comparing photos taken twenty years apart, Bonvie makes us aware of perception judgements and conditions. What we perceive cannot be automatically taken for truth. Our perception is always selective and dependent on time.

The 3-part works *Weimar* (fig. 373, p. 422) and *Mark* (Mal, fig. 374, p. 423) evade the glance of quick consumption and challenge the observer's apperception. In the work *Weimar* it is the inscriptions "Salve" on the threshold of the Goethe-Haus and "To each his own" at the entrance gate to the Buchenwald concentration camp, which make clear the immediate closeness of Humanism and National Socialist contempt for human life. While the Latin greeting was appropriated and abused by the Nazis, Frederick I's principle of "suum cuique" from the Roman doctrine of natural right, in this context, represents an outright perversion. A simple stele surrounded by gravel stones on the middle panel refers to the former Block 17 of the concentration camp. The history of this place, with all of its individual fates, appears to be more vividly preserved in the stones of many different shapes than in the conceptual abstractions. The stone, as the symbol for remembrance, belongs to a Jewish burial ritual. Thus the memorial stone-covered gravestone of Moses Mendelssohn (1729-1786) in Berlin's oldest Jewish Cemetery is to be seen on the middle panel of the work *Mark*.[2] The grave recalls the significant enlightener who as a Jew first had to assert his residence rights in the Prussian capital in order to fight for the emancipation of the Jews in Germany.[3]

The Wall built by the GDR stood partially on the same site of the former toll wall along which Mendelssohn sought admittance into the city.[4] In 1788, two years after his death, the Brandenburg Gate was errected, which since then has repeatedly become the scene of the important events in German history and the symbol for the reunification after 40 years of Germany's division. In 1990, the year the work *Mark* was created, it was possible for all Germans to see the Brandenburg Gate from both sides again for the first time. Rudolf Bonvie photographed this new perspective shortly after the *Wende* (political change) while the Wall was still standing. The narrow horizontal picture detail from West to East opens the view over the Wall on two of the column shafts with the architrave laying on top. In the opposite line of vision we see through the columns onto the graffiti covered Wall. The oblong format had appeared already in Bonvie's early work in the blinding of portraits by black horizontal bars, also used by the press to insure the anonymity of persons.[5]

While the horizontal format of the Wall stands here for border and separation, the verticality of the columns signalizes openness and freedom. The work culminates in the top view of Mendelssohn's tomb, which like a light stripe, vertically divides the dark brown middle panel into two nearly equal halves as symbol of tolerance. *Mark*, the title of the work, encompasses a spectrum of meanings from a neutral mark or characteristic up to the negative connotation of blemish and stigma, but also to signs of remembrance and memorial. The mark is always a sign constantly undergoing changes in meaning, which can be appropriated and abused.

Rudolf Bonvie shows us the transformation of perception and changeability of meaning, as they are also considered in the recent memorial debate. The discussion around a Holocaust Monument in Berlin, in particular, revealed the entire dilemma of a nation struggling for an appropriate form of remembrance of crimes perpetrated by a State whose legal successor this nation is.[6] The scope of the "memoria" ranges from memory as a dynamic creative process up to remembrance as static repository of what is remembered.[7] Bonvie undertakes the activation of memory, by reproducing forgotten or suppressed connections. How could it happen that the concentration camp Buchenwald was erected in immediate proximity to Humanist Weimar? How is it possible, that on the same place where Mendelssohn once surmounted a wall a new one was erected about 200 years later?

Dorothea Zwirner

[1] S.D. Sauerbier had already made a connection between the works *Compare all single column photographs that depict a person* and *Mark* in: *Rudolf Bonvie*, exhibition catalog (Städtische Galerie Lenbachhaus Munich, 1991).

[2] On the history of the cemetery, destroyed in 1943 and in the meantime rebuilt, see: Ulrich Eckhardt/Andreas Nachama, *Jüdische Orte in Berlin*, with feature texts by Heinz Knobloch and photographs by Elke Nord (Berlin, 1996), 15.

[3] Lessing built a literary monument of religious tolerance to him in his *Nathan der Weise*.

[4] Ulrich Eckhardt followed Moses Mendelssohn's imaginary historical path from the Hamburger train station to the Anhalter train station, *Der Moses Mendelssohn Pfad* (Berliner Festspiele GmbH, Berlin, 1987).

[5] In his more recent works, Bonvie takes up the bar motif again, which is also formally concretized into black wall surfaces.

[6] After the presentation of the prize winning-design by Christine Jackob-Marks, and others, for a *Monument to Europe's murdered Jews* failed in 1995 because of the Federal Chancellor's veto, the Berlin Senate Administration for Cultural Affairs held a colloquium with the participation of the three prize winners and 80 experts in Spring, 1997.

[7] Today's monument debate moves in a similar field of tension, countering a static space and time-dependent solution with the dynamic model of transitoric, disappearing or interactive "Counter-Monument".

372 **Rudolf Bonvie**
*Compare all single column photographs that
depict a person, DER SPIEGEL* No. 7, vol. 11, 1957 –
vol. 31, 1977
2-part photographic work
Each: 120 x 170 cm
M. DuMont Schauberg, Cologne

373 **Rudolf Bonvie**
Weimar, 1991
3-part photographic work
185 x 185 cm
Staatsgalerie Stuttgart,
Graphische Sammlung

Rudolf Bonvie had reworked the photo works
Weimar and *Mark* into an installation and
enlarged each photo to a format of 280 x 280 cm
for the exhibition "Deutschlandbilder"

374 **Rudolf Bonvie**
Mark, 1990
3-part photographic work
185 x 185 cm
Städtische Galerie in Lenbachhaus, Munich

423

Synchronicities

The IG-Farben-House
Photography by Günther Förg

Whether Günther Förg photographs Mies van der Rohe's German Pavilion in Barcelona, the Wittgenstein House in Vienna, the Casa Malaparte in Capri, or the structures of Italian Rationalism – the photographs are always engaging appropriations of Modern architectural icons. Unlike the representatives of the so-called Dusseldorf School, the artist is not primarily concerned with cultivating the spirit of neutrality. Förg's sometimes out-of-focus photographs were taken with a 35 mm camera, revealing his his desire to renounce the harmony of parallel lines which a larger camera would have captured. Indeed, the photographs acknowledge the aforementioned architects' decisions regarding form but at the same time reveal the wish to reach the Modern's level of demand and to occupy once again the ambience of the time. This happens all too clearly now and then when he poses Ika Huber, his partner in life, or when his own reflection appears as a self-portrait in a photo – but now, in a broader sense, by linking outer and inner view. In this manner, the architecture becomes inverted, opened, and deciphered in the photographic account. Although Förg is always searching for a feeling of life from the past – to be regained, to be inherited or to be refuted – his photographs stage a Post-modern experience. What occurs is an unceasing survey of the inner world of the outer world of the inner world, of an ultimately infinite terrain in which there is neither a fall into the depths nor a real arrival. We have come to deal with the dismissals and paradoxes of the Modern in a casual way and that's why particularly the Proteus figures among artists, writers, musicians, and architects have become more interesting. The architect Hans Poelzig (1869-1936) belongs to these shape-givers who are able to transform, who, precisely by adapting contemporary forms of expression, were able to maintain the adaptations as their own and to make them even more distinct. As *Werkbundarchitect* and a rather conservative renewer, Poelzig created the expressive atmospheric images of a Jewish ghetto for the film *The Golem,* using clay structures that transformed the Große Schauspielhaus theater building in Berlin into an architecture of light – in the vernacular called "stalactite cave" – and, finally, built functionalistically, apparently without great labor pains. Poelzig's last project realized before the Nazi's seizure of power and finished in only 28 months between 1928 and 1930, was the administration building of IG-Farben in Frankfurt/Main. Although it was regarded as a model of functionalist objectivity, the building is thoroughly ambivalent: its theatrics can hardly be denied. The convex curved structure encased in travertine whose main entrance was a pillared hall with a drive-up in front has a fortress character, with six compartment towers, embanked base, and upward shortening of stories. The symbolic effect of the largest office complex in Europe was not overlooked. The commentators of the day confirmed its hybrid form as a "power center and work place", spoke of a "Palace of Money". The building was conceived as a headquarters of rulership – the IG-Farben Concern belonged to the greatest industrial cartel in the world. The concern's tentacles reached into the Nazi State's war and extermination politic and soon gained power beyond measure. Filmmakers such as Visconti, Fassbinder, or Sinckel who, in their analyses of the Nazi era mentality, rediscovered this type of architecture, treating it as a chief witness to the emotional situation of the time and therefore as a concrete form of the mindset. The Americans, too, grasped the mythical nature of the IG-Farben complex. Although frequently photographed by reconnaissance fliers, the building was never bombed. Could it be that the building was then already earmarked as the seat of a future military government and center of command? Was this seat of power meant to be taken in an exemplary manner and occupied anew by the ruling power? Here, in any case, events pregnant with symbolism accumulated later. The parties investigating into the IG-Farben concern managed just in time to prevent bulldozers from junking mountains of files. This was where the "Trizonal Conference" initiated the foundation of the Federal Republic of Germany, and where the currency reform was announced and the air-lift planes coordinated, and where finally the headquarters of the Fifth Corps of the American military forces was established. Red Army Faction bombs which exploded during the Viet Nam War and the Israeli invasion of Lebanon led to the building's fortification by fences, corridor blocks, and sentry posts. The aura of power affirmed itself unwillingly through the exclusion of the public. For Frankfurt's citizens, the Poelzig building degenerated to a terra incognita, paling increasingly to a picture postcard. Even after the Americans withdrew hardly anything changed. Still, the fate threatening the Poelzig building - of becoming an architectural ruin staffed by security guards - could fortunately be prevented. After appropriate reconstruction, the University faculties in the Humanities, the Institute for North American Studies, and the Fritz-Bauer Institute for Holocaust Documentation and Research are due to move in in 1998.

But today the building is experienced as an echoing palace from a silenced time. Original substance is still offered by the entrance area with its semi-circle entrance hall, the curved stairway leading upwards at the side, its Italian marble walls in rhombic patterns, and the silver

hall ceilings. From the adjoining glass "Eisenhower Rotunda", the eye falls onto the water pool and the casino at the other end of the axis. The Americans had imbued the casino, called "Terrace Club", with the atmosphere of home: plates of smoked glass at the entrance, a wall-to-wall carpet with a peal of stars-and-stripes, and deep blue wallpaper. All of this where there once had been a light ensemble of rooms. The world power's interior decorators' banalization created a strangely unselfconscious effect. The large conference chamber in the wing of the main building where the decisions concerning "Auschwitz IG" and the delivery of Zyklon B had been made, were transformed by the Americans into a squash court and fitness center. All the same, there is also some sense of relief to this covering up of historical substance, above all, because it ultimately managed to do so without destructive intervention. Perhaps the Americans even saw the Poelzig-House as just a film set in which they established themselves pragmatically and without much ado. Kirk Patrick, the military historian of the fifth Corps, came to the point: "A magnificent building, I have always liked it."

These things are mentioned because they may also serve as evidence of Postmodern practice and because they make clear what Günther Förg did in fact not photograph, although he could have. In any case, Günther Förg used this pre-transition situation in which the shields of power were dismantled, to make his photo series *IG-Farben-House*. In and with the series, something exemplary happens: This building is appropriated by an artist's temperament. Förg's photos of Italian Rationalist architecture were already marked by similar moments of a de Chirico-like metamorphosis, by a deserted silence, and by a moment of reflection and dream. The artist apparently appreciated the bare spaces permeated by light reflections, and the glaring facades subdued by geometric screening because they contained so much unexhausted potential, and as contructed substance they served as ground for his pattern images. It was precisely politically charged architecture which interested the artist. To what extent are forms themselves actually culpable or to what extent is this impression due to the observer's susceptibility to cliché and being taken by surprise? Thus it is not so much the wish to partake in Poelzig's monumentalism, when Günther Förg enlarges his photographs to the format 2.5 x 1.5 m. For a refined subversion of monumentalism takes place when namely the course-grain texture of the blow-ups begins to artistically dissolve the architectonic objectivity. Power, exclusivity, and severity appear broken down into pigments. Förg's photography stands at a significant threshold: distanced enough to give room to pathos, close enough to suggest touch. Details of facades and inner rooms correspond to each other. In both perspectives - albeit with considerable difference in degree - breakthroughs of light, reflexes, structural clusters create the impression of transparency. Reflecting glass panes, with which Förg covers his framed photographs, mirror the observer as observer. In the Frankfurt gallery Bärbel Grässlin, where these pictures were shown for the first time in October/November 1996, the walls were painted Veronese green. The photographs stood against these color surfaces like windows going down to the floor. The painting of the walls was a statement of the event to take place at the opening night of an art play. It served to thematize the perception of historical form and release it from restrictive vision.

For that reason, Förg's engagement with the IG-Farben-House is enlightening not only for artists. Its accompanying promise to open one's perception coincides with the intended transformation of this architecture and center of power. Using the building for intellectual purposes would make this building accessible to the public. After its initial fateful, then ghetto-like existence, the luminous and perhaps more cheerful chapter of its history can at last begin.

Rudolf Schmitz

375-384
Günther Förg
IG-Farben-House, 1996
10 photographs from a 28-part
series, framed
Each 242 x 162 cm

upper row:
375 *IG-Farben-House I*
Galerie Bärbel Grässlin, Frank-
furt/Main

376 *IG-Farben-House V*
Private collection, Cologne

377 *IG-Farben-House XI*
Private collection, Cologne

378 *IG-Farben-House VII*
The Art Collection of DG Bank,
Frankfurt/Main

lower row:
379 *IG-Farben-House III*
Galerie Bärbel Grässlin,
Frankfurt/Main

380 *IG-Farben-House X*
Deutsche Bank AG, Frankfurt/Main

381 *IG-Farben-House VIII*
Deutsche Bank AG, Frankfurt/Main

382 *IG-Farben-House VI*
Galerie Bärbel Grässlin,
Frankfurt/Main

383 *IG-Farben-House IX*
The Hoffmann Collection

384 *IG-Farben-House II*
Private collection, Cologne

Why a Commentary on the Constitution?

My interest in "discourse" and its analysis, in legal issues, in conventions on human rights, in the basic rights laid down in Germany's Constitution, resulted from my pre-occupation with grammar. Law and grammar are both normative systems. Grammar is no mere set of rules for language. A grammatical rule is first and foremost a mark of power and only then a mark of syntax. What the law has in common with grammar is that it is an imperative construction. The command, the codeword, the slogan are the intention and statement of rules and directives. Yet each and every set of rules is basically different from that which it regulates or describes. A fundamental non-identity exists between the two, that is to say, the rules are not the game. Nevertheless, there is a necessary link between text and referent, between constitution and society. And this link is not merely a question of inter-pretation.

One reason for me to comment on the constitution was that one can ask urgent questions regarding the law, questions which are perhaps essentially questions of poli-tics — of power, authority, legitimacy, ideology, of justice and of how we deal with the Other and with the Self, what features we want to ascribe to the Other and to ourselves. My assumption is that it is impossible to ask all the important questions of the law, and that it is equal-ly impossible to believe that a question can be answered simply because it can be raised.

My work is oriented around language, thus it is not unusual for me to approach the law as a "textual model". The law is text, and text refers to text. What language does the law speak? Even if the law is the result of parlia-mentary decisions, that is to say, is formulated by subjects, it is formulated in a non-subjective language, a language that communicates objective knowledge. The position its statement takes is pure and absolute. The constitution is a particular text imbued with the greatest of validity for all those who can be subsumed under the term nation, country, or society. The constitution is positive law that grounds positive rights and thus determines how politi-cal power is organised and organises itself. Lawyers characterise the constitution as an autological text. The constitution sees itself as part of the law and equally as the right of the law. It excludes itself from the rule that new laws break with old laws. Luhmann characterises constitutional law as a self-referential and closed system. Each and every legal norm can be unconstitutional, except the constitution.

In my commentary on the Constitution, I assume that law is an ideological field, and that in this ideologi-cal field there are points at which the truth of the "narra-tive", which the field essentially conceals and whose non-recognition forms the very basis of the field, breaks through. One symptomatic example of this non-recogni-tion is the force behind legislation, the force that brings about laws. Legislative force becomes a traumatic cause that tries to reintegrate and defend the constitutional system after the fact. What are the origins of the law? Something illegal, actual force. The act of establishing the law coincides with the act of founding a state based on the rule of law. That is the covert scandal of even the most reasonable state based on the rule of law. And this ob-scured and suppressed force that establishes the law is occasionally reflected in the meticulousness of the author-ity of the state that maintains the law and in enforcing it causes it to be experienced as something negative. The law threatens, seems threatening, and is threatened above all by itself. The foundation of a state based on the rule of law proves to be a fiction: the constitution as a symbolic order in which, if it is to function, nothing may be taken literally. This distinguishes symbolic order from real order. The cause does not precede the effect but vice versa. The effectiveness of the symbolic order rests on a constant "re-writing" of its own past, an "integration of significant past traces into new contexts which alter their meaning retroactively".

The content of the law is often contradictory, yet indispensable. Take, for example, the concept of equality. This principle necessarily negates the idea of a possible and natural superiority of specific individuals over others. Positive law rejects the classification, sorting, or sub-divi-sion of individuals, be it into social or political categories, or by gender or race. At the same time, the law must as-sume a universal concept of the individual. This generalises the subject while at the same time excluding any concept of the Other. Everyone knows that there is neither equal-ity nor equal rights within society, and nevertheless, the concept of equality is indispensable. It represents an aspir-ation and is thus a postulate promising a better future. There is another contradiction in this important postulate of equality: in the provisions of constitutional law, equal-ity is formulated as a restriction of equality and thus becomes the cause of unequal treatment.

My commentary is intended as an interpretation, an exegesis, a reading, a pleasure. It abides by the tradition of the legal commentary but is not a legal commentary. It will not, and cannot, be part of the legal discourse, as this is only possible within the legal system. To gain any hearing within the legal system one must speak the right language, the legal jargon (this also applies to art). One must have the appropriate competence in order to gain

385 Thomas Locher
Round Table, 1995
7 chairs, 2 stools, varnished
and engraved
Chair: each 78 x 42 x 53 cm,
Stool: each 45 x 30 cm
The Steigenberger Collection,
Frankfurt/Main and Galerie Klemens
Gasser und Tanja Grunert GmbH,
Cologne

1. Chair
If you had asked me I would have
answered.

2. Chair
Even though I ask you you should
remain silent.

3. Chair
Even though I know that what I say is
not what I mean I continue to speak.

4. Chair
Do not say what is expected of you, it is
not what you should say.

5. Chair
I CANNOT ANSWER YOUR QUESTION /
YOU CANNOT ANSWER MY QUESTION

6. Chair
We will have known about each other.

7. Chair
I know that you / you yourself / you me /
one you / others you / you no one / you
nothing / everyone you / one to you /
through you / for you / on you / to you /
against you / with you / without you /
beside you / to you / through you / for
your sake / because you / you to no one /
you nothing / from you

8. Stool
I know that we know each other but I
don't know who you are.

9. Stool
You know that we know each other but
you don't know who I am.

386 Thomas Locher
A Small Hermeneutics of Discourse,
1995
4 tables, engraved aluminum construc-
tion, 4 engraved chairs
Each table 73 x 150 x 60 cm,
each chair 78 x 42 x 53 cm
(German version)
Südwest LB, Stuttgart/Mannheim
(English version)
The Ernst Ploil Collection, Vienna.
(On permanent loan to the Neue Galerie
am Landesmuseum Joanneum, Graz)

TEXT/TABLES:
my name is
I'm speaking
I'm taking the initiative to speak
I'm articulating it
I could say something, but I don't want
to
I'm saying it
I'm turning to you
I'm sharing my thoughts with you
I'm reporting
I'm saying what must be said
I talk the way I want to
I say what I want to
I hear you
you're speaking and I'm listening to you
I have my doubts about what you are
saying
I can't talk about everything

I have nothing to say
I'm saying no more
I can't talk any more
I mustn't say anything although I'd like to
I can't tell everything
I don't want to talk to anyone else
whatever I say, you don't understand
anything
I can say whatever I want, nobody listens

it is happening / it is taking place / who /
what / when / to whom / about what / why
/ how and in which way / whoever says
nothing, cannot be heard / something can
be said thus or otherwise / what's true for
you is not necessarily true for me /
something is being discussed and
something is not being discussed / a matter
is not a matter / it is possible that / it is

impossible that / we can't talk about
everything / it is not absolutely necessary
that something is said / nothing is said the
way it's meant / from one to the other /
a sentence and then another sentence

TEXT/CHAIRS
I, You, He, She, It, We, You, They, A Man,
A Woman, That one, Every Man, Every
Woman, Everybody, Every One, Somebody,
Someone, Anyone

**CONSTITUTION OF THE
FEDERAL REPUBLIC OF GERMANY / JULY 1996
PREAMBLE** 1

Conscious of their responsibility before God and human-kind. Animated by the <u>resolve</u> 2 to serve world peace as an equal part of a united Europe. The <u>German people</u> 3 have <u>adopted</u> 7, by <u>virtue</u> 4 of their <u>constituent power</u> 5, this <u>Constitution</u> 6.

The Germans in the Land of Baden-Württemberg, Bavaria, Berlin, Brandenburg, Bremen, Hamburg, Hesse, Lower Saxony, Mecklenburg-Western Pomerania, North-Rhine/Westphalia, Rhineland-Palatinate, Saarland, Saxony, Saxony-Anhalt, Schleswig-Holstein, and Thuringia have achieved the unity and freedom of Germany in free self-determination. This <u>Constitution</u> 9 is thus <u>valid</u> 8 for the whole German nation.

387 **Thomas Locher**
Preamble
Article 1 (Protection of Human Dignity)
Article 16a (Right to Political Asylum)

from: Preamble and Basic Rights in the Constitution of the Federal Republic of Germany Article 1-19 [Discourse 2] A Commentary, 1995
Double columned, writing on wall
Each column approx. 350 x 120 cm
Galerie Klemens Gasser und Tanja Grunert GmbH, Cologne

1 the Preamble: the proclamation of the constitution? the preamble is part of the constitution? that means: the constitution itself includes the proclamation of the constitution?

1 the preamble: an announcement? or: explanation? or: an explanation that obligates? and – an explanation that precedes the law? and before this explanation? what precedes the preamble?

1 what are the prerequisites of basic rights?

1 what precedes basic rights? what is at the beginning of law? an injustice? or merely an old law that has been replaced by a new law? or – the resolve to be just? the resolve to be humane? an ethic obligation?

1 *can you inquire about the basis of basic rights?* > THERE IS NO BASIS? IT IS PROHIBITED, IT IS FORBIDDEN? THAT MEANS – THE PROHIBITION PROHIBITS WHAT IS ITSELF ALREADY IMPOSSIBLE TO PUT INTO EFFECT: YOU CAN NOT SINCE YOU SHOULD NOT? YOU MAY NOT BECAUSE IT WON'T WORK? IT IS IMPOSSIBLE; THEREFORE YOU CAN NOT? <

1 what is the basis for basic rights? is the basis for basic rights contained in the basic rights themselves? what is the origin the law is based upon?

1 is it at all necessary to inquire about the basis/reason of basic rights?

2 > WE WOULD LIKE YOU TO [] / WE WANT YOU TO [] / WE WOULD PREFER YOU TO [] / IT IS REQUIRED THAT YOU [] / WE WANT YOU TO [] / IT IS COMMON VOLITION THAT YOU [] / IT IS EXPECTED THAT YOU [] / WE REQUIRE YOU TO [] / IT IS A PREREQUISITE THAT YOU [] / YOU ARE MEANT TO [] / YOU ARE ASSIGNED TO [] / IT IS MANDATORY THAT YOU [] / ORDERS HAVE BEEN GIVEN THAT YOU ARE TO [] <

3 *must this be read? for whom is it supposed to be interesting? and your rights? you have the freedom to stop reading this. and – you can contest the value of this commentary with your own ideas? and the value of basic rights?*

4 who puts the law into effect? the people? a power? the power of the people? who exercises this power?

5 is the enactment of the law an act of authority/force (Gewalt)? and how can the moment of enactment of the law be described? and: justified (begründet = to give the reason (Grund) for something)? and: if it can not be justified, is the basis/reason (Grund) of basic rights unjustified? is the nature of the law without basis?

6 the duty of basic rights: they protect the individual from the state? but: how can these rights be guaranteed by the state then? is the state interested in its own control? what function do basic rights have for the state?

6 how can the state, which enacts laws, appeal to the laws?

7 "have adopted" (German Preamble: "hat sich gegeben" = 'has given itself')? > WHAT? WHAT CAN I GIVE MYSELF THAT I DON'T ALREADY HAVE? WHOEVER GIVES CANNOT SIMULTANEOUSLY BE THE RECIPIENT OF THE GIFT / AND, WHAT ABOUT THE LEGISLATOR? OR DOES THAT MEAN: GIVING OF YOURSELF IS TAKING? FROM WHERE? TAKING FROM WHERE? <

8 "...is thus valid...": with this sentence it is valid / from now on / from this moment on / > IT IS VALID: FOR ALL PEOPLE? FOR EVERYONE? WITHOUT EXCEPTION? NOT ONLY FOR YOU, BUT ALSO FOR ME? WHO SAYS SO? AN UNKNOWN PERSON? BUT: SOME ONE? WHO? <

9 is the law trying to hide its origins? is the law trying to deny its forcible act of establishment? why?

9 why does the law enjoy such highly esteemed recognition? because rights are purposeful? because basic rights are righteous? or reasonable? because the law for everyone is the same law? is the law held in such esteem because it is what it is: the law?

9 on what principles does the validity of authority rest? when is sovereignty legitimate? when its authority is the result of consensus?

9 when is the law legitimate? when everyone obeys the law? when the legality of the laws is guaranteed? when the process of the law is formally correct?

9 *what questions do you have concerning basic rights?*

9 *does the law reach everyone? even you?*

ART. 1. [PROTECTION OF HUMAN DIGNITY] 10

(1) The dignity 11 of man shall be inviolable. To respect and protect it shall be the duty 12 of all state authority 13.

(2) The German people 14 therefore acknowledge inviolable and inalienable human rights 15 as the basics of every community 16, of peace and of justice in the world.

(3) The following basic rights 17 shall bind the legislature, the executive, and the judiciary as directly enforceable law 18.

10 *what is dignity? can you describe it?*

11 is dignity a prerequisite for human beings to be able to socialize themselves as individuals but what does dignity look like? how can I show myself dignified? by acting dignified? or, through education? through money? through more property?

12 > OBEY OR BE SUBJECT TO? < law or command? which demands more obedience? a sentence demands obedience if the addressee is subject to it? why? and if the addressee is able to explain why he is subject to it? does subjection become invalidated through explanation? then the addressee can explain something himself and obligate someone else? but how? by delivering the explanation along with the obligation? so one must be able to be convincing?

12 > HERE, AT THIS POINT: SAY SOMETHING: [SAY MORE THAN JUST SOMETHING / MORE THAN JUST A LITTLE BIT / BUT NO MORE THAN THAT / A LITTLE MORE THAN THAT AND SOMETHING MORE IN ADDITION / NOT MUCH MORE, JUST A BIT / NOT MORE THAN THAT, BUT NOT JUST THAT] <

13 > DON'T KNOW [WHAT TO SAY / WHAT TO DO / WHY / FOR WHAT AND FOR WHOM / WHOSE / WITH WHOM / HOW TO RECOGNIZE / HOW TO UNDERSTAND / HOW TO QUESTION / HOW TO CONTINUE / HOW TO EXPLAIN / HOW TO JUSTIFY / HOW TO ACCOUNT FOR / WHAT TO GIVE / HOW TO DECIDE / WHAT TO INTEND / WHENCE / WHITHER] <

13 is the law's power of enforcement a necessary force? necessary for whom? or for what? for justice or for the law? is force the means to achieving justice? without exception and unconditionally?

13 are there different forms of force/authority? more or less necessary forms? more or less justified forms? is the justification of force/authority inalienable? can justice be enacted another way? how can I judge the force/authority that is concealed in the law? with what criteria?

14 what is The People? a community? or a representative community that has reached a common point of view? *and you? are you part of this community? and: do you share this point of view?*

14 > BUT WHAT DOES THAT MEAN FOR YOU? DOES THIS MEAN YOU? YOU FEEL YOU HAVE BEEN ADDRESSED? WHAT DO THEY WANT FROM YOU? JUST TO SAY SOME THING? OR MORE? BUT WHAT? [HAS SPOKEN / HAS SAID SOMETHING / HAS DONE EVERYTHING / HAS MADE AN EFFECT / HAS AGREED/SPOKEN AND GIVEN HIS CONSENT]<

14 *who is meant? you or []? you are obligated because []?*

14 *what have you got to do with basic rights? what do the basic rights want from you? are they speaking about you here? or: have you put in your word?*

15 are human rights only discussed when they have been violated? and: can human rights be protected only by a constitutional state?

16 > AND YOU? WHAT ABOUT YOU? WHAT CAN WE DO FOR YOU? WHAT CAN YOU DO? AND THE COMMUNITY? WHAT ARE YOU DOING FOR THE COMMUNITY? <

17 can basic rights explain the principle of their own origins? in order for the law to legitimate itself must it have begun before its authorization became effective? so the law must have begun before it was law?

17 how can the enactment of the law be traced back to its origins? how can it be explained?

18 how is authority legitimated? here: by justifying its own validity?

18 does authority exist only because it is obeyed? or: because the executive force helps to enforce it? how can a law have the authority to demand obedience from its subjects? by tracing the law back? to where?

18 and: if authority can not legitimate itself? is it then purely arbitrary? and regulations? are regulations justifiable? but isn't the essence of a regulation the fact that it can not be justified because otherwise the regulation wouldn't be a regulation?

18 *and you? what have you got to do with this sentence?*

CONSTITUTION OF THE FEDERAL REPUBLIC OF GERMANY/JULY 1996

ART. 16a [ASYLUM]

(1) Anybody persecuted on political grounds has the right to asylum. 1

(2) Paragraph (1) may not be invoked by anybody 2 who 3 enters the country from a member state of the European Communities or another third country where the application of the Convention relating to the Status of Refugees and the Convention for the Protection of Human Rights and Fundamental Freedoms is assured. Countries outside the European Communities which fulfil the conditions of the first sentence of this paragraph shall be specified by legislation 4 requiring the consent of the Bundesrat. In cases 5 covered by the first sentence measures 6 terminating a person's sojourn may be carried out irrespective of any remedy sought by that person. 7

(3) Legislation 8 requiring the consent of the Bundesrat may be introduced to specify countries where the legal situation, the application of the law, and the general political circumstances justify the assumption that neither political persecution nor inhumane or degrading punishment or treatment takes place there. It shall be presumed that a foreigner from such a country is not subject to persecution on political grounds so long as the person 9 concerned does not present facts 10 supporting the supposition that, contrary to that presumption, he or she is subject to political persecution.

(4) The implementation of measures terminating a person's sojourn shall, in the cases 11 referred to in paragraph (3) and in other cases that are manifestly 12 ill-founded or considered to be manifestly ill-founded 13, be suspended by the court only where serious doubt exist as to the legality of the measure. The scope of the investigation may be restricted and objections submitted after the prescribed time-limit may be disregarded. Details shall be the subject of a law.

(5) Paragraphs (1) to (4) do not conflict with international agreements of member states of the European Communities among themselves and with third countries which, with due regard for the obligations arising from the Convention relating to the Status of Refugees and the Convention for the Protection of Human Rights and Fundamental Freedoms, whose application must be assured in the contracting states, establish jurisdiction for the consideration of applications for asylum including the mutual recognition of decisions on asylum.

1 what is being said here? > IN SAYING THIS, ARE YOU THE ONE IN MIND? <

1 here, at this point: > IS THIS CORRECT OR NOT [YOU ARE NOT SURE, YOU DOUBT] < this sentence is correct, that means: it is true? or: it expresses the truth? and the other sentences? if this sentence is correct, then the other sentences are correct, too? > I KNOW THAT THAT IS NOT TRUE, BUT [] / I KNOW THAT WHAT I SAY IS CORRECT, BUT [] <

1 I appeal to a right, I am entitled to the right: can I rely upon the reliability or the right? in any case? even in the worst case? even when my right is not adjudged me?

1
adverb adjective noun verb noun noun

Politically pursued people enjoy the right to asylum.

└─── nominal phrase ───┘ └─── predicate ───┘

1 *and you? what does the word enjoy mean to you?*

2 in order to be listened to, must one be able to submit an occurance as a fact? is a fact then a true fact? and: will it be accepted as a fact? by my furnishing proof? in order to be recognized as a fact, must I be able to depict the occurance? or, can only that be depicted which is permitted by law? only depict what is depictable?

3 > YOU WILL NOT SUCCEED / YOU WILL ATTAIN NOTHING / YOU WON'T MAKE IT / THEY WON'T LET YOU / YOU WILL NOT BE ABLE TO DO WHAT YOU INTEND TO / WHAT YOU IMAGINE IS NOT POSSIBLE / IT WON'T BE THE WAY YOU THOUGHT IT WOULD BE <

4 *the law that you are subject to: can that be a power? a law, a regulation, makes you the recipient of a law? can you give an answer to that?*
do you even have the possibility to do so? in any case? and in your case?

4 *can you reject the obligation? and the responsibility? is being obligated by the law different from responsibility? can you reject the responsibility?*
and: can you imagine a case when you might ask yourself this question?

5 *is justice the experiencing of the impossible?*

5 can justice only be archieved through loss? what gets lost?

5 can every case be settled? can it also be justly settled?

5 will only that be settled which can be settled? are the possibilities of a settlement written into the law? and those of a just settlement?

5 how can a settlement be just at the moment it is made?
I obey the law? I follow the regulation? I keep to the law? or?

5 is a just settlement possible even in a case where I do not acknowledge the law?

6 is the term the same as its application? its meaning is its use? but: how to use some terms? where apply them? can a term be an instrument? for what?

6 *and you? how do you understand this term? have you got a clear understanding of it? or is your understanding of it blurry? and, do we have the same understanding of it? what does this word mean for you?*

7 is a decision an obligation? to what purpose? to carry out the law in a rightful manner or to follow one's conscience?

7 *can you imagine a case: "I acknowledge the law, but..." or: "I will take an infringement of the law into account because..."? can there be a case in which a well-founded disobedience of the law is of greater importance to you than the obligation to the law?*

8 what does it mean to decide? to take a loss into account? what loss?

8 *to refuse to make a decision, is that a possibility?*

9 I KNOW THAT YOU [YOU YOURSELF / YOU ME / ONE YOU / OTHERS YOU / YOU NOBODY / YOU NOTHING / EVERYONE YOU / ONE YOU / THROUGH YOU / FOR YOU / TO YOU / AT YOU / AGAINST YOU / WITH YOU / WITHOUT YOU / BY YOU / THROUGH YOU / BECAUSE OF YOU / BECAUSE YOU / YOU TO NOBODY / YOU NOTHING / OF YOURS]

9 *and you are meant here:* > I KNOW THAT IT'S YOU / I KNOW THAT YOU ARE THERE / I KNOW YOU ARE THE ONE / I KNOW YOU / I HAVE RECOGNIZED YOU / IT IS CLEAR TO ME, YOU ARE THE ONE / IF YOU ARE NOT THE ONE, THEN WHO IS / YOU ARE THE ONE / YOU ARE THE ONE BECAUSE I'M NOT IT / YOU ARE THE ONE BECAUSE I SEE YOU / YOU AND ONLY YOU / I WAS EXPECTING YOU / I WANT TO MEET YOU / WE KNOW EACH OTHER / YOU MUST BE HERE / HERE WHERE YOU ARE <

10 **> I CAN CONFIRM / I CAN WITNESS / I CAN PROVE / I HAVE SEEN WITH MY OWN EYES / I WAS PRESENT / I WAS THERE / I WAS ALONG <**

10 can a sentence depict reality? how does a sentence relate to its own contents? does one sentence refer to another one? is there such a thing as a speech of immediacy? how can one express that which is true? is there an objective language? is every sentence a statement?

10

happened	didn't happen
true	untrue
possibly	possibly
really	really
necessary	necessary
probable	improbable
believable	unbelievable
holds true	doesn't hold true

11 what is a case? how to desribe a case?

11 if there is a case, then there is also something which excludes the case?

11 when does a case correspond to reality? how can the case be connected to reality?

11 can every case be settled? can there be a moment of indecision in a case?
what lies between decision and indecision? nothing? or: the truth?
or: justice? or: a vacuum? a lack? a hesitation?
fear of making a wrong decision? reason? or: unreason?

11 how can a decision be just at the moment it is made?
a decision must be made: **> I KNOW THAT THE CASE IS SO, BUT [] <**
and: where does what cannot be decided go? it becomes part of the decision?
undecidibility becomes part of the decision?

11 *and: you? how would you decide? in a certain case in which you are not affected? but: is that at all possible? to have nothing to do with it?*

11 how can a decision be just at the moment it is made? obeying the law? in which justice arises occurs in the recurring function of the judgement? are the cases the same cases? and: the law is the same? or: is each case different and must therefore be settled differently? can each case be settled uniquely?

12 "manifestly", that means: it is the way it is? the case does not have to be explained in more detail? the case is self-evident?

13 *can an expression mean an imputation for you?*

recognition there. That is to say, an institutional line has been drawn between law and non-law. This work, therefore, sees itself as a critique of the institution of the law.

One precondition for every thematic approach is the question of one's own self-understanding, the question of one's own artistic identity. I can select this identity and re-formulate it at will. Either I define myself as a stable unit that constantly reproduces itself, i.e., I behave like an institution and thus establish an irrevocable position, or I try to constitute myself as an eminently vulnerable identity in a dubious and constantly contestable realm.

We know that the historical avant-garde failed in its attempt to completely transform art into a way of life, which it saw as the only feasible path. One reason for this is that it assumed the existence of an abstract concept of society. This overall view, this aspiration to absoluteness, turned out to be a fantasy of totality. My commentary is an attempt to reply — with the logic of particularity — to this aspiration to absoluteness, an aspiration also expressed in constitutional law.

Basically, art oscillates between two poles. It has established itself in a paradoxical situation. Becoming autonomous, becoming an institution, was the price it paid for its existential survival. The consequences of this are that art has become self-referential and relatively inconsequential. Yet how do we proceed so as to avoid inconsequentiality? How do we proceed when one essential aspect of aesthetic production is an interest in fields that are "external to art"? On the one hand, autonomy means the "independence of works of art in the face of aspirations to utility that are external to it" — unless we ourselves formulate those aspirations. On the other hand, we know that art is impossible without a reference to discourses external to it or fields that determine it. What else is art to refer to if not to something that is external to it? Yet what position ought it take? And how? From what position ought it speak? In a global economy it is not possible to assume a purely exterior position. No one can be just an observer. To any conceived, imagined or even "impossible" position, I can always take up a different one, be it as an observer or as an actor. Perhaps the moment I categorically refuse to recognise real conditions, I have the possibility of making "another" statement about those very conditions. The position from which I speak, therefore, is obviously a marked contradiction. Whereas I am aware of the basically affirmative character of art, of artistic articulation, I still feel obliged to take every opportunity that enables me to evade the obligation of having to confirm everything, even if this strategy functions only partially or only in my imagination.

Perhaps this contradictory and truly "impossible" standpoint corresponds to that moment of openness when subjectivity can show itself. One way or the other, it is a decisive moment that separates politics from the political and favours the concept of the political as representing the very moment of openness, of indecision, of postponement. Derrida describes the undecidable not as something placed between two decisions but as that which eludes the calculable, exempts itself from the rule. If the law is not just, then perhaps justice is concealed there.

Thomas Locher

Timecuts

1 Hanns Eisler, "Die Erbauer einer neuen Musikkultur", *Musik und Politik, Schriften 1924-1948* (Leipzig, 1973), 161.

2 John Heartfield, *Das Wort* (Moscow, 1937), 102-104. Quoted in John Heartfield, *Der Schnitt entlang der Zeit. Eine Dokumentation*, ed. Roland März in collaboration with Gertrud Heartfield (Dresden, 1981), 317.

3 Compare: "Walter Benjamin, The Work of Art in the Age of Mechanical Reproduction", *Iluminations* (New York, 1968). Humanity's self-alienation "has reached such a degree that it can experience its own destruction as an aesthetic pleasure of the first order. This is the situation of politics which Fascism renders aesthetic. Communism responds by politicizing art."

4 *AIZ*, no. 42 (10/16/1932), 985.

5 G. Dimitroff, *Ausgewählte Werke in zwei Bänden* (Frankfurt/Main, 1972), 105.

6 Heartfield, together with his brother Wieland Herzfelde, continued working on the exile – *AIZ* (as of 8/19/1936: *Die Volks-Illustrierte im Sinne der antifaschistischen Volksfront*) after having fled from Berlin in the middle of April, 1933. After edition No. 10 of 3/5/1933, the last edition before the ban from the *Neuer Deutscher Verlag*, the exile edition could already be published as early as 3/25/1933. However, the circulation of Germany's second largest magazine sank from 500,000 in 1931 to about 12,000 in 1936 due to its limited sales possibilities. Compare also the Gestapo spying and the intensified censuring in the last years of the Prague exile with the protest letters from the German ambassador in: Michael Krejsa, "NS-Reaktionen auf Heartfields Arbeit 1933-1939", *John Heartfield,* exhibition catalog, Akademie der Künste zu Berlin (Cologne 1991), 368f. Harald Olbrichs' thesis on the "continuity" and "further development" of agitation art "thanks to the press in exile" is not so tenable. It is the expression of an historical understanding that in reptrospect wants to inherit history without reflecting on its ruptures. (Harald Olbrichs, "Kunst und antifaschistischer Widerstand", *Widerstand statt Anpassung*, exhibition catalog, Badischer Kunstverein, Karlsruhe (Berlin, 1980), 88. This exhibition turned the notion of political resistance into a selection criterion and saw itself as a reaction to the exhibition by Janos Frecot and Elisabeth Moortgat "Between Resistance and Conformity" at the Akademie der Künste (Berlin, 1978).

John Heartfield counted among the artists of the Weimar Republic who single-mindedly pursued the question regarding which "changes in materials" were required in the transformation of the function of art demanded by the Left wing into the "great master of society".[1] His photo montages for the *Arbeiter-Illustrierte-Zeitung (AIZ: Worker's Illustrated Magazine*, close to the Communist Party) brought him into contact with readers who were to have cooperatively produced the magazine as long-term worker-correspondents and worker-photographers. As an engineer in the service of his party, he wanted to make visible the political-economic "causal complex" in his montage of images and ideas during the intensified class struggle at the end of the Weimar Republic. János Reismann, one of the photographers who worked for him, stated in 1937 that Heartfield cut photos apart, reduced and enlarged them, "in order to reveal their actual, deliberately distorted content".[2] The "aesthetization of politics"[3] in the ritual of National Socialist's self-representation and staging of the masses was to be burst asunder and its ridiculousness betrayed by a "politicization of the aesthetic". Thus the photo montage *The Meaning of the Hitler Greeting:/Motto: Millions stand behind me!/Little Man requests large presents*[4] from 1932, exposed Hitler as a politician with banks and big industry as financers standing behind him, rather than the masses. Heartfield's montage brought the current Communist International Soviet provenance's one-sided definition of Fascism as "the open terrorist dictatorship by the most reactionary, mainly chauvinist, mainly imperialist elements of finance capitalism"[5] to a succint image formula. The art work's so-called parasitic dependency on cult and ritual was displaced by the dependency on party politics, which had the means of production for a massive scale reproduction of photo montage at its disposal.

Although he was exiled in Prague as of the middle of April, 1933, Heartfield retained the political-organizational framework of his photo montage work, despite the *AIZ* editorial's move to Prague.[6] However, the publication had to be adjusted to a drastically reduced, middle-class readership among German speakers living abroad, even though they tried to smuggle a small-format version to Germany over various channels in order to reach its regular readers in the work force. Heartfield's picture rhetoric, which before his exile stood in the context of the magazine's political argumentation, could assume the Communism-schooled class consciousness of its reader,

in contrast to middleclass readership. Under the pressure of the debates within the German Communist Party and the Moscow exile magazine *The Word*[7], about Formalism, Schematism, and Mechanism vs. Realism, the montages became more and more like text-illustrating picture compositions "painted" with photographic props. Heartfield said: "The painter paints his pictures with paint and I with photographs." Thus, for example, the text to his photo montage *The Seeds of Death* (fig 404, p. 445) presents no dialectic contradiction to the picture of skeletons sowing swastikas. Similar to the surrealist paintings of the 1930s, Heartfield composed a desert-like landscape in which the allegory of death is presented as a timeless, moralizing memento mori, updated only by the attributes of steel helmet and swastika. The caption no longer functions as a fuse that "leads the critical sparks to the mixture of images."[8]

In view of the horror images of the NS terror that reached Heartfield from Germany in his Prague exile, he no longer reacted analytically but became more analogous. For example the juxtaposition *As in the Middle Ages ... just so in the Third Reich* (fig. 401, p. 444). The montage is divided into two picture fields arranged over each other. Over the photo of the relief sculpture of St. George broken on the wheel, whose body is intertwined with the wheel spokes, respectively, the rose window lattice, he set the studio photo of a naked man[9] wearing a loincloth, similarly intertwined with the swastika. By connecting swastika and sacrifice, Heartfield turned the National Socialist appropriation of the swastika as an Arian symbol of sun and redemption[10] into its opposite: The swastika becomes the cross and therefore the symbol of death; redemption becomes Final Solution. The victims of NS terror were compared to the sacrificial death of Jesus Christ on the cross, an analogy that was already used in the German Socialist Party's election poster, designed by K. Geiss, for the parliamentary election on September 14, 1930, and connected to the inscription *The Worker in the Reich of the Swastika*. In the picture of the crucified proletarian the poster gives warning of the "swindle monstrosity" of a "National Socialist German worker party", in which "the murderers and their victims greet each other as comrades".[11] At the same time, the picture of the crucified protelarian is an expression of a political fatalism that had absorbed both worker parties even before power had been handed over to Hitler. Walter Benjamin's critique that the German Socialist Party pleased itself by passing on "the role of savior of coming generations to the working class",[12] contained the challenge to struggle and not to suffer. But even the Communist Party, for which Heartfield worked, had already given up being the motor of history. Ernst Bloch quoted a party bulletin from 1930: "In the Berlin Communist Party headquarters, the confi-

7 Compare Georg Lukács, "Reportage oder Gestaltung?", *Die Linkskurve, No. 8*, 1932 and Georg Lukács, "Es geht um den Realismus", *Das Wort*, No. 6, 1938. Compare also Hubertus Gaßner, "Heartfields Moskauer Lehrzeit 1931-1932", *John Heartfield*, exhibition catalog, Akademie der Künste zu Berlin, 300f.

8 Walter Benjamin, "Pariser Brief II, 1936", *Ges. Schriften*, vol. III (Frankfurt/Main, 1974), 505.

9 The actor Erwin Geschonnek was the model.

10 The swastika sign (Sanskrit for feeling of well being) goes back to prehistoric times as a symbol of the sun. According to an ancient Chinese interpretation, the hooks bent to the left mean happiness and those running to the right mean unhappiness (NS swastika). (Compare: Adrian Frutiger, *Der Mensch und seine Zeichen* [Wiesbaden, 1991], 276). The 'völkische' ideologist Guido von List *(Die Bilderschrift der Ario-Germanen, 1910)* introduced the "H" as a symbol of redemption of the "Arian race".

11 Ernst Bloch, "Inventar des revolutionären Scheins, 1933", *Erbschaft dieser Zeit* (Frankfurt/Main, 1981), 71.

12 "The conformism which has been part and parcel of Social Democracy from the beginning attaches not only to its political tactics but to its economic views as well. ... Nothing has corrupted the German working class so much as the notion that it was moving with the current". Walter Benjamin: "Theses on the Philosophy of History", *Illuminations* (New York, 1968), 258.

13 "Amusement Co., Grauen, Drittes Reich", in: Bloch, 67. Despite the NSDAP's landslide election in September, 1930, (mandate increase from 12 to 107), the Communist Party leadership believed that this brown dictatorhip would only be short-term and would accelerate the revolutionary development in Germany.

14 Bertolt Brecht, *Gesammelte Werke*, vol. 18 (Frankfurt/Main, 1967), 243.

15 Quoted from Karl-Ludwig Hoffmann, "Antifaschistische Kunst in Deutschland", *John Heartfield*, exhibition catalog, Akademie der Künste zu Berlin, 67.

dence prevails that sooner or later the lion's share will be pulled out of this political monster-speculation's bankrupt estate."[13] This feeling of powerlessness and resignation was even greater in face of the unimaginable brutality with which the National Socialists annihilated the worker's movement. Heartfield's view of his homeland from his exile was as spellbound as the rabbit's view of the snake, the victim face to face with his executioner. Instead of reacting progressively or analytically, he reacted unhistorically with Christian sacrifice iconography as did many of his artist colleagues living in inner and outer exile. In the St. George analogy to the murdered NS victims, he suggested an unstoppable relapse in Germany to the barbarism of the grim Middle Ages. The wheel in whose spokes the Christian martyr is entwined and the circle in which the swastika and its victim is inscribed, as in the National Socialist flag, suggest the conservative symbol of the eternally rotating wheel of life and world that runs down the victims of history. This corresponds to Nietzsche's metaphor of the eternal recurrence that dehistorized life as an eternal circulation of becoming and passing away. In this way, Heartfield worked against the NS regime's propaganda that German history would attain its goal and end in the "Thousand Year Reich". The observer's consequence can only be resignation and pity. Heartfield associated the draping of the loincloth around the victim's thighs with Michelangelo's *Pietà* in the Cathedral of St. Peter in Rome, and thus operates with the Christian symbol for sympathy. You can only "have sympathy for the victim" if "you yourself have just the slightest chance" to intervene. "But when thousands were slaughtered ... silence prevailed ...", Bertolt Brecht assessed in his "Speech at the I. International Writers' Congress for the Defense of Culture", 1935 in Paris, where he warned the artists and writers "not to mistake brutality for natural disaster or unconquerable powers from hell".[14] In 1934, Otto Pankok commented on his Passion cycle *Jesus of Nazareth, King of the Jews* 1933-34, charcoal drawings, which also made the analogy between Nazi regime's persecution and the Christian Passion story, although without the aspect of resurrection: "Evil, until now kept in check, is today unleashed, the world is running to hell."[15] Andrzej Szcypiorski wrote about the concentration camp system to counter this notion of NS terror being a relapse into barbarism as a Middle Age outbreak of untamed human drives: "The person of the Middle Ages felt great humility before God and before powerful forces of nature and saw himself as an incomplete creation The camp was not the Middle Ages. Rather the opposite. To a great extent it was a bastard of Enlightenment thinking and certainly the final logical consequence of the illusion which the Enlightenment had planted in the European's mind. ... The camp is ... the consequence of the post-Enlightenment illusion about my own omnipotence. My omnipotence is the freedom from conscience. Yet, without conscience, there is nothing there, there is nothingness."[16]

Heartfield's 1930's photo montages hit against the boundaries that also limited a conception of art which consciously functionalized its artistic possiblities in order to become the political means of a "weapon in the class struggle". The hope that Heartfield's method demystifies politics absurd and chaotic character by confronting reality "with its own myth" and thus revealed the wrongs in the system,[17] was no longer realizable. If the spheres of art and politics came into contact, hollow spaces formed in the social consciousness, which the National socialists were able to successfully occupy by founding their politics on ritual.[18]

John Heartfield's method has found successors.[19] Born in Jena in 1947, Georg Herold was "bought free" at the age of 27 after his arrest for attempting to escape and was deported to the West. Similar to Heartfield, he developed a sense for the absurdity of Real Socialism: "The functionaries had to read their daily ideology from the telex. There was no ideology before the telex and at the moment of distribution, the telex, with its ideology, was pulp. ... The GDR was characterized for me in being split into a state of passing-with-the-crowd and running-against-the-wall."[20] In contrast to Heartfield, Herold no longer believed in an alternative ideology as antidote: "Nonsense is better than irony and always better than the raised forefinger which only challenges my scepticism." Schooled in the reality of the GDR, Herold found all ideologic constructions to be only interest-accompanied manipulations of the living subject. Reality is fiction and fiction is reality. Then what is reality? He tried to get a hold on it with a "topic that is distinguished by suggestive misinterpretations and fortunately marked by precise ideas. Which says nothing else except that certain processes become transparent only for me (I can form an image from them myself), on the other hand, everyone else – please – should provide their (own) pictures themselves!"[21]

In contrast to Heartfield's purpose-oriented montage that strives to reveal the truth in a grotesque picture puzzle, the essence beneath the appearance, Herold assembled random, aimlessly banal, disjointed waste materials such as boards, rubble, wire, brick, string. "Because: there is no work without waste, and the daily efforts to keep these things a secret have lead to a completely concealed and pasted-together world conquered by the handyman and the do-it-yourselfer".[22] Like Heartfield, he added title and commentary, which, however, spoke scornfully to the willing audience's claim to being enlightened as being the "simplest method not to say

Continued on p. 442.

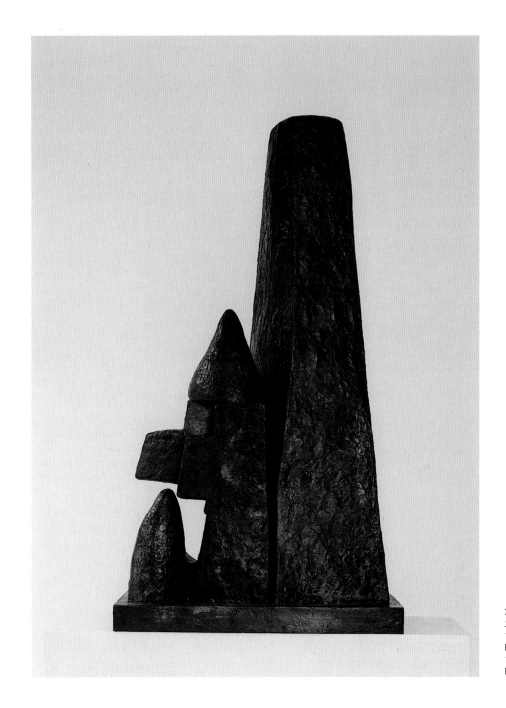

388 **Otto Freundlich**
Sculpture architecturale
1934/35
Bronze
128 x 69 x 43 cm
Private Collection

Germany 1997 – Stewed in Its Own Juice, or Packed in Oil?

Veiled, the True shows itself: the all-digesting cloak poses unmistakably and fundamentally before an uninterrupted and resolute ornament of parallel, naked roof slats. This is symbolism and Germany 1937.

After an initial attempt at correcting Germany and Helvetia with roof slats in 1985, the contures of the culture's ritual body finally dominate in 1989, following the disposal of a placating and flattening pluralism. In that year, Cologne (with the oil in the middle) is the ubiquitous center of imperial roof-slat pleasure and artistic hobbies.

At the same time, though, with the end of the Cold War, arrogance takes over the course of history in a surprise attack. With a backwards roll, it permits the reunification strategists to celebrate in 1997 the anniversary of visual and mental dyslexia (motto: aus zweierlei mache einerlei oder allerlei (of two, make homogeny or hash)). However, the festival takes place off-screen and ends up spinning its wheels in neutral: after the *Butterfrau* and sausages, now cold coffee from Halberstadt. Quelle idée! A person just has to have ideas (they have Quelle (mail order, trans.) in the meantime anyway), and for that, 40 (!) years (and not just 4) would be good and plenty. Déjà vu. So you invite yourself to an exhibition, get yourself charged up, and shut the doors tight. For the sake of habit and order (Halberstadt!), boarded up with cardboard and Bonmot:

– CLOSED DUE TO EXHIBITION –

Is it worth mentioning that the door was opened for a short time, just long enough for half of the exhibition to be stolen? According to the last Roswell report, anyway. And a few other things come to mind, too. Quotes, for one, preferably ones own:

String, in contrast to slats, is perfect for reaching convincing results by crooked paths, even though string is excellent for drawing direct solutions (laser). Its flexibility, its unprotesting pliancy for straight as well as for crooked things, make it an object of extraordinary strategic significance. The hangmans noose is the most convincing example of a concise, thematic formulation, just one of the wide selection of string's universal *Formsprache*. An incomparably richer variant of the slat's relative severity, its range of application includes binding, tying, bundling. It not only replaces special receptacles, but simultaneously enables (with living creatures (the paralysis of uncoordinatable impulses (such as muscle spasms, nose blowing, and cramplike movements). Its talent for impenetrable, inscrutable entanglement is perfect for

diverting the eye away from the goal (theme, character, slat) and to the numerous, incidental capriciousnesses of coincidental constellations and knots (cf. also ensnaring, scaling, dangling, looping). The string of saliva (history's first plumb line) made its way from perpendicular (vertical) to horizontal (as laid-out bait). On the other hand, the string ties into two statistics (stringing things together), jurisdiction (bringing things into line), and the party line (fidelitas lineae: true to the line) and, last but not least, the geometrical alignment of domesticity (clotheslines, puppet strings, garden fences). Even in shifts to the emotional realm, which lead to the well-known weeping phase, respectable success in achieving health can be

Halberstadt, 1997

attained with the help of a guiding thread. The string's intentionless ubiquity invites its direct comparison with the so-called public key of the backpacker's code. The coding system does at first appear to be a case for the slat (symbol, sign, cunning), but the question of capacity comes up automatically when one takes a closer look at a chip of roofing slat. Its antithesis is clear: there's plenty of room in a pant's pocket for several kilometers of string.[1]

Laokoon 1) one of these crazy ideas of Greek making and never-ending interpretive possibility. Two boys, an old man: father and sons. A snake (the string's Creation parable: the snake – Evil – Woman/Eve – the apple – temptation – banishment: the drama of string and humankind begins), yes, a snake doesn't round off the picture. Who's against whom? Who threw the first stone? Where's the water? Contradictions wherever you look. Where's the mother? Is the snake supposed to be the mother? Or is the snake standing at the stove, offering the apple . . . to itself, or is the snake an apple disguised as a snake, and the real snake, in the meantime, brings the little soup to a boil. But then the mother is the symbol of it all. For hygienic reasons, we will refrain from an overly extreme presentation of the inner Laokoon.[2]

Actually, a person feels at home either way. The system pushed in by the Party and the Stasi, "as

we know – but didn't know" (or: as we don't know – but knew), was designed to be self-perpetuating – and continues to fulfill itself (by) itself. The Stasi has withdrawn, not because it was done, but because it wasn't needed. It was just standing in its own way. The doctrinaire atrophy (of the aesthete) and the moralizing self-importance (of values) are itching to finally establish themselves and win back the ground that they've lost. So you build yourself a wall and make yourself at home. Now, settling the accounts with your own sentiments can (back to the future) finally occur in the past, and the moments not worth living become worthwhile again, just like a person (and the Stasi) would have liked to have had it. Perestroika: the Stasi doesn't close off the meetings, the citizen does, making himself responsible for other citizens, armed with a lawyerly impulse to obligatoy scrupulousness and fuss (he has to stick out his neck for others and protect his fellow citizens). A victim out of self-obligation! Whipped into action by the survival instinct – such an extra-orbitant person likes to see himself made of that sort of wood. Wood is power – and it floats to the top. Like plain common sense, which, however, has the characteristic of bathing only in crowds. (How can identical brains possibly produce different kinds of plain common sense?)

An excerpt from the Halberstadt spiritual exercises, rectified and freely adapted from Plato:
Anyone, then, in possession of a certain knowledge, who regards something that he sees or hears, may come to the false impression in the following way. When he holds what he knows for that which you know, but did not know, and holds this for that which he does not know, but knew, and then again for that which you do not know, but knew. For when he holds what he knows to be something else, something that you know, or when he holds something he does not know (and which you know) for something else, something that he knows, or when he holds that which he knows of you for somethings else, something that he knows of someone else, something which you, however, do not know, but did know. But if you know this, and he does not, so is that which he knows that which you know. But if you know this, and don't know if he does, what he knows is enough.

What becomes of a *Besser-Wessi* when he goes East? A *Besser-Ossi*? Or a *Schlechter-Wessi*? Or maybe a *Schlechter-Ossi*? We can't say, not even in Saxon dialect *(Schlächter-Wessi)*.

Georg Herold

1 & 2 Georg Herold, *Unschärferelationen*, exhibition catalog (Berlin: Neue Gesellschaft für bildende Kunst, 1986), 24ff., 19.

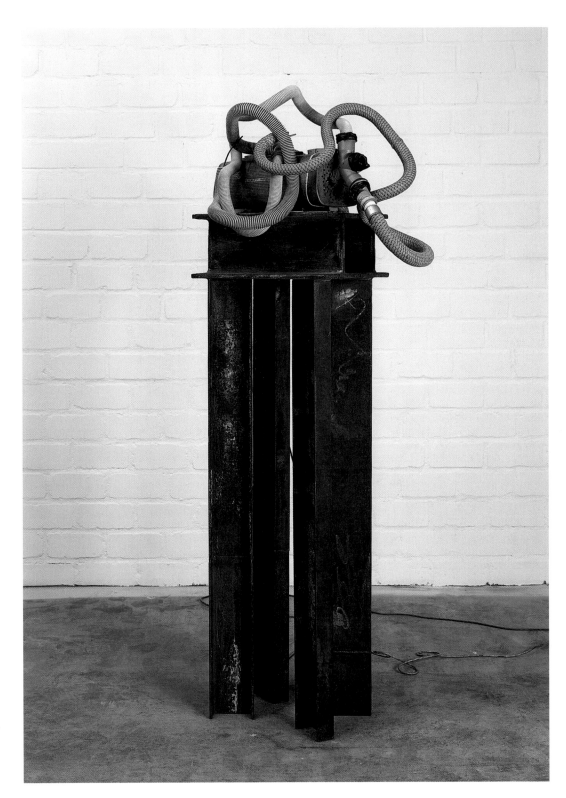

389 **Georg Herold**
Laokoon, 1984
Steel girder, vacuum cleaner, tape-recorder with 3 min. endless tape: Hitler's speech at the opening of the "Große Deutsche Kunstausstellung" exhibition 1937, about "Entartete Kunst" (degenerate art); original tone and as Walter Ulbricht Georg Herold speaking Saxon
205 x 60 x 50 cm
Private collection

16 Andrzej Szcypiorsky, "Das Ende aller Zivilisation", *DIE ZEIT*, No. 13 (3/24/1995), 64.

17 Hans Hess: "John Heartfield und das Wesen der künstlerischen Realität", lecture from 1969, quoted from Heartfield, 493.

18 The proletarian interests, not appearing to be politically relevant, disappear as trivialities That is the reason why the worker behaves differently in decisive moments than the Party assumes." (Oskar Negt/Alexander Kluge, *Öffenlichkeit und Erfahrung* (Frankfurt/Main, 1973), 391.

19 Two distinguished poster artists, Manfred Butzmann (Berlin-Pankow) and Klaus Staeck (Heidelberg, previously Bitterfeld), who "walk in the footprints of John Heartfield" (*Der Tagesspiegel*, 8/21/96), will be exhibited "parallel" to "Deutschlandbilder" in the Festspielgalerie from 9/7/1997 until 1/11/98.

20 Georg Herold, quoted in *XTOONE*. *Georg Herold*, exhibition catalog, Kunstmuseum Wolfsburg, 1995, 29, 31.

21 *XTOONE*, 65.

22 G. Herold, quoted from *Unschärferelationen*, exhibition catalog, NGBK Berlin, Realismus Studio 31, 1985, 7.

23 *Unschärferelationen*, 24.

24 *Unschärferelationen*, 21.

25 On the occasion of the exhibition "Young Artists", Ulbricht passed judgement: "You cannot create any work of art that enriches Socialst thought and the feelings of the working people with formal, decadent or the so-called modernist means of design that are taken from late middle class art. That means, not in the actual sense of Socialist art." Quoted in *Bittere Früchte*, exhibition catalog, Akademie der Künste zu Berlin (Berlin, 1991), 24. Compare also the essay *Time Held Still* in this catalog.

26 *XTOONE*, 19.

27 The plaster stood in the first "Große Deutsche Kunstausstellung" exhibition which opened at the Haus der Deutschen Kunst, Munich, on 7/18/1937.

28 *AIZ*, No. 47, 11/30/1933: 787.

29 *XTOONE*, 9.

30 *XTOONE*, 117.

390 Georg Herold, *Germany Within the 1989 Borders,* 1995
Collage, 24 x 32 cm, Collection of the artist

something that you want to say and to mean something that you don't mean (string)".[23]

At first glance, Herold's works seem to be works of art in the conventional sense, in their formal (Constructivisim, Bauhaus, Surrealism) and iconographic references (Dürer-Hare, fig. 330, p. 338 and *Laokoon*). However, the search for sense and meaning is disappointed: "The need to receive and the sense of mission, however, give way to an inner logic (sign salad). Care packages as well as Pajok-Parcels are sent off in the course of this logic to bring order into the 'nothingness'. Filled with signs."[24]

Hitler's speech at the opening of the *Haus der Deutschen Kunst* in Munich on July 18, 1937, about the "Stone Agers" and "prehistoric art stutterer" sounds from the belly of a vacuum cleaner. Georg Herold let nothing stop him from also giving the speech in Saxon, the idiom of the GDR Head of State Walter Ulbricht.[25] A monumental iron construction with a steel T-form as platform supports the tiny vacuum cleaner with its knotted hose as sculpture. ("A parabolic mirror of the fall of culture, *Endlösung [Null Lösung]* and the end of the world. Hitler's vision came true [Murphy's Law]; even the last pole of a 'Street lamp' disap-

peared...")[26] In shifting the meaning and importance from the sculpture to its bearer, the emotional charge of the monumentally large sculpture is carried *ad absurdum*. According to his motto, the material "has to become the idea carrier", he named his resounding object *Laokoon* (1984, fig 389, p. 441) and took inventory of this work in his *Panel Work* (1992) under the category "IV. Symbolic Figures". Herbert List's reknown photograph showing Josef Thorak's nine-meter-high, still veiled bronze group *Comradeship* near the entrance to the German pavilion built by Albert Speer at the 1937 World's Fair in Paris,[27] had certainly inspired Heartfield to create his montage *The Hangman and Justice*[28] with a bandaged, blood-stained Justice as figure in plaster and Göring's statement in the parliament arson trial: "For me, the law is something bloody."

Georg Herold had also gratefully seized on this photograph, in this case it was the two figures on the slats leaning on the travertine pedestal in particular which had inspired him and which he captioned with "Cologne". "What pleases in art ... is its cheapness in serving great ideals."[29] He larded the wrapped sculpture with strips of paper on which "Cologne" was written and called this montage *Germany Within the 1989 Borders* (fig. 390, p. 442). Cologne remains Cologne, be it within or outside the 1989 borders. With fine irony, the long shadows of the "Thousand Year Reich" are projected into the present and "... the unsharpness passes from the object onto the observer".[30]

Eckhart Gillen

391-407
John Heartfield
17 photo montages from
the 1930's exile magazine
AIZ/VI (Prague)
copper plate etching
Each 38 x 27 cm
Stiftung Archiv der Akade-
mie der Künste, Kunst-
sammlung (John-Heart-
field-Archiv), Berlin

left: 391 *The Crucifix Was
Still Not Heavy Enough*
AIZ, 23 (1933): 403

center: 392 *The War*
AIZ, 29 (1933): 499

right: 393
German Acorn
AIZ, 37 (1933): 627

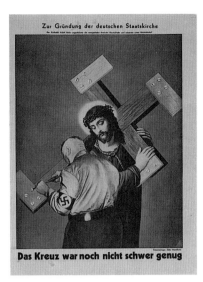

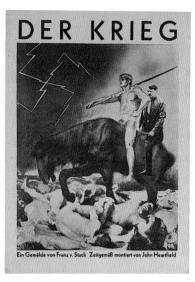

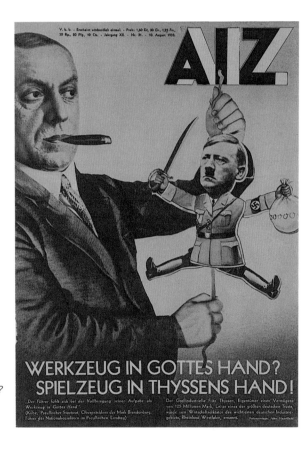

394 *A Tool in God's Hands?
A Toy in Thyssen's Hand!*
AIZ, 31 (1933): 529 (title
page)

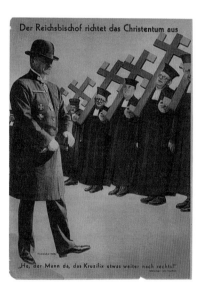

395 *The Reich Bishop
Arranges Christianity*
AIZ, 3 (1934): 35

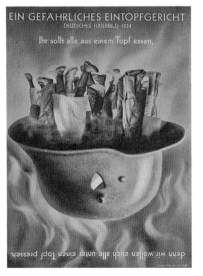

396 *A Dangerous Stew.*
AIZ, 45 (1935): 736

443

left:
397 *Diagnosis*
AIZ, 12 (1935): 192

right:
398 *O Christmas Tree in Germany, How Crooked are Your Branches!*
AIZ, 52 (1934): 848

left:
399 *Hitler Tells Fairy Tales II*
AIZ, 10 (1936): 160

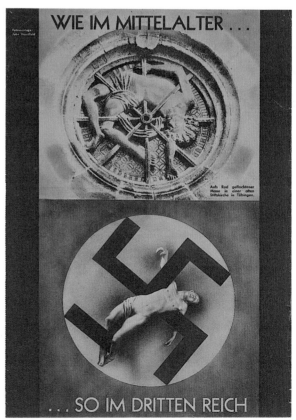

left:
400 *Voices from the Swamp*
AIZ, 12 (1936): 179

right:
401 *As in the Middle Ages ... So in the Third Reich*
AIZ, 22 (1934): 352

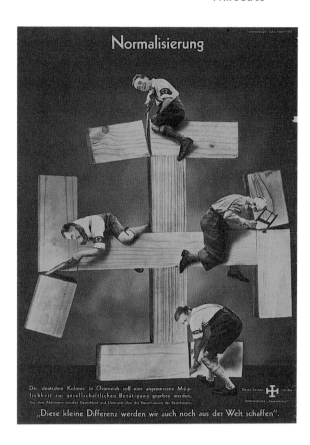

Normalisierung

Der deutschen Kolonie in Österreich soll eine angemessene Möglichkeit zur gesellschaftlichen Betätigung gegeben werden.

Aus dem Abkommen zwischen Deutschland und Österreich über die Normalisierung der Beziehungen.

„Diese kleine Differenz werden wir auch noch aus der Welt schaffen".

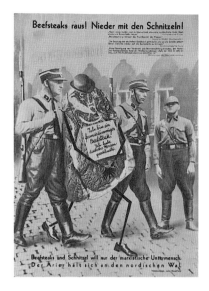

Beefsteaks raus! Nieder mit den Schnitzeln!

Beefsteaks und Schnitzel will nur der marxistische Untermensch. Der Arier hält sich an den nordischen Wal.

Die Saat des Todes

Wo dieser Sämann geht durchs Land, Erntet er Hunger, Krieg und Brand.

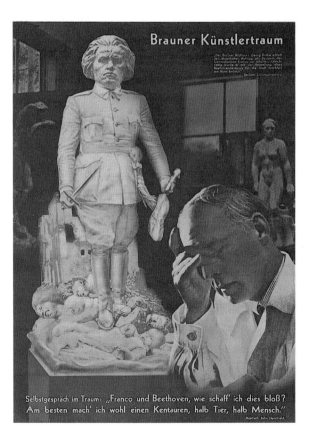

Brauner Künstlertraum

Selbstgespräch im Traum: „Franco und Beethoven, wie schaff' ich dies bloß? Am besten mach' ich wohl einen Kentauren, halb Tier, halb Mensch."

Der Gipfel ihrer Wirtschaftsweisheit

„Noch nie, solange die Erde besteht, ist so viel Blech geredet und gesammelt worden."

upper right:
404 *The Seeds of Death*
AIZ/VI, 15 (1937): 237

lower right:
407 *The Biggest Liar of All Times*
VI, 40 (1938)
(completely printed over)

upper left:
402 *Normalization*
AIZ, 31 (1936): 496

upper center:
403 *Beefsteaks Out! Down with Schnitzel*
VI 1, 12 (1936): 192

center:
405 *The Height of their Economic Wisdom*
VI, 17 (1937): 269

lower left:
406 *Artist's Brown Dream*
VI, 29 (1938)

Rudolf Herz:
Dachau. Museum Pictures

The nine exhibited photos, (see fig. 408, p. 448), were selected by Rudolf Herz out of hundreds of negatives which came from his numerous visits to the Dachau concentration camp memorial between 1976 and 1980. The exemplary collection of enlargements is from his own private archive which documents the "injuries" to the photos inflicted on them by scandalized visitors. The process of documenting the repeated cases of damage to the photos of concentration camp guards and of Hitler and his accomplices finally came to an end in 1980 as the museum's direction decided to enclose the photos behind glass.

The physical "grappling" with the past the boundaries of looking and reflecting had been broken like a taboo which damaged the integrity of the pictures. The transgression of the boundaries carried out secretly by the viewers became a scandal, which the museums direction quietly contained by placing the photos behind glass.

Although these scratches and scrapes and their documentation, which were really found at Dachau more by chance, led the artist to a change in emphasis from media aesthetics to media history, he did not decide until 1996 to use any of this material for his own artistic work. "I lack the confidence to deal with such difficult material."[1] Why so difficult?

These signs of the attempt to confront the past reveal the actuality of a past which continues to break into the present. The wounds that time could not heal rupture forth in the defaced surface of the photos. The traces of the apparently past, but actually only repressed, embed themselves in the smooth finnish of the photos, ripping them apart like the veil of forgetting which has descended as a consensus of silence over the horror upon the individual as well as the collective trauma.

Only the extreme enlargements of the scratched photos, the ingenious use of the available light to accentuate the gouges, the contrast between the light and dark sections, and the use of a minimal depth of field made visible that which would normally escape the sight of the average museum visitor. Differences between the scratches are recognizable as signs of resistance. The demonstrative wounds range from simple marks to deep punctures. Solitary gestures of negation and destruction stand next to repeated marks and incisions, carried out by a series of hands on one and the same face. Such repeated occurrences can lead to the total disfigurement of the entire head, which can be seen clearly in the case of Hitler.

That which is brought to light through photo-technical method appears, although subjectively understandable, as inappropriate to the object, an irrational substitute and powerless reaction, which is itself perhaps a result of the fact that most of the figures on the photos, the actual perpetrators, are no longer within reach.

The photographs of Rudolf Herz bring this phenomena into the public light and with it the breaking of a taboo in public space. Here the question arises as to the sense and function of this visual appropriation.

How can one tell if a blonde has been working at the PC? From the white-out on the monitor. We laugh because blondes cannot tell the difference between the surface of traditional and electronic picture media. With conventional writing paper the characters are on the surface, and can be covered with white, hidden whereas the computer text appears not on the surface of the glass monitor, but behind it. We look at the text as if through a window separating the viewer from the viewed. Direct access is blocked. Protected by a transparent shield, the letters do not belong to the same world as that of the reader or viewer.

Like the text behind the screen, the phenomena depicted on the photographs lie on a spatial level accessible to the eye but not to touch. This distinguishes photography and its descendants, like film and electronic visual-media, from the traditional forms of painting and drawing, which build their objects out of physical material and remain in the realm of tactility.

Are the museum visitors who destroy the photos of hated persons acting like the blonde because they confuse the paper-thin layer on the photos with the skin of those behind the pictures? Photography is particularly suited to such a magical substitution of the picture for those pictured because of the techniques of mechanical reproduction, which create the belief with every photographically created image, that the persons depicted must have been present for the image to have come into being.

This evidentiary character of photography in our perceptive sensorium lends it a measure of reality greater than that of painting or drawing because their objects can also be created purely out of fantasy and out of the reality of the eye, hand, and spirit of the artist. This technically mediated suggestion of photography to be the direct representation of something that has been, and therefore not only to portray that which is not present, but to make present its immediate trace, gives to photography not only its documentary, but also its auratic quality. The transition from "objective" document to magic takes place when the photo allows its image-character to be forgotten and the recognizable difference between the picture and the pictured disappears. When looking at a photo, a film, or television program, we tend to forget,

1 "Spieltrieb und der Wille zum Widerspruch. Rudolf Herz im Gespräch mit Dirk Halfbrodt", *HERZ*, Peter Friese/Dirk Halfbrodt (eds.), (Nuremberg, 1997) 11-32.

in comparison with a visit to a gallery or the experience of a sculpture, the technical fabrication of the image. The less clearly the technical apparatus leaves its mark on the image, the greater the suggestion of the immediate presence of the presently absent that was nevertheless once there. A talkshow, just like a soap opera, or a cop show, take place in our living room. Not until the film is over do we recognize the artificial studio-world in which we had forgotten ourselves. We find the same magic in looking at slides or the family photo-album because the persons depicted seem to come to life in a way that allows us to forget the technical quality of the photos in their paper form or to overhear the hum of the slide projector.

As with family photos which can only unfold their magic of making present those who are not in the familiar surroundings of the home – to someone outside of this circle such pictures mean nothing – so to with *Dachau. Museum Pictures* are only able to unfold the force of their effect at the authentic place of events, the memorial at Dachau, where the pictorial documents give rise the magic effect of making present those portrayed. This pictorial magic in the moments of illusion brings into the present the bodies of the pictured in a way that drives the viewer to such mock executions.

Rudolf Herz's work *Dachau. Museum Pictures* posits the question as to the precarious relationship between signifier and signified in the realm of photography. The photo-technical reproduction and enlargement of the deep gashes and scratches in the photos at the memorial exhibition have brought the many layered and normally invisible relationship between the depicted bodies and the bodily actions of the viewers into light and thereby into consciousness without however making it fully clear or understandable. Precisely the destruction of the images and the mock executions demonstrate the power of visual appearance. To derive out of this the power of seduction inherent to the fascist aesthetics of images which suggests an exoneration of the German "masses" seduced against their will is an argument, common on the left, that *Dachau. Museum Pictures* calls into question.

Hubertus Gaßner

447

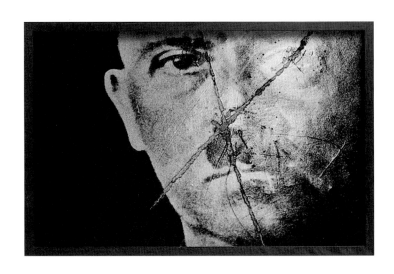

408 **Rudolf Herz**
Dachau. Museum pictures, 1976/80
No. 1-9, 1996
Each 87 x 130 cm
Private collection

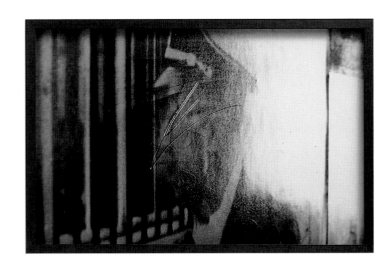

449

Ulay's Performance Piece "There is a Criminal Touch in Art"

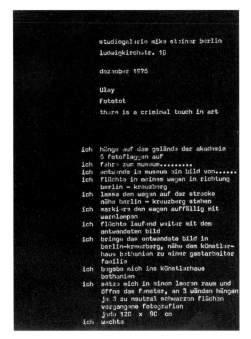

Announcement of the Performance
November 1976
Notice given by the Studiogalerie
Mike Steiner, Berlin
In *Kunstforum International* 18
(1976): 13.

If Spitzweg's painting *The Poor Poet* is but mentioned in conversation, the talk inevitably turns to the "crazy story": The and acious theft of the million-fold reproduced original from the West Berlin Neue Nationalgalerie and its prompt, unconditional return by the thief.

The incident from the year 1976 proves – 21 years later – to have become an element in the collective West German memory. The reasons behind this phenomenon, however, remain obscure. Reconstructing the details will not bring us on its tracks. They are known, for the most part – anyhow – but no one enjoys thinking about them. Yet insight into what fascinates here is offered in the always stereotypical course of conversations which attempt to recall the story.

Three roles are assigned in the stereotype of a such a conversation: the wise one, the informed one and the crafty one. When the Spitzweg "theft" is mentioned, a grin first sets in on the face and lingers even through the embaressment when his or her attempt to tell the story flounders. The narrator always feels "unable to put the story together". Then, the second sees the opportunity to help out. With a serious facial expression that should remind us at once that the incident was not considered so amusing at all, he or she says it all goes back to a media event, for instance, BILD had to publish a correction on the title page months later, formulated by Ulay's lawyer. It is the informational character of the details that disappoints the hope of hearing a story told. "The context in which the entire matter must be seen" doesn't change that. *The Poor Poet* was brought to Kreuzberg-Berlin by the thief and hung for a moment in the apartment of a Turkish "guest worker" family. Neither the knowledge of the "context" nor the information that the robber had insisted on personally presenting the painting to the Museum Director brings enlightenment or gratification to the group talking, instead making the listeners react unappreciably to the two narrators. Yet a third interrupts with the key explanation (to change the subject) that the whole thing was only an art action. He'll mention, as an aside, that the artist's deed was never punished under law. Silence falls over art, the painting from 1839 and the art action from 1976.

Again unspoken, the questions continue to wander aimlessly. What led to the popularity that this Spitzweg painting achieved at different phases of German history, lastly after WWII? Why was it labeled the icon of the German petty bourgeois by the postwar generation, whose schoolbooks contained it as if out of obligation? Was the social criticism it contained overlooked and not conveyed by teachers? Or was the contemporary comment from the days of the Vormärz (1815 – March Revolution of 1848) passed off as currently, even eternally valid? Was the aggression directed at the painting – it had already been spat on in the museum earlier – actually against an exonerating self-criticism which would deny Auschwitz because it so satisfies and amuses itself with that farce of "the people of poets and thinkers" that it should face penalty? Or did the picture of (satirical) idyll chafe against the feeling of being unprotected that was suppressed and embedded more deeply into the soul by the bombed-out cities, the Cold War and its waves of refugees from the GDR and East Europe and above-ground nuclear testing, than the *Wirtschaftswunder* allowed anyone to admit? Did the fears which one hoped to have peacefully put to sleep rise up out of the bed of this proto-hippy "in" the painting? The modalities of the quickly ritualized mass protest against the VietNam War with its escapist-identificatoric displacements indicate, in any case, a background of unconfronted and unresolved fears. The function of repressing them also produced a 1970's curiosity: the "protest culture". Without differentiating, the protest was directed against all subjects of culture – with the exception of cultural-religious principles, whose ethical fundamentalism allowed it to appear legitimate.

And now to the art performance. Was it part of the "protest culture", or did it hold a mirror to it? What are the conjunctions, respectively, oppositions in the cunning juxtaposition of a Turkish guest worker family and *The Poor Poet* that make up a picture of socio-political relations, which as a consequence serve an aesthetization of political perception and practise, conjunctions between the Turkish family's humble, tidy apartment and the "exotic" interior in the painting, between a well-known painting in a museum and a working-class district extolled as picturesque by Berlin's own public relations, between the various "cultures", the culture of art, the culture of workers' lives, finally, of the Turkish guest worker? Did the Germans' image of Turkish people reflect or misjudge their social situation in West Berlin in the year 1976? Which image of the city and of Germans did Berlin's PR want to convey, when they referred to the large number of Turks living among them, without, as it was proudly said, the Turks being ghettoized?[1] Did the action cause an iconoclastic effect of an updated reception of the painting? Did it sensitize the public to the social situa-

[1] Using what is foreign as a signifier for the signification of one's own is a strategy, which the action apparently wanted to criticize. Yet the action reproduced precisely this strategy as an actionist tactic.

tion of the Turks in Germany? Or did it break the middle-class taboo against making fun of minorities?[2] Or should the signifier "Turks" merely emphasize the social isolation of Performance Art, in which the artist represents himself as victim by means of an antithesis to the audience.

Finally, the art-sociological question: How does art attain that immunity which excludes crime? And why, when it is in fact possible to commit crime in art, is it not at all a criminal matter? Why does the citizen expect art to provoke, to break taboos and cast off or transgress boundaries? In nourishing these expectations, what social function does art serve? Questions such as these, brought up by the action, answered numerous times, do not explain why the action, as a fragmentary story, could dig itself deeply into the collective memory.

Contrary to the prevailing notion of the collective memory, that it transfigures the factual, it is shown here that it did not transfigure "the deed", nor did it mytho-poetically elaborate the factual. Much more, the collective memory captured a "poetic sense", which lay outside of the deed's possible purpose or intention but within its "blind motive", which is engraved in actions, but has not caused, that is to say, is not responsible for them. And the collective memory places itself in the service of neither enlightenment nor conscience. The grin over the "Spitzweg story" arises from the blind motive, appears unmotivated in rationally conducted conversation and is therefore condemned for being inappropriate. Such repression corresponds to the types of explanation such as "what did the poet want to say to us". Rather than explaining, they throw clouds of fog around what knowingly-unknowingly fascinates the collective memory. In its poetic-aesthetic "reception", the deed is certainly transposed from history to myth and its perpetrator is "sacrificed" by his transformation into a hero. The hero may carry the same name as an historical culprit, but in the mythical narrative the "culprit" is not the subject of his action, only a participant in an event. It even takes his name. Thus, "the story about the Spitzweg" is likewise called "the Ulay kidnapping". Typically, Ulay's identity as the artist, who later with Marina Abramovic, advanced to become a "classic" in Performance Art, remains unrecognized.

The utopic-romantic goal of many art movements – from the early Modern through the 1960's until today – was fulfilled in Ulay's performance: the negation of art, the nihilation of what is artificial in art, the complete absence of an art object and the artist-subject, the dis-solving of an artwork into the "whole" of life.

What is exceptional in Ulay's performance was therefore not its audaciousness nor its distribution as a media sensation, but rather that the extreme case came true, in which art attained autonomy outside of art then as non-art slipped out of the artist's control. This extreme exposes the artist to the situation in which he cannot perceive and is exlcuded from the effects of the process he initiated. The opportunity arises to evaluate this, Modern Art's, utopic goal, as to whether it expresses not only the intentions, but the real desire of the artist – the curator and art critic.

In a restorative reaction, Ulay had tried to "reconstruct" the action in the sense of historicism. By means of documentary material, he wanted to establish an authorized legitimation as "criticism" of it,[3] and he endowed it with a never intended, presentable "body" in the form of a video installation. It was the attempt to "win back" an art performance that had already turned into non-art, as an art object and as an artist's signature.[4]

The artist's curatorial praxis, in view of an action less typical for his oeuvre, represented the ambivalence intrinsic to contemporary art in an at once extreme and objectifiable way – and in this its significance can be recognized today. The ambivalence originates in the "dream of art", which "longs to return" to a mythical world thought to be lost. But at the same time, the dream finds its own yearning disgraceful, as long as the yearning – and with it, the myth – are not portrayed as criticism.

As what, however, did Ulay's performance embed itself in the collective memory? As the puzzling myth of an absolute evil! Because it is not a possible ethical motive on the part of the culprit that fascinates the memory, rather the "lunacy" to commit a "crime against" a crime – to have returned the "million coup" with disinterested innocence. Since the deed was an offense against the norm, blindly just in the realm of good as well as evil, it presents the parable of an absolute evil, incompatible with human interests. The parable shows evil as such is not to be feared, rather the interest in whether it is evil or good. And thus, in its mythical result, the performance affirms the "law of art" that only disinterested attention accords with art and only disinterested attention can be just to art. Because art, like this attention, is not based on rationality but rather finds its "ground" only in the aesthetic. Therefore, art stands outside of the absolute as well as outside of the ethical relative – life.

Wolfgang Winkler

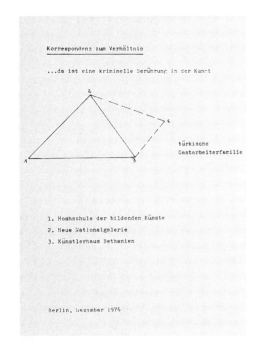

Schematic description of the performance places
Illustration taken from the video documentation "Ulay. Irritation. ... da ist eine 'kriminelle' Berührung in der Kunst", ed. by Studiogalerie Mike Steiner

2 A comparable performance today would be recognized as satire and certainly jeopardize the social peace in Kreuzberg.

3 Thomas McEvilley, *Ulay. Der erste Akt* (Ostfildern, 1994).

4 This attempt is also reflected in the practise of giving a title to the performance which formerly went only under the code name, *there is a criminal touch in art*. Thus, after being given the name "An Irritation" from the anti-sensation video documentation edited by Mike Steiner in 1977, the performance was entitled *An Event by Ulay* in 1989, and as of 1993, *The First Act* or *Die erste Tat*.
Originally, a game with "verbatim" translation had been part of a neo-dadaist practise. For instance, the idiom "there is" had been taken literally as "here is" and the metaphorical "touch" had been arbitrarily misinterpreted as a physical attack ("da ist eine 'kriminelle' Berührung in der Kunst"). After 1989, the year of the German unification, however, Ulay decided to cleanse the politically provocative caprice from the documented memorabilia of his original art-action.

409 **Ulay (Uwe Laysiepen)**
There is a criminal touch in art, 1976/1997
Video installation: 1 monitor,
1 SONY U-matic player, 2 sofas,
shelf for copies
Camera: Jörg Schmid-Reitwein,
Producer: Mike Steiner,
Wilma Kottusch
Ground surface: 32 square meters
Collection of the artist

Ulay (Uwe Laysiepen)
There is a criminal touch in art, 1976/1997
6 out of 20 filmstills
Camera: Jörg Schmid-Reitwein.
Each 40 x 50 cm framed
Collection of the artist

Is the Personal Really Political?
Notes on Marcel Odenbach's
"A Fist in the Pocket"

Before we as viewers have even entered Marcel Odenbach's *A Fist in the Pocket* (fig. 410, p. 455), two of the work's elements have made a claim for our attention. The first point of contact is aural: as we near the enclosed space in which the piece has been installed, the faint but unmistakable sound of Indonesian gamelan music, looseley wrapped in an electronic envelope of sound, drifting from the interior.

The second point of contact occurs at the entrance of the Berlin version of the installation, where the famous line by Ingeborg Bachmann is projected in video format onto a wall: "I am writing with my burnt hand about the nature of fire".

In his Madrid exhibition "The Raw and the Cooked", 1994 in the Reinia Sofia, Odenbach chose for the first presentation of his work a famous line from Fidel Castro which declared that a homosexual can never be a true, upright revolutionary. Both quotes clue us in that Odenbach is leading us into dangerous territory.

More specifically, he has released the promise of exotic pleasures into the stern atmosphere of politics – in particular that messianic subcategory of political discourse once conjured up by the single word "revolutionary". This use of Castro's well-known antipathy towards male homosexuality in the form of an epigram makes its utterance seem embarassingly archaic, as if it exposed all too quickly the reactionary puritanism concealed in the heart of every revolutionary.

Entering *A Fist in the Pocket,* our attention is drawn first to a large video projection which fills almost all of the closer wall. At first it takes time for one's eyes to adjust to the slow motion, soft-focus action on the screen, which offers a close-up view of a massage being given in what appears to be a hotel room or brothel. The main activity consists of feet being applied expertly to the surface of someone's back, although other images, some pleasant, others less so, float ambiguously in and out of the frame. In keeping with the particularly fleshy form of pleasure being enjoyed on-screen, the overall mood of this end of the room is delirium mixed with a tinge of seasickness, as if it had been filmed on a water-bed. Mixing as effortlessly as it does with the work's "soundtrack", however, this segment offers the only encounter in *A Fist in the Pocket* where the visceral experience and its intellectual overlay are completely integrated.

We are led from the massage scene into a hotel room, where a Thai man is confronted with the xeno-phobic aggressions of German youth in Hoyerswerda and Rostock-Lichtenhagen on television, with scenes of, among others, Vietnamese poeple fleeing a burning house.[1]

Facing this spectacle of bodies languidly touching other bodies and the television images of sheer violence against Vietnamese, Odenbach installed seven video monitors at eye level as a way of bringing the viewer closer. We see how someone types the German Constitution using two fingers, letter for letter in agonizing slowness, on a 1960's typewriter. Odenbach shifts back and forth between the black-and-white typing footage and film sequences from the book burning of 1933. Book burning crowds, caught up in a frenzy of anarchic destruction are superimposed over scenes from the 1968 student revolts, behind which there is the typewriter image on the various monitors. On each monitor, Odenbach shows scenes from the international protest movement in other countries: from the Viet Nam War Protestors March on Washington, from the protesting students from more than 30 American universities and colleges in October, 1965, from the 1968 May Revolt in Paris, from the desperate resistance against the Soviet tanks on August 22, 1968 in front of the university grounds in Prague, in West Germany, Spain, Mexico, and Italy; from a feeling of general dissatisfaction, they led to a politicization against the establishment. We cannot escape the impression that this is the tragic legacy of the 20th Century summed up in the images of a crowd whipped up into a warlike mob in the name of a good cause. The observer of these images becomes aware of the contradiction between the slowness with which a new Constitution as guidance for a rational democratic co-existence is put down on paper, and the terrifying speed at which the words are covered and consumed by the flames and masses.

Most worldly viewers do not need to be reminded that Thailand, the crown jewel of South Asian landscape and cuisine, is also the capital of an immense sex industry, whose customer base is made up largely of the many thousands of European, Australian and American men who come to this pocket of the world for the express purpose of getting laid. Although in official terms the sex industry is both scorned and tolerated as the dirty underside of the region's remarkable economic growth since the 1980s, the precise societal role played by its many thousands of employees is not a subject that has given much pause to either the industry's client base or to its legions of would-be detractors. As an artist who has long been driven to decoding oblique manifestations of racism and other forms of intolerance, Odenbach has chosen to document the Thai sex industry not as a way of casting moral aspersions on those whose relationship to the pleasure industry are considerably less self-conscious than his own,

[1] Between September 17 and 23, 1991, radical right-wing youths attacked housing for political asylum seekers in Spremberg, Cottbus, Schwedt, Leipzig, Freital, and Saarlouis. In Saxon Hoyerswerda, once model Socialist city, (compare Brigitte Reimann), radical right-wingers, from both the local area and further regions, attacked a home for immigrants housing about 150 workers from Vietnam and Mocambique with stones and fire for several days. With 17 people murdered from August 22-27, 1992, the escalating hostility towards immigrants reached a new postunification high point. On the outskirts of Rostock, hundreds of youths again attack the completely over-filled Mecklenburg-Vorpommern Admissions Center for asylum seekers. With the approval of the local residents, a neighboring hostel housing 100 Vietnamese immigrant workers who had been taken into the country and ghetthoized there during GDR times, was set in flames. The police evacuated the area and left the Vietnamese to their fate. On August 29, more than 15,000 people from the entire country demonstrated in Lichtenhagen against the brutal hatred against foreigners and right-wing radicalism. (Compare Hartwig Bögeholz, "Die Deutschen nach dem Krieg. Eine Chronik. Befreit, geteilt, vereint", *Deutschland 1945 bis 1995* (Reinbek bei Hamburg 1995), 719, 729).

MIT MEINER VERBRANNTEN HAND SCHREIBE ICH VON DER NATUR DES FEUERS (Ingeborg Bachmann)

410 **Marcel Odenbach**
A Fist in the Pocket, 1994
Video installation: 8-channel video,
7 monitors, video projection, quote:
"I am writing with my burnt hand about
the nature of fire" (Ingeborg Bachmann)
10 x 7 m
Collection of the artist

but in order to focus us on the moment itself, the exchange of flesh for money as a performative mode: intimate yet anonymous, mundane in its casual promise of ecstasy or remuneration. We may find ourselves just outside the reach of the transaction's visceral overload, but our voyeur's position gives us plenty of material to fill in the blank spaces for ourselves.

Where, then, does the connection lie between these seemingly unrelated spheres of activity: the individual body seeking solace and the collective body running amok? Or to put it another way, by what shared frame of reference are these quite separate realms brought together into a fused statement about human behavior and politics?

Cutting once more to the action on the larger screen, it is clear that Odenbach is anything but neutral on the question of contributing to the prostitution marked in Bangkok. However, since he is also physically unable to document it without also becoming to some degree a participant, he allows us to examine the activity from the privileged perspective of the client without actually compromising either subject's identity. His complicity is equivalent to ours within the scenario presented, but its nature can be read both ways: the form of sexual gratification on display reads as either an incriminating act or an example of human resourcefulness, depending on how one responds to the situation. The large screen size and close proximity of the camera to the action serve to drive home the point that our subjective relationship to what's before us is the only perspective that matters.

On one level, *Fist in the Pocket* reminds us that every present moment is made up of an incalculable number of layered conditions that can be traced backwards in time through their earliest historical predicaments. Even the furtive episode of erotic pleasure with a Bangkok call-boy is circumscribed by sets of interwoven conditions, in particular the cultural inheritance from centuries-old colonial relationships that provide the social underpinnings of the sex industry today. From this perspective, the title of the piece becomes particularly relevant, as its standard usage is to indicate a situation in which one's anger cannot be expressed openly, so it has to subsist in the form of a clenched fist that one conceals from the world. Since in this usage an unequal balance of power would be the assumed justification for the concealment, one is tempted to ask who in the present situation is so angry, and for what reason? Certainly the crowd in the multiple monitors is angry, but then they're not making any effort to conceal it. Could it be the young man in the color video, who resents the need to satisfy the lust of strangers in order to make ends meet? Or is the fist in the pocket a symbol of our own impotence in the face of things we either don't understand or else can't control?

Considered in this light, Odenbach's work is clearly about articulating this midway point between sexual indulgence and social anarchy. His point doesn't seem to be that one leads to another, but rather that these two very different forms of expression are linked through the individual's willed desire to take charge of a morally ambiguous situation and make it right. As we watch the 1968 riot footage, our romantic attachment to the date and its legacy have not prepared us for the orgy of wanton destruction that not only took place, but seems to have largely overshadowed the more constructive outcome of the May events. Perhaps Odenbach is exploring the notion that this sweeping away of societal norms, even for an instant, has the potential of bringing out the anarchist in any of us, just as the availability of desirable partners seems to be a much stronger factor in our decision to make use of prostitutes or not than any voice of conscience that condemns such behavior as demeaning or even politically incorrect. None of us, it would appear, is in a position to be able to influence other's behavior, in fact, if it is true that many of us can barely keep our basest instincts in check, then the fist in the pocket may serve yet another purpose – to remind us that no matter how lascivious the urge or how wanton the chaos, our hope of standing safely outside the zone of responsibility is all but diminished by our realization that the only possible formula for escaping involvement in any crime, large or small, is to forget that each of us is fully and inescapably human.

Dan Cameron

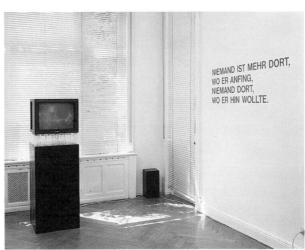

411 **Marcel Odenbach**
No One Is Left There,
Where He Began, 1990
Video installation,
1-channel video, sound
installation with a monitor
standing on glasses for a
6-minute tape and a text
Collection of the artist

NIEMAND IST MEHR DORT,
WO ER ANFING,
NIEMAND DORT,
WO ER HIN WOLLTE.

Klaus vom Bruch's Images of Germany: The Military-Industrial Complex

The railway tracks that run together and yet do not run together, that run together only to drift and remain far apart again beyond, the world that accords with my perspective in order to be independent of me, that exist for me in order to exist without me, to be a world.
Maurice Merleau-Ponty[1]

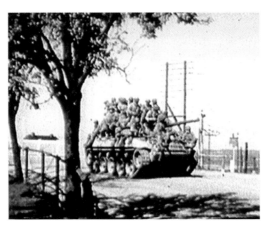

Art is a clearly delineated realm. So far, all attempts by art to intervene directly in the realms of everyday life with the aim of altering it, to lend the supporting arm of artistic form to a political truth, whatever that may be, have been destined to fail. The political element in art is discreet in appearance. It only accompanies an artistic work when, in Rilke's sense, that work allows the "unsealed forms" of things to enter into the work, when the secret is fabricated and preserved. Art installs itself in finely devised networks. Its secret aim and open secret is nothing more or less than the refinement of the senses.

Since 1974 Klaus vom Bruch has been working with a medium which more than any other in contemporary art comes under discussion in the context of the social and political function of art. Great indeed were the hopes that were pinned to video technology, which was regarded as an adequate medium for an art operating at the conceptual level and with political ambitions. What actually happened, notwithstanding this utopia, was that the medium was exploited by a market-oriented industry and the similarly inclined mass media. Like photography, video technology is at the very heart of worldwide communications. From its position in the realm of the everyday, it fulfils clearly defined functions within a mercantile system.

Artists working with video must constantly reconsider the preconditions of the medium. The chain that has been shackled to the medium of video through its seductive similarity with the apparatus of the entertainment, information and surveillance industries in our mass media society continues to have its pernicious effect. Yet the medium's very strength lies in this proximity to art's opposite poles, this proximity to the strictly goal-oriented systems which force the artist to constantly experiment and even break with tried and tested solutions, applying significantly more force, in fact, than the idioms of art, which have been only passably freed from the onslaughts of the everyday.

Before developing his video installations, Klaus vom Bruch undertook various kinds of experiments in the field of video technology. The conjugated forms he has found for the medium range from video performance to the projection in large format of a video tape being edited simultaneously by the artist in the auditorium, to a wealth of video productions. Klaus vom Bruch's works unfurl a purposefully constructed web of superimposed or interlocked strands of meaning. By interlocking different media, by combining and contrasting video tape, sculptural form and altered space, a complex system of signs emerges that doubles for the simultaneity of unrelated discourse and image systems.

Klaus vom Bruch's *Deutschlandbilder* take the plural of their title both seriously and literally. An image that would seem to promise an authentic expression is confronted with an ever changing flow of images that in ever new combinations give rise to ever new constellations of meaning. Four projections in parallel show four differently edited video tapes, each running in an endless loop and containing different, integral motif worlds. As the video tapes also differ in length, the images constantly appear in new relationships to one another. The motifs are constantly repeated, but their constellations seem just as metaphorical as the images themselves. For this colourful round dance of complex images Klaus vom Bruch has

1 Maurice Merleau-Ponty, *Das Auge und der Geist* (Hamburg, 1984).

chosen a title that suggests one-dimensional perception, reducing what we see to a common denominator. That intractable title is *The Military-Industrial Complex* (fig. 412, p. 458-459).

Metaphorically, Klaus vom Bruch has transformed the space at his disposal for this exhibition into a maritime world. Life is a voyage into the unknown on the surging waves of the images. History is made, things progress — and the observer watches. It is the primary duty of every citizen to watch. The image sequence is the foil on which the democratic vision appears. Clearly, participation in the world is a visual act. Thus the wall sur-

of destruction proudly presented in the armaments firm's commercial. Here they all can or will make their appearance, like the hackneyed picture transfers of the business machine that defines domestic bliss as dependent on the choice of the right car or washing power. Heedless of what images we are watching, the mechanics of the machinery run on and on, irrespective of which masquerade of reality is being shown.

All images are the same in the eyes of the observer. Only when their absurd harmony, staged by Klaus vom Bruch in his *The Military-Industrial Complex*, becomes visible, are these "curiosities" transformed into "realities".

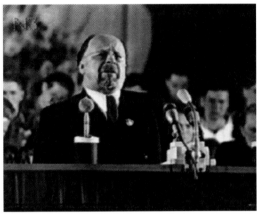

412 Klaus vom Bruch
The Military Industrial Complex, 1997
4-channel video projection; opposite a smoothly polished
wall as projection surface
16 x 4.50 m
Collection of the artist

faces in the room become a broad horizon on which the images of history are projected. The observer has actually been assigned the ideal position — leaning on a railing at a comfortable distance and letting the spectacle of the global theatre pass before one's eyes.

The images not only span a horizon, they also move on the vertical. As if driven by a crankshaft, the four parallel projections wind on, up and down, in alternate rhyme, conveying the general impression of being an image for mechanical propulsion. The engine of this ship of images, on which we will continue to travel until we are all in the same boat once again, is a rhythmically running four-stroke engine. The world of images is a machine, and Klaus vom Bruch's installation gives that machine a mechanical face. The make-and-break contact becomes the engine of an image machine. Each image tows another in its wake. Each image ignites the next. A self-rotating mechanism, a perpetuum mobile, a visual flow. The images are staggered, set pieces, each one interchangeable. Interlocking, they wind their way onwards, only revealing their sense and nonsense, the assets and liabilities of history, as they are combined, compared and contrasted.

We see fragments of the world in front of the camera lens, the supposedly important speech by a political protagonist, the facts of global history in all their annihilating reality, the astonishing precision of weapons

This short-circuiting of the images takes place with the installation in the room. The wit is added by the montage of reality, the gaze. The drunken ship will remain the vehicle of the future, denying supposed progress as long as we have eyes to see. Thus emerges that playful uncertainty which holds things at a certain distanced proximity in which we can gauge their meaning, their real content, in which they become part of a complex system of power strategies. The observer watches, *"e la nave va"*.

Carsten Ahrens

Poison Cabinet
Report from the Project
"The Glass Block"

The state is no temple, yet often enough Gods have been born from its mouth, for its oracles are regarded as certain. Denied to us is a clarifying view through the glare of the powerful sun of the system, or behind the foggy gray veil, there where the spirits of secret agencies loom: *The Glass Block* (fig. 413, p. 461) is blind. Today truth and lies are without meaning anyway. *The Glass Block* devotes itself to insanity in the system. The collection of materials includes literary fictions and fictional biographies on the tyranny of intimacy.

For the isolated member of society all senses are turned outward: listening, sounding out, smelling for danger. Lone individuals see themselves surrounded by enemies and use the graduations on the scale to locate their own position in the sights of the enemy.

Whether the infiltrator or the resident agent provocateur eavesdrops behind the door or just barges through unannounced, whether the informant or the G-man joins in the jostling camaraderie at the bar, the result is a constant state-of-alert.

The observed individual compensates for the feeling of all-encompassing powerlessness through every sort of knowledge about his mirror image, his neighbors. *The Glass Block* sets forth the research into the recent German past undertaken with the *camera silens* (Zentrum für Kunst und Medientechnologie, Karlsruhe 1994) and *Buna 4* (Festspielhaus Hellrau, Dresden 1995).

Standing in the center of a scientifically functioning apparatus are elaborate passable rooms, re-stagings, according to historical images, in which the sensory presence of discursive form grows. The character of a socio-political or historical-reception machine makes itself clearer to the viewer through its technical effect, from which one cannot withdraw because its impact is immediately physical. Provided the viewer gives in to the offered situation, he becomes a part of it, can become an accomplice or a victim.

Common to all three projects are the experiments of state institutions with the identity, the forming, the standardizing, of those people at their mercy.

The Glass Block records the cultural techniques of the perceptive obsessions of a divided land: Germany from 1933 to 1997. Here Jewish culture collides with anti-Semitism, the capitalist with the socialist economic order, as well as other more severely splintered opposites with their specific traumas.

Passages from novels, letters, and prose concerning the main lines of struggle and the peripheral contradic-tions will be recorded and can be heard over headphones.

In these stories there is a mood that is formed by the internalized omnipresence of mistrust and the climate of mutual surveillance, the most potent expression of which is the written fixation of the observed.

The production of the Listening-Archive as a transparent cube with 28 listening-cubicles resulted from this idea. In them are workplaces in the style of a language learning-lab, each of which contains a part of the materials. One who wants to hear more, must be prepared to change location.

In a central register can be found a record of that which has been heard. However, with the given techniques a general command over the material is not possible for the simple reason that the number of texts is inestimable (over nine hours), streams of information and data break over the listener unfiltered, without the possibility of active pre-selection.

Despite all staging of clarity and structure, which declines in every shade of meaning, the threadbare wish for transparency, the free decision, the direction of ones own knowledge around an object, remains an illusion.

Archivists, census-takers, and security experts know this. Creative power is attributed to the word, the world is created out of the logos. The word animates the things. Persecutors, like the persecuted, believe in the power of the letters.

The collection of materials for *The Glass Block* is a deliberate quixotism and not a pedantic report of professional visionaries. The organization of the *Block* cubicles illustrates the magical idea of the word: Archive – Computer – Library – Dictionary – Parliament of Spirit – Controllers and Controlled – Collective Journals – Education – The Suspicion – Body under Surveillance – Communities of Compulsion – Strange Perspectives – The Glass Subject – Private Rooms – Political Careers – German Conditions.

The *Poison Cabinet* is a preliminary study of the *Glass Block* on which the group (Olaf Arndt, Mario Mentrup, Janneke Schönenbach, Thomas Belling and Dagmar Wünnenberg) has been working since October 1996.

Next to a model of the installation, a sealed book case will be shown. It contains exemplary parts of the material that was used for the *Block*. A catalog will also appear which is considered by the group to be an essential part of the work and contains, in addition to a detailed treatment of the work, extracts from the sources used.

Olaf Arndt & Mario Mentrup

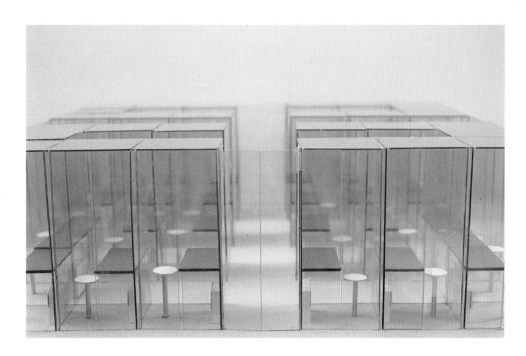

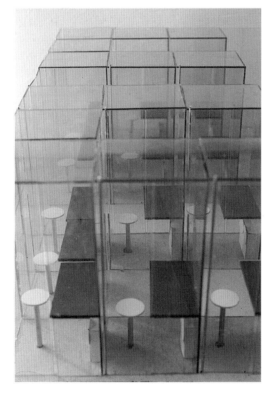

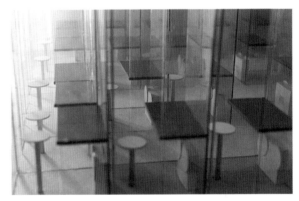

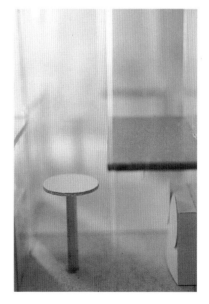

413 **Olaf Arndt**
The Glass Block
Model of an enterable instal-
lation not realized until now:
28 telephone booth-size glass
work stations, 28 tape recorders
with texts on the subject
"Control", Listening device
Planned outer dimensions:
7 x 7 m
Collection of the artist

Extracts from the texts heard in the cubicles:

2. Teichoscopy: ENIGMA functioned with the help of a row of cog wheels on an axle (in 1942 it was 56!) arranged at variable intervals from left to right transporting each other. Every wheel corresponded to the alphabet and the numbers 1 through 0. The system was so complicated that the letters were not only changed among themselves (for example A=O), but every letter was multiply coded within each text (for example A=O, =Z, =E, =R, etc.) Even these were changed daily, which was supposed to make it impossible for the opponent without knowledge of the daily code to decipher the messages of the ENIGMA=System.

The prison alphabet appears as follows:

```
          ' ' ' ' '
    1 x " a b c d e
    2 x " f g h i k
    3 x " l m n o p
    4 x " q r s t u
    5 x " v w x y z
```

The character ' stands for a knocking tone, the character " a double knocking. Double knocks denote a diagonal row. For example, the letter "m" finds itself in the third diagonal row. So here I give three double knocks. It is the second letter in this row, so after the three double knocks, I give two single knocks.

```
    m = " " " ' '
    a = " '
    r = " " " " ' '
    t = " " " " ' ' ' '
    a = " '
    Marta
```

If computers had existed at the time of Hitler's seizure of power, the whole world would today maintain that the Nazis control over the German people and the systematic transport of millions to concentrations camps and gas-chambers would only have been possible with the help of their computers. But the Second World War happened, and millions died, although there were no computers.

ENDLESS REPETITION OF THE PRESENTATION + IMAGES - ADVERTISING TELEVISION 1 2 3 PROGRAM - RECORDS: SRC Milestones Capitol ST 134, LOVE Forever Changes Elektra EKL 40 13, DOORS Strange Days Elektra EKL 40 14, THE ROLLING STONES Between The Buttons Decca LK4852, - PASE 2 - STANDARDIZED - CONTROLLED FROM A STANDARDIZED DATA-STORAGE MAGNETIC TAPE - CHANGE IN THE SYSTEM OF COORDINATES - IT BECOMES UNCLEAR WHERE THE THINGS BEGIN AND END - WORDS AND PHRASES REPEATED IN ALMOST UNCHANGED SERIES DURING THE 9 O'CLOCK NEWS LOOSE THEIR MEANING - INFORMATION IS BEING STANDARDIZED!

Count! ... Faster! ... Start again from the beginning! ... Count!

Only after the war did we discover that there were recording devices, which explains why German intelligence was in such a good position to intercept and understand radio messages. Secret radio codes are sent so fast that a stenographer cannot write them down. Additionally they are encoded. A recording device can record them and then play them slowly so that they can be decoded. Schulenburgs spontaneous comment to Molotov gave us the first clue that the Germans had invented the recorder.

How low should one sink? How low will one sink of one's own free will? Why does the question "Do you have any printed materials with you?" normally follow the question "Do you have any munitions with you?" Why is writing considered more dangerous than painting? Why do I have to hide my journal at the border crossing? Why is there no feeling that would prevent them from snooping around in it?

In your bathtub there are sitting smooching pigs no work with an illusion like breeding rats in the age of make-yourself-useful a circle of writing workers, bloodthirsty, secretly doubting themselves in front of a mirror in the fourth fall of childhood kneeling in front of a bathroom door as monument to every behaviorally disturbed boa of our alliance of refugees DESPITE IT ALL!!!: again and again in the same ghetto like hate wayne on MOTHERSDAY between appearance and slavery going in the morning to a place of execution cigarette butts prickling until carthage drowns in the milk rice of a macho taxes the patience of the indigenous

population jolts itself awake: every air-conditioner reveals an admission a collective guilt for beginners the last aztec we're at the bar you belong to yourself as long as you give in to yourself you belong to yourself as long as you are defeated the junta waits in the air-raid cellar of your evening dress

Exhibit "Jewish, male": - ...what happens when suddenly a commission from Berlin comes in the middle of the night? According to the directions of the Ministry ascertainment of existence should be carried out strictly according to the inventory numbers ... On the other hand, it would of course be rational – in the event that the inventory list doesn't match, who would be responsible? Certainly not us, myself and this Sarah Michaelis, inventory number so and so, and not these naked-ass employees, all pederasts with one another ... –the director would get a thrashing, our Prof. Dr. Wondratschek. He is barely hanging on – has already reached retirement age –, and has not even joined the party. The greatest mystery is why they ever chose him. There must have been a hand looking out for him in high places, which is now gone. Nothing to be done about it, Mr. Professor, new times, new hands...

In the order of their appearance: Frank Wolf Matthies, Günther Weisenborn, Harun Farocki quoting Joseph Weizenbaum, Rolf Eckart John, Arnold Schönberg, Nikita Chruschtschow, Marianne Herzog, Matthias "BAADER" Holst, Oleg Jurjev.

Heracles' Cave – War of the Viruses

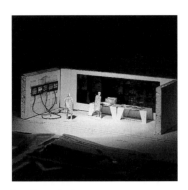

Lutz Dammbeck
Model for *Heracles Concept,* 1997
Laboratory situation

1 Doctors and natural scientists, infected with general progress euphoria, sang: "... colleagues, to the merry war/with the bacteria, – victory beckons!" (Song book for German doctors and natural scientists, 1892.) Compare: Christoph Gradmann, "Bazillen, Krankheit und Krieg. Bakteriologie und politische Sprache im deutschen Kaiserreich", *Berichte zur Wissenschaftsgeschichte,* 19 (Weinheim, 1996).

2 Compare: Eberhard Jäckel / Annette Kuhn, eds., *Hitler* (Stuttgart, 1980).

3 Lutz Dammbeck, *Konzeptpapier zur Installation,* 1997.

4 Lutz Dammbeck, *Konzeptpapier zur Installation,* 1997.

5 Joachim Riedl, "Von der Freiheit der Migranten", *profil extra* (February, 1997), 31.

6 See Peter Ulrich Hein, *Die Brücke ins Geisterreich. Künstlerische Avantgarde zwischen Kulturkritik und Faschismus* (Reinbek bei Hamburg, 1992).

7 Quoted from: "Now, you are on your own, boys ..." A conversation between Lutz Dammbeck and Eckhart Gillen, *21 – was nun? Zwei Jahrzehnte Neue Gesellschaft für bildende Kunst* (Berlin, 1990), 54.

When Modernism, state hygiene control guarded over public cleanliness and order in the spirit of Enlightenment. Microbes were fought vigorously as if they were bandits. War was declared against the microorganisms invisible to the naked eye.[1] It was only a small step from the personalization of bacteria as enemies to be fought to the projection of these disease-causing agents onto minorities and political enemies. Social Darwinism ("survival of the fittest") and racism joined hands at the same time as bacteriology developed as a field of study. Hitler seized on these verbal extermination fantasies and carried them out with deadly consequences. He announced as early as August 7, 1920: "Do not think that you can fight a disease (author's note – he meant the Jewish mind) without killing its pathogen, without destroying the bacillus. And do not think that you can fight the racial tuberculosis without making sure that the Folk are free of the racial tuberculosis pathogen. The effects of Judaism will never disappear as long as the pathogen – the Jew – is not removed from our midst."[2]

Lutz Dammbeck had arranged a laboratory situation in the exhibition "Deutschlandbilder". The cave of some kind of computer freak, equiped with PC, printer, and Internet connection, follows in the tradition of the alchemist's kitchen, Faust's study, the atelier of the artist engineer and designer of a new society. The exhibition visitor finds a WORLD FORMULA on the hard disk which "simulates the unlimited access to the collective genetic material. Theoretically, it makes possible the planning of new peoples without long periods of evolution and the time factor of history."[3] From the material offered, the player can put together what he or she needs: identities, cultures, peoples. Having taken on the role of demiurge one has to decide: "WHAT do you want to be? WHO do you want to be? Respectively, WHAT/WHO do you not want to be?[4] Illuminated boxes project photo transparencies, complementing the laboratory situation with profiles from the Modern (See fig. 414, p. 464f.): The building plan of a virus, the schema of nomad trains, outlines of the Goetheanum in Dornach, of a supermarket, of airports, a Corbusier living cell, the Monte Verita settlement plan, etc. The construction of an idea, of a world (Roman Empire, Occident), dissolves in the principle of nomadization. Despite the world-wide networking through the Internet, globalization and the world market determine thought in the different camps of the "global players": Those settled down are played off against the nomads, multicultural "mixing" against "purity" ("ethnic cleansing"), "natural hierarchies and cultural characteristic against the global nomadism of the Modern: "What do you want to click on?"

The Jewish philospher of communication, Vilem Flusser, who was born 1920 in Prague and brought up speaking German, emigrated via London to Brazil. There he took part in the attempt to develop a Brazilian identity. After the project failed he arrived at the insight: "Those driven out are uprooted people who try to uproot everything around them in order to be able to take root." "Homeland" is not an eternal value, but rather a function which that humanity would demand from the settled form of existence necessary for agriculture and industry. "Liberated" from the global modernization to the nomad existence, the emigrants recognized themselves "as outposts of the future".[5]

An additional element of the installation are the video monitors, which demonstrate the simultaneity of the most heterogeneous designs by showing assembled sequences of images from an international art market. Art of the Modern goes in circles. It was itself deeply entangled and interwoven with the "Geisterreich"[6] of the esoteric, escapist, and utopic movements of this century. Art led a nomadic existence between the longing for identity and the expression of the non-identity felt by the artist him/herself.

Lutz Dammbeck amuses himself with the modern magician's apprentice's unbroken belief that the world can be ruled by an all-explaining formula. At the same time, he is disturbed by the inability to deal with the not-identical. He started working on his *Heracles Concept* in Leipzig 1982. It's a kind of media collage that reflects the tabooized functioning of certain structures at numerous levels of time. Concept pairs such as obstinacy and punishment, tactic and unreasonableness, turn up again and again as leitmotifs. A point of departure is the Brothers Grimm's black pedagogy in their fairytale "The Stubbornness of the Child". The stubbornness of the child is punished with death as the failed teacher's last resort. This educational method ended in Auschwitz and in the Gulag: "In Auschwitz, the Modern comes into its own," said one of the speakers in his new film.

Dammbeck's *Experimental Arrangements,* built at the end of the 1980's in Hamburg from identikit pictures of BKA vision mixing which was developed for hunting terrorists, uses his own childhood portrait as starting material for trying out role models. "In the meantime, we know quite well that we basically are not different from our parents and we become more and more mistrustful of ourselves. The material that you collect betrays very simply that you are jeopardized."[7]

Eckhart Gillen

414 **Lutz Dammbeck**
Heracles Concept: War of the Viruses, 1996/97
Fluorescent wall, acrylic glass, fluorescent tubes, slides,
monitor and recorder with automatic rewind built into
the wall, fax machine, printer, computer, telephone
Room: approx. 3.90 x 10 m
Wall: 6 x 2 m
Collection of the artist

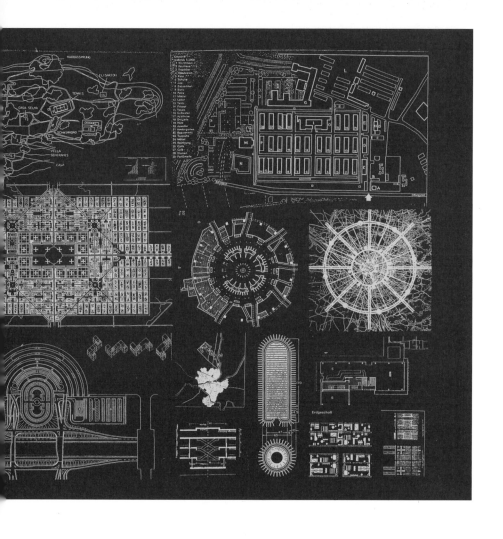

$$+\left[\substack{SMR\\pq}(X,Y)\substack{:\alpha\beta\gamma\\r}(g,t)\right]$$

DAS INTERIM VERFLACHT DAMIT
VERBINDET SICH FELLACHISIE-
RUNG EIN DASEIN OHNE HISTO-
RISCHES BEWUSSTSEIN UND
HÖHEREN ANSPRUCH. MAN LEBT
FÜR DEN TAG.

ERNST JÜNGER

The Film Diary "Bildersturm"

November 14, 1995, Hamburg.
I'm working on the finishing touches of my documentary film *Dürer's Heirs*. The filmmaker B. comes into the editing room with a text he got from the painter Arnulf Rainer in Vienna. A 17-page "confession", anonymously sent in an envelope from the "Institut für Gegenwartskunst", to Arnulf Rainer and several other residents of Vienna in 1995.
B:... Rainer thinks that the text is from the right, but he can't decipher some parts of it, neither can other specialists he'd consulted. Didn't I make a film about Breker, so I must know something about the right-wingers, right? Why don't I just take a look at it, maybe I can find something that would point to a possible author or group of authors.
To recall: In September 1994, Rainer's art dealer, W., informed the police that unknown persons had destroyed paintings valuing up to ca. 25 million Austrian shillings in Rainer's atelier in the Academy on Schillerplatz by "completely covering them with black paint, sometimes painting things in with different colors."

The scene of the crime: the Vienna Academy

Rainer, the police and the media start the hunt for the "Phantom of Vienna", but certain members of the press and the art scene agree: it's Rainer.
Shocked and injured, Rainer suffers a stroke, and bitterly leaves the academy just before being granted emeritus status. The culprits have not been found to this day.
The copy of the "confession" in my possession is full of allusions, quotes and references, from Buber, Benjamin and Raimundus Lullus, right up to Worringer ... bewildering, interesting, but is it really a "national Sanskrit"? Definitely a text against the "modern", but too long for an anti-modern "manifesto". Spontaneous reaction after the first reading: definitely film material.

In the text, the author claims to have painted over Rainer's pictures. Are the *Übermaler* and "author" really identical? Or is the author just along for the ride? Strange, the fax identification "meyer" at the top of the text's first page. Rainer and his art dealer had it checked out, and it's a fake. So who's "meyer"?

September 10, 1996, first visit, with B., to Arnulf Rainer's home in Enzenkirchen. He lives and works with his family on a former farm just beyond the border: "because it's close to Germany and the collectors and sales are there," says B. Conversation with B. and Rainer in one of the farmhouse's rustic rooms, antlers on the wall, a Christ on the cross—not painted over.

Arnulf Rainer in Enzenkirchen, 1996

Yes, Rainer would be interested in a film about the case and is willing to support the project, but not with money, that I'll have to find elsewhere, how about trying the Austrian Broadcasting Corporation ... "You know who it was?" He doesn't look at me directly while speaking, talks fast and at length about the case, his theories and suspicions about various possible culprits. You know Christian B.-E.? No. Used to be one of his students, talented, came to him on Weibel's recommendation. Identified as a suspect, shot himself in March 1996. In the same house and in a similar manner as one of his heroes, Otto Weininger.
Belonged to the milieu surrounding the Freiheitliche Partei Österreichs (FPÖ) and to a circle of young dandies fascinated with Jünger and everything military, Mishima and the New Right.
"You know 'Aula'?" (central press organ of the fraternities and German nationalists of the old

Grammelknödel and Grüner Veltliner

school). "No." "*Ja,* you don't know our rightists at all, don't have the slightest idea what the right-wing scene in Austria is about. You absolutely have to read 'Aula'!" Rainer appears worried. Gives me tips: just go to the National Library, they have it there.
We reach an agreement: I'll investigate on my own, make some contacts in the milieu where he, and some of the press, presume the culprits and the authors of the "confession" to be. B. admonishes Rainer with a serious expression and urgent words not to spread this around, because: dangerous ... keep it absolutely secret (which will be difficult, if not impossible, in Vienna). Conspiratorial atmosphere, a touch of *The Third Man*. Dinner at a country inn, Grammelknödel and Grüner Veltliner.

September 25, 1996, Hamburg. Meeting with Mr. O., at the suggestion of the Hamburg filmmaker C.: O. is supposedly the "rightest" person I can talk to in Hamburg.
O. was born in Dresden, went to school in Leipzig and then to jail for trying to escape the country, studied in Hamburg, and became the instructor for Marxism and Leninism in the local Sozialistischer Deutscher Studentenbund (SDS). Belonged to the "Faction of GDR-children (versus the Nazi-children in the SDS)". Then came the Mussolini Syndrome: from Left to Right. According to a 1995 internal security report, one of the "intellectualizers of the right-wing scene". Personally, he sees himself as a Marxist and a member of the national opposition. Lives in a red-brick settlement area in Hamburg-Barmbek, typical university lecturer. The apartment: two rooms, kitchen, small hallway. Paintings by Werner Tübke and Horst Janssen on the walls.
O. is the author of several books and a member of the Hegel Society. The ambiance and O. have a whiff of isolation and futility—like in quarantines.
O. takes a look at the "confession" text. Laughs: yes, altogether the operation and the text remind him of what he was always preaching in lectures in Vienna: rather than "mutilating yourself" in the bloody fencing of the fraternities, an *action directe* in the style of the left-wing '68 *Spaßguerilla*. Nevertheless, for him, still a frustrated style, maybe because of all those doctoral candidates who've been around too long, reminds him of H. in Bonn. H. is the editor of the magazine "Etappe" (the central publication of the "Schmittians"). In the text's uncompromising criticism of the modern, he sees similarites to his own position. For him, the agenda is: a new order, Hegel's philosophy of law and Bismarck's Reich its only possible basis, also Marx and German idealism.
As for art: the ideal had been reached by antiquity, see Hegel's dictum "the end of Art". He lets Janssen, Tübke and Dali pass.
He sees himself as a "dragon slayer" of a modern age that destroys Western civilization with its corruption of its cultural concepts. Modern is for him neolithic counterrevolution and global nomadism. Historically: the high culture of Bismarck's

empire versus lower powers, with the assistance of the Jews, who, like bacteria, bring into motion the process of destruction and disintegration. Enquiry: bacteria? Or viruses? Conversation about viruses and bacteria, plagues, hygiene, infection.

Are the confession and the painting campaign a "cultural element of the people in the genome of modernity"? Interesting, yes, could be.

But then, everything goes up in smoke anyway, a complete triumph for modernity, with its weapon of racial interbreeding, a multicultural Europe and a nomadic world order based on the American model ... nothing left but a pile of ashes ... but then there'll be a new beginning, a *IV. Reich*, he's ready for it, working on ideas ... Vienna will be its cultu-

EuroCity train Hamburg-Vienna

ral, Berlin its political and Zurich its financial capital ... once again, the preview will be in Vienna, the insignia of the *Reich* are there in the Hofburg, the scepter and the starry cloak of the German emperor ... It's a world-power myth, Herr Dammbeck, it has to be a *REICH*, not just a STATE. He works himself into euphoria, gets excited, louder.

I suddenly can't help thinking that O. is being watched, as he said himself, by the internal security agency. And thinking of viral things: infecting, contagious ... at what point does the intellectual discourse become justifiable? So, Mr. Dammbeck, M. in Vienna can surely help you further. M. supposedly the *éminence grise* of the FPÖ, a national adviser to parliament, former chief ideologue and intellectual forerunner to Haider, but with the FPÖ's late yuppification and coalition politics, it's not his moment, so lately he's in the background. Say hi to him from me.

The treasury of the Vienna Hofburg: Insignia of the Reich

February 22, 1996, travel from Altona to Vienna in a sleeping car of the EuroCity train "Hans Albers". Chance meeting with the Vienna filmmaker M. on the platform, coming in on the same train from Braunschweig, where she has a guest professorship in Experimental Film.

Café "Rosenkavalier" in West Station, large *Brauner* coffee with milk, cream cheese strudel. Mara is skeptical about my project: "You don't know Vienna, it's a snake pit ..." She thinks Rainer is a macho.

According to her he separated the "boys and girls" in his class at the Art Academy so that the girls wouldn't be influenced by the guys' aggressive painting. Women have their own aesthetic, he said. The senior female students decided which guys would be accepted. M. sees it as a consequence of the NAPOLA, where Rainer was for four years. No chance that he painted over his own pictures; too stingy for that.

The Academy, *genius loci:* Otto Mühl made two 8mm Hitler films in the seventies with child actors from the Friedrichshof commune. Hitler returns to Vienna and is accepted at the Academy, from artist to politician and back.

Afterwards a taxi to Café Salgries, meeting with the journalist Z. He considers the "Rainer case" unfinished business. First of all, nobody stands to gain, the paintings in the Academy were uninsured so there were no damage claims. The police were helpless and out of their league, having to distinguish between Rainer's "real" black painting and the "fake" black painting of the culprits. Rainer was in the media every day, the free publicity bothered a lot of folks in Vienna and led the police to suspect that Rainer and his management wanted to "initiate a new development in the art market." The confession changes things, though.

Z. sees a connection to the confession letters of the mail bombings. In the Oberwart bombing (four gypsies blasted to bits), there was a scrawled tablet with similarities to the text written on one of the defaced paintings in the Rainer case: UND DA BESCHLOSS ER AKTIONIST ZU SEIN—a paraphrase of a Hitler quotation from *Mein Kampf?*

Z. is familiar with the group surrounding B.-E., all of which are in their mid-twenties, call themselves the "Conservative Club", and perceive themselves as a new elite. B.-E. was their idol, they visited Ernst Jünger together, organized a military church service on the first anniversary of B.-E.'s death. Dreams of a new concept of art, one that combines politics, aesthetics and feeling, a "modernity from the Right", seeking their "Stahlgewitter" and freedom at rave parties and in techno music in the Vienna Gasometer. A reclusive group, don't let anyone near them. As preparation, Z. suggests I contact the Austrian Resistance Archive. There, nice people, lots of gray papers, mountains of copies of the "opponent's" books and articles. Well organized, they seem to live in close symbiosis with their "opponent". I make myself copies of material on B.-E., he

wrote for the *Junge Freiheit Österreich* under the pseudonym "Resita Trenck". In a lecture at a 1991 symposium at the School of Applied Art, he ascribed Concept Art to Hitler and his work.

The halls of the archive are bustling, in two days the fraternities are holding a festive convention at the Vienna Hofburg: "1000 Years of Austria", put on by the "3rd camp", 3000 fraternity members from German-speaking countries are expected. In the Resistance Archive, plans are being spun for an opposition demonstration, "hopefully the autonomous Germans will come, otherwise it'll be bad ... "

Afternoon meeting with H. of the magazine "news", he's written numerous articles about the case. H. is a big, sluggish reptile, eyes half-closed as he listens and speaks. Vending machine coffee. He considers himself a leftist, wanted to help Rainer because a lot of people in Vienna thought he was the one behind it. An informant contacted H., some guy "meyer", whose identity, however, he doesn't want to reveal. "meyer" apparently stands for "meyer & meyer" = Vienna Intelligence Agency, a fictive American-Jewish detective agency who provided the "news" (circulation: 326,000) and the police with cassettes and inside tips from the Academy about the case. The material made the Academy look like a virulent right-wing nest, with neo-Nazi students in Jewish professors' classes, painting girls from the Bund Deutscher Mädchen and writing letters to right-wing politicians, publishers, etc. He, H., still doesn't understand it all. "meyer" was calling him all the time, Rainer also provided him with information and kept the thing going. It all led to nothing, though. After a while he decided the Academy was a nuthouse and lost interest in the case.

It looked to him as though someone was using the press, the police and the media for some kind of obscure game. Maybe even our conversation and my investigations are a calculated part of the game. The whole thing a *"Gesamtkunstwerk"?* The sum of calculated and intended effects?

May 16, 1996. Vienna. Café Schwarzenberg, meeting with M., mobile phone, suit, blue seal ring. On his right cheek a fencing slash (quarte). M. is a frat brother, a legal historian and the co-editor of "Junge Freiheit." Newsstand sales: 1,000 issues.

The hand of Vienna's Mayor Zilk after the BBA's letter bomb attack, 1996

He's just arriving from an auction at Sotheby's, dabbles in art with his brother-in-law, as a silent partner. Wigele, Kolik, Nötscher Circle, classical modernism ... "you can't make a living from the "Junge Freiheit", Mr. Dammbeck." First small talk. How was the trip, how did you hook up with O., what can I do for you? Oh yeah, questions and problems of the modern age. Vienna, yeah, yeah, I see, interesting.

Suggests people to talk to, names names, phone numbers, his mobile phone rings every 40 seconds. He doesn't want to say anything about the confession yet, but just ask yourself, who wins, which milieu profits? Maybe the thing is a sign of a paradigm shift in views and relations to modernity.

Lutz Dammbeck, Bildmischer LKA NRW, 1988 (I- II), variation 1

"Furthermore, Mr. Dammbeck, the Right is generally overrated." Laughs.
A man in a dark suit walks by, M. greets him fawningly, introduces me:
"A filmmaker from Germany, he's got a really interesting project here ..."
The man is Dr. H., a prominent Right-wing lawyer, and like M., every first Wednesday of the month a guest at a meeting of Right intellectuals in the Jockey Club, initiated by an ex-colonel of the Austrian Armed Forces, G.
His son also belongs to the circle around B.-E., who worked off and on in Dr. H's law office. Later, B.-E. was a personal assistant to M. in the FPÖ's educational program, "a talented boy, too bad he had such a tragic end, eaten up with Ectasy and plagued by hallucinations." Near the end, he thought he was being followed by Jews, Communists and Freemasons, barricaded himself in his apartment with sharp weapons, claimed to have material on a "world formula". On the day he died he was on the phone with his girlfriend for four hours: scared, at 12:00 THEY are coming. At exactly 12 o'clock he filled his mouth with water and shot himself in the mouth with a rifle, an old imperial-and-royal officers' ritual. His head was blown off his body like a pumpkin. When further questioned, M. suddenly becomes distanced and stonewalls.
Yes, Mr. Dammbeck, keep Austria's special situation in mind, the tense relations between the metropolis Vienna and the surrounding area. Intellectuals live in the metro area, "noble people", out in the country you have the "waiters, elevator boys and folk-dancing fools". When somebody comes to the city from the country (like Rainer did in 1948), he conforms, he bows to the pressure. Rainer's family, gentlemen farmers from Kärnten, had very national-socialistic views during the Third Reich. The farm was named RAINERMENTE. It's still there today.
Great, what are you doing now? Going to the Jewish Museum. Interesting. I have a little time. I'll take you there.
Tour of the city with M.: this is where Hitler spoke from the window of the hotel, here, look, the Hrdlicka monument, the Japanese always sit on the back of the scrubbing Jew to have their picture taken. That's why there's barbed wire on the back. At the entrance of the Jewish Museum, M. is recognized. The director and three bodyguards (from Mossaud, whispers M.) appear. The director is short, serious and very polite. Offers to show us through. Uncertainty on both sides.
M. requests press material on the exhibit, thanks him for the offer of a tour, "we'll find our way." In the center of the exhibit is an installation: "The flying Herzl-Room", with a portrait of Max Nordaus. M. lectures about Herzl's membership in the Viennese fraternity "Albia". Herzl's idea of a "new Jewish empire" and the outline of the plan for the Zionistic State were supposedly influenced by fraternity thinking and values. Music from Richard Wagner is playing in the background, a recording of "Chor der Älteren Pilger" at the 2. Zionist Congress, Vienna 1898. I say goodbye to M., attentively ogled by the bodyguards. M. suggests that I contact D. in Klagenfurt.

June 9, 1996, appointment with H. from Bonn. He's analyzed the text and made notes. Is also ready to talk to me briefly.
Agreed meeting place: Cologne's central station, by the potato-pancake stand in front of the cathedral square.
H. appears in a blue windbreaker, with a briefcase and a folder under his arm. Gives me a copy of the text with pasted-on notes. We talk standing among the alcoholized bums in the bustle around the fast-food stand on the square in front of the train station. His analysis: an interesting text, not written within a week. Certainly, the author wants to free himself of pathological pressure but is also looking for discussion. Doesn't see Rainer as a prisoner to be reeducated (blotted out), destroyed but wants to step into the context of Rainer's art, "touch" him. Come to your senses! Better yourself! The author is actually quite close to what he's attacking.
A monologue? Could even be an "antimodern modernist" who doesn't feel comfortable in the present, wishing himself away from it. Age over 50, solitary, well versed in media reactions and perfectly informed on inside information from the Academy and the Vienna art scene, might even himself be from that sphere.
The author polemicizes against a modern age that dissolves substance, values and the line of tradition. H., too, sees art as transporting truth beyond the centuries. Truth lies in tradition, and Rainer interrupts the chain.
On the other hand, one can't just drop out of the modern age, it's always happening.
Question: Kaiser Karl's white elephant, for example, was that "modern", too?
Yes, even the white elephant of Kaiser Karl in Aachen was "modern", ninth century "Carolingian modern". Just look at the tomb of the Kaiser's children in Lorch, Oriental patterns and ornaments, these artists were no Teutons or Franks.
Anyway, the white elephant is also a symbol for the power of the state and the idea of the empire, you can read about in C. Schmitt's "Land and Sea", but we're getting off the topic, back to your text: Interesting, he finds, is the series of quotations, which refer to an undefined area, a publisher from the old-left 68ers in Munich, for example, that in the meantime has gone under ... "you leftist-Pandora's box ... etc." even S. from Vienna is quoted: "... the Beautiful is experimental proof that becoming human is possible ..."
S., along with Dr. B. from Munich, is editor of the magazine "TUMULT", for which Bazon Brock, Paul Virilio, Jean Baudrillard and Dr. K. from Salzburg also write. Oh, you absolutely have to talk to Dr. K., a phenomenon, came from a very simple background and developed into a philosopher ... well, unfortunately he has to get going. If anything else occurs to him, he'll get in touch.
Return trip from Cologne central station to Hamburg-Altona with the InterCity train "Ingeborg Bachmann".
It's "Austrian Week" in the restaurant car. I order a Kärntner snack plate and Grüner Veltliner.

Lutz Dammbeck

FLATZ: Hitler in Good Hands[1]

Since 1991 Hitler has become a dog following at the heals of his "Führer" FLATZ. Applied to such a historical object, this form of sinister humor reaches the boundaries of tastelessness. However, beyond a mere provocative gesture as a conscious artistic strategy, it can lead to a renewed confrontation.

According to the artist's own definition of his program, art should be concerned with "what breaks norms and taboos, with repression, and with the resulting deficits and obstructions."[2] In the mid-eighties the abbreviation "FLATZ" became a symbol of this approach. In order to break the borders of the "padded cell" of the art market, FLATZ brought to bear the strategic means of constructive provocation - standing in the tradition of the 1960's - and vitalizing the form of Conceptual Art through the concrete socio-political dimension of his work.[3] The attempt to address the fascist past, and its continuities with the present, obligates the viewer to take his or her own position and is a constant in his aesthetic production. In the center of this work with repressed history and ideology stands the person of Adolf Hitler as a representative figure of National Socialism. Already in 1976 with the 19-part series *Two Austrians Or History Determines Interpretation,* FLATZ began to work with this icon of evil.[4] Originally unauthorized pictures of Hitler are placed next to pictures of the artist mimicking his fatuous gestures. As background for the montage, he selected a colorful Formica surface on which the photos are mounted in pairs. The arrangement is a testament to the possibilities for manipulation and control through visual media, which played a major role in the creation of the "Führer Myth," while at the same time actualizing the historical problematic by directing the viewers attention to the artist.[5]

The artist has met the problems of habituation and desensitization by continually increasing and actualizing the dose of provocation. Accordingly, in 1990 the concept *Hitler - A Dog's Life* came into being. In 1991 the artist became the owner of a mastiff, considered among dog breeders to be the "Aryan" among breeds, and which, as a living sculpture, carried the name "Hitler". Again encroaching on the border between art and life, the dog has been the object not only of repeated photographic works by the artist, but cuts into daily life as well, for example in the identification-tags that were prepared for the documenta exhibition with the name "Hitler", or whenever "Hitler" and his "Führer" FLATZ are engaged for theater or for advertising work.

The gold framed photos of "Hitler," with their engraved metal plaques, move in the realm of tense ambivalence between historical allusion and apparently thoughtless platitude. Analogously, the photos range technically from the blurred snapshot for the family album, to the consciously staged. These works build a concrete discourse on the themes of sign, image, and code.

In 1996 the book "Hitler - A Dogs Life" appeared, consisting of a complex collage of these photographs, texts, and other documents that integrate in the most subtly different contexts, material ranging from society, politics, and economy, to art history.[6] The "comic" writ large is a brazen attack on the continuing integrity of the historical figure and the continuity of fascist thinking, which comes like a sudden liberation without loss of memory. In the simultaneously banal and provocative form of the man made animal, history is brought up close for those who were left ignorant by virtue of late birth.[7] A comparison can be made with the technique of the American photo-artist William Wegman, who since the end of the seventies has portrayed his hunting dogs as human on shinny finished photo paper: "a self-assertion of humanity through self-assertion of the dog," as Heinz-Norbert Jocks put it in his essay on the relevance of comics.[8] The typically human sinks to the level of bare animality. It is not without reason that in C. G. Jung's dream interpretation the dog is the symbol of compulsion. While Wegman presents his dogs with clothing and accessories, FLATZ adamantly concentrates on the historically problematic figure, which the mastiff as namesake constantly makes present.

In the next step, the image of the dog is replaced by the real object and his surroundings. A planned second "Hitler" volume is to be composed entirely of computer animated material, renewing, in the age of virtual reality, a critical discourse on the deceptive effects of the visual image and the malleability of the viewer, far from the level of a purely theoretical and abstract reflection.

Diana Ebster

1 The title of a photographic work from 1991 showing FLATZ with the young "Hitler"; see picture in: FLATZ, *Hitler - Ein Hundeleben. Akte I: Der Junge Hitler* (1990-1996), ed. by the Kunstverein Rosenheim, (Ostfildern, 1996), 102.

2 "Wirkung jenseits der Fünf-Prozent-Klausel". A discussion with Rainer Metzger, in: FLATZ, *Strategien über Kunst und Gesellschaft* (Regensburg, 1994): 52-61; 54.

3 Problems concerning a "public" reception of historically "provocative" works can be well observed in the FLATZ work *Bic light* (1993). For documentation see: Diana Ebster, *Werbung für Nazis - Zur Kritik eines 'spekulativen Umgangs' mit faschistischer Ästhetik,* to appear in 1997.

4 See *"Zwei Österreicher oder Geschichte bedingt Interpretation"* (1976-80), in: *Arbeit in Geschichte - Geschichte in Arbeit,* ed. Georg Bussman, exhibition catalog Kunsthaus und Kunstverein Hamburg (Berlin, 1988), 136f.

5 The exhibition of Rudolf Herz in the Stadtmuseum München "Hitler & Hoffmann" shows this clearly. See *Hitler & Hoffmann. Fotografie als Medium des Hitler-Mythos,* exhibition catalog, Stadtmuseum München (Munich, 1994).

6 FLATZ, 1996.

7 In association the viewer may be reminded of Art Spiegelmans Comic *Maus - A Survivor's Tale* (New York, 1986).

8 Heinz-Norbert Jocks, "Das amerikanische Lachen oder vom Nutzen und Nachteil der Komik für das Leben", *Kunstforum International,* vol. 121, 64-120; 68.

415-438 **FLATZ**
Hitler – A Dog's Life, Akte I,
The Young Hitler (1990-1996)
24 photos, each 23 x 18 cm
Brass plaques, each 4 x 10 cm
Collection of the artist

415 *Hitler with Goebbels in tow,* 1993

416 *Hitler in Front of the Guest House on the Obersalzberg,* 1993

417 *Hitler's Yearning Glance Towards Austria,* 1992

418 *Hitler on the Way to Seizing Power,* 1993

419 *Hitler in Fine Society,* 1994

420 *Hitler and noble fabric (Edelstoff),* 1991

421 *Hitler gets Fucked,* 1993

422 *Hitler Suffers from One of His Usual Epileptic Fits,* 1992

423 *Hitler has Hiccups,* 1992

424 *Hitler and Germany,* 1992

425 *Hitler Decides to Build the Volkswagen,* 1991

426 *Hitler Observes the Progress of the Building of the German Autobahn,* 1992

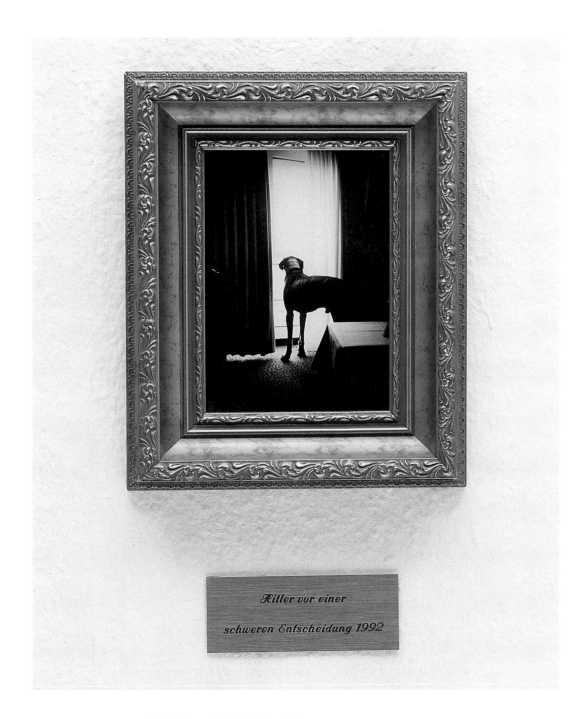

427 *Hitler Before a Difficult Decision*, 1992

428 *Hitler After the Inspection of Blast Furnaces at the Krupp Steel Forge*, 1993

429 *Hitler on the River of Banks*, 1993

430 *Hitler Invents Social Housing*, 1993

431 *Hitler Inspects an Exemplary Camouflaged Combat Tank*, 1995

432 *Hitler's First Speech to the German Motor Industry*, 1991

433 *Hitler Visits the IG-Farben*, 1992

434 *Hitler in the Forest before Stalingrad*, 1992

435 *Hitler Doesn't understand People*, 1992

436 *Hitler Tells Dirty Jokes to His Bodyguards*, 1995

437 *Hitler and His Babysitters*, 1993

438 *Hitler and His Führer*, 1991

To Matti Braun.
Not This Way.

All of a sudden it happened. Finally it was done. Preparations were made, and over with, without our having had, or perhaps I should say having been permitted, to experience such a surprise.

We are talking about a work of art which in its absence, is present – about reality and virtuality - at one and the same time, about the point culminating in confrontation, which, if it's okay, will be briefly postponed.

Matti Braun, who grew up in the reform-happy 70's, cast his glance at the newly camouflaged structures of old doctrinaire gullibility and scored a direct hit. A break with the evil fathers of repression is not a topic which he was close to. "Hunting for Terrorists" could have been a game that he played at elementary school during recess. Substantively and formally, here there was no question, we warmly greeted this work, which was a book, even though we decided, despite its dense coherence, not to show it. Why this?, asks the art historian and critical critic, still thinking idealistically. Can a work really be good but nevertheless not suitable for discussion? And can an exhibition do without a contribution, which achieves exactly that which one can only wish from art – expansion and transgression of boundaries, and controversy. Are we finally tired, after years of staring at our navels, of a German disposition? Of course this is just what we asked ourselves.

The discussion moved to a new level. An artwork which in a biotope of art experts and practiced discussants takes over the function of experiment, can easily run up against itself in a larger public. The passionless comparison that characterizes Matti Braun's work, evokes even in the most intimate circles controversial discussion. This work, in its unspectacular appearance has given rise to extreme polarization everywhere it has been shown. In the anonymous framework of reception, which an exhi-

bition of this size necessarily has to offer - and here we damage all those involved including their artworks - the actually developmental and thereby interesting component, an exchange of ideas and opinions, is missing. We must therefore, regrettably, forego a public presentation

of this "Ride across Lake Constance". A shame too, but just ask at your local dealer.

Regina Schultz-Zobrist

439 **Matti Braun**
Sofa, armchair, stool and book, 1996/97
Glass fibre fortified polyester
Sofa: 230 x 140 x 75 cm
Armchair: Ø 117 cm, height 75 cm
Stool: Ø 107 cm, height 39 cm

Print and Double Print:
Felix Droese's Graphic Series
"The Doubled Center"

"Morever, the navel is the central part of the body. Namely, if a person lies on his back with arms and legs spread, and you put the needle of a compass at the place where the navel is found and make a circle, it touches the finger-tips of each hand and the tips of the toes. Just as a circle can be made of the body, so can the shape of a square be found in it. If one measures from the soles of the feet to the top of the head, and applies this measurement to the extended arms, it yields the same width and height as planes that have been drawn according to square."
Vitruvius, On Architecture

Felix Droese's print series *Der doppelte Mittelpunkt (The Double Center)* was conceived largely in the course of 1989, a few individual prints followed in 1990. It is comprised of more than 78 works and includes wood block and silkscreen printing on diverse materials, mostly various papers, oftentimes news print, in different paints and colors.[1] Every print is a singular event. No further editions of the series exist. Its distinguishing feature is a "trademark" printing plate that Droese had completed in 1988 from a cross section of tree trunk.[2] A segment of a circle formed by a dwindling crack in the wood, the latter compressed to form a gentle oval, provided a natural *Vor-Bild* (first model): First, around a hole in the wood's center, a circle was cut with a V-tool enclosing the segment, around this aureole a square was drawn. Finally, joining the first hole with a further one,[3] Droese transformed the center into a double locus, *The Doubled Center*. Circle and square are cut free-hand into the wood and clearly imprinted on its grained surface. While the engraved circle concentrically follows the tree's rings, the square is positioned in opposition to the tree's naturally unfolding geometry cutting through the original structure. The diagram is modeled after Leonardo's proportional schema in the famous quill drawing *Homo ad quadratum et ad circulum* which has become a virtual topos—indeed, a cliché. Droese cites the Renaissance motif, first as an ornament, borrowing from it the idea of the doubled center, as Leonardo's version of the Vitruvian man demonstrates, circle and square both have their own center. In one case, it is the navel. In the other, it is somewhat lower, just above the genital area. Leonardo's double center resulted from his critical analysis of antiquity's metrological canon. He set himself the task of finding a contemporary, aesthetic, and accurate standard for the representation of the human body. It clearly deviates from the traditional

schema of the medieval square, no longer forcing circle and square together but distinguishing the two systems after the new anthropometry.[4]

In Droese's version, the naturally formed and artificial-artistic circular models overlap and intersect. Used as printing plates, the combination of forms impresses its image on the paper, evincing the fundamental modal difference between the two linear systems—further emphasized by the cross section's amorphous, frayed periphery. The woodcut was first used as a silkscreen pattern, issued in 1989 as a contribution to the Mönchengladbach Museumverein.[5] With the motif of the tree's geometrically overlapping cross-section, an offset print was created with uncut photographs of the postcard edition *Omnibus für direkte Demokratie in Deutschland.*[6] This campaign was initiated on the occasion of documenta 8 by a circle of friends, among them the artist Johannes Stüttgen. Conceived in 1987 as a political project for both educational and research purposes, and in the spirit of Joseph Beuys' "expanded concept of art," it promoted the idea of democracy as "social art." The omnibus, transformed into a kind of "infomobile," was conceived as a "movable sculpture" and declared a "public work of art," visiting approximately 130 cities within the space of a year. On February 25, 1988, during the Beuys exhibit in the GDR's Academy of the Arts,[7] an attempt failed to cross the East German border with the program-matic vehicle. Initially it allowed to enter the "border area" Invalidenstraße but was stopped and ordered back after proceeding only about 200 meters. The postcard photo shows the "Campaign East/West" at the moment of the bus's exit from the GDR zone, its passage through an extremely narrow opening bristling with traffic lights. Significantly, the traffic light going west is red. In printing the *Doubled Center* over the postcard photo image of the campaign, Droese lends the formerly apparently simple aesthetic construct a pointedly political dimension. Over the documented event of the postcard's photo, he print-ed his "trademark," transforming the representation into a programmatic image. Not only do the two centers, recalling an empty traffic light pushed into the center, represent two opposing political systems both claiming that people are the center of their respective endeavors, or even—in a loose adaptation of Protagoras—that man is the measure of all things. An emblematic image, the political geometry of the clear lines resists the rough, compartmentalized, and somewhat dirty structure of the untreated stamp's surface. Two systems are held up for comparison, but not just in the usual political way, rather, a contrast is drawn between the apparently inviolably valid homomensura pronouncement, along with all the slogans derived from it, and nature's formula of chaos, for which anthropocentrism has no measure. In this sense,

1 In the first exhibition of 1990, the series included 78 prints, but the goal was only an overview not a complete work. Individual prints had already made their way into collectors' hands, and it seems that no record was kept of the series' evolution. See the exhibition catalogs *Felix Droese—Der doppelte Mittelpunkt*, Galerie Siegfried Sander (Kassel, 1990) (with the introduction by the gallery owner), and *Felix Droese—Drucke vom Holz 1984-1993*, Museum Ludwig (Cologne, 1993). In the latter, catalog no. 118, the series is comprised of 44 works. The silkscreens were not included.

2 As Droese reports.

3 See note 1, p. 5, in the exhibition catalog *Felix Droese—Der Doppelte Mittelpunkt*, where Siegfried Sander writes of a slice of wood "with two holes in its center, as can often be found in older or diseased trees." The exhibition catalog *Drucke vom Holz* comments similarly. This might lead to the assumption that nature was responsible for both holes. However, Droese reports having added the second hole himself.

4 Cf. Frank Zöllner's detailed analysis of the proportional figure in *Quellenkritische Studien zur Kunstliteratur im 15. und 16. Jahrhundert* (Worms, 1987), 77ff.

5 Erhard Klein ed., *Felix Droese—Werkverzeichnis der Editionen 1977-1991* (Bonn, 1992), no. 77.

6 Of the respective Droese editions of 1988 and 1990 (E. Klein, nos. 58, 78 and 81). On the campaign, see the documentation *Omnibus für direkte Demokratie in Deutschland—eine Projektbeschreibung*, compiled by Brigitte Kenkers and Herbert Schliffka, (Dusseldorf: Omnibus für direkte Demokratie GmbH, 1989).

7 Josef Beuys, *Frühe Arbeiten aus der Sammlung van der Grinten*, Akademie der Künste der DDR (East Berlin, 1988).

Leonardo da Vinci, Proportional Schema
of the Human Figure, ca. 1490.
Quill drawing with brown ink and silver pen
34.3 x 24.4 cm
Galleria dell' Accademia, Venice

Felix Droese, *The Doubled Center*
1989, wood print, black on white paper
41.5 x 29.5 cm
Collection of the artist

8 Droese, *Der Doppelte Mittelpunkt,* 14,
no. 62.

9 Droese, 21, no. 28.; cf. also 15, no. 30.

10 The printing plate is 29 cm long and 24
cm wide.

11 *Frankfurter Allgemeine Zeitung,* 9/9/1989:
11: "Aufgabe für Herkules" and "Autos mit
Fehlern".

12 *Doubled Center* prints are also to be
found on city maps, artistic prints and illus-
trated broadsheets, as well as on diverse,
unprinted papers and materials—even on a
pair of cotton underwear, for example.

Droese sees *The Doubled Center* as a distinguishing schema, variously historically and systematically encoded aesthetically and artistically, politically and socially, naturally and biologically, an image for labeling our cultural rumblings, and in the act of labeling, the opportunity to question, and in some cases, to markedly stigmatize them.

For Droese, it is primarily the unceasingly appearing daily papers which serve as (print) witness to humankind's self understanding, disseminating and disclosing it. He also saw himself as a chronicler of running events, as in the summer of 1989 he began to mark with his stamp the pages of newspapers dealing with the historical event that ultimately led to the fall and the opening of the Wall. As the political fusion took place, West Germany simulta-neously pursued an economic fusion, namely, the corporate merger between Daimler-Benz, Messerschmidt-Boelkow-Blohm and the Deutsche Bank to form an armaments giant. While the *Frankfurter Allgemeine Zeitung* reports on one page of David's victory over Goliath (the case of the GDR),[8] on another page it describes the "Herculean task" facing the chief executives of the car company (the Daimler-Benz case),[9] employing in both cases nothing less than Biblical and classical mythology. Droese, in contrast, uses the *Doubled Center* emblem to imprint the newspaper pages with his pictorial commen-tary, the wood's massive solidity[10] and heavy opacity covering the patterned filigree of the newspaper's lines and columns. The overlaid stamp, sometimes doubly or triply repeated, creates new connections and contexts, as textual blocks, photos or advertising are absorbed by its contours and brought into tangential contact. With this, the contents of each respective page are newly arranged and specifically marked, as on the previously mentioned page, where the texts in the upper left and that in the lower right are brought into relation by the double, slightly staggered overlay. Two juxtaposed texts, one trumpeting the huge economic success of a West German car company, the other describing the East European automobile industry's miserable failure.[11]

Newspapers of every political color[12] serve as the image's channel of conveyance and the ground for *The Doubled Center: Neues Deutschland* and *die tageszeitung,* the *Hamburger Abendblatt* and the *Algemeen Dagblad,* Der *Morgen* and *De Volkskrant,* the *Moscow News* and *Bild.* Though most of the marked pages are devoted to the subject of German-German unification, Droese is also provided with other points of reference in the form of articles and reports from the realm of "Science and Nature," blocking the print of the respective page and allowing it to continue, but in every case, meeting it with marked commentary.

One might assume that the method of joining, and thus abrogating, substratal (news-) print with overlaid artistic print might quickly lead to mechanical repetition, the stiff re-employment of the selfsame piece of wood allowing only the slightest variation in form and content. But Droese's series proves exactly the opposite. The apparently simple principle makes possible, through the slightest variation and modulation of impression, of color density, and the turning and twisting of the wood, a surprising variety of designs, further augmented by the medium's ever-changing background and basis, and by the calculated coincidences of the printing process. The result is an impressive number of inspiring compositions, all with their starting points in the visually weak graphics of newsprint. Politically poetic images emerge which, firstly and generally, consider the measurability and incommensurability of humankind; furthermore, more specifically, they critically consider a country once again known as simply "Germany," its ecological, economical and political constitution. This Droese expresses not in static, isolated images but in a sequence of impressioned graphic events—at once historical document and artistic monument.

Michael Diers

Thanks to Felix Droese, Mettmann and Siegfried Sander, Kassel, for providing information and materials.

440-463 **Felix Droese**
The Doubled Center, 1990
24 from a total of 78 wood engravings
and silk screen prints on newspapers,
illustrated broadsheets, art prints, city
maps, other papers and one pair of
underpants

440 *Westfälische Rundschau,
Gelsenkirchen 2/28/1952*
Wood engraving and oil paint on
newspaper
51 x 39 cm
Siegfried Sander, Kassel

441 *Neues Deutschland 9/28/1989: 7*
Wood engraving and oil paint on
newspaper, in duplicate
42 x 59.2 cm
Galerie Brigitte Ihsen, Cologne

442 *Neues Deutschland 9/29/1989: 5*
Wood engraving and oil paint on
newspaper
42 x 59 cm
Galerie Brigitte Ihsen, Cologne

443 *Frankfurter Allgemeine Zeitung
9/12/1989: 16/1*
Wood engraving and oil paint on
newspaper, in triplicate
57 x 40 cm
Galerie Brigitte Ihsen, Cologne

444 *tageszeitung 8/25/1989*
Silk screen print on newspaper
31.3 x 46.4 cm
Galerie Bernd Lutze, Friedrichshagen

445 *Neues Deutschland
9/29/1989: 1*
Wood engraving, acrylic on
newspaper
42.2 x 59.2 cm
Galerie Brigitte Ihsen, Cologne

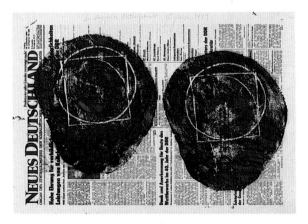

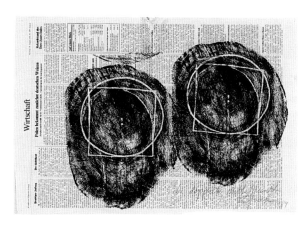

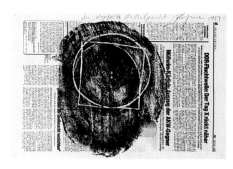

446 *Frankfurter Allgemeine
Zeitung 8/26/1989: 9*
Silk screen print on newspaper,
in duplicate
39.8 x 57 cm
Galerie Bernd Lutze,
Friedrichshafen

447 *tageszeitung 9/1/1989: 4*
Silk screen print on newspaper
31 x 46.8 cm
Galerie Bernd Lutze,
Friedrichshagen

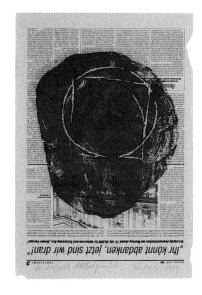

448 *tageszeitung 10/4/1989: 3*
Wood engraving and oil paint
on newspaper
47 x 40 cm
The Jatzke-Wigand Collection

449 *Flying Saucer,* 1989
Wood engraving and oil paint
on collector's color offset
Illustrated broadsheet
42.6 x 30.4 cm
Elena Granda Alonso, Kassel

450 *Underpants,* 1989
Wood engraving and
oil paint on cotton
45 x 55 cm
Galerie Erhard Klein,
Bad Münstereifel

451 *Hamburger Abendblatt,
11/11-12/1989: 5*
Wood engraving and oil
paint on newspaper
57.3 x 40 cm
Museum für moderne Kunst
Weddel

452 *Hamburger Abendblatt*
11/11-12/1989: 11
Wood engraving and oil paint
on newspaper
40 x 47 cm
Collection of the artist

453 *NRC Handelsblatt*
9/11/1989
Wood engraving and oil paint
on newspaper
57 x 41 cm
Collection of the artist

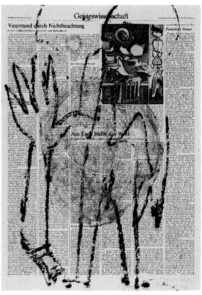

454 *Der Morgen 5/3/1989: 3*
Wood engraving and oil paint
on newspaper
72 x 51 cm
Collection of the artist

455 *Frankfurter Allgemeine*
Zeitung 11/8/1989: 3
Wood engraving and oil paint
on newspaper
39.9 x 57 cm
Collection of the artist

456 *Neues Deutschland*
9/29/1989: 8
Wood engraving and oil paint
on newspaper
42 x 58.5 cm
Collection of the artist

457 *Stars of the 1950's*
(WS-Verlag Wanne-Eickel, 1989)
Wood engraving and oil paint of
the backside of a collector's
offset illustrated broadsheet
46.5 x 32.5 cm
Collection of the artist

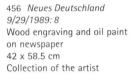

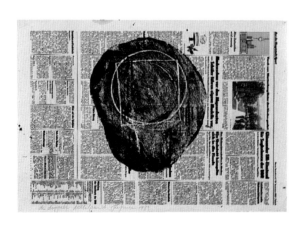

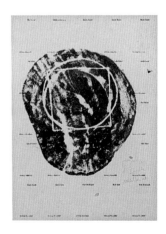

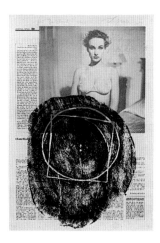

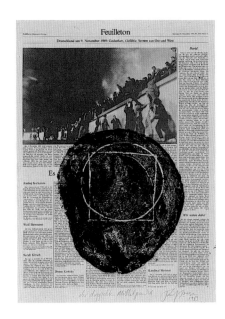

458 *tageszeitung 8/29/1989*
Silk screen print on
newspaper
47 x 31.5 cm
Burkhard Siemsen

459 *Frankfurter Allgemeine
Zeitung 11/11/1989: 27*
Woodprint and oil paint
on newspaper
57 x 40 cm
Collection of the artist

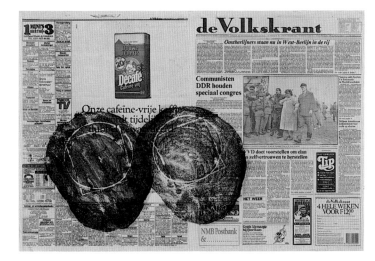

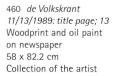

460 *de Volkskrant
11/13/1989: title page; 13*
Woodprint and oil paint
on newspaper
58 x 82.2 cm
Collection of the artist

461 *tageszeitung 8/21/1989:
8–9*
Wood engraving and oil paint
on newspaper
62.8 x 46.6 cm
Collection of the artist

462 *Frankfurter Allgemeine
Zeitung 8/16/1989: N1*
Silk screen print on newspaper,
in duplicate
40 x 57 cm
Galerie Siegfried Sander, Kassel

463 *de Volkskrant 11/11/1989: 7*
Wood engraving and oil paint
on newspaper
43 x 57.9 cm
Galerie Siegfried Sander, Kassel

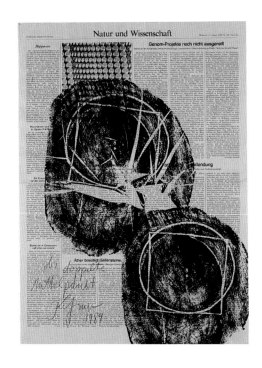

Raffael Rheinsberg:
Broken German

Frottage of the found photograph
Gestern Wunde - heute Narbe (Yesterday
Wounds – Today Scars),
Berlin 1980

Raffael Rheinsberg, *Botschaften*,
(Messages), Berlin 1981

On the floor, in a sense at ones feet, lays a field of about 900 broken East Berlin street signs in a rectangular pattern of 5 x 7 meters. This work is usually exhibited with overhead lighting in the Kunsthalle in Kiel. As a floor-picture, *Broken German* stands in an immediate context with the 1971 paintings *Les Saints de la Mer* by Franz Gertsch which depict in a camera-like manner a tourist paradise that is at one and the same time a pilgrimage site of the Gypsis. Sigmar Polke's *Art Deco* from 1974 connects trivial boredom – the World Cup soccer game on television – with a Far East Asian dream world. Not far away hangs Gerhard Hoehme's wall writing *Jesus, My Faith* from 1962. Between the tourist world at the Gypsie's place of pilgrimage in the province, the ironically trans-figured television world of the good German citizen, and the wall writings with their scribbled texts and signs from an archaic age, belongs the tightly organized floor instal-lation, the letter-wood of Raffael Rheinsberg. As with the Kiel paintings, the sign-mosaics give rise to a new concep-tualization of linguistic and cultural remains in pictorial form. As a tableau, Rheinsberg's *Broken German* from 1993 fulfills all of the criteria that make a material construction an artwork: it preserves the past, interprets the present, and opens consciousness for the future.

In order to crystallize what has been said into an image it is necessary to look more closely at the technical execution of Rheinsberg's work as a whole.

In the following examples we will be concerned with works that, like *Broken German*, were produced in Berlin and can thus seen as precursors. The perception of the immediate environment, an attunement to everyday life, and a capacity to hear the language of things, are the signs under which the early artistic interest of Rheinsberg stands. If in his home city of Kiel Rheinsberg made use of the objects left behind in the abandoned building Sophienblatt 22/24, the objects that demanded his regard, and even love, after moving to Berlin in 1979 are those found on the Anhalter Bahnhof site, an old train station to which he then turned his attention. Here he found materialist history. Also belonging to the found objects is an old billboard which had probably been erected not far from the Berlin Wall. It portrays a cop *(Schupo)* from West Berlin helping a badly wounded refugee, slumped in his arms, over the border obstacles. This photo was mounted on a piece of wood together with another one. It was then used by Rheinsberg as the object of a further work titled *Yesterday Wounds, Today Scars* from 1979, executed in

"rub-through" technique. This image depicts the wall's gruesome consequences for the people. Touching the actually flat surface becomes a helpless attempt at appro-priation, which at the same time produces the closest nearness. The rubbing through of the originally smooth,

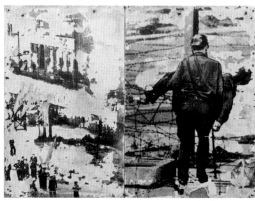

Raffael Rheinsberg, *Gestern Wunde - heute Narbe* (Yesterday Wounds – Today Scars), found photograph, Berlin 1980

but in the meantime damaged, surface which carries the traces of the past becomes a tabula rasa, a Freudian "wonder-block", a miraculous writing machine which registered the existance of another dimension and can be erased by its removal. This frottage is an optical impres-sion of that which is, one that indifferently records all of the unevenness of time and leaves them behind as imprints.

The necessary precondition for the frottage is the assembly, the search for and arrangement of the objects. Shortly after the discovery of the Anhalter Bahnhof, Rheinsberg found the old Danish embassy. It was a villa in the diplomatic district *(Diplomatenviertel)* which had been designed and built by the Nazis, making up a part of the larger Tiergarten area. The powerful old building with its 13 great windows and distinct features was rela-tively intact. Despite the fact that the lower windows had been bricked up, and even though there were police patrols and steel doors, the homeless continued to use the embassy as a sanctuary. Correspondingly, the furni-ture, banisters and railings, wood floors, and the like had been neglected. As in Kiel at the Museum Sophienblatt, Rheinsberg read the passable sculpture as a dust bin of German history. What he found in this container check he displayed in 1992 in the Berlin Museum under the title *Botschaften. Archeology of a War* (trans. note: In German the word Botschaft can mean both "embassy" and "message"). Little remained, for example, the list on the fuse box: Dining Hall, Guest-Rooms, Rotary Iron, etc., and an old sign: "KONGELIG DANSK KONSULT" "KONSULAT DUNSKI", household appliances, and an old portable peattoilet. Another work of the same period closely related to *Botschaften*, reacted, like *Broken German*, to changes,

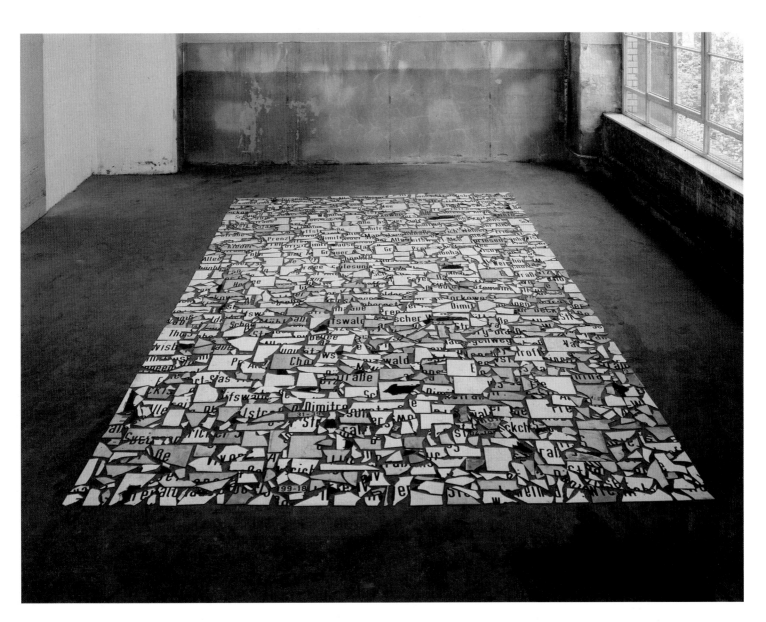

464 **Raffael Rheinsberg**
Broken German, 1993
Floor work: broken up street signs,
objects found in East Berlin
300 x 500 cm
Kunsthalle zu Kiel
(bought with the support of the
Sparkassen- und Giroverband Schleswig-Holstein)

developments and renovations in Berlin. *The City* from 1982 consists of 33 granite stones which had once had their place as curbstones on the edge of streets and had to make way for the modernization measures designed to facilitate even traffic flow through technical improvements. Modern asphalt surfaces allow for a smooth, low-noise, bounce-free ride. Arranged on the edge, the stones bring back the image of a city, that with their removal, one strove to extinguish.

The preservation of the past takes place in Rheinsberg's work not in the form of reconstruction. On the occasion of a joint exhibition with the painter Lilli Engel in the Summer of 1989, Rheinsberg brought the Langemarck Hall of the Olympia Stadium, designed as a holy site in 1936, back to life with a presentation of two large ground installations: *Rust Field* and *Hand and Foot*. While the iron pieces found on the site of Anhalter Bahnhof, in part fully rusted, are arranged into large image on the ground, the found boots and gloves present themselves like forced laborers standing at attention. They couple themselves to the site and especially to the inaugural text from Walter Flex, which remembers the World War I dead of the Battle of Langemarck, stating in part "DON'T COUNT THE DEAD" without didactically direct connection. Through Rheinsberg's arranging and grouping an overview is brought about, they are transformed, and seen from above, joined as fragments of a whole. The Langemarck Hall, permeated by the soleman emotiveness of the National Socialists, is brought together, through the rusty found objects, with disintegration. Alluding to the humanly produced character of the concrete building, covered in natural stone, and at the same time to those sentenced to death through work throughout the greater German Reich, are the worn work gloves and boots of *Hand and Foot*.

Rheinsberg's impression, his sense for artefactual, orients itself, even when unconsciously, according to patterns exercised when learning a language, in internalizing the alogical order of an alphabet. Just as the European ethnologist encounters in indigenous cultures organizational forms that are unfamiliar or unknown, Rheinsberg finds on the heaps of our cities *Known and Unknown* (1980): bricks that have been made redundant as building blocks of our cities. They reveal with their own names, an index of their origin, the history of those cities in which Rheinsberg found them during the phase of their "renewal." For the first brick presentation in the Neuer Berliner Kunst Verein (The New Berlin Art Association) in December 1980, Janos Frecot presented a text with the title *The Dead Live* in which he wrote: "He found bricks which were obviously of pre-industrial origin: they show human traces, the touch of a hand on the malleable material, fingerprints of those that formed and placed

them in the oven. ... He found bricks into which these hands pressed the signs of their makers and day of production. Bricks that were imprinted with the emblems, trademarks, seals, the names of the places from which they came, and which told the history of the city's surrounding industrial development, bricks which first made possible the emergence of the great cities of the continent." For Rheinsberg these great Known-Unknowns are more than simply witnesses to social, political and economic development. He reads their language, like Schwitters the

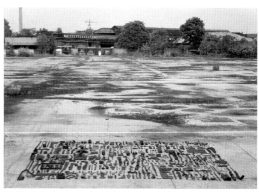

Raffael Rheinsberg, *Rostfeld* (Rust Field),
arranged at the Lehrter Bahnhof train station in Berlin-Moabit, 1985, for the exhibition "1945-1985 Kunst in der Bundesrepublik Deutschland" at the Neue Nationalgalerie in West Berlin

written fragments of his collage, or like Wols collecting the traces of everyday life in his Paris photographs. The poetry of sound is stronger than the logic of semantics: "EISSTOCK" "RENNBERG" "THONBERG" "DITHMER" "DOM" "O. KRAUSSE BIRKENWERDER" "PALATINA-XX".

Neon letters no longer in use, the lighted advertising of companies gone bankrupt after the German reunification, are assembled by Rheinsberg into a field of figures whose strict alphabet is not immediately decipherable: *Dead Neon* from 1991. From this point the circle leading to *Broken German* is closed. We have followed Rheinsberg's artistic development from the early frottage works, the rust fields with found objects from Anhalter Bahnhof, and the arranged and displayed curbstones from the newly asphalted streets, to *The City* whose letter fields unfolded by way of own silent poetry, their exact arrangement, like the model of an old craftman cleaning and preserving his tools. In the context of the discarded street signs of *Broken German* new material appears: the work *New Germany* (*Neues Deutschland* – a collection of house number signs that were attached below the street names and wrapped in newspaper), *Taken Down – Packed Up* (*Abgewickelt – eingewickelt* – spare street signs wrapped in soft cloths to protect them from scratches), and *Capitol City* (East Berlin street signs stacked on end leaning against a wall).

Raffael Rheinsberg, *City*
Installation in the Galerie Giannozzo,
33 Granite cobblestones, set up in
an area with the dimensions
405 x 400 cm, Berlin 1982

Raffael Rheinsberg, *Hand and Foot*, 1980,
in the exhibition "Destroyed
Pictures", 1989, in the Langemarck-Halle
of the Berlin Olympic Stadium

Particularly characteristic of the work *Broken German* are the multiplicity of associations already mentioned in the descriptions of Rheinsberg's techniques. Almost always there are laid out and arranged objects that remind one of an archeological excavation site. In the case of the photo of the Wall once used for propaganda purposes, one sees the artists perception in the form of a frottage. With *Botschaften* – again a telling title – the inscriptions on the fuse box or from the building itself, are the only relicts which left messages – Botschaften – behind. The exhibited curbstones from the installation *The City* still reveal something of a past city built of stone. The strict order of the assembled objects reminds one of the scientific quality of an archeological dig. With *Broken German*, the eye is caught by a particular shade of color, caused by the aging of the material. In the case of the street signs one thinks of the signs made unreadable in occupied cities. The still partially readable remains of street names which are completed in thought, like *Dimitroff,* recall political relations under which changes have been brought about that can be called by name. *Broken German* also calls forth the memory of changed street signs. The renaming of streets in pre-war names, as well as entirely new descriptions like *Square of the United Nations,* are almost unperceived markers of an everyday life, and especially of linguistic forms, that, with the political and economic ruin of the GDR, have disappeared, or been broken apart. The sensitivity of people when the topic of naming in relation to the change of systems is mentioned, is illustrated by the reception of the exhibition of works by Lothar Baumgarten at the Guggenheim Museum in New York, which dealt with the disappearing of indigenous peoples and their names. Craig Owens made clear in his writing about Baumgarten in *Beyond Recognition: Representation, Power and Culture,* (especially in the chapter "Improper Names,") the degree to which European in the process of their take over of the Americas obliterated the names of cities, landscapes, rivers, etc., and replaced them with new, or old (New England) names. Not only linguists and cultural critics have written about the use of language in the exercise of hierarchy and domination, but reflective eyewitnesses as well. The eyewitness Victor Klemperer showed in his 1946 book *LTI Notebook of a Philologist* the way that the Nazis used the finest control of language to perpetuate their social domination: *Broken German* presents the obedience exercise with which order is established in order to maintain control. The linguistic exercise of power is relevant not only in the context East-West relations, but also in relation to foreigners. Rheinsberg's field of broken names enfolds itself as tableau from representation to symbol. As material removed from the sphere of use, it hardens itself to categorization according to standard metaphorical interpretive schemes, thereby withdrawing itself from political misuse. It remains aesthetic, true to the romantic sense in the work of Friedrich Schlegel, who introduced the concept of "Chemism" as a living criteria in the process of aesthetic judgment. As an unreadable field of fragments from street names, a quasi-archeological exhibition of shards of meaning, it preservers the reactivity of an unknown chemical substance waiting to make contact with that trusted material, with our habits, and become something else.

Ulrich Bischoff

Pages 484 - 489
465 **Frieder Schnock
Renata Stih**
Neues Deutschland BILD, 1997
Headlines from 1953-1989 on CD-ROM
Collection of the artists

Headlines

Neues Deutschland
Bild

*

1.1.61
Ein erfolgreiches neues Jahr
Frieden und Glück für unser Volk
Tony bleibt ohne Adel

2.1.61
Diplomatisches Korps
gratulierte dem Staatsrat
Berlin: 15jähriger
auf offener Straße erschlagen!

3.1.61
Erfolgreicher Start ins Planjahr
»VW go home«-Parole
gegen europäische Autos

4.1.61
Belgien marschierte auf
Nach 14 Streik-Tagen: SEUCHEN-
GEFAHR in Belgien

5.1.61
Unserem Staat höchste Qualität
und neue Erzeugnisse
Explosion nach dem Frühstück:
13 TOTE

6.1.61
Unsere Arbeit trägt Früchte
Das Jahr 1961 wird gut
War das zuviel für den Kanzler?

7.1.61
Neue Wohnbauten
im Zentrum der Hauptstadt
Autobahn-Brücke Berlin-München
wird wieder aufgebaut

8.1.61
Leipziger Kumpel an der Spitze
Fabiolas Krone ist nicht echt

9.1.61
Blutiges Referendum in Algerien
Ein Jahr Sperre! Hary droht:
Ich laufe nicht mehr!

10.1.61
Wir sichern die Republik vor Störungen
Start-Verbot für 80 Flugzeuge:
Material-Prüfung

11.1.61
XXII. Parteitag wird neues Programm
der KPdSU beraten
Doppelmörder Derz
auf Leben und Tod operiert

13.1.61
DDR-Aggregate für DDR-Schiffe
Üble Geschäfte mit Berlins
Ferienkindern

14.1.61
Bei uns gestaltet das Volk
seine Geschicke selbst
Einmaliges Urteil in Berlin:
Tierquäler ins Gefängnis!

15.1.61
Dr. Dieckmann erhob Stimme der
Verständigung und des Friedens
Spione enthüllen die Pariser Mode

16.1.61
Der Weg in eine gute Zukunft:
Kampfgemeinschaft aller Arbeiter
Dafür schicken Sie Tausende ins Zucht-
haus – Herr Dieckmann

17.1.61
Jetzt erst recht freie Aussprache der
Bürger beider deutscher Staaten
SOS! Klopfzeichen vom Meeresgrund

18.1.61
Die Schande von Marburg
empört alle Demokraten
Todes-Fahrer von Neukölln in Haft:
Er war doch betrunken!

19.1.61
Marburg ist der Ausdruck
des unseligen Bonner Klimas
»Ich habe Jutta Rehfeldt
aus Berlin entführt!«

20.1.61
Bonn überschwemmt Westzone
mit dem Ungeist von Marburg
40000 Mark Beute!
Posträuber in Berlin verhaftet

21.1.61
Weltlage ändert sich entschieden
zugunsten des Sozialismus
Flucht in den Tod aus Angst vor
der Polizei

22.1.61
Halbleiterwerk begann Produktion
Schon ein Plus für Kennedy

23.1.61
Reparaturen in Eis und Schnee
Berlin: Schuß nach dem Ball

24.1.61
Initiatoren des Stahlwettbewerbs bei
Genossen Walter Ulbricht
Brötchen teurer!
Preise über Nacht erhöht

25.1.61
Treffen der Kontinente
zur Frühjahrsmesse in Leipzig
Um Mitternacht stürmten
die Piraten das Schiff!

26.1.61
Brandenburger Stahlwerker erzielen
höchste Tagesleistung
Rebellenschiff auf Geisterkurs
nach Afrika

27.1.61
Wir geben die Antwort an unserer
Walzstraße
Schießbefehl für Portugals Kriegsmarine

28.1.61
Konföderation ist die historische
notwendige Form der Verständigung
Altersheim in Flammen

29.1.61
Nationales Forum über die Lebensfrage
in Deutschland
US-Admiral geht an Bord
des Rebellen-Schiffs

30.1.61
Das Gespräch von Weimar
muß sich in Ost und West wiederholen
Treffen Kennedy-Chruschtschow
in Berlin?

31.1.61
Zweites Gespräch Nasser - Rau
Stehen Borgward Auto-Fabriken
vor dem Ruin?

1.2.61
Über die weitere Entwicklung der
sozialistischen Rechtspflege in der DDR
Kindes-Mord in Berlin

2.2.61
Wir sichern die DDR gegen
Wirtschaftssabotage der Militaristen
Kindesmord: Neue Festnahme

3.2.61
Industrieproduktion der DDR
stieg um 5,5 Milliarden DM
»Ich fordere die Todesstrafe
für den Mörder meines Kindes!«
Geständnis!

4.2.61
Wenn Strauß auch noch so brüllt,
der Plan wird übererfüllt
Geständnis!

5.2.61
Sozialistische Arbeitsgemeinschaften
übertreffen alle Erwartungen
Noch 16 unter der Schuttlawine

6.2.61
Menschenflug in den Kosmos
wird planmäßig vorbereitet
Ein 7jähriger Junge – ENTFÜHRT
ERMORDET

An dieser Stelle ...

... hätte das Photo des siebenjährigen Jungen stehen sollen,
der in einem verschneiten Feld ermordet worden ist. Das Pho-
to lag der Redaktion vor. Es ist so grauenhaft, daß BILD auf die
Veröffentlichung verzichtete. »Bild«, Berlin, 6.2.61, S.1

7.2.61
Engere Zusammenarbeit mit den
sowjetischen Gewerkschaften
Ost-Professor in Moabit verhaftet

8.2.61
Bonn befiehlt Menschenjagd
MEHR KINDERGELD!
Ab April auch für das 2. Kind

9.2.61
Brandts Frontstadtpolizei mißhandelt
britischen Abgeordneten
Kripo gräbt auf dem Flughafen
Tempelhof nach Gold

10.2.61
Sozialisten und Christen verbinden
gemeinsame Ideale und Ziele
»M6«– Das ist die erste Spur
des Kanzler-Attentäters

11.2.61
Französischer Luftüberfall
auf Flugzeug Leonid Breschnews
... und die Welt hielt den Atem an

12.2.61
Gründung der SED – ein historischer
Sieg des Marxismus-Leninismus
Gehetzter Bandit besetzt nachts
ein Haus

13.2.61
Sowjetische Raumstation
auf dem Weg zur Venus
Berlin: Mordanschlag mit dem Auto

14.2.61
Die Sowjetunion vollbringt den
erstaunlichsten Flug aller Zeiten
Lumumba ermordet

15.2.61
Empörung in allen Kontinenten
über den feigen Mord an Lumumba
Kreml stürzt UNO in schwerste Krise

16.2.61
UNO muß die Mörder stellen
und Aggressor verurteilen
Eislauf-Elite der USA verbrannt

17.2.61
Die DDR ist mit den Völkern Afrikas
Die 73 Toten von Brüssel
– Opfer eines Attentats?

18.2.61
Empörung nimmt ständig zu
Fünf Kontinente verurteilen die Mörder
Berlin: Neuer Kindes-Mord!

19.2.61
Bonns Polizei schützt Lumumbas
Mörder
Blutiger Überfall auf Demonstranten
20000 Mark auf diesen Kopf

20.2.61
In der LPG Görzig ist der Sommerweizen
im Acker
Freundin erwürgt – trotzdem Freispruch!

21.2.61
Belgischer Offizier ermordete Lumumba
BONN: Keine billige Butter für BERLIN!

22.2.61
Antwort von Rostock bis Suhl
Stefanie Burgmann darf
nie wieder an den Giftschrank

23.2.61
DDR-Standards als Grundlage
Schlagersänger Bully Buhlan verurteilt

24.2.61
Handel zwischen UdSSR und DDR
um 13 Prozent höher als 1960
Unsere jungen Paare heiraten
zu protzig – Hauptsache auffallen

25.2.61
Große demokratische Beratung
mit den Bürgern des Kreises
16 Jahre Sibirien konnten
ihre Liebe nicht zerstören

26.2.61
In Forst begann eine Beratung
der ganzen Republik
145 Meter geflogen – aber gestürzt

27.2.61
Treffpunkt Berlin des RGW
Kronprinz Harald ließ
Königstochter stehlen

28.2.61
14. Tagung des Rats für Gegenseitige
Wirtschaftshilfe
Babys für 420 Mark!

1.3.61
Staatsrat beriet Vorschläge für Abkom-
men über 10 Jahre Frieden
Endlich: Bildschirm frei
für das Zweite Programm

2.3.61
Frühjahrsmesse – ein großer Magnet
»Ich habe mein Kind getötet!«

3.3.61
Kommunisten wollen für den Bundestag
kandidieren
Steuer-Streik! Berlins Kinos machen zu!

4.3.61
Messepremiere 1961
Kirche empört über Königin Elizabeth

5.3.61
Höchste Zeit für Abschluß eines
Friedensvertrags
Bonn zieht die D-Mark-Bremse

6.3.61
Technischer Aufstieg der sozialistischen
Länder
Erhard zu Bild:
Es ging mir um Hausfrauen und Sparer!

7.3.61
DDR-Industrie auf dem Vormarsch zur
Weltspitze
Es sind die Peugeot-Entführer!

8.3.61
Die industrielle Attraktion des Jahres
Wir haben die halbe Million verjubelt!

9.3.61
Ehre und Dank den Frauen der Republik
Die Post führt 225000 Berliner hinters
Licht!

10.3.61
Sowjetunion startete Raumschiff IV
Nach Erdumkreisung sicher gelandet
Selbst der Osten gibt zu:
Ulbrichts Lage ist hoffnungslos!

11.3.61
Eine Milliarde DM Umsatz
Wettersturz droht –
und vier hängen in der Wand

12.3.61
Arbeiterklasse an der Spitze im Kampf
gegen Atomrüstung
Hinter Gittern züchtet unser Staat
Ganoven!

13.3.61
Rekordabschlüsse des sozialistischen
Lagers
Geschafft!

14.3.61
Eishockeypräsident Lebel, Kanada:
»Schande für unseren Sport!«
Ein Toter hängt in der EIGER-Wand

15.3.61
Bisher größte Messe beendet
Umsatz der DDR 4,7 Milliarden DM
Noch einmal in den Eiger –
weil die Versicherung nicht zahlt!

16.3.61
G&M spüren Millionen auf
50000 Berliner sollen höhere
Miete zahlen

17.3.61
Plus im Stahlwettbewerb
Rätselhafter Skelett-Fund:
Doppelmord in Berlin?

18.3.61
G&M Millionäre in Finsterwalde
Verbrecher-Ring ausgehoben:
53 auf einen Schlag verhaftet

19.3.61
Heute interessieren sich
alle Dreher für Mitrofanow
Müssen die Fußgänger
Rückstrahler tragen?

20.3.61
Kommuniqué
Bankrott!

21.3.61
Höhere Arbeitsproduktivität
ist die wichtigste Planaufgabe
Über Nacht reich:
Halbe Million für Rentnerin

22.3.61
Sozialistische Arbeitsgemeinschaften
beschleunigen Standardisierung
Brennende Frau im Grunewald

23.3.61
Die DDR ist eine feste, ökonomisch
solide fundierte Staatsmacht
Großalarm! Meuterei im
Gefängnis Moabit

24.3.61
Genosse Heinrich Rau gestorben
»Ich habe die Toten im Garten
vergraben!«

25.3.61
Unaufhaltsamer Aufstieg
zum Sieg des Sozialismus
Neuer Gorilla im Zoo

26.3.61
Volkswirtschaftsplan beschlossen
Nun mit Elan ans Werk!
Hitze macht unsere Elf mürbe

27.3.61
Letztes Geleit für unseren Heinrich Rau
Das zweite Baby für Kaiserin Farah

28.3.61
DDR-Delegation in Moskau
Berliner Opern-Sänger als Dieb entlarvt!

29.3.61
Übertritt afro-asiatische Studenten aus
Westdeutschland in die DDR
Flugzeug-Absturz bei Nürnberg:
52 Todesopfer!

30.3.61
Warnung vor Nazis am NATO-Drücker
Krach mit Maria Schell –
das war nicht fein, O.W. Fischer!

1.4.61
Moskauer Beratungen von
außerordentlich großer Bedeutung für
das deutsche Volk
Berlin: Todesdrama im U-Bahn-Schacht

4.4.61
Wehrt euch, ihr habt in der ganzen Welt
Verbündete
Enttäuschung trieb Berliner
Schauspielern den Tod!

5.4.61
Bauarbeiter zeigen was sie können
Bombe in der Börse

6.4.61
DDR allzeit treuer Gefährte im
Befreiungskampf der Völker
Warum?

7.4.61
Kurs in allen Bezirken:
Schneller Abschluß der Aussaat
»Ich hole ihn nach BERLIN zurück!«

8.4.61
Bedeutsame Beratungen über neue
Probleme der sozialistischen Demokratie
Abgeordneter bekam Führerschein
zurück

9.4.61
Bonn als Feind der Völker
Afrikas und Asiens verurteilt
HSV-Sturm schon prächtig in Fahrt

10.4.61
Jugend der Hauptstadt geht voran
Sie brachte ihn!

11.4.61
Bonn bezahlt Wühlarbeit
der rechten DGB-Führung
Bier wird teurer!

12.4.61
Leipziger Spinnerei an der Spitze
Dreimal gab Eichmann nur eine Antwort:
JAWOHL!

13.4.61
Beispiellose Tat für den Frieden und
den Fortschritt der Menschheit
»Ich war 106 Minuten im All!«

14.4.61
Moskau erwartet J.A. Gagarin
Gagarins Bordbuch

15.4.61
Chruschtschow: Für die Menschheit
Gagarin: Ich bin ein Sohn der Partei
Berlin: Zuchthaus für
gewissenlosen Lehrer

16.4.61
Für den Triumph des Friedens
und des Sozialismus
Bomben auf Kuba

17.4.61
Scharfe Anklage gegen Luftpiraten
So holt man sein Geld
vom Finanzamt zurück!

18.4.61
Verbrecherischer Überfall auf Kuba
KUBA Invasion hat begonnen

19.4.61
Die Welt steht an der Seite Kubas
Harte Schläge gegen Aggressoren
Es geht um seinen Kopf

20.4.61
Lang lebe Kuba!
Nieder mit den Aggressoren!
19jährige stellt dem Öl-Scheich
Ultimatum

21.4.61
15 Jahre SED –
Festtag für Arbeiterklasse und Nation
Es ist aus!

22.4.61
Unsere Partei – Kraftquell des Volkes für
die Wiedergeburt der Nation
Vater tötete seine Kinder –
Der Grund: SCHULDEN

23.4.61
Einheit der Arbeiterbewegung
höchstes nationales Gebot
Putsch in Algerien

24.4.61
Von der DDR wird stets der Frieden
ausstrahlen
»Verweigert den Gehorsam!«

25.4.61
Hochofen VI angeblasen
Mobilmachung in Frankreich

26.4.61
Das Volk drängt zur Tat
Die ersten Schüsse ...

27.4.61
Aktionseinheit schlug Faschisten
TODESSTRAFE für Rebellen-Generale?

28.4.61
Washington leitete den Überfall auf Kuba
Autobahn-Brücke stürzte ein

29.4.61
Spitzenleistung im Vortrieb
Claudias Mörder soll lebenslang ins
Zuchthaus!

30.4.61
Kampfmai in der ganzen Welt
Wahnsinnstat eines Polizisten

2.5.61
Für den Abschluß eines
Friedensvertrages
Für den Sieg des Sozialismus
in der DDR
LAOS: Weltkrise!

3.5.61
Start zum Wettbewerb
gegen Bonner Störversuche
Ermordet!

4.5.61
Gewerkschafter aus vier Erdteilen
berieten mit dem FDGB
Mein Junge ist kein Mörder!

5.5.61
Arbeiter kontern Störenfriede
JUTTAS Freund blieb eiskalt

6.5.61
Arbeitsstil unter der Lupe
Amerika hat es geschafft!

7.5.61
Die DDR grüßt die Völker der UdSSR
Gefährlich dieser Mann

8.5.61
Deutsch-Sowjetische Freundschaft
Unterpfand des Friedens in Europa
Wieder Pockenalarm!
Berliner Arzt unter Verdacht

9.5.61
Unsere Freundschaft ist das Fundament
aller Erfolge der DDR
»Notfalls mit Waffengewalt!«

10.5.61
Friedensfahrer in Berlin
stürmisch umjubelt
Kriminal-Kommissar unter Mordverdacht
verhaftet!

12.5.61
Erfolgreicher Start im
Normteilewettbewerb
Berlin: 2 Kinder vergiftet

13.5.61
DDR und Kuba
in fester Freundschaft vereint
Generalstreik

14.5.61
Tausende LPG wetteifern
Der deutsche Film fiel durch

15.5.61
Erfahrungsaustausch DDR-Kuba
Schießen die Sowjets eine Frau in
den Weltraum?

16.5.61
Gute genossenschaftliche Arbeit führt
zu besserer Versorgung
Anastasia ist tot

17.5.61
Friedensfahrer am Ziel / Freudiger
Empfang in Prag
VW-Aktie auf 1000!

18.5.61
Neues hochproduktives Verfahren in
Glauchauer Kammgarnspinnerei
VOPO schoß Eisenbahner nieder

19.5.61
Glückwünsche und Auszeichnungen
für unsere Friedensfahrer
Vier Sowjet-Generale abgestürzt – tot!

20.5.61
Globke vor Gericht!
»Wir gaben unserm Kind Tabletten!«

21./22.5.61
Arbeiterjugend schmiedet
Pläne des Glücks
Triumph für die Borussia

23.5.61
Wir schreiten voran für Frieden und
Abrüstung
Berlin: Alarm in der Nacht!
Taxifahrer überfallen

24.5.61
Kommuniqué
Die Burgmann soll begnadigt werden!

25.5.61
Walter Ulbricht in Prag herzlich
verabschiedet
Abschießen!

26.5.61
Gute Hand und fester Boden
für unsere Literatur
Ein Baby für Margaret und Tony!

27.5.61
Halle ist Vorbild für alle
Seuchen-Gefahr!

28.5.61
Sport für alle!
Toller Morlock schoß drei Tore

29.5.61
Start klar für den Volkssport
Bankkonto kurz vor dem Tod aufgelöst!

30.5.61
Höhere Produktion mit weniger
Arbeitskräften
Traumhaus wird noch einmal verlost!

31.5.61
Völker erwarten von Wien
Schritt zur friedlichen Koexistenz
Kennedy zu Berlin:
Rückzug um keinen Preis

1.6.61
Walter Ulbricht über Friedensvertrag
und Westberlin-Frage
Berlin: 15jährige aus Liebeskummer
in den Tod

2.6.61
Konstruktive Vorschläge
zum Vorteil aller Völker
Eine Stunde den Tod vor Augen

3.6.61
»Wer guten Willen hat, kann auch
innerhalb kurzer Zeit viel erreichen«
Baustop bei der Gedächtniskirche!

4.6.61
Das Gespräch begann
Bittere Pille für 1.FC Köln

5.6.61
Zwei Tage nützlicher Begegnungen
Reporter rettete einen Mörder –
für den Henker!

6.6.61
UdSSR erstrebt schnellstens Abrüstung
und friedliche Regelung der Streitfragen
Kreidebleich hörte sie das Urteil!

7.6.61
Das ganze Dorf packt zu
Verbrecher sprang aus dem 3. Stock

8.6.61
Nach nützlichen Gesprächen
jetzt nützliche Taten
Der Eisenbahn-Mörder von Dresden!

9.6.61
Westdeutsche Revanchisten stoßen auf
Widerstand der Völker
Kennedy erkrankt

10.6.61
Markkleebergs gute Bilanz
Todesangst im Raubtierkäfig

11.6.61
Ein Fest der Arbeiterklasse
Endspiel mit 1.FC Nürnberg

12.6.61
Unverzüglich Friedensvertrag
abschließen
Chruschtschow will
ganz Berlin
ganz Deutschland
ganz Europa

13.6.61
Sowjetische Vorschläge dienen dem
deutschen Volk
»Die Frauen haben es mir leicht
gemacht!«

14.6.61
Jetzt sind Verhandlungen über
Friedensvertrag unumgänglich
Eisenbahn-Katastrophe
Schon über 35 Tote

15.6.61
Vorschläge der UdSSR stimmen mit
friedlichen Interessen des deutschen
Volkes völlig überein
Der Heirats-Schwindler weinte:
3 1/2 Jahre Zuchthaus

16.6.61
Endlich den Schlußstrich
unter den zweiten Weltkrieg ziehen
Hauptsache: Totale Abrüstung
Berlins Circus Busch bankrott

17.6.61
Friedensvertrag lebensnotwendig
Für Borgward das große Geschäft

19.6.61
Hauptfrage der Weltpolitik
Berliner Opern-Sängerin stürzte sich
in den Tod

20.6.61
Führen wir die große Aussprache
über die Chance der Nation
Rohlinge schlugen seine Katze tot

21.6.61
Unsere gute Tat
für unsere gerechte Sache
Lebensgefahr für spielende Kinder

22.6.61
Wir klirren nicht mit Waffen
Wir wollen Frieden und Abrüstung
Berliner LOTTO soll Circus Busch retten!

23.6.61
Glück der Völker erfordert
Bändigung des Militarismus
Notlandung mit Jayne Mansfield

24.6.61
Friedensvertrag stärkt DDR –
vereitelt Pläne der Militaristen
Vorhang auf!

25.6.61
Tausendjähriges Halle am Beginn einer
neuen Epoche der Menschheit
Klasse! So siegt eine Meister-Elf!

26.6.61
Jede Stunde gilt es zu nutzen
SKANDAL – dann flog der Filmstar raus!

27.6.61
Der Friedensvertrag bringt
sechsfachen Nutzen
Staatsanwalt fordert
FREISPRUCH für die Lebenslängliche

28.6.61
Arbeiten auf dem Land
gehen zügiger voran
Verteidiger: »Ich klage an!«

29.6.61
Telegramm des Staatsrats der DDR an
den deutschen Bundestag und die
Regierung der Bundesrepublik
BERLIN: S-Bahn ohne Strom

30.6.61
Appell an Bonn erneuter Beweis
unseres guten Willens
Berlin: Dreijähriges Kind in hellen
Flammen

1.7.61
Thema Nr.1 der Weltpolitik:
Abschluß eines Friedensvertrages
1000 Zentner Zucker und Mehl
verschoben

2.7.61
Unsere Republik dankt den Bergleuten
Maria Rohrbach im Kloster

3.7.61
Friedensvertrag rottet Kriegsherd in
Europa aus
Hemingway hat sich erschossen

4.7.61
Heuwetter gut genutzt
Siamesische Zwillinge in Berlin geboren

5.7.61
Konsumgüter aus Großbetrieben
Siamesische Zwillinge
sollen getrennt werden

6.7.61
Kommuniqué
Siamesische Zwillinge sind tot

7.7.61
Der Deutsche Friedensplan
Berliner Familie fuhr in den Tod

8.7.61
Die Welt spricht über den
Deutschen Friedensplan
Frauenmörder schwer verletzt

9.7.61
Friedensvertrag ist der beste Schritt
zum Frieden
108 verbrannten
in Osteuropas Muster-Zeche

10.7.61
Ostseemesse – ein Beitrag Rostocks
zum Friedensplan
Schwere Explosion nach
Gas-Selbstmord

11.7.61
Friedensplan bringt Sicherheit für uns
und unsere Nachbarn
Mario Tuala in der Havel ertrunken

12.7.61
Friedensvertrag verhindert neue
Nazi-Invasion in Nordeuropa
Vopo läßt Bischof nicht nach Berlin

13.7.61
Unser Deutscher Friedensplan gewinnt
Hirne und Herzen
Wimmernde Hilferufe aus dem
Flammenmeer

14.7.61
Friedensvertrag und Verständigung
abgelehnt / Ganz Deutschland soll
NATO-Ketten tragen
Berlinerin will einen TOTEN heiraten

15.7.61
Wählt nur Atomkriegsgegner!
Erst Rücktritt - dann vergiftet

16.7.61
Westdeutsche Arbeiter klagen Bonn an:
Arbeitshetze unterm Atomknüppel
Ärzte retteten Grolman

17.7.61
Friedensvertrag für Völker
an der Ostsee lebensnotwendig
Raubmord in Berlin

18.7.61
Hohe Marktproduktion ist unser Beitrag
zum Friedensplan
Frauen-Mörder gefaßt:
»Ich brauchte Geld!«

19.7.61
Die Feinde des Friedens
werden nicht durchkommen
Sie kommen Tag und Nacht

20.7.61
Westmächte leisten Bonner
Kriegstreibern gefährlichen Vorschub
Wer den Frieden bricht ...

21.7.61
Bonn kann man nicht trauen
Militaristen herrschen wieder
Harte Kämpfe / 150 Gefallene / Düsenjä-
ger-Angriff / USA: Feuer einstellen!

22.7.61
Friedensvertrag bringt Deutschland die
große Wende zum Guten
Geglückt!

23.7.61
Frieden und Sozialismus – unsere Wahl
Immer noch Jagd auf Dr. Mengele!

25.7.61
Räte gehen mit gutem Rat in alle
LPG Typ I
17jährige in Berlin entführt?

26.7.61
Der Plan wird erfüllt – Ultras ohne
Chance
Attentat auf Adenauer

27.7.61
Direkte Leitung vom Erntefeld
Ein Wille! Ein Weg! Ein Ziel!

28.7.61
Mit erfülltem Plan zur Wahl
Von Spielkameraden umgebracht?

29.7.61
Gute genossenschaftliche Arbeit sichert
schnelle und verlustlose Ernte
Härteste Strafe!

Joachim Sch. (25)

Bernhard Z. (21)

30.7.61
Aufgaben der Staatsorgane
zur Wahl und bei der Ernte

Sie unterzeichneten den Brief an den Vorsitzenden des
Staatsrates: Maschinenkontrolleur Eberhard Göhring,
Presserin Grete Falk, Presser Harry Speck (v.l.n.r.) aus dem
Berliner Kabelwerk Oberspree (Foto Rasch)

14 Ärzte hatten keine Zeit

1.8.61
Das Programm des Kommunismus geht
um die Welt
Tot! Vater überfuhr sein einziges Kind

2.8.61
Keine Liebeserklärungen –
aber normale Beziehungen!
Pankow in Panik!

3.8.61
Wir nehmen den Kampf auf
Alle Kraft für die Republik
Treten Sie endlich ab – Herr Ulbricht!

4.8.61
Es wird Frieden sein,
weil wir dafür kämpfen
Dieses Mädchen rettete 3 Menschen
aus sinkendem Bus

5.8.61
Über Friedensvertrag
muß verhandelt werden
SED-Befehl ruiniert 52000 Berliner

6.8.61
Mitteilung
Vopos mit Gummiknüppel gegen
Westberliner

7.8.61
Die Erde viele Male umkreist
Gruß an die Völker der Welt
Abendessen im All

8.8.61
Vernunft statt Kriegshysterie
Amerika wußte VORHER Bescheid!

9.8.61
Wir lassen uns nicht
gegen die DDR aufhetzen
Friedensvertrag auch in unserem
Interesse
Flüchtlings-Strom VERDOPPELT!

10.8.61
Mit dem Elan der Kosmonauten
für den Friedensvertrag
Einer der höchsten Zonen-Richter
geflohen

11.8.61
Friedensvertrag bändigt Militaristen und
öffnet den Weg zur Wiedervereinigung
Deutschlands
13jähriger Schüler zog das Todeslos

12.8.61
Die Zeit für entschlossene Maßnahmen
zur Festigung des Friedens ist da
ALARM!
Feuer in der Ostberliner Universität

13.8.61
Beschluß des Ministerrats der
Deutschen Demokratischen Republik
Erklärung der Regierungen der
Warschauer Vertragsstaaten
Sie kommen Hals über Kopf

14.8.61
Maßnahmen zum Schutz des Friedens
und zur Sicherung der Deutschen Demo-
kratischen Republik in Kraft

»Lokomotivauswäscher Friedrich Otto,
Bahnbetriebswerk Oberschöneweide: Es wurde wirklich
Zeit, die Weiche so energisch auf Frieden zu stellen. Uns
schmeckt das schon lange nicht. Mit wahrer Engelsgeduld
haben wir immer wieder die Hand zur Verständigung ausge-
streckt. Die Militaristenbande hat aber unsere Warnungen
und Angebote in den Wind geschlagen und das Störzentrum
Westberlin weiter ausgebaut. Sollten wir diesem verbreche-
rischen Treiben noch länger tatenlos zusehen? Nein und
nochmals nein! Natürlich wird mancher vorübergehend klei-
ne Unannehmlichkeiten in Kauf nehmen müssen, ich denke
an Verwandtenbesuche, aber lieber ein kleines Opfer jetzt
als nachher das große Opfer für den Krieg. (...)«
»Neues Deutschland«, Berlin 14.8.61, S.1

Berlin kocht vor Empörung
»Flammender Protest in der Zone und in beiden Teilen Ber-
lins! Protest dagegen, daß Ulbricht die Berliner Sektoren-
grenze zur »Staatsgrenze« erklärt und damit die Fluchtwege
für die Mitteldeutschen abgeriegelt hat. Das Brandenburger
Tor wurde zum Fanal des Freiheitswillens, nachdem 100000
»Volks-armisten« in rollendem Einsatz in den sowjetischen
Sektor transportiert worden waren. I Die Zwischenfälle häu-
fen sich. Am Bethaniendamm im Bezirk Kreuzberg wollten
Berliner den Drahtverhau an der Grenze niederreißen. Eine
Schlägerei ent-stand. Die »Vopo« warf Tränengas-
Handgranaten. I Ein anderer Zwischenfall: Ein Berliner wur-
de an der Sektorengrenze von Volkspolizisten durch einen
Bajonettstich verletzt. I Trotz Panzern, Kanonen und Sta-
cheldraht: Tausend Flüchtlinge schlüpften noch durch Kel-
ler und Kanäle nach West-Berlin. Mancher Vopo hat wegge-
sehen, wenn sie über-wechselten.«
»Bild«, Berlin 14.8.61, S.1

15.8.61
Hauptstadt bietet ein Bild kraftvoller
Tätigkeit / Berliner sagen: Wir haben den
Militaristen auf die Zehen getreten
Verbrecher Ulbricht am Tatort

16.8.61
Republik bewies ihre Macht
Mit guten Taten machen wir sie noch
stärker
Der Westen tut NICHTS!

17.8.61
Wir sind gute Deutsche, deshalb stärken
wir unsere Republik mit Taten
»Berlin erwartet mehr als Worte!«

18.8.61
Die DDR – das Vaterland aller guten
Deutschen
Schon 30 Vopos geflüchtet

19.8.61
Ansprache des Vorsitzenden des Staats-
rates der Deutschen Demokratischen
Republik, Walter Ulbricht, im Fernsehen
und Rundfunk
Amerikas Vize-Präsident heute in Berlin

20.8.61
UdSSR unterstützt vollkommen die
Schutzmaßnahmen der DDR
Geld in der Zone wird UNGÜLTIG!

21.8.61
Parade des Optimismus
Welcome to Berlin, Friends!

22.8.61
Bereit zum Schutz unseres sozialisti-
schen Vaterlandes!
Britische Truppen an der Berliner Grenze

23.8.61
Die friedliebende Welt an der Seite der
DDR
Flucht mit dem Leben bezahlt

24.8.61
Stets kampfbereit für die großen Ideen
des Friedens und wahrer menschlicher
Freiheit
Alliierte Truppen besetzen
Sektorengrenze

25.8.61
Brief Dr. Albert Schweitzers
an den Vorsitzenden des Staatsrats,
Walter Ulbricht
Flüchtling erschossen

26.8.61
Am Brandenburger Tor hat der
Arbeiter- und Bauern-Staat
die Weichen für Frieden gestellt
Das war höchste Zeit!

27.8.61
Der 17. September wird unser
zweiter großer Schlag
Pankow baut die zweite Mauer

28.8.61
Westen soll verhandeln
Steinhagel gegen Vopos

29.8.61
Brandt schreit nach Krieg
Das ist der Tote vom Humboldthafen

30.8.61
So sieht die Welt von oben aus
Wieder Flüchtling erschossen

31.8.61
WGB ruft die Arbeiter der ganzen Welt
1000 DM Belohnung / MORD

1.9.61
Zum Schutze der Menschheit vor einem
neuen Kriege
UdSSR beschließt Kernwaffenversuche
Totale Abrüstung ist und bleibt
wichtigste Aufgabe
Die ganze Welt ist empört

2.9.61
Ein Jubelruf erfüllt Berlin
Titow – Ulbricht – Frieden
78 Tote

3.9.61
Walter Ulbricht: Raumflug kündet von
der überlegenen Stärke des Sozialismus
German Titow: Es ist eine Freude, im er-
sten deutschen Arbeiter- und Bauern-
Staat zu sein
Todes-Sprung von der Zonenfähre

4.9.61
Im Bunde mit der sozialistischen Welt
vertreten wir die Zukunft der Nation
Geschäft ist Geschäft ...

5.9.61
»Einmütigkeit der Bürger der DDR
Garantie des Sieges des Sozialismus«
Auf Luftmatratze über die Ostsee

6.9.61
Walter Ulbricht: Kosmonauten
künden von der großen Zukunft des
Kommunismus
Flucht ins Sprungtuch

7.9.61
Produktionsaufgebot
Attentat

8.9.61
Dem Frieden unsere Stimme
Dem Frieden unsere Tat
Wir werden auf Deutsche schießen!

9.9.61
Die ganze Republik antwortet
Es gibt wieder KZ's in der Zone

10.9.61
Wir sind Bonn weit überlegen, weil
wir mit dem Frieden verbündet sind
Attentat auf de Gaulle

11.9.61
Nieder mit dem Militarismus
Her mit dem Friedensvertrag!
Graf Trips raste in den Tod

12.9.61
Produktionsaufgebot wird
ein neuer 13. für die Militaristen
500000000 DM

13.9.61
Arbeiter und Bauern Seite an Seite
So starb Graf Trips

14.9.61
Wir stehen treu zu unserer DDR
Grenz-Haus von VOPO gestürmt

15.9.61
Mit der Kraft des ganzen Volkes
schreitet die DDR unbeirrt voran
Düsenjäger der Bundeswehr
in West-Berlin gelandet

16.9.61
Unsere Stimme für ein friedliches,
blühendes, sozialistisches Leben!
Zehntausende sollen verschleppt
werden!

17.9.61
Für den deutschen Friedensvertrag!
Für Frieden und Sozialismus!
Päckchen-Bombe auch an Strauß

18.9.61
Ein Siegeszug ohne Beispiel für die
deutsche Politik des Friedens
Wahllokale überfüllt

19.9.61
99,96 Prozent stimmten für die
Kandidaten der Nationalen Front
Kongo: UNO-Chef tot!

20.9.61
Schwedt baut Block der Bauarbeiter
Sowjet-Düsenjäger neben
Clays Flugzeug

21.9.61
DDR ist der erste deutsche Staat, der der
Welt nicht Krieg, sondern Frieden erklärt
Wer die DDR verteidigt, verteidigt den
Frieden
Massen-Austreibung hat begonnen!

22.9.61
Besser handeln
freundlich bedienen
sparsam wirtschaften
General Clay in Steinstücken

23.9.61
Weltweite Offensive für Friedensvertrag
Die eigenen Landsleute verraten!

24.9.61
107 Millionen Gewerkschafter
fordern den Friedensvertrag
Viel los!

25.9.61
Aktionen für den Friedensvertrag
Wird Deutschland jetzt verkauft?

26.9.61
Ruf zur Tat für den Friedensvertrag
Demütigung des freien Westens!

27.9.61
Ehrlich nachgerechnet
und 350000 Mark gewonnen
Mutti, sag doch was!

28.9.61
UNO soll die Friedenskräfte
des deutschen Volkes unterstützen
Adenauer soll doch Kanzler bleiben!

29.9.61
Sofortmaßnahme zur Entspannung
Hauptaufgabe totale Abrüstung
Freiheit für die Kolonialvölker
Luftkorridore bleiben frei!

30.9.61
Arbeitsproduktivität steigt
1% über den Plan
TOT – weil sie ihre Enkel sehen wollte

1.10.61
Weltjugend beginnt Offensive für den
deutschen Friedensvertrag
Fußball-Star geht vor Gericht

2.10.61
Weltjugend kämpft an unserer Seite
Sakrower Fährmann verriet Flüchtlinge

3.10.61
Berlin wird seine Aufgaben
weiter ehrenvoll erfüllen
Flüchtlinge rasen in West-Berliner Bus

4.10.61
Was Walter Ulbricht verkündete,
verwirklicht das ganze Volk
55 Menschen kamen Hand in Hand

5.10.61
Viel geschafft,
aber jetzt geht es erst richtig los
Unsere Polizisten gaben Feuerschutz

6.10.61
Prüffeld der Wissenschaft ist die
sozialistische Praxis
Ist das der deutsche Alltag?

7.10.61
Stärker denn je und verbunden mit den
mächtigsten Ländern der Erde schreitet
die DDR vorwärts zum Friedensvertrag
»Ich hatte den Zug vergessen!«

9.10.61
Je stärker die DDR,
desto sicherer der Frieden!
6 Vopos getötet

10.10.61
Erfolge bei der Planerfüllung
Ansporn für neue Taten
Schlägerei mit Sowjet-Botschafter

11.10.61
Kartoffeln roden! Kartoffeln abliefern!
Amerikanische Waffen
für die Berliner Polizei

12.10.61
Anastas Mikojan: Sozialistische
Freundschaft unserer Länder eine
historische Tatsache
Walter Ulbricht: Die Bevölkerung der
DDR bereitet den Friedensvertrag mit
Taten vor
Seit der Flucht vermißt!

13.10.61
VEB Meßgerätewerk Hötensleben
gewinnt 54000 Produktionsstunden
Wie 1945: Schwarzer Markt in der Zone

14.10.61
Chruschtschow: Wir sind bereit,
mit dem Westen zu verhandeln
Wir wurden verraten!

15.10.61
Im Sozialismus finden alle Frauen
wahres Glück
4mal Lebenslänglich!

16.10.61
Delegation unseres ZK in Moskau
... aber dann kam General Clay

17.10.61
Das neue Programm der KPdSU das
Kommunistische Manifest
des zwanzigsten Jahrhunderts
Berlin-Ferngespräche wurden abgehört!

18.10.61
Der Triumph des Kommunismus ist gewiß
Sache des Fortschritts
siegt in der ganzen Welt
Gigantischer Aufstieg der UdSSR
seit dem XX. Parteitag
Für jeden Verrat einen Fußball ...

19.10.61
Dokument des kommunistischen
Humanismus
Höchste Menschheitsideale werden
Wirklichkeit
Treten Sie ab – Herr Senator!

20.10.61
Der Kommunismus ist die Hoffnung der
Völker, die Garantie ihrer strahlenden
Zukunft
Berliner Radsport-Star an die Vopo
verraten ...

21.10.61
A.I. Mikojan: Ein Glück für Europa,
das die DDR existiert
Lautsprecher-Kette quer durch Berlin

22.10.61
20 Millionen Sowjetmenschen im
kommunistischen Wettbewerb
Jetzt liegt alles bei Lübke

23.10.61
XXII. Parteitag der KPdSU Ansporn für
Produktionsaufgebot
In Berlin: Bundeswehr-Piloten
vor Militärgericht

24.10.61
Es ist unsere heilige Pflicht,
die Militaristen zu bändigen
Superbombe explodiert!

25.10.61
Wir haben die Möglichkeit,
Raketen im Flug zu vernichten
»Eine schöne – eine wunderbare
Bombe!«

26.10.61
Frieden und Sicherheit nur durch
deutschen Friedensvertrag
Clay schaltet Washington ein

27.10.61
Unter dem Deckmantel des
Antikommunismus verraten die
Imperialisten ihre eigene Nation
Gespräche CDU-FDP geplatzt!

28.10.61
Aufbau des Kommunismus
jetzt praktische Aufgabe der KPdSU
XXII. Parteitag bewies Einheit der
kommunistischen Weltbewegung
Das erste Mal: Panzer auf beiden Seiten

29.10.61
KPdSU wurde zur Partei
des ganzen Sowjetvolkes
Auto rast in Bundeswehr-Kolonne

30.10.61
Karl-Marx-Monument
in Moskau feierlich eingeweiht
Von Sowjets gestoppt!

31.10.61
»Kommunist sein, heißt bei der Arbeit
und im Leben in vordersten Front stehen«
Druckwelle über Berlin

1.11.61
Ein neuer Abschnitt der Weltgeschichte!
Das grandiose Programm zum Aufbau
des Kommunismus ist beschlossen!
Moskau droht mit Einmarsch in Finnland

2.11.61
XXII. Parteitag der KPdSU
Anleitung für unser Handeln
Das ist die neue Regierung

3.11.61
Den sozialistischen Staaten unseren
Dank – Unseren Fluch den NATO-Mord-
brüdern
Einspruch gegen Minister Schröder

4.11.61
Im Mittelpunkt des XXII. Parteitages
standen der Mensch und sein Glück
Diesmal fiel Adenauer um

5.11.61
Wir stärken die DDR für den
Friedensvertrag
Mehr Stahl durch das Produktionsaufgebot
Streit um Minister-Sessel

6.11.61
Diesem Staat unser ganzes Wissen

Durch ihre Verbesserungsvorschläge haben Hobler Herbert Kluge, Brigadier Walter Otto und Fritz Haubold (von links nach rechts) aus dem VEB Großdrehmaschinenbau »8.Mai« in Karl-Marx-Stadt wesentlichen Anteil an der Steigerung der Arbeitsproduktivität in ihrem Betrieb. Fast 2300 Normstunden konnten die Arbeiter des Großdrehmaschinenbau »8.Mai« im Produktionsaufgebot bisher einsparen. (Foto: Zentralbild)

Massenflucht im Vopo-Feuer gescheitert

7.11.61
**Kommunismus und Frieden –
Zukunft der Menschheit**
SED druckt Hetzzeitung in West-Berlin

8.11.61
**Moskau im Zeichen der nahen
kommunistischen Zukunft**

»Höhepunkt der Feiern zum 44. Jahrestag der Großen Sozialistischen Oktoberrevolution waren die gestrige traditionelle Demonstration von Hunderttausenden Werktätigen und die Militärparade auf dem Roten Platz der sowjetischen Hauptstadt. Der historische Gedenktag stand in diesem Jahr völlig im Zeichen der nahen kommunistischen Zukunft. Die auf dem XXII. Parteitag gesprochenen Worte: »Es gilt für uns, den Kommunismus aufzubauen« werden von den Sowjetmenschen bereits in die Tat umgesetzt. Deshalb trugen die Moskauer in ihrem Demonstrationszug mit so großem Stolz Plakate, auf denen sie ihre Arbeitssiege zu Ehren des XXII.Parteitages des KPdSU und zu Ehren des 44. Jahrestages des Roten Oktober zeigen. Die Demonstration kündete von der Entschlossenheit des ganzen 220-Millionen-Volkes, die historischen Aufgaben zu erfüllen, die der Parteitag gestellt hat. Die Militärparade dokumentierte, daß die sowjetischen Streitkräfte über die Mittel verfügen, die notwendig sind, um friedliche Bedingungen für den Aufbau des Kommunismus zu sichern. Die Parade stand mehr denn je im Zeichen der jüngsten, wichtigsten und mächtigsten Waffe der Sowjetarmee, der Raketen. Auf der Tribüne des Lenin-Mausoleums erlebte eine Delegation der DDR mit Genossen Friedrich Ebert, Mitglied des Politbüros, und Volkskammerpräsident Dr. Johannes Dieckmann an der Spitze Seite an Seite mit N.S. Chruschtschow und den übrigen Mitgliedern des ZK der KPdSU und des Präsidiums den Vorbeimarsch der Moskauer Werktätigen und die Parade. Auf der Tribüne befanden sich ferner die Führer vieler Bruderparteien aus aller Welt..«
»Neues Deutschland«, Berlin 8.11.61, S.1

Hollywood in Flammen

»Die amerikanische Filmmetropole steht in Flammen. Über 350 Häuser, darunter viele Luxusvillen prominenter Stars, wie Burt Lancaster, Cary Grant und Kim Novak, sind nur noch rauchende Trümmer. Zwei verheerende Feuersbrünste drohen sich in den heutigen frühen Morgenstunden zu vereinigen. Man befürchtet, daß dann eine Feuerwalze auf einer 16 Kilometer breiten Front in Richtung Ozean vorrückt. Südkalifornien wurde zum Notstandsgebiet erklärt.«
»Bild«, Berlin 8.11.61 S.1 (sad.)

9.11.61
**Es ist unser eiserner Wille,
die Republik zu stärken**
Bank-Skandal in Berlin

10.11.61
**Der XXII. Parteitag gab der DDR
viele neue Impulse**
Die ersten Festnahmen

11.11.61
**Zwei erfolgreiche Monate
im Produktionsaufgebot**
Chruschtschow will durch die Hintertür!

12.11.61
Fest der internationalen Gemeinschaftsarbeit in Bitterfeld
Parteifeind Molotow kam bis Warschau

13.11.61
**Friedensvertrag gegen die Gefahr des
westdeutschen Militarismus**
Ulbricht kämpft um seinen Kopf

14.11.61
Ben Bella in Lebensgefahr
Adenauer: Sofort zurückkommen!

15.11.61
**Angespornt vom XXII. Parteitag
Planerfüllung bis 15. Dezember**
Morddrohung am Telephon

16.11.61
**Wir studieren das Lehrbuch
und steigern die Produktivität**
Berlin: Mord an 14jährigem?

17.11.61
**Sowjetunion legt der UNO Hauptgrundsätze eines Vertrags über allgemeine
und vollständige Abrüstung vor**
Chruschtschow: »So töteten wir Berija!«

18.11.61
**Papierkombinat Schwedt
begann mit der Produktion**
Clay: »Wir hätten die Mauer
einreißen sollen!«

19.11.61
**Mörderregime Tshombe erhielt
westdeutsche Flugzeuge**
Vier junge Leute rasten in den Tod

20.11.61
**Bauwissenschaftler werten
XXII. Parteitag aus**
Großeinsatz der Vopo an der Mauer

21.11.61
**Höchste Monatsleistung
in den Leunawerken**
Tausende schuften –
weil Ulbricht Angst hat

23.11.61
**»Besser leiten – mein Beitrag
im Produktionsaufgebot!«**
Vopo holzt die Linden ab

25.11.61
**Fruchtbringender Austausch von
Forschungsergebnissen mit UdSSR**
Für vier Millionen Juwelen geraubt

26.11.61
14. Tagung des Zentralkomitees der SED
Schüsse auf Bonner Politiker

27.11.61
Kommuniqué
Mord vor den Augen der Tochter

28.11.61
Beschluss
Rätsel um unbekannten Toten gelöst

29.11.61
Was wird aus Deutschland?
Sektorengrenze soll geöffnet werden

30.11.61
Das Wort der Partei stählt unsere Kraft
Dramatischer Weltraumflug
der Amerikaner

1.12.61
**Unser Ziel ist großartig
Erreicht wird es durch Arbeit**
Halbe Million in einer Woche

2.12.61
**Entwicklungstermine verkürzen –
mehr moderne Regelgeräte**
14 Jahre als Mörder im Zuchthaus –
jetzt plötzlich frei?

3.12.61
Verständigung beider Staaten über Minimalprogramm vorgeschlagen
Erschossen vor dem Palast-Hotel

4.12.61
**Sofortige Verhandlungen über
deutschen Friedensvertrag**
Auto-Luftbrücke für Berliner

5.12.61
**Weltkongreß der Arbeiter
in der Metropole des Kommunismus**
Abgestürzt!

6.12.61
**Regis beantragt höheren Plan der
Arbeitsproduktivität**
Hohenzollern-Hochzeit in Berlin

7.12.61
**Große Reserven aufgedeckt
10,7 statt 2,3 Prozent möglich**
Die Helden des Tages

8.12.61
**Werkleiter studieren Erfahrungen der
Kumpel von Regis**
Ulbricht schäumt vor Wut

9.12.61
**Finnlands Arbeiter fordern
Verhandlungen**
Berlin: 2 Tote! Gas-Explosion

10.12.61
**Kennedys Autobahn-Idee
ist nicht ernst zu nehmen**
Sturmgefahr! Besatzung geht von Bord

11.12.61
**Dank und Anerkennung
für Ärzte und ihre Helfer**
Von Vopos ermordet

12.12.61
**Mehr Energie, höhere Produktivität im
Kraftwerk Eisenhüttenstadt**
Senator Lipschitz gestorben

13.12.61
**Kriegsverbrecher Heusinger
verhaften und ausliefern**
Marlene Dietrich enttäuscht Berlin

14.12.61
**Einige offene Worte
an unsere Rostocker Kollegen**
Von den eigenen »Kameraden«
erschossen!

15.12.61
**Rostocker Bauarbeiter begannen
mit der Beratung des offenen Briefes**
13jährige beging Selbstmord!

16.12.61
**Liga für Völkerfreundschaft der DDR
gegründet**
Keine Passierscheine zu Weihnachten

17.12.61
**Zusammenarbeit beschleunigt
Aufstieg der sozialistischen Länder**
Heldentat jenseits der Schallmauer

18.12.61
Erfolgreicher Kampf um den Plan
20 Grad Kälte-Rekord in Berlin!

19.12.61
**Wir sind ehrliche Arbeiter,
die zu ihrem Staat stehen**
Die Welt ist empört über Nehru

20.12.61
**Weltforum des Friedens
verurteilt Bonner Politik**
Stefanie Burgmann begnadigt

21.12.61
**Sofort mit DDR über Einrichtung ihrer
Reisebüros in Westberlin verhandeln**
10 Millionen für 5 Monate Ehe ...

22.12.61
**Produktionsaufgebot bleibt
entscheidende Aufgabe**
Es gibt weiße Weihnachten!

23.12.61
**Beratung sowjetischer und
deutscher Kernforscher**
100 Mark Urlaubsgeld für jeden Berliner!

24./26.12.61
**Hand und Herz der Frauen
für das große Ziel**
20 standen auf der Straße

27.12.61
Frohes Fest des Friedens
31° Kälte

28.12.61
**Revier Senftenberg schafft den Plan
trotz Kälte und Schnee**
Juwelen-Raub am Kurfürstendamm

29.12.61
**Zusammenarbeit bei friedlicher Nutzung
der Atomenergie erweitert**
Zwei Kinder aus den Flammen gerettet

30.12.61
Rote Hochöfner am Planziel

»Ihren heldenmütigen Kampf gegen die Kälte krönten die roten Hochöfner von Eisenhüttenstadt am Donnerstagabend mit einem großartigen Sieg. Mit dem Abstich an den Öfen V und VI erfüllten sie ihren Kampfplan in Höhe von 1 227 000 t Roheisen. Ihr neues Kampfziel lautet: Bis Jahresende weitere 12 000 t Roheisen. In einem Schreiben an das Zentralkomitee versichern sie, alle Waggons schnell zu entladen und Höchstleistungen in der Energieerzeugung zu erreichen. Sie beschlossen, auch am Silvesterabend und am Neujahrstag voll zu arbeiten. 200 freiwillige Helfer je Schicht aus anderen Betrieben, der Volkspolizei, der FDJ, Oberschüler und Lehrer werden an der Seite der Hüttenwerker mit zupacken, um die Produktion auf vollen Touren zu halten.« »Neues Deutschland«, Berlin, 30.12.61, S.1

Pille gegen Promille!

»Autofahrer und Fußgänger! Seht nicht zu schwarz in die Zukunft: Die Anti-Alkohol-Tablette ist in Sicht! Eine Pille gegen Promille! Ein Mittel, das wirklich nüchterner macht! Ein Bonbon, der die Wirkung von beispielsweise vier Glas Bier halbiert. Vielleicht gelingt es der Wissenschaft, das vom Justizminister Stammberger geplante 0,8-Promille-Gesetz überflüssig zu machen. Die Pille gegen Promille verspricht mehr Sicherheit im Straßenverkehr! Vielleicht schon nächstes Jahr ... 1,5 Promille billigen Ihnen heute äußerstenfalls Polizei und Staatsanwaltschaft noch zu. Das wäre etwa vier halbe Liter oder acht kleine Schnäpschen.« »Bild«, Berlin 30.12.61, S.1 (df-bey.)

Joshua Neustein: Aschenbach

In the installation *Aschenbach* by Joshua Neustein, a magnificent crystal chandelier is hanging from the high ceiling and lowered down to touch the floor. On the whole floor is spread the map of Berlin, made from ashes. "What had been the floor is now something else, an expanse of indeterminate dimensions holding the map" of the city, the site of the museum at a certain point of its history. "The map is enlarged so that it's drawn streets have become paths that constrain the visitor's movements through the space, very much as if one were walking through the city itself."[1]

Neustein's strikingly evocative installation would be easy to read as an allegory on German recent past. A Jew from Danzig exhibits ashes in Berlin – what else can it be? Neustein rejects such han interpretation. He passionately, denies historic connotations and wants to banish memory from the realm of art. Immediately he qualifies that statement "not to banish memory from scholarship, from schools and libraries."

For this artist the work of art should occupy center stage and reinterpret the world with reference to itself. If we will ever vest our faith in the victory of art over the needs of museum themes and institutional requirements, we must overcome history. Like the Kantian individual with a quest for the sublime that must, need be a lonely search. It is dangerous when the passionate for the sublime becomes a collective rage or a national agenda.

The *Aschenbach* installation "seeks an internal relationship to the space and indeed to the site of the museum itself. The internal relationship means that the work is not in the space the way an object is in a box".[2] The experience at a metaphorical level is clearly intended to be transformative. The metaphor addresses and emblematic vision of Berlin through the fictional lens of Thomas Mann's protagonist in "Death in Venice". The main character in the 1912 novella is Aschenbach, an aging artist (Neustein's age) who struggles with two sides of his temperament – the Nordic rational organized character versus the romantic impulsive Southern sensibility. Gustav Aschenbach named after the great musician Mahler who died the year Mann wrote "Death in Venice". Mahler, the Jew who converted to Catholicism and submitted to social pressures for the sake of his music. Neustein's Aschenbach is yet a commentary on the commentary, twice removed.

Neustein's idiom has been erected on a supposition that the real world is incomprehensible and can only be understood by turning to fiction. This follows Giambattista Vico's and Lévi-Strauss's example. Vico, the great Renaissance philosopher and father of the study of mankind as a science, looked to myths to understand the present Myths are poetic wisdom to deal with the world

Places of Remembrance A Contribution of the Jewish Museum in Martin-Gropius-Bau

If anywhere is everywhere then *Deutschlandbilder* privileges the world with Germany as a starting point. Its cosmopolitan consciousness, its traditions integrate and interpret art made in its confines. Berlin Tel Aviv Venice Majdanek figure more than random instances. As we pronounce the names of these places they bring pictures to mind, deep structures transcend the perspective. We need to cool down the implications and the possibilities.

How shall we enter Berlin? Perhaps by following in the footsteps of Walter Benjamin through his essays "Einbahnstrasse" and "Childhood in Berlin" we may move past places loaded with historical stratification, to the inner spaces of Martin-Gropius-Bau, to the three installations made for the exhibition *"Deutschlandbilder"*.

Aschenbach by Joshua Neustein from New York, *Mental Maps – Involuntary Memory, Berlin 1997* by Penny Yassour from Kibbutz Ein-Harod, Israel, and *Portraits from the Majdanek Trial* by Minka Hauschild from Dusseldorf. Tracking Walter Benjamin of 1920's threads us in and out of familiar sights made more familiar by approaches in another time and another traveler. But we are in Berlin 1997. We pass the Wall which Benjamin never saw, which we no longer see, but feel so deeply. We walk in the Grande Allee, fitted by Albert Speer's streetlamps, we face the Brandenburg Gate, see the GDR Tower of communication on Alexanderplatz, nearly touching the tower of the Rote Rathaus. We turn to the forests of cranes in the skyline. Berlin is building its heart which was a wasteland of ruins, a no-mans land for 50 years. What we see in these places is beyond what we see with our eyes: the point of convergence of historical ground-swells. The tectonic movements, which make the place an ever erupting lava of memories. Edmond Jabes wrote "To remember means to forget what our eyes have seen."

Three projects attract my attention because they ask crucial questions and undertake a self destruction, conditional on themselves. They ask: Is it possible to make art after the German catastrophe in the 20th century? Is the drama of reality and history so destructive to the makers of art that to encounter its devastation is to go blind? Can modernism free itself from the fatal fascination of that which is more imaginative than any art, poetry, or prophecy? The three installations were conceived remote from one another, so different in styles, materiality, conception. They are however joined by resorting to the generic denominator of maps.

[1] Arthur Danto, "The Message in the Ashes", *Joshua Neustein. Light on the Ashes*, exhibition catalog, Southeastern Center for Contemporary Art (SECCA), Winston-Salem (USA, 1996), 26–45; 31.

[2] Danto, 30.

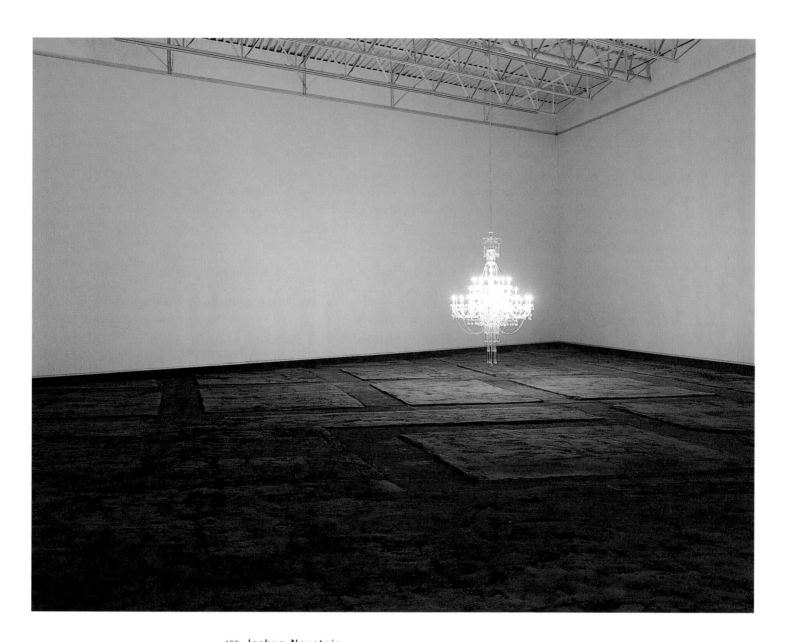

466 **Joshua Neustein**
Aschenbach, 1997
Installation
Crystal chandelier, ashes
The illustration shows the preliminary version
Light on the Ashes, 1996
at the Southern Center of Contemporary Art,
Winston-Salem, North Carolina

467 **Penny Yassour**
Mental Maps – Involuntary Memory, Berlin 1997
1997
Installation
Iron, aluminum, wood, PVC, silicon, rubber
shelves, neon
Collection of the artist

The illustrations show the preliminary version
Mental Maps – Production Halls, 1993
in the Mishkan Le'Omanut, Ein Harod

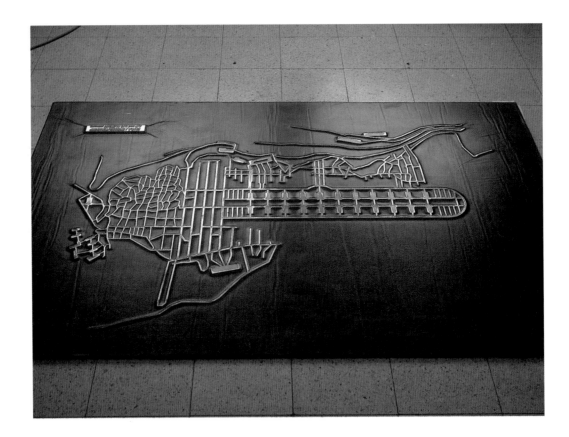

a

468 **Minka Hauschild**
Portraits from the Majdanek Trial, 1995/96
25 paintings from a 40-part series
Oil on cotton
Collection the artist

a *Elisabeth Adler-Cremers,*
 Witness Supervisor, 60 x 65 cm

b *Arthur Liebehenschel,*
 SS Camp Commanding Officer, 60 x 75 cm

c *Unknown (Archive photo)*, 75 x 55 cm

d *Simon Wiesenthal, Investigator*
 63 x 50 cm

e *Elsa Ehrich, SS Head Warden*
 60 x 70 cm

f *Emil Laurich, Defendant*, 70 x 65 cm

g *Hildegard Lächert, Defendant*
 50 x 60 cm

h *Unknown Witness*, 50 x 70 cm

i *Thomas Ellwanger, Defendant*
 45 x 63 cm

b

c

d

e

f

g

h

i

j

k

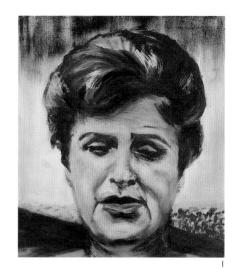

l

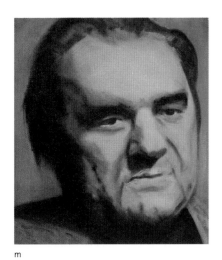

m

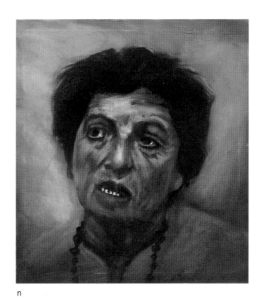

n

j *Leo Miller, Witness,*
 Former Prisoner, 65 x 85 cm

k *Luzie Moschko, Witness*
 Former SS Warden, 75 x 90 cm

l *Zippora Pestes, Witness*
 Former Prisoner, 60 x 70 cm

m *Erwin Mierick*
 Trial Observer, 60 x 70 cm

n *Maryla Reich, Witness*
 Former Prisoner, 85 x 95 cm

o *Günter Bogen*
 Presiding Judge, 85 x 80 cm

p *Ludwig Bock, Defense Attorney*
 45 x 55 cm

q *Alice Orlowski, Defendant*
 60 x 70 cm

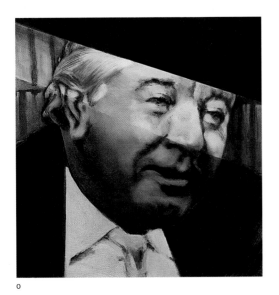

o

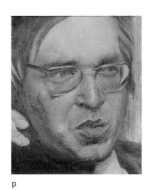

p

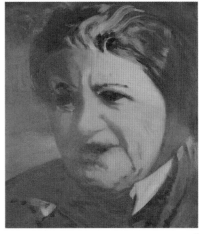

q

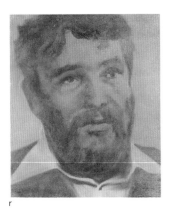

r

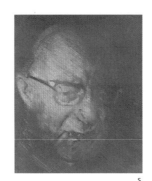

s

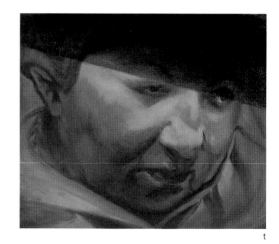

t

r *Dieter Ambach, State Attorney*
 65 x 80 cm

s *Hans Mundorf, Defense Attorney*
 45 x 55 cm

t *Chawa Jakubowicz, Witness*
 Former Prisoner, 80 x 70 cm

u *Johann Barth, Witness*
 Former Police Officer, 85 x 95 cm

v *Henryka Ostrowska, Witness*
 Former Prisoner, 85 x 75 cm

w *Josefine Jürgens "Silent Help"*
 50 x 60 cm

x *Hermann Hackmann*
 Main Defendant, 95 x 85 cm

y *Dr. Jan Nowak, Witness*
 Former Prisoner, 70 x 60 cm

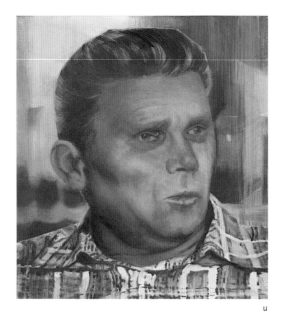

u

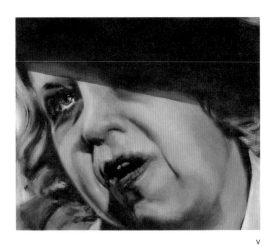

v

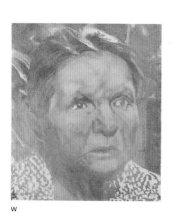

w

x

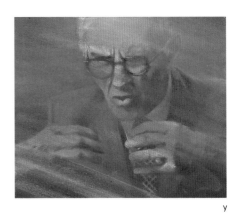

y

not directly but at one remove. Myths are man's attempt to explain the world as he sees it, to explain society and its structure. As the structuralist view, true nature of things lie in the relationship between perceiver and perceived, that the objects perceived are not discrete components, but interactions, even events.

The word play of Aschenbach (in German, it literally means a brook of ashes) is filtering this installation through Thomas Mann's "Death in Venice". In the novella Aschenbach is appalled and desperately struggles against a conspiracy of silence about a plague that rages in the city. The authorities keep it quiet, not to scare away the tourists, their priority is economic. Eventually, Aschenbach colludes in the silence for selfish reasons. Neustein chose a German author, a novella about a German fictional person modeled on a converted Jew, Mann turned him from a musician to a writer. In a metamorphosis late in life, the protagonist transforms from a rational, German type, to a romantic Mediterranean type, enthralled with beauty. Is the conflict between the Nordic and the Southern in Aschenbach – a replay of the agony of Mahler's conversion from Jew to Catholic? Are we asked to witness the pain of transfiguration and abandonment? The next item on the installation inventory is the chandelier. Arthur Danto attributes Neustein's fixture to the chandelier in Adolf Menzel's painting of *Flute Concert of Frederick the Great at Sans Souci* (1850–52). Playing the flute under the magnificent chandelier; is this a transformation of the great warrior into delicate muse hallowed by the crystal light? Danto writes: "The first mystery of Neustein's installation is that he has retained the symbolic connotations of the chandelier but lowered it dramatically, so that it sits above the ground, the like a burning bush, so that there is no way for us to stand beneath it ... We enter from the sort of outer darkness Menzel paints so marvelously, and because we have entered the work – because we do not stand outside it as in the standard gallery experience, we ourselves are 'put in a new light'."[3]

The ashes made into a map erupts from a cartography into an ontology. The ashes are a waste material in the burning of coal for the production of electricity, that electricity lights the chandelier. The map of ashes then is a fictional flight or is it an allegory on Berlin, as the mythic Phoenix bird that rises out of the ashes. Is then the chandelier the Phoenix bird made of ashes just as a the light made by electricity is part of the carbon cycle?

Or is this chandelier Menzel's figuration of the German spirit in its glory? The ashes are compulsively self ravishing and Neustein escapes the history of Berlin to return via Venice via Mahler the converted Jew. Berlin is the capital of loaded history and Venice is the ash tray of the essential culture in the western world. The cruelty of imposing Diamonds on Ashes. We can recuperate endless

analogies. Emmanuel Levinas writes "perception is the primordial act of being ... and is exercised to the same purpose as the other vital acts of being; without derogation of the spiritual."[4] In a recent letter, Neustein remarked: "I believe that Aschenbach the installation is as much a personal exploration of my origins and about writing myself into the history of this city."

Penny Yassour: Mental Maps – Involuntary Memory, Berlin 1997

If Neustein turns cartographically away from history, Penny Yassour turns her work as a material documentary, back to history. She relates directly to the complex installation to the massive underground factories for the Messerschmitt war planes in Kahla/Großeutersdorf, operated from 1944–45, south of Jena, named Reimahg (after Reichsmarschall Hermann Göring). More than 12,000 forced laborers, many of which died there operating the production. *Mental Maps – Involuntary Memory, Berlin 1997* is a series of plans of underground bunkers. The artist translated the engineering plans into synthetic materials – iron impregnated in silicon rubber formed by vacuum moulding. Her installation includes large scale black rubber aprons that hang suspended like in a slaughterhouse. A third element in the installation are a series of models of arsenal production facilities. The dramatization of the environment is radiated from the materiality and the change in scale. Yassour refers to Jean François Lyotard's statement "the Holocaust is like an earth quake, which destroyed all measuring tools."[5] Yellow alphabet printed on the aprons arouse references with violence and order. The aprons made of rubber remind us of Rembrandt's effulgent painting of a slaughtered beef carcass. The cool, estranged synthetic breathes an anxiety that transports our perception to organic vivisection.

Hi tech objects that insinuate a smooth standardized conversion of power into production, invite a prepositional contradiction of a concept of beauty. Yassour's solution is to press closely to seeming dispassionate. Judgments of taste are for Kant purely disinterested and have nothing to do with one's contingent inclinations or desires. Yassour re-asks the question formulated by Adorno: Can art be made after Auschwitz? There is a difficult tension here even before we approach the work of art because it is further aggravated by art made not only after but from the stuff of the Holocaust. Terry Eagleton in his essay "The Law of the Heart" writes: As a kind of terror, the sublime crushes us into admiring submission, if this resembles a coersive rather than consensual power, engaging our respect but not, as with beauty, our love ... it is the difference between what Louis Althusser called the ideological and the repressive state apparatuses."[6] The engineering plans of the tunnels and architectural

3 Danto, 39.

4 Emmanuel Levinas, "Reality and Its Shadow", *The Levinas Reader* (Oxford, 1989).

5 Jean-François Lyotard, "Ticket to a New Decor", *Copyright 1* (Autumn 1987): 14f.

6 Terry Eagleton, *The Ideology of the Aesthetic* (Oxford, 1990), 54/55.

models of the factories, is made from synthetic materials that have no organic reference, that have no indications of their weight and tensile strength, seems to be suffocating the viewer. Advanced technology is revealing the dark side of modernization as it is imbued in the consciousness of Western society and the tendency towards totalization in dictatorial regimes.

The promise of technological utopia embraced and exploited by a destructive power fuses the poetic and the technological into a violent mechanism. It is a basic concept in Yassour's non-scale *mental maps*. The map is a document absorbed into her collective mental map which is redefined again and again. The multiplication of her production spaces, where the human figure is presented by its absence, contains personal dynamics as repressed forgetting (experience).

"The tradition of the oppressed teaches us that the 'state of emergency' in which we live is not the exception but the rule. We must attain to a concept of history that is in keeping with this insight."[7]

The relations between the elements within the *Kahla/Großeutersdorf* installation, with their simulation of congestions and functional provoke a mental and physical claustrophobia. It is a denial of technological achievement at the expense of human values. Yassour is enthralled by the technological possibility and at the same time seeks to equate it as a narrative of foreboding. Sean Hand writes that in Levinas' view "The way in which the closed world of art freezes time within images doubles and immobilizes being ... characters suffer an eternal anxiety, imprisoned in an inhuman interval."[8]

Minka Hauschild: Portraits from the Majdanek Trial

Between 1975–1981, at the County Court of Dusseldorf, the possibly longest and perhaps most spectacular Nazi law suit took place, partly due to the female defendants and the practices of the defence counsel. The filmmaker Eberhard Fechner documented the Majdanek law suit in a poignant four and a half hour film, a compilation of interviews with perpetrators, victims, witnesses and judges. In 1991 Minka Hauschild saw the film for the first time on television, and she began photographing faces off the tv screen, using simple technology. As these cheap photos began to bleach, she developed the idea for a project. She would present "these unknown faces, having only once been seen by the public",[9] using different formats and oil paints.

"This is about observing faces which have been captured in a photo, frozen in an image. It is about events of the past and their wide-reaching consequences. About characters, instincts, life mechanisms, attitudes, about their visibility and invisibility. I was also interested in the

phenomenon of the information transfer and perception. There was a kind of filtering through time and through the media with facts changing before they would reach me, the recipient. What part of history will be forgotten, or repressed. Which kind of filters exist? Every piece of history, mediated again and again, will undergo a process of change on its path to the present time. I wanted to be like an interpreter who is positioned between the faces and the images, and remain as neutral and distanced as possible. In the beginning I was fascinated by the seeming exchangability between victims and perpetrators, but this fascination has vanished by now."[10]

The faces painted by Minka Hauschild are oil paintings that read like maps. In exploring the topography of the portraits, carved by tectonics of historical forces, she tried to grasp a possibility of deciphering. Or find a system of deciphering. Let us backtrack a moment: The artist was confronted with a documentation of a trial. The trial investigated and searched for facts and truth. At the same time, the very imposition of the trial recovered that history by translating into legal code. The legal language and procedure brings back the indescribable horror into the social context. The legal procedure proportions the event. The artist attempted to understand through painting, not because painting is privileged with a dictionary of ideas, but because painting was to be an act in a therapeutic method. She painted portraits of faces, this powerful icon melts away the context. Perhaps all the faces in her works are self portraits that pose the questions, Who am I. Who are you.

The common denominator of the three artists that occupied my attention was the fusing of the spiritual and the indexical in art.

In maps, above all, the impossible dilemmas of existence take on life. The map is an image that insinuates its factuality. We are starkly confronted with a mapping impulse, to order the incompatible world into will and representation. The map that is the receptacle, no more than an emblem, patterns of an endless additive information, is not a representation of the world as we see it but yet its most expansive and accurate code. It is the frontier where the locus we live in is will and the object as signs is representation. Inside and outside the map come hypnotically together.

We return to the mapping cityscape of Walter Benjamin, given a specific inflection for our own journey to and through the Gropius Bau. What is this place? What place was it?

Again, we turn to another time and another writer's perspective in order to see our reality. We must look to the *art* of mapping to find emancipation from our limited figural vision. The cartographic aesthetic presents the world as artifact, as abstraction, as will, as theater

7 Walter Benjamin, "Thesis on the Philosophy of History", *Illuminations* (New York, 1968), 257.

8 Levinas, 129.

9 Minka Hauschild, "Gesichter durchleuchten", *PROZESSPORTRAITS,* exhibition catalog, Landgericht Düsseldorf (Dusseldorf, 1996), n. p.

10 Hauschild.

stage where millions of swarming lives play out endless patterns of their daily dramas. "Art for Adorno is less some idealized realm than contradiction incarnate. Every artefact works resolutely against itself, and this in a whole variety of ways. It strives for some pure autonomy but knows that without some heterogeneous moment it would be nothing, vanishing into thin air. It is at one being for itself and being for society, always simultaneously itself and something else, critically estranged from its history yet incapable of taking up a vantage point beyond it."[11]

Finally we do not summon objects separate by themselves but in relationship to other objects. The map is that *mise-en-scene* where the connections are played out. The map instructs us to look to detail, to look closer. The map demands that we skew the eyes into the microcosm and when we see inside the elaboration, the magnification, it is because it is present in us.

Amnon Barzel

[11] Terry Eagleton, 350.

499

Josef Albers
Photo: Jon Naar

Gerhard Altenbourg
Photo: Christian Borchert,
Berlin

Josef Albers
Born 1888 in Bottrop, Westphalia
Died 1976 in New Haven, USA

Josef Albers attended teacher training college in Büren, Westphalia from 1905-1908 and went on to become a primary teacher. At the age of twenty, he traveled to Munich and visited the Folkwang Museum in Hagen, where he met Christian Rohlfs and Karl Ernst Osthaus and saw works by Cézanne and Matisse. Inspired by these and by Mondrian, he painted his first abstract work in 1913. From 1913-15, Albers trained as an art teacher at the Königliche Kunstschule in Berlin, during which time he regularly visited exhibitions at the galleries of Paul Cassirer, Galerie Gurlitt and the Berliner Secession. At the Kunstgewerbeschule in Essen from 1916-19, he created his first lithographs, woodcuts and linocuts, which were shown at his first solo exhibition in Munich. He studied at the Akademie der Bildenden Künste in Munich until 1920, attending the painting class of Franz von Stuck. From 1920-33, Albers joined the Bauhaus, initially as a student, then as a teacher, working mainly in the glass workshop, and later in the furniture workshop. In 1929, twenty of his pictures in glass were exhibited at the exhibition of Bauhaus masters at the Kunsthalle in Basel and the Kunstgewerbemuseum in Zurich. When the Bauhaus was closed down in 1933, he emigrated, with his wife, to the USA and taught at Black Mountain College in North Carolina until 1949. In 1935, he traveled to Mexico, where his first major solo exhibition was mounted in Mexico City in 1936. His systematic exploration of colour culminated in his *Homage to the Square* series from 1949 onwards (fig. 102, 103, p. 86) which demonstrates the process of reduction of form and colour. In these superimposed squares, each colour enters into a free-floating correspondence with the adjacent colour. By systematically exploring colour as an autonomous entity, Albers became a precursor of the young American generation of colorfield painters. Although he had already had major exhibitions in the USA, it was not until 1957 that Albers' work was shown again in Germany, at the Ulmer Museum and at the Karl Ernst Osthaus Museum in Hagen. In 1965, The Museum of Modern Art in New York launched a retrospective exhibition of his Square series which toured South America, Mexico and the USA until 1967. Albers taught at a number of American universities until 1966, including Yale, where Eva Hesse was one of his students.

Josef Albers Retrospective, exhib. cat., Musée du Jeu de Paume, Paris; Haus der Kunst, Munich; Kunsthalle, Hamburg, 1997.

Gerhard Altenbourg
Born Gerhard Strörch in 1926 in Rödichen-Schnepfenthal, Thuringia
Died 1989 in Meissen

In 1944, the 18-year-old Gerhard Altenbourg was conscripted into the army. He was released from armed service before the end of the war. Initially working as a writer and journalist under a pseudonym, he developed his artistic oeuvre on the tradition of the Bauhaus "Blaue Vier" (Feininger, Jawlensky, Kandinsky, Klee), moving in the direction of gestural abstraction. In 1948-50, he studied under the Altenburg painter and sculptor Erich Dietz and at the Hochschule für Baukunst und bildende Künste in Weimar. With his finely-strung, rhizomatic images, Altenbourg pursued the surrealist tradition of Max Ernst and Richard Oelze. At the end of the 40s he worked on his triad of *Ecce homo* drawings (fig.124, 125, 126, pp. 107 ff.) and in 1952, he had his first solo exhibition at the Galerie Rudolf Springer and exhibited at the Maison de France in Berlin with Arnulf Rainer and Georg Gresko. At the first documenta in 1955, he admired the works of Wols and Dubuffet and felt an affinity with Beuys. 1956 and 1958 saw the first acquisitions by the Staatliches Lindenaumuseum in Altenburg, which also mounted his first museum exhibition in 1957. That same year, he created his first sculptures and in 1959 his first woodcuts. In 1964, Altenbourg was sentenced to two years on probation for alleged violation of customs and exise regulations. His first exhibition in West Germany was held at the Galerie Brusberg in Hanover in 1964, which has represented the artist ever since and which helped him to achieve wider recognition. In 1966, he received the Burda Prize for graphic art at the Grosse Kunstausstellung in Munich, in 1967, the prize of the II. Internationale der Zeichnung in Darmstadt and in 1968, the Will Grohmann prize of West Berlin. To mark the artist's sixtieth birthday, major retrospective exhibitions were held in the GDR in 1986-87, in Leipzig, Dresden and Berlin, followed by a show of his work in 1988, at the Kunsthalle in Bremen, the Kunsthalle in Tübingen, the Sprengel Museum in Hanover and the Akademie der Künste in West Berlin. Altenbourg, who was not permitted to travel to West Berlin after 1961, died in 1989 following a car accident.

Gerhard Altenbourg. Arbeiten aus den Jahren 1947-89, exhib. cat., published by the Institut für Auslandsbeziehungen, Berlin 1992.

Olaf Arndt
Photo: Janneke
Schönenbach,
Berlin

Georg Baselitz in his Derneburg studio, 1984
Photo: Benjamin Katz, Cologne

Olaf Arndt
Born 1961 in Hanover
Lives and works in Berlin

Since graduating in German and philosophy in 1989, Olaf Arndt has sought to achieve an interdisciplinary link between science and art in his work. His machines, which are simple, self-steering, low-tech robots, have appeared at a number of art events involving the BBM group (Beobachter der Bediener von Maschinen), founded in 1988 to celebrate what H. P. Schwarz has described as a "barbaric marriage of technology and art", in which rampant machines function as witnesses in much the same way as the books, which for Arndt are not so much documentations as integral components of the intended "art product". Since 1991, Arndt has collaborated with other artists, including the sculptor Rob Moonen (born 1958), on projects in which the individual biography of the artist is secondary. On a stipend to the Akademie Schloss Solitude in Stuttgart in 1993, they explored the subject of isolation for the first time in a photographic postcard book entitled *Achse Solitude-Stammheim*, which led to a detailed study of the use of soundproof rooms in the field of psychiatry and in prisons. As a result, Arndt and Moonan, with the support of the Karl-Hofer-Gesellschaft, Berlin, the Kunstfond Bonn, the Deutsche Bundesbahn and the Siemens-Kultur-Programm, Munich, realised the technically sophisticated installation of a *Camera silens* at the Medien-museum des Zentrums für Kunst und Medientechnologie in Karlsruhe in 1994. In 1995, this work was also exhibited at the Parochialkirche in Berlin, where it was accompanied by a two-day symposium. The opportunities and dangers of using new technologies in ways for which they were not intended also formed the basis for the book and installation *Buna 4* at the Festspielhaus Hellerau in Dresden in 1995. As a contribution to an exhibition entitled *Gummi* on the subject of rubber at the Hygiene-Museum in Dresden, the installation refers to the artificial rubber works run by the IG Farben company at Auschwitz, once the biggest manufacturing plant of its kind in Germany. After the state of (almost) absolute calm in *Camera silens*, the brilliant white of *Passage 1* at Bahnhof Zoo in Berlin and *Passage 2* at the FaXX Kunsthalle Tilburg in 1996 uses the synthetic sound of "white noise" superimposed on all exterior sounds to create a state of uneventfulness. His design for a planned walk-in installation *The Glas Block* (fig. 413, p. 461), in which the visitor is both perpetrator and victim in a situation of observation, with texts on the theme of "surveillance" addressing an aspect of German mentality and history can be seen in this book.

BBM, Dieser Wahnsinn muß ein Ende haben, Hanover 1994.
Camera silens. Ein Projekt von Moonen & Arndt, second edition,
 extended and revised, Hamburg 1995.

Georg Baselitz
Born Hans Georg Kern 1938 in Deutschbaselitz, Saxony
Lives and works in Derneburg, Lower Saxony

His native Saxony, his rejection by the Kunsthochschule in East Berlin in 1956 and his move to West Berlin in 1957, where he studied under Hann Trier at the Hochschule der Künste, are important personal experiences explored by Georg Baselitz in his early paintings of the 1960s, such as *The Night of the Senses* (1963, fig. 143, p. 121), with impassioned expressiveness. A sense of isolation and perceived provinciality in the divided city of Berlin weigh heavily in these paintings. Though this factor may initially have impeded their acknowledgement, in retrospect it makes them authentic documents of a change of generation in art. In addressing German history, the repressed and the unspoken are excavated by what Baselitz has referred to as a "fatherless generation going back to before their fathers day in search of role-models". In 1961, the artist adopted the name Baselitz from the place where he was born. That same year, together with his friend Eugen Schönebeck, he expressed his revolt in the manifesto *Pandemonium I* (fig. 150, p. 129) in his first exhibition at Schaperstrasse 22 near Fasanenplatz in Berlin. A second followed in 1962 (fig. 152, p. 131). Over and above the desire to express a sense of "Germanness", Baselitz untiringly explored the possibilities of painting on the borderline between the figural and the abstract. Turning his subject matter quite literally upside-down has, since 1969, been his most radical means of doing so – fractures, breaks and distortions are further indications of the same purpose. He has lived in Derneburg since 1975, and since 1980 he has been working on large scale wooden sculptures in addition to his painting and prints. Since 1977, he has held a professorship at the Staatliche Akademie der Bildenden Künste in Karlsruhe and since 1983 at the Hochschule der Künste in West Berlin, from which he resigned in 1988 in protest of the appointment of the former GDR artist Volker Stelzmann. After the fall of the Berlin Wall, Baselitz played an active role in the debate surrounding East and West German art, most notably in his infamous "Arschloch" (asshole) interview in which he refutes the artistic integrity of official GDR state artists. In 1992, he was re-appointed to the Hochschule der Künste in Karlsruhe.

Fred Jahn, *Baselitz. Peintre Graveur. Werkverzeichnis der Druckgrafik,*
 Vol. 1: 1963-1974, Vol.2: 1974-82, Bern/Berlin 1983/87.
Georg Baselitz, Skulpturen, exhib. cat., Hamburger Kunsthalle, 1994.
Georg Baselitz, exhib. cat., Solomon R. Guggenheim Museum, New York;
 Nationalgalerie, Berlin, 1995/96.
Georg Baselitz, exhib. cat., Musée d'Art Moderne de la Ville de Paris, 1996/97.

Willi Baumeister, c. 1948
Photo: Volkhart-Forberg

Max Beckmann in Amsterdam, 1938, Photo: Helga Fietz, Munich

Willi Baumeister
Born 1889 in Stuttgart
Died 1955 in Stuttgart

From 1905-07 Willi Baumeister trained as a painter, attending the classes of Adolf Hölzel at the Kunstakademie Stuttgart during the winter semesters between 1908 and 1910, where he met Oskar Schlemmer. He stayed in Paris and Amden (Switzerland) in 1911, and in 1913 he took part in the *Erste Deutsche Herbstsalon* at the Der Sturm gallery in Berlin. Conscripted into the army from 1914-18, Baumeister returned to Stuttgart in 1919. Between 1919 and 1923, apart from typographical works and stage sets, Baumeister created his *Mauerbilder* series with backgrounds containing a mixture of sand and putty to create a wall-like relief. In 1924, he met the French artists Léger and Ozenfant in Paris, where he had his first solo exhibition in 1926-27 at the Galerie d'Art Contemporain. An appointment to the Städelsche Kunstschule brought him to Frankfurt am Main in 1928. Exhibitions of his work, such as those mounted by the Galerie Flechtheim in Berlin and Düsseldorf in 1929 or by Paul Cassirer in Berlin in 1932, were no longer feasible in Germany after his dismissal in 1933. With his paintings defamed as degenerate by the *Entartete Kunst* exhibition in 1937, Baumeister participated in international exhibitions in Paris and Basel, and his work was also shown at the 1938 London exhibition of contemporary German art. In 1938, he transferred sixty of his paintings to Switzerland. Like his former fellow-student Schlemmer, Baumeister, who was barred from painting in 1941, was able to secure a means of living during the war by working in the technical painting institute of the Herbert paint manufacturing company in Wuppertal. There, from 1943 onwards, he worked on his book *Das Unbekannte in der Kunst*, which was published in 1947 and hailed as a manifesto of abstraction. In the conflict between the figurative and the non-figurative debated in the *Darmstädter Gespräche* of 1950, Baumeister proved a protagonist of abstract art (opposing Karl Hofer) and railed against the conservative approach posited by Hans Sedlmayr's book *Verlust der Mitte*. In his paintings *Two Epochs II* of 1947/48 (fig. 104, p. 87) and *Atlantis* of 1949 (fig. 105, p. 87) Baumeister presented a spiritual world of a new beginning in which figural motifs intensify only to dissolve. From 1946 until his death in 1955, Baumeister held a professorship at the Kunstakademie in Stuttgart.

Dietmar J. Ponert (ed.), *Willi Baumeister. Werkverzeichnis der Zeichnungen, Gouachen und Collagen*, Stuttgart/Cologne 1988.
Willi Baumeister, exhib. cat., Nationalgalerie, West Berlin 1989.
Gottfried Boehm, *Willi Baumeister*, Stuttgart 1995

Max Beckmann
Born 1884 in Leipzig
Died 1950 in New York

Rejected by the Akademie in Dresden, Max Beckmann attended the Kunstschule in Weimar from 1900-1903 and then went to Paris, where he was deeply impressed by the work of Cézanne. Following a fellowship in 1906 to the Villa Romana in Florence, he moved to Berlin with his wife, Minna Tube. His work was shown in exhibitions at home and abroad, and his first retrospective was mounted at the gallery of Paul Cassirer in 1913. These, together with the inauguration of a school for modern painting, are milestones in an artistic career marked by controversy, most notably in the debate with Franz Marc on abstraction in 1912. Beckman enlisted as a voluntary medical officer in the first world war and was discharged from the army in 1915 due to a mental breakdown, after which he settled in Frankfurt am Main. In concentrating on black and white prints until 1923, he developed a new painting style influenced by Gnostic teachings, Buddhism and the Cabbala, as well as by Schopenhauer's pessimistic philosophy. In 1919, he declined an appointment to the Kunstschule in Weimar, and in 1925 took over a master workshop at the Städel art school in Frankfurt am Main, where he was appointed professor in 1929. With the *Neue Sachlichkeit* exhibition in Mannheim in 1925, at the latest, Beckmann had won recognition as a painter. Spending his winters in Paris, he found the work of Picasso a challenging inspiration. Dismissed from his post by the National Socialists in 1933, and with his works included in the exhibition of *Entartete Kunst* in 1937, he went into exile for ten years with his second wife, Mathilde, (known as Quappi), in Amsterdam. The vertical format he chose to use in the 1920s marks the transition to his mature style with its strong black contours and compositional density. In particular, the nine potently symbolistic triptychs and the self-portraits he created in the period 1932-50 (fig. 1, 2, 3, pp. 23 ff.) are key-paintings of his years in exile. After the war, Beckmann turned down appointments at the universities of Munich, Darmstadt and Berlin, and in 1947 accepted a professorship at Washington University Art School in St. Louis. During the last of his three successful years in the USA, Beckmann taught at the Art School of the Brooklyn Museum in New York.

Erhard and Barbara Göpel, *Max Beckmann. Katalog der Gemälde*,
 2 vols., Bern 1976.
Stephan von Wiese, *Max Beckmanns zeichnerisches Werk 1903-25*, Düsseldorf 1978.
James Hofmaier, *Catalogue raisonné of Beckmann's graphics*, Bern 1984.
Max Beckmann, ed. by Klaus Gallwitz et al., exhib. cat.,
 Galleria Nazionale d'Arte Moderna, Rome 1996.

Joseph Beuys, Photo: Stiftung Museum Schloss Moyland, Bedburg-Hau

Julius Bissier, c. 1942
Photo: Gertrud Hesse,
Wiesbaden

Joseph Beuys
Born 1921 in Krefeld
Died 1986 in Dusseldorf

Born in Rindern, Joseph Beuys' formative years were shaped by the Hitler Youth and armed service. As a bomber pilot, he was seriously injured in 1943, returning to duty in 1944. He returned to Kleve in 1945, having been held by the British as a PoW. In 1946, he joined the Klever Künstlerbund and made friends with its leading collectors, Hans and Franz-Joseph van der Grinten. Impressed by the work of Wilhelm Lehmbruck, he began training as a sculptor at the Kunstakademie in Dusseldorf in 1947 under Josef Enseling and Ewald Mataré. Still a student, he had his first solo exhibition in 1953 at the van der Grinten house and at the Von der Heydt Museum in Wuppertal. After a depressive phase, he spent some time convalescing in Kranenburg. Appointed to the Kunstakademie in Dusseldorf in 1961, he continued to exert an enormous fascination on the younger generation of artists, even after his dismissal in 1972. In a number of happenings, closely related to the Fluxus movement, Beuys used autobiographical, mythical or historically charged subjects and materials such as felt, copper, fat and wax to illustrate the storage and flow of energy and thermal processes. From 1964 onwards, Beuys took part in every documenta. His first gallery exhibition was in 1965. All the works shown at the Städtisches Museum in Mönchengladbach in 1967 were purchased in 1968 by Karl Ströher, who exhibited them in 1970 as the *Beuys Block* at the Hessisches Landesmuseum in Darmstadt. His oeuvre includes drawings, sculptural images, complex installations, multiples and writings. With his "extended concept of art", Beuys addressed the immediate impact of "social sculpture" and the release of creativity in each individual. From the 1970s onwards, Beuys extended his work to the field of politics and ecology, making astute use of mass media. In 1967, he founded the "German Student Party" and in 1970 the "Organisation of Non-voters, Free Referendum", in 1971 the "Organisation for Direct Democracy through Referendum", and in 1973 the "Free International University For Creativity and Interdisciplinary Research". In 1979, he stood as a candidate for the European Parliament, and in 1980 for the North Rhine Westphalian Landtag as a representative of the Green Party. Major retrospective exhibitions of his work were held in 1979, at the Guggenheim Museum in New York; contributions to the Venice Biennale in 1976 and the *Zeitgeist* exhibition at the Gropius Building in Berlin in 1982 bear witness to Beuys' powerful capacity to convey his creative message.

Joseph Beuys, Die Multiples. Werkverzeichnis der Auflagenobjekte und Druckgrafik, ed. by Jörg Schellmann, Munich 1992.
Joseph Beuys, exhib. cat., Kunsthaus Zurich, 1993/94.
Götz Adriani, Winfried Konnertz, Karin Thomas, *Joseph Beuys,* Cologne 1994.
Uwe M. Schneede, *Aktionen,* Stuttgart 1994.

Julius Bissier
Born 1893 in Freiburg
Died 1965 in Ascona

After studying for a short time at the Grossherzogliche Akademie der Künste in Karlsruhe, Julius Bissier was conscripted into the army in 1914, where he met the painter Hans Adolf Bühler, whose student he became around 1917. His friendship with the orientalist Ernst Grosse introduced him to East Asian culture. His first solo exhibition as a painter was at the Freiburger Kunstverein in 1920, and in 1923-24, he pursued a career in decorative arts, receiving the painting prize of the Deutscher Künstlerbund in Hanover in 1928. An adherent of Neue Sachlichkeit, he underwent a radical change in style, adopting abstraction with the encouragement of Willi Baumeister in 1929 and Constantin Brancusi, whom he visited in Paris in 1930. This radical break coincided with the end of a profound personal crisis. Around 1930, he created his first psychograms in the style of Chinese ink drawings. From 1929-33, Bissier was head of the painting class and teacher of drawing at the University of Freiburg, where almost his entire early work was destroyed in a fire in 1934. He was dismissed from his teaching position as a result of National Socialist art policy, and increasingly forced into "inner emigration". Bissier then turned to smaller formats. From 1935-38, he travelled in Italy and when war broke out in 1939, he withdrew to Hagnau on the shores of Lake Constance. Virtually ignored by the public, he suffered another creative crisis in 1943. That same year, his friend Oskar Schlemmer died. Bissier dedicated four orientally inspired pen and wash drawings to him under the title *To Oskar Schlemmer's Death* (1943; fig. 11, p. 39). From 1946 onwards, he created coloured monotypes in which he sought to expand his pen and wash drawings by including an element of colour. Around 1945-46, Bissier began creating miniatures in oil-tempera and watercolour. It was not until 1957 that he achieved his breakthrough with an exhibition at the Kestner Gesellschaft in Hanover. He was included in the Cologne exhibition of *Neue Kunst nach 1945* in 1958, documenta II and III in Kassel in 1959 and 1964, and in international retrospective exhibitions at Haags Gemeentemuseum in 1960, at the Palais des Beaux-Arts, Brussels in 1961 and several American cities in 1963. In 1959, he received the Cornelius prize awarded by the city of Dusseldorf, and in 1961 he became a member of the Akademie der Künste in West Berlin, receiving the Grosser Kunstpreis of the state of North Rhine Westphalia in 1964. From 1961 until his death, he lived in Ascona.

Julius Bissier, exhib. cat., Kunstsammlung Nordrhein-Westfalen, Dusseldorf 1993.
Julius Bissier. Vom Anfang der Bilder 1915-1939, exhib. cat., Städtisches Museum Freiburg, 1994.

Manfred Böttcher
Photo: Christian Kraushaar,
Berlin

Rudolf Bonvie, 1997, Photo: private

Manfred Böttcher
Born 1933 in Oberdorla, Thuringia
Lives and works in Berlin

The son of a craftsman, Manfred Böttcher and his three brothers were all destined to pursue artistic careers. Böttcher enrolled at the Hochschule für Bildende Künste in Dresden, where he studied painting under Wilhem Lachnit from 1950-55. Together with his fellow students Werner Stötzer, Dieter Goltzsche and Harald Metzkes, he continued his studies as a master student of Heinrich Ehmsen at the Deutsche Akademie der Künste in East Berlin from 1955-58. The move to Berlin catapulted this group of artists into the exciting atmosphere of a thriving metropolis in which traces of destruction were ubiquitous, as they were in Dresden. The painting *Rubble Tips (Chancery of the Reich Ruin)* of 1958 (fig. 118, p. 102) was inspired by the ruins around Pariser Platz, where the studios of the master students where located then as now. With their "black pictures" the artists of the Berlin school increasingly found themselves going against the grain of the official line of realism that called for optimistic and illustrative works of art. On a visit to the Hermitage in Leningrad and the Pushkin Museum in Moscow in 1957, Böttcher was profoundly impressed by the work of Matisse and Picasso. Exhibited at the annual exhibitions of the Deutsche Akademie der Künste in East Berlin in 1956 and 1958, the "black pictures" were rejected by the jury and, although they were not even exhibited, they were attacked for their decadent leanings towards Western existentialism. After spending a year in Dresden in 1960, Böttcher returned to East Berlin in 1961, where he took part in the exhibition *Junge Künstler Malerei* at the Akademie der Künste, which met with harsh criticism from the SED and the East German government. Böttcher, by now increasingly oriented towards Cézanne's painting, had his first solo exhibition in 1964 at the Kunstkabinett headed by Lothar Lang, at the teacher training institute of East Berlin. Group exhibitions at the Staatliches Museum in Schwerin and the Kulturhistorisches Museum in Magdeburg in 1965 resulted in the first acquisitions of his works by museums. In 1977, Böttcher exhibited at the Berliner Galerie am Prater, which, like the Galerie Mitte where his work was shown in 1983, was one of the most important cultural oases in East Berlin at the time. Awarded the Goethe Prize by the City of Berlin in 1978, and the Käthe Kollwitz Prize by the Akademie der Künste der DDR in 1984, his most extensive exhibition was held at the Marstall in 1992. In 1995, the Galerie Mitte showed his works on paper.

Manfred Böttcher, exhib. cat., Akademie der Künste, Berlin 1992.

Rudolf Bonvie
Born 1947 in Hoffnungstal
Lives and works in Cologne

After studying at the Werkschule in Cologne from 1968-73, Rudolf Bonvie enrolled in theatre studies at the University of Cologne. In the mid 70s, he began to create a series of conceptual photographs exploring the human image. His first solo exhibition was held at the Galerie Hinrichs in Karlsruhe in 1973. In his photographs of friends and acquaintances, using newspaper clippings combined with texts or superimposed with black fields, both psychological and sociological aspects play a role. His *Compare all single column photographs that depict a person* of 1977-78 (fig. 372, p. 421), using photographs published in the weekly news magazine *Der Spiegel* in the years 1957 and 1977 is a case in point. It can be read as a chronicle of West German history and media development, with the increasingly dynamic portraiture of the period echoing the growing self-confidence of the young Federal Republic, and at the same time reflecting the newfound strength of the media — a theme addressed by the exhibition *Vorher Nachher* at the Kunstverein in Gelsenkirchen in 1979. In the exhibition *Die Jagd ist eröffnet...* in 1982 at the Galerie Magers in Bonn and the Produzentengalerie in Hamburg, Bonvie addressed the manipulative nature of sensationalist press photography and extended the concept of photographic work to the field of sculpture and installation. He first turned to drawing as a new form of expression while on a stipend from the Deutsch-Französisches Jugendwerk in Paris in 1981. His close collaboration and friendship with Astrid Klein led to their joint exhibitions at the Kunsthalle in Bielefeld in 1985, the Museum am Ostwall in Dortmund in 1986 and the Bibliothèque Municipale de Lyon in 1997. In addition to solo exhibitions at the Museum Folkwang in Essen in 1988, the Forum Stadtpark in Graz in 1989, the Badischer Kunstverein in Karlsruhe and the Stadtgalerie in Saarbrücken in 1990, the Lehnbachhaus in Munich in 1991, Bonvie also exhibited at the Galerie Kicken in Cologne (1989, 1991, 1993) and at Françoise Paviot in Paris in 1996. In his more recent works, he has returned to the technique of superimposition, which he has developed in murals and narrow horizontal formats and in his 3-part photographic works *Weimar* and *Mal* of 1990 (ill. 373, p. 422). In these works, Bonvie creates a multiple view of reality through the simultaneous perception of certain visual sections, for example in his reference to the tourist attractions of Weimar when he makes a correlation between the inscription over Goethe's house and the concentration camp of Buchenwald.

Rudolf Bonvie, Prace fotograficzne / Fotoarbeiten, exhib. cat., Panstwowa Galeria Sztuki, Warsaw 1996.

Matti Braun
Photo: private collection

Klaus vom Bruch
Photo: private collection

Matti Braun
Born 1968 in Berlin
Lives and works in Cologne

Matti Braun began his studies at the Hochschule der Bildenden Künste in Brunswick in 1989. At his first public appearance in 1991 at the Friesenwall 116a exhibition space in Cologne, he gave a reading with slides, presenting his book *Adolf Hitler. Installationen und Happenings,* based on the exhibition catalogue of the major 1988 Joseph Beuys retrospective at the Martin-Gropius Building in Berlin. The catalogue was re-written or "over-written" by Braun, while retaining its original. That same year, Braun moved to Frankfurt am Main where he enrolled at the Städelschule. He took part in the exhibition of the Kippenberg class at the Galerie Grässlin-Erhardt in Frankfurt am Main and at the Galerie Bleich-Rossi in Graz in 1991, for which a small book entitled *Virtuosen von dem Berg* was produced using the same layout as the popular Baedecker tourist guides. In 1993, Braun returned to Brunswick to study at the Hochschule der Bildenden Künste again. Within the scope of a group-exhibition at Luis Campaña in Cologne in 1994, he exhibited Chinese vases with blue painting. In 1995, together with Jörn Bötnagel, he realised his next project, *Jussila.* Braun rented a shop in Friesenstrasse for two weeks and installed a self-built bar and exhibited painted plates, which he showed again at the group-exhibition *Jahreswechsel 95/96* at the Lecesse Sprüth exhibition-venue in Cologne. Matti Braun has described his colourful polyester furnishings citing the 70s-revival trend as "vulgar Colanis" (fig. 439, p. 473). Beyond the hackneyed typology of applied art and fine art, they were exhibited in 1996 at Luis Campaña in Cologne, and in 1997 they were used as seating for the group exhibition of young English video artists *Ein Stück vom Himmel,* organised by the Institut für Moderne Kunst together with the Kunsthalle in Nuremberg. In 1997, Reinhard Hauff mounted a solo exhibition of Matti Braun's works under the title *Sonne, Farben, gute Laune II* at Achim Kubinski in Stuttgart. Braun was involved in the inaugural exhibition *Was nun!?* at the Galerie Schipper & Krome in Berlin 1997 and in a group exhibition of young German artists at the same gallery. Since completing his studies in 1996, Matti Braun has been living and working in Cologne.

Matti Braun. Jussila, exhib. cat., Temporärer Ausstellungsraum Friesenstraße 50, Köln, Jörn Bötnagel Projekte, Köln 1995.

Klaus vom Bruch
Born 1952 in Cologne
Lives and works in Cologne and Karlsruhe

Klaus vom Bruch began working with video in 1974 and exhibited his experimental videos at the Oppenheim studio in Cologne. After studying at the California Arts Institute in Valencia, California under John Baldessari in 1975-76, he studied at the University of Cologne from 1976-80. His first solo exhibition was held at the Galerie Magers in Bonn and at de Appel in Amsterdam in 1977-78. In 1981, he was awarded a production stipend by the Long Beach Museum of the Arts, California. Media reality and its impact on the individual are the leitmotif of his video tapes, in which he combines historic film material, advertising film sequences and self-portraits in a strictly formalis editing technique. Since the 80s, he has used this to develop installations with sculptural elements, in which the monitors are used both as screens and as sculptural objects. In 1984, his first installation *Pas de Deux* was shown in the central pavilion of the Venice Biennale. In 1985, together with Marcel Odenbach, he installed *Zick-Zack durchs Palais* in the Museum van Hedendaagse Kunst, Gent. In 1986, vom Bruch was awarded the Dorothea von Stetten art prize and the Städtisches Kunstmuseum in Bonn presented his *Die Verhärtung der Durchschnittsseelen* which, like *Angriff und Verteidigung* at the Galerie Daniel Buchholz in Cologne, is based on the dialectic principle of broadcaster and receiver. In 1987, vom Bruch was represented at documenta 8 in Kassel with his *Coventry – War Requiem.* In 1988, solo exhibitions were held at the Winnipeg Art Gallery and at the Städtisches Museum Abteiberg in Mönchengladbach. With the assistance of the Karl Schmidt-Rottluff Foundation in Berlin, the Städtische Kunsthalle in Dusseldorf presented a survey of his work in 1987-89, followed by an exhibition at the Moderna Museet in Stockholm in 1989. The exemplary exploitation of the media under the National Socialist regime is the take-off point for his reflections on the correlation between war, masculinity and technology which can be found throughout his oeuvre, from the early video tapes (*Das Duracellband,* 1980; *Das Softiband,* 1980; *Das Alliiertenband,* 1982) to his most recent installations *Artaud spricht vor den Soldaten* at the Kunst- und Ausstellungshalle der Bundesrepublik Deutschland in Bonn in 1995 and *Simplicissimus – War is Everywhere* (1997; fig. 412, p. 459). Since 1982 Klaus vom Bruch has held a professorship at the Staatliche Hochschule für Gestaltung in Karlsruhe.

Klaus vom Bruch. Video Installationen 1986-1990, exhib. cat., Kestner-Gesellschaft Hannover 1990.
Klaus vom Bruch. Videobänder 1975-1984, exhib. cat., Kölnischer Kunstverein, Köln 1993.

Werner Büttner
Photo: Renate Pukies,
Hamburg

Carlfriedrich Claus
Photo: Hilmar Messenbrink,
Chemnitz

Werner Büttner

Born 1954 in Jena
Lives and works in Hamburg

In 1961, shortly before the Berlin Wall was built, Werner Büttner and his family moved to Munich, and then to Berlin in 1968. After studying law for five years in Berlin from 1973-77, Büttner was sent down in 1977. He moved to Hamburg, where he became part of the young artist generation that emerged in the early 80s under the direct or indirect influence of Sigmar Polke, and which included Georg Herold, Albert Oehlen and Martin Kippenberger. In 1976, together with Albert Oehlen, he founded the *Liga zur Bekämpfung des widersprüchlichen Verhaltens* (League to Combat Contradictory Behaviour) and from 1977-79 he was editor of its central organ *Dum Dum,* at a time when they still regarded themselves as a "propaganda office of the RAF". Their visual and verbal attacks were aimed, for the most part, at the German petty bourgeoisie, with all its smugly cosy "gemütlichkeit" and its intractable ideologies. Without adopting a clear position, a sense of contradiction and absurdity are taken to the point of grotesque parody. In doing so, the strategy of verbal and symbolic overcoding, which takes on its own dynamism through group jargon, no longer aims at unequivocal interpretation, nor at the affirmation or negation of social contexts, but at reflecting them. In his 1986 work addressing the Nuremberg trials *Drei Versuche über Nürnberg (Three Attempts on Nuremberg,* fig. 341, p. 348), wet sacks placed on high pedestals symbolised the perpetrators of Germany's crimes against humanity. The individual artist's biography and signature was subordinated to the group work. In 1978, Büttner and Oehlen displayed a wall painting in the "Welt" bookstore in Hamburg. Together with Oehlen and Herold, also from the GDR, Büttner developed his 1980 project *Samenbank für DDR-Flüchtlinge.* Büttner's first solo exhibition was held in 1981 at the Galerie Max Hetzler in Stuttgart, where he continues to exhibit, and in the galleries Ascan Crone, Hamburg, Helen van der Meij, Amsterdam, Bärbel Grässlin, Frankfurt am Main, and others. Apart from solo exhibitions at the Institute of Contemporary Arts in London in 1986, at the Kunstverein der Villa Stuck in Munich and at the Palais Liechtenstein in Vienna in 1987, at the Städtisches Kunstmuseum in Spendhaus Reutlingen in 1989 and at the K-Raum Daxer in Munich in 1993, Büttner has also participated in major German exhibitions such as the *Mülheimer Freiheit* at the Galerie Paul Maenz in Cologne in 1980, *Zeitgeist* at the Martin Gropius Building in Berlin in 1982 and *Von hier aus* in Dusseldorf in 1984. Since 1990, Büttner has held a professorship at the Hochschule für Bildende Künste in Hamburg.

Werner Büttner. Heimspiel. Arbeiten aus der Sammlung Grässlin 1980–1995,
 exhib. cat., St. Georgen, Schwarzwald, 1995.

Carlfriedrich Claus

Born 1930 in Annaberg, Saxony
Lives and works in Annaberg

Carlfriedrich Claus grew up in a family of booksellers and art dealers. In this domestic climate, even as a child he was familiar with the "degenerate" artists, read Marx, Steiner and Bloch, and learnt a number of languages, including Hebrew. By 1944, he had turned his attention to creating automatic drawings and natural poems. In 1951, he began writing experimental poetry, which he sent to Will Grohmann, who became his first patron. After contracting tuberculosis, Claus began to explore the theory of existentialism while staying at a sanatorium. His *Sprechversuche* of 1956-58 foreshadowed his tape-recorded *Lautprozesse* of 1959. From 1960 onwards, his field of experimentation shifted towards the realm of writing and signs found in his *Sprachblätter,* and his extensive studies included the cabbala, Jewish alchemy and mysticism, linguistics, Paracelsus, Benjamin, Brecht, Freud, cybernetics and karate. His prolific correspondence with artist friends such as Franz Mon, Dick Higgins, Dieter Rot, Emmett Williams and others provoked the suspicion of the East German secret police, the Stasi, but at the same time brought him contacts in the West, so that he was able to participate in the *Konkrete Poesie* international manuscript exhibition in Wuppertal in 1961. After that, he began systematically expanding his work on tracing paper to create a system of pages he described as *Kombinate.* Amongst those who visited his first solo exhibition in 1962 at the home of the Grüss family in Freiberg were the art historians Fritz Löffler and Werner Schmidt. Pictorial signs were now added to his handwriting traces. In 1963, Claus was represented at the *Schrift und Bild* exhibition in Amsterdam and Baden-Baden, and the Kupferstich-Kabinett in Dresden purchased some of his works. In 1966, in spite of his international standing as an artist, his financial situation was precarious. It was not until 1975 that he had his first major exhibition at the East Berlin Galerie Arkade which Klaus Werner had to defend against the attacks of the cultural bureaucracy. In 1977-82, together with Ranft, Morgner and Schade, Claus founded the Galerie Clara Mosch in Adelsberg. Following solo exhibitions at the Kupferstich-Kabinett in 1980 and 1988, a retrospective exhibition was held at the Städisches Museum in Karl-Marx-Stadt, touring West German venues in 1990-91. In 1991, Claus became a member of the Akademie der Künste in West Berlin, received an honorary professorship from the Hochschule für Bildende Künste in Dresden and was awarded the Harry Graf Kessler prize.

Carlfriedrich Claus. Erwachen am Augenblick, exhib. cat., Städisches Museum,
 Karl-Marx-Stadt 1990/91 (with catalogue raisonné by Klaus Werner).

Lutz Dammbeck, Photo: Karin Plessing, Hamburg

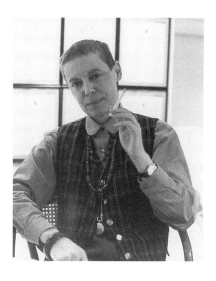

Hanne Darboven
Photo: Dietmar Schneider,
Cologne

Lutz Dammbeck
Born 1948 in Leipzig
Lives and works in Hamburg

While he was a student at the Hochschule für Grafik und Buchkunst in Leipzig from 1967-72, Lutz Dammbeck also worked as an author and director, producing experimental and animated films for the DEFA. Around 1975, he and Hans-Hendrik Grimmling joined the Gartenstudio Mogollon, one of the cultural niches on the periphery of the official art scene in Leipzig. Following his initial exhibitions with Grimmling at the Galerie Wort und Werk in Leipzig in 1979 and a solo exhibition at the Galerie Mitte in Dresden in 1980, he started work in 1983 on his *Herakles Konzept* which has remained the focus of his activities ever since. Taking the classical heroic myth as his basis, Dammbeck explores the ideology and aesthetics of National Socialism and Stalinism. He creates images, collages, texts, film fragments and media collages. Together with the dancer Fine Kwiatkowski, he began rehearsing media collages *(La Sarras, Herakles, REAL-Film)* using text extracts from the brothers Grimm and Heiner Müller's *Herakles oder Die Hydra*, which were performed in 1983 at the Bauhaus in Dessau and in 1985 at the Galerie Oben in Karl-Marx-Stadt. Dammbeck's applications for an exit visa in order to travel were repeatedly rejected, in spite of his invitations to exhibit in the West. The artists of Gartenstudio Mogollon secretly prepared a major event to coincide with the *First Leipzig Autumn Fair* in 1984, causing a political scandal, in the wake of which Dammbeck moved to Hamburg in 1986. That same year, he participated in the *Hang zum Pathos* group exhibition at the Stollwerkfabrik in Cologne. In 1988, his *Herakles Höhle* was installed at the Kunsthaus and Kunstverein in Hamburg, where the installation *Herakles Höhle 2* was also created one year later as part of the *Arbeit in Geschichte – Geschichte in Arbeit* exhibition. At the same time, Dammbeck worked on the film collage of the same name which was broadcast in 1990 by the German television channel SWF 3 and also screened at the *Deutsche Videokunst 1988-90* exhibition in Marl, at the 4. Videonale at the Kunstverein in Bonn and at the Duisburg film week. His archaeology of memory continued in Herakles Höhle 3 at the Realismus Studio der Neuen Gesellschaft für Bildende Kunst in Berlin in 1990. Since then, Dammbeck has been represented in major group exhibitions, addressing the issue of German-German art history. Following a guest professorship at the Fachhochschule in Hamburg in 1994, Dammbeck accepted a teaching post in the field of design until 1995. For the 1997 *Deutschlandbilder* exhibition Dammbeck has further developed his *Herakles Konzept* (fig. 414, p. 464).

Lutz Dammbeck. Herakles Konzept, exhib. cat., Haus am Waldsee, Berlin; Lindenau-Museum, Altenburg; Städtische Galerie Ränitzgasse, Dresden; Kunstverein Heidelberg; Galerie für Zeitgenössische Kunst, Leipzig, 1997/98.

Hanne Darboven
Born 1941 in Munich
Lives and works in Hamburg

After studying from 1962-65 at the Hochschule für Bildende Künste in Hamburg under Wilhelm Grimm and Almir Mavignier, Hanne Darboven moved to New York in 1966-68 and became a close friend of Sol LeWitt. Under his influence, she made constructionist drawings on graph-paper, geometric and numeric representations of time – adding calendar date digits according to "indeces" she devised. Darboven's first solo exhibition was at Konrad Fischer's conceptual programme gallery in Dusseldorf in 1967, which has exhibited her work a number of times since. Since 1968, she has worked with mathematical additions of calendar dates. In 1969, Hanne Darboven returned to Hamburg and began copying poetry according to her indices. In 1969, the Städtisches Museum in Mönchengladbach screened films based on books about the year 1968, and in 1971 the Westfälisches Kunstverein in Münster mounted her first retrospective. In 1974, the Kunstmuseum in Basel showed her works from the period 1968-74, and exhibitions at the Kunstmuseum in Lucerne and the Stedelijk Museum in Amsterdam followed in 1975. Since then, Darboven has concentrated on *Schreibzeit,* in which she documents experienced history in the form of numerical codes, texts, diagrams and photographs, in a bid to verify the subconscious passage of time through information and news. In Darboven's conceptual approach writing, copying, counting and calculating all serve as a means of addressing the limited human capacity for awareness of time and history. In her work *For Rainer Werner Fassbinder* (1982-83; fig. 312, p. 297) she explores the question of attitudes to and awareness of history by addressing the director of the film *Lili Marleen* who took a rather different artistic approach to Germany's past. She has based her works on the poetry of Heinrich Heine and Rainer Maria Rilke and has touched upon such questions as the Bismarck era in *Bismarckzeit* at the Rheinisches Landesmuseum in Bonn in 1978. These themes are all part of the image of Germany, which Darboven visualises with painstaking care in her systematic analysis of the flow of time and thought. She has participated in major conceptual exhibitions such as *Konzeption/Conception* in Leverkusen and *When Attitudes become Form* in Bern in 1969 and *Prospect '71* in Düsseldorf in 1971 and at documenta 5, 6 and 7. In 1982, Hanne Darboven exhibited at the Venice Biennale and in 1986 she was awarded the Edwin Scharff prize of the City of Hamburg. In 1991, she had an exhibition at the Deichtorhallen in Hamburg and in 1996 at the Dia Art Foundation in New York.

Hanne Darboven. Für Rainer Werner Fassbinder, exhib. cat., Kunstraum München, 1988.
Ingrid Burgbacher-Krupka, *Hanne Darboven: konstruiert – literarisch – musikalisch,* Ostfildern 1994.

Otto Dix
Photo: Otto Dix Stiftung,
Vaduz

Felix Droese
Photo:
Manos Meisen,
Dusseldorf

Otto Dix
Born 1891 in Gera
Died 1969 in Singen

Otto Dix, the son of a working class family, completed an apprenticeship as a decorative artist before going on to study at the Kunstgewerbeschule in Dresden from 1909-14 with the aid of a Fürsten von Reuss stipend. As a young man, he was profoundly influenced by reading Nietzsche. In 1914, he volunteered for military service. His war drawings were exhibited in Dresden in 1916. The experience of war was to influence his choice of motifs until the 40s. Using traditional glaze-painting techniques he sought to lend expression to this experience of reality through the portrayal of fantastic visual worlds. After the war, he became one of the co-founders of the Dresden Secession and was a master student at the Kunstakademie there until 1922. He then moved to Dusseldorf, where he became involved in the left-wing artists' group *Junges Rheinland*. After his marriage, he moved to Berlin in 1924, where he joined the Berlin Secession and was represented by the Galerie Nierendorf. In 1924, he participated in the *Erste Allgemeine Deutsche Kunstausstellung* in Moscow and in 1925 in the *Neue Sachlichkeit* exhibition in Mannheim. In 1927, Dix moved to Dresden, where he held a professorship at the Kunstakademie until his dismissal in 1933. Banned from exhibiting in Germany in 1934 and classified as a "degenerate artist" according to the *Entartete Kunst* exhibition of 1937, he took part in major group exhibitions abroad. In spite of his perilous situation, he remained in Germany, withdrawing to the shores of Lake Constance in 1936. In 1938, 260 of his publicly owned works where confiscated and in 1939, Dix was briefly arrested on charges of involvement in a plot to assassinate Hitler. He was called up for military service in 1945 and taken prisoner by the French, resulting in his *Self-Portrait as Prisoner of War* of 1947 (fig. 61, p. 74). In 1946, he returned to Hemmenhofen, and took part again in major group exhibitions at home and abroad, including the *Allgemeine Deutsche Kunstausstellung Dresden*. In *Hiob* (1946, fig. 60, p. 74), Dix used the biblical figure of Job as a metaphor for the German individual in postwar Germany, over whose life the Third Reich seemed to have broken like some fateful evil. Stylistically, he increasingly turned towards a romanticism inspired by Runge and the old German masters. In West and East Germany alike, he had numerous exhibitions and accolades, including honorary professorships in Dresden and Dusseldorf.

Florian Karsch, *Otto Dix. Das graphische Werk*, Hanover 1970.
Fritz Löffler, *Otto Dix. Werkverzeichnis der Gemälde*, Recklinghausen 1981.
Otto Dix, exhib. cat., Galerie der Stadt Stuttgart, 1991.
Rainer Beck, *Otto Dix. Zeit, Leben, Werk*, Konstanz 1993.

Felix Droese
Born 1950 in Singen, Hohentwiel
Lives and works on the "Am Höchsten" farm in Mettmann-Diepensiepen

Felix Droese grew up on the North Sea coast in a Catholic clerical family and became familiar with Christian iconography in his early childhood. In 1970, he enrolled at the Kunstakademie in Dusseldorf under Peter Brüning, and also attending classes by Beuys. Politically involved in a number of organisations, Droese was arrested at an anti-Vietnam demonstration in Cologne in 1972 and sentenced to seven months imprisonment on parole. Rejected as a master student in 1976, he dropped out at school and worked for various newspapers. In 1979, he ran for the Alternative Liste in Dusseldorf's local elections. In 1980, the museum in Bochum showed his first *Schattenrisse* and published his first catalogue. At the same time, the Galerie Arno Kohnen in Dusseldorf, the Produzentengalerie in Hamburg and the Galerie Rudolf Zwirner in Cologne took note of him and have repeatedly exhibited his work since. In 1982, he received the North Rhine Westphalia prize for young artists in Dusseldorf and exhibited his installation *Ich habe Anne Frank umgebracht* at the documenta VII in Kassel. In addition to participating in major German group exhibitions such as *Westkunst* in Cologne in 1981, *Von hier aus* in Dusseldorf in 1984 and *1945-85 Kunst in der Bundesrepublik Deutschland* at the Berliner Nationalgalerie in 1986, and numerous solo exhibitions, mainly in German museums, Droese has repeatedly been involved in political art activities. In 1988 he took part in the *Überfahrt-Aktion* travelling from West Berlin to East Berlin with the "bus for direct democracy in Germany" and in 1990 he became involved in a project planting trees on the former inner-German border. He also addressed the events of 1989 in woodcuts and screen prints entitled *The Doubled Center* (fig. 440-463, pp. 476 ff.), which appeared on the cover pages of newspapers. His idealistic commitment culminated in 1988 at the 43rd Venice Biennale with his *Haus der Waffenlosigkeit* which also became his first US exhibition at the MIT List Visual Arts Center in Cambridge (Mass.).

Felix Droese. Werkverzeichnis der Editionen 1977-1991, exhib. cat., Galerie Klein, Bonn 1992.
Felix Droese. Drucke vom Holz 1984-1993, exhib. cat., Museum Ludwig, Köln 1993.
Felix Droese. Vanishing Images, exhib. cat., The New York Kunsthalle; IMF Art Society of the International Monetary Fund, Washington; PCC Kunstraum im Politischen Club Colonia, Cologne; Art Center of Cincinnati, 1993-1995.
Felix Droese. Das Gleichmaß der Unordnung, issued by the Institut für Auslandsbeziehungen Stuttgart, exhib. cat., Kunsthalle Zurich; Museum of Modern Art, Mexico; Obala Art Center Sarajevo and others, 1991-1997.

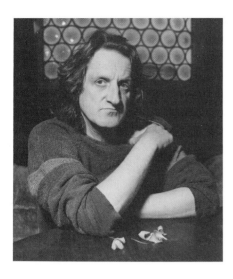

Hartwig Ebersbach
Photo: Udo Hesse, Berlin

Max Ernst, 1936
Photo: Wols

Hartwig Ebersbach
Born 1940 in Zwickau
Lives and works in Leipzig

After attending the Mal- und Zeichenschule in Zwickau from 1958-59, Hartwig Ebersbach continued his studies in 1959-64 at the Hochschule für Grafik und Buchkunst in Leipzig. Because of his political non-conformity and his excessive lifestyle, he increasingly took on the role of the "enfant terrible". This is reflected in the figure of the clown in his works inspired by the masquerades of James Ensor. After his studies, he earned his living as a free-lance designer for trade fairs and exhibitions. His contribution to the Seventh Regional Exhibition of the Federation of Fine Artists in Leipzig in 1965, which gave rise to the initially derogatory term Leipziger Schule, came under the crossfire of criticism. His proximity to the officially disparaged Western art of the CoBrA and SPUR groups is evident in such early works as his *Burning Man I* (1966; fig. 198, p. 167), which is the expression of an increasingly profound personal crisis that led Ebersbach to turn away from painting until 1971 and again in 1975-76. His former teacher and rector of the University in Leipzig, Bernhard Heisig, appointed him to teach experimental painting (1979-85). In 1979, he travelled to the West for the first time to visit the Basel art fair. In addition to his expressively gestural painting, from 1978 onwards, he developed a performance-type media collage together with composers and musicians, and had some initial success in 1979 with his *Missa Nigra* music performance. Following two minor gallery exhibitions in Dresden in 1981 and Karl-Marx-Stadt in 1982, his first solo-exhibition was mounted at the Staatliches Lindenau-Museum in Altenburg in 1982. Although he participated in the exhibition *Zeitvergleich. Malerei und Grafik aus der DDR* that went on tour from the Kunstverein in Hamburg in 1982-83, Ebersbach did not receive a permit to travel to any of the exhibition venues. In 1983, he suffered a heart attack which triggered a further crisis. In 1985, he was awarded the art prize of the City of Dusseldorf and since then has been represented by the Frankfurt gallerist Timm Gierig. In 1986, he had his first solo exhibition in the West, but once again received no travel permit. Eventually, Ebersbach managed to cut through the red tape, enabling him to travel to New York in 1988, to Japan in 1989 and to South Africa in 1992. In 1992, Ebersbach became one of the founding members of the Freie Akademie in Leipzig. It was here that his first major retrospective exhibition took place in the Museum der bildenden Künste in 1996.

Hartwig Ebersbach. Gemälde, Installationen, Plastiken;
 exhib. cat., Museum der bildenden Künste Leipzig, 1996.

Max Ernst
Born 1891 in Brühl near Cologne
Died 1976 in Paris

After studying philosophy at the University of Bonn from 1910-14, Max Ernst, who had no artistic training, found his precursors in German romanticism (including Caspar David Friedrich). In 1911, he made friends with August Macke and exhibited with the Rhenish expressionists in Bonn in 1913. That same year, he travelled to Paris for the first time, where he met Apollinaire, Delaunay and Arp. The sense of French esprit was to have a far deeper influence on Ernst than the tradition of German expressionism. After military service in World War I, the Dada movement in postwar Cologne signified what Ernst described as the true break with his origins as a "Prussian subject". By 1922, he had left Germany forever, settling in Paris amongst the circle of surrealists, of whom he was officially a member until excluded by André Breton in 1954. With the new techniques of collage, frottage, grattage and décalcomanie, the source of inspiration and the creative process became the subject matter. Blacklisted by the National Socialists in 1933 and branded as "degenerate" in 1938, he was keenly aware of the threatening political situation in Europe. In the 1930s, he created such images as *La ville entière* and *Barbares,* visions that were to culminate in 1937 in his various versions of *L'ange du foyer* (fig. 4, p. 31). Following his internment in the early war years, Ernst succeeded in leaving Europe in 1941, and went into exile in America, where he initially lived in New York with his third wife, Peggy Guggenheim, later settling in Sedona (Arizona) in 1946 with his fourth wife, Dorothea Tanning. In 1953, he returned to Paris, where he began to explore a more distinctly international painterly style. Major exhibitions of his work were mounted in 1959 at the Musée National d'Art Moderne in Paris, in 1951 at the Museum of Modern Art, New York and in 1962 at the Wallraf-Richartz-Museum in Cologne, emphasising his already international status. Max Ernst died in Paris in 1976, shortly before his 85th birthday.

Werner Spies (ed.) *Max Ernst. Das grafische Werk,* compiled by R. Leppien,
 Cologne 1975.
Catalogue raisonné compiled by W. Spies, G and S. Metken in 4 vols: *Werke 1906-1925,*
 Cologne 1975; *Werke 1925-1929,* Cologne 1975; *Werke 1929-1938,* Cologne 1979;
 Werke 1938-1953, Cologne 1987.
Max Ernst. A Retrospective, exhib. cat.,
 Tate Gallery London; Staatsgalerie Stuttgart; Kunstsammlung
 Nordrhein-Westfalen, Dusseldorf; Centre Georges Pompidou, Paris, 1991-1992.
Max Ernst. Dada and the Dawn of Surrealism, exhib. cat., Museum of Modern Art,
 New York; The Menil Collection, Houston; The Art Institute of Chicago, 1993.

FLATZ with his dog Hitler, Photo: Thomas Degen, Munich

Günther Förg, 1996
Photo: Claude Joray,
Biel (Switzerland)

FLATZ

Born 1952 in Dornbirn, Austria
Lives and works in Berlin and Munich

Wolfgang FLATZ began a goldsmithing apprenticeship in 1967, qualifying with distinction in 1971. He received a stipend to study metal design at the Höhere Technische Bundeslehrakademie in Graz from 1972-74. During that period he took a keen interest in contemporary art, especially the work of Alan Kaprow and the Wiener Aktionisten. His application to the Kunstakademie in Vienna was turned down. His first happenings put him in prison and in a psychiatric clinic. In 1975, FLATZ moved to Munich, where he studied at the Akademie der Bildenden Künste until 1981, initially studying goldsmithing and later painting under K. F. Dahmen and Günter Fruhtrunk, as well as art history at the University of Munich. In his studies, projects and works, FLATZ goes beyond traditional systems of art, exploiting all available media. He juxtaposes clashing elements from high culture and sub-culture, and uses violence and destruction as a means of expressing and liberating socially reglemented and stigmatised aggressions within an art context. He has found inspiration in the films of Rainer Werner Fassbinder and Stanley Kubrick. His auto-aggressive works of the 70s in which FLATZ used his own body as a material or medium, often at serious personal risk, developed in the 80s into his *Demontagen,* in which the aggression is projected outwards. His staging and marketing of the self in performances with shorn head, leather gear and a dog named Hitler echo some of the artistic strategies of Warhol and Beuys. In addition to his performances, he also produced visual works, which were exhibited in his first solo exhibitions in 1980 at the Galerie Rüdiger Schöttle in Munich and Konrad Fischer in Dusseldorf. In 1981, the Galerie Max Hetzler in Stuttgart showed his photo series *Zwei Österreicher oder Geschichte bedingt Interpretation* (1976), in which FLATZ reconstructs private portraits of Hitler. Following exhibitions at the Kunstraum Wuppertal in 1989 and the Palace of Youth in Leningrad in 1990, the Kunstverein in Munich showed a retrospective of his performances and demontages in 1991. In 1992, FLATZ took part in documenta 9. In 1993, the Galerie der Stadt Stuttgart showed his series *Zeige mir einen Helden... und ich zeige Dir eine Tragödie* (1988). His photo series *Hitler – A Dog's Life* (1995; fig. 415-438, pp. 470ff.) in which FLATZ uses elements of caricature and shows photos of his dog Hitler with appropriate captions, placed him in the crossfire of criticism, with the left accusing him of indulging in an "aesthetics of the radical right wing", and the right issuing death-threats.

FLATZ, Strategien über Kunst und Gesellschaft, Regensburg 1994.

Günther Förg

Born in Füssen in 1952
Lives and works in Areuse, Switzerland

Günther Förg studied at the Akademie der Bildenden Künste in Munich under K. F. Dahmen from 1973-79, and exhibited his *Sechs graue Bilder* there in 1974. In 1980, he had his first solo exhibition at the Galerie Rüdiger Schüttle in Munich. All the "classical" genres in which Förg works, such as bronze sculpture, paintings and murals, architectural and portrait photography, function on a material and reflective level in every sense of the word. His large-format photographs in heavy glass frames, later in mirrors, are often placed in relation to murals — mostly monochrome planes, but also simply structured patterns, blending the fiction of absence with the reality of presence. Referring to the Bauhaus, constructivism, Jean-Luc Godard and Blinky Palermo, Förg upholds a tradition of minimalist reduction and stringent constructions. Whereas Förg, with his lead pictures, sculptures and reliefs, has adopted an international formal syntax, his large-format photographs also explore the iconography of architecture. In his large-format photographs of the IG Farben Haus, built by Hans Poelzig in Frankfurt am Main in 1929-30 (1996; fig. 375-384, p. 426ff.), Förg examines the administrative building of Germany's leading industrial company, which was involved in the production of Zyklon B poison gas and even ran its own concentration camp at Auschwitz. Since 1984, Förg has exhibited at the Galerie Max Hetzler in Cologne, and since 1986 at the Galerie Grässlin-Ehrhard in Frankfurt am Main. His international standing as an artist is reflected in his numerous solo exhibitions, which have included the Kunsthalle in Bern and the Westphälischer Kunstverein in Münster in 1986, Haags Gemeentemuseum and the Renaissance Society of Chicago 1988, the Museum Boymans van Beuningen in Rotterdam and van Hedendaagse Kunst in Ghent 1989-90, the Museum Fridericianum in Kassel, the Museum van Hedendaagse Kunst in Ghent, the Museum der Bildenden Künste in Leipzig and the Kunsthalle in Tübingen in 1990-91, the Musée d'Art Moderne de la Ville de Paris in 1991, the Kunstverein in Munich in 1992, the Deutscher Werkbund in Frankfurt am Main and the Galerie der Stadt Stuttgart in 1993, the Kunstmuseum in Bonn in 1994, the Stedelijk Museum in Amsterdam in 1995, the Kunstmuseum in Lucerne in 1996. Förg's work was included in the *Von hier aus* survey of German art in Dusseldorf in 1984. In 1992, he was represented at the documenta IX in Kassel and in 1996 he received the Wolfgang Hahn prize, Cologne.

Günther Förg. Verzeichnis der Arbeiten seit 1973, Munich 1987.
Günther Förg. Gesamte Editionen/The Complete Editions 1974-88, exhib. cat.,
 Museum Boymans-van Beuningen, Rotterdam, Stuttgart 1989.
Günther Förg. Paintings 1974-94, exhib. cat., Stedelijk Museum Amsterdam, 1995

Otto Freundlich, c. 1925
Photo: Fondation Freundlich,
Pontoise

Jochen Gerz
Photo: Gitty Darugar,
Ruvigliana, Switzerland

Otto Freundlich

Born 1878 in Stolp, Pomerania
Murdered at the concentration camp of Lublin-Majdanek in Poland in 1943

In 1903-04, Otto Freundlich studied art history (his teachers included Heinrich Wölfflin), music theory and philosophy in Berlin and Munich, and his work as an artist began relatively late, around 1905. He broke with his family, a wealthy merchant family of Jewish origin. On his first study trip to Florence in 1906-07, he found sculpture to be his strong point and in 1907-08 he attended private art schools in Berlin. In 1908, a visit to the legendary Bateau Lavoir studios in Paris introduced him to the work of the French avant-garde. It was here that he found his personal figurally constructivist style of symbolism, in which sculpture and painting were of equal importance to him. At the beginning of the century, the human head was the main theme of his sculptures. Time spent in Munich, Berlin, Cologne and Chartres led to his involvement in the New Secession in Berlin in 1910, the *Sonderbund* exhibition in Cologne in 1912 and the *Erster Deutscher Herbstsalon* in Berlin in 1913. Conscripted as a medical officer in the First World War, Freundlich spent most of his time in Cologne, Bonn and Berlin in the years up to 1924. He became a member of the Novembergruppe and had contacts to the circle of later Dadaists. His political and social views and his concept of the gesamtkunstwerk underline this affinity to the Bauhaus. At the same time, the brightly coloured spectrum of simultaneous colour contrasts are reminiscent of Delaunay's orphism. Back in Paris in 1924, Freundlich exhibited his work at the Salon des Indépendants with the artists with whom he had been involved in the Cercle Carré and Abstraction Création groups in the 30s. The Cologne gallery of Becker & Newman mounted Freundlich's first solo exhibition in 1931. While in Germany, his sculpture *Der neue Mensch* was shown on the cover page of the *Entartete Kunst* catalogue in 1937, Freundlich exhibited at the international *Konstruktivisten* exhibition in Basel the same year. An exhibition of his work was held at the Galerie Jean Bucher in Paris in 1938 to mark his sixtieth birthday. Upon outbreak of the war, Freundlich was interned and after his release in 1940, he fled to the Pyrenees. His *Komposition* of 1943 was the last work he completed before his arrest and deportation to the concentration camp.

Joachim Heusinger von Waldegg, *Otto Freundlich (1878-1943)*,
 Cologne 1978 (with catalogue raisonné).
Otto Freundlich. Ein Wegbereiter der abstrakten Kunst, exhib. cat.,
 Museum Ostdeutsche Galerie Regensburg 1994-95.

Jochen Gerz

Born 1940 in Berlin
Lives and works in Paris since 1966

Jochen Gerz began studying Chinese, German and English at the University of Cologne in 1958, switching to pre- and proto-history in Basel in 1962. From 1967 onwards, he began creating works for public spaces and in 1969 his first photo-and-text works appeared. His first solo-exhibition was held in 1968, at the Galleria Rinascita in Modena. Influenced by the Situationists, certain aspects of Gerz' early works resembled the approach of the student movement in seeking to establish direct communication with people in the street by distributing flyers and leaflets. His early concrete poetry developed in the early 70s into a number of refusenik strategies, by which he reflected the problems of our modern media society. Since 1971, he has also used videos in complex installations, performances, workshops etc. In *Exit: Material on the Dachau Project* (1972; fig. 367, p. 411), he uses photographs of the signs installed at the former concentration camp of Dachau to evoke a thought-provoking link between language and location. Language is revealed as an empty form to be filled with meaning according to the context. In addition to numerous solo exhibitions at home and abroad Gerz was represented along with Beuys and Ruthenbeck at the 1976 Biennale in Venice and at documenta 6 and 8 in Kassel in 1977 and 1987. In the 1980s, he created huge tableaux of individually framed photo-and-text works whose black, white and red contrasts are sober and hard-hitting in their documentary approach. In recent years, Gerz has created a number of major projects for public spaces, working closely since 1984 with his wife Esther Shalev-Gerz. These include the 1986 *Mahnmal gegen den Faschismus* in Hamburg and his *2146 Steine – Mahnmal gegen den Rassismus* in Saarbrücken in 1993. He was awarded the Preis der Deutschen Kunstkritik in Berlin in 1996 for his texts on art theory and aesthetics . In 1994-95, he held a professorship at the Hochschule für Grafik und Buchkunst in Leipzig.

Jochen Gerz. Life after Humanism, exhib. cat., Neues Museum, Weserburg, Bremen;
 Badischer Kunstverein, Karlsruhe; Cornerhouse, Manchester;
 Saarland Museum, Saarbrücken; Staatliches Lindenau-Museum, Altenburg;
 Altes Rathaus, Potsdam, 1992-1994.
Jochen Gerz. Les Images, exhib. cat., Musée d'Art Moderne et Contemporain,
 Strasbourg, 1994.
Jochen Gerz. People Speak, exhib. cat., Vancouver Art Gallery;
 Newport Harbor Art Museum; Neuberger Art Museum, Purchase NY;
 Winnipeg Art Gallery, 1994-1996.
Jochen Gerz. Selfportrait, exhib. cat., Tel-Aviv University Art Gallery, 1995.

Raimund Girke
Photo: Galerie Brandstetter
& Wyss, Zurich

Hermann Glöckner
Photo: Pan Walther, Dresden

Raimund Girke

Born 1930 in Heinzendorf, Lower Silesia
Lives and works in Cologne

After studying at the Werkkunstschule in Hanover from 1951-52, Raimund Girke continued his training at the Kunstakademie in Dusseldorf from 1952-56. It was here that he developed the fundamental principles of his painting, in which the increasing reduction of forms and colours to monochrome planes expresses the spirit of an entire post-war generation (Manzoni, Yves Klein, Uecker, Ryman). His *Erinnerung an eine Landschaft* (1956; ill. 140, p. 118) addresses his Silesian background and his childhood in a rural Prussian Protestant home, from which the family moved after the war to the Weserbergland region. Influenced by Cézanne's late landscapes, his *Large Vibrations* (1958; fig. 142, p. 119) is executed in an impasto technique reminiscent of earth textures, and the final remains of a "disturbed order" (*Gestörte Ordnung*, 1957; fig. 141, p. 118). They are the basis of a new order oriented towards the structure of the painting itself rather than its subject matter. Following one of his first exhibitions at the Adam Seide gallery in Hanover in 1958, he received the painting prize of the City of Wolfsburg in 1959 and the youth art prize of Stuttgart in 1962. In the course of the 60s, the landscape aspect of his work was gradually replaced by a constructive visual language. In place of memory, he explored the visual order inherent in the highly charged modulations from black to white to endless variations of grey. The suprematism of Malevich and American Minimal Art were as influential in Girke's work as contemporary poetry and music. From 1966-71, he taught at the Werkkunstschule in Hanover and has been professor at the Hochschule der Künste in West-Berlin since 1971. Together with Pfahler and Fruhtrunk, he had his first museum exhibition in 1969 at the Kestner-Gesellschaft in Hanover. The beginnings of public success that came with exhibitions at the Westfälischer Kunstverein in Münster, the Städtisches Kunstmuseum in Bonn and the Kabinett für Aktuelle Kunst in Bremerhaven in 1974, led to a further change of style that harked back to his earlier works with their freer rhythmic forms, such as those exhibited in 1977 at documenta 6 in Kassel. In addition to solo exhibitions at the Kunstmuseum in Düsseldorf in 1982, at the Neuer Berliner Kunstverein in 1986, touring to the Museum Quadrat in Bottrop and the Frankfurter Kunstverein, and in 1988 at the Wilhelm-Hack-Museum, Ludwigshafen and the Museum Morsbroich in Leverkusen, Girke has also been included in a number of group exhibitions such as *1945-1985. Kunst in der Bundesrepublik Deutschland* at the Nationalgalerie in Berlin in 1985. In 1995, he was awarded the Lovis Corinth Prize of the artists' community of Esslingen.

Raimund Girke. Malerei, exhib. cat., Sprengel Museum, Hanover; Saarland Museum, Saarbrücken; Von der Heydt-Museum, Wuppertal; Kunsthalle Nuremberg, 1995/96.

Hermann Glöckner

Born 1889 in Cotta near Dresden
Died 1987 in West Berlin

After studying at the Kunstgewerbeschule in Dresden from 1904-07, Hermann Glöckner decided in 1909-10 to become an artist. However, he was rejected by the Kunstakademie and was not admitted until 1923-24, after military service and career experience. As early as 1919-20, he undertook his first experiments in non-figurative planar compositions. In 1927, he became a member of the Deutscher Künstlerbund and had his first solo exhibition at the Kunsthandlung Victor Hartberg in Berlin. He consistently developed his geometric, abstract approach in an oeuvre of some 110 works between 1930 and 1937, continuing into the 60s. In 1932, Glöckner joined the Dresdner Secession, exhibiting with them on two occasions. As a largely unknown artist, he was not persecuted by the National Socialists, though his opportunities of exhibiting and selling virtually ceased from 1938 onwards and he turned increasingly to decorative architectural work. Because of his delicate health, he was exempted from military and voluntary service. Just before the bombing of Dresden in 1945, in which his house and his studio were destroyed, his works were moved elsewhere. As a member of the Dresdner artists' group "der ruf" between 1945 and 1948, he participated in the first postwar exhibition in Dresden at the Grünes Haus in 1945. He continued to work in an abstract direction, mainly on paper, including newspaper, from 1947 onwards. In the 1950s, in the course of the debate on formalism, Glöckner became increasingly isolated, and once again had to earn his living with architecture-related design. From around 1959, he devoted his attention to sculptural works. In 1964-65, Werner Schmidt began systematically collecting Glöckner's works for the Kupferstich Kabinett in Dresden, and in 1969, despite official resistance, Schmidt exhibited the artist's early works, providing the first encounter with abstract constructivist art in an East German museum. It was not until 1974, that Glöckner's works were shown in an international context at the Stuttgart *Konstruktivisten* exhibition, making his name known in the West as well. His first solo exhibition in West Germany was held in 1979, at the Galerie Alversleben in Munich. Glöckner worked in his Dresden studio until shortly before his death. In 1986, he moved to West Berlin to join his partner. He died there in 1987.

Hermann Glöckner. Die Tafeln 1919-1985, Stuttgart 1992 (with catalogue raisonné).
Hermann Glöckner. Werke 1909-1985, exhib. cat., Saarland Museum,
 Saarbrücken 1993.

HAP Grieshaber, 1974
Photographer unknown

Hans Grundig, c. 1947
Photographer unknown

HAP Grieshaber

Born 1909 in Rot a. d. Rot
Died 1981 at Achalm near Reutlingen

While he was training as a typesetter in Reutlingen in 1926-27, HAP Gries-haber also studied at the Kunstakademie in Stuttgart. In 1928-31, he travelled to London and Paris, and in 1931-33 to Egypt and Greece, where he was charged with anti-fascist activities and deported to Germany. In 1932, he produced his first woodcut. This technique, which underwent a revival in German Expressionism, was to become an important element in his oeuvre as a whole. Grieshaber had his first exhibitions in London in 1931, and in Alexandria and Athens in 1932, but he returned to Germany, where he built a secluded studio on the Achalm near Reutlingen after the National Socialists came to power in 1933. He earned his living as a casual labourer and newspaper deliverer, pursuing his creative and artistic work clandestinely. With the cooperation of other opposition artists, including Willi Baumeister and Arthur Fauser, the so-called *Reutlinger Drucke* (1933-39) were created, clearly inspired by Gothic woodcuts. In 1940, Grieshaber was called up for military service. In 1945, he became a prisoner of war in Belgium, and was released in 1946. His first exhibition in Germany was held in 1949, at the Studenten-Studio für moderne Kunst in Tübingen. From 1951-53. He taught at the Bernsteinschule near Sulz on the Neckar from 1951–53. As a politically active artist, Grieshaber used his woodcut posters and flyers to address social and cultural issues. He developed the woodcut into a monumental mural, incorporating word and image, craft and art. Inspired by the new typography of H. N. Werkman and W. Sandberg, Grieshaber also made a major contribution to German postwar modernism in the field of the artist's-book and designed the poster for the exhibition *Deutsche Kunst nach 45,* which was held at the Kunsthalle Recklinghausen in 1954. That same year, the first retrospective exhibitions of his work were held at the Württembergische Kunstverein in Stuttgart and the Kestner Gesellschaft in Hanover, followed by exhibitions throughout Germany. In 1955, Grieshaber was appointed to the Staatliche Akademie der Bildenden Künste in Karlsruhe, where his students include Horst Antes and Walter Stöhrer. He resigned his professorship in 1960. In 1956, he was admitted to the Akademie der Künste in West Berlin, and in 1961 was awarded the art prize of the City of Darmstadt, and the Cornelius prize of the City of Dusseldorf in 1962. That year, he represented the Federal Republic of Germany at the Biennale in Venice and his work was also included at documenta 2 and 3 in Kassel.

Margot Fürst, *Grieshaber. Die Druckgrafik.* Werkverzeichnis vol. 1 1932-65,
 Stuttgart 1986.
Grieshaber – das Werk. Hommage zum 80. Geburtstag, exhib. cat.,
 Städtisches Kunstmuseum, Spendhaus Reutlingen and other venues, 1990.

Hans Grundig

Born 1901 in Dresden
Died 1958 in Dresden

Having trained under his father as a scene painter from 1915-19, Hans Grundig went on to study at the Kunstgewerbeschule in Dresden from 1920-21 and then at the Kunstakademie from 1922-27. In the late 1920s, the incisive social criticism that Dix had worked into his painting elicited a considerable response in Dresden both in the German Communist Party, which Grundig joined in 1926, and in the Dresden ASSO (Association of German Revolutionary Artists), of which Grundig was a co-founder, in 1929. In this context, Grundig took part in the *Grosse internationale Kunstausstellung* in Dresden in 1926, and in the *Deutsche Neue Sachlichkeit* exhibition in Amsterdam in 1929. Grundig's artistic roots are to be found in the German Gothic art of Hieronymous Bosch and Matthias Grünewald. In 1928, Grundig married the artist Lea Langer, with whom he was to exhibit jointly from then on. In 1933, he was affected by the first defamatory Nazi exhibition *Spiegelbilder des Verfalls* in der Kunst in Dresden. In the face of increasing political pressure, he began to undertake various trips to Switzerland and northern Italy in 1935. In 1936, he was barred from practising his profession, and in 1937, in Munich, was included among the banned adepts of "degenerate art". His wife, Lea, emigrated to Palestine in 1939. In 1940, having been arrested several times, Hans Grundig was deported to the concentration camp Sachsenhausen near Berlin as a political prisoner. He survived five years of imprisonment there before being dispatched in a penal division to the war front near Budapest, where he immediately went over to the Red Army. His brother, Herbert, ensured that his works were kept in safety. In 1945, Grundig attended an anti-fascist school near Moscow and returned to Dresden in 1946. Together with Will Grohmann, he organised the *Allgemeine Deutsche Kunstausstellung* in Dresden and was appointed head of the Akademie there when it re-opened in 1947. Grundig's attempt to come to terms with the immediate past is concentrated in his 1947 work *Den Opfern des Faschismus* (To the Victims of Fascism, fig. 59, p. 73), the second version of which was shown for the first time in 1948, in Dresden, in the exhibition *150 Jahre soziale Strömungen in der Kunst.* With this new German social realism, and in a spirit of anti-fascist renewal, Grundig tried to re-establish the tradition of the ASSO artists, but gradually came under the growing influence of the doctrine of socialist realism. In poor general health due to his years in the concentration camp, Grundig suffered repeated bouts of tuberculosis. In 1958, the year of his death, there was a first large-scale retrospective exhibition of his and his wife's works at the Albertinum in Dresden. This was followed by numerous awards and exhibitions, mainly in the GDR and Eastern Europe.

Günter Feist, *Hans Grundig,* Dresden 1979.

Hans Hartung in his studio ir
Arcueil, 1938
Photo: Roberta Gonzalez

Hans Haacke
Born 1936 in Cologne
Lives and works in New York

After studying at the Hochschule für Bildende Künste in Kassel from 1956-60, Hans Haacke went to Paris where he worked for a year in S. W. Hayter's studio. In close cooperation with the Zero movement, he produced monochrome grid reliefs. A scholarship he received in 1961 allowed him to spend some time in New York teaching at Temple University, Philadelphia. Out of his kinetic beginnings, Haacke developed an independent physical-kinetic system art. He returned to Cologne in 1963 and taught at the Pädagogische Hochschule in Kettwig and at other institutions. Minor shows in the USA in 1962 were followed by his first solo exhibition in Germany at the Schmela gallery in Dusseldorf in 1965. That same year, Haacke finally emigrated to New York. He taught at various art colleges (1966-67 University of Washington, Seattle, Douglas College, Rutgers University, New Jersey and Philadelphia College of Art; 1967 professorship at Cooper Union, New York; 1973 guest professorship at the Hochschule für Bildende Künste, Hamburg; 1979 at the Gesamthochschule, Essen.) Since the 1970s, Haacke has been investigating the social and economic context of art with reference to physical, biological and ecological systems analyses, and to structuralism and conceptual art. By a sparing use of purely documentary and sometimes polemically-charged means, he has succeeded in exposing highly explosive interrelations, a fact that resulted in the cancellation of a presentation by him at the New York Guggenheim Museum in 1971. Nevertheless, he has had a series of exhibitions at various venues including the Museum Haus Lange in Krefeld in 1972, the Renaissance Society in Chicago in 1979, the Tate Gallery in London in 1984, and the Boymans-van Beuningen museum in Rotterdam in 1996. As a German living in New York, Haacke has a more distanced view of the German past. In his *Manet Project '74* (fig. 321, p. 321), he pursued the ownership history of Manet's *Bunch of Asparagus* still life through famous Jewish collections (Paul Cassirer, Max Liebermann) to its purchase by the Wallraf-Richartz-Museum in Cologne, initiated by Hermann J. Abs. In *Germania*, his contribution to the 1993 Biennale, Haacke returned to the year 1934 and Hitler's visit to the Biennale. The raised floor of the German pavilion was intended, literally, to pull the ground out from under the feet of any national monopolisation of art. In 1997, Haacke was represented at documenta X and the exhibition of sculpture in Münster.

Hans Haacke. Nach allen Regeln der Kunst, exhib. cat., Neue Gesellschaft für Bildende Kunst, Berlin 1984/85
Hans Haacke. Unfinished Business, exhib. cat., The New Museum of Contemporary Art, New York 1986/87
Hans Haacke. Bodenlos, exhib. cat., Venice Biennale, Ostfildern 1993.

Hans Hartung
Born 1904 in Leipzig
Died 1989 in Antibes

Under the influence of Kandinsky and Klee, Hans Hartung was already painting abstractly in 1922. In addition to studies at the Leipzig and Dresden art academies from 1924-26, he also studied philosophy and art history at the University of Leipzig. At the last *Internationale Kunstausstellung* in Dresden in 1926, Hartung was confronted for the first time with modern painting produced outside Germany. Impressed by the French Avant-Garde, he travelled to Paris in 1927. From 1928-30, he studied at the Kunstakademie in Munich and undertook extended trips around Europe. During his first solo show at the Heinrich Kühl gallery in Dresden in 1931, he met Will Grohmann and Fritz Bienert. Despite the increasingly difficult conditions in Germany, he continued to develop his particular art of psychic improvisation. With the rise of National Socialism, Hartung left Germany and spent the years from 1932-34 in Minorca. It was there that the unusual painting *T 1932-11* (fig. 23, p. 47), a primeval image made up of closed, dark forms, was created. In the 1930s, these forms gradually transmuted into elements of movement against a transparent ground, as in the paintings *T 1938-2* and *T 1938-3* (fig. 24, 25, p. 49, 50), in which the two possible directions of movement were already determined by the round and straight forms. Forced by financial difficulties, Hartung returned to Germany, where he came into conflict with the Gestapo. In 1935, he fled to Paris. The wire figures by his father-in-law, the sculptor Julio González, he saw there made a lasting impression on him. Between 1935-38, Hartung exhibited in the salon of the *Surindépendants* and also took part in various international group exhibitions, such as the London exhibition of contemporary German art in 1938. He joined the Foreign Legion in 1939 and before the German occupation of France, fled to Spain in 1943, where he was arrested and interned. After his release, he rejoined the Foreign Legion and was wounded in 1944. He returned to Paris in late 1945. He developed a gestural mode of painting, introducing a dynamism into Bauhaus abstraction that made him a forerunner of abstract expressionism. Hartung received French nationality, and was awarded numerous prizes. After the war, his works were exhibited and lauded internationally. Hartung took part in documenta I in Kassel in 1955. In 1957, the Kestner Gesellschaft in Hanover devoted a large-scale retrospective to him, which travelled to various German cities. At the 1960 Venice Biennale, his exhibition in the French pavilion was awarded the major painting prize.

Rolf Schmücking, *Hans Hartung. Werkverzeichnis der Grafik, 1921-65,* Galerie Schmücking, Braunschweig 1965.
Pierre Daix, *Hans Hartung,* Paris 1991.
Hans Hartung, exhib. cat., Tate Gallery, London 1996.

Minka Hauschild
Photo: Bernd Limberg

John Heartfield, Prague 1935
Photo: Karel Grüner, Prague

Minka Hauschild
Born 1962 in Haan
Lives and works in Dusseldorf

Minka Hauschild studied philosophy and French language and literature at Dusseldorf University from 1981-84, and in 1984 began studying painting at the Dusseldorf Kunstakademie under Beate Schiff and Jan Dibbets. In 1991, she was a student in Dibbets' master class. That same year, she was awarded a scholarship by the Dusseldorf Kunstakademie. From 1987-91, parallel to her art studies, she trained as a yoga teacher. Hauschild had her first solo exhibition at Galerie Herweg in Leverkusen in 1990. This was followed by a second exhibition *Mond(op)positionen* at Galerie Raum 77A in Dusseldorf in 1992, for which a catalogue was published. She also participated in group exhibitions at the Dusseldorf Kunstpalast and the Kunstkabinett in Cologne in 1990, at the Thomas Jering gallery in Duisburg in 1991 and the Raum 77A gallery in Dusseldorf in 1992. In 1993, Hauschild spent some time studying and working in Asia and India/Ladakh. In 1994, she received a scholarship from the State of Brandenburg, enabling her to spend a year at the Schloss Wiepersdorf artists house, where she took part in a group exhibition on the occasion of the symposium *Zeit des Überholens – Zeit des Wiederholens*. In 1995, Minka Hauschild began work on a cycle of forty paintings after stills from a documentary film by Eberhard Fechner about the Majdanek trial. The *Portraits from the Majdanek Trial* (1995-96; fig. 468, pp. 494 ff.), exhibited in the Dusseldorf regional court in 1996, are neither historical documents nor static inventories. Instead, they show perpetrators and victims, investigators and trial observers alike as human individuals who resist any attempt at historicisation.

Minka Hauschild, *Prozessportraits,* exhib. cat., Landgericht Düsseldorf, Mahn- und Gedenkstätte Düsseldorf, 1996

John Heartfield
Born Helmut Herzfeld in 1891 in Berlin
Died 1968 in Berlin

Because Helmut Herzfeld's father wrote socialist poetry, the imperial censorship authorities forced his family into exile so that Helmut Herzfeld spent his childhood with foster parents in Switzerland and in Austria. He was apprenticed to a bookseller in Wiesbaden, but abandoned it to study drawing with Hermann Bouffier. In 1907, he went to Munich to study at the Kunstgewerbeschule until 1911 and moved back to his birthplace Berlin in 1913 where he attended the Kunst- und Handwerkschule in Charlottenburg. In 1914, he won first prize in a competition for the German Werkbundausstellung. A fervent conscientious objector, Heartfield avoided military service in 1914, by simulating a nervous disorder. Through the bohème circle around Else Lasker-Schüler in Berlin in 1915, he got to know George Grosz, with whom he developed the photomontage technique. In protest against Germany's war mongering against England, Heartfield assumed the English translation of his surname as a pseudonym. Together with his brother, Wieland, he founded the magazine *Neue Jugend,* in which his first montages were reproduced, and the Malik publishing house, specialising in satirical magazines. At the end of the war, Heartfield joined the German communist party for which he designed posters, prints, and brochures. After working for various newspapers, the theatre and cinema, in 1930 he began a fruitful collaboration with the *Arbeiter Illustrierte Zeitung* that was to continue until 1938 and inspired major artistic achievements: full-page photomontages whose simple but highly expressive means were aimed at warning people against Hitler and the threat of war emanating from the right (fig. 391-407, pp. 443 ff.). Heartfield emigrated to Prague in 1933 and in 1938 to England, where he worked as a book designer for a London publisher. He returned to Germany in 1950 for health reasons, initially to Leipzig and then to East Berlin. Heartfield's concept of art, however, was anything but welcome in the German Democratic Republic. After two heart attacks, in 1951 and 1952, Bertolt Brecht took him on as a costume and set designer with the Berliner Ensemble, during which time he also worked for the Deutsches Theater. In 1956, he became a full member of the Akademie der Künste, which showed a first major exhibition of his oeuvre a year later. Further acknowledgements of his artistic achievements followed: the 1957 national prize for art and literature, the title of professor in 1960, and the Karl Marx Order in 1967. As the inventor of the photomontage during the battle against National Socialism, John Heartfield was one of the major sources of inspiration for politically committed art in the 1960s.

John Heartfield, exhib. cat., Akademie der Künste zu Berlin, Altes Museum; Rheinisches Landesmuseum Bonn; Kunsthalle Tübingen; Sprengel Museum Hanover, Cologne 1991.

Bernhard Heisig
Photo: Udo Hesse, Berlin

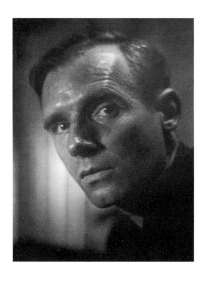

Werner Heldt, c. 1946-52
Photo: Siegfried Enkelmann;
property of Hermann Enkelmann,
with courtesy of Galerie
Brusberg, Berlin

Bernhard Heisig
Born 1925 in Breslau
Lives and works in Strodehne, Havelland

The son of a painter, Bernhard Heisig began training as a commercial artist at the Meisterschule des Deutschen Handwerks in Breslau in 1941. In 1942, he volunteered for military service and was dispatched to a tank force. He was seriously wounded several times and at the end of the war was detained in a Russian prisoner-of-war camp. He returned to Breslau in 1946 as a war invalid. He moved to Zeitz in Saxony with his mother and worked as a graphic artist with various companies there until, having become a member of the SED, he was able to start studying at the Leipzig Kunstgewerbe in 1948. He continued his studies at the Kunstakademie in 1949. Out of dissatisfaction with the rigorous art ideology of the SED, he abandoned his studies in 1951. He then had to earn his living as a free-lancer, doing commercial art and construction-related drawings. As his painting showed leanings towards the pictorial idiom and themes of the nineteenth century, as well as the influence of Lovis Corinth and Max Beckmann, by 1961 he apparently concurred once again with the official demand for a "partisan" art devoted to "the great realistic themes". As a result, he was appointed professor at the Leipzig Hochschule, of which he was later elected rector. In the wake of a critical speech he made at the 5th Congress of the Association of Artists (VBK) in 1964 about the restrictive art policy of the SED, Heisig was suspended from his post as rector, though not from his teaching post. Under growing political pressure, however, he resigned from the latter in 1968. By treating the theme of the "fascist nightmare" in the mid-1960s, he again offended against the "model of socialist perfection". His personal experience of war formed the background for the "historical pessimism" with which he was reproached and which he also portrayed in his *The Unteachable Soldier's Christmas Dream* (1964; fig. 199, p. 168). It was not until the 1970s that Heisig gradually began to receive more recognition in the GDR. In 1972, he became a member of the Deutsche Akademie der Künste in East Berlin, and in 1973 he received important awards and had his first comprehensive exhibitions in Dresden and Leipzig. He was elected rector of the Leipzig Hochschule again from 1976-87. A retrospective exhibition of his work was shown in Leipzig, Moscow and Berlin in 1985. In the mid-1970s, Heisig also began to receive more and more acclaim in the West. He took part in documenta 6 in Kassel in 1977, and a retrospective exhibition of his work could be seen in West Berlin, Bonn and Munich in 1989-90. Heisig resigned from the SED in 1989, returning all the state awards he had received. In 1992, he moved to Strodehne in Havelland.

Bernhard Heisig. Retrospektive, exhib. cat., Berlinische Galerie 1989/90
Bernhard Heisig. Geisterbahn, exhib. cat., Galerie Berlin 1995.

Werner Heldt
Born 1904 in Berlin
Died 1954 in Sant Angelo, Ischia

Werner Heldt attended the Berlin Kunstgewerbeschule from 1923-24, then studied at the Akademie from 1924-30 under Maximilian Klewer. In 1927, he produced his first paintings, sombre night scenes from the same milieu as Heinrich Zille, who was a friend of the young artist's. During an extended stay in Paris in 1930, Heldt's style began to change, the anecdotal element receding into the background and the colours becoming more radiant. His street scenes earned him the epithet "the Berlin Utrillo", although the stringency and cubist compartmentalisation of his compositions contrasted increasingly with the atmosphere for which the Montmartre artist was renowned. Between 1929-33, Heldt had to undergo psychoanalysis because of depression. After the National Socialists came to power in 1933, Heldt went to Majorca, but was forced to return to Berlin in 1935 when the Spanish civil war broke out. In Berlin, he lived in the Klosterstrasse where he shared a studio with Werner Gilles and the sculptor Hermann Blumenthal. He was conscripted for active war service in 1940 and returned to the ruins of Berlin from a British prisoner-of-war camp in 1946. Whereas his formal idiom simplified into basic geometric shapes, his range of colours lost its radiance in favour of more sombre tones. The austere window views painted between 1945-50 capture the dreariness of the immediate post-war period in defeated Germany. Free of any real geographical reference, they evoke a place full of memories, a place of sadness and longing: *Berlin am Meer,* as Heldt called some of his paintings and watercolours. In 1950, he was awarded the art prize of the City of West Berlin in recognition of his oeuvre to date, from its romantically melancholic beginnings in the 1920s to its later almost totally abstract symbolism. In still-lifes painted during this period, such as *Une gifle aux Nazis* (1952; fig. 62, p. 75), Berlin seems like a nature morte, an empty and desolate city. Werner Heldt did not live to see the first major exhibition of his work at the Haus am Waldsee in West Berlin to mark his 50th birthday in 1954. He died on the island of Ischia as a result of a stroke. Despite a large retrospective exhibition at the Kestner Gesellschaft in Hanover in 1968 and the publication of a catalogue raisonné of his works in 1976, Werner Heldt's oeuvre, with its deliberate concentration on Berlin as the birthplace of the catastrophe of the century, has not as yet captured the attention of an international public.

Wieland Schmied, *Werner Heldt, Cologne 1976* (with a list of his works by Eberhard Seel).
Werner Heldt, exhib. cat., Kunsthalle Nuremberg 1989.

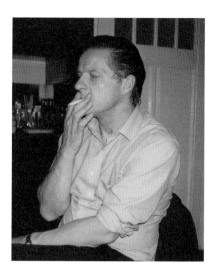

Georg Herold
Photo: privately owned

Peter Herrmann, Photo: Heidrun Melinski-Frank, Berlin

Georg Herold
Born 1947 in Jena
Lives and works in Cologne

Georg Herold forst trained as a metal smith and draughtsman. He studied mathematics and finally art at Burg Giebichenstein in Halle from 1969-73. After an attempted escape from East Germany, he was sentenced to prison and was bought free from the GDR in 1973. He studied at the Akademie der Bildenden Künste in Munich from 1974-76 and at the Hamburg Hochschule für Bildende Künste under Sigmar Polke from 1977-78. He exhibited his *Präsentation der ersten Latte* there in 1977. Together with his fellow student Albert Oehlen, he had an exhibition at the Hamburg Künstlerhaus in 1979. His unwieldy objects continued the anti-art tradition initiated by Duchamp and Picabia and espoused by his teacher Polke, with whom Herold shared a leaning towards intelligent and subversive humour. Herold became famous for sculptures out of roof laths such as his *Goethe-Slat (In Comparison with some other Jerk* (1982; fig. 329, p. 338), through which he sought to confront time-honoured tradition and rugged materiality. His utilisation of simple materials such as roof laths, bricks and found objects together with language, in the form of inscriptions or work titles, served this goal. In his sculpture *Laokoon* (1984; fig. 389, p. 441), two intertwined vacuum cleaners imitate Laocoon's struggle with the sea serpents, while an endlessly running tape of Hitler's opening speech at the *Entartete Kunst* exhibition of "degenerate art" in 1937 provides the necessary pathos. Herold continued this confrontation of material and theme, in a different key after 1989 in his "caviar works" which deal with terrorism in Germany. Herold has been exhibiting at the Max Hetzler gallery in Cologne since 1984, and also at the Arno Kohnen gallery in Dusseldorf, the Susan Wyss gallery in Zurich, at Koury/Wingate in New York, and Juana de Aizpuru in Madrid. In 1985, the Neue Gesellschaft für Bildende Kunst in West Berlin showed his *Unschärferelationen,* and the Kunsthalle Zurich his *Ziegelbilder* in 1989. In 1990 his caviar works could be seen at the Cologne Kunstverein under the motto *Geld spielt keine Rolle.* Works by Herold and Albert Oehlen were shown at the Renaissance Society in Chicago in 1989 and at the Musée d'Art Moderne et Contemporain in Geneva in 1993. Herold has been included in major exhibitions of German art: the *Mülheimer Freiheit* at the Paul Maenz gallery in 1980, the *BiNationale* in Dusseldorf and Boston in 1988, the touring exhibition *Refigured Painting / Neue Figuration,* the sculptureshow in Münster '77 and '97. Herold teaches at the Städelschule in Frankfurt am Main and at the international Atelier 63 in Amsterdam.

Georg Herold, Gekrümmte Poesie / Shifted Verses, exhib. cat., Stedelijk Museum Amsterdam, 1993-94.
Georg Herold, XTOONE, exhib. cat., Kunstmuseum Wolfsburg 1995.

Peter Herrmann
Born 1937 in Grossschönau near Zittau
Lives and works in Berlin

Peter Herrmann began studying painting in an adult education class in Dresden in 1954 under Jürgen Böttcher. Along with Peter Graf and A. R. Penck, he soon became part of the circle that had formed around the artist and experimental film-maker Böttcher. Böttcher's 1961 documentary film about this group entitled *Drei von Vielen* (Herrmann, Graf and Makolies) sets out the aims of the artists who, though they never developed a group style, strove to achieve a type of painting that was true to life and credible. Whereas the film was banned, at the invitation of Fritz Cremer Herrmann and his artist friends were nevertheless able to take part in the exhibition *Junge Künstler. Malerei* at the German Akademie der Künste in 1961, after the construction of the Berlin Wall. Attempts to integrate the potential of these young artists into the official GDR art scene failed due to criticism and disciplinary measures by the party. Subsequently a joint exhibition with "partisan-like" character at the Puschkin Haus in Dresden in 1965 was abruptly called off by the artists because the organiser wanted some controversial works removed. Herrmann's first solo exhibition took place in 1976 at the Leonhardi Museum in Dresden. Of great significance for his artistic development was his encounter with the artist Petra Brandt, who later formed a close relationship with A. R. Penck. In the early 80s, Herrmann exhibited his works at the few galleries in the GDR that had managed to corner a niche within the official art scene: Galerie Mitte in Dresden in 1980, Galerie Arkade in Berlin in 1981, and galerie oben in Karl-Marx-Stadt in 1982. In 1984, a few years after Penck, Herrmann moved to West Germany, at first to Hamburg then to West Berlin where he exhibited repeatedly at the Galerie am Savignyplatz as of 1985. In keeping with the motto "I only paint what I see and experience", Herrmann tried to establish a link with the naive and eye-catchingly bold formal idiom often found in the art of children and the mentally ill. In his 1987 work *Tod des Vaters,* and his *The Homecomer* (1988; fig. 313, p. 304), which focus on important moments in German postwar history, the defenceless and helpless child is confronted with the fate of its parents' generation, a fate for which it cannot be held responsible but the consequences of which it has to suffer. In 1987, Herrmann was awarded a scholarship by the Berlin department of cultural affairs. In addition to solo exhibitions at the Poll gallery in West Berlin and the Niepel gallery in Dusseldorf in 1989, Herrmann has been represented in group exhibitions at the Kunsthalle in Nuremberg in 1991 and the Lindenau Museum in Altenburg in 1992.

Peter Herrmann, exhib. cat., Galerie am Savignyplatz, Berlin (West) 1988.

Rudolf Herz
Photo: Wilfried Petzi,
Munich

Eva Hesse
Photo: The Estate of Eva
Hesse, courtesy of the
Robert Miller Gallery,
New York

Rudolf Herz
Born 1954 in Sonthofen, Allgäu
Lives and works in Munich

While studying at the Akademie der Bildenden Künste and the University of Munich between 1974-81, Rudolf Herz began work on his *Museumsbilder,* in which he addressed a theme that was to have a determining influence on his work in general. These two series of nine photographs each were not to receive their final form until 1996 (fig. 408, pp. 448f.). In the photographs, which Herz took of photographs on show in the Dachau concentration camp museum that had been scratched or smeared by museum visitors, Herz is concerned with the symbolic identification of representation and person represented, a concern which in our media era seems like an anachronistic relic of a magical belief in the image. Yet a belief in and an attack on images are not mutually exclusive but determine each other. A preoccupation with culture, history, philosophy and aesthetics Herz had in common with his fellow student Thomas Lehnerer, with whom he undertook joint projects as of 1979. After his first solo exhibitions in Munich in 1979 and in Cologne in 1987, Herz presented his installation *Schauplatz* at the Kunstforum der Städtischen Galerie in the Lenbachhaus in Munich — a wall-sized photograph of the final frame from the film *The Battleship Potemkin* in front of red chipboard pillars. The failure of a system and its political iconography introduced the problem of how to deal with the past and its symbols, something that Herz has dealt with in other projects, such as the installation *Moskau-Depot* in Esslingen in 1989, or his unrealised 1991 project *Lenins Lager.* In depositing a huge five-pointed Soviet star plus hammer and sickle made of rusty steel on a truck in front of the Kunsthalle in Schwerin and later the Kunstraum in Wuppertal in 1992, Herz' aim was to criticise what he regarded as a throw-away mentality. Parallel to his exhibitions, Herz has been involved in 19th and 20th century photography, in particular into its function within revolutionary movements. For fear of possible misunderstandings, Berlin and Saarbrücken refused to take over his exhibition *Hoffmann and Hitler* from the Munich Stadtmuseum in 1994. Like this latter exhibition, Herz' 1995 installation *Zugzwang* also intended to proffer arguments against the omnipotence of images. For this installation, Herz "wall-papered" the Kunstverein Ruhr in Essen with portraits of Duchamp and Hitler by the photographer Heinrich Hoffmann, creating an overwhelming chessboard-like pattern. Herz has been awarded numerous scholarships and prizes. In 1994-95, he was visiting professor at the Gesamthochschule Kassel. His exhibition *Transit-I-III*, shown at the Neue Gesellschaft für Bildende Kunst in Berlin, the Neue Museum Weserburg in Bremen, and Halle K in Hamburg in 1997 was accompanied by a publication on his work to date.

Peter Friese / Dirk Halfbrodt (eds.), *HERZ*, Nuremberg 1997.

Eva Hesse
Born 1936 in Hamburg
Died 1970 in New York

In the face of National Socialist persecution, the Jewish Hesse family was forced to leave Germany and emigrate to New York in 1939, where Eva Hesse lived until her death. In 1952, she began studies in the field of commercial design at Pratt Institute. In 1954, she changed to the Cooper Union School. After her final examination there in 1957, she continued studying at the Yale School of Arts in New Haven from 1957-59, where her teachers included Josef Albers. She began producing small format gouaches and oil paintings. As of 1962, she also produced large-formats, plus collage gouaches and pen drawings on paper. Her first solo exhibition took place in 1963 at the Allan Stone Gallery in New York. Thanks to an invitation from the textile manufacturer and collector F. A. Scheid to her husband, the sculptor Tom Doyle, Eva Hesse returned to Germany for the first and only time in her life in 1964-65 where she spent the year working in a disused factory in Kettwig an der Ruhr. Both artists visited documenta 3 in Kassel and undertook numerous trips around Europe. Eva Hesse participated in an exhibition mounted by the Dusseldorf Kunstverein in late 1964. In 1965, she began developing three-dimensional works in different materials which were exhibited, along with her drawings, at the Städtische Kunsthalle in Dusseldorf in 1965. Her reliefs, such as the 1965 *Legs of A Walking Ball* (fig. 188, p. 151) form the transition from pictorial to sculptural work, and herald an increasing renunciation of colour. After her return to New York, she participated in numerous solo and group exhibitions throughout the USA. Hesse then began producing works for walls and free-standing sculptures which were shown for the first time in 1968 in a solo exhibition at the Fishbach Gallery in New York. At the time, she was experimenting with new materials such as latex, fibreglass, plastic, string and rubber. From 1968-69, she taught at the School of Visual Arts in New York. Hesse died of a brain tumour in 1970 at the age of 34. The reception of her work in Germany was initiated by the Szeemann exhibition *When Attitudes Become Form* at the Kunsthalle Bern in 1969, the inclusion of her works in documenta 5 and 6 in 1972 and 1977 in Kassel, and the retrospective exhibition mounted by the Kestner Gesellschaft in Hanover in 1979.

Lucy Lippard, *Eva Hesse,* New York 1976.
Bill Barrette, *Eva Hesse. Sculpture*, catalogue raisonné, New York 1989.
Eva Hesse. A Retrospective, exhib. cat., Yale University Art Gallery,
 New Haven/Hirshorn Museum and Sculpture Garden, Washington 1993.
Eva Hesse, exhib. cat., Musée du Jeu de Paume, Paris 1993.
Eva Hesse, Drawing in Space. Bilder und Reliefs, Ulmer Museum/
 Westfälisches Landesmuseum, Münster 1994.

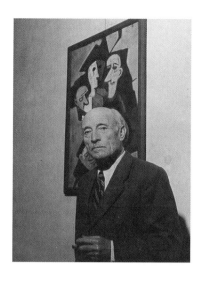

Karl Hofer
Photo: Brigitte Dittner, Berlin

Jörg Immendorff, 1995, Photo: Benjamin Katz, Cologne

Karl Hofer
Born 1878 in Karlsruhe
Died 1955 in Berlin

Karl Hofer's preference for the world of the German-Roman tradition was already evident during his studies at the academies in Karlsruhe and Stuttgart from 1896-1903 under Hans Thoma and Graf von Kalckreuth. This preference took him to Rome from 1903-08 where he adopted the classical idealism of Hans von Marées. This was followed by an apprenticeship in Paris from 1908-13, during which Cézanne's later work exerted an obvious influence on him. Two extended trips to India in 1909 and 1911 also marked his style. On his return to Germany, Hofer moved to Berlin in 1913 where he was included in a first large-scale group exhibition at the Paul Cassirer gallery in 1914. Hofer was surprised by the outbreak of war during a stay in France. He was interned there until 1917, later in Zurich. He returned to Berlin in 1919 where he was appointed to the Hochschule für bildende Künste. In 1923, he became a member of the Prussian Academy of Arts. Around 1919, disillusioned by his experience of war, Hofer made a breakthrough to his very personal style – classical idealism could no longer be reconciled with lived experience. His mode of painting became dry, exhibiting a sparing use of construction lines with harsh outlines. The themes of the girls at the window, the dinner-party, card players, and the rowing boat are recurrent in his work. In 1925, he painted his first Tessin landscapes. After a brief abstract period between 1930-31, Hofer returned to his old style. In 1933, the National Socialists expelled him from the Academy and banned his works as degenerate. After a last exhibition at the Galerie Nierendorf in Berlin in 1939, the difficulties experienced during the Nazi regime reached a climax for Hofer. His divorced wife was murdered in a concentration camp and his studio and a large number of his works were destroyed in a bomb attack in 1943. The naked figure of the drummer in the famous second version of his *The Black Room* (1943; fig. 58, p. 72) represents an attempt to secure a hearing for the helpless despair experienced in the face of the war-time destruction of Germany and Europe. After the war, Hofer was reinstated in his teaching position and was elected rector of the Hochschule für bildende Künste in Berlin-Charlottenburg. A first retrospective of his works took place in 1946 at the Akademie der Künste. In 1950, he became president of the German Artists Association, and in 1953 was awarded the art prize of the City of Berlin. Despite the fact that in the struggle between realism and abstraction in the post-war period Hofer espoused the cause of figurative art, more often than not, his paintings are regarded as allegorical rather than realistic.

Karl Hofer 1878-1955, exhib. cat., Staatliche Kunsthalle, Karlsruhe 1987.
Jürgen Schilling, *Karl Hofer*, Unna 1991.

Jörg Immendorff
Born 1945 in Bleckede near Lüneburg
Lives and works in Dusseldorf

His first exhibition in 1961 fired Immendorff's ambition to make a career for himself as an artist. Consequently, he began studying at the Kunstakademie in Dusseldorf in 1963, first in the stage design department, then from 1964-66 under Joseph Beuys. With his provocative petition to "stop painting" (1966, ill. 228, p. 183), Immendorff adopted the cause of the social effect of art, which placed him somewhere between happening and painting. Between 1968-70, following on Fluxus and the student movement, he translated his political ambitions into exhibitions and anarchist activities. With the report he presented at documenta 5 in 1972, in which he makes himself the subject of a critique of an art tarnished by a desire for fame and politically naive behaviour, Immendorff shifted his focus from the artistic happening to painting, developing a regular Agitprop painting. For a time, his sympathies for Maoism became the main theme of his work. In 1975, his first encounter with the artist A. R. Penck, who was living in Dresden at the time, gave rise to a joint short manifesto on working in a collective. This period also saw the creation of his *Brecht Series (Question of a Reading Worker)* (1976; fig. 229-234, pp. 184ff). A second encounter with Penck in 1977 in East Berlin resulted in the two artists forming an artistic alliance that led to joint activities and exhibitions such as the 41 works on paper *Immendorff Visits Y* (1979; fig. 235, p. 189). Between 1978-82, an encounter takes place between the two artists in Immendorff's series of paintings *Café Deutschland*, which, in reference to Guttuso's *Caffé Greco* of 1976, deals with the theme of German partition. In the first version (1978; fig. 236, p. 199) Immendorff stretches a hand of reconciliation through the wall, while in the background the two heads of state Honecker and Schmidt agree to mutually recognise their respective states. In his iconographic set pieces, Immendorff resorted to highly-charged symbols such as the eagle, the hammer and sickle, the swastika, the Berlin Wall and the Brandenburg Gate, which he also transformed into monumental sculptures as of 1977. In his academy paintings of the 1980s, the experienced art teacher (1969-80) reflects on his teaching activities at the different academies. Jörg Immendorff's many and varied stage sets betray a continued indebtedness to an educative form of stage art influenced by Brecht.

Jörg Immendorff. Bild mit Geduld, exhib. cat., Kunstmuseum Wolfsburg 1996.
Jörg Immendorff. Gyntiana, exhib. cat., Neuer Berliner Kunstverein, Berlin 1996.
Jörg Immendorff. Respect I, exhib. cat., Dresdner Kunstverein 1996.

Manfred Kempfer, 1995, Photo: Hermann Kiessling, Berlin

Manfred Kempfer
Born 1938 in Berlin
Lives and works in Berlin

Although he lived to the east of Berlin, Manfred Kempfer opted to apply for admission not to the Kunsthochschule in East Berlin (Weissensee) but to the Meisterschule für Graphik und Buchgewerbe in West Berlin (Friedenau) where he studied from 1956-60. Through his teachers Gerhard Kreische, Walter Peter and Harry Kögler, Kempfer got to know the art of classical modernism and visited documenta II in Kassel in 1959. After the construction of the Berlin Wall in 1961, however, he became systematically cut off from international developments in art. Influenced by the tradition of abstract art, in particular by the works of Paul Klee, the former conscientious objector Kempfer became increasingly isolated and was subjected to close observation by the state authorities. Apart from his participation in the *Grosse Berliner Kunstausstellungen* of 1958, 1959 and 1960, he had no possibility of exhibiting or selling his works. Instead he earned his living as a commercial artist designing posters and record sleeves. Retiring into a state of "inner emigration", Kempfer produced spiritual landscapes in which he traversed a wide-ranging painterly domain in the border area between the figurative and the abstract. Of importance for his work were such artists as Fritz Winter, Emil Schumacher and Ernst Wilhelm Nay. Kempfer's pictorial planes with their cubist structures condense into informal compositions made up of gestural and expressive elements. In his *Menetekel* (1965; fig. 197, p. 166) a glowing red warning sign emerges out of the black ground in the thickly painted crude outlines of a crucifixion. Towards the end of the 60s, an increasing simplification in his pictorial composition led to almost monochrome works depicting amorphous bodily forms. Jürgen Schweinebraden placed his private rooms, which had been transformed into a gallery, at Kempfer's disposal for the first time in 1974 and again in 1980. Throughout the 1970s the small EP gallery in Prenzlauer Berg in East Berlin offered the non-conformist artist a modest forum. When Schweinebraden had to leave the GDR for political reasons, Kempfer lost that particular possibility of exhibiting his work. Between 1972 and the mid-eighties there were repeated, lengthy breaks in his artistic work. As of 1985, his paintings began to display changing and superimposed informal structures with clearly geometric forms that point to an underlying scriptural structure. It was not until 1991, after the fall of the Berlin Wall, that another exhibition was held at the Insel Galerie in Berlin, followed by a show at the Galerie Pankow in 1992, which presented a first overview of Kempfer's painting and graphic works from three decades.

Manfred Kempfer, Bilder 1959-1989, exhib. cat., Galerie Pankow, Berlin 1992.

Anselm Kiefer
Born 1945 in Donaueschingen
Lives and works in Barjac (southern France)

Parallel to studies in law and romance languages and literature, which he began in 1965, Anselm Kiefer studied painting under Peter Dreher in Freiburg in 1966, continuing at the Akademie für bildende Künste in Karlsruhe under Horst Antes in 1969. In the same year, he had his first solo exhibition at the Galerie am Kaiserplatz in Karlsruhe. During that period, Kiefer painted heroic landscapes and wrote about heroic symbols. After his final examination in 1970, he went on to study in Beuys' class at the Dusseldorf Kunstakademie until 1972. He moved to Hornbach in Odenwald in 1971 where he lived in a former school house. In many ways, his attic studio there constituted a kind of stage on which German history, Germanic-Nordic mythologies, and religious-biblical material played the main roles and to which Kiefer referred in his paintings by means of emblematic pictorial signs and direct inscriptions. Kiefer's confrontational approach to the conflict-laden theme of German history reflects an artistic stance that oscillates between analysis, affirmation and mimicry, shying away neither from pathos nor taboo. His *Germany's Spiritual Heroes* (1973; fig. 326, pp. 335f.), a mural-type work exhibited in the German pavilion at the 1980 Venice Biennale, sparked a controversial debate both in and outside Germany. Kiefer was accused of glorifying a blood-and-soil ideology in his painting. The sensual quality of his superimposed, earth-coloured layers of paint, which at first glance suggest the natural materials of wood or earth, which he actually includes later, raised the question of appropriateness in the treatment of Germany's past. Alongside his relief-like paintings, Kiefer also produced large-format lead sculptures and works in traditional techniques, woodcuts, water-colours and, above all, photography. From 1973-77, Kiefer was represented by the Michael Werner gallery in Cologne. Since 1981, he has exhibited at the Paul Maenz gallery in Cologne and since 1983 at the Anthony d'Offay gallery in London. Solo exhibitions in the Kunsthalle Berne in 1978, the Stedelijk Van Abbe Museum, Eindhoven in 1979, the Museum Folkwang, Essen in 1981, the Städtische Kunsthalle Dusseldorf in 1984, and the Art Institute of Chicago in 1987/88, plus participation at documenta 6, 7 and 8, represent just some of the more important stages in the career of this artist, who in 1990 was awarded the Wolf Prize, Jerusalem, and the Kaiserring of the City of Goslar.

Anselm Kiefer, exhib. cat., Nationalgalerie Berlin 1991.
Anselm Kiefer. Cette obscure clarté qui tombe des étoiles, exhib. cat.,
 Galerie Yvonne Lambert, Paris 1996.

Martin Kippenberger
Photo: Elfie Semotan, Vienna

Konrad Klapheck
Photo: privately owned

Martin Kippenberger
Born 1953 in Dortmund
Died 1997 in Vienna

Soon after enrolling at the Hochschule für Bildende Künste in Hamburg to study under Rudolf Hausner and Franz Erhard Walther in 1972, Martin Kippenberger dropped out of art school. Hamburg, where Albert Oehlen, Georg Herold and Werner Büttner also studied in the early 80s, had seen the birth of a group of young artists who cultivated subjectivism in the spirit of Dada through anarchistic banter and provocation. Kippenberger moved from Hamburg to West Berlin where in 1978, together with Gisela Capitain, he founded the *Kippenberger Büro* in which joint exhibitions with his artist friends were held. In 1979, he founded the SO 36 club in Berlin-Kreuzberg, plus the punk band *Die Grugas*. In 1984, he became a member of the Lord Jim Lodge. His group activities were aimed at relativising values in all cultural realms, be that politics, morality or art. Kippenberger's work *For the Life of Me, I Can't See any Swastikas* (1984; fig. 333, p. 343) sums up the difficulties Germans have not only in dealing with their historical heritage but in putting up decisive opposition to proliferating neo-fascist and xenophobic slogans. His work is characterised by a wealth of expressive means, a mixture of slapstick, dilettantism and blasphemous pathos. From 1981 onwards, Kippenberger exhibited at the Max Hetzler gallery, initially in Stuttgart then in Cologne, as well as at the Peter Pakesch gallery in Vienna, Metro Pictures in New York, Bärbel Grässlin in Frankfurt am Main, Gisela Capitain in Cologne, and Juana de Aizpuru in Madrid. In 1981, the Neue Gesellschaft für Bildende Kunst in West Berlin mounted the first non-commercial solo presentation of his works. Exhibitions followed at the Neue Galerie Sammlung Ludwig in Aachen in 1983, the Hessisches Landesmuseum in Darmstadt in 1986, the Kunsthalle Winterthur in 1988, the Institute of Contemporary Art in Philadelphia in 1989, the San Francisco Museum of Modern Art in 1991, the Centre Georges Pompidou in Paris in 1993, and the Museum Boymans-van Beuningen in Rotterdam in 1994. Kippenberger has also been represented in major exhibitions of German art including *1945-1985. Kunst in der Bundesrepublik Deutschland* at the West Berlin Nationalgalerie in 1985, and the touring exhibition *Refigured Painting / Neue Figuration* in 1988. He held a visiting professorship at the Städelschule in Frankfurt am Main in 1991, and in 1996 was awarded the Käthe Kollwitz Prize of the Akademie der Künste in Berlin. Kippenberger was represented at the 1997 documenta X in Kassel and the exhibition of sculpture in Münster.

Martin Kippenberger. Retrospektive, exhib. cat., Musée d'Art Moderne et Contemporain, Geneva 1997.
Martin Kippenberger. Der Eiermann, exhib. cat., Städtisches Museum, Museum Abteiberg, Mönchengladbach 1997.

Konrad Klapheck
Born 1935 in Dusseldorf
Lives and works in Dusseldorf

Konrad Klapheck comes from a family of art historians and has, therefore, been familiar with classical art since his earliest childhood. While still at school, he began to develop an interest in the art of the classical modern era, in jazz, and in modern literature. The untimely death of his father in 1939 and early memories of the war, such as the bomb attack on Leipzig and the Red Army invasion, have had a lasting effect on him. After studies at the Dusseldorf Kunstakademie from 1954-58, and with the support of his teacher Bruno Goller, Klapheck opted for figurative painting as opposed to the abstract trends of the 1950s. Figurative painting — in the tradition of René Magritte's academically precise mode of painting — monumentalised profane objects in such a way as to lend them a magical dimension. After his first painting of a typewriter in 1955, Klapheck went on to develop the main themes of his work between 1955-59. In contrast to the sober pictorial world of his machines, his titles assumed a surprisingly poetic function, typical of surrealism. His 1957 work *Tired Heroes* (fig. 121, p. 103), for example, which clearly betrays the influence of Goller in its preference for grey and brown tones, is a reference to leg prostheses similar to those often displayed in shop windows in the post-war period. Between 1959-63 Klapheck simplified and stylised his motifs, producing works such as *The Will to Power* (1959; fig. 120, p.103). The artist sees in these works a reflection of the totalitarian architecture familiar to him from the time of his childhood. Here the typewriter becomes a metaphor for a bureaucratic power apparatus. Klapheck's first solo exhibition was in 1959 at the Schmela gallery in Dusseldorf. In 1961, he made contact with surrealist circles in Paris and had his first exhibition there in 1965 at the Ileana Sonnabend gallery. The accompanying catalogue to this exhibition contained an introduction by André Breton. His first solo exhibition in New York was at the Sydney Jannis gallery in 1969. The Boymans-van Beuningen museum in Rotterdam mounted a retrospective exhibition in 1974, which was also shown in Brussels and Dusseldorf. A second large-scale retrospective exhibition was mounted by the Hamburg Kunsthalle and shown later at the Kunsthalle in Tübingen and the Staatsgalerie für moderne Kunst in Munich.

Konrad Klapheck. Retrospektive, exhib. cat., Hamburger Kunsthalle, Munich 1985.
Konrad Klapheck, *Ecrits,* Paris 1996.

Paul Klee, Dessau 1933
Photo: Josef Albers

Astrid Klein, 1997, Photo: privately owned

Paul Klee

Born 1879 in Münchenbuchsee near Berne
Died 1940 in Muralto near Locarno

Though from a family of musicians, Paul Klee opted to attend the Heinrich Knirr school of painting in Munich from 1898-1900. He then studied under Franz von Stuck at the Kunstakademie until 1901. After a study trip through Italy in 1902, he moved to Berne where he lived until his marriage in 1906. Later he moved back to Munich where he had his first exhibition at the Tannhauser gallery in 1911. That same year he got to know Alfred Kubin and the Blaue Reiter artists Kandinsky, Macke and Marc, and took part in their second exhibition in 1912. It was at that exhibition that Klee saw works by Delaunay, whom he subsequently visited in Paris in 1913. Inspired by French orphism and cubism, Klee began to grapple with the problem of colour, for which he found a solution during his trip to Tunis with Macke and Moilliet in 1914. Between 1916-18 Klee fought in the First World War in which his friends Macke and Marc were both killed. Walter Gropius appointed him to the Bauhaus in 1920, and Klee moved to Weimar in 1921. His teaching obligations forced him to systematise the romantic point of departure of his work, thus giving rise to such seminal writings on modern art as *Über die moderne Kunst* (1924) and the *Pädagogisches Skizzenbuch* (1925), in which he examined the creative potential of the primary pictorial elements. Together with Kandinsky, Feininger and Jawlensky, Klee founded the group *Die Blauen Vier* in 1924. In 1929, on the occasion of his fiftieth birthday, the Flechtheim gallery in Berlin mounted an exhibition which was taken over by the Museum of Modern Art in New York in 1930. In 1931, Klee was appointed professor at the Dusseldorf Kunstakademie but was suspended by the National Socialists in 1933, the same year in which he produced his *Struck from the List* (fig. 13, p. 40). After his suspension he returned to Berne. Two years later, the fatal disease (sclerodermia) that was to be the cause of his death at the age of 61 began to manifest itself. Klee's final creative period began in the shadow of his intimations of his own death and the growing threat of war. During that phase he turned to large formats, and his compositions became simpler, structured by just a few strong lines. His *Storm Underway* (1934; fig. 14, p. 41) refers to conditions in Germany. Klee painted his *Marked* (fig. 15, p. 41) in 1935, immediately prior to the confiscation of more than 100 of his works, 17 of which were shown in the Nazi exhibition *Entartete Kunst* in 1937.

Paul Klee. Die Zeit der Reife, exhib. cat., Kunsthalle Mannheim, Munich 1996.

Astrid Klein

Born 1951 in Cologne
Lives and works in Cologne

Astrid Klein studied at the Fachhochschule für Kunst und Design in Cologne from 1973-77. Her first solo exhibition was held at the Künstlerhaus in Hamburg in 1980. As of the mid-seventies, Klein developed a politically-involved art, primarily in the medium of black-and-white photography. Using various kinds of technical manipulation, she blew her photographs up into huge formats that possess a painterly quality and quasi-x-ray transparency. In doing so she usually processed existing newspaper material, texts, or her own photo series enlarged into monumental formats or multi-part works and installations. To suggest the break in German national identity, Astrid Klein selected the motif of a flag without an emblem, such as the one that fills the whole pictorial composition of *Untitled* (1988-97; fig. 371, p. 419). This finds a correspondence in her text montage *Untitled* (1974-97; fig. 370, p. 418), an artistic form with which she had already worked in the 1970s, as evident in her *Kamikaze* (1978; fig. 369, p. 417) which addressed the theme of the RAF's self-destructive struggle. After exhibitions at the Galerie Gugu Ernesto in Cologne in 1981 and the Galerie Wittenbring in Regensburg in 1982 and 1984, Klein began to collaborate regularly with the Produzentengalerie in Hamburg. That same year the Neue Gesellschaft für Bildende Kunst in Berlin mounted the first non-commercial exhibition of her works. In 1984, Klein participated in *Von hier aus,* a presentation of new German art in Dusseldorf, and in *1945-1985. Kunst in der Bundesrepublik Deutschland* in the West Berlin Nationalgalerie in 1985. Her close collaboration and friendship with Rudolf Bonvie resulted in joint exhibitions at the Kunsthalle in Bielefeld in 1985, the Museum am Ostwall in Dortmund in 1986 and the Bibliothèque Municipale de Lyon in 1997. Klein was represented at documenta 8 in Kassel in 1987. In 1989, the Kestner Gesellschaft in Hanover mounted a retrospective exhibition accompanied by an extensive catalogue. Having been awarded the 1991 BDI Prize for room design (Ars Viva), Klein designed the stage set for Botho Strauss' *Kalldewey Farce* performed at the Schauspielhaus in Dortmund. Klein has been professor at the Hochschule für Grafik und Buchkunst in Leipzig since 1993. Along with numerous scholarships (from the Deutsch-Französisches Jugendwerk in 1980, the Kulturfond e.V. Bonn in 1982, the 1987 Karl Schmidt-Rottluff and the 1992 Krupp stipends) and prizes (the 1983 Förderpreis of the State of North Rhine-Westphalia, the 1984 prize of the City of Cologne, the 1986 Glockengasse prize, Cologne), Klein was awarded the Käthe Kollwitz Prize of the Akademie der Künste in Berlin in 1997.

Astrid Klein, exhib. cat., Saarland Museum, Saarbrücken; Kunsthalle Nuremberg 1994.
Astrid Klein, exhib. cat., Akademie der Künste, Berlin 1997.

Gustav Kluge
Photo: Ralf Tooten, Hamburg

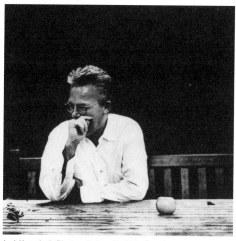

Imi Knoebel, Photo: Anton Corbijn, London

Gustav Kluge
Born 1947 in Wittenberg (Elbe)
Lives and works in Hamburg

Once German partition had become an official fact, the Kluge family moved to the young Federal Republic in 1950. Having completed military service from 1966-68, Gustav Kluge began studying at the Hochschule für Bildende Künste in Hamburg under Kai Sudeck and Gotthard Graubner, graduating in 1974. From 1972-76, he worked freelance for the Produzentengalerie in Hamburg where he exhibited regularly as of 1977. Kluge taught at secondary school from 1976-78 and then at the Hochschule für Bildende Künste in Hamburg from 1978-85. He has been a free-lance artist since 1985. His works are characterised primarily by heavy oil colours which, thanks to their relief-like surface, resemble natural organic structures. In his woodcuts and printing blocks made out of door panels, floor planks or sections of tree trunks, he consciously focuses attention on the pictorial means, similar to Felix Droese, there by rendering the emergence of the work visible. His human figures, depicted as naked and vulnerable, are also caught up in a natural process of birth, growth, life and death. Even when Kluge takes specific events in German history as the inspiration for his works, as in his *Stammheim Duet* (1984; fig. 318, p. 313), his *Abtransport* of 1987, or his *Escape* (1992; fig. 317, p. 311), he always places them in a timeless context. With reference to the northern German expressionist tradition, Kluge attempts a direct depiction of existential borderline situations. After a first exhibition at the Produzentengalerie of his works from the years 1974-77, which also included a catalogue, the Kunstverein in Brühl mounted a solo exhibition in 1983, as did the Hamburg Kunsthalle in 1984. Between 1986-92, Kluge exhibited at the Rudolf Zwirner gallery in Cologne, and since 1991 at the Galerie van de Loo in Munich. In 1986, 1987 and 1992 Kluge's woodcuts were shown at the Städtische Kunstmuseum, Spendhaus Reutlingen and the Kunstverein in Oldenburg, followed by the Kunstverein Göttingen. His more recent works were presented in the Bonn, Hamburg and Karlsruhe Kunstvereine in 1988, and at the Saarland Museum in Saarbrücken in 1992.

Gustav Kluge. Die Elemente — Die Künste, exhib. cat., Saarland Museum, Saarbrücken, Stuttgart 1992.
Gustav Kluge. Verbotene Orte — Betretene Orte. Bilder 1992-1997, exhib. cat., Hamburger Kunsthalle; Die Neue Sammlung, Munich 1997.
Gustav Kluge. Aquarelle und Wasserzeichen von 1982-1997, exhib. cat., Kunsthalle zu Kiel 1997.

Imi Knoebel
Born 1940 in Dessau
Lives and works in Dusseldorf

Imi Knoebel was born Klaus Wolf Knoebel in Dessau and spent his childhood in the vicinity of Dresden. In 1950, his family moved to Mainz. He attended the Werkkunstschule in Darmstadt from 1962-64 where, together with Rainer Giese (1942-1974), he became familiar with constructive and structural compositional exercises based on the Bauhaus preliminary course drawn up by Johannes Itten and László Moholy-Nagy. Fascinated by the personality and courses of Joseph Beuys, Knoebel and Giese, both of whom gave themselves the first name Imi, moved to the Kunstakademie in Dusseldorf where they studied from 1964-71. After a waiting period of one year, the two of them gained admission to the popular Beuys class in Room 20, laying claim to the adjoining Room 19, together with Immendorff and Palermo. In 1968, at a spatial distance and in outward contrast to Beuys, Knoebel created his first installation, *Room 19* (fig. 278, p. 254) which consists of different geometric objects, among them numerous wedges, made of hardboard and spruce. Like Beuys' disciple Palermo, with whom he shared a studio in 1968, Knoebel devoted his attention in various analytical series to the relationship between space, carrier and colour. He was indebted to his second great model Kasimir Malevich for a certain reduction to the elementary co-ordinates of painting. In 1968, he and Imi Giese had their first solo exhibition entitled *Imi & Imi* at the Charlottenborg gallery in Copenhagen, followed by *Imi Art etc.* at the René Block gallery in Berlin. After his purist line paintings, light projections and white works (1972-75), Knoebel used colour (green) for the first time in 1974. In 1975, he moved on to superimposed colour rectangles painted in lead compounds, and finally to vividly coloured and expressively gestural colour applications on layers of woodchip, hardboard and metal planks set in a specific relation to the respective room. Projects such as the *Deutsches Tor* and *Kinderstern* (both 1988) expressed the artist's social and political involvement and betrayed links with Beuys' "social sculpture". Alongside solo exhibitions in museums, among other places, in Eindhoven in 1972 and 1982, Dusseldorf in 1975, Winterthur and Bonn in 1983, Mönchengladbach and Duisburg in 1984, Otterlo in 1985, Baden-Baden in 1986, and Darmstadt and Hamburg in 1992, Knoebel has also taken part in major group exhibitions such as documenta 5, 6 and 7, and exhibitions surveying German art, like the Art *Allemagne Aujourd'hui* at the Musée d'Art Moderne de la Ville de Paris in 1981 and the *1945-1985. Kunst in der Bundesrepublik Deutschland* exhibition at the Nationalgalerie in Berlin in 1985.

Imi Knoebel, Retrospektive 1968-1996, exhib. cat., Haus der Kunst, Munich; Stedelijk Museum, Amsterdam; IVAM Valencia; Städtische Kunsthalle, Dusseldorf; Musée de Grenoble 1996/97.

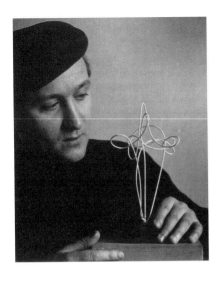

Norbert Kricke
Photo: Ruth Bähnisch,
Dusseldorf

Wilhelm Lachnit
Photo: unknown photographer

Norbert Kricke
Born 1922 in Dusseldorf
Died 1984 in Dusseldorf

After serving in the airforce during the Second World War, Norbert Kricke began studying at the Hochschule der Künste in Berlin in 1946, in the master class given by Richard Scheibe. It was there that he saw the first post-war exhibitions of sculptures by Hans Uhlmann which made a lasting impression on him. Kricke returned to his hometown of Dusseldorf in 1947. Already in his early 1950s sculptures made of metal rods welded, bundled or knotted together (fig. 111-113, pp. 92f.), Kricke's obvious concern is with being able to see and experience the dimensions of space and time — in the tradition of the Russian constructivists Naum Gabo and Antoine Pevsner. After his first exhibitions at the Ophir gallery in Munich in 1953 and the Parnass gallery in Wuppertal in 1954, the Dusseldorf Kunstverein showed sculptures and drawings by him in 1955. In the mid-1950s, Kricke developed a new method of representing movement by means of forms of water. He first described these in his 1956 exposé *Forms of Water* and in 1959 applied the process in his water design for the new university building in Baghdad, in cooperation with Walter Gropius. Exhibitions at the Iris Clert gallery in Paris in 1957 and 1959, participation in documenta 2 in Kassel in 1959, and an exhibition at the New York Museum of Modern Art in 1961 helped Kricke gain international recognition. His sculptures communicate the intensity of the post-war longing to experience the infinite expanse of space, transparency, lightness, and freedom. A series of exhibitions in German museums soon followed: Haus Lange, Krefeld 1962; Karl Ernst Osthaus Museum, Hagen 1963; Rheinisches Landesmuseum Bonn 1968; Wilhelm-Lehmbruck-Museum Duisburg 1975; Staatsgalerie Stuttgart 1976; Westfälisches Landesmuseum Münster 1977; Städelsches Kunstinstitut Frankfurt am Main 1980. In 1964, Kricke represented the Federal Republic at the Venice Biennale along with Joseph Fassbender, and in the same year took part in documenta 3 in Kassel. Of his numerous works installed in public places, the sculpture commissioned by the Mannesmann company for Expo 67 in Montreal won him particular acclaim. Kricke was awarded the 1958 prize of the Graham Foundation for Advanced Studies in the Fine Arts, Chicago, the 1963 art prize of the state of North Rhine-Westphalia, and the 1971 Wilhelm Lehmbruck prize of the City of Duisburg. He was appointed professor at the Kunstakademie in Dusseldorf in 1964 and was director of the academy from 1974 until his death in 1984.

Norbert Kricke. Zeichnungen, exhib. cat., Kunstmuseum Bonn 1995.
Norbert Kricke. Zeichnungen und Raumplastiken 1922-1984,
 exhib. cat., Institut für Auslandsbeziehungen, Ostfildern 1996.

Wilhelm Lachnit
Born 1899 in Gittersee near Dresden
Died 1962 in Dresden

Having attended evening classes at the Kunstgewerbeschule in Dresden from 1918-20, Wilhelm Lachnit then studied at the Dresden Kunstakademie from 1921-23 during which time he made friends with two older students, Otto Griebel and Conrad Felixmüller, both of whom were founder-members of the German Communist Party and belonged to the Dresden Secession. The marked influence of Otto Dix on artists in Dresden at the time also affected Lachnit, though in a sketchily romantic rather than a veristic aggressive way. In 1925, Lachnit joined the Communist Party and together with Hans Grundig, Otto Griebel and Fritz Skale founded the *Neue Gruppe* known for its critical objectivity. Several group exhibitions culminated in the *1. Internationale Kunstausstellung* in Dresden in 1926. That same year, Lachnit got to know Fritz Löffler. In 1927, he participated in the *Neue Sachlichkeit* exhibition at the Galerie Neumann und Nierendorf in Berlin. In 1928, at the height of escalating political activities at the time, the local Dresden branch of the ASSO was founded, of which Lachnit was a central figure. He took part in large protest marches against National Socialism. The last major exhibition by the Dresden Secession before the Nazis came to power took place in 1932 on the Brühlsche Terrasse. Lachnit was arrested for a brief period in 1933. His *The Sad Spring* (fig. 20, p. 45), painted in 1933, would seem to anticipate the twelve years of dictatorship, during which he was hindered in his artistic activities, persecuted by the Gestapo, and threatened by poverty. Lachnit developed a metaphorical idiom which enabled him to combine elements from ancient mythology, biblical themes and current events. His flower allegories invoke an Arcadian realm as a counter-world to National Socialist reality. Despite this, Lachnit was able to take part in several group exhibitions up until 1944. In 1945, he was conscripted into the army. Most of his works were destroyed in the bombing of Dresden. After his demobilisation, his artistic work was primarily concerned with coming to terms with the past. This was accompanied by a return to realistic painting. In 1947, Lachnit was appointed professor at the re-opened Hochschule für Bildende Künste in Dresden but came into increasing conflict with the ever more stringent doctrine of socialist realism. In 1953, he was given leave of absence, and one year later he resigned his post altogether in order to teach privately in his "small academy".

Wilhelm Lachnit. Gemälde, Graphik, Zeichnungen, exhib. cat., Akademie der Künste,
 Berlin 1990.

Mark Lammert
Photo: Ferdinando Scianna,
Magnum

Via Lewandowsky, 1992, Photo: unknown photographer

Mark Lammert
Born 1960 in Berlin
Lives and works in Berlin

Mark Lammert, grandson of the Berlin sculptor Will Lammert, grew up in East Berlin and studied at the Kunsthochschule in East Berlin under Heinrich Tessmer from 1979-86. Being the last decade of the GDR, the political climate at the time allowed a relatively high degree of artistic application and independence. After his studies, he had his first exhibitions at the youth centre of the Staatliche Museen in Berlin, the Schaufenster gallery, and the Aufbau publishing house in 1987, at the studio bildende Kunst in Berlin in 1988, and at the Greifen gallery in Greifswald in 1989. Lammert was a master student under Werner Stötzer at the Akademie der Künste in Berlin from 1989-92. Together with Martin Colden, he exhibited at the Sauer gallery in Schweinfurt in 1990, at the Rotunde gallery in the Alte Museum in Berlin in 1991 and 1993, and at the galerie refugium in Neustrelitz in 1993 and 1995. Lammert's oeuvre to date centres on the theme of the human body, whose form, vulnerability and transience he scrutinises with an almost x-ray eye. The contours, outlined in charcoal, vary specific poses which dissolve into separate body fragments, almost to the point of complete abstraction. Lammert studied human anatomy in the pathology section of a Berlin hospital and was also able to observe human movement as a guest at the German theatre in Berlin in 1991. During rehearsals for *Mauser*, directed by Heiner Müller with a stage set designed by Jannis Kounellis, he produced subtle lithographs and etchings which were published in a double volume. His personal relationship with Heiner Müller finds an intimate and generally valid expression in his cycle of etchings of Müller's daughter *Chins* (1993; fig. 316, pp. 309f.) and in the four drawings *January 2, 1996* (1996; fig. 315, p. 308). In 1995, the Kunsthalle Rostock put on an exhibition of his drawings. His most recent exhibition, together with Martin Assig, in the Kunstmuseum Kloster Unser Lieben Frauen in Magdeburg is devoted to his paintings. Whereas Lammert's drawings characterise the human figure in just a few lines, in recent years his painting has varied the colour red in all its nuances, from deep blood red to the orange and pink shades underneath various layers of skin. The pictures he has painted on the reverse side of maps avail themselves of the pattern of the folded paper as a faded surface structure on which the red spots of colour seem like gaping wounds. In 1994, Lammert was awarded a scholarship by the Berlin senator for cultural affairs and another from the Kunstfond e.V. Bonn in 1996.

Mark Lammert. Zeichnungen, exhib. cat., Kunsthalle Rostock 1995.
Mark Lammert. Malerei, exhib. cat., Kunstmuseum Kloster Unser Lieben Frauen, Magdeburg 1996.

Via Lewandowsky
Born 1963 in Dresden
Lives and works in Berlin

While studying at the Hochschule für Bildende Künste in Dresden between 1982-87, Via (Volker) Lewandowsky began doing performances with his fellow students Micha Brendel, Else Gabriel and Rainer Görss. As of 1987, this group called themselves *Autoperforationsartisten.* Their first performance took place at the Hochschule für Bildende Künste and the Leonhardi Museum in Dresden in 1987, and the Akademie der Künste der DDR in Berlin in 1988. Like the Wiener Aktionisten and the Fluxus artists in the 1960s, these artists were looking for a way out of the "art ghetto". Once Lewandowsky felt the group's potential had been exhausted, he initiated a series of performance readings with the Dresden poet Durs Grünbein. These began in 1988 with *Ghettohochzeit* in the Samariterkirche in East Berlin. The two artists were seeking new images, from the viewpoint of a later generation, for the history of the holocaust — thus in their performance *Deutsche Gründlichkeit* at the Galerie Weisser Elefant in East Berlin in 1989, they poked around in a dead pigeon with a long iron rod. At the same time, Lewandowsky developed a new type of panel image with mounted film, a kind of reproductive painting based on his experience with Super 8 film. His first shows took place in 1988 on the premises of the publicly owned organisation for the preservation of historic monuments and in the Zionskirche in Dresden. A constant motif in his work is the human body, its vulnerability, deformities and mutations, all of which question the perfect image of man propagated by socialist realism. The traces of the artist's urine in *Eight Portraits about Euthanasia* (1989; fig. 322, pp. 326 f.), exhibited in 1989-90 at the Neue Gesellschaft für Bildende Künste in Berlin, were intended to demonstrate the degradation of human life. That was the year Berlin Wall fell and also the year Lewandowsky began collaborating with Pina Lewandowsky with whom he transferred the *Freie Praxis,* founded in 1988, to West Berlin. It was there in 1990 that he exhibited at the Galerie Vier and took part in the *Endlichkeit der Freiheit* project. After a stay in New York financed by a PS 1 scholarship in 1991-92 and participation in documenta 9 in Kassel in 1992, *Freie Praxis* was disbanded and the *Art Catering Service* founded in 1993. Alongside solo exhibitions, Via and Pina Lewandowsky have been represented in exhibitions of German-German art such as *Deutschsein* at the Kunsthalle in Dusseldorf in 1993, *Westchor Ostportal* at the Galerie im Marstall in Berlin, an exhibition which also toured to Bonn and Dresden, and *Kunst in Deutschland 1945-95* at the Museum Ostdeutsche Galerie in Regensburg in 1995.

Bemerke den Unterschied, Autoperforationsartistik, exhib. cat., Kunsthalle Nuremberg 1991.
Pina und Via Lewandowsky. Alles Gute, exhib. cat., Museum der Bildenden Künste, Leipzig, Berlin 1995.

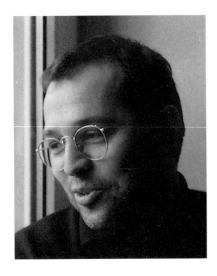

Thomas Locher
Photo: privately owned

Roger Loewig, 1989
Photo: Matthias Weber,
Berlin

Thomas Locher
Born 1956 in Munderkingen
Lives and works in Cologne

As a student at the Staatliche Akademie der Bildenden Künste in Stuttgart from 1979-85, Thomas Locher got to know a number of artists, among them Thomas Grünfeld, Raimund Luckwald, Platino, Lothar Römer, Rolf Walz and Peter Zimmermann, all of whom were deeply involved in a critical debate with the tradition of concept art. The Ralph Wernicke gallery in Stuttgart took on these artists and in 1985 and 1986 mounted group exhibitions of their works. In the light of philosophical post-structuralist theories and the writings of Derrida, Lyotard and Lacan, Locher sees the difference between the signifier and the signified as the theoretical point of departure for his text works, whose outward form is determined by the severe beauty of the textual image and by technical precision. Thomas Locher examines the structure of various order systems at the cutting edge between philosophy and art, concept and plasticity. Locher's first exhibitions took place in 1987, at the Christoph Dürr gallery in Munich, the Karsten Schubert and Interim Art galleries in London, and the Tanja Grunert gallery in Cologne. The latter has since been representing and regularly exhibiting not only Locher but most of his fellow students in Stuttgart as well. In 1988, Locher received a scholarship from the Bonn Kunstfond and exhibited at Jay Gorney Modern Art in New York together with Thomas Grünfeld. Further exhibitions followed at the Rumma, Neapel and Metropol galleries in Vienna in 1990, the Trans Avant-Garde Gallery in San Francisco, and the Anne de Villepoix gallery in Paris in 1991. Locher was awarded the 1991 Karl Schmidt-Rottluff scholarship, and a first overview of his work was shown at the Kunsthalle in Bielefeld in 1992. Whereas for the *Vier imaginäre Räume* exhibition in the Cologne Kunstverein in 1992 Locher opted for a sculptural, object-like presentation by applying texts to furniture and spatial installations, at the Kunsthalle in Zurich in 1993 he exhibited the whole range of his text and image panels. The theme that unites the group of artists named above is, in the broadest sense, *Kunst um Kunst* (art about art), which is also the title they chose for a group exhibition in the Kunsthalle in Bielefeld in 1993. In his 1995 commentary on the preamble to, and the fundamental rights laid down in German Basic Law (fig. 387, pp. 432 ff.) Locher examines writing as a system of political order with the aim of sounding out the structural scope that exists for discretionary action between aspiration and reality, norm and life, signifier and signified.

Thomas Locher. Wörter Sätze Zahlen Dinge — Tableaus, Fotografien, Bilder
exhib. cat., Kunsthalle Zurich 1993.
Thomas Locher. Präambel und Grundrechte im Grundgesetz für die Bundesrepublik Deutschland (Diskurs 2). Ein Kommentar, exhib. cat.,
Kunstverein Munich 1995.

Roger Loewig
Born 1930 in Striegau, Silesia
Lives and works in Berlin

Shortly before the end of the war, Roger Loewig was conscripted to dig anti-tank ditches. In 1945, he found himself with no place to live and survived until 1951 in the Lusatia area doing casual labour as a wood-cutter and farm worker. During this period, Loewig taught himself to write, paint and draw. He then moved to East Berlin, where he enrolled at the Institut für russische Sprache. After graduation in 1953, he worked for ten years as a teacher of Russian, German and history. Parallel to his teaching career, he created a secret "literary and painterly oeuvre" made up of poems, short stories, oil paintings, gouaches, watercolours and drawings, often in cycles and series. His three works on the division of Berlin, painted in black and red ink and entitled *From German History and Present* (1961; fig. 194-196, p. 165), are not so much a depiction of a surreal dream world as an exploration of aspects of German history. On the occasion of his first exhibition, which he mounted for his friends in 1963, he was arrested by the East German secret police (Stasi) and his paintings and manuscripts confiscated. After more than a year in detention awaiting trial, he was freed, but had to resign from his school post. His life as a freelance painter and graphic artist began with his admission to the Association of German Artists (VBKD) in 1966. This also marked a new beginning in his artistic work which now became mainly graphic. His first lithographs were printed in 1965 by the East Berlin Zentrale Werkstätten, his first major solo exhibition took place in 1966 at the Small Palais in Warsaw. Loewig applied to leave East Germany in 1967, resigned from the VBKD in 1971 and in 1972 was granted an exit permit for West Berlin. In West Germany, however, he received little recognition, though he had already won a prize at the *II. Internationale der Zeichnungen* in Darmstadt in 1967. He exhibited at Galerie Brusberg in Hanover 1972 and in 1973 was a guest at the Villa Massimo in Rome. The Cologne Galerie Baukunst devoted a major retrospective exhibition to his work in 1975. Loewig travelled throughout Europe and to Israel and Mexico. Supported by a scholarship from the Aldegrever Society, he began working on etchings in 1976. Exhibitions followed at the Hamburg Kunsthalle in 1978, the Ostdeutsche Galerie in Regensburg in 1979, the Ernst Barlach Museum in Ratzeburg in 1983 and the Erfurt Kunstverein in 1991. In 1981, the Künstlergilde Esslingen awarded Loewig the Lovis Corinth Prize and a book of his drawings was published. Loewig donated the greater part of his works to the National Museum in Warsaw, where an exhibition was mounted in 1986. In 1992, his works were shown in the State Museum in Auschwitz.

Roger Loewig, Zeichnungen und Lithographien, exhib. cat., Berlinische Galerie,
West Berlin 1988-89.

Markus Lüpertz
Photo: Benjamin Katz, Cologne

Wolfgang Mattheuer
Photo: Udo Hesse, Berlin

Markus Lüpertz

Born 1941 in Reichenberg, today Liberec, Czech Republic
Lives and works in Dusseldorf and Berlin

The Lüpertz family moved to West Germany in 1948, where Markus' child-hood and adolescence were marked by their straitened social circumstances, his repeated expulsions from schools, and his unfinished apprenticeship. His career led from training at the Werkkunstschule in Krefeld under Laurens Goosens from 1956-61, to a study visit to Kloster Maria Laach and the Kunst-akademie in Dusseldorf in 1963, to West Berlin, interrupted by spells working in coal mining and road construction. His actual artistic work began in Berlin, with the development in 1964 of his "dithyrambic" painting. That same year, Lüpertz, together with Bernd Koberling and Karl Horst Hödicke, founded, among other things, the gallery Grossgörschen 35, an artists' cooperative in West Berlin, where his first solo exhibition took place in 1964. "Dithyrambic painting", a term raised to the status of a manifesto in 1966, refers to the ancient Greek songs of the Bacchus cult, and in Lüpertz' early work serves as an abstract form which the artist filled with expressive pathos, expanding it to the limits of representationalism. Lüpertz cultivated a type of life-style and art reminiscent of the nineteenth century cult of genius and availing itself of expressive pathos in order to articulate, among other things, the problems that arise in the face of Germany's recent history. With this in mind, he emo-tionally charged and monumentalised the subject of his triptych *Black-Red-Gold-dithyrambic* (1974; fig. 332, p. 340). In the 1970s, his "German motifs" — steel helmets and officer's caps, ears of corn and grapes — led critics to accuse Lüpertz of promoting an uncritical renaissance of a fascist aesthetic. In 1970, he won a year's scholarship to the Villa Romana in Flor-ence, and in 1971 received the prize of the German critics association. In 1974, the Michael Werner gallery in Cologne began exhibiting Lüpertz' works. That same year, the artist was a visiting lecturer at the Akademie der Bilden-den Künste in Karlsruhe, where he was given a professorship in 1976. Via his 1975 architectural works *Babylon,* Lüpertz went on to develop his *Stil* paint-ing in 1977. The Hamburg Kunsthalle, followed by the Kunsthalle Berne and the Stedelijk Van Abbemuseum in Eindhoven, showed a first overview of his work in 1977. In the early 1980s, Lüpertz abandoned abstraction in favour of a new figural and perspectival art, using quotations and set pieces from art history. Alongside a mastery of all the printing and graphic techniques, Lüpertz also writes poetry, and since 1981 has been producing sculpture. In 1986, he was appointed to the Kunstakademie in Dusseldorf, of which he has been rector since 1988. Lüpertz was awarded the Lovis Corinth Prize by the Künstlergilde Esslingen in 1990.

Markus Lüpertz, exhib. cat., Kunstmuseum Bonn 1993.
Markus Lüpertz, exhib. cat., Kunstsammlung North Rhine-Westphalia, Dusseldorf 1996.

Wolfgang Mattheuer

Born 1927 in Reichenbach in Vogtland
Lives and works in Leipzig

Following training as a lithographer from 1941-44, Wolfgang Mattheuer was drafted into the army from 1944-45, wounded, and finally returned to Germany from a Russian POW camp. He attended the Kunstgewerbeschule in Leipzig from 1946-47, after which he studied at the Leipzig Hochschule für Grafik und Buchkunst, a bastion of socialist realism. After graduating in 1951, his artistic development was still marked by his graphics background. In his early years, Mattheuer had been impressed by C. D. Friedrich. Later he came under the influence of the Neue Sachlichkeit painters and soon devel-oped his own pictorial idioms, rich in metaphors and symbols. From 1953 on, in his function as assistant, then as lecturer, and as professor from 1965-74, he promoted a modest degree of modernisation against massive opposi-tion from cultural and political dogmatists. As of 1954, Mattheuer was repre-sented in all major exhibitions in the GDR. He had his first solo show in 1956 in Leipzig, his first museum exhibition in 1963 in Reichenbach and the Staat-liche Lindenau Museum in Altenburg. In 1965, the Staatliche Galerie Moritz-burg acquired his *Kain* (fig. 201, p. 169), which was painted the same year and marks the beginning of a series of works on mythological motifs. The out-break of war in Vietnam is transposed into the Christian motif of fratricide, the ambivalence of which implies a rejection of the unambiguity of moral judgements and norms for action. A first comprehensive show of Mattheu-er's work took place in 1971 at the Staatliche Museum Schwerin. As of the mid-1970s, West German museums and collectors began buying his work, and in 1977 he was exhibited at documenta 6 in Kassel. Mattheuer gained the highest form of state recognition in 1978, with a retrospective at the Museum der bildenden Künste in Leipzig and membership of the GDR Akade-mie der Künste. He participated in the *Zeitvergleich* exhibition, which toured several cities in the Federal Republic between 1982-84. Mattheuer, among others, was selected for the GDR contribution to the 1984 Venice Biennale entitled *Die Aktualität der Mythen.* After a retrospective at the Alte Museum Berlin (east) and a first exhibition in New York in 1988, Mattheuer resigned from the SED party. A year later, he attempted to come to terms with the events that brought about political change in eastern Germany in his work *Suite '89.*

Hartmut Koch, *Das druckgrafische Werk 1948-86,* Leipzig 1987.
Heinz Schönemann, *Wolfgang Mattheuer,* Leipzig 1988.
Wolfgang Mattheuer. Nähe und Horizont, exhib. cat., Nationalgalerie der Staatlichen Museen zu Berlin im Alten Museum, Berlin 1988.
Ursula Mattheuer-Neustädt, *Bilder als Botschaft. Die Botschaft der Bilder,* Leipzig 1997.

Olaf Metzel
Photo: Simone Böhm

Harald Metzkes
Photo: Udo Hesse, Berlin

Olaf Metzel

Born 1952 in Berlin
Lives and works in Munich

After studying at the Freie Universität and the Hochschule der Künste in West Berlin from 1971-1977, Olaf Metzel spent a year in Italy. In 1979, he was awarded the *Junger Westen* art prize. Metzel's first installation *Skulptur Böckstr. 7, 3. O.B.*, in a condemned house in Berlin in 1981, previewed a theme that became central to his work: destruction. This particular work, for example, has only survived as a video. Destruction as a physical process is communicated in a very direct manner. Metzel advertised his work *Türken-wohnung 12.000 DM Abstand VB* in several daily newspapers. In the respective flat, he demolished the installations, making a video film as he did so and finally carving a swastika sign into the wall. In an interview, he spoke of "living contexts". His space and place-related installations were initially produced in the form of drawings, which were published in a first catalogue by the Kunstraum Munich in 1982. In 1984, René Block exhibited Metzel's work for the first time. That same year, Metzel turned his attentions to specifically German themes in his reinforced concrete sculptures *Stammheim* (Württembergische Kunstverein, Stuttgart) and *In die Produktion (Von hier aus,* Dusseldorf). In 1986, he was granted a PS 1 scholarship financed by New York and the Bonn Kunstfond, after which he held a visiting professorship at the Hochschule für Bildende Künste in Hamburg. His contribution to the Sculpture Boulevard in West Berlin in 1987, *13.4.1981*, touched a sore point in the history of West German postwar democracy. That year, he was also awarded the Roman Villa Massimo Prize, and took part in documenta 8 in Kassel and the exhibition of sculpture in Münster. His work has been shown at several galleries in West-Berlin (1985, 1989, 1991, 1992), in Cologne (1989) and in Hamburg (1990), the Westfälische Landesmuseum in Münster in 1990, and the Hamburger Kunsthalle and the Kunsthalle Baden-Baden in 1992. Metzel received the Munich Kurt Eisner Prize in 1990. Since then, he has been professor at the Akademie der Bildenden Künste in Munich, and he was appointed rector in 1995. Metzel was awarded the Förderpreis zum Internationalen Preis of the State of Baden-Württemberg in 1991 and the 1994 Arnold Bode prize in Kassel. Exhibitions followed in 1996, for example, *Freizeitpark* in Munich, and an exhibition of his sculpture *Meistdeutigkeit* in front of the German Bundestag in Bonn. The models for his outdoor projects were shown at the daadgalerie in Berlin and the Wilhelm Lehmbruck Museum in Duisburg. In 1997, he participated again in the exhibition of sculpture in Münster. For the show *Deutschlandbilder,* he completed the sculpture *German crate* (fig. 366, p. 405), begun in 1993.

Olaf Metzel, exhib. cat., Hamburger Kunsthalle, Ostfildern 1992.
Olaf Metzel. Freizeitpark, exhib. cat., Städtische Galerie im Lenbachhaus, Munich 1996.

Harald Metzkes

Born 1929 in Bautzen
Lives and works in Berlin

Drafted into the Wehrmacht in the final year of the war and having spent a brief period in an American POW camp, Harald Metzkes' youth was very much influenced by the war and post-war periods. He began studying painting in 1946, but then took an apprenticeship as a stonemason in Bautzen between 1947-49, before taking up his studies in painting again at the Hochschule für bildende Künste in Dresden under Wilhelm Lachnit from 1949-53. After his studies, he worked as a free-lancer in his hometown. As a master student under Otto Nagel at the Deutsche Akademie der Künste in East Berlin from 1955-58, in collaboration with Manfred Böttcher, Werner Stötzer and Ernst Schroeder, he laid the corner stone for the *Berliner Schule,* an attemp to return to the realist tradition of secessionist painting and the urbane objectivity of the 1920s among the ruins of post-war Berlin. In coming to terms with the works of Picasso and Beckmann, both criticised as formalistic and hermetic by socialist cultural policy, Metzkes produced sombre paintings such as his *Abtransport der Sechsarmigen Göttin* and *Mann mit Geigerzähler (Man with Geiger Counter,* fig. 119, p. 102), which were condemned by East Germany's official critics as decadent formalism. The major work in this Black Period is his 1957 triptych *The Friends* (fig. 117, p. 101), portraying his circle of friends. In the 1960s, Metzkes' particular formal idiom developed into a new style influenced by artists of the late nineteenth century such as Cézanne, Chardin, Goya and Courbet. In the show *Junge Künstler* organised by the Akademie der Künste in 1961, this style too was met with criticism followed by sanctions. As a result, Metzkes was not selected for the *V. Deutsche Kunstausstellung* in Dresden in 1962-63. Nevertheless, he was still able to mount a first solo exhibition at the Institut für Lehrerweiterbildung in East Berlin in 1963. This was followed by several small shows in lesser museums and galleries. A commission Metzkes received in 1971 to design the stage set and costumes for Molière's *Le médecin malgré* lui led to a preoccupation with themes from the commedia dell'arte. Metzkes first gained state recognition by winning the Käthe Kollwitz Prize of the East German Akademie der Künste in 1976 and the National Prize, third class, in 1977. That same year, the Nationalgalerie in West Berlin held a show of his works. After a study trip to the Federal Republic, Metzkes had his first show in the West at the Brusberg gallery in Hanover in 1978. He also took part in the Venice Biennale of 1984 and 1988. Metzkes, who had been a member of the East German Akademie der Künste since 1986, resigned his membership in 1991 due to the conflict surrounding the merger of the two academies.

Harald Metzkes, Malerei, Zeichnungen, Druckgraphik, exhib. cat., Staatliche Kunsthalle Berlin 1990.

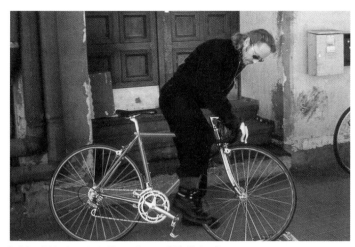

Reinhard Mucha, 1996, Photo: Lorcan O'Neill, London

Ernst Wilhelm Nay, 1968
Photo: Gerold Jung,
Munich

Reinhard Mucha
Born 1950 in Dusseldorf
Lives and works in Dusseldorf

Reinhard Mucha studied at the Dusseldorf Kunstakademie under Klaus Rinke from 1975-82. He first showed at the Verwaltungs- und Wirtschaftsakademie there in 1977. Typical of Mucha's approach to the space in which his works are exhibited is his contribution to the first Jürgen Ponto Foundation show mounted in Frankfurt am Main in 1980. He added elements to the showcases and tables he found on the premises, integrating the whole into the existing refectory. With the support of an Annemarie and Will Grohmann grant, he also exhibited at the Staatliche Kunsthalle in Baden-Baden in 1981. In *Astron Taurus,* for the *ars viva* exhibition at the Kunsthalle in Bielefeld in 1981, for which he received the BDI promotional prize, Mucha used a similar inventory. By a sparing use of what was already available on site, he staged the exhibition as an exhibition, creating a monument to standstill between past and future, an "intermediary stage in memory" (G. Inboden). In Mucha's work, movement in time recurs in the leitmotif of the journey as movement in space. *Wartesaal* was the title he gave to his first show at the Max Hetzler gallery in Cologne in 1982, where he has been exhibiting since. In *Zurück nach Werden,* 242 panels with names of German railway stations were concealed on eleven shelves mounted on wheels suggesting a state of latency. In 1985, Mucha exhibited his *Hagen Vorhalle* at the Bärbel Grässlin gallery in Frankfurt am Main and his *Das Figur-Grund-Problem in der Architektur des Barock* at the Württembergischer Kunstverein in Stuttgart. In 1986, his *Wasserstandsmeldung* was shown at the Konrad Fischer gallery in Dusseldorf. Three other exhibitions, at the Centre Georges Pompidou in Paris in 1986, and the Kunsthallen Berne and Basel in 1987, provided an almost complete survey of the work he has produced since 1981. His installation, *Mutterseelenallein* at the Galeria Rumma in Naples in 1989 is now on permanent loan to the Museum für Moderne Kunst in Frankfurt am Main. In 1990, Haus Esters in Krefeld showed his *Kopfdiktate* (fig. 348, p. 358), developed in 1980 for the Annelie Brusten gallery in Wuppertal. In 1993-94, he exhibited at the Anthony d'Offay gallery in London and in 1996 at the IfA in Berlin. Mucha was represented at the 1990 Venice Biennale with his *Deutschlandgerät.* He has also been represented at major surveys of German art such as *Von hier aus* in Dusseldorf in 1984, and the *BiNationale. Deutsche Kunst der späten 80er Jahre* in Dusseldorf and Boston in 1988. He participated in documenta IX in Kassel in 1992, the 1992-93 touring exhibition of contemporary German photography, which began at the Walker Art Center in Minneapolis, and at documenta X in Kassel and the show of sculpture in Münster in 1997.

Reinhard Mucha. Mutterseelenallein, exhib. cat., Museum für Moderne Kunst, Frankfurt am Main 1993.

Ernst Wilhelm Nay
Born 1902 in Berlin
Died 1968 in Cologne

After an apprenticeship as a bookseller, Ernst Wilhelm Nay undertook independent studies of the works of C. D. Friedrich and Matisse. He studied at the Berlin Hochschule für bildende Künste on scholarship, from 1925-28, under Karl Hofer. He also had his first shows, reviews and sales between 1926-27. In 1928, Nay was particularly impressed by the work of Poussin in Paris. In 1931, he was awarded the Rome Prize and spent a scholarship sojourn at the Villa Massimo in Rome painting his surreal-abstract works. Upon returning to Germany, he met the art dealer Günther Franke in Munich, who since then has devoted himself to Nay's art. In his *Dünen- und Fischerbilder,* painted between 1934-36, Nay developed an independent form of figure painting, exploring stylistic elements of German expressionism on a new, abstract level. Banned as "degenerate" and prohibited from exhibiting, the artist travelled to Norway as a guest of Edvard Munch, a contact mediated by C. G. Heise. His creativity reached a first zenith between 1937-38 in his *Lofoten Bilder.* In 1940, he was drafted into the army and sent to France, where a French sculptor placed his studio at his disposal. Nay's artistic processing of the war and post-war periods is evident in his *Hekatebilder* and his *Familie des Zauberers* (*The Magician's Family,* fig. 107, p. 88) painted between 1945-48, which resound with motifs from myth, legend and poetry. The glowing tones and intricate forms of his *Fugale Bilder* of 1949-51, and his *Grosse Liegende* (*Large Reclining Woman,* fig. 109, p. 89) of 1950, herald a whole new beginning. The Kestner Gesellschaft in Hanover showed a first Nay retrospective in 1950. From 1951 on Nay lived as a freelance artist in Cologne where he took the final step towards completely non-figurative painting in his *Rhythmische Bilder* of 1952-53, using colour as a purely formal component. This he described in 1955, in his book *Vom Gestaltwert der Farbe.* Between 1954-62, the circle represented the basic form in his work, as evident in his *Scheibenbilder.* He developed this form further in his *Augenbilder* of 1963-64. Nay achieved an international breakthrough with his first American solo show at the Kleeman Galleries in New York in 1955 and his contribution to the 1956 Venice Biennale. He was awarded major art prizes and included in the representative exhibitions of German art at home and abroad.

Werner Haftmann, *E. W. Nay,* Cologne 1960, re-worked new edition 1991.
Ernst Wilhelm Nay. Retrospektive, exhib. cat., Josef Haubrich Kunsthalle, Cologne 1990/91
Aurel Scheibler, *Werkverzeichnis der Ölgemälde,* vol. I: 1922-1951, vol. II: 1952-1968, ed. by Museum Ludwig, Cologne 1990.

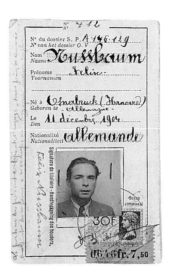

Felix Nussbaum in his last known
passport photo
Photo: Kulturgeschichtliches Museum,
Osnabrück

Joshua Neustein
Born 1940 in Danzig
Lives and works in New York

Uprooted during the Second World War, Joshua Neustein's family emigrated from Russia to New York in 1951. There Neustein studied at the City College under the historian Hans Kohn, and at the Arts Student League. Having completed his studies in 1964, he left New York for Israel in search of his identity. His career as an artist began in Jerusalem with his first solo exhibition at the Bertha Urdang gallery. Soon afterwards, he abandoned traditional painting and in 1968 began a series of projects and installations which were to form the conceptual basis for his later work. (1968 *Rainwater,* Artist's House, Jerusalem; 1970 *Jerusalem River Project: Sounds of flowing River in the Dry Wadi of Abu Por,* Israel Museum, Jerusalem). In his 1976-78 happening *Territorial Imperative,* Neustein had a dog mark his territory along various borders. After similar border marking performances on the Golan Heights (Israel), in Krusa (Denmark) and Belfast (Northern Ireland), Neustein's attempt to repeat this performance at the German-German border within the framework of documenta 6 in 1977 failed and led to his exclusion from the exhibition. Alongside other projects (1983 *Still Life* at the Lebanese border, 1988 *Gold Shit,* an environmental happening in Israel, London, Rio de Janeiro, 1990-93 *The Wedding,* Schauspielhaus Dusseldorf, Fisher Gallery Los Angeles, Grohmann Palast, Lodz, Poland), Neustein had solo exhibitions at the Bertha Urdang Gallery, New York in 1974, the Tel Aviv Museum in 1977, the F. Johnson Museum, Cornell, N.Y. and the Israel Museum, Jerusalem 1983, the Philadelphia Museum of Judaica 1989-90, the Albright Knox Art Gallery Buffalo, New York in 1992, the Wynn Kramarsky, Berlin-Shafir Gallery, New York and the Israeli pavilion at the Venice Biennale in 1995, and the Ackland Art Museum and SECCA, North Carolina in 1996. In his installation *Aschenbach* (1997; fig. 466, p. 491) for the exhibition *Deutschlandbilder,* Neustein transposed a city plan of Berlin onto a large field of ashes, above which hangs a chandelier reaching almost to the ground. Named after the protagonist Gustav Aschenbach in Thomas Mann's short story *Death in Venice,* this work is concerned not so much with the German past as with the roots of cultural identity.

Joshua Neustein, Light on the Ashes, Southeastern Center for Contemporary Art, Winston-Salem, North Carolina 1996.

Felix Nussbaum
Born 1904 in Osnabrück
Murdered in 1944 in the Auschwitz death camp

After attending the Staatliche Kunstgewerbeschule in Hamburg in 1922, the then 18-year-old Felix Nussbaum went to Berlin in 1923 to study art, initially at the private Lewin Funcke art school, then from 1924-29 at the Vereinigte Staatsschulen für freie und angewandte Kunst. The artist's early work, largely destroyed in 1932 after a Nazi arson attack, does not yet betray his preoccupation with contemporary art. His main influence at the time was van Gogh, on whose trail Nussbaum undertook a one-year study trip to Belgium and southern France in 1928-29. For a brief period, he was also influenced by the naive art of Henri Rousseau, but it was metaphysical painting and the conservative classical realism characteristic of Karl Hofer, in particular, that had a more lasting effect on him. After his return to Germany in 1929, he produced his first works of an independent artistic calibre. These were shown in the Secession exhibition of 1931 and helped him to achieve a breakthrough. In 1932-33, he was awarded a scholarship to the Villa Massimo in Rome, which was immediately withdrawn by the National Socialists. As a result, Nussbaum went into exile, passing through various stops in Italy before finally settling in Belgium. His period in exile was marked by constant fears about residence permits and the related changes of domicile. Despite being prohibited from working, Nussbaum took part in group exhibitions in Gent, Paris and Amsterdam in 1937-38. At the outbreak of war, however, the financial situation among German emigrants began to deteriorate. Nussbaum regarded his works of that period, which for security reasons he recorded in photographs, as documentary of the political circumstances. When German troops invaded Belgium in 1940, Nussbaum was interned in a camp in southern France, from which he was able to flee to Brussels after several months. With the introduction of the Register of Jews and the confiscation of Jewish property, Nussbaum became destitute. In 1941, he failed to fulfil his duty to register with the authorities and in 1942 went into two years of hiding in an attic. Finally, just before the liberation of Belgium in July 1944, he and his wife were deported to Auschwitz, where they were murdered. Nussbaum produced his last paintings in a cellar studio in 1943, among them the famous *Self-Portrait with Jewish Identification* (fig. 21, p. 45). It was 1971 before research work on Nussbaum really commenced, inspired by an exhibition mounted from his estate in the Dominican Church in Osnabrück and concentrating on his life and work against the historical background of the time.

Peter Junk, Wendelin Zimmer, *Felix Nussbaum. Leben und Werk,* Cologne/Bramsche 1982.
Felix Nussbaum. Verfemte Kunst — Exilkunst — Widerstandskunst, exhib. cat., Kulturgeschichtliches Museum, Osnabrück 1990.

Marcel Odenbach, 1997
Photo: Nikos Araldi, Cologne

Albert Oehlen
Photo: Benjamin Katz,
Cologne

Marcel Odenbach

Born 1953 in Cologne
Lives and works in Cologne and New York

Marcel Odenbach studied architecture, art history and semiotics at the Technische Hochschule in Aachen in 1974, graduating in engineering in 1979. During that time, he was preoccupied with drawing, text combinations, and performances. In his first video installation, *Der Konsum meiner eigenen Kritik,* in 1976, Odenbach used video in a manner that was to become typical of his work, namely, as a pure medium that is placed in a specific context with the aid of only a few props or wall texts. His own autobiography forms the point of departure for a concentration on history in general and German history in particular. After his first exhibition at the Hinrichs gallery in Lohmar in 1976, Odenbach later exhibited, among others, at the Magers gallery in Bonn (1978, 1982), at Stampa in Basel (1984), at Ascan Crone in Hamburg (1985, 1987), and at the Daniel Buchholz gallery in Cologne (1991). He had solo exhibitions at the Folkwang Museum in Essen and the Städtische Galerie in the Lenbachhaus in Munich in 1981, the Stedelijk Museum in Amsterdam in 1982, the ICA in Boston in 1986, the Centre Georges Pompidou in Paris in 1987, the Musée d'Art Contemporain in Montreal and the Badischer Kunstverein in Karlsruhe in 1988, the Centro de Arte Reina Sofia in Madrid in 1989 and the Kunst- und Ausstellungshalle der BRD in 1994, and was also represented in major surveys of German art like *Von hier aus* in Dusseldorf in 1984 and *1945-1985. Kunst in der Bundesrepublik Deutschland* at the Nationalgalerie in West Berlin in 1985. Odenbach also received the 1982 Glockengasse prize of the City of Cologne, the Darmstadt Karl Schmidt-Rottluff scholarship in 1983, and first prize at the 1984 Locarno film and video festival. He participated in documenta 8 in Kassel in 1987 with *Dem Augenzeugen im Blickwinkel stehen,* which he completed in 1986. His 1982 installation *Das Schweigen deutscher Räume erschreckt mich* and his 1986 *Dans la vision péripherique du témoin* both confront the observer with his or her own role as witness, with his or her social responsibility. The principle of broadcaster-receiver inherent in the medium is transferred to the dialectics of acting and suffering, thus Odenbach accompanied his installation *A Fist in the Pocket* (1994; fig. 410, p. 455) with a quotation from Ingeborg Bachmann: "With my burnt hand I write about the nature of fire". Odenbach has been professor at the Staatliche Hochschule für Gestaltung in Karlsruhe since 1992.

Marcel Odenbach, Video-Arbeiten, Installationen, Zeichnungen 1988-1993, exhib. cat., Galerie der Stadt Esslingen; Villa Merkel / Braunschweiger Kunstverein, Ostfildern 1993.
Marcel Odenbach. Besenrein, exhib. cat., Sprengel Museum, Hanover 1996.

Albert Oehlen

Born 1954 in Krefeld
Lives and works in Hamburg and Madrid

Albert Oehlen trained at a Dusseldorf publishing house from 1970-73, after which he moved to Berlin. There, in the course of his search for a "universal political folk art", he produced his first drawings, "over-paintings", and portraits of dictators. In 1977, he moved to Hamburg. In 1978, he painted a mural in the "Welt" bookshop with Werner Büttner, with whom he also founded the *Liga zur Bekämpfung des widersprüchlichen Verhaltens* (The league to combat contradictory behaviour), the central organ of which was *Dum Dum.* That same year, he began studying at the Hochschule für bildende Künste under Sigmar Polke. His first exhibition, with his brother Markus Oehlen, also took place that year. With Büttner and Georg Herold, both of whom were from the GDR, he conceived of the *Samenbank für DDR Flüchtlinge* (Sperm bank for East German refugees) project in 1980. He often collaborated with Büttner, Herold and Kippenberger, on musical and literary works, book projects, lectures, photomontages, drawings, carpet designs, and graphic works. Pure painting, however, was still of prime importance, and he tested its traditions, conventions and remaining potential in "bad paintings". His work, often serial, constituted an art about art, with a dual strategy of overtaxing the painting in terms of content, while undertaxing it in terms of form. Inscribed text or a given title force our perception in a certain direction. In the late 1980s, however, his painting developed in a "post-nonfigurative" direction. Oehlen began showing at Max Hetzler in Stuttgart and Cologne, in 1981, and also at the Ascan Crone gallery in Hamburg, Ileana Sonnabend in New York, Six Friedrich in Munich, Grässlin-Ehrhardt in Frankfurt/Main, and Juana de Aizpuru in Madrid. He had solo exhibitions at the Kunsthalle in Zurich in 1987 and the Deichtorhallen in Hamburg in 1994, and one with Büttner in the Neue Gesellschaft für Bildende Kunst in Berlin in 1982. In 1984, the Folkwang Museum mounted *Wahrheit ist Arbeit,* which included works by Kippenberger and Büttner, and in 1989, Oehlen, Georg Herold and Christopher Wool were shown by the Renaissance Society, Chicago. Oehlen has participated in the major surveys of German art as the *Mülheimer Freiheit* in the Paul Maenz gallery in Cologne in 1980, *Von hier aus* in the Dusseldorf Messehalle in 1984, the *BiNationale* in Dusseldorf and Boston in 1988-89, and *Refigured Painting: The German Image 1960-88* in 1989.

Albert Oehlen. Malerei, exhib. cat., Deichtorhallen Hamburg, 1994.
Burckhard Riemschneider (ed.), *Albert Oehlen,* Cologne 1995.
Albert Oehlen, exhib. cat., I.V.A.M., Valencia 1996.

Richard Oelze
Photo: Galerie Brockstedt,
Hamburg

Heribert C. Ottersbach, 1997
Photo: Carl-Victor Dahmen,
Cologne

Richard Oelze

Born 1890 in Magdeburg
Died 1980 in Posteholz near Hamlin

After studying at the Bauhaus in Weimar under Paul Klee and Johannes Itten from 1921-25 and under Otto Dix at the Kunstakademie in Dresden from 1926-29, Richard Oelze travelled to Ascona and Berlin. In Paris, between 1933-36, he came into contact with the French surrealists around André Breton, who included him in the major exhibitions of surrealist art at the new Burlington Gallery in London in 1936 and at the Museum of Modern Art in New York in 1942. Influenced by the constructivist tendencies of the Bauhaus and the Neue Sachlichkeit of Otto Dix, Oelze developed a verist surrealism from around 1930. Salvador Dali's concept of "handpainted dream photography" is a description that fits his works of the 30s, such as *Tägliche Drangsale* (Daily Hardships,1934; fig. 5, p. 32) or *Erwartung* (1936) perfectly. In his fine glaze painting technique, in the manner of Dix, his works unfurl their menacing, jungle-like Ur-landscapes from which demonic faces and faceless figures emerge, boding evil. Fascinated by the ominous sense of morbidity, Alfred Barr chose *Tägliche Drangsale* for his 1936 exhibition of *Fantastic Art, Dada, Surrealism* in New York. Oelze spent 1937 in Ascona and Positano. In 1938, on the eve of war, he returned to Germany, where his meticulous painterly technique and traditional craftsmanship protected him. In 1939, he joined the artists' colony at Worpswede, though he had nothing in common with them artistically. Nevertheless, he returned there in 1945 after his military service and internment as a prisoner of war. In the 1950s, the figurative elements in his work increasingly gave way to abstract landscapes. From 1962 onwards, although he had gained recognition and had been included in retrospective exhibitions of surrealism in Paris (1959) and New York (1960), documenta 2 (1959) and documenta 3 (1964) in Kassel, he nevertheless spent the last years of his life in the seclusion of the Weserbergland countryside. In 1961, the Karl Ernst Osthaus Museum in Hagen and in 1964 the Kestner Gesellschaft in Hanover mounted major exhibitions of his works. Various accolades followed, including the Max Beckmann prize of the City of Frankfurt am Main, which was awarded to him in absentia in 1978, just two years before his death.

Richard Oelze 1900-1980. Gemälde und Zeichnungen, exhib. cat.,
 Akademie der Künste Berlin and other venues, 1987/88 (with catalogue raisonné).
Renate Damsch-Wiehager, *Richard Oelze. Ein alter Meister der Moderne*,
 Munich and Lucerne 1989.
Richard Oelze, exhib. cat., Musée d'Art Moderne de la Ville de Paris, 1997.

Heribert C. Ottersbach

Born 1960 in Cologne
Lives and works in Cologne and St. Léon sur Vézère, France

After studying German language and literature, philosophy and art in Cologne from 1979-83, Heribert C. Ottersbach spent extended study periods in Portugal, New York and Paris. In 1982-87, he took a studio in the former Stollwerck chocolate factory in Cologne, where he organised and participated in the 1986 group exhibition *Der Hang zum Pathos*. He selected painstakingly researched "remembered images" from mythological, historical and everyday contexts, then collaged and painted over them to the point of unrecognisability, creating entire cycles in this way. Taking, as his starting point, questions of history and philosophy, Ottersbach addresses memory in terms of change rather than innovation. It is no longer a question of reinventing the world, but of reinterpreting it constantly through memory. The Galerie Janine Mautsch in Cologne has regularly shown his works since 1984, and in 1987, the Museum Morsbroich in Leverkusen mounted his first museum show. Apart from painting, Ottersbach has also designed a stage set and costumes for Gertrude Stein's *Doctor Faustus – lights the lights* at the Theater Trompe L'oeil in Berlin and other cities in 1988-89. In his *Genius Loci* edition (1989) and his artist's book *Angelus Novus* (1993), he adopted the technique of the wood cut. Whereas his work of the early 80s dealt primarily with mythological themes, his first artist's book, published in 1985-86, adressed the father and son complex. As such, it may be regarded as a transition to the kind of exploration of Germany's past he undertook in his 1991 *Wallhalla-Projekt* and in his 1992-93 cycles *40/I* and *40/II*, in which memories of the past 40 years of divided Germany's history shimmer through the layers of translucent paint, creating only a fragmentary overall image. Similarly, his work *Untitled (Youth)* of 1994-95 (fig. 347, pp. 354 ff.), consisting of forty-four parts aligned in four rows, constitutes what H.C. Ottersbach himself describes as a "speculative combination" of fragments on the theme of the youth movement in the broadest sense. Ottersbach explores the way memory becomes image and addresses the reappraisal of that image in the wake of German unification.

Heribert C. Ottersbach. Bilder und Arbeiten auf Papier 1987-89, exhib. cat.,
 Städtisches Museum, Mülheim/R.; Städtische Galerie, Regensburg;
 Kunstverein Mannheim, Regensburg 1990.
Heribert C. Ottersbach. Wider die Vollendung, exhib. cat.,
 Rheinisches Landesmuseum Bonn, 1993.
Heribert C. Ottersbach. Erinnerte Bilder, Ostfildern 1995.

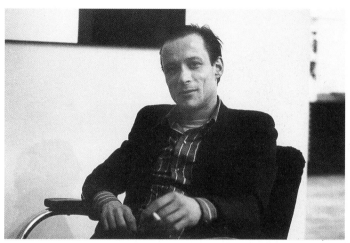

Blinky Palermo. Photo: Benjamin Katz, Cologne

A. R. Penck, 1995. Photo: Benjamin Katz, Cologne

Blinky Palermo
Born Peter Schwarz 1943 in Leipzig
Died 1977 at Kurumba, Maldives

Blinky Palermo and his twin brother were adopted by the Heisterkamp fami-ly and moved to Münster in West Germany in 1952. He enrolled at the Werk-kunstschule in Münster in 1961 and studied there until 1962, when he was admitted to the Kunstakademie in Dusseldorf. Though he initially studied under Bruno Goller, he changed in 1964 to the class of Joseph Beuys and graduated in 1966-67 as Beuys's master student. In the course of the radical change in his painting, he adopted the new name of the Italian boxing promot-er and mafioso Blinky Palermo, whom he resembled in appearance. The Heiner Friedrich & Dahlem gallery in Munich mounted his first solo exhibition in 1966. In addition to works in traditional techniques, he created wall paint-ings, installations and wooden forms wrapped in canvas or adhesive tape such as *Green T* (1966; fig. 274, p. 247), *Composition Red/Orange* (1967; fig. 273, p. 245), *Blaue Scheibe und Stab* (1968), which, propped laconically against a wall, suggested new spatial contexts. His fabric images, using lengths of cotton in various colours (fig. 275, p. 248), appear as a final solemn homage to the tradition of the panel painting. Unlike the Russian construc-tivists or the American minimalists, with whom he shares a spiritual dimen-sion in his reduction to geometric and coloured basic forms, Palermo's works invariably address painting, the relationship of colour, form and carrier, and the spatial context. Palermo's constructive approach invariably contrasts starkly with the fleeting, fragile and laconic impression his work conveys. In this respect, it resembles the work of another Beuys' student, Imi Knoebel. In fact, Palermo shared a studio in Düsseldorf with Knoebel in 1968 and with Ulrich Rückriem in Möchengladbach in 1969. As early as 1968, the Von der Heydt Museum in Wuppertal mounted a studio exhibition of Palermo's work. Together with Gerhard Richter, he travelled to New York in 1970, and spent some time in New York between 1973 and 1976, travelling through Ameri-ca with Imi Knoebel in 1974. One year after returning to Dusseldorf, Paler-mo died in 1977 at the age of 34. Before his death, his art received museum recognition with a number of solo exhibitions at the Städtisches Museum Abteiberg in Mönchengladbach (1973), the Museum Morsbroich in Leverku-sen and the Städtisches Kunstmuseum in Bonn (both 1974). Since then, Paler-mo has been included in all major surveys of German art.

Blinky Palermo. Werkverzeichnis, catalogue raisonné in two volumes edited
 by Thordis Möller for the exhibition at the Kunstmuseum in Bonn,
 Stuttgart 1995.

A. R. Penck
Born Ralf Winkler 1939 in Dresden
Has lived and worked in Dublin, Berlin, Dusseldorf and Cologne since 1983

After being turned down by the Kunstakademie in Dresden, A. R. Penck completed an apprenticeship as an advertising graphic artist in 1956-57. His main artistic influences are the work of Picasso, and his friendship with the experimental film maker Jürgen Böttcher-Strawalde and the artist Georg Baselitz. Earning his living with casual work, Penck began to develop his typi-cal visual world of archaically simplified sign systems in 1960-61. His inter-est in mathematics, cybernetics and theoretical physics triggered a process of abstraction culminating in 1961 and 1965 in his first *Weltbilder* (World View I, fig. 204, 205, p. 175). The *Junge Kunst* exhibition at the Deutsche Akademie der Künste in East-Berlin in 1961 marked the beginning of a career that was destined to develop predominantly in underground circles, because it ran against the grain of the official socialist realism. At first, however, Penck was genuinely committed to the ideals of socialism and the tradition of the workers' movement. Indeed, this political commitment formed the basis for his theoretical concept of *Standart-Bilder,* which Penck regarded as a positive contribution to socialism. The very word "Standart", in German, unites a number of concepts, described by Penck himself as including "standard (measure) and standard (banner), stand (status) and art". Using this concept, he combines graphic elements from a variety of different cultures and eras, different writing systems and symbols in the style of pictogram-like cave paintings. His interest in Ice Age cave paintings prompted him, in 1969, to adopt the pseudonym of the Leipzig scholar Albrecht Penck (1858-1945), an expert on the Ice Age. When the Berlin Wall was built in 1961, a cultural and political ice age broke out that froze all artistic and intellectual freedom. The two versions of *Übergang* (Passage, 1963 and 1966; fig. 208, 209, p. 177) show the situation of a borderline artist, who achieved recognition in the West once the Cologne gallerist Michael Werner had begun to represent him in 1965 and, at the latest, after his work was included in documenta V in Kassel in 1972. In the GDR, which he left in 1980, Penck had been barred from exhibiting since 1970. His move to Kerpen near Cologne followed a personal crisis that led to his first wooden sculptures in the late 70s (later to be cast in bronze). At the same time, Penck began playing percussion and making music. In 1983, he lived mainly in London and Dublin, but now also spends some of his time in Cologne, Dusseldorf and Berlin. Since 1989, he has been teaching at the Kunstakademie in Dusseldorf.

A. R. Penck. Retrospektive, exhib. cat., Nationalgalerie Berlin; Kunsthaus Zürich, 1988.
A. R. Penck, exhib. cat., Brandenburgische Kunstsammlungen, Cottbus 1993.

Sigmar Polke, 1995
Photo: Benjamin Katz,
Cologne

Heimrad Prem, 1973
Photo: Monika Prem, Munich

Sigmar Polke
Born 1941 in Oels, Silesia
Lives and works in Cologne

When his family moved to the new Federal Republic of Germany from Polish Silesia in 1953, twelve-year-old Sigmar Polke discovered the ambivalent blessings of West-Germany's economic miracle, the "Wirtschaftswunder". Its consumer and media dreams were to become the trivial subjects of his works. After training in stained glass at Dusseldorf-Kaiserswerth in 1959, he studied at the Kunstakademie in Dusseldorf from 1961-67. In contrast to the prevailing trend towards abstraction, which was also pursued by his teachers Karl Otto Götz and Gerhard Hoehme, Polke joined forces with his fellow-students, Konrad Fischer, alias Lueg, and Gerhard Richter, in propagating "capitalist realism" at their "demonstrative exhibition" in Dusseldorf in 1963 in a bid to highlight the machinations of consumerist ideology. With his family pictures of the mid-70s (fig. 268, p. 230), he sought to disturb the idyll of the western petty bourgeoisie. In 1966, he received the Kunstpreis der Deutschen Jugend in Baden-Baden and the same year he had his first solo exhibition at René Block in Berlin and Alfred Schmela in Dusseldorf. In 1970-71, Polke was appointed lecturer at the Hochschule für Bildende Künste in Hamburg, where he received a professorship in 1975. Polke avoided the risk of public acceptance inherent in artistic success by attacking his audience in the style of Handke with his *The Great Bitching Sheet* (1968; fig. 267, pp. 228f.) and finally declaring himself to be a medium "commanded by higher powers to paint the right hand corner black!" (*Höhere Wesen befahlen: rechte obere Ecke schwarz malen!* 1969; fig. 272, p. 243). Although his work was closely related to the pop art imported to Germany, Polke managed to avoid such categorisation in the 1970s through his extended travel, his photographic work and a stylistic purism reminiscent of Picabia. For his continuous self-renewal, he received numerous accolades, including the prize of the São Paulo Biennale in 1975 and the Will Grohmann prize of the City of West-Berlin in 1983. No myth is safe from his iconoclasm, be it grid paintings or decorative fabrics, famous motifs or stylistic cults, experiments with materials or colours. In *Die Lebenden stinken* (The Living Stink,1983; fig. 324, p. 329), he draws parallels between the Nazi's murderous euthanasia programme and the banality of bureaucratic administration. In 1986, he filled the German pavilion at the Venice Biennale with alchemistic colour experiments. Without allowing himself to be defined, Polke has inspired a new generation of artists.

Sigmar Polke. Transit, exhib. cat., Staatliches Museum Schwerin, 1996.
Sigmar Polke, exhib. cat., Kunstmuseum Bonn, 1997.

Heimrad Prem
Born 1934 in Roding
Died 1978 in Munich

After his apprenticeship as a decorative artist in Schwandorf from 1949-52, Heimrad Prem studied at the Akademie der Bildenden Künste in Munich and Berlin from 1952-57. Prem, Lothar Fischer, HP Zimmer and Helmut Sturm, founded the SPUR group in 1958. They were influenced by the programme of the Munich avant-garde gallery van de Loo, which concentrated on informel painting and the work of the CoBrA group. At an exhibition in Leopoldstrasse in 1958, the group met Asger Jorn, who arranged contacts with the Galerie van de Loo and Guy Debord's Situationist International in Paris. In 1958, the group issued a manifesto, demonstrating a tongue-in-cheek blend of cultural renewal and cultural criticism. Its pictoral counterpart, *Manifest* (Manifesto, 1960; fig. 192, p. 155), upheld the tradition of classical modernism, e.g. the emotionality of the expressive art eras. Prem was influenced by Beckmann's early figures and by late Gothic portrayals of the passion of Christ, though he was interested less in their content than in the dramatic portrayal and the dialectics of aggression and suffering. In a joint painting by Prem and Sturm, *Sturz* (Fall, 1960; fig. 190, p. 153), there is a sense of stifled explosiveness. As winner of the 1959 youth art prize of Baden-Baden, Prem received a stipend in 1960 from the Kulturkreis der Deutschen Industrie. In 1962, SPUR magazine had legal troubles, and Prem was sentenced to several weeks on parole. That year, his painting title *Only Struggle Strengthens Me* became his motto (*Nur Kampf stärkt mich,* 1962; fig. 193, pp. 158). Increasing differences led to SPUR being excluded from the Situationist International. Following group shows in Scandinavia, Prem had his first solo exhibition and catalogue at the Galerie van de Loo. In 1964, he married the photographer Monika Maier, with whom he had seven children. By the time he contributed to documenta 3 in Kassel in 1964, and with the break-up of the SPUR group in 1965, to be replaced by the WIR group in 1965 and the Geflecht group in 1966, the apex of Germany's new postwar art revolution had already been and gone. Prem's career continued with annual exhibitions at German galleries. In 1975, Prem became one of the founding members of the Herzogstrasse collective and taught at the Winterakademie in Schloss Kiessling in 1975-76 and 1977-78. He committed suicide in 1978. In 1984, the Cordon House in Cham, Bavaria mounted his first retrospective exhibition.

Heimrad Prem. Retrospektive, exhib. cat., Bonner Kunstverein, Kunsthalle zu Kiel, Heidelberger Kunstverein, Städtische Galerie im Lenbachhaus, Munich, 1996 (with catalogue raisonné).
Heimrad Prem. Papierarbeiten, exhib. cat., Kulturamt Prenzlauer Berg, Berlin; Augsburger Kunstverein, 1997..

Raffael Rheinsberg, Photo: Roman März, Berlin

Gerhard Richter
Photo: Thomas Struth,
Dusseldorf

Raffael Rheinsberg
Born 1943 in Kiel
Lives and works in Berlin

Raffael Rheinsberg grew up in the war-torn city of Kiel and trained as a metal-worker from 1958-61. He then moved into a former apartment and office building at Sophienblatt 22/24. From 1973-79 he studied at the Fachhoch-schule für Gestaltung in Kiel, where he explored such techniques as collage, assemblage and frottage. The Sophienhof building was earmarked for demo-lition and became an important source of his work, with found objects as traces of history, which he initially kept in suitcases and from 1981 began ordering in large fields or arrangements, sometimes combining them with photos. In Rheinsberg's oeuvre, the process of sublation has a central func-tion in every sense of the word: suspending, resolving into a higher unity, and removing altogether. The development of his approach from one of aliena-tion to one of revelation is reflected in the development of his studio from a "laboratory" to the "Museum Sophienblatt". Following initial exhibitions at galleries in Kiel from 1974 onwards, and a survey of his work at the Kunst-halle in Kiel in 1977, his Koffermauer-Klagemauer, consisting of some 800 suitcases piled on top of each other, displayed in Kiel in 1978, marks the point of intersection of both these working approaches. In 1979, he received a stipend from the state of Schleswig-Holstein and went to the Künstlerhaus Bethanien in West Berlin, where he exhibited his installation Transit in 1980. Commuting between Kiel and Berlin, Rheinsberg exhibited in 1979 at the Jürgen Schweinebraden gallery in West Berlin and at the Kunsthalle in Kiel. In 1981, his Fundstücke, Fotos, Konzepte were shown at the Neuer Berliner Kunstverein and the installation Von unten nach oben was shown at the Muse-um Sophienblatt, before it was demolished. With a working stipend from the West Berlin Senator for Cultural Affairs, the exhibition Botschaften. Archäo-logie eines Krieges was held at the Berlin Museum in 1982. With a stipend from the state of Berlin for PS 1, he spent 1983 in New York. In 1984, he received the German Critics' Prize and the Berlin Art Prize of the Akademie der Künste (West Berlin), where he explored the motif of travelling and fleeing with his Ton aus der Ferne installation, involving a railway track laid through the foyer. With his Rostfeld, he took part in the 1985 exhibition 1945-1985. Kunst in der Bundesrepublik Deutschland at the Nationalgalerie in West Berlin. After the fall of the Berlin Wall, Rheinsberg collected redundant East Berlin street signs and used them to create a kind of a map in his floorwork entitled Broken German (1990-93; fig. 464, p. 481). In 1988, he was awarded the Art Prize of the City of Kiel, and in 1994, the Art Prize of Schleswig-Holstein.

Raffael Rheinsberg. Der Kreislauf der Dinge, exhib. cat., Kunsthalle Recklinghausen;
 Kunsthallen Brandts Klædefabrik, Odense; Tallinna Kunstihoone/Kunsthalle Tallinn;
 Städtisches Museum Flensburg, Köln 1995.

Gerhard Richter
Born 1932 in Dresden
Lives and works in Cologne

Gerhard Richter studied scenic painting and advertising in Zittau from 1948-51, and painting (later mural painting) from 1952-57 at the Kunstakademie in Dresden. At the documenta 2, he was fascinated by the work of Jackson Pollock and Lucio Fontana. On discovering abstract painting, he resolved to go to West Germany, moving to Dusseldorf shortly before the Berlin Wall was built in 1961. There, he studied at the Kunstakademie under K. O. Götz, together with Sigmar Polke, Konrad Lueg (later the gallerist Konrad Fischer) and Blinky Palermo. Initially influenced by Giacometti and Dubuffet, Richter's interest turned towards an art "that has nothing to do with painting, nothing to do with composition, nothing to do with colour". He began painting from photographs, most of them from newspapers, typically German images, Sekretärin (The Secretary,1963; fig. 266, p. 227), Corridor (1964; fig. 265, p. 226) and Stukas (1964; fig. 264, p. 226). In 1964, he had his first solo shows at the Heiner Friedrich gallery in Munich and the Alfred Schmela gallery in Dusseldorf. In 1967, he took part in the Hommage à Lidice exhibition at the René Block gallery in West Berlin, with Onkel Rudi (1965; fig. 261, p. 224). He travelled to New York in 1970 and in 1972 was shown in the German pavilion at the 36th Venice Biennale. Just as he had used photographs merely as point of departure, he began using and dissolving art historical images, resulting in his first abstract paintings in the late 70s. After a major retrospective in Dusseldorf, West Berlin, Bern and Vienna in 1986, an exhibition of his work toured the USA. With his cycle 18. Oktober 1977 (1988; fig. 349-363, p. 389) and Baader Meinhof Komplex, purchased by the Museum of Modern Art in New York in 1995, Richter began to focus once more on images highly charged with meaning, touching sensitive and even taboo subjects. Richter is a widely accoladed artist who has achieved the paradoxical ability to conceal more than he reveals and in doing so, has prompted a discourse on the various ways of reading his work, from "capitalist realism" to pop art and concept art. Richter taught at the Kunstakademie in Dusseldorf from 1971 until 1994. In 1988, he accepted a guest professorship at the Städelschule in Frankfurt am Main. His work has been included in every documenta since 1972, most recently at the 1997 documenta X, where his work Atlas was shown.

Gerhard Richter, exhib. cat., Musée d'Art Moderne de la Ville de Paris;
 Kunst- und Ausstellungshalle der Bundesrepublik Deutschland, Bonn; Moderna
 Museet, Stockholm; Museo Nacional Centro de Arte Reina Sofia, Madrid, 3 vols.
 (vol. 1: catalogue, vol. 2: texts, vol. 3: survey of works from 1962-1993), Ostfildern-
 Ruit 1993/1994.
Gerhard Richter. 100 Bilder, exhib. cat., Carré d'Art, Musée d'Art Contemporain de
 Nimes, Ostfildern-Ruit 1996.

Dieter Rot, 1996
Photo: Andreas Züst, Zurich

Wilhelm Rudolph
Photo: Sächsische
Landesbibliothek, Staats- und
Universitätsbibliothek
Dresden,
Dezernat Deutsche Fotothek

Dieter Rot
Born 1930 in Hanover
Lives and works in Basel

As a child, Dieter Rot experienced the destructive power of National Social-ist Germany until moving to Switzerland with his family from Hanover, in 1943, at the age of thirteen. It was here that he created his first drawings, pastels and poems, and from 1946 onwards, he made etchings on tin-plate and painted in oils. He trained as a graphic artist from 1947-51 and during this period, he worked with linocuts and woodcuts, collages, and watercolours. From 1945 onwards, he lived in Copenhagen, working as a textile designer, and from 1947, as an artist in Reykjavik, where his first solo-exhibition was held in 1958. His *Ideograms* (1956) and his coloured drawings made with compass and drawing pen (1957) reveal an affinity to concrete poetry. Visits made to New York, Amsterdam, Paris and Basel in 1960 resulted in collabo-ration with Emmett Williams, Jean Tinguely and Robert Filliou. In 1964, he moved to America, where he taught at a number of art schools, including Yale University, New Haven, and collaborated with Fluxus artists, including Alison Knowles, Dick Higgins, George Brecht, Charlotte Moorman and Nam June Paik. Returning to Reykjavik in 1967, he became known in Germany with the publication of his *Mundunculum* and had his first exhibition at the Rudolf Zwirner gallery in Cologne. In 1968, Rot was included in documenta 4 in Kassel and accepted a teaching position at the Kunstakademie in Dusseldorf. By processing foods – silkscreen prints with chocolate in 1964, decaying ob-jects and pictures, etchings with chocolates, bananas etc. in 1965, self-portraits made of food in 1968 and spice pictures in 1969 – Rot explored the organic processes of growth and decay. German heroic images are under-mined in his work *The Bathtub for 'Ludwig van'* (1969; fig. 331, p. 339). The ceaseless growth of his "mould" pictures corresponds to the ambivalent power of creation that defies convention in his material collages and assemblages. The Museum Haus Lange in Krefeld and the von der Heydt Museum in Wupper-tal mounted his first museum exhibition in 1971. That same year, Rot began work on publishing his entire oeuvre in two editions of 20 volumes, the book being the most important medium and object for Rot (1954 first book with holes, 1958 design of slit books, 1960 unique books). In addition to numer-ous exhibitions at home and abroad, Rot was also represented at the Venice Biennale in 1982. In 1983, he received the Rembrandt prize of the Goethe foundation in Basel, the Hamburg Lichtwark Prize in 1989 and the Berlin Art Prize of the Akademie der Künste in 1994.

Dieter Rot, Gesammelte Werke. Bücher und Grafik (1. Teil) 1947-71, 20 vols.;
 Bücher und Grafik (2. Teil) 1971-79, 20 vols., Stuttgart 1972 and 1979.
Dieter Rot, exhib. cat., Hamburger Kunsthalle; Staatsgalerie Stuttgart;
 Kunstmuseum Solothurn, 1987/88.

Wilhelm Rudolph
Born 1889 in Chemnitz
Died 1982 in Dresden

Wilhelm Rudolph studied at the Kunstakademie in Dresden under Robert Stern and Carl Bantzer from 1908-14. After military service in World War I, the Dresden art dealer Emil Richter mounted his first exhibition in 1924, followed by the Berlin art dealers Goldschmidt and Wallerstein. In 1932, Rudolph was appointed to teach at the Akademie der bildenden Künste in Dresden, losing his professorship and all hope of a teaching post in 1938, on grounds of "polit-ical unreliability". Almost his entire oeuvre was destroyed in the 1945 bombing of Dresden. Under the immediate effect of this event, Rudolph began to ex-plore the consequences of the catastrophe in his major cycle of 150 drawings entitled *Dresden – February 13, 1945* (1945, fig. 78-99, pp. 81 ff.), with which he made a significant documentary and artistic contribution to postwar German history. Together with some 200 watercolours and graphic cycles on this theme, from which he could never free himself, they form the climax of his oeuvre. He addresses the consequences of war, as other artists before him had done — Jacques Callot in his *Misères de la guerre*, Goya in his *Desastres de la Guerra* and Otto Dix in his *Der Krieg*. After an enforced absence from exhibitions, Rudolph's works were included in the *Allgemeine Deutsche Kunst-ausstellung* in Dresden in 1946. In 1947, he was reinstated in his teaching position, which he held until 1949, and then went on to work freelance as an artist in Dresden. In 1955, 1958 and 1960, the Staatliche Kunstsammlung in Dresden mounted solo exhibitions of his work. His cycle addressing the destruction of Dresden was purchased by the Dresden Kupferstich Kabinett in 1959. He received a number of accolades, including the National Prize of the GDR in 1961 and 1980, the FDGB Art Prize in 1961 and 1966. In 1979, Rudolph was given the key to the City of Dresden and in 1982 the key to the City of Karl-Marx-Stadt. His work was also shown in the west, with an exhi-bition at the Stuttgart trade union headquarters as early as 1965, and he was included in Werner Hofmann's exhibition of German art, *Kunst in Deutsch-land 1898-1973,* as representing the year 1945. In 1975-76, the Städtische Kunsthalle Düsseldorf held a retrospective exhibition of his work, followed by an exhibition at the Nationalgalerie in East Berlin in 1977.

Wilhelm Rudolph, exhib. cat., Städtische Kunsthalle Düsseldorf, 1975/76.
Wilhelm Rudolph, Gemälde, Zeichnungen, Holzschnitte, exhib. cat.,
 Nationalgalerie East Berlin, 1977.
Wilhelm Rudolph, exhib. cat., Galerie Döbele, Ravensburg, 1982.

Oskar Schlemmer, 1925
Photo: Hugo Erfurth,
Fotoarchiv C. Raman
Schlemmer,
I-28050 Oggebbio

Frieder Schnock and Renata Stih, Photo: private collection

Oskar Schlemmer
Born 1888 in Stuttgart
Died 1943 in Baden-Baden

Following his apprenticeship as a draughtsman with a Stuttgart intarsia-maker from 1903-05, Schlemmer studied at the Kunstakademie in Stuttgart from 1908-10, where he met Otto Meyer-Amden and Willi Baumeister. In the course of various visits to Berlin, Schlemmer came into contact with Russian emigrants and the artists of the "Sturm" circle around Herwarth Walden, who exhibited their works for the first time at Walden's own gallery in Stuttgart. In 1921, Gropius invited Schlemmer to teach at the Bauhaus in Weimar. He taught there until Oskar Moll invited him to teach at the Staatliche Akademie für Kunst und Kunstgewerbe in Breslau (Wroclaw). By 1930, Schlemmer had become the first victim of National Socialist iconoclasm, when his mural for the workshop building in Weimar under the new director Paul Schultze-Naumburg was destroyed. When the Breslau academy was forced to close in 1932, Schlemmer went to Berlin, where he also held a teaching position. The existential approach of his art became increasingly evident in the face of the ominous political situation. "We need figures, measurements and laws as weapons and arms, so that we are not devoured by chaos," declared Schlemmer. His work in various disciplines (drawings, sculptures, murals, paintings, stage sets) explored the theme of figures and space and was aimed at the general rather than the particular. In 1933, the National Socialists cancelled his first major retrospective exhibition in Stuttgart and he lost his teaching position at the Vereinigte Staatsschulen in Berlin. From 1933-37, Schlemmer and his family stayed in Switzerland. In 1937, the *Entartete Kunst* exhibition of "degenerate art" put an end to his artistic freedom and financial independence in Germany. Schlemmer was able to find work in Stuttgart. From 1941, he worked at the Kurt Herberts paint factory in Wuppertal, where he collaborated with Willi Baumeister. Represented at the exhibition of *Twentieth Century German Art* organised by Herbert Read in London, Schlemmer had to fear sanctions. His mural *Familie* (Family, 1940-41, fig. 10, pp. 36f.) for the home of his friend Dieter Keller was not only his last major commission, but also became a symbol of eternal hope in the midst of war in Germany, like the Wuppertal *Fensterbilder* he created in 1942, the year before he died.

Will Grohmann et al., *Oskar Schlemmer, Zeichnungen und Graphik,* Stuttgart 1965.
Wulf Herzogenrath, *Oskar Schlemmer. Die Wandgestaltung der neuen Architektur,* Munich 1973.
Karin von Maur, *Oskar Schlemmer, Monographie und Oeuvrekatalog der Gemälde, Pastelle, Aquarelle und Plastiken,* 2 vols., Munich 1979.
Oskar Schlemmer, exhib. cat., Baltimore Museum of Art, Baltimore 1986.

Frieder Schnock
Born 1953 in Meissen, Elbe
Lives and works in Berlin

Renata Stih
Born 1955 in Zagreb
Lives and works in Berlin

Frieder Schnock and Renata Stih studied together at the Staatliche Akademie der Bildenden Künste in Karlsruhe from 1975-81. Renata Stih had public exhibitions as an artist from 1982 onwards (1984 Kunstforum, Städtische Galerie im Lenbachhaus, Munich, Staatsgalerie Stuttgart and Skulpturenmuseum Marl; 1986 Städtisches Kunstmuseum Bonn, on the occasion of the Dorothea von Stetten Art Prize; 1996 Museum of Contemporary Art, Zagreb). During this period, Frieder Schnock continued his studies of art history at the Freie Universität Berlin, worked in the field of advertising and marketing, ran the Gesellschaft für Blickschulung gallery and the Loft 44/45 in Berlin, curated exhibitions at the Museum Fridericianum in Kassel, acted as an art consultant for collectors in the USA, foundations and the architect Jean Nouvel in Paris, and wrote his doctoral thesis on land art (Richard Long). Since 1991, Renata Stih has held an interdisciplinary teaching position for Art and Technology at the Technische Fachhochschule Berlin. With the urban rehabilitation study *Baden-Baden: Sophienstraße* from 1979-82, they began working on joint projects for public spaces, in which the artists' personal biographies are secondary to the work. In their 1992-93 memorial *Orte des Erinnerns* at the Bayerisches Viertel in Berlin-Schöneberg, Stih and Schnock presented eighty text-and-image panels citing National Socialist laws and regulations, highlighting the resultant alienation, displacement and murder. Confronted with that which cannot be depicted, the artists reject symbolic monumental works in favour of a tangible rendering of historic contexts. In the current debate on memorials, they made their position clear in 1994, with their *Bus Stop Projekt* for the planned memorial to the murdered Jews of Europe in Berlin. Their concept was to use public bus stops in the centre of Berlin to create a link with the respective places of destruction. In 1994, Schnock and Stih created their audio-visual memorial *Bomben auf Walle* in Bremen-Walle and in 1995, their *Denkpause* communications and recreation areas for the Fachhochschule in Pforzheim, in 1995, a memorial for the former fashion centre of Hausvogteiplatz in Berlin, entitled *Nähset-Automaten* and in 1995-97, they realised a one-year, 24-hour programme for an LCD wall at the FHT (polytechnic) in Ettlingen. For the *Deutschlandbilder* exhibition, they explore the history of divided Germany through the headlines of the daily tabloids *Bild* and *Neues Deutschland* from the years 1953-89 (fig. 465, p. 484ff.).

Renata Stih/Frieder Schnock, Arbeitsbuch für ein Denkmal, Berlin 1993
Bus Stop – Fahrplan, issued by the Neue Gesellschaft für Bildende Kunst, Berlin 1995.
Renata Stih. Arroganz. Präpotenz. Indolenz, exhib. cat. of the Museum of Contemporary Art, Zagreb 1996.

Emil Schumacher
Photo: Ralf Cohen,
Ettlingen

Eugen Schönebeck
Born 1936 in Heidenau near Dresden
Lives and works in Berlin

Soon after starting an apprenticeship at the Meisterschule für angewandte Kunst in Berlin (east) in 1955, Eugen Schönebeck moved to the western part of the city, where he studied until 1961 at the Hochschule für bildende Künste under Hans Jaenisch and Hans Kuhn. It was there that he got to know Georg Baselitz in 1957, with whom he worked intensively over the following years. Their first joint exhibition in 1961, which was accompanied by a large-format poster with drawings and texts called *Pandemonium I Manifest* (fig. 150, p. 129), took place in a condemned house in Berlin. Supported by texts borrowed from their common model Antonin Artaud, they demanded a new kind of art which, with merciless candidness, would face up to reality in all its ugliness, obscenity and blasphemy. These joint activities ended with the publication of the *Pandemonium II Manifest* in 1962 (fig. 152, p. 131). Schönebeck then went his own way with a solo exhibition at the gallery in the Berlin Hilton Colonnades. After his second solo exhibition at the Benjamin Katz gallery in Berlin in 1965, to which there was also a poster, this time with a text by Eberhard Roters, Schönebeck, who was then 30 years old, gave up painting and retired from public life. The oeuvre he produced between 1957-1966 raises existential questions that in condensed form reflect the great dissent of that time at the cutting edge between history and the individual. In his early paintings, such as *Ginster* (1963; fig. 181, p. 145), the human body becomes a metaphor for human torment and vulnerability. His *Gekreuzigten* of 1963/64 are accusatory, forcing the observer to take a stand. His initially anonymous portraits, such as *The Real Human* (1964; fig. 185, p. 149), were followed by icons, in the style of mural painting, of revolutionary hope, figures such as Mayakovsky, Pasternak, Trotsky, and Mao Tse-tung. In 1973, the Abis gallery in Berlin showed his portraits again. Since 1980, his works from the years 1957-66 have been selected for inclusion in all the important exhibitions of German art since 1945. His drawings were shown by Silvia Menzel in Berlin in 1986 and by Jule Kewenig in Frechen in 1987. In 1992, Schönebeck was the first artist to be awarded the Fred Thieler Prize for painting presented by the Berlinische Galerie. That same year, the Kestner Gesellschaft in Hanover mounted the first comprehensive exhibition of his works.

Eugen Schönebeck, Zeichnungen 1960-63, exhib. cat., Galerie Silvia Menzel, Berlin 1988.
Eugen Schönebeck. Die Nacht des Malers. Bilder und Zeichnungen 1957-1966, exhib. cat., Kestner-Gesellschaft, Hanover 1992.

Emil Schumacher
Born 1912 in Hagen (Westphalia)
Lives and works in Hagen

Between 1932-35, Emil Schumacher trained at the Kunstgewerbeschule in Dortmund as a commercial artist. From 1935 onwards, he lived as a painter in his hometown of Hagen, but without participating in any exhibitions. His meeting in 1937 with Christian Rohlfs, who at that time was prohibited from painting by the National Socialists, was of great importance. Schumacher was obliged to work as a technical draughtsman in an armaments factory from 1939-45, so during that time he lacked both scope and time for artistic development. As a result, his success as an artist only began to take shape directly after the war. His first solo exhibition took place in 1947, in the Studio für neue Kunst in Wuppertal. In 1948, he was awarded the *junger westen* art prize of the City of Recklinghausen. Whereas initially Schumacher overlaid his landscapes with a cubist order, his experience of French art informel during a visit to Paris in late 1951 led to his first non-figurative paintings. *Der Herd* (The Stove, 1950; fig. 122, p. 104) belongs to this transitional phase, where as in works such as *Green Gate* (1958; fig. 123, p. 105), Schumacher achieved a breakthrough to a style which became typical of him and which involved gestural inscriptions into semi-sculptural, encrusted grounds, reminiscent in their pastose and sometimes brittle materiality of the structures of the earth's surface. His paintings combine the spontaneous painterly gestures characteristic of tachisme with pastose artistic material to form a German variant of the international art informel movement. The "tactile objects", with which he experimented briefly around 1957, are also located somewhere between relief and painting. Thanks to many years of collaboration, at first with the Galerie Parnass in Wuppertal as of 1956, then with Schüler in Berlin, Van de Loo in Munich, and Stadler in Paris, Schumacher gained great popularity in Germany. The Karl Ernst Osthaus Museum in Hagen showed his first museum exhibition in 1958. This was followed, three years later, by an exhibition at the Kestner Gesellschaft in Hanover. From 1958-60, Schumacher held a professorship at the Hamburg Hochschule für Bildende Künste. He also taught at the Staatliche Akademie der Bildenden Künste in Karlsruhe from 1966-67. Schumacher was one of the first of the young artist generation in Germany to gain recognition abroad in the late 50s. He exhibited at galleries in Milan, New York and Rome in 1959, and at the 1962 Venice Biennale. In 1963, Schumacher was awarded the art prize of the state of North Rhine-Westphalia and in 1982 the Rubens Prize of the City of Siegen.

Emil Schumacher, exhib. cat., Musée du Jeu de Paume, Paris; Haus der Kunst, Munich; Kunsthalle Hamburg 1997.

Andreas Slominski
Photo: Christina Dilger

Horst Strempel, 1946
Photo: Pan Walther, Dresden

Andreas Slominski

Born 1959 in Meppen
Lives and works in Hamburg

Andreas Slominski studied at the Hochschule für Bildende Künste in Hamburg from1983-86. In his first solo exhibition at the Hamburg Produzentengalerie in 1987 he showed traps, including animal traps, and "setting traps" is a theme that has remained central to his work. At the Kabinett für Aktuelle Kunst in Bremerhaven in 1988 Slominski installed a high-jump right next to the display window. In 1991, also in Bremerhaven, he embedded a human hand in a wall. The unlikelihood of his work permeated the empty exhibition space. Slominski's installations are frequently accompanied and influenced by apparently strange happenings. His Coup, at the Krefeld Museum Haus Esters in 1995, was clearly inspired by Mallarmé's Coup de Dés: Slominski had golf balls hit over the museum roof until finaly one of them landed on the slanted loading area of a truck, bounced, and shot through an open window into the exhibition room. The course of the golf balls, exactly calculated and yet dependent on numerous preconditons and chance elements, appears to describe the same train of thought which led Slominski, in that same exhibition, to locate "flying saucers" in nostalgic postcard motifs. His works betray a poetic and playful logic reminiscent of Marcel Broodthaers. In his installation *heizen,* first shown at Portikus in Frankfurt am Main in 1996 and now part of the collection of the Hamburg Kunsthalle, he burnt windmill sails in a small oven. The motif of the windmill also played a role in the exhibition at the Galerie Jablonka in Cologne in 1996, for which Durs Grünbein wrote a catalogue contribution. Slominski was awarded the 1991 Karl-Ströher Prize, Frankfurt am Main, the 1994 art prize of the Adolf-Luther Foundation, Krefeld, the 1995 Hanover Sprengel prize, and in the same year the art prize of the City of Bremen. He also participated in group exhibitions of younger artists such as Aperto, the Venice Biennale, and the BiNationale in Dusseldorf and Boston in 1988, and the Qui, quoi, où exhibition at the Musée d'Art Moderne in Paris in 1992. In 1997 Slominski's works were on show in the exhibition of sculpture in Münster and at the Venice Biennale.

Andreas Slominski, exhib. cat., Museum Haus Esters Krefeld/Kunstverein Bremerhaven 1995.

Horst Strempel

Born 1904 in Beuthen
Died 1975 in West Berlin

From 1922-27, Horst Strempel studied at the Kunstakademie Breslau under Oskar Moll and Otto Mueller. He moved to Berlin in 1927 and continued his studies at the Vereinigte Staatsschule under Karl Hofer in 1929. His political activities, and his subsequent membership of the German Communist Party, also began in Berlin where he was part of the circle that had built up around Carl von Ossietzky and his cultural magazine *Die Weltbühne.* From 1931 onwards, Strempel participated in various exhibitions. His first solo exhibition was in 1932 in the Preuss lending library in Berlin-Wedding. Due to difficulties with censorship, Strempel emigrated to Paris in 1933, leaving his artistic work to date behind him in Germany. In Paris, he managed to make a living by working as a draughtsman, scene painter and wallpaper designer. After differences of opinion with the German Communist Party's foreign committee, he was expelled from the party in 1936. During the early years of the war, Strempel was interned in different camps in France and the works he produced in exile were presumably destroyed by the Gestapo. Worn down by the trials and tribulations of exile, he returned voluntarily to Germany in 1941 and was dispatched to the war fronts in Yugoslavia and Greece. He returned to Berlin, Soviet Sector, in 1945. Strempel concentrated all the suffering experienced in the camps into his 1945 triptych *Nacht über Deutschland* (*Night over Germany,* fig. 57, p. 71). After the war, he was part of a circle of anti-fascist artists bent on contributing to the success of socialism. As of 1947, he taught at the Hochschule für angewandte Kunst in East Berlin, where he was appointed professor in 1949. In the course of the formalism debate, which began to emerge in 1948, Strempel got into more and more political difficulties. This reached a climax in 1951, when his mural painting in the Friedrichstrasse railway station was painted over. As a result, Strempel fled to West Berlin in 1953, where, due to the Cold War, he also got caught politically and artistically in the general crossfire, failing either to pick up where his post-war work had left off or to establish links with the western Avant-Garde.

Gabriele Saure, *'Nacht über Deutschland'. Horst Strempel. Leben und Werk 1904-1975,* Hamburg 1992.
Horst Strempel. Im Labyrinth des Kalten Krieges. Gemälde, Zeichnungen, Druckgrafik in den Jahren 1945-1953, exhib. cat., Märkisches Museum, Berlin 1993.

Rosemarie Trockel, 1992
Photo: Curtis Anderson,
Cologne

Werner Tübke
Photo: Udo Hesse, Berlin

Rosemarie Trockel
Born 1952 in Schwerte
Lives and works in Cologne

After studying at the Werkkunstschule in Cologne from 1974-78, Rosemarie Trockel first showed her sculptures in 1983 at the Monika Sprüth gallery in Cologne, where she has since exhibited regularly. Trockel's paintings, sculptures and drawings scrutinise a symbolic female language for its effectiveness and its inherent clichés. In the untypical context of her decorative embroidered patterns, the symbols of the swastika, the Playboy bunny or the hammer and sickle tend to lose their meaning, while at the same time undergoing a critical examination for their explosive emotional potential. The world of emotions is ascribed to the world of women, which consists of needlework, fashion, cooking, eroticism and feminism. The exaggeratedly bold and simple aspect of her sculptural works finds a counterpoint in the fleeting and hermetic aspect of her drawings, which often merely suggest, rather than clearly, depict, vases, containers, patterns, skulls, monkeys faces and, repeatedly, women and their sense organs. After exhibitions in Bonn in 1983, in Hamburg and in Basel in 1984, a first survey of her work was shown at the Rheinisches Landesmuseum in Bonn in 1985, followed by the Kunsthalle in Basel and the ICA in London in 1988. That same year, Trockel was represented in the group exhibition *Arbeit in Geschichte – Geschichte in Arbeit* at the Kunsthaus and Kunstverein in Hamburg, the *BiNationale. Deutsche Kunst der späten 80er Jahre* in Dusseldorf and Boston, and the touring exhibition mounted by the New York Guggenheim Museum *Refigured Painting / Neue Figuration*. A first monograph was published in 1991, on the occasion of an exhibition at the Institute of Contemporary Art in Boston. And the Museum für Gegenwartskunst in Basel mounted an exhibition of her works on paper, which toured to five different venues until 1992. Recent exhibitions at the Museum of Contemporary Art in Sydney, the Centre d'Art Contemporain in Geneva and the São Paulo Biennial in 1994 bear witness to this artist's international reputation. Trockel's masks entitled *Vater*, father and *Mutter*, mother (1994; fig. 319, pp. 316f.), first exhibited at the Israel Museum in Jerusalem in 1995, link the intimately biographical with the general historical, both of which run through her whole oeuvre. Whereas her mask sculptures of 1983 and her terrorist masks of 1986 already used the mask motif, the masks of the father and mother, each affected in their own way by the experience of war, appear to the child as symbolic masks. At documenta X in Kassel in 1997, Trockel presented a joint work with Carsten Höller.

Rosemarie Trockel. Anima, exhib. cat., Museum für angewandte Kunst Vienna 1994.
Rosemarie Trockel, exhib. cat., The Israel Museum, Jerusalem 1995.
Rosemarie Trockel, Herde, Werkverzeichnis, ed. by Gerhard Theewen, Cologne 1997.

Werner Tübke
Born 1929 in Schönebeck (Elbe)
Lives and works in Leipzig

After attending the Meisterschule für das deutsche Handwerk in Magdeburg from 1945-47, Werner Tübke began studying at the Hochschule für Grafik und Buchkunst in Leipzig under Ernst Hassebrauk and Elisabeth Voigt in 1948. He abandoned this after one year and took up studies in psychology and art education at the university in Greifswald. After his final examination in 1953, he worked for a short period as a lecturer at the Zentralhaus für Volkskunst. In 1954, he decided to return to Leipzig and work as a free-lance artist. After an interrupted assistantship, he was given a teaching post at the Leipzig Hochschule in 1965. Following Tübke's first large-scale commission for the Hotel Astoria in 1958, Alfred Kurella, head of the commission for cultural affairs at the SED Politbüro, became his most important patron. Tübke's systematic debate with the Third Reich, to which his *Requiem* for the victims of National Socialism bears witness, caused quite a stir in the 1960s. At that time, Tübke was still regarded by GDR cultural politicians as an esoteric outsider and a puzzling oddity. His success in the west, which began with a touring exhibition in Italy mounted by the Galerie del Levante in 1971, gave him the opportunity of travelling to Italy and the Mediterranean countries, where he was able to study the works of Veronese, Tintoretto and Tiepolo. In 1972, he was appointed professor at the Leipzig Hochschule, of which he was rector from 1973-76. His monumental mural painting *Arbeiterklasse und Intelligenz* for the new Leipzig University became an icon of the 1970s. Tübke's preference for multi-part cycles, paintings of altarpiece character, and comprehensive biographical and historical representations came to a climax in his panorama in Bad Frankenhausen of the Peasant War, on which he worked for twelve years from 1976. Before his complete works were shown in Dresden, Leipzig and Berlin (east) in 1975-76, Tübke had a solo exhibition at the del Levante gallery in Munich in 1972. He was represented at documenta 6 in Kassel in 1977 and had solo exhibitions in West Germany (Bremen and Hanover in 1978, Berlin and Frankfurt am Main in 1981, Nuremberg and Ravensburg in 1984). Tübke was awarded all the major East German prizes (including the 1974 and 1982 national prizes) and in 1983 was made a member of the Akademie der Künste der DDR (until 1992). As an artist officially recognised by the East German state, he was closely scrutinised by western critics who attacked his historicism as untimely or defended its intense artistry, refinement and complexity.

Werner Tübke. Gemälde, Aquarelle, Zeichnungen, Lithografie, exhib. cat., Nationalgalerie, Berlin (Ost) 1989.
Werner Tübke. Gemälde, Aquarelle, Zeichnungen, exhib. cat., Korch-Haus, Leipzig 1994.

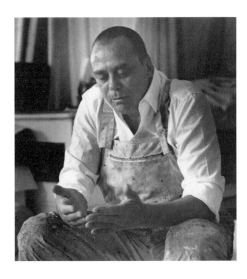

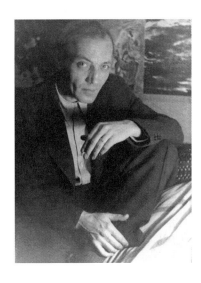

Günther Uecker
Photo:
Ingrid von Kruse,
Wuppertal

Hans Uhlmann
Photographer unknown

Günther Uecker
Born 1930 in Wendorf (Mecklenburg)
Lives and works in Dusseldorf

After an apprenticeship as a painter and advertisement designer in 1949, Günther Uecker studied at the Fachschule für angewandte Kunst in Wismar until 1953 and the Kunsthochschule in East Berlin. He then left the GDR, becoming one of the first "squatters" in West Berlin. Between 1955-57, he continued his art studies at the Kunstakademie in Dusseldorf under Otto Pankok. It was here that he developed his own formal idiom, in his first nail object of 1955-56 and his first nail paintings of 1957, which can be understood as an expression both of the injuries inflicted by the Third Reich and of the need for purification and a new beginning. Monochrome, initially often black, later white structured paintings, are damaged by the insertion of the nails, yet at the same time take on a new structure through the subsequent immaterial artistic means of the play of light and shade on the relief-like surface. In the late 50s Uecker got to know Heinz Mack and Otto Piene, members of the Zero group, which he also joined in 1961. In reaction to the already exhausted forms of art informel and abstract expressionism and with reference to ideas evident in the work of Yves Klein and Piero Manzoni on a new sensitisation, delimitation and liberation of art, the members of this group aimed to return to "point zero" by using light as their medium. Uecker's first solo exhibition took place in 1960 in the Schmela gallery in Dusseldorf. He then produced his first revolving light discs, organised Zero protests, and started covering everyday items of practical use with nails. As of 1958, he participated in all the important Zero exhibitions, until the group was disbanded in 1966. The Handschin gallery in Basel edited a first catalogue on Uecker's work in 1967. This was followed by exhibitions in the Kunsthalle in Bremerhaven and the Palais des Beaux Arts in Brussels in 1970, the Moderna Museet in Stockholm in 1971, and the Kestner Gesellschaft Hanover in 1972. Multimedia happenings and sculptures made of wood, planks, ropes and string are as essential to his oeuvre as his stage designs, outdoor sculptures and music projects. Uecker took advantage of extended trips around the world to pursue studies of indigenous cultures. He has been professor at the Dusseldorf Kunstakademie since 1974. A first comprehensive retrospective exhibition of his works was mounted in the gallery of the Hypo Cultural Foundation in Munich in 1993.

Dieter Honisch, *Uecker,* with a register of his works by Marion Haedecke, Stuttgart 1983.
Günther Uecker. Eine Retrospektive, exhib. cat., Kunsthalle der Hypo-Kulturstiftung, Munich 1993.

Hans Uhlmann
Born 1900 in Berlin
Died 1975 in Berlin

After graduating in engineering at the Technische Hochschule in Berlin between 1919-24, Hans Uhlmann produced his first sculptural works in 1925. He then taught at the Berlin Hochschule until 1933, when he was sentenced to two years' imprisonment for taking part in an anti-Nazi protest. On his release, he earned his living as an engineer until the end of the war, while at the same working secretly and in complete isolation on his sculpture. After a series of plaster sculptures, in 1935, he began to produce wire and tin sculptures that carried through trends prevalent in the Russian Avant-Garde. It is also possible that he was inspired by the early wire sculptures of Alexander Calder, whose works were shown in 1929 at the Nierendorf gallery. Although Uhlmann never made the personal acquaintance of Naum Gabo, who lived in Berlin from 1922-31, the latter's concept of sculpture as a weightless, transparent, architectonic construction is clearly recognisable in Uhlmann's almost abstract variations on the theme of the human head in the thirties (fig. 26-28, p. 51). These sculptures, constructed from the inside out, give rise to alternating overlaps, which seem at certain junctures to form pairs of eyes. As the foundation of his later work, this phase is the most important in his artistic development. Uhlmann's first exhibition was in 1945, in Kamillenstrasse in Berlin Lichterfelde, where, as head of the Steglitz adult education authority, he himself organised several exhibitions the following year. From 1946-48, he was head of exhibitions at the Gerd Rosen gallery in Berlin. An exhibition of his own works there in 1947 attracted great public attention. In 1950, Uhlmann received the Berlin art prize and was appointed to the Hochschule für bildende Künste. Relieved of material cares, he was then able to devote his full attention to his art. That same year, his works were exhibited for the first time outside Berlin, at the Günther Franke gallery in Munich. As of 1951, his steel sculptures, also intended for outdoors, began to demand new production methods and offered new potential for monumental design. Numerous commissions for large-scale sculptures for the public domain followed. His participation at documenta 1 in Kassel in 1955 brought him international recognition and resulted in important exhibitions in America. Thus, Hans Uhlmann is one of the few German sculptors, who after years of "inner emigration" was able to form a link with the international abstraction of the post-war period by taking up the sculptural trends of the constructivists.

Werner Haftmann, *Hans Uhlmann - Leben und Werk,*
with a register of his sculptures by Ursula Lehmann-Brockhaus (Schriftenreihe der Akademie der Künste, vol. 11), Berlin 1975.

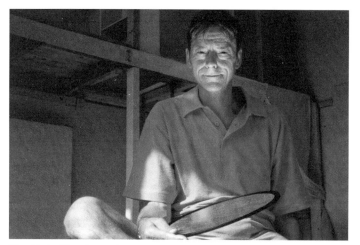

Ulay, Photo: Ulay, Amsterdam

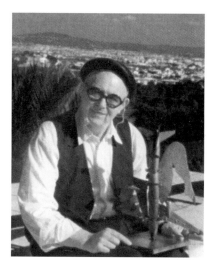

Wolf Vostell
Photo: privately owned

Ulay
Born Uwe Laysiepen in 1943 in Solingen
Lives and works in Amsterdam

While studying mechanical engineering from 1957-61, Uwe Laysiepen became interested in socially critical photography and opened a commercial photography laboratory, which he then handed over to his wife in 1968 before leaving for Amsterdam to make a whole new start. He began utilising photography as a means of questioning identity. He studied photography for a year and a half at the Fachhochschule in Cologne, where he met Jürgen Klauke. Commuting between Cologne and Amsterdam, he received a commission from Polaroid International in Amsterdam in 1970 and devoted his energies to environmental issues. Between 1971-73, he produced portraits of himself as a transvestite onto which he inscribed aphorisms. His performance with Klauke at Stichting de Appel in Amsterdam in 1974 represented a continuation of his investigations into identity. On the occasion of the first exhibition of his photographic works that same year at the Seriaal gallery in Amsterdam, he adopted the artist's name of Ulay. Disillusioned with how his work was being received, he turned his back on photography with his 1975 installation *Fototot* at Stichting de Appel, and took up performance art again. In 1975, he met the Yugoslav performance artist Marina Abramovic, with whom he lived and worked for twelve years. In 1976, they were invited to the Venice Biennale, after which they both moved to West Berlin, where in 1976 they staged and documented the theft from the Berlin Nationalgalerie of the German icon *Der arme Poet* by Spitzweg. This marked the end of the first phase in Ulay's career, or "Act One". The happening involved hanging the painting in the flat of a Turkish family, and served as the basis for the 1976-97 video installation *Da ist eine kriminelle Berührung in der Kunst* (*There is a Criminal Touch in Art*, fig. 409, pp. 452ff.). "Act Two" in his artistic career, which lasted from 1976-88, comprised performance work with Abramovic. During this time, the pair lived and worked with Australian aborigines and travelled to India, North Africa and China. When their relationship ended, "Act Three" of Ulay's career began with his return to photography in 1989. In 1991, he exhibited a first cycle of his *Photo-genes* at the New York Vrej Baghoomian Gallery. As of 1994, he has worked with colour prints and reversal processing. For the series *Ulay's Flags for the European Community,* he had colour negative flags made. Solo exhibitions of more recent photographic works have been held in Berlin, 1994-95 and 1996, Yamaguchi, Japan, 1997, and elsewhere.

Thomas McEvilley, *Ulay. Der Erste Akt,* Ostfildern 1994.
Wolfgang Winkler, *Transfer von Bildern durch Bilder hindurch,* exhib. cat.,
 The Yamaguchi Prefectural Museum of Art, Yamaguchi, Japan, 1997.
Ulay / Abramovic, 12 years performance, 1976-1988, exhib. cat.,
 Stedelijk Van Abbemuseum, Eindhoven 1997

Wolf Vostell
Born 1932 in Leverkusen
Lives and works in Berlin and Malpartida da Càceres, Spain

After an apprenticeship in lithography from 1950-53, Wolf Vostell studied for a year at the Werkkunstschule in Wuppertal, but during his first trip to Paris in 1954, enrolled at the Ecole Supérieur des Beaux Arts (1955-57). He then developed the décollage principle, which was to be so important for his work. He aimed, among other things, to draw attention to the destruction of the environment as a result of increasing technology. Vostell attended the Kunstakademie in Dusseldorf in 1957. In Paris, in 1958, he organised his first happening with television sets and car parts. His first solo exhibition took place in Paris in 1961, at the Le Soleil dans la Tête gallery. Vostell's utilisation and destruction of everyday items is related to concurrent happenings by French Nouveaux Réalistes, as well as to newspaper décollages by Rotella, Villeglé and Hains, to César's car body *Compressions,* and to Arman's *Accumulations.* Vostell confronted the greatest act of annihilation in German history, the annihilation of the Jews, in his environment *Schwarzes Zimmer* (1958; ill. 238-240, pp. 209 f.), avoiding the danger inherent in the décollage principle of becoming narrative or conciliatory by using deliberately sparing and suggestive means — in a totally darkened room a single spotlight from the concentration camp Auschwitz blinds the viewer. In 1959, Vostell moved to Cologne, commuting to Wuppertal to teach typography at the Werkkunstschule there from 1959-60. Vostell was involved in the 1962 Festum Fluxorum in Wiesbaden in collaboration with American students of John Cage. The first exhibition of his *TV Environment* in New York was in 1963. He also took part in the *Yam Fluxus Festival* and the happening *You* in 1964. As part of the close circle of Fluxus artists around Georg Maciunas, Vostell's happenings complemented Allan Kaprow's happening concept by adding a socio-political dimension. Further happenings with René Block in West Berlin and New York were followed in 1965-66 by a first retrospective exhibition at the Cologne Kunstverein. On the occasion of the Cologne Art Market in 1969, Vostell organised one of his décollage happenings, entitled *Ruhender Verkehr:* he covered his car in cement. This was followed by further sculptures with cars and cement. In 1971, Vostell moved to West Berlin, where he founded the Vostell Happening Archive and set up Germany's first videotheque at the Neuer Berliner Kunstverein. Retrospective exhibitions took place at the Musée d'Art Moderne in Paris in 1974, the West Berlin Nationalgalerie in 1975, and in Madrid, Barcelona and Lisbon in 1978-79. To mark his 60th birthday in 1992, the Museum Ludwig in Cologne mounted an exhibition that toured several German cities.

Wolf Vostell, exhib. cat., Museum Ludwig, Cologne; Rheinisches Landesmuseum,
 Bonn etc. 1992.

Franz Erhard Walther
Photo: Manfred Leve,
Nuremberg

Fritz Winter, Bauhaus 1928
Photo: Fritz Winter Haus,
Ahlen, Westphalia

Franz Erhard Walther
Born 1939 in Fulda
Lives and works near Fulda and in Hamburg

Franz Erhard Walther attended drawing classes given by Rudolf Kubesch in Fulda in 1955. He applied to the Werkkunstschule in Offenbach in 1956, passed the entry exam but was refused because he was too young; he was not admitted until 1957. In 1959, he began studying at the Staatliche Hochschule für Bildende Künste in Frankfurt am Main, only to be expelled in 1961 due to a controversy. His concept of the material process as a work form crystallised in 1962. In his use of simple materials, as for example in his *Seven Works of Glued Packing Paper II* (1963; fig. 277, pp. 251ff.), Walther promoted the aesthetics of arte povera, which is read in Germany as a reaction to the "economic miracle". While studying at the Dusseldorf Kunstakademie under K. O. Götz from 1962-64, Walther discovered the store-room as a form and in 1963 began work on his *I. Werksatz*. Objects designed by him and sewn by his wife serve as material for recalling primal experiences, a process he pursues from 1964 onwards, exhibiting all the objects for the first time at the Rudolf Zwirner gallery in Cologne in 1968 and in the Haus Lange museum in Krefeld and the Städtische Kunsthalle Dusseldorf in 1969. Walther's key term during his Dusseldorf years (1964-67) was "self-discovery". His motto was "using objects", a term also used the title of his first publication with the Gebr. König publishing house in 1968. He aimed to redefine the work of art to include interactivity and constant renewal of perception. While in New York from 1967-73, he showed his *I. Werksatz* at the Museum of Modern Art in 1969-70. From 1969-72, he also worked on his *2. Werksatz,* made of large walk-in metal objects. Walther attempted to systematise the perception of space, time and movement in the striding and standing pieces he created between 1973-78. He has been combining neutral with bright cotton fabrics into wall-formations based on classical-historical models of form since 1979. Walther has been represented in all major surveys of German Art and exhibitions of international importance, incl. *When Attitudes become Form* at the Kunsthalle Bern in 1969, *Westkunst*, in Cologne in 1971, and documenta 5, 6, 7 and 8 in Kassel. He has been professor at the Hochschule für Bildende Künste in Hamburg since 1971.

Franz Erhard Walther. Bild und Sockel zugleich. Zeit ruht,
 exhib. cat., Kunsthalle Dresden, 1997.
Franz Erhard Walther. Mit dem Körper sehen. Werkentwicklung, Werkbeispiele,
 1957-1997, exhib. cat., Kunstsammlung Gera, 1997.
Susanne Richardt (ed.), *Franz Erhard Walther. Stirn statt Auge. Das Sprachwerk,*
 Ostfildern-Ruit bei Stuttgart, 1997.

Fritz Winter
Born 1905 in Altenbögge, Westphalia
Died 1976 in Herrsching am Ammersee

Fritz Winter came from a modest background. His first attempts at drawing and painting were in 1924 and were modelled on the work of Paula Modersohn-Becker and Vincent van Gogh. While studying at the Bauhaus in Dessau from 1927-30, his work gained recognition from Kandinsky and Klee, in particular. Winter got to know Ernst Ludwig Kirchner in Davos in 1929. It was Kirchner who helped him to make his first sales by organising three exhibitions in Davos. In 1930, Winter took off a term to assist in Naum Gabo's studio in Berlin, an experience which left its mark on the work *Gerüst* (Scaffolding, 1933; fig. 29, p. 53). After his first solo exhibition in Germany, near Buchholz in Berlin in 1930, Winter worked as a drawing teacher in Halle an der Saale. His promising career was interrupted, when the National Socialists came to power in 1933, and this put Winter into a difficult situation, both financially and psychologically. He moved to Munich in 1933, with his friend and patron Margarete Schreiber-Rüffer. Having retreated into "inner emigration", his works became brighter, more expressive, larger: " ... the darker it becomes outside, the brighter my colours become ..." Despite the difficult situation for abstract painters, and without being able to exhibit, Winter continued to work until he was banned from doing so in 1937. At the outbreak of war, he was called up for mi litary service and wounded several times. He returned to Germany from a Russian prisoner-of-war camp in 1949. The cycle *Triebkräfte der Erde* was painted during the war (1943-44). As a founding-member of the Zen 49 group, Winter took a stand in the conflict between abstract and figurative art in the 1950s, resigning from the Deutscher Künstlerbund in 1954, along with Nay and Baumeister, despite the fact that the Künstlerbund had awarded him its first prize in 1951. In 1955, Winter was given a professorship at the Hochschule für bildende Künste in Kassel. In 1958, he received the art prize of the Brussels World Exposition and of the City of Berlin, and in 1959 the prize of the state of North Rhine-Westphalia. In 1966, on the occasion of Winter's sixtieth birthday, Kassel mounted a large-scale touring exhibition of his work. One year before his death in 1976, the Fritz Winter Haus in Ahlen, Westphalia, was inaugurated. Winter's estate is preserved in the form of a foundation in the gallery of the City of Stuttgart.

Gabriele Lohberg, *Fritz Winter. Leben und Werk,* with a register
 of paintings and an appendix on the various techniques, Munich 1987.
Fritz Winter, exhib. cat., Galerie der Stadt Stuttgart, 1990.

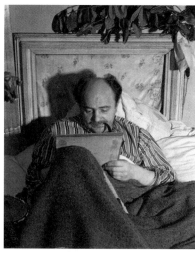

Wols in a hotel room
1948-49
Photo: Walter, Montreuil

Penny Yassour
Photographer
unknown

Wols
Born 1913 in Berlin as Alfred Otto Wolfgang Schulze
Died 1951 in Paris

The Schulze family moved from Berlin to Dresden in 1919, where Wols' many and varied talents soon became evident and received the full encouragement of his parents. He refused the offer of a position as concert master at the Dresden Opera House, opting instead for photography, a decision supported by Hugo Erfurth. On the advice of László Moholy-Nagy, under whom Wols wanted to study at the Bauhaus, the then 19-year-old, with his strong anti-fascist convictions, left Germany in 1932 and headed for the art metropolis of Paris. In 1933, he travelled to Barcelona with his future wife, Gréty. After an interim stay on Ibiza, he was interned in Barcelona for political reasons in 1935 and deported to France. The situation then became stable for a while, with the result that in 1937 he was able to work as an official photographer at the Paris World Exposition. While in Paris, he made friends with many surrealist artists and writers. At the outbreak of war in 1939, he was interned again. During that time he began to draw and water-colour, and turned to drink. On his release in 1940, he and his wife lived in abject poverty and continual fear of renewed internment. Several attempts to emigrate to the USA failed, due to his difficult economic circumstances. The Paris art dealer René Drouin mounted a first exhibition of his works in 1945, at the instigation of his friend the poet Henri-Pierre Roché. Though this did not bring him financial success, it did bring his work to the attention of Jean Paulhan, Henri Michaux and Jean-Paul Sartre, and the latter repeatedly supported him in the years to come. Up until then, Wols had been producing — primarily for financial reasons — mainly small-format drawings, water-colours, etchings, and above all photographs. As of 1946, he began to paint in oils. His sur-realist fantasies became compressed into proliferating organisms, be they heads, cities, ships or bundles, whose mode of depiction, despite their slen-der forms, intensify their oppressive and explosive power to an extreme degree. Wols' first forty paintings, including *Vert cache rouge* and *Oui, Oui, Oui* (fig. 30, 31, pp. 55f.) were shown by Drouin a second time. The artistic oeuvre Wols created in the four years before his death comprises about eighty paint-ings. Despite growing public recognition — his first exhibition at Jolas in the Hugo Gallery in New York took place in 1950 — his life was blighted by finan-cial worries and ill health, which contribute an existential dimension to the work of this forerunner of art informel. Wols died of food poisoning in Paris in 1951.

Wols, exhib. cat., Zurich; Kunstsammlung Nordrhein-Westfalen, Dusseldorf, 1990.

Penny Yassour
Born 1950 on the kibbutz Ein Harod in Israel
Lives and works in Ein Harod

Penny Yassour grew up in the place of her birth, the kibbutz of Ein Harod. After studying art and geography at the University of Haifa from 1972-75, she became preoccupied with maps as abstract copies of the real world. Her first exhibitions were held in 1980, at the Hakibbutz Gallery in Tel Aviv (repeat-ed in 1983) and the Mishkan Le'Omanut Art Museum in Ein Harod. That same year, she participated in the group exhibition *Landscape, Climate, Earth* at the Hakibbutz Gallery in Tel Aviv and the Sixth Biennial of young artists at the Haifa Museum of Modern Art. Having participated in meetings of contemporary artists in Tel Hai in 1983 and Ra'anana in 1984, group exhibi-tions in Tel Aviv and Ein Haros in 1985, the exhibition *A Myth without God* in Jerusalem, Tel Aviv and Ein Harod in 1987, and an exhibition of contem-porary Israeli art that toured Sweden, Denmark and Spain, Yassour returned to the University of Tel Aviv in 1988-89, to study art history. During that time, she began producing mainly flat sculptural elements made of iron, which were exhibited at the Artists Studios in Jerusalem and at the Jerusalem Foun-dation in 1990. Her installation *Mental Maps — Production Halls* (1993), exhib-ited for the first time in 1993 at the Mishkan Le'Omanut Art Museum in Ein Harod, is a reference to the enormous factory owned by the Messerschmidt company near Jena that produced fighter planes underground in 1944-45. A further development of this work entitled *Mental Maps — Involuntary Memory, Berlin 1997* (fig. 467, p. 492) was shown in the *Deutschlandbilder* exhibition. In 1994 Yassour went on to develop her spiritual maps further in the studio exhibition *Mental Maps — Default Space,* which took place within the frame-work of *Art Focus* held at the Mishkan Le'Omanut Art Museum in Ein Harod, while the Villa Arson in Nice published the artist book *Atlas: A Spatio-Histor-ical Voyage.* That same year, Yassour received a scholarship from the ministry of science and art. 1996 saw the creation of her installation *Mental Maps — Antarctica — Traces of impossible departure,* which was also exhibited at the Mishkan Le'Omanut Art Museum in Ein Harod, where, that same year, Yassour also mounted the studio exhibition *Acephalus Labyrinth Theater,* again within the framework of *Art Focus.* Penny Yassour has been working as an artist in residence at the University of Marseilles in France since 1996 (until 1998). She was represented at documenta X with her work *Mental Maps — Invol-untary Memory,* Kassel 1997.

Penny Yassour, Mental Maps — Production Halls, exhib. cat., Mishkan Le'Omanut, Museum of Art, Ein Harod 1995.

HP Zimmer, 1988
Photographer unknown

Hans Peter Zimmer
Born 1936 in Berlin
Died 1992 in Soltau

HP Zimmer gained his first impressions of art through his uncle, the Braun-schweig art collector Otto Ralfs. Zimmer began his studies at the Hochschu-le für Bildende Künste in Hamburg, under Kurt Kranz and Johannes Itten in 1956-57, continuing in Munich at the Kunstakademie between 1957-60. There, he made friends with Lothar Fischer, Heimrad Prem and Helmut Sturm, with whom, in 1958, he founded the group SPUR, which published both the SPUR magazine and the SPUR book. Shortly afterwards, he got to know Asger Jorn, who exercised a considerable influence on the group. It was Jorn who introduced Zimmer to the Situationist International, of which he was a member from 1959-62. The political thrust of SPUR, which linked the expres-sive pathos of CoBrA with contemporary political polemics and concrete fu-ture utopias, was directed against *Die oberen Zehntausend* (High Society, 1959; fig. 186, p. 150) and resulted in the SPUR trial of 1962-64 and the subsequent temporary exile of the group in Scandinavia. Zimmer's first solo exhibition took place at the Galerie Westing in Odense (Denmark) in 1963. Among others, the van de Loo gallery in Munich has exhibited his work since 1964. During that period, he produced plans for fantastic architectural works: the SPUR building for the Biennial in Paris in 1963 and a mural painting for the Palazzo Grassi in Venice. In 1965, he painted the dining room at the home of Paolo Marinotti in Milan. During his trips to Italy, he got to know the works of Dubuffet, through whom art brut was received in Germany, though some-what later than in other countries. When SPUR was more or less disbanded in 1965, Zimmer became a member of the newly founded group Geflecht in 1966. Having interrupted his artistic work for a year, Zimmer retired from that group in 1967 and in 1968 attempted a new beginning in Italy. This was characterised by an increasing concretisation of his pictorial idiom. In 1973, he moved from Munich to Aschau in Chiemgau. His first museum exhibition was in 1978 at the Sonderjyllands Kunstmuseum in Tondern, Denmark. He was then invited to the Ostsee Biennial in Rostock in 1979. In 1982, he was appointed professor at the Hochschule für Bildende Künste in Braunschweig and moved there in 1985. In 1986, he founded an Institute for Daemonological Aesthetics. The Kunstverein in Wolfsburg showed a solo exhibition in 1986. In his final years, Zimmer produced objects made of wood, wire and iron. He also kept a diary over many years, parts of which have been published. 1984 saw the publication of his *Selbstgespräche*. In 1989, the Kunstmuseum in Herning and the Kunsthallen Brandts Klaedefabrik in Odense mounted a retrospective exhibition of Zimmer's work, which was also shown at the Leopold Hoesch Museum in Düren in 1991.

German Dance. Hommage an HP Zimmer, exhib. cat., Gustav Lübcke Museum, Hamm 1996.

Selected Exhibitions and Publications on German Art after 1945

"Deutsche Kunst unserer Zeit, 20.10.–18.11.1945", Überlingen 1945. Rückkehr der Moderne. The first exhi-bition on banned Art after WW II in 1945, 1995 etc.

"Allgemeine deutsche Kunstausstel-lung", Stadthalle Nordplatz, Dresden 1946, compiled by Hans Grundig and Will Gromann.

"German Art of the Twentieth Century", selected by Werner Haft-mann, Museum of Modern Art, New York 1957, Saint Louis 1958.

"Weggefährten – Zeitgenossen. Bildende Kunst aus drei Jahrhunder-ten. Ausstellung zum 30. Jahrestag der Gründung der DDR", Berlin 1979. Günter and Ursula Feist. First attempt at a historical treatment of art from the GDR.

"30 Jahre Kunst in der Bundesrepublik Deutschland", Kunstmuseum Bonn, 1979/80.

"Art Allemagne Aujourd'hui", ARC/ Musée d'Art Moderne de la Ville de Paris, 1981.
With over 40 participants the first repre-sentative exhibition in a foreign country on contemporary German art.

"Expressions. New Art from Germany", ed. by Jack Cowart, touring exhibition through the USA 1983/84: Saint Louis, Philadelphia, Cincinnati, Chica-go, Washington D.C.
First showing of artists such as Baselitz, Immendorff, Kiefer, Lüpertz, A.R. Penck in the USA.

"Deutsche Kunst seit 1960. Sammlung Prinz Franz von Bayern", ed. by Carla Schulz-Hoffmann and Peter-Klaus Schuster, Staatsgalerie moderner Kunst (Munich 1985).

"Deutsche Kunst im 20. Jahrhundert. Malerei und Plastik 1905–1985", ed. by Christos M. Joachimides, Norman Rosenthal and Wieland Schmied, Royal Academie of Arts London 1985, Staatsgalerie Stuttgart 1986.

"Kunst in der Bundesrepublik Deutschland 1945–1985", National-galerie Berlin 1985/86.
With thorough documentation of events and exhibitions in the catalog (Berlin 1985), 454–616.

"Arbeit in Geschichte – Geschichte in Arbeit", Kunsthaus und Kunstverein Hamburg 1988 (catalog Berlin 1988). Compiled by Georg Bussmann and Petra von der Osten-Sacken. This exhibition addressed the question as to "why the proclaimed Antifascism of the time had no effect".

"Neue Figuration. Deutsche Malerei 1960–88", ed. by Thomas Krens, Michael Govan and Joseph Thompson, touring exhibition starting at Solomon R. Guggenheim Museum, New York 1989.

"Zeitbilder – 40 Jahre Bundesrepublik Deutschland", Mannheimer Kunstver-ein (Mannheim 1989).

"Die Endlichkeit der Freiheit". Berlin 1990. An exhibition project in East and West, places in public space (Berlin 1990).

"Zone D. Innenraum", Förderkreis der Leipziger Galerie für zeitgenössische Kunst, Leipzig 1991.

"Von der Teilung bis zur Wiederverei-nigung. 40 Jahre Kunst in Deutsch-land aus der Sammlung Ludwig", Cologne 1992.

"Deutschsein? Eine Ausstellung gegen Fremdenhaß und Gewalt", Kunsthalle Dusseldorf, Dusseldorf 1993.

"Kunst in Deutschland 1945–1995. Beitrag deutscher Künstler aus Mittel-und Osteuropa", Museum Ostdeutsche Galerie Regensburg, 1995.

Publications

Christoph Becker/Annette Lagler, *Biennale Venedig. Der deutsche Beitrag 1895–1995,* ed. Institut für Auslandsbeziehungen, Stuttgart (Ostfildern 1995).

Hans Belting, *Die Deutschen und ihre Kunst* (München 1992).

Martin Damus, *Malerei der DDR. Funk-tionen der bildenden Kunst im Realen Sozialismus* (Reinbek bei Hamburg 1991).

Martin Damus, *Kunst in der BRD 1945–1990. Funktionen der Kunst in einer demokratisch verfaßten Gesell-schaft* (Reinbek bei Hamburg 1995).

Wieland Schmied, *Malerei nach 1945 in Deutschland, Österreich und der Schweiz* (Frankfurt/Main and Berlin 1974).

Karin Thomas, *Zweimal deutsche Kunst nach 1945. 40 Jahre Nähe und Ferne* (Cologne 1985).